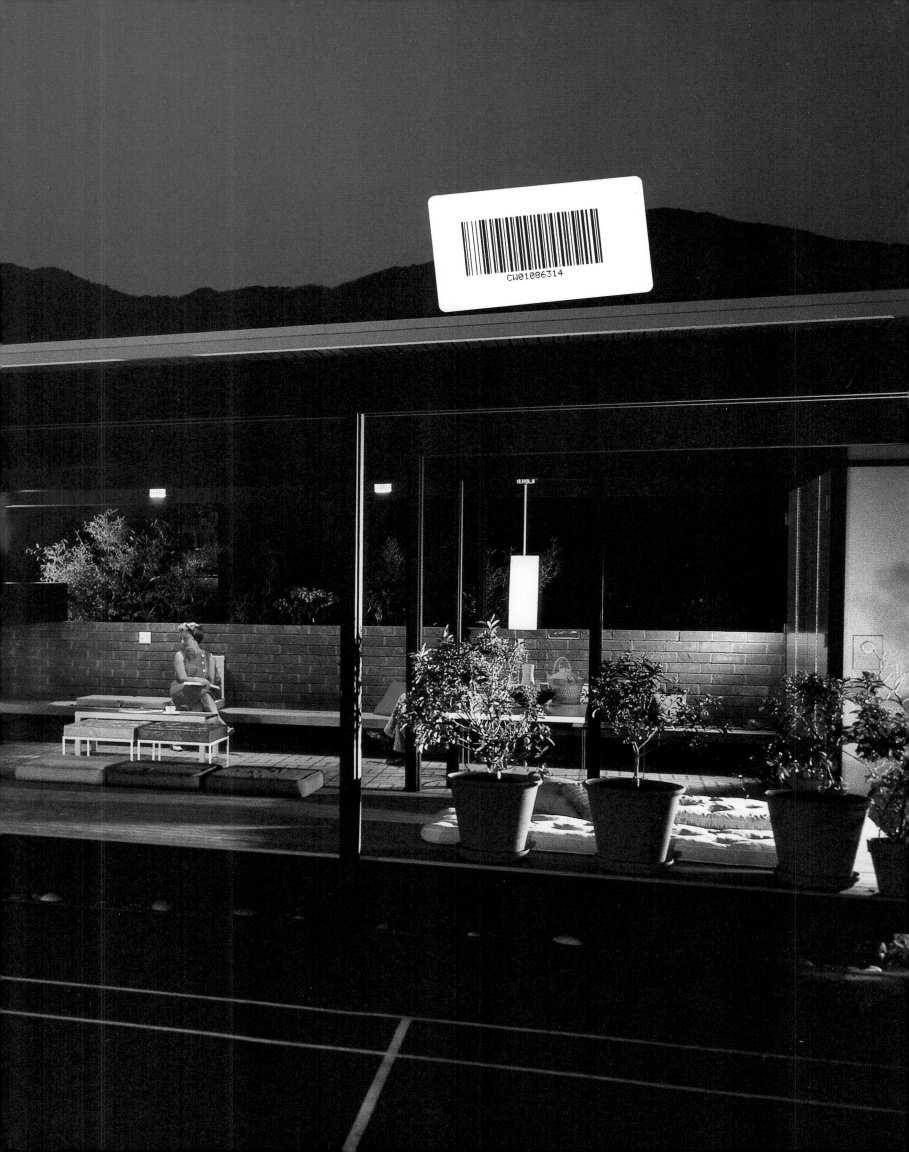

Julius Shulman
Modernism Rediscovered

Text by Pierluigi Serraino

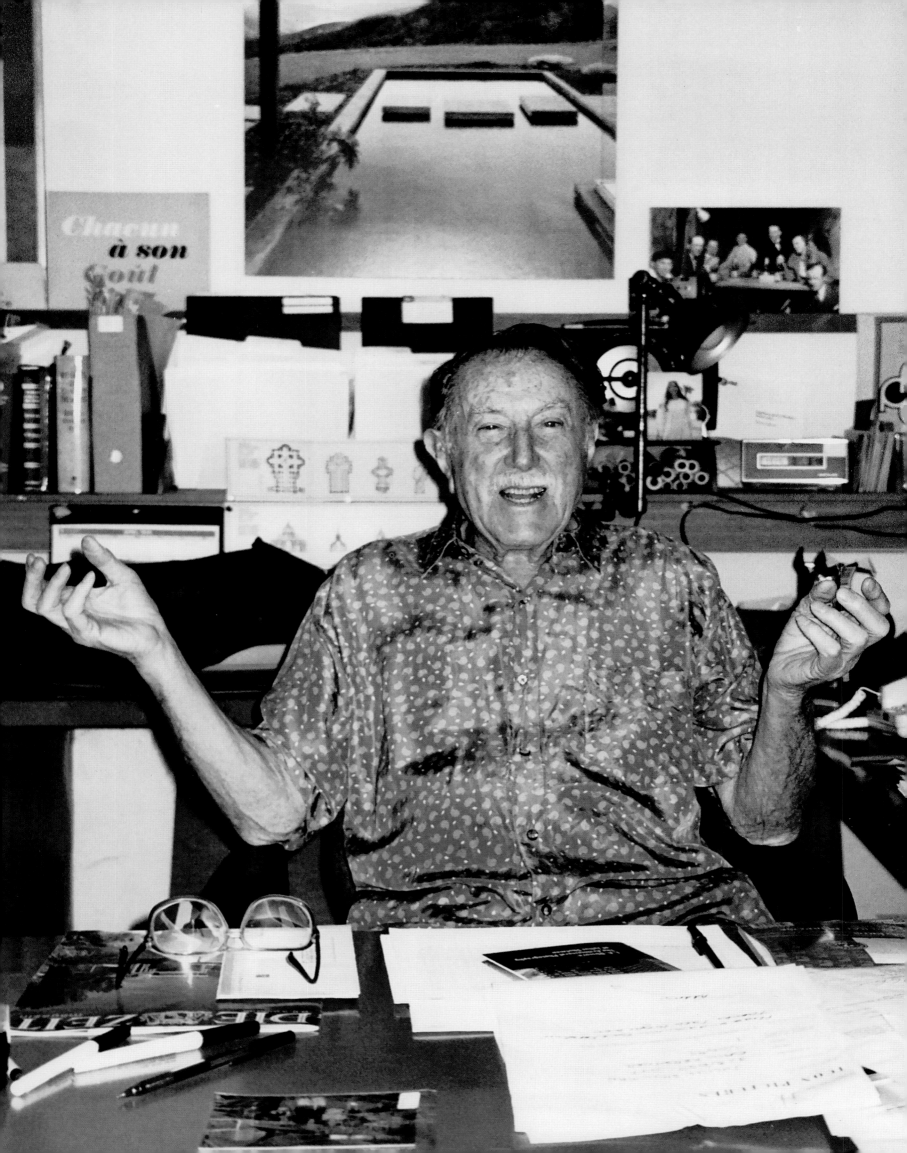

Julius Shulman
Modernism Rediscovered
Die wiederentdeckte Moderne
La redécouverte d'un modernisme

Text by Pierluigi Serraino

TASCHEN

HONG KONG KÖLN LONDON LOS ANGELES MADRID PARIS TOKYO

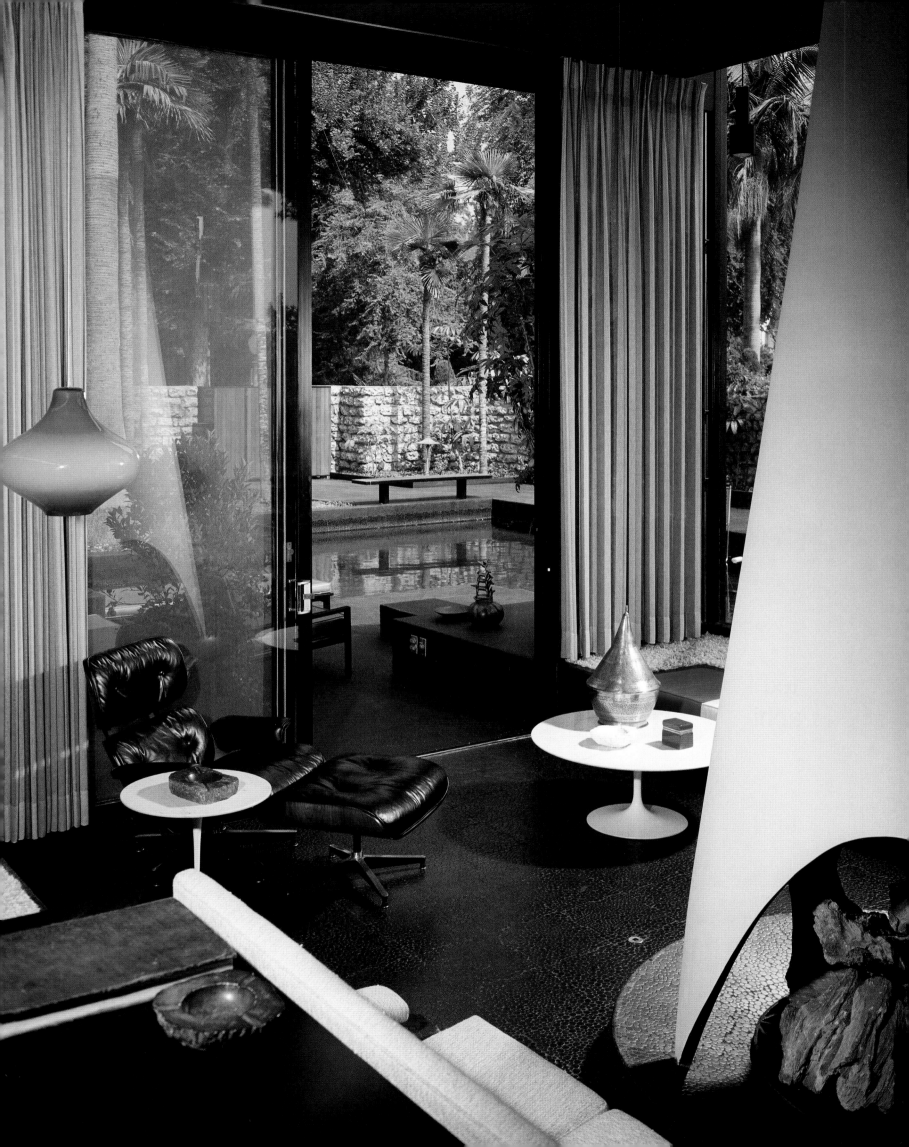

Contents | Inhalt | Content

Photography and the Emergence of American Modernism
From the Earliest International Style to the 70s

To enter architectural discourse, a building must be photographed and repeatedly published in widely read design magazines, or else it will be forgotten and never exist in the reader's consciousness. This argument was developed in the wake of primary research conducted in the private archive of Julius Shulman, architectural photographer of American Modernism. The photographic material retrieved, largely unknown to the general public, bears witness to the excellence of architectural exploration throughout 44 states. Why were these projects forgotten by the later generations? Is there a reason why some buildings are remembered and for others drop from memory? And what is the role of photography in this process? This study looks at the editorial machinery engineering the permanent inclusion of a work of architecture in the collective memory.

Three different objectives inform the literary format and the photographic content of this book.
The first is to exhibit the works of Julius Shulman that received minimal public exposure due to limited circulation. Pictures of Richard Neutra's Kaufmann House (1947) and Pierre Koenig's Case Study House #22 (1960) have permanently established Julius Shulman's photographic authority in architectural culture. Still widely published today, these two black and white images have become icons of post-war life in California. But the *œuvre* of the American photographer far exceeds these two well-known photographs. Between 1936 and 1986, Shulman completed some 6,000 photographic assignments in North America and in other continents. From the early 40s on, every single building was documented in black and white photographs and 35-mm color slides.

The second is to reopen the debate on California Modernism and Mid-West Modern Architecture. In 1945, the Case Study House Program of John Entenza, editor of *arts & architecture*, commanded the attention of the national and international community with its unprecedented visions of domestic space in Southern California. Parallel to Entenza's initiative, a lively professional scene was involved in radical architectural explorations without the editorial benefits of the large-scale publicity granted by *arts & architecture*. Outside California, architects practicing in remote areas of the United States produced design statements whose recognition hardly went beyond regional boundaries. Built far from architectural centers, these projects were known primarily to the local audience, and unfamiliar to a larger public. Next to the American and European modern masters, scores of less familiar architects and unknown designers, like William Sutherland Becket, Raymond Crites, Emerson Stewart Williams, Carl L. Maston, Gordon Drake, Richard Dorman and Mario Corbett among

others, populate the photographer's logbooks. Why are their names so little known to us?

The third is to show how current architectural databases available for scholarly research leave out documents of significant relevance for architecture, reducing certain buildings to a state of effective invisibility. Architects hungry for publication capitalized on Shulman's reputation and artistry to reach notoriety. The photographer's studio is filled with magazines, books and printed materials where his work was published. Many of these titles are not listed in the architectural indexes, making the search for information on a particular project extremely problematic. Magazines such as *Building Progress* and *Designers West*, for example, featured the architectural styles of the Mid-West and Pacific regions of the United States. Yet, their exclusion from the array of titles forming the databases limits our understanding of the complexity of the professional scene during the period covered in this study. A case in point is the Pereira Residence (see p. 328). Despite the numerous publications preserved in the photographer's archive and in university libraries, the project is registered only in one index and under one magazine, *House & Home*.

The publishing scene

With few exceptions, the selected projects feature public and private structures built between 1939 and 1980, which received marginal recognition through awards or media coverage.
During the period under investigation, the leading architectural journals in the United States were *Architectural Forum*, *Progressive Architecture*, *Architectural Record*, *House & Home*, *Interiors* and the *American Institute of Architects (AIA) Journal* [note1]. They were intended primarily for practicing professionals and were read by the majority of architects in the country. Between the 40s and the 50s, two additional periodicals, *arts and architecture*, based in Los Angeles, and *Architectural and Engineering News*, based in New York, appeared, but they folded in the early 60s [note 2]. These seven magazines became the sounding board of architectural events in North America. They outlined an editorial territory where a broad selection of designs were published and offered to the public attention.

A separate group of magazines chronicled the design debate at state level. *Building Progress, Architecture West, Pacific Architect and Builder, Designers West*, and *Concrete Masonry Age* brought a wide spectrum of projects by local builders to the attention of the professional readership. Occasionally the material featured in these publications appeared also in the

periodicals of the architectural establishment. More often than not, these design statements remained within the realm of regional publications.

A rather different type of literature exposed the general public to architectural matters. *American Home, Architectural Digest, Better Homes and Gardens, Good Housekeeping, Ladies' Home Journal, House & Garden* and *House Beautiful* were instrumental in selling a vision of modern living to the lay readership. These periodicals focused on residential settings to illustrate domestic values and housing priorities in post-war American society, while at the same time offering publicity outlets for architects in the non-specialized press. However, these magazines enjoyed less consideration in the specialized forum than the seven publications previously listed.

Popular journals such as *LIFE, Look, Newsweek, Horizon, Sunset* also generated interest. These publications catalysed public opinion around particular architects and/or buildings and marketed modernism as a global design style. In addition, the *Los Angeles Times Home Magazine* played a pivotal role in the construction of modern architectural culture in Southern California. The Sunday supplement of the *Los Angeles Times* regularly published residential projects shaped by the tenets of the International Style. With the support of chief editors James Toland and Dan MacMasters, authors such as Ethel McCall Head, Barbara Lenox, Esther McCoy and Dan MacMasters himself extensively covered the work of canonical as well as peripheral figures in the trajectory of California Modernism. As a contributing photographer, Julius Shulman helped to introduce the work of many architects to a wider public. The magazine became a pedagogical tool to systematically educate the non-specialist readership to accept modern domestic spaces and to increase its social status. Theoretical texts by Richard Neutra, Craig Ellwood, Calvin Straub, coverage of California Home Shows, publications of built designs by Albert Frey, Buff, Straub and Hensmann, Rudolf M. Schindler and Burton Schutt, and the theme of low-cost housing are just a few tangible examples illustrating the editorial range of the weekly magazine.

The strategies of architectural memory

When architects try to bring their work to the attention of the large-scale community, their chances of leaving a permanent mark on the mind of the reader depend on:

1) Architectural Photographers
2) Editorial Policy
3) Mass-media Coverage

These factors, of equal magnitude and mutually dependent, have a profound impact on the inscription of memory.

1. Architectural Photographers

Photographers are the link between the profession and the media. Their role in revealing a design to the public has two aspects. First, photographic skills are critical in creating visual perception and in generating the desire for particular architectural propositions. Second, photographers customarily provide connections to the world of publishing; in selling their photographs, they automatically advertise architects.

A pictorial account of a building is the result of a process of selection and creation of compositions determined by the photographer. Photographic lenses cut off the peripheral field of vision in very different ways, redefining the perceptual context for the buildings. Thus framed, a photograph presents a visual center of gravity and a hierarchy of elements drawn from the original setting. The signature of the photographer, therefore, exerts a tangible influence on the structuring of visual perception. Every photographic image is both an interpretative act and a document of its own age. It carries the traces both of the technology of the camera and the uniqueness of the photographer's eye. When the architectural photographer fixes the reality of the building with the camera, that optical outcome gains paramount importance. Unless the project portrayed is accessible to the public at large, that photographic record becomes a vicarious experience sealed into the photographer's careful composition. The work of Julius Shulman, in this sense, is paradigmatic in proving how architectural photography is a means for constructing a visual order. His most praised pictorial accounts are syntheses of the spatial culture and lifestyle of the age they depict, going well beyond the documentary function of producing a plain mechanical record of the building. Every single photograph he took reveals an awareness of lighting conditions, of camera positions, of the choice of lenses, of what is contained in the frame, of geometrical relationships and alignments of elements, which together define his readings of architectural events within the photographic space.

2. Editorial Policy

The process of selecting what material to publish is critical in the filtering of information. Editorial policies determine what will appear in print, and occasionally such decision-making is the prerogative of a single person. Magazine editors' criteria of the publishable are shaped by ideologies, personal bias against established or overexposed firms or simply personal preference. Yet, magazines do not have total autonomy. The publishing of an informative article, for example, is conditional on the cooperation of the architect in providing original drawings and access to the building for interior photographs [note 3].

The need for financial support leads to a magazine's dependence on subscribers and advertisers to secure its existence. In view of this need for revenue, magazines have to come to terms with the interests of advertisers on one hand and the necessity of building up a steady readership on the other.

It is not uncommon for editors to consult with photographers to get suggestions on what work might be worth considering for publication. Frequently, too, it is the photographer also who informs the editors of pioneering architecture emerging in remote areas [note 4].

3. Mass-Media Coverage

The press is a central disseminator of architectural discourse. Strong asymmetries of political power code the heterogeneous space of the publishing world, with tangible consequences for the editorial visibility of the project. Whether the magazine where an architectural project is published is specialized or popular, an academic journal or a daily newspaper, will affect the exposure the building will receive and the way it will be perceived. Depending on how extensive the coverage is, the work will be more or less noticed. The more frequently photographs of the building appear, the higher the chances that it will be noticed by the general public and will eventually make a durable impression. If for example the photographs of a building appear only once in a weekly issue of the *Los Angeles Times Home Magazine* and without further coverage that design statement is bound to be forgotten.

The distribution of the magazine featuring the building, will determine whether its circulation will be local, regional, national or international.

The camera can undeniably produce social consensus and celebrity for a work through its characteristic techniques of persuasion. Regardless of the sophistication of a design, without enticing photographs (Shulman calls them "eyestoppers"), it is unlikely that it will attract the attention of the casual reader.

Organization of the Julius Shulman archive

The archive comprises the following material:

a) 4 x 5-inch negatives and contact prints of all the photographic assignments of his career, including 4 x 5-inch transparencies and color negatives;
b) Several housands of 35-mm color slides.
c) A large number of 8 x 10-inch black and white prints;
d) Card files listing the place and date of publication of each job;
e) Three log books listing the job number, architects, location of the building and date of the photograph

The images presented in this book belong to two specific groups in Julius Shulman's archive. The first comprises photographs that are still occasionally requested for publication. They include assignments for corporate offices, such as Pereira & Associates and Welton Becket and Associates, or for architectural firms who are not part of the mainstream, such as Crites & McConnell from Cedar Rapids, Iowa. These images are primarily known to the local community where the architect was practicing, rising occasionally to national attention. The second group gathers a large body of work that was published only once or twice and was never ordered again for publication. These pictures were often commissioned by architects who wanted to submit entries for architectural competitions or by newspaper editors interested in covering the design, mainly in the supplements of their Sunday issues.

Methological notes

The criteria informing the selection of the material presented in this book are based on the contribution each design made to the architectural scene of its time. In order to reconstruct the history of the selected projects and review the literature, the following architectural databases were consulted: Avery Index, Architectural Index and Art Index, available only in paper version for the period under analysis. Many of the magazines and books documenting the architectures of this book were found directly in Shulman's library.

Each design in this book is identified by the job number, the name of the architect, the location of the building and the date when the photographys were taken. This format replicates Shulman's technique of archiving his work, which he adapted at the very beginning of his professional career. Whenever available, a selected bibliography follows the individual project description. When possible, information about the current state of the building is provided. In several instances, it was impossible to find information on the projects here published. In these cases, no explanatory text is given.

The mechanism of memory

The common denominator of all the case studies presented here is Julius Shulman. But the reputation and skills of the photographer are only some of the ingredients leading to the popularity and eventual permanence of a design statement in the larger context of architectural discourse.

Databases are critical in establishing a building's presence in history. The three most frequently consulted architectural databases in the United States (Avery Index, Architectural Index and Art Index) draw their data from specialized periodicals, leaving out journals of more general scope and tabloids. Yet a large number of built designs appear in popular publications, which are influential avenues for general cultural assimilation. *LIFE* magazine, for instance, was very active in disseminating architectural information with a focus on domestic space. Esther McCoy and Dan MacMasters were columnists for *Home Magazine*, the Sunday section of the *Los Angeles Times*. Designs reviewed only in non-specialized literature will therefore have significantly less chances to leave a permanent imprint on the collective memory, since the architectural databases will not list them. A case in point is the Spencer Residence, Malibu (see p. 182): it was generously illustrated in the *Pictorial Living* section of the *Los Angeles Examiner*, but that publication is invisible in the three indexes. Although its brief citation in *Arts & Architecture* gained the building a listing on the Avery Index, it was misssing from the two other databases. The *Los Angeles Examiner*, being a newspaper, is not among the publications whence the three data collections derive their figures. Thus, the printing locus where the Spencer Residence was reported at length to a broad readership escaped the mechanism for storing architectural information. Last, but not least, the Spencer Residence was never reported in any architectural guide. As a result, there is virtually no record of the house currently available in the architectural press.

Circulation, distribution, prestige and periodical type are other conditions affecting the kind of exposure the design will receive and the construction of a consensus around it. Each magazine presents a project through a unique editorial angle geared to a particular audience. Within the confined realm of architectural publications, the name of the magazine will have a bearing on the readers' consideration of the project. Published in *House & Garden*, the Upton Residence, for example, (see p. 072), was marketed to a lay readership interested in new residential models reflecting the values, lifestyles and social status of the American post-war upper class. At the same time, the literal adoption of the Wrightian language in the dwelling, its selling-point in the popular

press, may have decreased the chances of the Upton Residence being covered by journals targeting an audience of specialists. An early underdeveloped version of the project was published in the December 1946 issue of *Architectural Record*. The nationwide distribution of *House & Garden* gave the artifact extensive exposure to a lay readership. After numerous attempts to locate where this work was documented, its publication in *House & Garden* was detected with the direct help of Shulman. It is listed in the Avery Index as a holiday house with no reference to the Uptons. Other items were found randomly while researching material dealing with post-war American architecture.

Accessibility and visibility are also critical in increasing an artifact's chances for inclusion in discourse. Public buildings, more often than private houses, are potential candidates for collective attention. Private residences are difficult to enter, since homeowners are customarily protective of their privacy. Today, the Pereira Residence is invisible to the community. Never mentioned in guides or texts, this work is inevitably overlooked. Often, the unknown location and the inaccessibility of the interior make private houses less desirable items in the manufacturing of architectural history. Public works, on the contrary, offer spatial experiences to broader segments of the community. Both the Avery and the Architectural Index recorded the Pereira Residence, but not the Art Index. In addition, the house is referenced in the Reader's Guide to the Periodical Literature Index. The residence enjoyed insufficient contemporary exposure to leave a permanent imprint.

Geography is another component affecting a project's visibility to the mass audience. Designs realized in metropolitan areas are more likely to be noticed and documented in the mass media than those built in remote or rural regions. Projects falling into the second category are significantly less likely to figure in the press, unless photographers report their existence to magazines or the architect's reputation is solid enough to draw media attention wherever he builds. The University Lutheran Church in Lawrence, Kansas, designed by Ramey and Jones (see p. 436), possibly paid the price for its little known location. Although the Brutalist flavor of its concrete work might have gained this religious structure more editorial limelight, its remote location has confined it to a marginal role in architectural books. Though the building won official recognition from a professional organization, it did not appeal to the larger group of editors and publishers. The Avery Index reports the church in one listing, whereas the two other databases do not mention at all.

Architects' promotion of their work can be decisive in constructing professional recognition in the community. A long-

term investment in public relations helps to push designers' output in the media and institutional as well as professional organizations. The more a project is published in magazines and books, the deeper its impact on generations of readers who will internalize the architect's message and use that particular project as a reference for the production of new work. The disappearance of Crites & McConnell from surveys may be the result the of the lack of a long-term strategy to achieve professional acknowledgement within the specialized and general press. While the Avery Index lists fourteen publications for their projects, none of them refer to the Seiberling Residence (see p. 310). Instead it is cited solely in the Architectural Index under the Cedar Rapids location and without reference to the Seiberling name. Otherwise, the picture appeared only in two of Shulman's books *Photographing Architecture and Interiors* and *The Photography of Architecture and Design*, where it was shown to demonstrate how sunlight could be employed to visually isolate specific architectural elements. With the exception of the four volumes on architectural photography by or on Shulman, and despite the numerous citations obtained while the office was in full swing, the work of Crites & McConnell is little if at all covered in architectural textbooks.

An additional consideration is an architect's exclusion from cultural events that attract great public attention. Exhibits and expositions represent two effective sites for the promotion of designers. Traditionally architects capitalize on such information campaigns since they deliver a positive image of the picked designers to a wide audience. In this respect, the Case Study House Program conceived by John Entenza is paradigmatic. In 1945, the initiative became an international magnet drawing worldwide interest to Southern California. For the architects personally selected by Entenza, the Case Study House Program turned into a precious opportunity to market their reputation beyond the boundaries of California. But William S. Beckett was not one of those chosen. Although his office design was publicized locally and internationally, the young architect never again reached the same scale of recognition for his work.

Modification and demolition of artifacts may effect their historical trajectory. If altered or torn down, a project initially celebrated by the press may be dropped in later recollection of architectural events. In order to capture collective attention, a project has to contain innovative features pointing toward a new direction in design. If those features are changed or removed the work may not cast the same initial appeal and consequently lose its visibility. Victor Gruen's Tishman Building in Los Angeles (see p. 196) suffered oblivion on this account. Acclaimed as a model office design, the building's

unique louvered walls were replaced by pre-cast concrete panels in the eighties. This removal radically changed its urban identity and made its inclusion in architectural chronicles less likely.

The result was the removal of the building from current historical accounts of twentieth-century Southern Californian architecture. The Tishman Building has been catalogued under various readings in all three databases. In *The Architecture of Los Angeles*, published in 1981, Paul Gleye cited the Tishman Building as a major landmark in the Los Angeles cityscape of the 50s. Conversely, in *Los Angeles: An Architectural Guide*, David Gebhard labeled it as a rather dull example of Corporate International Style. After 1981, however, there is no published reference to it.

The time lag between the completion of a design and its submission to the mass media can harm that project's transmission in the community. Magazines' editorial interests constantly shift and what is appetizing today might not be tomorrow. The timing of a project's submission conditions its circulation. The Lagreco Residence (see p. 508) probably suffered from this delay. When the house was built, the 28-year old designer was not yet a registered architect and was not in a position to market his work. The project was not eligible for the AIA Awards because the rules of the time required that the designer be licensed. It was also ineligible for the Progressive Architecture Award, which would accept only unbuilt projects. All this probably reduced the houses' chances of gaining more public exposure. Furthermore, MacMaster's editorial angle, focusing mainly on the work's materials, may have harmed alternative readings of the project targeted to a critical analysis of the design. Five years later, the architect contracted the editor of a periodical of national prestige, who refused to review Lagreco's project because the magazine's focus was on 'high-tech' rather than post-Corbusieran references. As a result the house's existence has been ignored. The Lagreco Residence is listed in the Avery Index and Architectural Index, but is not reported in the Art Index. First published in 1972, it received full coverage only five years later. Retrieval of the publication in the Sunday section of the *Los Angeles Times* was made possible only through direct consultation of Shulman's file catalog. Since the three databases do not draw their data from newspapers, this first article is not reported.

Architects engaged both in professional practice and in teaching seek validation through the media for their career advancement and for the ratification of their prestige. Their agenda inevitably makes them more aware of the mechanics of memory and certainly more active in staging personal publicity campaigns through publications. To act out their promotional plans, architects use photography as an instrument to build consensus around their work.

Lastly, the public spectacle endorses the reality of architecture. A project invisible to the eye has no hold on social memory. To remember is to see that project replicated through all the editorial forms in which architectural information is embodied. Different magazines reach different readers, yet all contribute to keeping a memory alive. The media, therefore, is the only channel able to transmit artifacts to future generations. Disappearance from the editorial horizon effaces a project from the collective consciousness. But once the artifact has entered architectural discourse. Its existence is permanently fixed in the space of the text.

Notes

1) Julius Shulman, *Photographing Architecture and Interiors*, Whitney Library of Design, New York 1962, pp.12-7
2) John Morris Dixon, Kicking CoDependency, in *Arts Papers*, January/February 1996, p. 28
3) John Morris Dixon, ibid.
4) Julius Shulman, The Architect and the Photographer, in *AIA Journal*, December 1959, p.44

Die Fotografie und die Amerikanische Moderne
Vom frühen International Style bis zu den 70er-Jahren

Um im Architekturdiskurs eine Rolle zu spielen, muss ein Bau fotografiert und mehrfach in vielgelesenen Design- oder Architekturzeitschriften veröffentlicht worden sein. Sonst wird er vergessen und taucht nie wieder im Bewusstsein der Leser auf. Diese Feststellung stand am Beginn erster Untersuchungen im privaten Archiv von Julius Shulman, dem Fotografen der Architektur der Amerikanischen Moderne. Das neu durchgesehene, der Öffentlichkeit weithin unbekannte Bildmaterial ist ein Beweis für den ausgezeichneten Stand der Architektur in 44 amerikanischen Bundesstaaten. Warum haben spätere Generationen diese Projekte nicht zur Kenntnis genommen? Gibt es Gründe dafür, dass einige Bauten im Gedächtnis haften bleiben und andere ihm entfallen? Und welche Rolle spielt die Fotografie bei diesem Vorgang? Diese Untersuchung befasst sich mit den publizistischen Mechanismen, die dazu beitragen, dass ein Werk der Architektur in das kollektive Gedächtnis einbezogen wird.

Drei verschiedene Ziele bestimmen den Text und den fotografischen Inhalt des vorliegenden Buches.

Das erste ist, das Werk von Julius Shulman vorzustellen, das einer breiten Öffentlichkeit nur wenig bekannt ist, eben weil die gelegentlichen Publikationen nur begrenzte Verbreitung fanden. Bilder von Richard Neutras Kaufmann House (1947) und Pierre Königs Case Study House Nr. 22 (1960) haben Shulmans Autorität als Architekturfotograf dauerhaft bestätigt. Diese immer noch häufig reproduzierten Schwarzweiß-Aufnahmen sind zu Ikonen der Lebensform der Nachkriegsmoderne in Kalifornien geworden. Aber das Gesamtwerk des amerikanischen Fotografen umfasst weitaus mehr als diese wohlbekannten Fotografien. Zwischen 1936 und 1986 bewältigte Shulman etwa 6 000 Aufträge in Nordamerika und anderen Kontinenten. Seit den frühen 40er-Jahren dokumentierte er jeden einzelnen Bau in Schwarzweiß-Aufnahmen und 35 mm-Farbdiapositiven.

Das zweite Ziel ist, die Diskussion über die Kalifornische Moderne und die moderne Architektur im Mittelwesten neu zu beleben. 1945 forderte das Case Study House-Programm von John Entenza, dem Herausgeber von »arts & architecture«, die Aufmerksamkeit der nationalen und internationalen Öffentlichkeit durch seine völlig neuen Vorstellungen vom Wohnen in Südkalifornien heraus. Parallel zu Entenzas Initiative war die Architektenszene intensiv mit architektonischen Neuerungen beschäftigt, und das ohne die Vorteile einer weitgespannten Publicity, wie sie »arts & architecture« gewährleistete. Außerhalb Kaliforniens schufen Architekten in entlegenen Gebieten der Vereinigten Staaten Entwürfe, die über die regionalen Grenzen hinaus kaum Beachtung fanden. Diese Projekte, die weit entfernt von den Architekturzentren ent-

standen, waren häufig nur dem lokalen Publikum vertraut, der breiten Öffentlichkeit jedoch nicht zugänglich. Neben den Meistern der Amerikanischen und Europäischen Moderne bevölkern Scharen weniger bekannter Architekten und ganz unbekannte Erscheinungen wie William Sutherland Beckett, Raymond Crites, Emerson Stewart Williams, Carl L. Maston, Gordon Drake, Richard Dorman und Mario Corbett die Auftragsbücher des Fotografen. Warum sind ihre Namen uns heute so fremd?

Das dritte Ziel ist, zu zeigen, dass in den aktuellen architektonischen Datensammlungen, die der Forschung zur Verfügung stehen, Dokumente von entscheidender Bedeutung für die Architektur fehlen, so dass diese Bauten von der Allgemeinheit nicht wahrgenommen werden. Architekten, die dringend veröffentlichen wollten, nutzten Shulmans Ruf und künstlerisches Feingefühl, um bekannt zu werden. Das Studio des Fotografen ist angefüllt mit einer großen Zahl von Zeitschriften, Büchern und anderen Drucksachen, in denen seine Arbeiten veröffentlicht wurden. Ein großer Teil dieser Titel ist nicht in den Architekturverzeichnissen aufgeführt, was die Suche nach Information zu bestimmten Projekten äußerst erschwert. Zeitschriften wie »Building Progress« und »Designers West«, zeigten den Architekturstil des Mittelwestens und der pazifischen Regionen der Vereinigten Staaten. Aber da diese Veröffentlichungen nicht in den Datensammlungen erscheinen, ist unsere Kenntnis der vielgestaltigen Architekturszene während des Untersuchungszeitraums erheblich eingeschränkt. Ein typischer Fall ist das Haus Pereira (siehe S. 328). Obwohl sich zahlreiche Publikationen im Archiv des Fotografen und eher zufällig bei Recherchen in Universitätsbibliotheken fanden, ist das Projekt nur in einem Verzeichnis und in einer einzigen Zeitschrift, »House & Home«, erfasst.

Die publizistische Szene

Mit wenigen Ausnahmen zeigen die hier ausgewählten Beispiele zwischen 1939 und 1980 entstandene öffentliche und private Bauwerke, die nur wenig Anerkennung durch Preise oder Resonanz in den Medien fanden.
Im Untersuchungszeitraum waren die führenden Architekturzeitschriften in den Vereinigten Staaten: »Architectural Forum«, »Progressive Architecture«, »Architectural Record«, »House & Home« und die Zeitschrift des American Institute of Architects (AIA) [Anm.1]. Sie wandten sich vorwiegend an eine professionelle Leserschaft und wurden von der Mehrzahl der Architekten im Lande gelesen. In den 40er- und 50er-Jahren kamen zwei weitere Zeitschriften — »arts & architecture« aus Los Angeles und »Architectural and Engineering

News« aus New York — auf den Markt, aber beide stellten ihr Erscheinen in den frühen 60er-Jahren ein. [Anm.2] Diese sieben Zeitschriften wurden zum Resonanzboden für architektonische Ereignisse in Nordamerika, die Entwürfe in breiter Auswahl veröffentlicht und einem aufmerksamen Publikum vorgestellt haben.

Eine besondere Gruppe von Zeitschriften verfolgte die Architekturdebatte auf Landesebene. »Building Progress«, »Architecture West«, »Pacific Architect and Builder«, »Designer West« und »Concrete Masonry Age« machten eine professionelle Leserschaft mit einem breiten Spektrum von Projekten lokaler Bauunternehmer bekannt. Gelegentlich erschien das in diesen Publikationen vorgestellte Material auch in den Zeitschriften des Architektur-Establishments. Weitaus häufiger aber blieben diese Darstellungen auf den Bereich lokaler Publikationen beschränkt.

Eine wiederum ganz andere Art von Veröffentlichungen machte das allgemeine Publikum mit architektonischen Themen vertraut. »American Home«, »Architectural Design«, »Better Homes and Gardens«, »Good Housekeeping«, »Ladies' Home Journal«, »House & Garden« und »House Beautiful« trugen entscheidend dazu bei, einem interessierten Laienpublikum die Vision des modernen Lebens nahe zu bringen. Diese Zeitschriften konzentrierten sich auf die Wohn-Architektur, um der amerikanischen Nachkriegsgesellschaft häusliche Werte und die Bedeutung des Wohnungsbaus eindringlich zu vermitteln. Gleichzeitig boten sie den Architekten die Möglichkeit, ihre Arbeiten einem nicht fachlich vorgebildeten Publikum vorzustellen. Diese Art Zeitschriften fanden jedoch in der Fachwelt weniger Beachtung als die sieben vorher aufgeführten.

Beliebte Zeitschriften wie »LIFE«, »Newsweek«, »Horizon« und »Sunset« trugen gleichfalls dazu bei, das Interesse an Architektur zu wecken. Sie wurden zu Katalysatoren der öffentlichen Meinung, wenn es um bestimmte Architekten oder Bauten ging, und sie vermarkteten die Moderne als weltweiten Architekturstil. Außerdem spielte das »Los Angeles Times Home Magazine« eine Schlüsselrolle bei der Ausbildung der modernen architektonischen Kultur in Südkalifornien. Die Sonntagsbeilage der »Los Angeles Times« präsentierte regelmäßig Wohnprojekte, die von den Grundsätzen des International Style geprägt waren. Mit Unterstützung der Chefredakteure James Toland und Dan MacMasters äußerten sich Autoren wie Ethel McCall Head, Barbara Lenox, Esther McCoy und Dan MacMasters selbst ausführlich zu den Arbeiten etablierter Architekten wie auch von Randfiguren der sich entwickelnden Szene der Kalifornischen Moderne. Als freier Fotograf trug Julius Shulman dazu bei, das Werk vieler Architekten einer breiten Öffentlichkeit vorzustellen. Die Zeitschrift

wurde zu einem pädagogischen Instrument, das eine fachlich nicht vorgebildete Leserschaft systematisch dazu erzog, Konzepte modernen Wohnens zu akzeptieren und das Verständnis für seine gesellschaftliche Bedeutung zu erhöhen. Theoretische Texte von Richard Neutra, Craig Ellwood und Calvin Straub, umfassende Berichte von den California Home Shows, die Veröffentlichung ausgeführter Entwürfe von Albert Frey, Buff, Straub and Hensmann, Rudolf M. Schindler oder Burton Schutt, sowie Sonderausgaben zum Thema kostensparendes Wohnen sind nur einige Beispiele für die redaktionelle Bandbreite dieser Wochenzeitschrift.

Strategien für ein architektonisches Gedächtnis

Wenn Architekten versuchen, eine breite Öffentlichkeit auf ihre Arbeiten aufmerksam zu machen, hängen ihre Chancen, einen bleibenden Eindruck im Bewusstsein ihrer Leser zu hinterlassen, von Folgendem ab:

1) den Architekturfotografen
2) der Strategie der Zeitschrift
3) den ausführlichen Berichten in den Massenmedien

Diese Faktoren, die in ihrer Bedeutung gleichermaßen wichtig und voneinander abhängig sind, haben auch auf unsere Erinnerungen einen entscheidenden Einfluss.

1. Architekturfotografen

Fotografen sind das Bindeglied zwischen den professionellen Architekten und den Medien. Ihre Schlüsselrolle bei der Vermittlung eines Entwurfs an die Öffentlichkeit spielt sich auf zwei Ebenen ab. Erstens ist die fotografische Qualität einer Aufnahme entscheidend, um eine visuelle Wahrnehmung anzuregen und das Interesse an bestimmten architektonischen Projekten hervorzurufen. Zweitens stellen Fotografen gewöhnlich die Verbindung zu den Zeitschriften her. Indem sie ihre Fotografien an sie verkaufen, werden sie automatisch zu Werbeagenten der Architekten.

Ein Bildbericht von einem Bauwerk ist das Ergebnis einer Auswahl von Einstellungen, die der Fotograf bestimmt. Fotografische Objektive beschneiden die Peripherie des Sehfeldes auf sehr verschiedene Weise und definieren den Wahrnehmungskontext für die Bauten neu. In solch einem Ausschnitt zeigt die Fotografie einen visuellen Schwerpunkt und eine Hierarchie der architektonischen Elemente, die sie dem Aufbau des Gebäudes entnimmt. Die Handschrift des Fotografen hat daher einen spürbaren Einfluss auf die genaue Struktur der visuellen Wahrnehmung. Jedes fotografische Bild ist also beides: ein Akt der Interpretation und ein

Zeitdokument. Einerseits ist es geprägt durch die Technologie der Kamera, andererseits durch den einzigartigen Blick des Fotografen. Sobald der Architekturfotograf die Wirklichkeit eines Bauwerks mit der Kamera festhält, gewinnt dieses optische Ergebnis höchste Bedeutung. Sofern nämlich das Gebäude nicht für das allgemeine Publikum zugänglich ist, wird sein fotografisches Abbild für den Betrachter zum Gegenstand einer Erfahrung aus zweiter Hand, die geprägt ist durch die sorgsame »Inszenierung« des Fotografen. Das Werk Julius Shulmans ist in diesem Sinne beispielhaft: Es beweist nämlich, dass Architekturfotografie ein Mittel sein kann, eine Ordnung der sichtbaren Dinge herzustellen. Seine besonders hoch geschätzten Aufnahmen gelten als die Synthese von Raumkultur und Lebensstil der in ihnen abgebildeten Epoche. Jede seiner Fotografien offenbart eine genaue Kenntnis der Lichtverhältnisse, der Kamerapositionen, der Wahl des Objektivs, der Komposition insgesamt, der Beziehungen und Anordnungen von Elementen, die darin wetteifern, seine Deutung der architektonischen Ereignisse im Rahmen der Fotografie zu bestimmen.

2. Publizistische Strategien

Die Auswahl des zu veröffentlichenden Materials ist der kritische Augenblick, in dem Informationen gefiltert werden. Redaktionelle Strategien der Verlagshäuser entscheiden darüber, was im Druck erscheint, und gelegentlich liegt diese Macht der Entscheidungsfindung bei einer einzigen Person. Die Entscheidung von Redakteuren und Herausgebern darüber, welche Arbeit sie für publikationswürdig halten, wird von Ideologien bestimmt, von persönlichen Abneigungen gegen etablierte oder allzu deutlich hervortretende Architektenbüros oder einfach von persönlichen Vorlieben. Aber auch Zeitschriften verfügen nicht über die angeblich vollständige Autonomie hinsichtlich der herausgeberischen Richtlinien. Die Veröffentlichung eines informativen Artikels hängt auch von der Bereitschaft des Architekten ab, seine Pläne und Zeichnungen zur Verfügung zu stellen und den Zutritt zu dem Bauwerk für Innenaufnahmen zu ermöglichen. [Anm.3]

Und natürlich führt auch die Suche nach Finanzierungsquellen zur Sicherung des Marktanteils einer Zeitschrift zu einer Abhängigkeit von Abonnenten und Anzeigenkunden. Zeitschriften stehen also unter dem Druck, die Interessen der Werbeabteilung und den Aufbau einer beständigen Leserschaft in Einklang zu bringen. Es ist keineswegs ungewöhnlich, dass Redakteure und Herausgeber Fotografen, bei der Auswahl architektonischer Arbeiten für eine Publikation zu Rate ziehen. Häufig ist es auch der Fotograf, der den Redakteuren von innovativen Projekten in geographisch abgelegenen Gebieten berichtet. [Anm.4]

3. Verbreitung in Massenmedien

Die Presse ist ein wichtiger Multiplikator in der Architekturdebatte. Ungleiche Verteilung der politischen Macht schlägt sich auch in den vielgestaltigen Bereichen der Publizistik nieder, mit oft spürbaren Folgen für die redaktionelle Wahrnehmung eines Projekts. Die Art der Zeitschrift, in der ein Architekturprojekt veröffentlicht wird, beeinflusst seine Verbreitung im Publikum. Je nachdem, ob es sich um eine Fachzeitschrift, ein Massenblatt, eine akademische Publikation oder eine Tageszeitung handelt, variiert auch die Art, in der ein Bau vorgestellt und wie er wahrgenommen, behandelt und in seiner Qualität beurteilt wird. Und je nachdem, wie groß die Verbreitung ist, wird auch das Projekt mehr oder weniger beachtet. Je mehr Fotografien des Bauwerks veröffentlicht werden, desto höher ist die Chance, dass ein breites Publikum diesen Entwurf kennenlernt und er einen bleibenden Eindruck bei den Lesern hinterlässt. Wenn andererseits ein Bauwerk nur ein einziges Mal in der wöchentlichen Ausgabe des »Home Magazine« der »Los Angeles Times« erscheint, ohne anderswo veröffentlicht zu werden, dann wird dieser Entwurf mit Sicherheit in Vergessenheit geraten.

Der Vertrieb der Zeitschrift, die sich ausführlich auf ein Bauwerk einlässt, entscheidet darüber, ob sie eine lokale, regionale, nationale oder internationale Verbreitung findet.

Die Kamera ist sicher ein Instrument, das mit seiner spezifischen Technik der Überredung und der Auswahl der Bilder in der Lage ist, einen gesellschaftlichen Konsens über einen Bau herbeizuführen und ihn berühmt zu machen. Denn auch ein noch so raffinierter Entwurf wird ohne attraktive Fotografien (Shulman nannte sie »eye-stoppers«) kaum die Aufmerksamkeit des Lesers fesseln.

Die Organisation des Archivs

Julius Shulmans Archiv umfasst folgendes Material:
a) 4 x 5 Negative und Kontaktabzüge aller fotografischen Aufträge, die er während seiner ganzen Karriere ausführte, einschließlich der 4 x 5 Ektachrome und Farbnegative
b) Einige Tausend von 35-mm Diapositiven
c) Eine große Anzahl von 8 x 10 Schwarzweiß-Abzügen
d) Karteien, in denen der Veröffentlichungsort und das Datum jedes Auftrags aufgeführt ist
e) Drei Auftragsbücher, in denen die Auftragsnummer, der Architekt, der Standort des Bauwerks und das Datum der Aufnahme vermerkt sind

Die Bilder, die in diesem Buch vorgestellt werden, gehören zu zwei spezifischen Gruppen des Archivs. Die erste Gruppe umfasst Fotografien, die nur gelegentlich für Publikationen

angefordert werden. Diese enthalten in besonderem Maße Aufträge für Architekturfirmen wie Pereira & Associates und Welton Becket and Associates, oder für Architektengruppen, die nicht den herrschenden Architekturtrends angehören, wie Crites & McConnell aus Cedar Rapids, Iowa. Diese Bilder kennt man vor allem im näheren Umfeld der Architekten, nur gelegentlich erreichten sie auch die Aufmerksamkeit der gesamten Nation.

Die zweite Gruppe versammelt in großem Umfang Arbeiten, die nur ein oder zweimal veröffentlicht, danach aber nie wieder angefordert wurden. Diese Aufnahmen wurden oft von Architekten in Auftrag gegeben, die ihre Arbeiten für Architekturwettbewerbe einreichen wollten, oder von Zeitungsredakteuren, die an der Verbreitung des Entwurfs interessiert waren.

Anmerkungen zur Methode des Buches

Die Kriterien für die hier vorgelegte Materialauswahl orientieren sich an dem Beitrag, den der einzelne Entwurf für die Architekturszene jener Zeit leistete. Zur Rekonstruktion der Veröffentlichungsgeschichte der Bauten wurden die drei für diesen Bereich wichtigsten Datensammlungen der Vereinigten Staaten herangezogen: Avery Index, Architectural Index und Art Index. Viele der Bücher und Zeitschriften, die die hier vorgestellten Projekte dokumentieren, befinden sich in Julius Shulmans Bibliothek.

Jeder Entwurf wurde mit der Auftragsnummer, dem Namen des Architekten, dem Standort des Gebäudes und dem Datum der Aufnahme festgehalten. Diese Systematik, der auch das vorliegende Buch folgt, nimmt die Archivierungstechnik auf, die Shulman seit Beginn seiner Karriere verwendet hat. Soweit verfügbar, sind den Projekten Literaturangaben vorangestellt. Wenn möglich, wird über den gegenwärtigen Zustand des Bauwerks informiert. In einzelnen Fällen war es unmöglich, Informationen zu erhalten. Deshalb wurde dort auf einen erläuternden Text verzichtet.

Was den Mechanismus der Erinnerung in Gang setzt

Der gemeinsame Nenner aller hier vorgeführten Fallstudien ist Julius Shulman. Aber Ruf und Kunstfertigkeit des Fotografen sind nur einige der Charakteristika, die zum Bekanntheitsgrad und schließlich zur dauerhaften Präsenz eines Bauwerks im architektonischen Diskurs führten.

Um einem Bauwerk einen festen Platz in der Architekturgeschichte zuzuweisen, sind Datensammlungen unerlässlich. Avery Index, Architectural Index und Art Index beziehen ihre Informationen aus der Fachpresse und lassen Publikationen mit allgemeiner Thematik ebenso unberücksichtigt wie Boulevardzeitschriften. Und doch erscheint eine große Anzahl ausgeführter Entwürfe gerade in bestimmten Teilen dieser populäreren Presse, die zur Meinungsbildung der breiten Öffentlichkeit wesentlich beiträgt. Die Zeitschrift »LIFE« zum Beispiel war eine äußerst aktive und einflussreiche Informationsquelle, mit starken Betonung der Wohnkultur. Esther McCoy und Dan MacMasters waren Kolumnisten des »Home Magazine«, der Sonntagsbeilage der »Los Angeles Times«. Bedauerlicherweise haben Entwürfe, die nur in diesen Zeitschriften besprochen wurden, erheblich geringere Chancen, einen dauerhaften Eindruck im kollektiven Gedächtnis zu hinterlassen, da sie von den architektonischen Datenbanken nicht dokumentiert werden. Ein repräsentatives Beispiel ist das Haus Spencer in Malibu (siehe S. 182): Es wurde – reich illustriert – in der Sektion »Pictorial Living« des »Los Angeles Examiner« veröffentlicht. Diese Zeitschrift wird jedoch von keinem der drei maßgeblichen Indices ausgewertet. Und obwohl das Haus kurz in »arts & architecture« vorgestellt wurde und deshalb im Avery Index aufgeführt ist, wird es in den beiden anderen Indices nicht erwähnt. Als Tageszeitung fällt der »Los Angeles Examiner« nicht unter die ausgewerteten Publikationen. Folglich ist dieses Veröffentlichungsorgan, in dem das Haus Spencer einer großen Leserschaft ausführlich vorgestellt wurde, von dem Speicherungsmechanismus architektonischer Daten nicht erfasst worden. Zudem wurde das Haus in keinen Architekturführer aufgenommen. Deshalb findet sich heute praktisch kein Nachweis dieses Gebäudes in der Architekturpresse.

Verbreitung, Prestige und die Art des Veröffentlichungsorgans bestimmen, welche Publicity ein Entwurf erhält und wie er von der Leserschaft aufgenommen wird. Jede Zeitschrift stellt ein Projekt in einer einzigartigen redaktionellen Sichtweise vor, die auf ihre spezifische Leserschaft zugeschnitten ist. Auf dem begrenzten Gebiet der Architekturveröffentlichungen hat der Titel einer Zeitschrift einen wesentlichen Einfluss auf die Akzeptanz eines Projekts durch ihre Leser. Das Haus Upton (siehe S. 072) wurde von »House & Garden« für ein Publikum vermarktet, das sich für neue Wohnmodelle interessierte, die Werte, Lifestyle und sozialen Status der amerikanischen Eliten der Nachkriegszeit reflektierten. Für dieses Laienpublikum war die Imitation des Stils von Frank Lloyd Wright durchaus interessant; in der Fachpresse dagegen hatte das Haus Upton aus diesem Grund kaum eine Chance. Ein früher, noch nicht ausgereifter Entwurf des Projekts wurde im Dezember 1946 in »Architectural Record« veröffentlicht.

Durch die landesweite Verbreitung von »House & Garden« wurde der Entwurf einer großen Laienleserschaft vorgestellt. Nach längerer Suche konnte diese Quelle schließlich mit Julius Shulmans Hilfe im Avery Index aufgefunden werden, wo das Projekt als Ferienhaus ohne einen Hinweis auf die Familie Upton geführt wird. Weitere Nachweise wurden eher zufällig bei Untersuchungen zur amerikanischen Nachkriegsarchitektur entdeckt.

Zugänglichkeit und Sichtbarkeit sind gleichermaßen entscheidend, um die Chancen eines Projekts zu erhöhen, in die Architekturdebatte aufgenommen zu werden. Dabei haben öffentliche Gebäude eine größere Chance, von einem breiteren Publikum wahrgenommen zu werden als Privathäuser. Privathäuser werden seltener veröffentlicht, weil die Besitzer meistens ihre Privatsphäre schützen wollen. Heute ist das Haus Pereira für die Öffentlichkeit nicht »verfügbar«. In Führern oder Texten wird es nie erwähnt, nur wenige Daten sind über das Haus zu finden. Die oft unbekannte Lage und das nicht ohne Weiteres zugängliche Innere von Privathäusern hat zur Folge, dass sie weniger populäre Objekte für die Architekturgeschichte sind. Das Haus Pereira ist im Avery und im Architectural Index dokumentiert, es fehlt im Art Index. Darüber hinaus ist es im »Reader's Guide« des »Periodical Literature Index« erwähnt. Wegen seiner nur begrenzten Veröffentlichung in der Presse erhielt das Haus damals ungenügende Publicity, um einen dauerhaften Eindruck im öffentlichen Gedächtnis zu hinterlassen.

Die geographische Lage ist ein weiteres Element, das den Bekanntheitsgrad eines Projekts für das Massenpublikum bestimmt. Entwürfe in der unmittelbaren Nähe großstädtischer Ballungszentren haben größere Chancen, von den Massenmedien wahrgenommen und dokumentiert zu werden als Projekte, die weitab der Zentren liegen. Projekte dieser Kategorie haben sehr viel geringere Chancen, in der Presse zu erscheinen, es sei denn, Fotografen unterrichten Redakteure über ihre Existenz oder der Name des Architekten ist schon so bekannt, dass es egal ist, wo er baut. Die University Lutheran Church in Lawrence, Kansas, entworfen von Ramey und Jones (siehe S. 436) hat möglicherweise diesen Preis gezahlt, denn sie wurde in einem entlegenen Winkel der USA errichtet. Die vom Brutalismus beeinflusste Zementkonstruktion hätte durchaus mehr redaktionelle Beachtung verdient. Seine entlegene Lage brachte dem Sakralbau jedoch nur eine marginale Rolle in den Architekturveröffentlichungen ein. Obwohl der Bau im Architekturestablishment anerkennend gewürdigt wurde, hat er das Interesse der Redakteure und Verleger nicht auf sich ziehen können. Der Avery Index dokumentiert die Kirche mit einer Eintragung, in den beiden anderen Indexen ist sie nicht erwähnt.

Für die professionelle Anerkennung von Bauwerken in der Gesellschaft kann es eine entscheidende Rolle spielen, dass ihre Arbeiten in den Medien Beachtung finden. Eine langfristige Investition in Öffentlichkeitsarbeit hilft, das Werk eines Architekten über die Medien und die institutionellen und professionellen Organisationen vorzustellen. Je häufiger ein Entwurf in Zeitschriften und Büchern veröffentlicht wird, desto tiefer gräbt er sich in das Gedächtnis von Generationen von Lesern ein, die die Botschaft des Architekten verinnerlichen und dieses besondere Projekt als Bezugspunkt für die Schaffung neuer Entwürfe zugrundelegen. Dass die Entwürfe von Crites & McConnell aus der Berichterstattung verschwanden, kann das Ergebnis einer unzureichenden langfristigen Strategie sein, in der Fach- und allgemeinen Presse professionelle Anerkennung zu finden. Obwohl der Avery Index 14 Veröffentlichungen ihrer Projekte aufführt, ist keine Aufzeichnung über das Haus Seiberling (siehe S. 310) zu finden. Diese wiederum ist nur im Architectural Index unter dem Ort Cedar Rapids aber ohne einen Hinweis auf den Namen Seiberling dokumentiert. Die beiden einzigen anderen Veröffentlichungen, in denen das Bild erschien, sind die Bücher »Photographing Architecture and Interiors« und »The Photography of Architecture and Design« von Julius Shulman, in denen diese Fotografie demonstrieren soll, wie Sonnenlicht verwendet werden kann, um spezifische architektonische Elemente visuell zu isolieren. Außer den vier Bänden über Architekturfotografie, die von oder über Shulman veröffentlicht wurden sowie zahlreiche Erwähnungen aus der Zeit, in denen ihr Büro noch aktiv war, werden die Arbeiten von Crites & McConnell bis heute in Architekturtexten nicht erwähnt.

Ausstellungen und Messen mit großer öffentlicher Resonanz bieten Architekten die Möglichkeit, sich darzustellen und gesellschaftliche Anerkennung zu gewinnen. In diesem Zusammenhang ist das Case Study House-Programm von John Entenza repräsentativ. 1945 wurde diese Initiative ein internationaler Anziehungspunkt, der das Interesse der Welt auf diese südkalifornische Region zog. Den persönlich von John Entenza ausgewählten Architekten bot das Case Study House-Programm eine wertvolle Gelegenheit, ihren Namen über die Grenzen Kaliforniens hinaus zu vermarkten. Leider war William S. Beckett nicht unter den Erwählten. Obwohl seine Entwürfe für Bürohäuser regional und international veröffentlicht wurden, erhielt der junge Architekt nie eine entsprechende Anerkennung für sein Werk.
Die Veränderung und Zerstörung eines Bauwerks kann seine Bedeutung in der historischen Perspektive verändern. Wenn ein Projekt, das ursprünglich nach seiner Fertigstellung von der Presse gefeiert wurde, verändert oder zerstört wird, kann es bei späteren Darstellungen der architektonischen Ereignisse unberücksichtigt bleiben. Um die kollektive Aufmerksam-

keit auf sich zu lenken, muss ein Projekt innovative Elemente haben, die auf eine neue Richtung im Design hinweisen. Sobald diese Elemente verändert oder sogar von dem Bau entfernt werden, hat der Entwurf nicht mehr seinen ursprünglichen Anspruch und gerät im Gedächtnis der Öffentlichkeit völlig in Vergessenheit. Victor Gruens Tishman-Gebäude in Los Angeles (siehe S. 196) ereilte dieses Schicksal. Als ein vorbildliches Modell für Bürodesign gefeiert, wurden die einzigartigen Lamellenwände des Gebäudes in den 80er-Jahren durch Fertigbetonplatten ersetzt. Dieser Austausch veränderte die urbane Identität radikal und trug dazu bei, dass das das Gebäude für immer aus den aktuellen historischen Dokumentationen der Architektur Südkaliforniens des 20. Jahrhunderts verschwand. Das Tishman Building wurde in den drei Datenbanken unter verschiedenen Titeln katalogisiert. 1981 wies Paul Gleye in »The Architecture of Los Angeles« das Tishman Building als bemerkenswertes Baudenkmal in der Stadtlandschaft von Los Angeles der 50er-Jahre aus. Im Gegensatz dazu, bezeichnete David Gebhardt das Gebäude in »Los Angeles: An Architectural Guide«, als ziemlich einfallsloses Beispiel des korporativen International Style. Nach 1981 wird das Gebäude nicht mehr erwähnt.

Auch eine zu große Zeitspanne zwischen der Fertigstellung eines Projekts und seiner Vorstellung in den Massenmedien kann seiner Akzeptanz in der Öffentlichkeit schaden. Das redaktionelle Interesse von Zeitschriften verlagert sich ständig. Was heute noch hochaktuell ist, kann morgen schon nicht mehr relevant sein. Insofern ist die richtige zeitliche Platzierung eines Projekts ein wichtiges Element für seine Vorstellung vor einem breiten Forum. Die Beurteilung des Lagreco-Hauses (siehe S. 508) hat sehr wahrscheinlich unter dieser zeitlichen Verzögerung seiner Veröffentlichung gelitten. Als das Haus fertiggestellt war, war der erst 28-jährige Architekt noch nicht registriert und durfte seinen Entwurf nicht vermarkten. Er war auch nicht berechtigt, an den Ausschreibungen des AIA teilzunehmen, weil die damaligen Regelungen eine Registrierung zwingend vorschrieben. Er konnte auch beim Progressive Architecture Award nicht teilnehmen, der nur unverwirklichte Projekte zuließ. Es ist möglich, dass durch das Zusammentreffen dieser unglücklichen Bedingungen diesem Projekt eine durchschlagende öffentliche Anerkennung versagt blieb. Darüber hinaus mag MacMasters' Betrachtungsweise, die sich überwiegend auf die Materialien des Entwurfs konzentrierte, alternativen Interpretationen des Projekts geschadet haben, die auf eine kritische Analyse der Entwurfsidee ausgerichtet waren. Fünf Jahre später wandte sich der Architekt an den Redakteur einer überregionalen Zeitschrift, der sich aber weigerte, das Lagreco-Haus zu veröffentlichen mit der Begründung, der

Fokus seiner Zeitschrift läge mehr auf 'Hightech' als auf nach-corbusianischen Tendenzen. Das hatte zur Folge, dass das Gebäude von vielen ignoriert wurde. Das Lagreco-Haus ist im Avery Index aufgeführt, fehlt aber im Art Index. Trotz seiner Veröffentlichung 1972 erhielt es erst fünf Jahre später volle Anerkennung. Seine Entdeckung in der Sonntagsausgabe der »Los Angeles Times« war erst durch die Hinzuziehung von Julius Shulmans Archiv möglich.

Architekten, die sowohl in ihren Büros arbeiten als auch als Lehrer tätig sind, versuchen ihre Karriere und ihr Prestige durch die Anerkennung in den Medien zu fördern. Dieses Ziel schärft zwangsläufig ihr Bewusstsein für die Mechanismen des Erinnerungsprozesses und lässt sie die Medien zu ihren Zwecken nutzen. Zur Umsetzung ihrer Werbekampagnen benutzen Architekten die Fotografie, um allgemeine Anerkennung für ihr Werk zu erreichen.

Letztlich entscheidet das öffentliche Interesse über das »Dasein« eines architektonischen Werks. Ein Projekt, das dem Auge nicht zugänglich ist, existiert nicht in den Bildwelten der Gesellschaft. Nur wenn es in den relevanten Medien erscheint, bleibt ein Projekt in der Erinnerung lebendig. Verschiedene Zeitschriften erreichen unterschiedliche Leser, aber alle sind notwendig, um die Erinnerung wach zu halten. Daher sind die Medien das einzige Vehikel, das in der Lage ist, die Erinnerung an Werke an zukünftige Generationen weiterzugeben. Das Verschwinden aus dem redaktionellen Interesse führt zum Auslöschen aus dem kollektiven Bewusstsein. Hat ein Werk erst einmal die Architekturdebatte erreicht, dann ist seine Existenz im Rahmen des Textes für immer gesichert.

Anmerkungen

1) Julius Shulman, *Photographing Architecture and Interiors*, Whitney Library of Design, New York 1962, S.12-7
2) John Morris Dixon, »Kicking CoDependency«, in: *Arts Papers*, Januar/Februar 1996, S. 28
3) John Morris Dixon, ibid.
4) Julius Shulman, »The Architect and the Photographer« in *Zeitschrift des American Institute of Architect (AIA)*, Dezember 1959, S.44

La photographie et l'émergence du modernisme américain
Des débuts du Style international aux années 1970

Pour prendre sa place dans le discours architectural, un projet doit être photographié et publié à plusieurs reprises dans des magazines suffisamment lus, faute de quoi il sombrerait vite dans l'oubli le plus total. Cet argument a été développé au cours des recherches initiales menées dans les archives privées de Julius Shulman, photographe d'architecture du modernisme californien. Le matériel iconographique retrouvé, en grande partie inconnu du grand public, témoigne de l'excellence de son exploration de la création architecturale dans 44 Etats américains. Pour quelles raisons ces projets ont-ils été négligés par les générations récentes? Pour quelles raisons se souvient-on de certains bâtiments, alors que d'autres sont oubliés? Quel est le rôle de la photographie dans ce processus? Cet essai porte sur les mécanismes éditoriaux qui permettent l'inscription permanente d'une œuvre d'architecture dans la mémoire collective.

Trois objectifs différents déterminent la forme littéraire et le contenu photographique de cet ouvrage.
Le premier est de montrer des travaux de Julius Shulman pratiquement inconnus du public parce que publiés dans une presse d'audience limitée. Des photographies comme celles de la Kaufmann House de Richard Neutra (1947) ou de la Case Study House nº 22 de Pierre Koenig (1960) ont conféré à la photographie de Shulman une autorité durable dans la culture architecturale contemporaine. De nos jours encore, ces images en noir et blanc, très souvent publiées, sont devenues des icônes de la vie le l'apres-guerre en Californie. Mais l'œuvre complète du photographe américain dépasse de loin ces prises de vue si connues. De 1936 à 1986, Shulman a réalisé environ 6 000 reportages photographiques dans 44 Etats américains et dans d'autres pays. Dès le début des années 1940, chacun de ses reportages photographiques était réalisé en noir et blanc et en couleur.

Le second objectif est de rouvrir le débat sur le modernisme californien et l'architecture moderne dans le Midwest. En 1945, le Case Study House Program de John Entenza, éditeur de «arts & architecture», avait attiré l'attention des milieux architecturaux américains et internationaux et contribué à donner une forme tangible à la vision originale de l'habitat en Californie du Sud. Parallèlement à cette initiative, de nombreux professionnels s'étaient lancés dans des explorations architecturales radicales sans pour autant bénéficier de la publicité assurée par «arts & architecture». En dehors de la Californie, certains architectes de l'intérieur des Etats-Unis produisaient un travail théorique et pratique dont la reconnaissance ne dépassait que rarement les frontières de leur région. Eloignées des centres de la pensée architecturale, ces réalisations étaient essentiellement connues d'un public local, mais ignorées de la plupart. A côté des maîtres modernistes européens et américains, de nombreux architectes moins connus ou inconnus comme William Suther-

land Beckett, Raymond Crites, Emerson Stewart Williams, Carl L. Maston, Gordon Drake, Richard Dorman et Mario Corbett parmi d'autres, emplissent les portfolios du photographe. Pourquoi les avons-nous à ce point perdus de vue?

Le troisième objectif est de montrer comment les sources d'information mises à la disposition de la recherche universitaire laissent à l'écart des documents d'une importance significative pour l'architecture, rendant ainsi un grand nombre de bâtiments littéralement invisibles au regard collectif. Les architectes qui souhaitaient être publiés tirèrent profit de la réputation et de l'œil de Shulman pour atteindre à la notoriété. Son studio est ainsi rempli d'un grand nombre de magazines, de livres, de brochures et de toutes sortes de documents imprimés dans lesquels son travail a été publié. Un grand nombre de ces titres ne figure pas dans les index architecturaux, ce qui rend problématique toute recherche d'information sur un projet particulier. Des magazines comme «Building Progress» et «Designers West», par exemple, témoignaient à leur époque du climat architectural du Middle-West et de la côte Ouest. Mais l'absence de certains titres dans les bases de données limite grandement notre compréhension de la réalité professionnelle complexe pendant la période couverte par cette étude. Un bon exemple en est la Pereira Residence (voir p. 328). Malgré les nombreuses publications mentionnées dans les archives du photographe, une recherche dans les bibliothèques universitaires montre que le projet n'est mentionné que dans un seul et unique titre, «House & Home».

Le monde de l'édition

A quelques exceptions près, les exemples choisis portent sur des bâtiments publics ou privés réalisés entre 1939 et 1980, qui ont bénéficié d'une reconnaissance marginale des médias ou de distinctions officielles.
Au cours de la période étudiée ici, les principaux journaux architecturaux américains étaient «Architectural Forum», «Progressive Architecture», «Architectural Record», «House & Home» et le magazine de l'American Institute of Architects (AIA) [note 1]. Ils étaient principalement destinés aux professionnels et lus par la majorité des architectes du pays. Entre les années 1940 et 1950, deux autres périodiques, «arts & architecture», de Los Angeles, et «Architectural and Engineering News», de New York, apparurent sur le marché mais cessèrent leur publication au début des années 1960 [note 2]. Ces sept magazines étaient la caisse de résonance de l'architecture en Amérique du Nord. Ils délimitaient un territoire éditorial dans lequel une importante sélection de projets était publiée et soumise à l'attention des lecteurs.

Un groupe particulier de magazines, qui a cependant porté le débat au niveau national, reste absent des bases de données institutionnelles. «Building Progress», «Architecture West», «Pacific Architect and Builder», «Designers West» et «Concrete Masonry Age» ont fait connaître aux professionnels un large éventail de projets de praticiens locaux. Les sujets abordés dans ces publications paraissent parfois également dans les périodiques de l'establishment architectural. Mais ces publications engagées restent plus souvent du domaine des éditions régionales.

Un type de littérature assez différent sensibilisait le grand public aux thèmes architecturaux. «American Home», «Architectural Digest», «Better Homes and Gardens», «Good Housekeeping», «Ladie's Home Journal», «House & Garden» et «House Beautiful» jouèrent ainsi un rôle essentiel dans la promotion d'une vision moderniste de la vie à un public non spécialisé. Ils se concentraient sur l'architecture résidentielle pour mettre en évidence les valeurs domestiques et les priorités données au logement de la société américaine de l'après-guerre, tout en assurant dans le même temps la publicité des architectes auprès de leur public. Cependant, ce type de magazines jouissait d'une considération moindre de la part des cercles spécialisés que les sept publications citées plus haut.

Des titres de la presse populaire comme «LIFE», «Look», «Newsweek», «Horizon», «Sunset» suscitaient également un intérêt pour l'architecture. Ces publications catalysaient l'opinion publique sur certains architectes et/ou bâtiments et vendaient le modernisme comme un style global. Par ailleurs, le «Los Angeles Times Home Magazine» joua un rôle essentiel dans la formation d'une culture architecturale moderne en Californie du Sud. Ce supplément dominical du «Los Angeles Times» publiait régulièrement des projets résidentiels dus aux représentants du Style international. Avec le soutien des rédacteurs en chef James Toland et Dan MacMasters, des auteurs comme Ethel McCall Head, Barbara Lenox, Esther McCoy et Dan MacMasters lui-même couvraient de façon extensive le travail des architectes établis ou des intervenants périphériques du modernisme californien. En tant que photographe, Julius Shulman a contribué faire connaître l'œuvre de nombreux architectes auprès d'un public plus vaste. Le magazine devint un outil pédagogique qui éduquait systématiquement des lecteurs non spécialisés et les aidait à décoder et à accepter l'habitat moderne tout en renforçant son statut social autour d'un consensus. Des textes théoriques de Richard Neutra, Craig Ellwood, Calvin Straub, la couverture des California Home Shows (expositions de réalisations pilotes), la publication de réalisations d'Albert Frey, Buff, Straub & Hensmann, Rudolph M. Schindler, Burton Schutt, ainsi que des numéros sur le thème de la maison économique figurent parmi les nombreux exemples de l'approche éditoriale de cet hebdomadaire.

Les stratégies de la mémoire architecturale

Lorsque les architectes tentent de faire connaître leur travail auprès d'un plus vaste public, leurs chances de laisser une impression durable dans l'esprit des lecteurs dépend
1. du photographe
2. de politiques éditoriales
3. de la couverture médiatique

Ces facteurs, d'importance égale et interdépendants, exercent un impact profond sur l'écriture des livres consacrés à la mémoire.

1. Les photographes d'architecture

Les photographes sont le lien entre l'architecte professionnel et les médias. Leur rôle cardinal lorsqu'il s'agit de lancer un projet dans l'arène publique se joue à deux niveaux. Tout d'abord, au niveau du talent du photographe qui représente un élément critique dans la construction de la perception visuelle et la génération de désirs de propositions architecturales d'un type particulier. Dans un deuxième temps, ces spécialistes apportent généralement leurs connexions avec le monde de l'édition : en vendant leurs photographies, ils se font automatiquement les agents de publicité des architectes.

Le compte-rendu iconographique d'un bâtiment résulte de la sélection de compositions déterminées par le photographe. Les objectifs photographiques limitent le champ périphérique de la vision de manières très différentes, et redéfinissent le contexte de perception. Ainsi cadrée, une photographie montre un centre de gravité visuel et une hiérarchie d'éléments sortis du cadre original. La signature du photographe exerce ainsi un poids tangible sur la structure de la perception visuelle. Chaque photographie est à la fois une interprétation et un document sur sa propre époque. D'un côté, elle véhicule les traces de la technologie de l'appareil, de l'autre l'unicité de l'œil du photographe. Une fois que ce dernier a fixé la réalité d'un bâtiment sur la pellicule, sa production visuelle acquiert une importance de première grandeur. A moins que l'objet représenté ne soit accessible au grand public, cet enregistrement photographique devient pour celui qui le regarde l'objet d'une expérience déléguée, mise en forme définitivement par un travail soigné d'orchestration de la part du photographe. L'œuvre de Julius Shulman est en ce sens paradigmatique car elle prouve à quel point la photographie d'architecture est un moyen de construire un ordre de choses à voir. Ses reportages les plus appréciés sont tenus pour les synthèses de la culture de l'espace et du style de vie de l'époque qu'ils représentent, ce qui va bien au-delà de la fonction documentaire de production d'une analogie mécanique. Chacun de ses instantanés révèle une conscience des conditions d'éclairage, de la position de l'appareil, du choix des objectifs, de ce qui se trouve dans le champ visuel, des relations géométriques et des alignements des éléments qui

concourent ensemble à définir sa lecture d'événements architecturaux dans l'espace de la photographie.

2. Politiques éditoriales

La sélection du matériau à publier est un moment critique du filtrage de l'information. Ce sont les politiques éditoriales des éditeurs qui déterminent ce qui sera publié, et il arrive que ce pouvoir de décision soit la prérogative d'une seule personne. Le choix par les rédacteurs en chef de magazines de ce qui est jugé publiable se nourrit d'idéologies, de jugements personnels opposés à certaines agences architecturales établies ou trop souvent publiées, ou simplement de préférences personnelles. Cependant, les magazines ne jouissent pas d'une autonomie totale dans la détermination de leurs perspectives éditoriales. Parmi leurs préoccupations figure la recherche permanente de soutiens financiers, ce qui explique leur dépendance vis-à-vis de leurs abonnés et de leurs annonceurs. Pour s'assurer ces deux sources de revenus, les magazines doivent tenir compte de la pression de leurs concurrents d'un côté, et de la nécessité de se construire un lectorat stable de l'autre. De plus, la publication d'un article d'information dépend de la coopération de l'architecte qui fournit les plans originaux et permet l'accès au bâtiment pour les prises de vue [note 3]. Il n'est pas rare que les éditeurs consultent des photographes pour leur demander des suggestions d'articles. C'est également le photographe qui présente aux rédacteurs en chef les architectes qui innovent dans certaines régions lointaines [note 4].

3. Couverture médiatique

La presse est un diffuseur essentiel du discours architectural. L'espace hétérogène de l'univers des publications est codé par les fortes inégalités du pouvoir politique, ce qui a des conséquences tangibles pour la visibilité éditoriale du projet. Le type de magazine dans lequel l'œuvre architecturale est imprimée affecte l'étendue de sa diffusion parmi les lecteurs. Que ce soit un magazine spécialisé, populaire, professionnel, universitaire, ou un quotidien, l'exposition dont bénéficie le bâtiment et la façon dont il sera perçu, traité et jugé sur le plan qualitatif varie beaucoup. Selon l'importance de l'article, l'œuvre sera plus ou moins remarquée. Plus les photographies de cette œuvre sont publiées, plus les chances sont fortes qu'un large public la remarque. Un exemple typique en est la publication d'un bâtiment à une seule reprise dans un numéro hebdomadaire du « Home Magazine » de Los Angeles, non suivie de publication ailleurs. Les chances sont fortes que ce travail soit bientôt ignoré. La distribution du magazine explique généralement son rôle local, régional ou international.

L'ensemble des photographies qui illustrent une réalisation jouent un rôle dans la production du consensus social autour de l'œuvre. Les photographies contribuent à la construction

d'une célébrité par des techniques caractéristiques de persuasion et de choix des images. Quelle que soit la sophistication du travail présenté, en l'absence de photographies séduisantes (Shulman les appelle des « stop-œil »), il est peu probable qu'il capte l'attention d'un lecteur de base.

Organisation des archives

Les archives de Julius Shulman contiennent le matériel suivant :
a) négatifs 4 x 5 et tirages de contact de tous les reportages architecturaux réalisés au cours de sa carrière, y compris des diapositives 4 x 5 et des négatifs couleur
b) plusieur milliers de diapositives couleur 35 mm
c) un grand nombre de tirages noir et blanc 8 x 10
d) des fiches sur la publication de chaque travail
e) trois livres contenant le numéro de commande de chaque travail, les architectes, la localisation du bâtiment et la date de la prise de vue

Les images présentées icis correspondent à deux catégories spécifiques dans les archives de Julius Shulman. La première groupe comprend des photographies demandées occasionnellement par des publications diverses. Elles comprennent, spécifiquement, des reportages d'agences importantes comme Pereira & Associates et Welton Becket and Associates, ou d'agences d'architecture qui ne font pas partie des grandes tendances, comme Crites & McConnell de Cedar Rapids, Iowa. Ces images sont essentiellement connues dans les villes où l'architecte a travaillé, et n'accédaient qu'à l'occasion à une audience nationale.

Le second groupe réunit un vaste ensemble de réalisations publiées une ou deux fois, mais jamais redemandées par des éditeurs. Ces photographies étaient souvent commandées par des architectes qui en avaient besoin pour des dossiers de présentation à l'occasion de concours professionnels, ou par des éditeurs de journaux intéressés par le projet en général pour leur supplément du dimanche.

Notes méthodologiques

Les critères de sélection des matériaux présentés reposent sur la contribution que chaque projet a apporté à l'actualité architecturale du moment. Pour établir un bilan des parutions sur les exemples choisis et reconstruire leur histoire dans l'univers éditorial, les bases de données suivantes ont été consultées, disponibles sur version papier seulement pour la période analysée : Avery Index, Architectural Index et Art Index : De nombreux ma-

gazines et livres documentant les architectures présentées ici proviennent de la bibliothèque de Shulman.

Chaque projet illustré dans cet ouvrage reprend la même classification que celle utilisée par Shulman dans ses livres depuis le début de sa carrière professionnelle, c'est-à-dire par numéro de commande, nom de l'architecte, localisation du bâtiment et date de la prise de vue. Lorsqu'elle existe, une bibliographie sélectionnée précède le descriptif de chaque projet. A plusieurs reprises, il s'est avéré impossible de trouver des informations sur le projet publié dans ces pages. Dans ces cas, aucun texte explicatif n'est donné. Lorsque c'est possible, nous fournissons une information sur l'état actuel des objets archivés.

L'effet sur le mécanisme de la mémoire

Le dénominateur commun à toutes les études de cas présentées dans cet ouvrage est Julius Shulman. Sa réputation et son talent de photographe ne sont cependant que deux des éléments qui expliquent sa popularité et l'éventuelle permanence de son approche artistique dans le contexte plus vaste du discours architectural.

Les bases de données revêtent une importance critique dans la constitution de la présence historique d'une œuvre construite. Les trois bases les plus fréquemment consultées aux Etats-Unis (Avery Index, Architectural Index et Art Index) prennent comme source les périodiques spécialisés, laissant de côté les journaux d'intérêt plus général ainsi que les tabloïdes. Néanmoins, un grand nombre de réalisations sont publiées dans les sections de publications grand public qui exercent une influence réelle sur l'assimilation culturelle de l'architecture au sens large. Le magazine « LIFE », par exemple, a joué un rôle très actif dans la diffusion d'une information sur l'espace domestique. Esther McCoy et Dan MacMasters tenaient des rubriques dans « Home Magazine », rubrique dominicale du « Los Angeles Times ». En conséquence, les projets qui ne figurent que dans la presse non spécialisée ont significativement moins de chances de laisser une empreinte durable sur la mémoire collective, puisque les bases de données les ignorent. Un exemple à cet égard est la Spencer Residence à Mailibu (voir p. 182) : généreusement illustrée dans la rubrique « Pictorial Living » du « Los Angeles Examiner », elle n'apparaît dans aucun des trois grands index. Bien que sa brève présence éditoriale dans « arts & architecture » lui ait valu une entrée dans l'Avery Index, elle est absente des deux autres bases de données. Le « Los Angeles Examiner » étant un quotidien, il ne fait pas partie des publications d'où les trois index tirent leurs informations. Ainsi, le seul support dans lequel la Spencer Residence a bénéficié d'un traitement important, destiné à un lectorat qui ne l'était pas moins, a échappé au mécanis-

me de conservation de l'information architecturale. Par ailleurs, cette maison n'a jamais figuré dans le moindre guide d'architecture, d'où son absence de la presse architecturale actuelle.

La diffusion, la distribution, le prestige et la périodicité font également partie des conditions qui affectent la couverture médiatique du projet et l'élaboration d'une forme de consensus à son égard. Chaque magazine présente un projet à son lectorat sous l'angle éditorial qui lui est propre. Dans l'univers des publications architecturales, le nom du magazine exerce un poids non négligeable sur le jugement que les lecteurs peuvent porter. Publiée dans « House & Garden », la Upton Residence, par exemple (voir p. 072), s'adressait à un lectorat non spécialisé, intéressé par de nouveaux modèles résidentiels reflétant les valeurs, les styles de vie et le statut social des classes supérieures américaines de l'après-guerre. Au même moment, son langage wrightien, qui intéressait la presse populaire, a pu diminuer ses chances d'être couvert par les journaux destinés aux spécialistes. Une première version peu développée du projet avait été publiée dans le numéro de décembre 1946 d'« Architectural Record ». La diffusion nationale de « House & Garden » la fit connaître au lectorat non professionnel. Après de nombreuses tentatives pour retrouver les journaux dans lesquels elle avait été publiée, l'article de « House & Garden » fut repéré grâce à l'aide directe de J. Shulman. La Upton Residence figure dans l'Avery Index, présentée comme une maison de vacances, sans référence aux Upton. Les autres parutions furent découvertes à l'occasion de recherches sur l'architecture américaine d'après-guerre.

L'accessibilité et la visibilité jouent également un rôle essentiel dans les chances d'un artefact de se faire une place dans le discours ambiant. Les bâtiments publics, plus souvent que les résidences privées, sont des candidats potentiels à l'attention du public. Il est difficile de visiter certaines maisons car leurs propriétaires s'efforcent généralement de protéger leur vie privée. La Pereira Residence est aujourd'hui absolument invisible. Jamais mentionnée dans les guides ou les textes, elle reste systématiquement négligée par la plupart des auteurs, puisque les informations disponibles sont limitées. Fréquemment, une localisation inconnue et l'inaccessibilité de l'intérieur écartent des réalisations privées de l'histoire de l'architecture en évolution permanente. Les bâtiments publics, au contraire, sont accessibles et utilisables par tous. L'Avery et l'Architectural Index mentionnent tous deux la Pereira Residence, mais pas Art Index. De plus, elle se trouve dans le Guide du lecteur à l'index des périodiques. Du fait de la couverture limitée qu'elle connut à l'époque de sa construction, elle n'a jamais été suffisamment vue pour laisser une empreinte durable.

La géographie fait elle aussi partie des éléments qui affectent la

publicité d'une réalisation auprès du grand public. Les projets réalisés en zone urbaine ont plus de chance d'être remarqués et documentés par les mass media que ceux construits dans des régions éloignées ou rurales. Les projets de cette dernière catégorie ont beaucoup moins de chances d'apparaître dans la presse, à moins que les photographes ne les fassent découvrir aux magazines ou que la réputation de l'architecte soit telle qu'elle attire l'attention des médias quel que soit le lieu. L'University Lutheran Church de Lawrence, Kansas, conçue par Ramey and Jones (voir p. 436), paye sans doute le prix d'avoir été érigée dans une ville hors des sentiers battus. Bien qu'un certain brutalisme dans le travail du béton ait pu lui attirer l'attention de la presse, son éloignement l'a confinée à un rôle marginal dans les livres d'architecture. Et si elle a bénéficié d'une distinction décernée par un organisme professionnel, elle n'a pas su séduire les éditeurs et les rédacteurs en chef. L'Avery Index, la mentionne, alors que les deux autres bases de données l'ignorent.

La promotion de leur œuvre par les architectes eux-mêmes peut se révéler décisive dans la reconnaissance professionnelle. Un investissement à long terme dans les relations publiques contribue à rendre une carrière plus visible aux yeux des médias comme des organismes institutionnels et professionnels. Plus un projet est publié dans les magazines et les livres, plus profondément il s'enracine dans la mémoire de générations de lecteurs qui intériorisent le message de l'architecte, lequel devient éventuellement une de leurs références. La disparition de Crites & McConnell des médias pourrait ainsi résulter d'un manque de stratégie à long terme dans la conquête d'une reconnaissance professionnelle dans la presse spécialisée et généraliste. Si l'Avery Index fournit la liste de quatorze publications qui mentionnent leurs travaux, aucune ne parle de la Seiberling Residence. Elle n'est citée que par l'Architectural Index sous sa localisation à Cedar Rapids et sans mention du nom des Seiberling. Elle n'apparaît que dans deux livres de Shulman, « Photographing Architecture and Interiors », et « The Photography of Architecture and Design », où elle sert à montrer comment la lumière naturelle peut permettre d'isoler certains éléments architecturaux. A l'exception de quatre ouvrages sur la photographie architecturale de Shulman, ou sur celui-ci, et malgré de nombreuses citations obtenues lorsque l'agence était en pleine activité, l'œuvre de Crites & McConnell n'est actuellement pratiquement jamais citée dans les manuels d'architecture.

L'exclusion de l'architecte de manifestations culturelles destinées au grand public est un facteur d'oubli non négligeable. Les expositions constituent des lieux efficaces pour faire la publicité d'un projet. Traditionnellement, les architectes tirent profit, en termes de consensus social, de ce type d'occasions qui délivrent auprès d'un large public une image positive des prati-

ciens sélectionnés. A cet égard, le Case Study House Program conçu par John Entenza représente un paradigme. Cette initiative de 1945 s'est transformée en un événement international qui a focalisé un temps l'attention du monde entier sur la Californie du Sud. Pour les architectes sélectionnés par Entenza, ce programme offrait une superbe opportunité de développer leur notoriété bien au-delà des frontières californiennes. Mais un jeune architecte comme William S. Beckett qui n'avait pas été choisi, bien que la production de son agence ait été publiée sur le plan local et international, n'atteignit jamais au même niveau de reconnaissance que ses confrères retenus.

La modification ou la démolition d'une construction peut pondérer l'importance de sa trajectoire historique. S'il est transformé ou démoli, un projet célébré par la presse à son achèvement peut se voir écarté des recensions ultérieures. Afin de retenir l'attention collective, il doit présenter des caractéristiques novatrices qui indiquent une nouvelle direction. Une fois ces caractéristiques modifiées ou supprimées, l'œuvre exerce moins de séduction qu'à l'origine et peut être oubliée. La Tishman Builing de Victor Gruen à Los Angeles (voir p. 196) est dans ce cas. Acclamée comme un modèle d'immeuble de bureaux, elle a vu les lames de persiennes de ses murs remplacées par des panneaux de béton préfabriqués au cours des années 1980. Cette modification a radicalement changé son identité visuelle et nuit à ses chances d'être retenue dans les ouvrages sur l'architecture. La Tishman Building est cataloguée sous diverses entrées dans les trois bases de données. Dans « The Architecture of Los Angeles », publié en 1981, Paul Gleye en fait une des contributions majeures des années 1950 au panorama de la ville. A l'inverse, dans « Los Angeles : An Architectural Guide », David Gebhard voit en elle un exemple assez terne du style international institutionnel. Après 1981, cependant, plus personne n'y fait référence.

La durée qui s'écoule entre l'achèvement d'un projet et sa présentation aux mass media peut gêner sa diffusion. Les centres d'intérêt des magazines évoluent constamment, et ce qui est intéressant aujourd'hui peut ne plus l'être demain. Le calendrier de la publication d'un projet conditionne donc sa diffusion auprès d'un large public. L'évaluation de la Lagreco Residence (voir p. 508) a sans doute souffert de ce retard. Lors de sa construction, son architecte âgé de 28 ans n'était pas encore licencié et certainement pas en position de faire connaître son travail. Le projet ne pouvait pas être présenté aux American Institute of Architecture Awards, car la règle de l'époque voulait que son auteur possède une licence. Il ne l'était pas davantage aux Progressive Architecture Awards, qui n'acceptaient que les projets non encore réalisés. Il est probable que cette situation a diminué ses chances d'être mieux connue. De plus, l'angle rédactionnel de l'article de MacMasters qui s'attachait principalement aux matériaux a pu gêner une lecture différente du projet, ciblée sur une analyse critique des intentions du concepteur. Cinq ans plus tard, l'architecte entra en contact avec le rédacteur en chef d'un prestigieux périodique national qui refusa de faire un article parce que son magazine s'intéressait alors plus au high-tech qu'aux références post-corbuséennes. La Lagreco Residence est listée dans l'Avery Index et l'Architectural Index, mais non dans l'Art Index. Bien que publiée pour la première fois en 1972, elle n'a fait l'objet d'articles approfondis que cinq ans plus tard. La retrouver dans la rubrique dominicale du « Los Angeles Times » n'a été possible que grâce à la consultation des fichiers de J. Shulman. Comme les trois grandes bases de données ne travaillent pas à partir des quotidiens, le premier article n'est pas mentionné.

Les architectes engagés à la fois dans une pratique professionnelle et l'enseignement cherchent la reconnaissance des médias à la fois pour l'avancement de leur carrière et pour asseoir leur prestige. Leurs objectifs les rendent inévitablement plus conscients des mécanismes de la mémoire et certainement plus actifs dans l'élaboration de campagnes personnelles de publication. Pour eux, la photographie est un instrument qui contribue à construire un consensus autour de leur œuvre.

Enfin, c'est ce que l'on donne à voir au public qui confère à l'œuvre architecturale sa réalité. Un projet invisible au regard n'a pas sa place dans la banque d'images du corps social. Se souvenir, c'est aussi voir ce projet sous toutes les formes éditoriales que prend l'information architecturale. Les divers magazines touchent divers types de lecteurs, et pourtant tous sont nécessaires à la préservation de la mémoire. Les médias sont les seuls véhicules capables de transmettre la mémoire des artefacts aux générations futures. Disparaître de l'horizon éditorial entraîne la mort dans la conscience collective. Mais une fois qu'un projet a réussi à se faire une place dans le discours architectural, son existence est assurée pour longtemps dans l'espace du texte.

Notes
1) Julius Shulman, « Photographing Architecture and Interiors », Whitney Library of Design, New York 1962, pages 12–17
2) John Morris Dixon, « Kicking CoDependency », dans : Arts Papers, Janvier/Février 1996, page 28
3) John Morris Dixon, ibid.
4) Julius Shulman, « The Architect and the Photographer », dans le magazine de l'AIA, Décembre 1959, page 44

03 **Gordon Drake**
Drake Residence, Los Angeles, California
July 29, 1946

After his return from World War II, where he had served in the Marine Corps, Drake set out to build a house for himself. He purchased a hillside lot and in four months realized a low-cost prototype post-war home within limited square footage and a rugged topography. Solutions were found by rethinking the site's use. For the architect, the entire lot was lining space. Indoor and outdoor spaces were functional fields of equal significance in the all-year-around-outdoor living model the Southern Californian climate sustains. The complete integration of these two conditions affords amenities typical of houses of a much bigger size. The basic volume of the Drake residence is a 12 x 18-foot rectangular space, zoned in two parts: living room and sleeping area, with kitchen and bathroom as partitions. 4 x 4-inch posts, spaced at 6 feet, compose the structural frame. Redwood plywood used as the exterior surface and 1 x 8-inch siding, placed horizontally, pattern the interior walls. For economy of means, most of the furniture is built-in. The brick-paved terrace facing west doubles the living space of the house. Contained on three sides by a tall embankment, this open area is shaded by numerous existing trees and screened from the street by a louvered wood panel beside the front door. Dining and living area blend into the landscaped terrace. Here,

Nach seiner Rückkehr aus dem 2. Weltkrieg kaufte Drake ein Hanggrundstück und entwarf sein eigenes Haus, das er auf schwierigem Baugrund für wenig Geld in vier Monaten fertigstellte. Zu einer Lösung gelangte er, indem er die Flächennutzung neu durchdachte. Für Drake war die Grundstücksgrenze auch die „Wohngrenze". Innen- und Außenräume waren gleich bedeutende Funktionsbereiche eines Lebensstils, zu dem aufgrund des südkalifornischen Klimas das Wohnen im Freien das ganze Jahr über selbstverständlich dazu gehört. Die völlige Verschmelzung von Innen und Außen sorgt für Annehmlichkeiten, die sonst nur von größeren Häusern geboten werden. Ein Rechteckkasten (3,50 x 5,50 m) bildet das Gesamtvolumen des in Wohn- und Schlafzimmerbereich unterteilten Hauses, in dem Küche und Bad die Innenraumteiler abgeben. Die Fassaden sind mit Redwood-Sperrholzplatten verkleidet, die Innenwände mit Brettern quer verschalt. Aus Kostengründen sind die meisten Möbel eingebaut. Die mit Ziegelsteinen gepflasterte Westterrasse verdoppelt den Wohnraum des Hauses. Sie wird auf drei Seiten von hohen Böschungen eingefasst, von Bäumen beschattet und zur Straße von einer Holzlamellenwand neben der Haustür abgeschirmt. Wohn- und Essbereich gehen in die Terrasse über. Der Dach-

A son retour de la Seconde Guerre mondiale, Drake décida de se construire une maison. Il acheta un terrain en pleine nature sur une colline et réalisa en quatre mois le prototype d'une petite maison moderne économique de l'après-guerre. Sa proposition doit beaucoup à sa manière de penser le site. Les limites extérieures du terrain sont celles du « séjour ». Les espaces intérieurs et extérieurs sont des lieux fonctionnels qui revêtent une signification identique dans le mode de vie en plein air qu'autorise le climat de la Californie du Sud. L'intégration complète de ces deux espaces permet des équipements que l'on attendrait plutôt d'une maison beaucoup plus vaste. Le volume de base de la Drake House est une pièce de 3,50 x 5,50 m divisée en séjour et coin chambre à choucher, une cuisine et une salle de bains. Le bois rouge est utilisé à l'extérieur sous forme de panneaux de contre-plaqué et, à l'intérieur, de lattes de 2,40 x 20,50 cm disposées horizontalement. Pour des raisons d'économie, la plupart des meubles sont intégrés. Pavée de briques, la terrasse orientée à l'ouest double la surface de séjour. Cet espace ouvert, limité sur trois côtés par un talus, est ombragé par de nombreux arbres préexistants et protégé de la rue par un panneau de lattes de bois ajourées qui jouxte la porte d'entrée. La terrasse sert à la fois de séjour et

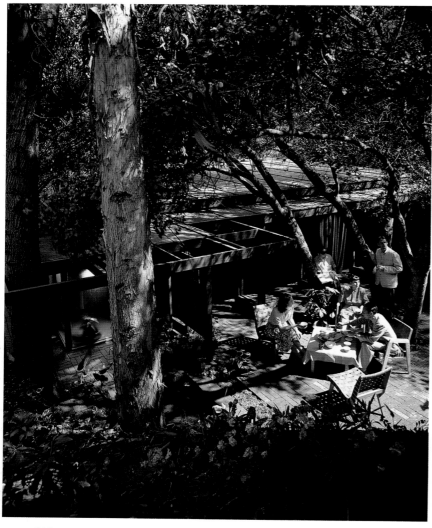
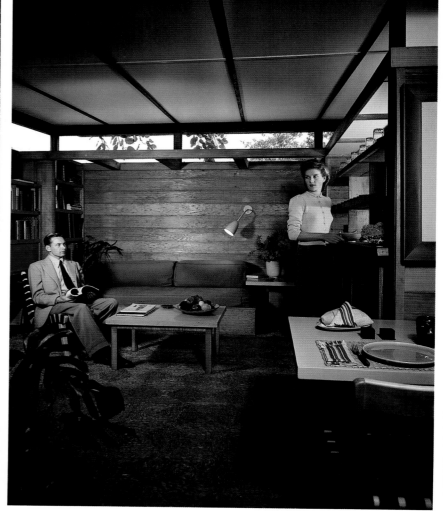

Selected Bibliography:
- Progressive Architecture, June 1947
- Progressive Architecture, July 1947
- Thomas H. Creighton, Frank G. Lopez, Charles Magruder, George A. Sanderson (eds), Homes, New York 1947
- L'Architecture d'Aujourd'hui, June 1948
- House & Home, March 1952
- Douglas Baylis and Joan Parry, California Houses of Gordon Drake, New York 1956
- House & Home, May 1957

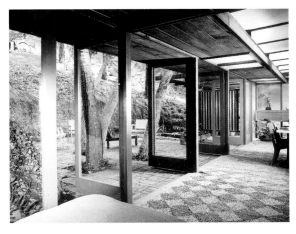 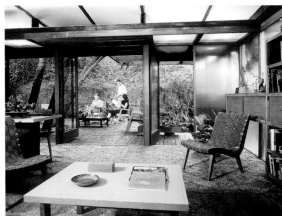

the roof structure rarefies, exposing the rafters which extend beyond the eaves to form a structural trellis.

A narrow band of windows at ceiling-height lighting the kitchen-bathroom area is the only opening of an otherwise rather solid rear elevation onto the street. The house access features textured glass panels modulating light in the entry court and a roof extension to embrace an existing tree. In 1947 the Drake residence was accorded a Progressive Architecture Award.

stuhl öffnet sich hier mit unverkleideten Dachsparren, die sich über der Terrasse in eine Pergola fortsetzen.

Ein schmales Fensterband knapp unter der Decke lässt Tageslicht in den Bereich von Küche und Bad einfallen und ist die einzige Öffnung in der ansonsten geschlossenen Straßenfassade. Der Zugang zum Haus umfasst den Eingangshof mit Strukturglasfeldern in der Umfassungsmauer und ein von einem großen Baum „durchwachsenes" Vordach. 1947 erhielt das Haus Drake den Progressive Architecture Award.

de salle à manger. La structure du toit s'allège, et les poutres se prolongent au-delà de la terrasse pour former une pergola.

Un étroit bandeau de fenêtres à hauteur du plafond éclaire la zone de la cuisine et de la salle de bains, seules ouvertures dans ce qui constitue par ailleurs une façade fermée sur la rue. L'accès de la maison est protégé par des panneaux de verre texturé qui tamise l'éclairage de la cour d'entrée et par une extension du toit qui encercle un arbre. En 1947, la résidence des Drake a reçu un prix d'architecture progressiste.

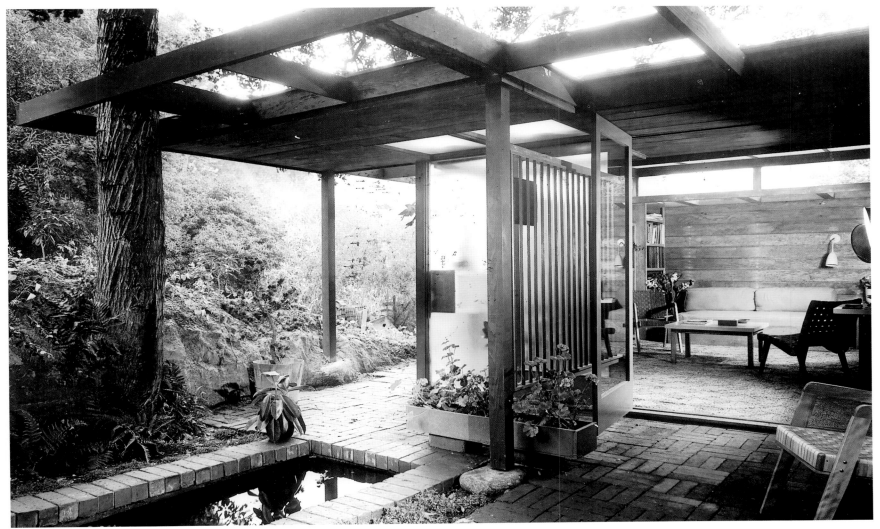

014 Griswold Raetze
Dudley Murphy Residence, Malibu Beach, California
December 18, 1946

The shoreline and a bluff define the narrow strip where the beach house stands. With few windows on the rear facade, the pavilion-like dwelling opens completely to the ocean to maximize the view. The middle section of the main front is recessed to form a protected patio: an outdoor stage for family activities with the ocean as a backdrop. Outlining a U-shape, the 1,100-square-foot living scheme wraps around the terrace, used as common space.Inside, the sleeping units are quite separate from the kitchen-dining area, yet each room has independent access to the outdoor area through sliding panels. From the patio, the horizon line continues inside the house through the living room, glass-walled on three sides.

Die Pazifikküste und eine Steilklippe begrenzen den schmalen Streifen Land, auf dem das Strandhaus steht. Der Bungalow hat nach hinten nur wenige Fenster, öffnet sich dagegen voll zum Meer. Der Mittelabschnitt der Fassade tritt hier zurück, so dass das 100 m² große Haus U-förmig eine geschützte Hofterrasse umgibt, auf der sich die Familie die meiste Zeit aufhält. Die Schlafzimmer – jedes mit Ausgang ins Freie – sind getrennt von Küche und Esszimmer angeordnet. Vom Patio setzt sich die Horizontlinie durch den auf drei Seiten verglasten Wohnbereich ins Haus fort.

La ligne côtière et un escarpement délimitent l'étroite bande de terre sur laquelle se dresse cette maison presque fermée sur l'arrière. Avec ses allures de pavillon, elle s'ouvre complètement sur l'océan pour bénéficier du superbe panorama. La partie centrale de la façade est en léger retrait pour créer un patio, lieu privilégié de la vie familiale, face à l'océan. Le plan de cette construction de 100 m² forme un U qui entoure la terrasse. A l'intérieur, les chambres sont isolées de la zone cuisine-repas. Chaque pièce possède son propre accès vers l'extérieur grâce à des panneaux coulissants. Vue du patio, la ligne d'horizon semble traverser la salle de séjour fermée sur trois côtés par des parois de verre.

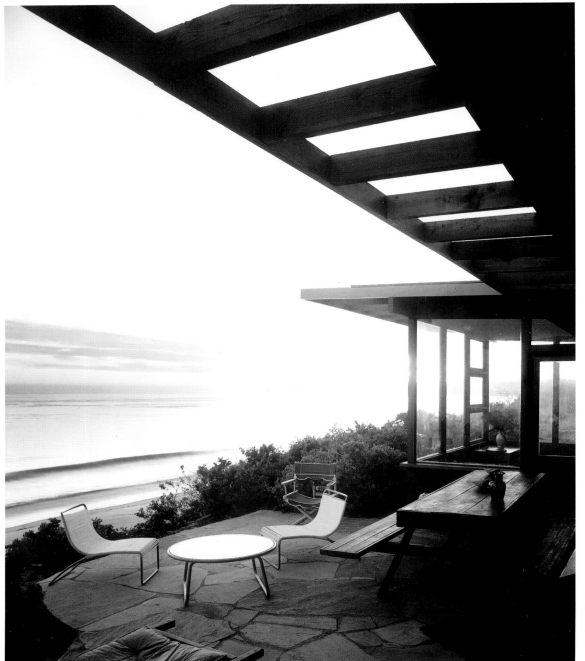

Selected Bibliography: - arts & architecture, March 1947

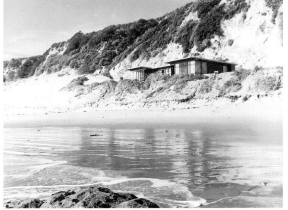

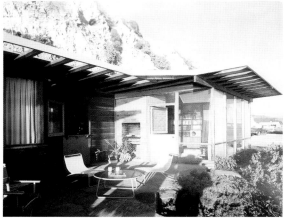

015 **A. Quincy Jones**
Jones Residence, Hollywood, California
December 20, 1946; June 10, 1950

Sited on a bank in the Lookout Mountain looking east toward Los Angeles, the twin redwood structure comprises the architect's first office and his private residence, and was built in two different phases. In 1938, the architect realized his house. In 1945, he added a studio next to it. Life-work functions are distributed on a two-story scheme, raised on the concrete base of the carport.

Two stairs flank the layout, defining the circulation system. On the lower floor, a terrace between the two separate wings connects the architect's personal office to two sleeping units. On the upper floor, an external path at the back of the property links a porch, reception room and drafting studio directly above the Jones' office to the living quarters of the house. An egg-crate ceiling, the first of the architect's career, tops both upper levels and slopes from east to west.

In sharp contrast with the windowless north walls, two full-height glass openings facing east bring large views of the cityscape to the interior. An external sun deck extends the living room.

Das mit Redwood verkleidete Doppelhaus auf einer Felsbank des Lookout Mountain mit Blick über Los Angeles beherbergt das Wohnhaus des Architekten aus dem Jahr 1938 und sein erstes eigenes Büro, das er 1945 neben seinem Haus errichtete. Wohnen und Arbeiten finden jeweils auf zwei Etagen statt, beide Häuser erheben sich auf der Betongarage, die als Sockel dient. Die Erschließung erfolgt über je eine Treppe zu beiden Seiten. Eine Terrasse auf der unteren Ebene verbindet das Büro mit zwei Schlafzimmern. Auf der oberen Ebene bildet ein Außenweg am Hang entlang die Verbindung zwischen einer Veranda, dem Empfangsraum und einem Zeichensaal direkt über dem Büro einerseits und den Wohnbereichen andererseits. Die Kassettendecken in beiden Obergeschossen (eine Premiere im Werk des Architekten) neigen sich von Osten nach Westen. In krassem Gegensatz zu den fensterlosen Nordfassaden sind zwei raumhohe Glasfenstertüren nach Osten orientiert und beziehen die Aussicht auf die Stadt in die Innenarchitektur mit ein. Eine Sonnenterrasse erweitert den Wohnraum ins Freie.

Edifiées sur une terrasse sur les pentes de la Lookout Mountain et bénéficiant à l'est d'une vue sur Los Angeles, ces constructions jumelles en bois rouge qui réunissent les premiers bureaux et la résidence de l'architecte, ont été bâties en deux phases. Après avoir construit la maison en 1938, Jones la compléta en 1945 d'un studio indépendant. Les zones d'habitation et de travail sont réparties sur deux niveaux construits sur un soubassement en béton servant de garage.

Deux escaliers extérieurs constituent le système de circulation principal. Au niveau inférieur, une terrasse intermédiaire entre les deux bâtiments réunit le bureau personnel de l'architecte aux deux chambres. Au niveau supérieur et à l'arrière, une passerelle extérieure relie une véranda, une pièce de réception et une salle de plans (juste au-dessus du bureau de Jones) à la salle de séjour. Un plafond incliné est-ouest à caissons ouverts, le premier dans la carrière de l'architecte, coiffe les deux niveaux supérieurs. Contrastant fortement avec les murs nord sans fenêtre, deux grandes baies vitrées de la hauteur de la pièce donnent sur la ville à l'est. Un solarium prolonge le séjour vers l'extérieur.

Selected Bibliography:
- *arts & architecture, March 1947*
- *California Book of Homes for 1948*
- *Los Angeles Times Home Magazine, September 29, 1974*
- *Process Architecture, number 41, October 1983*

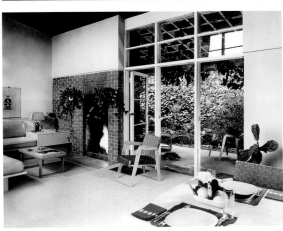

016 A. Quincy Jones and Paul R. Williams
Tennis Club, Palm Springs, California
January 6, 1947

Central elements in the architectural experience are the compelling views of the surrounding desert and the large-scale outcrop present on the site. Partially nestled into the rock formation, the entertainment facility in concrete integrates an existing structure into a quasi-organic plan.

The program is located on two floors. At the ground floor, a bar and office rooms occupy only a small subset of the outline of the second level. Upstairs, a grand dine-and-dance area, a lounge and an outdoor-dining deck define the collective spaces. Here, a glass wall permits an uninterrupted view of the desert valley. In the back, the rocky wall on the mountainside enhances the interiors, where a continuous glass surface the texture of rock blends into the visual landscape of the collective rooms. Sections for communal activities are kept separate from more intimate areas like the lounge and veranda.

Two outdoor stairs, one next to the swimming pool and the other behind the snack bar, give access to the main club floor. Native stone is used for walls, steps, floors and paving.

Das Architekturerlebnis dieser Clubanlage ist vor allem geprägt von den phantastischen Ausblicken in die Wüstenlandschaft und auf die großen Felsformationen des Grundstücks. Der Betonbaukörper des Clubhauses ist teilweise in die Felsen eingebaut und basiert auf einem quasi organischen Grundriss.

Eine Bar und Büroräume nehmen im Erdgeschoss eine wesentlich kleinere Fläche ein als der große Speise- und Ballsaal mit Küchen und Nebenräumen, Clubraum sowie Restaurantterrasse im Obergeschoss. Hier gewährt eine lange Glasfront freie Sicht auf das Wüstental, und durch das hohe Fensterband sieht man auf der Rückseite die natürliche Felswand von nahem. Die großen Gesellschaftsräume sind getrennt von kleineren Bereichen wie Salon und Veranda. Zum Hauptgeschoss gelangt man über Außentreppen (eine neben dem Schwimmbecken, die andere hinter der Snackbar). Für Wände, Trittstufen, Bodenfliesen und Pflaster wurde der vor Ort geschlagene Naturstein verwendet.

Les éléments majeurs de cette composition architecturale sont en fait les vues splendides sur le désert environnant et l'énorme éminence rocheuse présente sur le terrain. En partie niché dans le roc, cet équipement touristique édifié en béton intègre une construction préexistante dans un plan quasi organique.

Le programme est réparti sur deux niveaux. La partie inférieure, nettement moins longue que la partie supérieure, abrite un bar et des bureaux. A l'étage, une grande salle conçue pour la restauration et la danse, un salon et la terrasse du restaurant constituent les espaces collectifs. Un mur de verre offre une vue ininterrompue sur une vallée désertique. A l'arrière, côté montagne, un pan de rocher semble s'intégrer au bâtiment, et les parois vitrées donnent l'impression que le rocher entre les salles communes. Les parties réservées aux diverses activités sont séparées de zones plus privées comme un salon et une véranda. Deux escaliers extérieurs, l'un près de la piscine, l'autre derrière le snack-bar, donnent accès à l'étage principal du club. La pierre locale se retrouve dans les murs, les sols et le pavement extérieur.

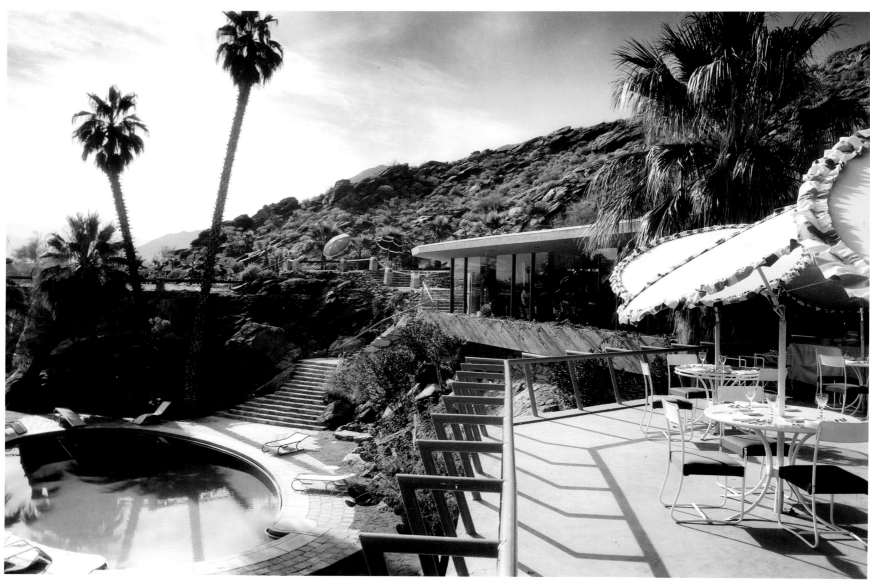

Selected
Bibliography:
- *arts & architecture, April 1947*
- *Progressive Architecture, November 1947*
- *Process Architecture, number 41,*
 October 1983

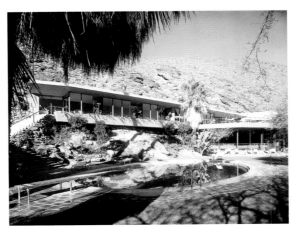
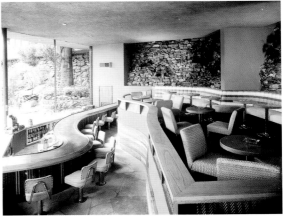

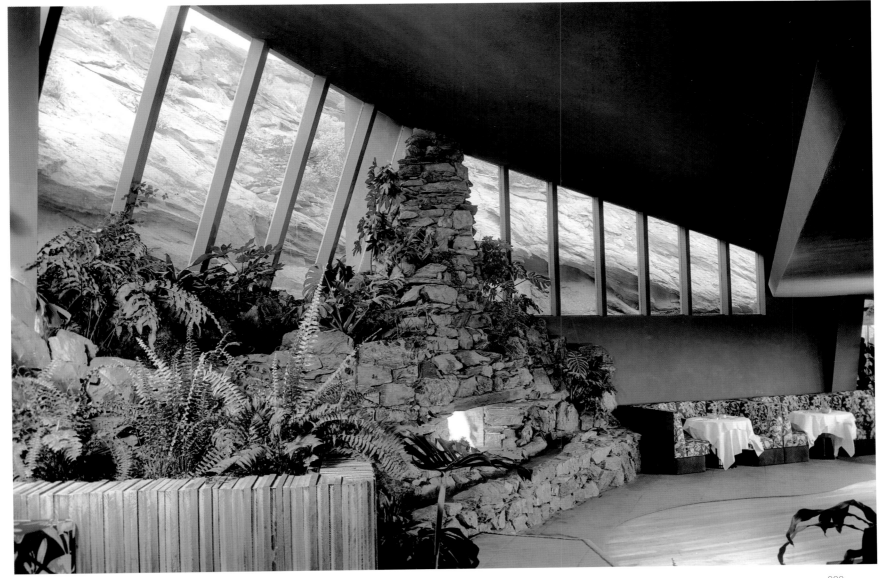

043 William Pereira, Walter Wurdeman and Welton Becket
Pan Pacific Auditorium, Los Angeles, California
March 15, 1942

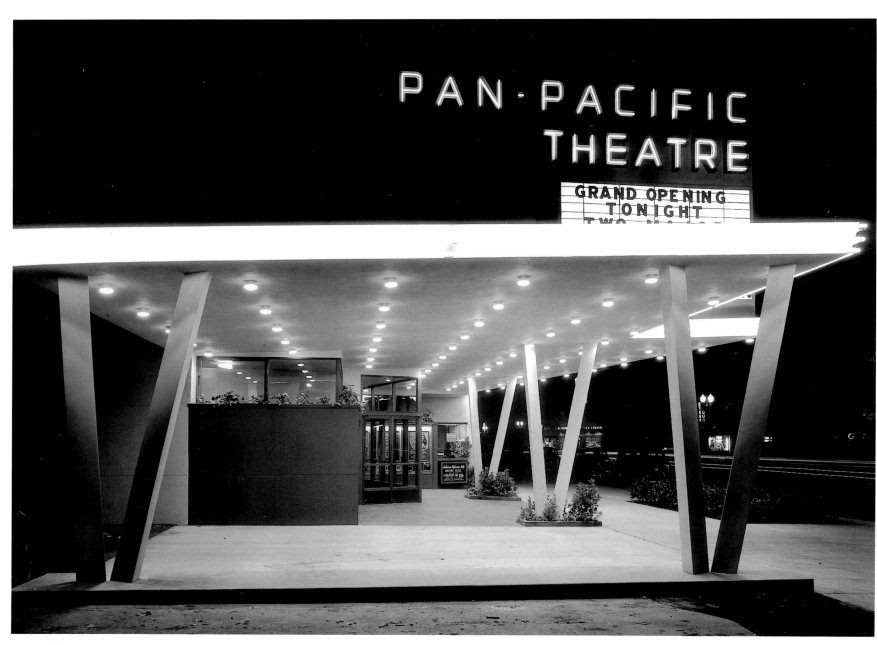

094 Gregory Ain and Visscher Boyd
Beckman Residence, Los Angeles, California
May 26, 1939

On a small, 50 x 135-foot level lot, a couple and their two children specified multiple outdoor areas for family activities. The residence comprises seven rooms each with independent access to private terraces. The master bedroom, dressing room and bath are on the second floor.

Facing the street, a carport and a den, used as guestroom, protect the roofed entry walk leading to the center of the lot. At the rear of the house, connected to the living area, a large 35 x 35 feet private garden provides an outdoor setting for social gatherings. A yard flanks the other side of the living room, where the children can be watched while playing. The construction is post, framing and stucco.

Das Bauherren-Ehepaar hatte zwei Kinder und wünschte sich auf dem 15 x 40 m großen ebenen Grundstück viele Wohnbereiche im Freien. Das Haus selbst enthält sieben Räume, jeder mit eigener Terrasse. Schlaf- und Ankleidezimmer sowie Whirlpool-Bad der Eltern befinden sich im Obergeschoss. Von der Straße »begleiten« Carport und Bibliothek (die auch als Gästezimmer genutzt wird) den Weg zum Eingang in der Mitte der seitlichen Hauswand. Ein 110 m² großer quadratischer Garten auf der Rückseite des Hauses wird für Parties genutzt. Der Spielhof befindet sich auf der anderen Seite des Wohnzimmers, so dass man die Kinder von dort aus beaufsichtigen kann. Das Haus wurde in Rahmenbauweise errichtet und mit weißem Zementmörtel verputzt.

Sur un petit terrain de 15 x 40 m, les propriétaires – un couple et deux enfants – souhaitaient vivre le plus possible à l'extérieur. La résidence est composée de sept pièces, chacune dotée de sa propre terrasse. La chambre principale, le dressing et la salle de bains sont à l'étage.

Face à la rue, un abri à voiture et un cabinet de travail faisant office de chambre d'ami protègent l'allée d'entrée couverte située au centre. A l'arrière, un vaste jardin privé de 110 m² qui jouxte la salle de séjour peut être utilisé pour les réceptions. Une cour de jeu flanque l'autre partie du séjour d'où l'on peut surveiller les enfants. La maison est construite à partir d'une ossature habillée de mortier blanc.

Selected Bibliography:
- Architectural Record, July 1940
- James Ford and Katherine Morrow Ford, The Modern House in America, New York 1940
- arts & architecture, February 1941
- David Gebhard, Harriette Von Breton, Lauren Weiss, The Architecture of Gregory Ain, Santa Barbara 1980
- Esther McCoy, The Second Generation, Salt Lake City 1984

095 Gregory Ain and George Agron
Scharlin Residence, Los Angeles, California
May 26, 1939

Set on a hillside lot, the common zones of the residence open onto terraces facing views of Silverlake. Ain articulates the transition from the public space of the neighborhood to the semi-public areas of the house by recessing the entry lobby and positioning it above street level.

Wood trellises roofing the outdoor decks complete the cubic geometry of the design. Inside, changes of level generate a ten-foot-high ceiling for the living room, while the dining room opens on three sides to the down-slope.

Die Wohnräume dieses Hauses am Hang öffnen sich zur Terrasse mit Blick über den Silverlake. Ain gliederte den Übergang vom öffentlichen Raum der Straße zu den halb-öffentlichen Bereichen des Hauses (Wohn- und Esszimmer), indem er die zurückgesetzte Eingangsdiele über Straßenniveau anlegte. Holzgitterwerk über den Balkonterrassen vervollständigt die kubische Geometrie der Baugestalt. Im Innern ermöglichte das Hanggefälle einen knapp über 3 m hohen Wohnraum. Das Esszimmer öffnet sich auf drei Seiten zum abschüssigen Teil des Grundstücks.

Les pièces communes de cette maison située dans les collines s'ouvrent sur des terrasses donnant sur Silverlake. Ain crée une transition entre l'espace public environnant et les espaces semi-publics de la maison par l'implantation en retrait du hall d'entrée surélevé par rapport au niveau de la rue. Des treillis de bois formant pergola au-dessus des terrasses parachèvent la géométrie cubiste du projet. A l'intérieur, des changements de niveau permettent d'obtenir un plafond de 3 m de haut dans la salle de séjour, tandis que la salle à manger s'ouvre de trois côtés sur la partie en pente du terrain.

Selected Bibliography:

- David Gebhard, Harriette Von Breton, Lauren Weiss, *The Architecture of Gregory Ain,* Santa Barbara 1980

- Esther McCoy, *The Second Generation,* Salt Lake City 1984

098 Gregory Ain
Domela Residence, Tarzana, California
March 1943

On a mountain lot overlooking the valleys and the ocean, two independent volumes articulate the program specifications of Jan and Jocelyn Domela, an artist and a landscape designer. A sweeping breezeway, linking the living unit to the joined carport and artist's studio, gives access to the residential quarters, with the serpentine wall shielding the garden from the wind. The overall plan is designed to provide maximum separation between the owners' activities. Individual patios for the living room, dining area, and master bedroom overlook panoramic views of the city. Sloping canopies cover both sections of the scheme. Rafters stretch the roof overhangs to shelter the open spaces and the gardens. Redwood sheathing for the exterior envelope displays the influence of Rudolph M. Schindler and Harwell Hamilton Harris.

An einem Berghang mit Blick über Meer und Täler beherbergen zwei Baukörper das gewünschte Raumprogramm der Bauherren Jan Domela, Künstler, und seiner Frau Jocelyn, einer Landschaftsarchitektin. Ein Gartenweg führt in einer großen Kurve vom Garagen- und Atelierbau zum Wohnhaus, vorbei an einer gekrümmten Holzlattenwand, die den Garten vor starken Winden schützt. Der Entwurf zielte darauf ab, die Funktionsbereiche so deutlich wie möglich zu trennen. Einzelne Patios für Wohnraum, Essplatz und Elternschlafzimmer bieten Panoramablicke über die Stadt. Geneigte Dächer bedecken beide Baukörper. Die Dachkonstruktion dehnt die Dachüberstände zu Schutzbaldachinen über den Terrassen und Gartenbereichen. Redwoodbretter als Fassadenverkleidung sprechen vom Einfluss Rudolph M. Schindlers und Harwell Hamilton Harris' auf den Architekten.

Edifiés sur un terrain montagneux, dominant vallées et océan, ces deux volumes indépendants répondent avec pertinence au programme établi par Jan et Jocelyn Domela, un artiste et une paysagiste. Le passage couvert en courbe qui relie le séjour à l'abri aux voitures et à l'atelier de l'artiste, donne accès aux chambres. Un mur sinueux protège le jardin du vent. L'objectif poursuivi est d'isoler au maximum les diverses activités des occupants. Les patios du séjour, de la salle à manger et de la chambre principale, bénéficient chacun d'une vue panoramique sur la ville. Des auvents inclinés, couvrent les deux corps du bâtiment. Un ouvrage de charpente prolonge le tait et abrité une partie des espaces ouverts et des jardins. Le bardage en bois rouge de l'enveloppe extérieure marque l'influence de Rudolph M. Schindler et de Harwell Hamilton Harris.

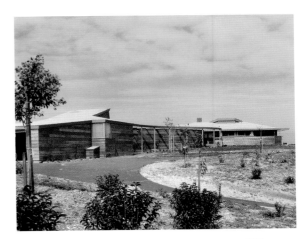

Selected Bibliography:
- California Arts and Architecture, April 1943
- David Gebhard, Harriette Von Breton, Lauren Weiss, The Architecture of Gregory Ain, Santa Barbara 1980
- Esther McCoy, The Second Generation, Salt Lake City 1984

0102 Gregory Ain, George Agron and Visscher Boyd
Daniel House, Los Angeles, California
October 1, 1939

Ms. Urcel Daniel, a young single woman, owned the hillside property on filled ground with a slope both parallel and perpendicular to the street. One requirement for the overall plan was the local building code, which demanded the adoption of a pitched roof; the other requirement was an informal living space requiring minimum maintenance.

Ain designed two hipped roofs to manifest architecturally the distinction between the living-dining area and the sleeping zones. Solid white-plastered screens laid out on a rectangular plan shield the entry path and house interior from public exposure. Openings are positioned to minimize visual interference from

Urcel Daniel, eine alleinstehende junge Frau, besaß ein Hanggrundstück, das sich sowohl parallel als auch quer zur Straße hin neigte. Beim Entwurf mussten die Architekten die örtlichen Baugesetze berücksichtigen, die geneigte Dächer forderten, und den Wunsch der Bauherrin nach pflegeleichten Räumen erfüllen. Ain entwarf zwei Walmdächer, um die Trennung zwischen Wohn- und Essbereich sowie Schlafzimmer zu betonen. Massive, weiß verputzte Mauern auf rechteckigem Grundriss schützen Zugangsweg und Innenräume vor Einblicken von der Straße. Auch die Fensteröffnungen sind so platziert, dass sie weitgehenden Schutz der Privatsphäre bieten, dabei aber für

Urcel Daniel, jeune célibataire, possédait un terrain à flanc de colline dans une zone de remblai dont la pente était à la fois parallèle et perpendiculaire à la rue. Elle souhaitait une maison originale, très facile à entretenir. La réglementation locale imposait un toit à pignon.

Ain conçut deux toits en croupe qui marquent la séparation entre le séjour, le coin repas et la zone des chambres. Des murs-écrans en plâtre blanc, montés selon un plan rectangulaire protègent l'entrée et l'intérieur de la maison du regard des passants. Les ouvertures sont positionnées pour protéger des regards extérieurs tout en apportant le maximum de lumière.

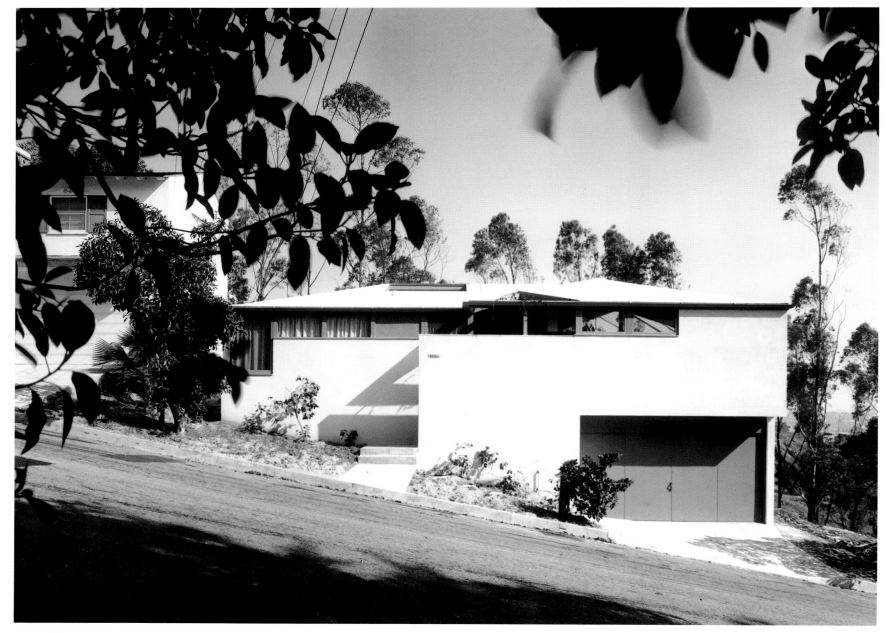

the outside while providing maximum natural light. High horizontal windows on the street front and the sides contrast with the large glass surfaces opening onto a roofed deck at the rear, while a clerestory window catches the afternoon sun in the kitchen.

Framing members above the entry loggia and part of the terrace are left exposed. A five-foot bookcase screens the entrance. One pitched ceiling caps the living and dining room, entry hall, and outdoor deck, making the space appear as a single room.

größtmöglichen Lichteinfall sorgen. Direkt unter der Dachtraufe befindliche Fensterbänder in den Vorder- und Seitenfassaden kontrastieren mit der großen Glasfront zum Garten, die Zugang und Ausblick auf eine überdachte Balkonterrasse bietet. In der Küche fangen Oberlichter das Licht der Nachmittagssonne ein. Teile der Dachkonstruktion über der Eingangsloggia und der Terrasse sind unverkleidet. Ein etwa 1,50 m hohes Einbauregal bildet die Blendwand des Eingangs. Eine Walmdachunterseite überwölbt den Eingang von Wohn- und Esszimmer und die Außenterrasse, so dass alle drei wie ein einziger Raum erscheinen.

Les hautes fenêtres horizontales de la façade sur rue et des côtés contrastent avec les baies vitrées qui donnent sur une terrasse couverte à l'arrière de la maison, tandis que les lucarnes de la cuisine laissent entrer le soleil du soir.

Les poutres de la charpente, sont laissées apparentes au-dessus de la loggia de l'entrée et d'une partie de la terrasse. L'entrée est délimitée par une bibliothèque de 1,50 m de haut. Le séjour, la salle à manger, le hall d'entrée et la terrasse extérieure sont regroupés sous un même plafond incliné qui donne l'impression que l'espace se compose d'une seule et unique pièce.

Selected Bibliography:
- California Arts and Architecture, August 1940
- James Ford and Katherine Morrow Ford, The Modern House in America, New York 1940
- David Gebhard, Harriette Von Breton, Lauren Weiss, The Architecture of Gregory Ain, Santa Barbara 1980
- Esther McCoy, The Second Generation, Salt Lake City 1984

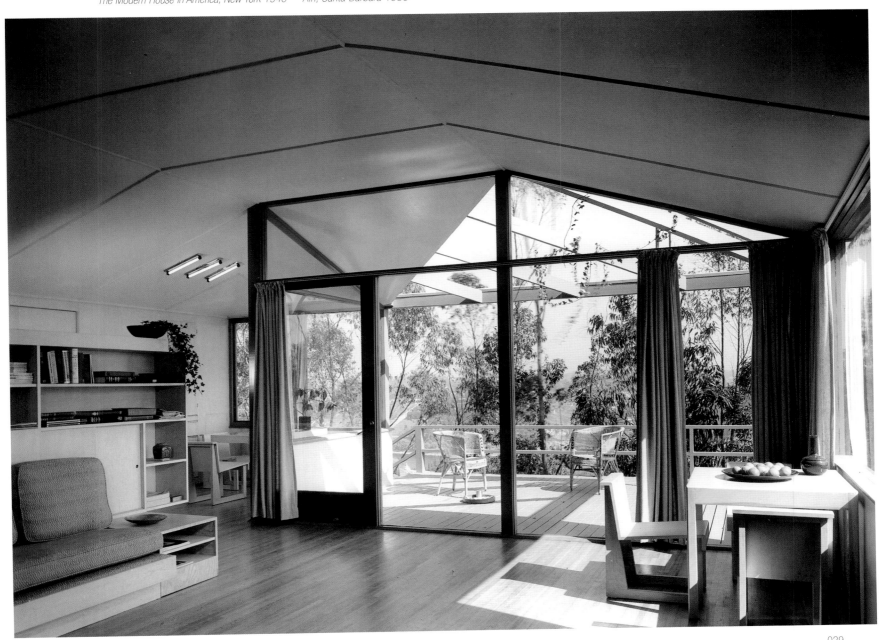

14 Maynard Lyndon
Santa Fe Ticket Office, Los Angeles, California
March 18, 1947

Located on 601 South Hill Street in Downtown Los Angeles, the ticket office supplements the existing booths in the Union Station.

Large glass panels between columns at street level admit natural light into the interior and display the transactions between clerks and customers. The office is divided into two parts: the sweeping counter where the public buys tickets and a separate section, where travel agents advise clients in planning more complicated itineraries. Most of the furniture is custom-designed by Lyndon. Behind the curved front desk, built-in ticket cabinets accommodate tickets up to 24 inches length. The big leather chairs next to the entrance have their stainless steel legs fastened to the floor to facilitate maintenance of the travertine floor. Maynard Dixon painted the mural on the curved surface.

In 1950, the National Chapter of the American Institute of Architects honored this project with an Award of Merit.

Diese Fahrkarten-Verkaufsstelle in der South Hill Street Nr. 601 im Zentrum von Los Angeles wurde zur Entlastung der Schalterhalle des Bahnhofs Union Station errichtet.

Große Glasscheiben zwischen Pfeilern lassen auf Straßenniveau Tageslicht ins Innere und gewähren Einblicke von außen. Im Grundriss ist das Bahnreisebüro zweigeteilt: An dem geschwungenen Schalter kann man Fahrkarten kaufen und in einem abgeteilten Bereich Fernreisen buchen und sich beraten lassen. Die meisten Möbel wurden von Lyndon eigens für das Reisezentrum entworfen. In die Theke sind Fächer für die bis zu 60 cm langen Fahrkarten eingebaut. Die großen Ledersessel neben dem Eingang sind mit ihren Chromstahlrohren am Boden festgeschraubt, die Travertinböden lassen sich so leichter reinigen. Das geschwungene Fresko über dem Schalter stammt von Maynard Dixon. 1950 zeichnete das American Institute of Architects die Schalterhalle mit einem Award of Merit aus.

Situé 601 South Hill Street dans le centre de Los Angeles, ce bureau de vente de billets désengorgeait les guichets de l'Union Station.

Le mur de baies vitrées entre les colonnes du rez-de-chaussée permettait à l'intérieur de bénéficier d'un éclairage naturel et aux passants de percevoir les activités de la billetterie. En plan, la partie publique est divisée en deux zones. Le comptoir incurvé est consacré à la vente des billets, tandis que dans une autre zone, des conseillers aident les clients à organiser leurs voyages. L'essentiel du mobilier a été dessiné par Lyndon. Derrière le comptoir, des cabines intégrés distribuent les tickets dont la longueur peut atteindre 60 cm. Les grands fauteuils de cuir près de l'entrée sont scellés par leur piétement d'acier pour faciliter l'entretien du sol en travertin. Maynard Dixon est l'auteur de la peinture murale qui orne un plan incurvé suspendu au plafond. En 1950, le chapitre national de l'American Institute of Architects a accordé un Prix du mérite à ce projet.

Selected Bibliography:
- Douglas Honnold, Southern California Architecture, Los Angeles 1956
- Wolf von Eckardt (ed.), Mid-Century Architecture in America, Washington D.C. 1961
- Contemporary Backgrounds, Exhibition Catalog, Berkeley 1993

22 Gordon Drake
Rucker House, Los Angeles, California
April 10, 1947

The two-story Rucker house later became the residence of the Spillmans. Drake wanted to provide as much openness as possible for the living area, but the hillside lot presented a number of difficulties. Heavy foliage shut in the 35-foot-wide and 30-foot-deep building site. In addition, a rocky cliff on the north side and a precipitous road surrounded the wooded canyon in which the site is located.

To accomplish his goal, the architect decided to place the main living functions on the upper level, acquiring scenic views of the surrounding and more suitable lighting conditions for the house interior. Garage, laundry, and a partially covered garden occupy the lower floor, open on three sides through built-up wood posts. On the same level, an outdoor sitting room is carved into the curve of the hill in the rear and screened from the carport by a massive masonry pier.

A flight of wooden steps leads via a suspended walkway to the upper level of the house. The covered area of the upper floor is only 15 x 39 feet. A minimal number of partitions, large glass surfaces, differences in ceiling-height and built-in furniture yield an overall sense of spaciousness, when compared with the actual scale of the house. Kitchen, living room, and entrance occupy a single space. The sleeping unit can be reached through a movable partition. A long balcony provides an outdoor area for the living room and bedroom. One end of the structure is firmly anchored to the hill; the other is propped up by the chimney. Sheets of plywood form the framework.

The house received second prize in the 1947 House & Garden Awards in Architecture and an Honorable Mention in the 1948 Progressive Architecture Awards.

Drake wollte den Wohnbereich des zweistöckigen Hauses so offen wie möglich gestalten, das sehr schattige Hanggrundstück (11 m breit, 9 m tief) hielt jedoch einige Hindernisse bereit. Auf der Nordseite ist es von einer Felsenklippe begrenzt, und der bewaldete Canyon, in dem es liegt, ist von einer stark abschüssigen Straße umrundet. Zur Verwirklichung seiner Vorstellungen verlegte der Architekt die Hauptwohnräume ins Obergeschoss, das die weitere Aussicht in die Landschaft und bessere natürliche Belichtung bietet. Garage, Waschküche und ein teilweise überdachter Garten befinden sich auf der unteren Ebene, die auf drei Seiten von den Holzstützen des Obergeschosses umgeben ist. Auf der gleichen Ebene findet sich eine in den Hang eingeschnittene rückseitige Terrasse, die mittels einer massiven Stützmauer vom Carport abgeschirmt ist.

Eine Holztreppe mit Hängebrücke führt von unten zur Hauptebene, deren überbaute Fläche nur rund 4,50 x 12 m misst. Nur wenige Trennwände, große Glasflächen, verschieden hohe Decken und Einbaumöbel sorgen für den Eindruck von Geräumigkeit. Küche, Wohnraum und Eingangsbereich bilden einen einzigen großen Raum. Der Schlafbereich ist durch eine Schiebewand zugänglich. Ein langer Balkon ist dem Wohnraum und dem Schlafzimmer vorgelagert. Eine Hausseite ist fest im Hang verankert, die andere wird vom Kaminschacht abgestützt. Sperrholzplatten bilden die Balkonbrüstungen.

Im House & Garden Awards in Architecture-Wettbewerb von 1947 gewann das Haus den 2. Preis, und 1948 eine Belobigung im Wettbewerb um den Progressive Architecture Award. Das Haus Rucker wechselte später in den Besitz der Familie Spillmann über.

Cette maison sur deux niveaux a été conçue pour un couple, construite par un autre, et habitée par un troisième, les Spillman. Drake souhaitait ouvrir au maximum le séjour, mais le terrain à flanc de colline présentait plusieurs difficultés. Des arbres touffus enserraient la partie constructible de la parcelle de 11 x 9 m, et une falaise au nord plus une route entouraient le canyon boisé où se trouvait le terrain.

Pour arriver à son but, l'architecte décida d'implanter les principales fonctions domestiques au niveau supérieur, afin de bénéficier de la vue sur le cadre verdoyant et d'un meilleur éclairage naturel à l'intérieur de la maison. Le garage, la buanderie et un jardin partiellement couvert occupent le niveau inférieur, ouvert sur trois côtés par une séquence de poteaux. Au même niveau, un salon de plein air en partie creusé dans la colline à l'arrière, est séparé de l'abri aux voitures par un contrefort en maçonnerie. Une volée de marches en bois conduit à une passerelle suspendue au second niveau. La partie couverte de celui-ci ne mesure que 4,50 x 12 m. Un nombre de cloisons réduit au minimum, d'importants plans de verre, les variations de hauteur sous plafond et les meubles intégrés confèrent à cette zone un effet de grande ouverture. La cuisine, le séjour et l'entrée occupent un même espace. On accède à la chambre par une cloison mobile. Le long balcon est commun à la chambre et au séjour. Une des extrémités de la maison est solidement ancrée dans la colline, tandis que l'autre appuyée à la cheminée, est surélevée par rapport au sol. Des panneaux de contreplaqué raidissent l'ossature. Cette maison a reçu le second Prix d'architecture de « House & Garden » 1947, et une mention aux Progressive Architecture Awards de 1948.

Selected Bibliography:
- Progressive Architecture, January 1948
- House & Garden, May 1948
- William J. Hennessey, America's Best Small Houses, New York 1949
- Katherine Morrow Ford and Thomas Creighton, The American House Today, New York 1951
- Douglas Baylis and Joan Parry, California Houses of Gordon Drake, New York 1956

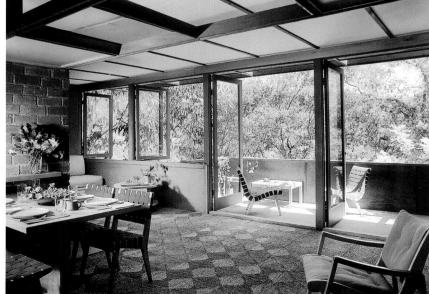

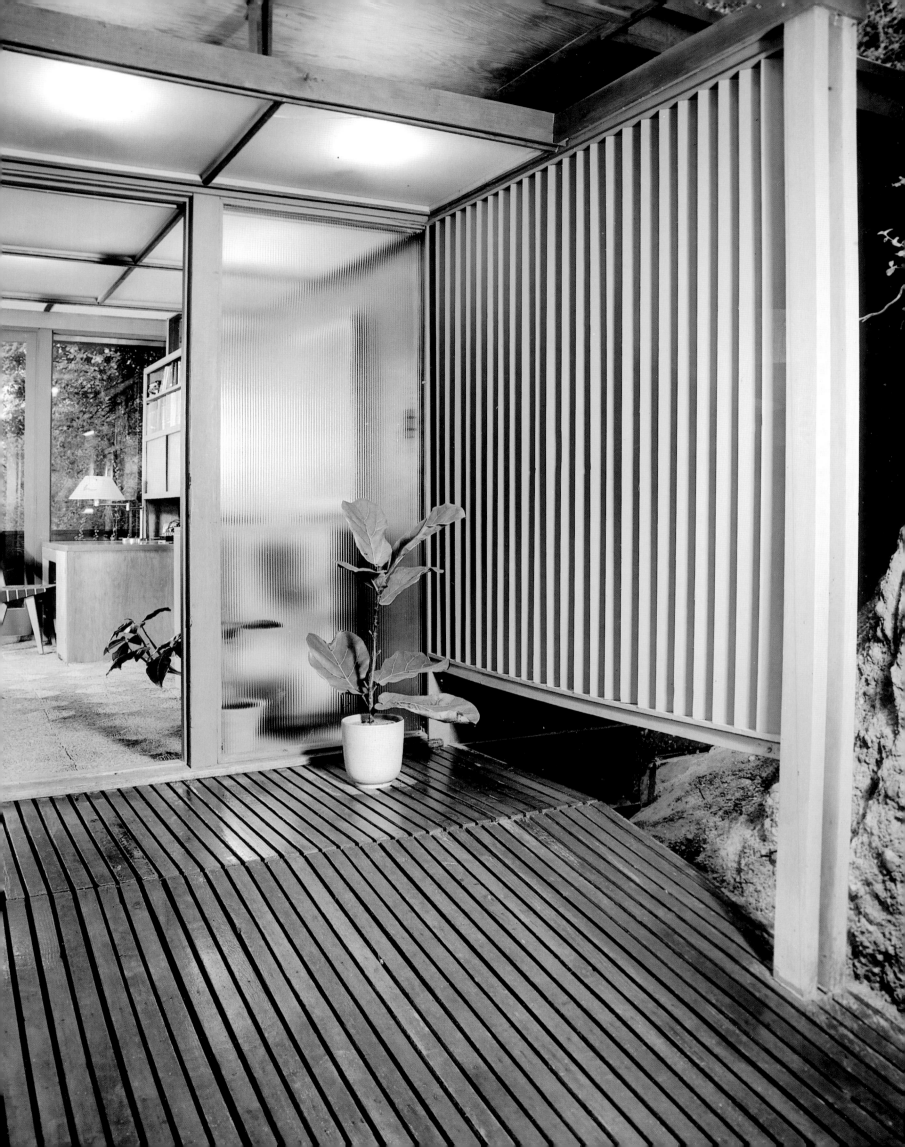

148 Herbert W. Burns
Town and Desert Apartments, Palm Springs, California
November 30, 1947

An unconventional building at the time, this apartment hotel serves as a vacation spot for a community of nature friends. Town and Desert Apartments is located near the center of Palm Springs and contains five rental units, as well as the office and private residence of Herbert W. Burns who owns the complex. Developed along an L-shaped plan, the complex stretches horizontally into the landscape opening onto a meadow looking out to the southwest. Intended to house temporary visitors, the architectural setting welcomes the guests with a sense of community. The rental units, fully equipped with utilities, provide the feeling of a small apartments and face a swimming pool area serving as the collective stage for social interaction. The elevation overlooking the meadow progresses in a jagged fashion, creating semi-private spaces for each unit mediating the passage between private and public areas. The merging of exterior and interior space into a homogeneous scene informs the design strategy. Floor levels are the same inside and outside. Glass-screen windows unite rather than separate. A chocolate-brown color carries over from the underside of the overhanging roof to the interior ceiling. Walls of Arizona flagstone punctuate the court elevation to secure privacy for the different sections of the complex. Further continuity is achieved by integrating the color palette from the natural environment into the architectural scheme. The interior colors pick up the hues of the rocks and the desert foliage. The red-brown coloring of the ceilings, combed plywood walls and curtains alludes to the Chocolate Mountains. Silvery tamarisks along the recessed walls at the rear and mesquite shade along the front walls provide varying degrees of depth. Within, the color combinations change from room to room giving each a characteristic identity.

Diesem Appartement-Hotel für einen Ferienort – seinerzeit ein unkonventioneller Gebäudetyp – lag die Idee eines naturverbundenen Urlaubs zugrunde. Der Komplex gehörte Herbert W. Burns, dessen Wohnung zum Kern der Anlage gehörte. Unter einem langen, niedrigen Dach finden fünf Mieteinheiten, die Wohnung des Architekten und ein Büro Platz. Die flache, L-förmige Anlage, obschon für nur zeitweilig anwesende Besucher gedacht, fördert doch ein Gemeinschafts-Bewusstsein der Gäste. Die typische Mieteinheit ähnelt einer kleinen Wohnung. Sie ist komplett ausgestattet und ist auf den Swimming Pool ausgerichtet, einer Art Bühne für gemeinsame Unternehmungen. Die zerklüftete Anhöhe oberhalb der Wiese bietet halbprivate Nischen und bildet so den Übergang zwischen privaten und öffentlichen Bereichen. In der homogenen Verbindung von Innen- und Außenraum wird die Entwurfsstrategie deutlich. Die Wohnniveaus sind innen und außen gleich und haben keine Schwellen. Die Fenster werden zu gläsernen Schiebeelementen und verlieren so ihre trennende Funktion. Das Schokoladen-Braun an der Unterseite des überkragenden Daches setzt sich an den Decken der Innenräume fort. Wände aus Arizona-Steinplatten gliedern die Hoffront und sichern die Privatheit der einzelnen Trakte.. Die Farbpalette der umgebenden Landschaft spiegelt sich in der Architektur. Das Rotbraun der gerauhten Sperrholzwände und der Vorhänge ist beeinflusst von den nahegelegenen Chocolate Mountains. Das Silbergrau der Tamarisken für die zurückgesetzten Wände und der Mimosenton der vorderen Wände vermitteln unterschiedliche Stufen von Tiefenräumlichkeit. Die Farbkombinationen wechseln von Raum zu Raum, um jedem eine charakteristische Identität zu geben.

D'un type de construction inhabituel pour son époque, cet hôtel d'appartements dans une villégiature annonce un nouveau genre de vacances en communion avec la nature. L'appartement d'Herbert W. Burns, propriétaire de ce complexe, en occupait le centre. Le plan en L s'étire à l'horizontale sur un terrain à proximité du centre de Palm Springs. L'ensemble comprend cinq logements, dont celui de Burns et un bureau, réunis sous un long toit bas, et tous ouverts au sud-ouest sur une prairie. Bien que conçu pour des visiteurs de passage, le cadre architectural crée un sens communautaire. L'unité de location typique se présente sous la forme d'un petit appartement totalement équipé, face à la piscine, lieu de socialisation par excellence. La façade qui donne sur la prairie est animée de retraits semi-privatifs qui correspondent à chaque logement et jouent un rôle de transition entre espace public et espace privé. La fusion du dedans/dehors en un lieu homogène est l'objectif stratégique recherché. Le sol est au même niveau à l'intérieur comme à l'extérieur. Les fenêtres sont des écrans de verre, dont la fonction séparatrice est remise en question. La couleur brun chocolat du soffite de l'avant-toit se poursuit à l'intérieur. Des murs en dalles de pierre de l'Arizona animent la façade sur cour et protègent l'intimité des différentes parties du complexe. L'esprit de continuité est confirmé par une gamme chromatique inspirée de l'environnement naturel. Les couleurs intérieures rappellent celles des rochers et de la végétation du désert. Le plafond brun rouge, les murs en panneaux de contre-plaqué assemblés par enfourchement et les rideaux sont inspirés des Chocolate Mountains. Les murs en retrait sont couleur de tamarinier argenté et les murs en avancée vert pâle, ce qui crée des différences de profondeur. Les harmonies de couleurs changent d'une pièce à l'autre pour donner une identité à chacune d'entre elles.

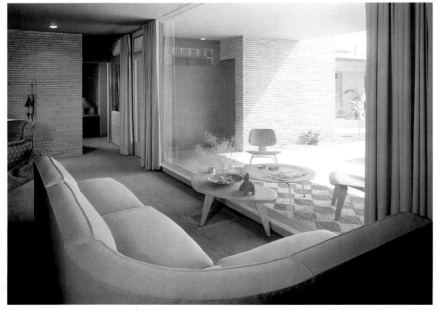 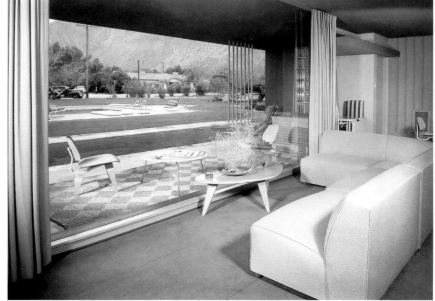

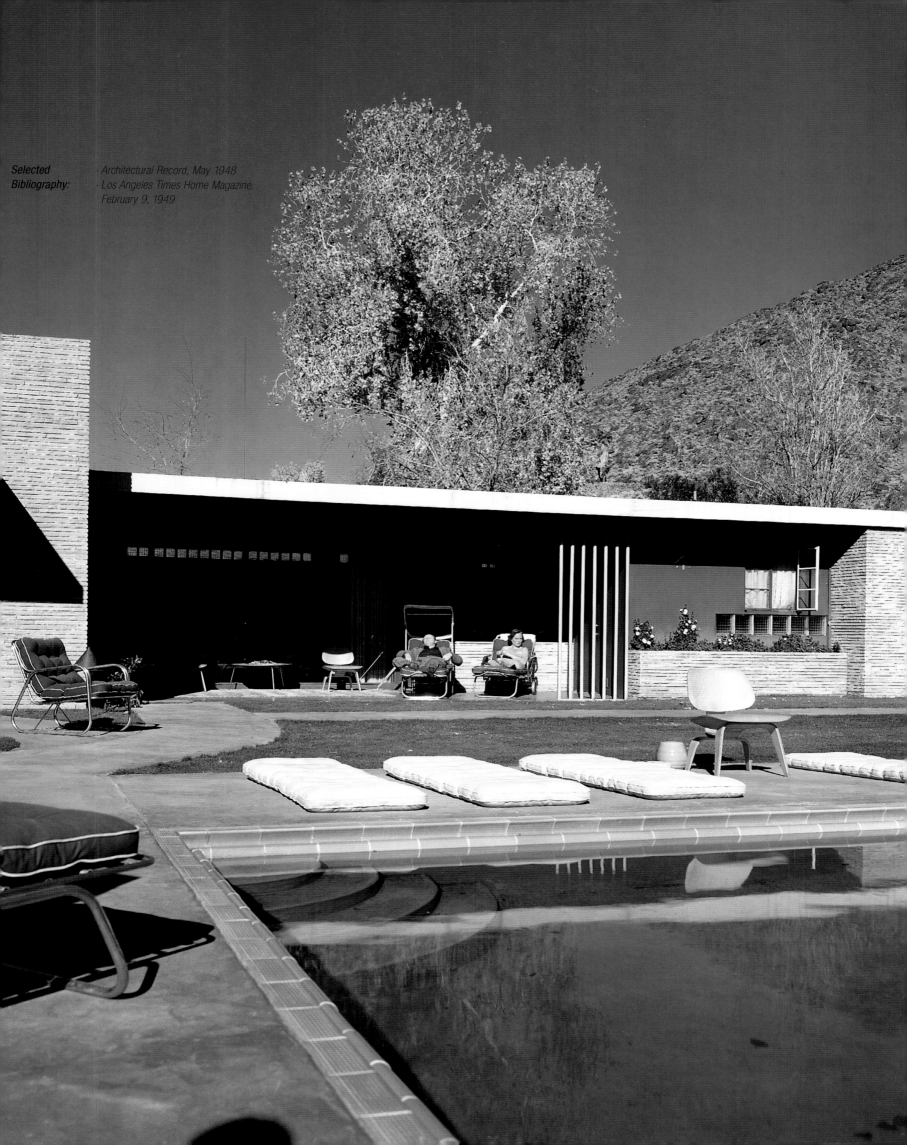

Selected
Bibliography:
- *Architectural Record, May 1948*
- *Los Angeles Times Home Magazine,*
 February 9, 1949

200 **Whitney Smith**
Smith Residence, Pasadena, California
April 25, 1948; June 3, 4, 1953

The architect's residence is the result of four remodeling increments within a 20-year period. In its initial stage there was only a double garage with a pitched roof. When the Smiths bought the property in 1936, the garage had been turned into a residential unit with the living room and two storage spaces projecting out of the original footprint. Five years later, part of the storage space was converted into a laundry, and an additional room was added for the owners' daughter. Major alterations to the scheme occurred in 1946: The living space was turned into a dining area raised 15 inches above the ground, and a new larger living room for outdoor entertaining was designed with a small greenhouse in-between. Together with the old structure, the slanted canopy of the added volume forms a butterfly roof. To screen the sunlight off the living room, Smith profiled a deep overhang supported by slender posts. The final change occurred in 1954 when a new room was added to the child's wing.

The exterior space features existing trees planted forty years earlier, plus a garden and car parking rotated 45-degrees off the house alignment. A trellised terrace for outdoor dining displays two long redwood tables and four benches designed by the architect.

Das Haus des Architekten ist das Ergebnis eines »vierstufigen Bauprozesses« über insgesamt 20 Jahre: Ursprünglich bestand es aus einer Doppelgarage mit Satteldach. Als die Smiths das Anwesen 1936 kauften, war die Garage bereits ein kleines Haus mit angebautem Wohnzimmer und zwei Abstellräumen. Fünf Jahre später installierte Smith in einem Abstellraum die Waschküche und baute ein Zimmer für die Tochter an. 1946 erfolgte die weitgehende Umstrukturierung des Hauses: Im Wohnzimmer entstand der um 40 cm erhöhte Essplatz; ein größerer Wohnraum mit Wohnterrasse und kleinem Glashaus dazwischen kam hinzu. Das neue flache Pultdach bildet zusammen mit dem des Altbaus ein Schmetterlingsdach. Der tiefe Dachüberstand des Wohnzimmers sorgt für Sonnenschutz. Die letzte Erweiterung erfolgte 1954 mit dem Anbau eines zusätzlichen Kinderzimmers.

Im Garten stehen große (40 Jahre zuvor gepflanzte) Bäume; die offenen Garagen sind um 45° aus der Hausachse herausgedreht. Eine mit einem Holzgitter gedeckte Terrasse stattete der Architekt mit zwei selbst entworfenen Esstischen und Bänken aus.

Résidence de l'architecte, cette maison est le fruit de quatre opérations de restructuration menées sur vingt ans. Au départ, le terrain n'était occupé que par un double-garage à toit en pignon. Lorsque les Smith l'achetèrent en 1936, celui-ci avait été transformé en logement par l'adjonction (en avancée par rapport à l'emprise originale) d'un séjour et de deux espaces de rangement. Cinq ans plus tard, une partie de ceux-ci fut transformée en lingerie et une nouvelle pièce créée pour la fille des propriétaires. De profondes transformations furent apportées à ce schéma en 1946. Le séjour fut transformé en salle à manger surélevée de 40 cm par rapport au niveau du sol, et un nouveau séjour plus vaste se prolongeant vers l'extérieur pour les réceptions fut ajouté, séparé du précédent par une petite serre. Par rapport à l'ancienne construction, l'auvent incliné du nouveau volume donne l'impression d'un toit en aile de papillon. Pour protéger le séjour du soleil, Smith a imaginé un grand auvent soutenu par de minces piliers. La dernière modification a été apportée en 1954, par l'adjonction d'une nouvelle pièce à l'aile occupée par l'enfant.

L'espace extérieur orné de trois arbres plantés quarante ans plus tôt, se compose d'un jardin et d'un emplacement de parking qui pivotent de 45° par rapport à l'alignement de la maison. La terrasse sous treillis pour prendre les repas en plein air est dotée de deux longues tables et de quatre bancs en bois rouge dessinés par l'architecte.

Selected Bibliography:
- arts & architecture, August 1949
- Sunset, April 1954

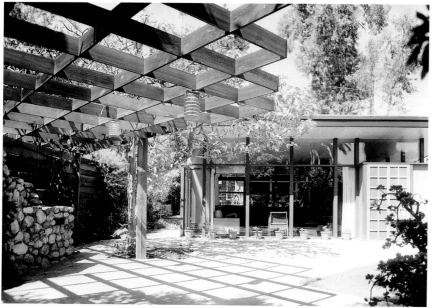
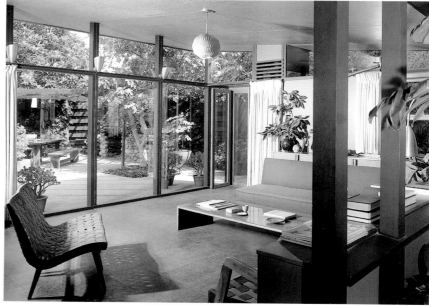

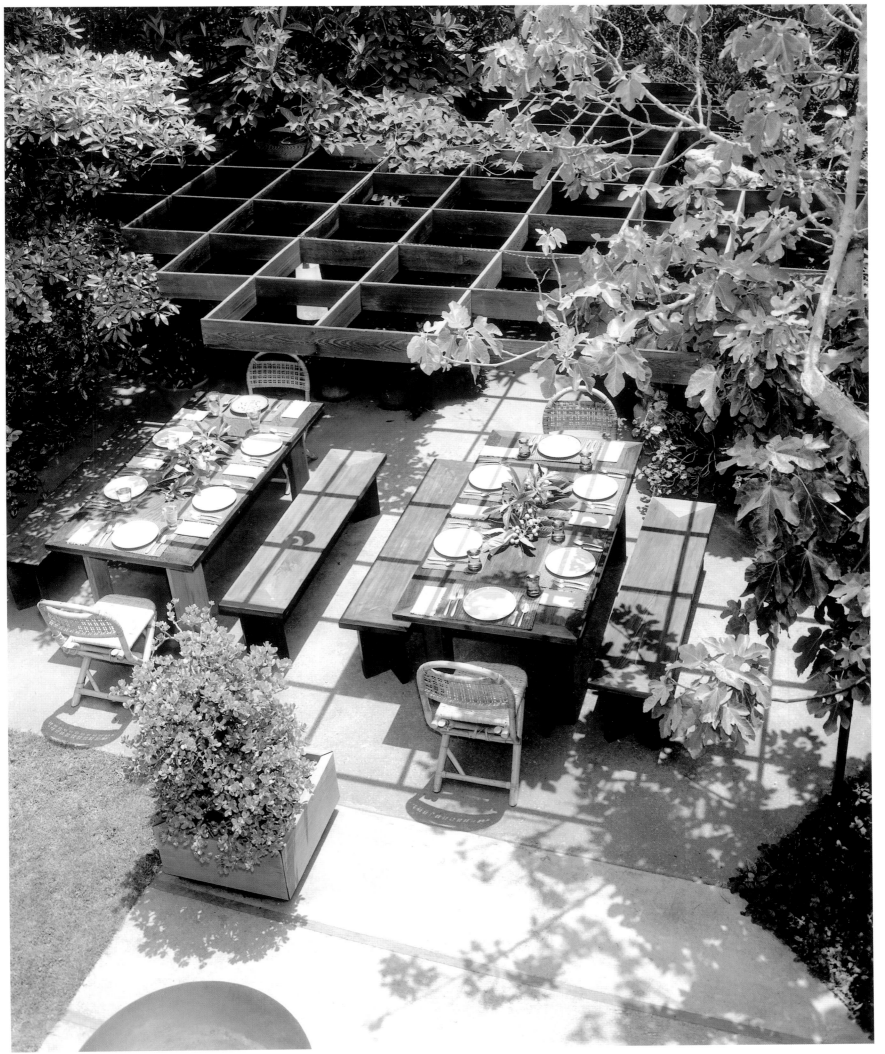

223 Douglas Honnold and John Lautner
Hancock Residence, Silverlake, California
June 19, 1948

Within a rectangular property on level land, the architects concocted an architectural scheme based on two masses rotated 30 degrees from each other, resulting in a clearly zoned interior with an abundance of outdoor, space in the front and rear of the house on a small city lot. Buffered from public exposure by a planting area and a driveway, the entry hall accesses the core of the house a few steps below ground level and is closely connected to all common spaces of the house. A diagonal brick wall at the entry and a large glass window framing the front garden run over two stories and form the double height of the living room. Upstairs, the sleeping area comprises the master bedroom overlooking the living area and a guestroom. Both units have direct access to a sun deck in the treetops with views of the surrounding landscape.

Für ein rechteckiges flaches Grundstück ersannen die Architekten ein ungewöhnliches Haus, dessen Volumen um 30° gegeneinander versetzt sind und klar umrissene Innenräume sowie relativ geräumige Terrassen und Gartenbereiche vor und hinter dem Haus auf einem knapp bemessenen Stadtgrundstück ermöglichten. Eine schrägstehende Ziegelmauer am Eingang und eine hohe gegliederte Fensterwand bilden die Straßenfassade des zweigeschossigen Wohnraums. Die Schlafräume im Obergeschoss umfassen den der Hancocks (mit Blick in den Wohnraum) und ein Gästezimmer. Beide haben Zugang zu einem Sonnendeck in Höhe der Baumkronen mit Durchblicken in die Umgebung.

C'est pour un petit terrain rectangulaire situé en pleine ville que les architectes ont conçu ce projet architectural à partir de deux volumes formant un angle de 30°. Ce principe permet une répartition claire des fonctions intérieures et de l'espace utile extérieur. Le hall d'entrée permet d'accider directement par quelques marches aux espace privés situés en contrebas. A l'entrée, un mur de brique en diagonale et une grande baie vitrée qui s'élève sur les deux niveaux du séjour cadrent le jardin côté rue. En haut, la zone des chambres comprend une chambre principale qui donne sur le séjour et une chambre d'amis. Toutes deux ont accès à un solarium à hauteur de la cime des arbres avec vue sur le cadre environnant.

Selected
Bibliography: - House & Garden, July 1949

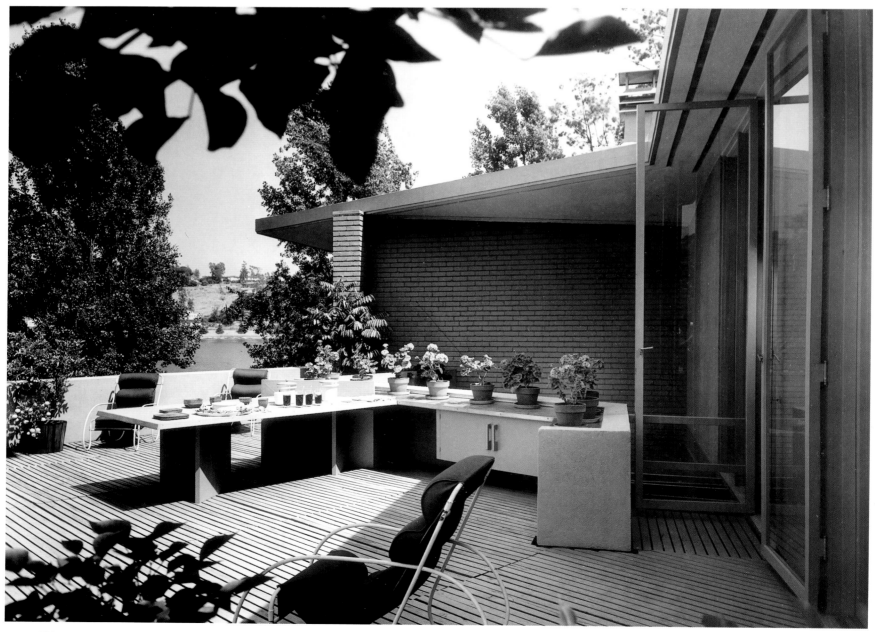

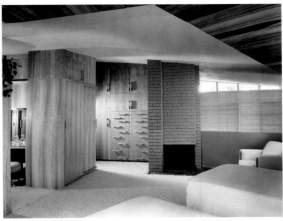

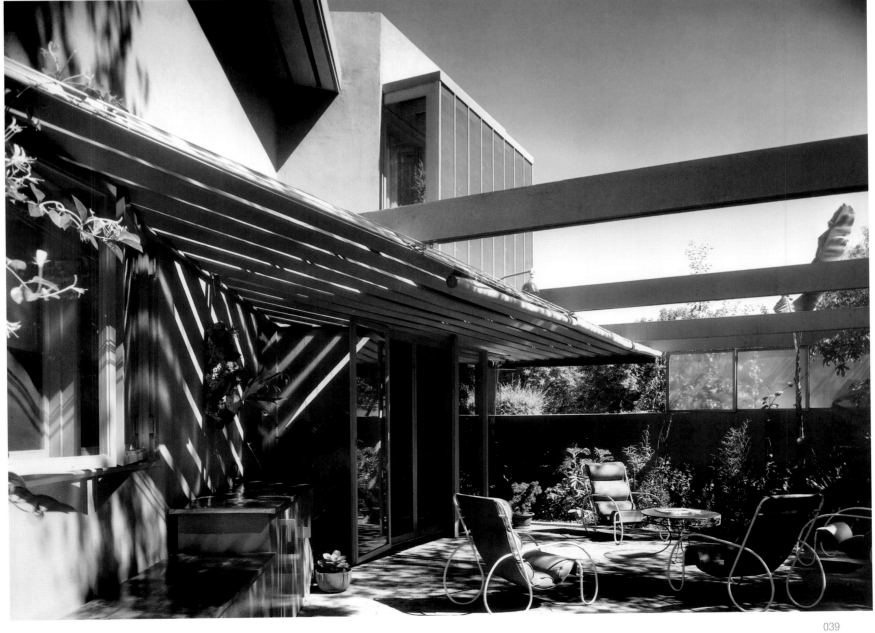

303 Paul László
László Residence, Brentwood, California
September 14, 1948

When Paul László moved to the United States prior to World War II, his architecture and interior designs were already well known in Germany. Comfort and technical conveniences were the elements of his design formula for modern living, that appealed to a wealthy clientele. He settled in Southern California, where he built a large number of luxurious residences that became the symbol of an opulent lifestyle.

The setting of his own residence (see p. 176) is a plateau in the Brentwood Hills with views of the valleys beyond. Domestic life is centered on a wide outdoor patio oriented south to take advantage of the all-year-round gentle California climate. L-shaped in plan, the house occupies two sides of the patio with a cabana wall on the third one to shield the interior from street activity. Beyond the cabana wall shaded by the deep overhang, a covered walkway connects the kitchen and dining area to the generous living room open on two sides with floor-

Als Paul László vor dem 2. Weltkrieg in die USA emigrierte, hatte er sich in Deutschland als Architekt bereits einen Namen gemacht. Wohnkomfort und technische Annehmlichkeiten kennzeichneten seine Bauten, die einer wohlhabenden Klientel zusagten. László ließ sich in Südkalifornien nieder und schuf eine große Zahl luxuriöser Einfamilienhäuser, die zum Inbegriff eines opulenten Lebensstils wurden.

Sein erstes eigenes Haus (s. S. 176) errichtete er auf einem Bergplateau bei Brentwood mit Ausblick in mehrere Täler. Das Wohnerlebnis konzentriert sich auf die große Südterrasse, die im milden Klima Kaliforniens das ganze Jahr über genutzt werden kann.

Das L-förmige Haus umfasst die Terrasse auf zwei Seiten; die »Cabana«, eine überdachte Gartenveranda, bildet die dritte Seite. Dahinter verbindet ein überdachter Weg Küche und Esszimmer mit dem geräumigen, auf zwei Seiten offenen und raum-

Lorsque Paul Laszlo vint s'installer aux Etats-Unis avant la Seconde Guerre mondiale, ses réalisations architecturales et ses aménagements intérieurs étaient déjà connus en Allemagne. Le confort et diverses solutions techniques pratiques constituaient les ingrédients d'une vie moderne qui séduisait une clientèle aisée. Il s'installa en Californie du Sud où il construisit un grand nombre de luxueuses résidences devenues les symboles de l'opulence.

Cette maison, la première qu'il réalisa pour lui-même (voir p. 176), est située un plateau dans les collines de Brentwood. La vie se déroule autour d'un vaste patio extérieur orienté au midi pour bénéficier tout au long de l'année de la douceur du climat californien. De plan en L, la maison occupe les deux côtés du patio, tandis qu'une sorte de claustra protège l'intérieur de l'animation de la rue. Derrière cet écran, ombragé par un profond auvent, une allée couverte réunit la cuisine et le coin-

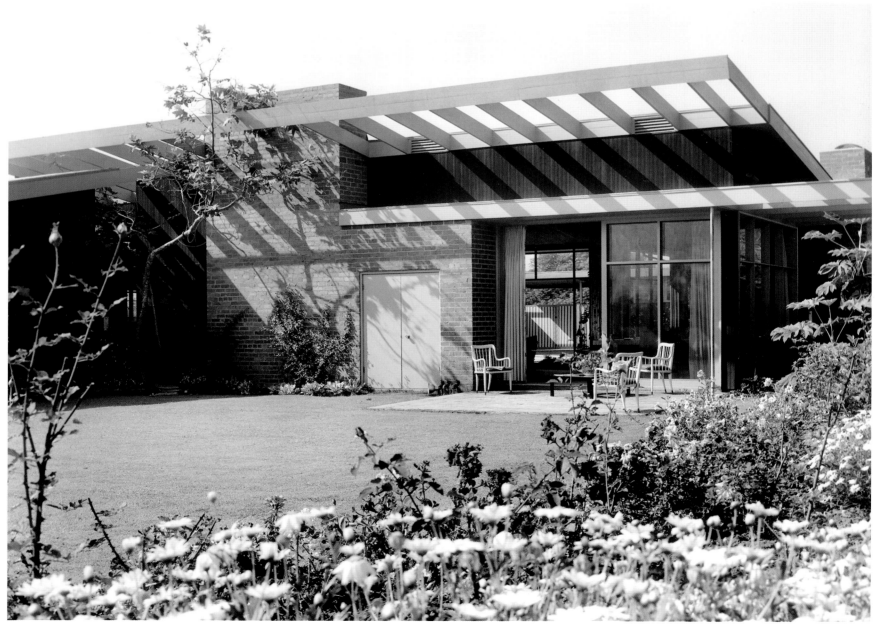

Selected Bibliography:

- House & Garden, February 1949

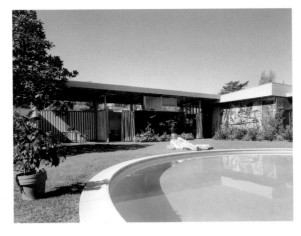

to-ceiling windows. At the far end of the passage, the sleeping wing contains the bedroom units within a rectangular area.

hoch verglasten Wohnraum. Am Ende des Weges steht der kompakte rechteckige Schlafzimmertrakt.

repas au grand séjour ouvert des deux côtés par des baies toute hauteur. A l'extrémité du passage extérieur, les chambres sont regroupées selon un plan rectangulaire.

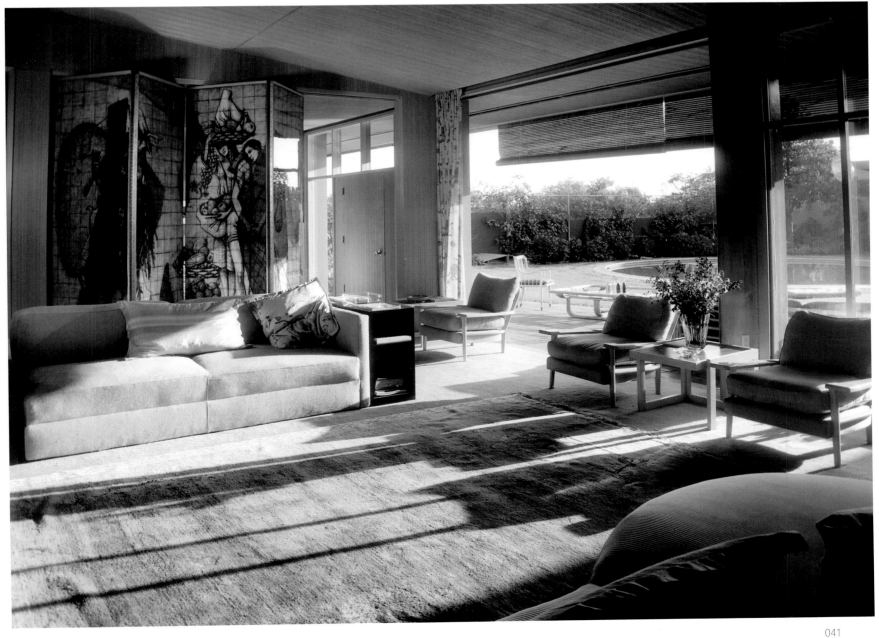

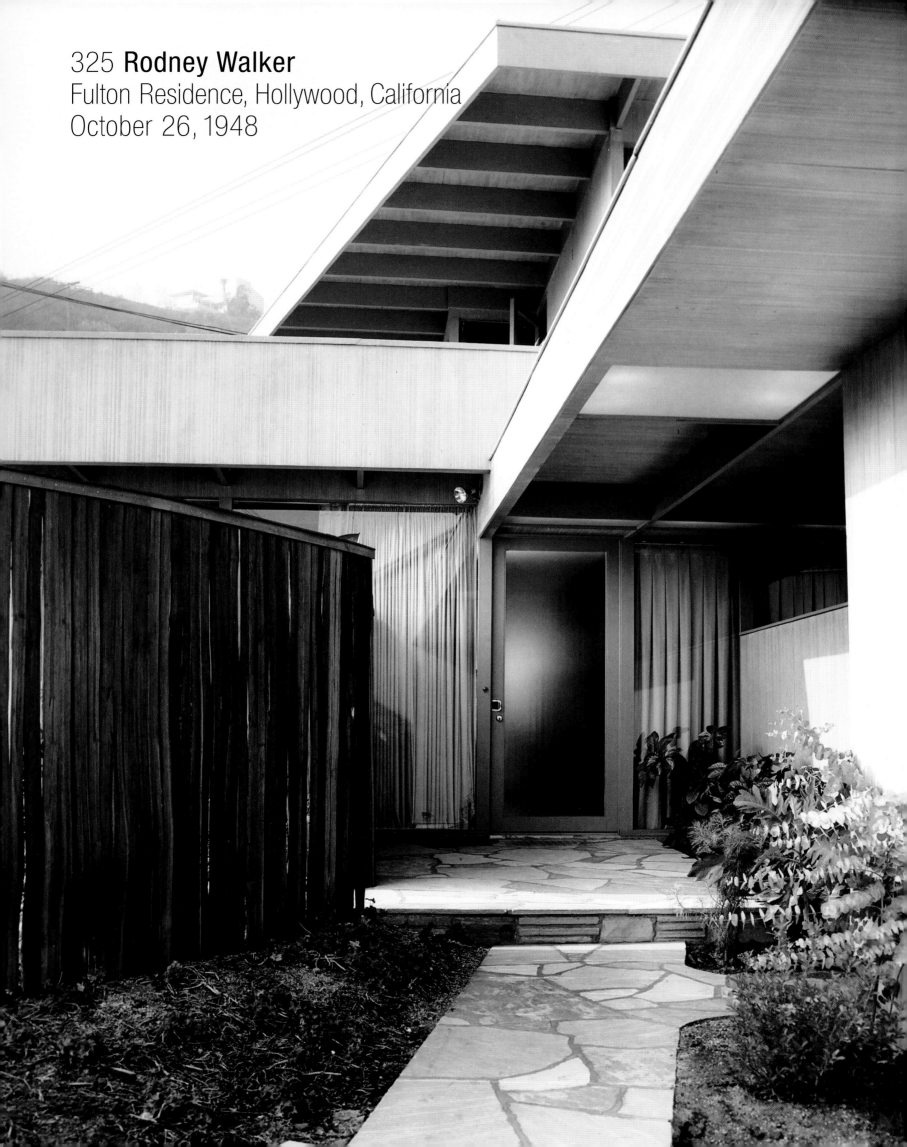

325 **Rodney Walker**
Fulton Residence, Hollywood, California
October 26, 1948

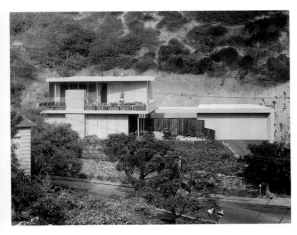 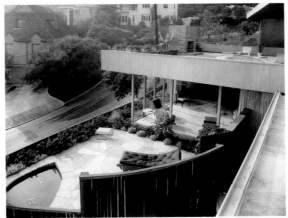 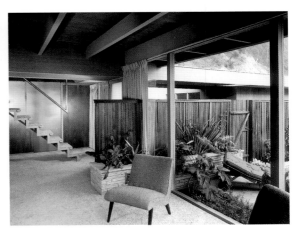

Although the two-story residence containing a living-dining room, two bedrooms and two baths is moderate in size, the architecture looks rather spacious. Two sun decks – double the covered space of each floor – open to a panorama view of the city and expand the house's scale.

In section, a street below and a mountain above contain the hillside lot. Despite its close proximity to the road, a sharp change in level guarantees the house's privacy. The architect carefully articulates the transitions between public, semi-public, semi-private, and private areas. From the outside, the residence appears to be sitting on a basement bordered by a tall retaining stonewall. A driveway on one side of the lot buffers the interior from the street and connects to the entry path leading in a series of steps up to the center of the house. In the lobby, the intended blending of indoor and outdoor finds harmonious expression. Here, a light freestanding staircase with a minimalist railing hanging from the ceiling is glass-walled on one side, cutting a passage to the first floor bedroom; the other side opens onto the living room and a small garden screened by a high redwood fence.

Despite the simple rectangular floor plan of the house, spaces merge into each other with a minimal use of partitions. A flagstone terrace expands the living room outside while the redwood fence and the planted areas continue from the exterior in; floor-to-ceiling windows frame large portions of the cityscape; all these architectural elements emphasize the idea of uninterrupted space.

When Ethel McCall Head reviewed the Fulton Residence in the *Los Angeles Times Home Magazine*, the house had already changed ownership. Originally designed for Miss Geneva Fulton, the house was bought later by Mr. and Mrs. Kenneth O. Timkham.

Obwohl das zweigeschossige Wohnhaus eine bescheidene Größe hat (ein Wohn-/Essraum, zwei Schlafzimmer und zwei Bäder), wirkt die Architektur trotzdem weitläufig. Zwei auf das Stadtpanorama ausgerichtete Sonnenterrassen verdoppeln auf jedem Stockwerk die Fläche des überdachten Raumes. Das Hanggrundstück wird unten durch eine Straße und oben durch den Berg begrenzt. Trotz der Nähe zur Straße garantiert der große Niveauunterschied eine gewisse Privatheit für das Haus. Der Architekt hebt sorgfältig die Übergänge zwischen den öffentlichen, halböffentlichen und privaten Bereichen hervor. Von außen betrachtet scheint das Wohnhaus auf einem Untergeschoss zu sitzen, das von einer hohen Mauer umgeben ist. Eine seitlich der Anlage verlaufende Zufahrt schirmt das Hausinnere von der Straße ab. Der Eingangsweg setzt sich über einige Stufen gradlinig direkt bis in die Mitte des Hauses fort. In der Eingangshalle findet das Hauptthema dieses Entwurfs, nämlich die Verbindung von Innen und Außen, seinen deutlichsten Ausdruck. Eine leichte freistehende Treppe, abgehängt von der Decke, mit einem minimalistischen Geländer, hat auf der einen Seite eine Glaswand und bildet einen Übergang zum Schlafzimmer im ersten Stock; die andere Seite öffnet sich zum Wohnraum und zu einem kleinen Garten, der durch einen hohen Zaun abgeschirmt ist. Trotz des einfachen rechteckigen Grundrisses fließen die Räume mit nur wenigen Trennwänden ineinander. Eine Terrasse setzt den Wohnraum nach Außen fort. Der Zaun und die Pflanz-Inseln außen werden umgekehrt auch innen wahrgenommen. Deckenhohe Fenster rahmen große Ausschnitte des Stadtpanoramas ein; alle diese Details verstärken die Idee eines fließenden Raums. Als Ethel McCall Head die Fulton Residence für das »LA Times Home Magazine« besprach, hatte das Projekt bereits neue Besitzer. Der ursprünglich für Miss Geneva Fulton entworfene Bau, wurde dann von Mr. und Mrs. Kenneth O. Timkham erworben.

Bien que de taille moyenne, cette maison à étage (un séjour, deux chambres et deux salles de bains), semble beaucoup plus spacieuse grâce à son architecture. Deux solariums qui donnent accès à une vue panoramique sur la ville doublent les surfaces couvertes de chaque niveau et augmentent l'impression d'espace.

En coupe, le terrain est pris entre une rue en contrebas et la pente de la montagne. Malgré l'étroite proximité du bâti de la route, un brusque changement de niveau assure une certaine intimité. L'architecte a articulé avec soin les transitions entre les zones publiques, semi-publiques, privées et semi-privées. De l'extérieur, la maison semble reposer sur un soubassement entouré d'un haut mur de soutènement en pierre. Une allée sur le côté de la parcelle fait tampon avec la rue et conduit au chemin d'entrée, d'où l'on accède perpendiculairement par une marche au centre de la maison. Dans le hall d'entrée, le thème principal du projet – la fusion dedans-dehors – s'exprime pleinement. Un escalier autoporteur de structure légère doté d'une rampe minimaliste suspendue au plafond est fermé de verre d'un côté et laisse un passage vers la chambre du rez-de-chaussée, tandis que de l'autre il est ouvert sur le séjour et un petit jardin isolé par un écran constitué d'une haute claustra en bois rouge. Malgré l'emprise au sol rectangulaire, les espaces fusionnent, et n'utilisent que le minimum de cloisonnements. Une terrasse en dalles de pierre prolonge le séjour vers l'extérieur. La claustra en bois rouge et les jardinières passent de l'extérieur à l'intérieur. Les baies qui vont du sol au plafond cadrent de vastes pans de paysage, et la conjonction de ces mouvements renforce l'idée d'un espace ininterrompu.

A l'époque où Ethel McCall réalisa un reportage sur la Fulton Residence pour le « LA Times Home Magazine », le projet avait déjà changé de propriétaire. Conçu à l'origine pour Miss Geneva Fulton, il avait été acheté par Mr. et Mrs. Kenneth O. Timkham.

Selected Bibliography: - *Los Angeles Times Home Magazine,* *April 2, 1950*

381 **William F. Cody**
Del Marcos Hotel, Palm Springs, California
January 3, 1949

This resort facility epitomizes what was a new trend in the vacation experience after World War II. Small-scale units, often developed horizontally, were intended to provide an intimate setting where guests could engage in social interaction around a swimming pool or a bar. Since elevators were not needed and guests could park their cars close enough to their units to be able to carry their luggage themselves, operating costs were significantly reduced. Positioned on a corner lot, the two-story-high hotel comprises nine apartments for a capacity of 48 guests. All units wrap around an interior court and a pool with the San Jacinto Mountains as a backdrop. Each guestroom is equipped with a full-size kitchen and access to open areas on both sides. The second floor bridges the entry court, giving access to the outdoor communal space from the street front and providing the bathers with a shaded zone. The sloping rooflines of the upper level are echoed in the slanted planes

Dieses Appartement-Hotel verkörpert einen neuen Trend in den Urlaubsgewohnheiten der Amerikaner nach dem 2. Weltkrieg: Kleine, häufig eingeschossige Flachbauten umfassen einen Gartenhof mit Schwimmbecken, der sich für Spiel und Geselligkeit anbot. Da keine Fahrstühle erforderlich waren und Hotelgäste ihre Autos fast direkt vor den Zimmern parken und ihre Koffer selbst tragen konnten, waren die Betriebskosten derartiger Anlagen niedrig. Dieses zweistöckige Hotel auf einem Eckgrundstück enthält neun Ferienwohnungen für insgesamt 48 Gäste und umfasst U-förmig den Gartenhof mit Schwimmbecken, von dem aus man auf die San Jacinto-Berge schaut. Jedes Appartement ist mit einer Küche und Balkonen auf beiden Seiten ausgestattet. Im Mittelteil überbrückt das Obergeschoss den offenen Eingangsbereich und fungiert so zugleich als Durchgang von der Straße zum Garten und als schattenspendendes Dach. Die Dachneigung wiederholt sich in den schrägen Abde-

Cet équipement hôtelier est exemplaire d'une nouvelle mode de vacances apparue après la Seconde Guerre mondiale. De petites structures comme celle-ci, souvent sur un seul niveau, proposaient un cadre intime dans lequel les hôtes pouvaient se retrouver autour d'une piscine ou d'un bar. Comme les ascenseurs étaient inutiles et que les clients pouvaient garer leur voiture près des chambre et porter eux-mêmes leurs bagages, les coûts de fonctionnement étaient limités.

Situé sur une parcelle d'angle, cet hôtel sur deux niveaux comprend neuf appartements pouvant recevoir 48 hôtes. Toutes les chambres sont regroupées autour d'une cour intérieure et d'une piscine avec vue sur les San Jacinto Mountains. Chaque chambre est équipée d'une vraie cuisine et d'un accès des deux côtés. L'étage surmonte la cour d'entrée qui donne accès aux installations communes à partir de la rue et offre aux baigneurs une zone ombragée. Les pentes du toit font écho avec

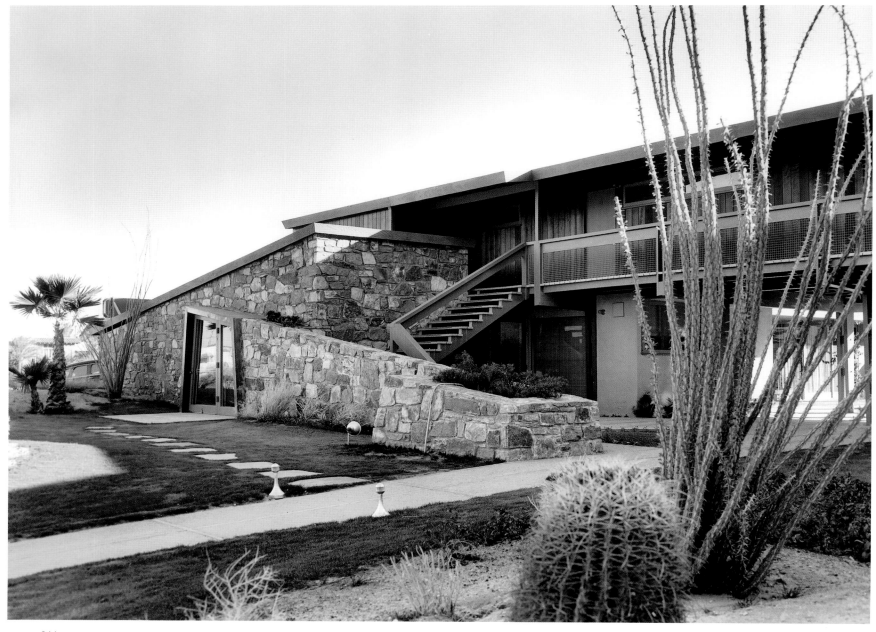

covering the basement made of local stone. In 1949, the Southern California Chapter of the American Institute of Architects accorded the project a creditable mention.

ckungen des aus Bruchsteinen gemauerten Gebäudesockels. Die Sektion Südkalifornien des American Institute of Architects zeichnete das Hotel 1949 mit einer Belobigung aus.

les plans inclinés qui masquent le soubassement en pierre locale. En 1949, le chapitre de Californie du Sud de l'American Institute of Architects a décerné une mention à ce projet.

Selected - *arts & architecture, July 1949*
Bibliography: - *Architectural Forum, July 1949*

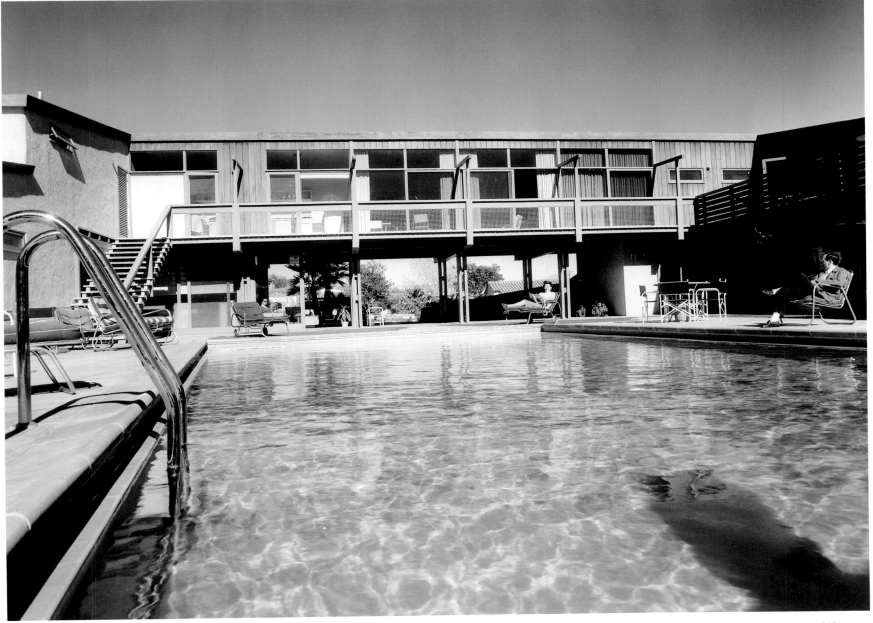

383 William F. Cody
Levin Residence, Palm Springs, California
January 5, 1949

In designing the Levin Residence, the architect paid primary attention to the view of the San Jacinto Mountains and to the climatic conditions of the desert. Part of a new Palm Springs subdivision at the time, the entire property was treated as a space for living and fenced in by an adobe wall. Landscaping was integral to the organization of the house. The L-shaped house opens to a patio facing southwest. The court, protected from the occasional north wind, is the center of activity, reflecting an emphasis on outdoor recreation and year-round use. The plan follows a 3 x 5-foot module, made visible by concrete paving patterned with redwood strips and by the spacing of the window mullions. The entry path begins on the south side of the lot and runs alongside a badminton court and a driveway. Turning 90 degrees to the left it leads to the front door at the corner of the L-shape. One wing of the residence houses the bedrooms while the other wing contains the communal living areas. From the solarium and the living room, the paving continues onto the terrace, alluding to architectural continuity between indoors and outdoors.

The structural system is composed of wooden frames with the ceiling joists exposed in the main rooms. A glass roof is installed between the wood members of the solarium. Folding partitions in the guestroom and kitchen, together with sliding glass doors in the living room, afford flexibility of use. During the daytime technological solutions limit the heat absorption of the walls: glass openings are tinted green and have awning-type screens to cut down glare and heat; roof surfacing reflects the heat; and mineral wool insulates both walls and ceilings.

Beim Entwurf des Hauses für Dorothy Levin berücksichtigte der Architekt vor allem die Aussicht auf die San Jacinto-Berge und die Bedingungen des Wüstenklimas. Als Teil einer Baulandaufteilung in Palm Springs wurde das gesamte Grundstück als Wohngebiet deklariert und mit einer Mauer aus Lehmziegeln eingezäunt. Die Landschaftsgestaltung spielte eine wichtige Rolle bei der Planung. Das L-förmige Gebäude öffnet sich nach Südwesten auf einen vor dem Nordwind geschützten Patio. Dieser Hof ist der Mittelpunkt der häuslichen Aktivitäten und lässt die Bedeutung der Erholung im Freien und der ganzjährigen Benutzbarkeit erkennen.
Der Plan basiert auf einem Modul von 0,90 x 1,50 m, das im Betonboden mit Redwood-Leisten und in den Fensterachsen wiederkehrt. Der Eingangsweg führt an einem Badmintonplatz und einer Zufahrtsstraße entlang; er schwenkt um 90° nach links und endet an der Eingangstür im Winkel der L-Form. Ein Flügel ist für die Schlafzimmer bestimmt, der andere Flügel enthält den gemeinsamen Wohnbereich. Der Bodenbelag in Solarium und Wohnbereich setzt sich auf der Terrasse fort und unterstreicht so die Verbindung zwischen Innen und Außen.
Das Konstruktionssystem besteht aus Holzrahmen, wobei die Deckenbalken in den Haupträumen offen liegen. Zwischen den Holzbalken des Solariums ist ein Glasdach angebracht. Falttrennwände im Gästezimmer und in der Küche sowie Glasschiebetüren im Wohnraum gewähren eine variable Raumnutzung. Technische Installationen schränken die Hitzeabsorption der Wände ein; alle verglasten Öffnungen sind grün getönt und haben Sonnenschutzelemente; eine Beschichtung des Daches wehrt die Hitze ab. Wände und Decken sind mit Mineralwolle isoliert.

C'est d'abord en pensant à la vue sur les San Jacinto Mountains et aux conditions climatiques du désert que l'architecte a conçu la Levin Residence. Appartenant à l'époque à un nouveau quartier de Palm Springs, cette propriété fut traitée intégralement comme un espace de vie entouré d'un mur d'adobe, le traitement paysager faisant partie intégrante de l'organisation de la maison. La partie habitable en L s'ouvre sur un patio orienté à l'ouest, centre d'activité qui reflète l'accent mis sur la vie au grand air et l'utilisation de la maison tout au long de l'année.
Le plan se base sur un module de 0,90 x 1,50 m, mis en évidence par le motif du pavage à joints de bois rouge et l'espacement des montants des fenêtres. Le chemin d'accès part du sud de la parcelle et longe un terrain de badminton et l'allée des voitures. Il tourne à angle droit vers la gauche pour mener à la porte d'entrée implantée à l'angle du L. Une aile de la maison est consacrée aux chambres, l'autre à la zone de vie commune. Du solarium et du séjour, le pavement se poursuit sur la terrasse confirmant la continuité entre l'intérieur et l'extérieur. La structure se compose d'une ossature en bois, dont les solives sont laissées apparentes dans les pièces principales. Un toit de verre fut posé entre les poutres de bois du solarium. Des cloisons repliables dans la chambre d'amis et la cuisine, et des portes coulissantes dans le séjour permettent une grande souplesse d'utilisation. Des solutions techniques limitent l'absorption de la chaleur par les murs pendant le jour : des baies sont en verre teinté gris et équipées d'écrans en auvent pour briser l'éclat de la lumière et limiter la réverbération de la chaleur. Le traitement de la surface du toit réfléchit la lumière ; murs et plafonds sont isolés à la laine de roche.

Selected Bibliography:
- Los Angeles Times Home Magazine, February 9, 1949
- Architectural Record, February 1950
- arts & architecture, April 1950

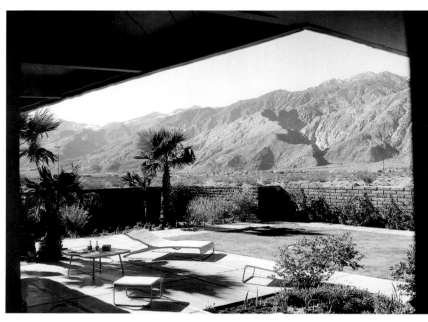

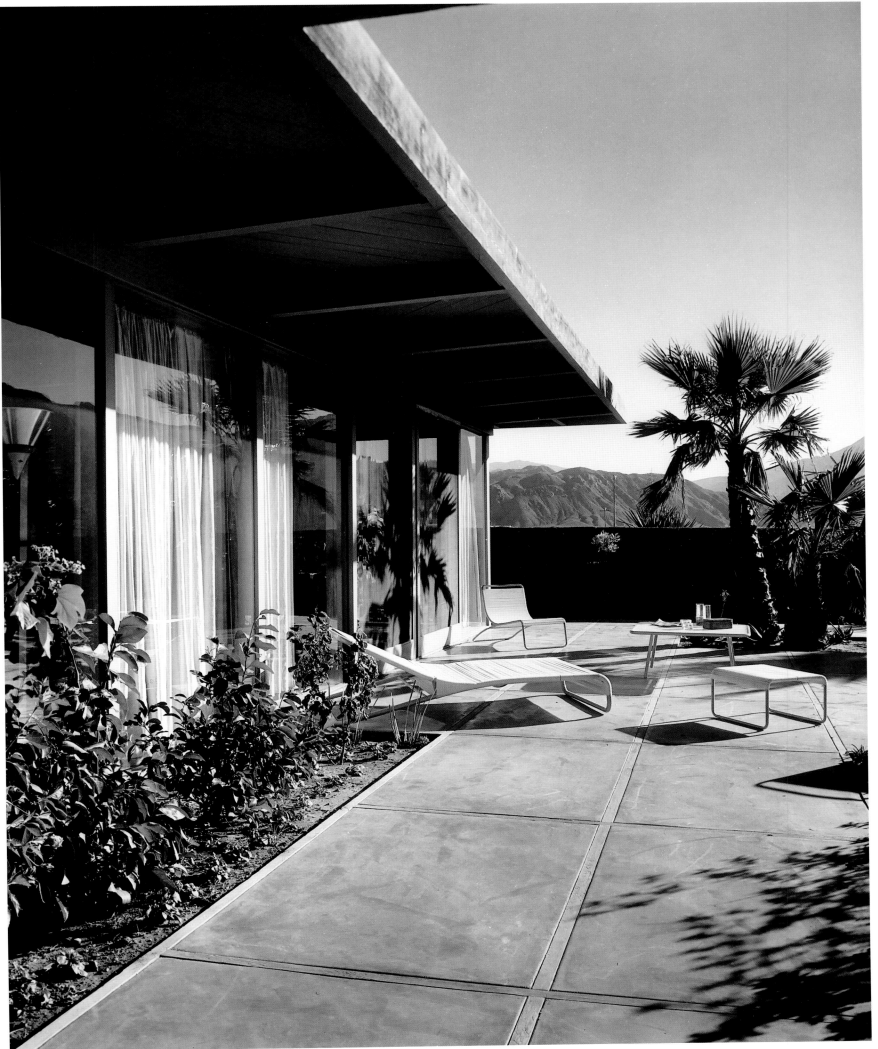

452 **Parkinson, Briney, Bernard**
Greer Robbins Agency, Los Angeles, California
April 15, 1949

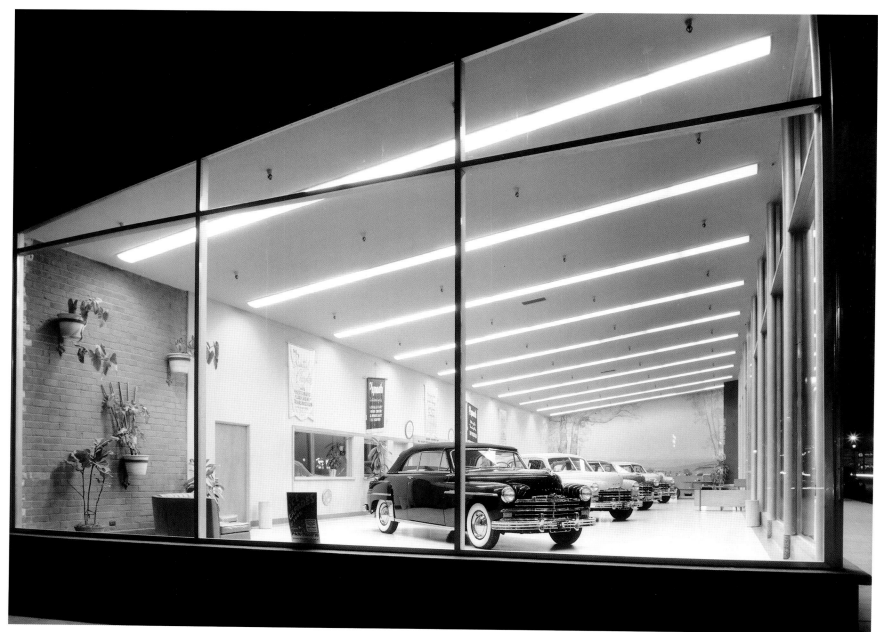

548 Lewis E. Wilson
Baldwin Village Theater, Baldwin Hills, California
August 17, 1949; September 19, 1950

By using laminated wood construction, the architect was able to build this movie theater located on 3745 South La Brea Avenue and Coliseum Avenue, for a very limited budget. Designed for a 1,800-seat capacity, the entertainment facility is shaped around the increasing size of the projection beam. Starting 23 feet high at the entrance and 55 feet high at stage, ten arches give built form to the cone of vision from the projector toward the screen. Two additional arches hold the marquee and the canopy of the foyer, bringing the structural concept into the city scape. The adoption of a vaulted ceiling was severely critisized at the time, since its enclosure was deemed unsuitable from an acoustical point of view. However, the design choice was justified by saving financial resources. Construction costs were approximately one-third less than those of a conventionally built theater of the same size.

Weil er die Konstruktion aus Schichtholz errichten ließ, konnte der Architekt dieses Kino an der Ecke von South La Brea Avenue und Coliseum Avenue trotz äußerst knappem Budget realisieren. Er plante es für 1 800 Zuschauer und formte den Kinosaal entsprechend des sich zur Leinwand erweiternden Projektionskegels: Am Eingang ist er 7 m hoch und an der Leinwand fast 17 m. Zehn Rundbögen steifen diese »Lichtkegelhülle« aus. Von zwei weiteren Bögen ist das Flachdach über dem Foyer und dem Vorplatz abgehängt. Bögen und Dach tragen die konstruktive Idee also an die Öffentlichkeit. Das Tonnendach erregte seinerzeit Kritik, da es keine gute Akustik bot. Es war allerdings durch die Kostenersparnis – um fast ein Drittel der üblicherweise veranschlagten Kosten – gerechtfertigt.

C'est en recourant au bois lamellé-collé que l'architecte a pu édifier ce cinéma pour un budget très limité. Situé 3745 South La Brea Avenue, il offre 1 800 places assises. L'aménagement de la salle suit la forme d'un faisceau lumineux. De 7 m de haut à l'entrée et 17 m sur la scène, dix arcs accompagnent le cône de projection de la cabine à l'écran. Deux arcs additionnels soutiennent la marquise et le plafond suspendu du foyer, montrant le principe structurel dans l'espace urbain. L'adoption d'un plafond voûté qui s'est révélé problématique sur le plan acoustique fut l'objet de sévères critiques à l'époque. Ce choix était néanmoins justifié par des raisons économiques. Le coût fut réduit d'un tiers par rapport à celui d'une salle construite de manière plus conventionnelle.

Selected Bibliography: - Architectural Forum, November 1949

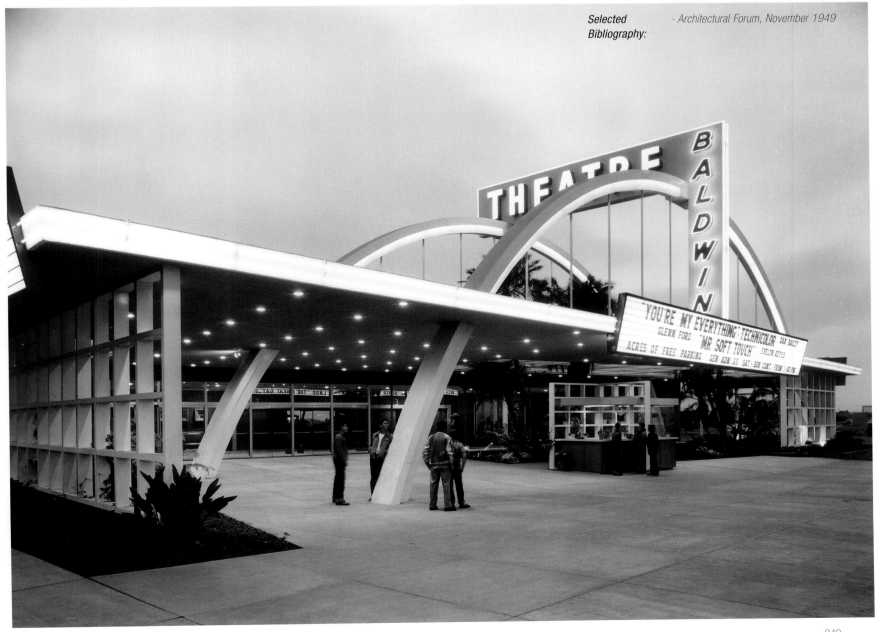

610 **Douglas Honnold**
Eatons Restaurant, Studio City, California
16 February 16, 1948; May 7, 1948

This large food facility was on 12010 Ventura Boulevard and is now demolished. A dining area, a cocktail lounge, a quick-service coffee shop, large and small banquet rooms were housed under one roof. The interior featured of masonry walls, murals, natural woods and green leather upholstery.

Dieser große Restaurantbau am Ventura Boulevard 12010 existiert heute nicht mehr. Das Gebäude umfasste das eigentliche Restaurant, eine Cocktailbar, eine Kaffee- und Snackbar, einen großen und einen kleineren Bankettsaal. Die Fassaden bestanden aus Ziegelmauerwerk und waren mit Fresken, naturbelassenem Holz und grünen Lederpolsterflächen ausgestattet.

Cet important restaurant construit 12010 Ventura Boulevard est aujourd'hui démoli. Une salle à manger, un salon pour les cocktails, un coffee-shop, une grande et une petite salle de banquets coexistaient sous un même toit. A l'intérieur, murs en maçonnerie, fresques, bois naturels et sièges en cuir vert.

Selected Bibliography: - Frank Harris and Weston Bonenberg (eds), *A Guide to Contemporary Architecture in Southern California, Los Angeles 1951*

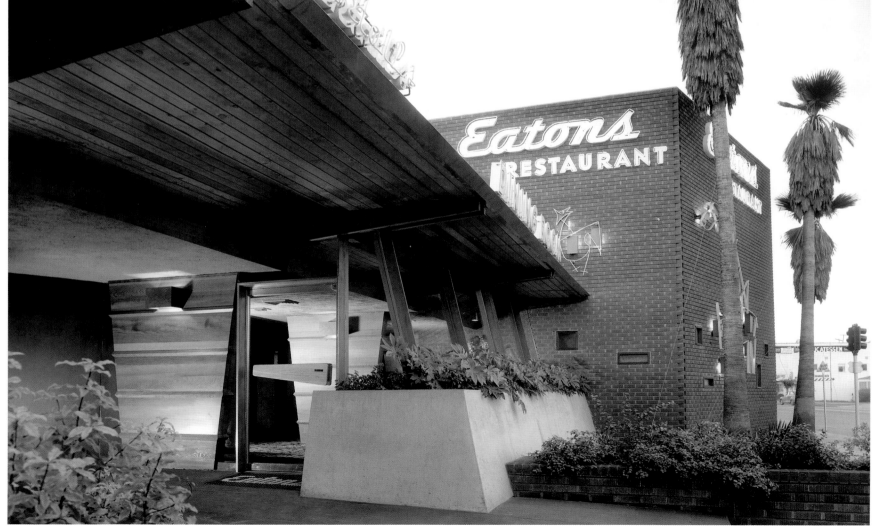

633 Gregory Ain
Miller Residence, Beverly Hills, California
December 21, 1949

The Millers, both doctors, had their one-bedroom house on a lot with a steep slope on the east edge. A trellised outdoor terrace doubles the 2,500-square-foot interior space. Sleeping area, living and dining room are oriented south and can be connected through sliding doors. Aligned with the dining area, a lath house projects out of the plan. Garret Eckbo designed the garden.

Das Ärztehepaar Miller besaß ein Haus auf einem Grundstück mit Steilhang an dessen Ostrand. Eine Pergola-gedeckte Terrasse war genau so groß wie der gesamte Innenraum, nämlich etwa 230 m². Das einzige Schlafzimmer, Wohn- und Essraum sind nach Süden orientiert und durch Schiebetüren miteinander verbunden. Ein weiterer Bauteil tritt in einer Linie mit der Esse-cke aus dem Hauskörper heraus. Garret Eckbo gestaltete den Garten.

La maison des Miller — deux médecins — est édifiée sur une parcelle aplanie dominant une pente escarpée en bordure est du terrain. Une terrasse protégée par un treillis double les 230 m² de la surface intérieure. La chambre, le séjour et la salle à manger sont orientés au sud et peuvent être réunis en ouvrant des portes coulissantes. Dans l'alignement de la salle à manger, une gloriette se projette au-delà de l'emprise au sol. Le jardin a été dessiné par Garrett Eckbo.

Selected Bibliography:
- *arts & architecture, April 1950*
- *Esther McCoy, The Second Generation, Salt Lake City 1984*

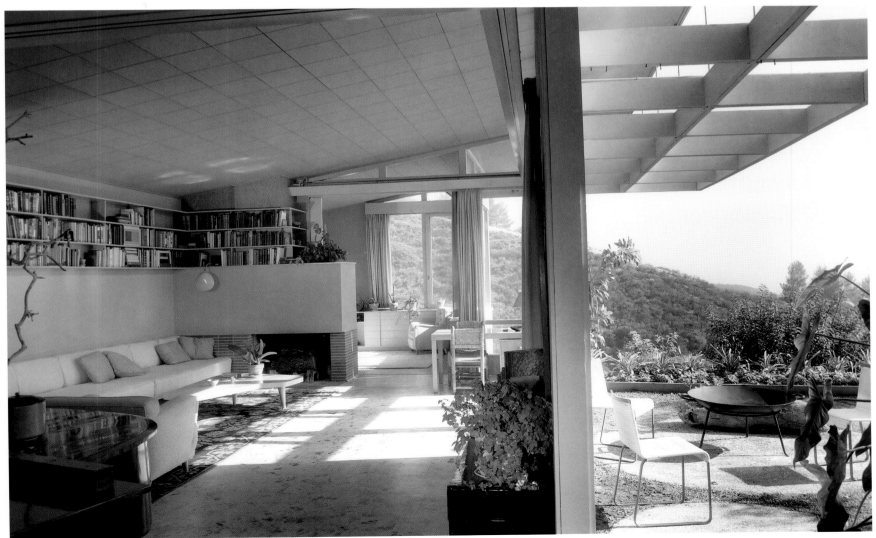

710 Paul Schweikher and Winston Elting
Upton Residence, Scottsdale, Arizona
April 13, 1950

Louis Upton, at the time President of the 1900 Corporation, a laundry-machine manufacturing company, commissioned to Schweikher a winter-holiday retreat on a 20-acre plot of land in Paradise Valley, near Scottsdale, Arizona.

The house is built over the foundations of a previous house, which had burned down, but is more than 75% larger. Four distinct parts – a living-dining section, master suite, guesthouse, and servants quarters – are arranged in a U-shape around a cactus garden and a pool. A continuous roof, occasionally pierced for natural light, connects the separate parts providing shaded outdoor areas in the hot desert climate. Upstairs, the trellised sundeck screened from the winter breeze, opens onto a panoramic view ranging from the Camelback Mountain across to the alfalfa fields and cacti of Paradise Valley. Set between the roof beams of the sundeck are pipes from which water drips into the pool, generating a refreshing sound to mitigate the discomfort of the heat.

Louis Upton, der damalige Präsident einer Waschmaschinen-Firma beauftragte Schweikher, ein Winterdomizil in Paradise Valley in der Nähe von Scottsdale, Arizona, zu entwerfen. Der Bau ist auf den Fundamenten des durch Brand zerstörten ersten Upton'schen Hauses errichtet, aber um 75 % größer. Vier Baubereiche, ein Wohn-/Ess-Trakt, die Suite des Hausherrn, ein Gästehaus und die Personalräume, sind U-förmig um einen Kakteengarten mit Schwimmbad angelegt. Ein durchgehendes Dach, das, um natürliches Licht einzulassen, gelegentlich durchbrochen ist, verbindet die Bauteile und bietet schattige Außenbereiche im heißen Wüstenklima. Im ersten Stock öffnet sich eine geschützte Sonnenterrasse auf ein Panorama, das vom Camelback Mountain bis zu den Feldern und Kakteen des Paradise Valley reicht. Zwischen den Dachbalken der Sonnenterrasse sind Rohre angebracht, aus denen Wasser ins Schwimmbad tropft – ein erfrischender Klang in der großen Hitze. Die Offenheit des Grundrisses steht im Kontrast zur Schwere des Mauer-

Louis Upton, à l'époque président d'une entreprise de machines à laver, la 1900 Corporation, avait demandé à Schweikher de lui construire une résidence d'hiver sur un terrain d'une dizaine d'hectares qu'il possédait dans Paradise Valley, près de Scottsdale, Arizona.

La maison au trois quarts plus grande est édifiée sur les fondations de la première résidence des Upton qui avait brûlé. Les quatre parties distinctes – vaste séjour-salle à manger, chambre du maître de maison, maison d'amis, et chambres des domestiques – sont disposées en U autour d'un jardin de cactées et d'un bassin. Un toit continu, percé par endroit pour l'éclairage, recouvre ces différentes parties et abrite les terrasses de la chaleur du soleil du désert. A l'étage, le solarium protégé des vents d'hiver par un treillis s'ouvre sur un panorama qui va de la Camelback Mountain jusqu'à Paradise Valley, par-delà les champs d'alfa et de cactus. Entre les poutres du solarium, le propriétaire a disposé des tuyaux qui laissent l'eau couler gout-

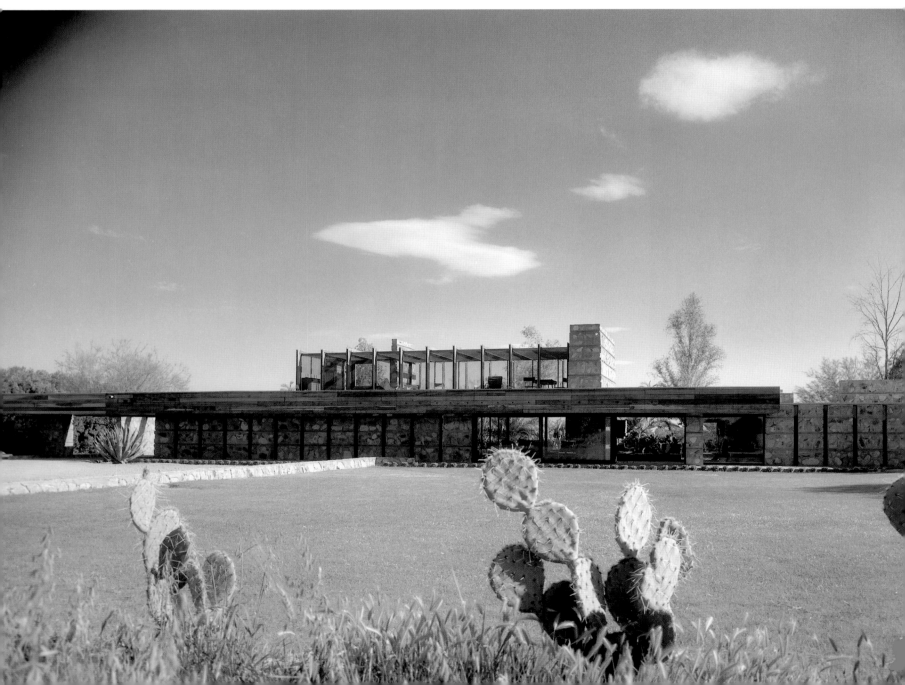

The openness of the plan contrasts with the heaviness of the stonework, composed of concrete poured around desert stone. 6-inch floor-to-ceiling glass slits placed at three-foot intervals cut the masonry walls creating planes of light in the communal areas and the master bedroom. Floors are made of earth-brown concrete with occasional flat desert rocks embedded in the surface. Two fireplaces and a pool etablish the character of the house and its informal life-style. The architect ascribes Frank Lloyd Wright's influence here to George Ellis, a carpenter with whom Schweikher had worked on another project. The article in *Triglyph* attributes the presence of Wrightian characteristics, both in the use of materials and in the spatial organization, to the proximity of the site to Taliesin West and perhaps to hiring the same contractor used by Frank Lloyd Wright to build the first Upton Residence. When Louis Upton died, his widow sold the property. The house was turned into a nightclub and eventually demolished.

werks, das aus Beton mit eingestellten Bruchsteinen der Wüste besteht. 15 cm breite, vom Boden bis zur Decke reichende verglaste Schlitze unterbrechen die Steinmauern in Abständen von 90 cm und bilden Lichtinseln. In die erdbraunen Betonböden sind gelegentlich flache Wüstensteine eingebettet. Zwei Kamine und ein Schwimmbad tragen zu einer ungezwungenen Lebensweise bei. Der Architekt behauptet, dass der Einfluss von Frank Lloyd Wright durch George Ellis entstanden ist, einen Schreiner, der mit Schweikher bei einem anderen Bau zusammengearbeitet hat. Andere schreiben die Spuren von Wrights Handschrift sowohl in den Materialien als auch in der Organisation des Raums der Nähe zu Taliesin West zu. Bald nach dem Tod seines Sohnes starb Louis Upton, und seine Witwe verkaufte das Anwesen. Später wurde es zu einem Nachtklub und schließlich abgerissen.

te à goutte dans le bassin, avec un bruit rafraîchissant et apaisant par grande chaleur.

L'ouverture du plan contraste avec la lourdeur de la maçonnerie en pierre du désert et les épais joints de béton. Des ouvertures sol-plafond de 15 cm de largeur à 90 cm d'intervalle découpent les murs pour laisser pénétrer la lumière dans les pièces communes et la chambre principale. Les sols sont en béton brun, où l'on a inséré quelque pierres plates du désert. Deux cheminées et un bassin renforcent le caractère de cette maison vouée aux loisirs.

L'architecte soutient que l'influence wrightienne est due à George Ellis, un charpentier qui avait travaillé avec Schweikher sur d'autres projets. Un article relève la présence de Wright dans les matériaux et l'organisation spatiale, et fait remarquer la proximité de Taliesin West. Peu après la mort de son fils, Louis Upton décéda et sa femme vendit la maison, qui fut transformée en night-club, puis démolie.

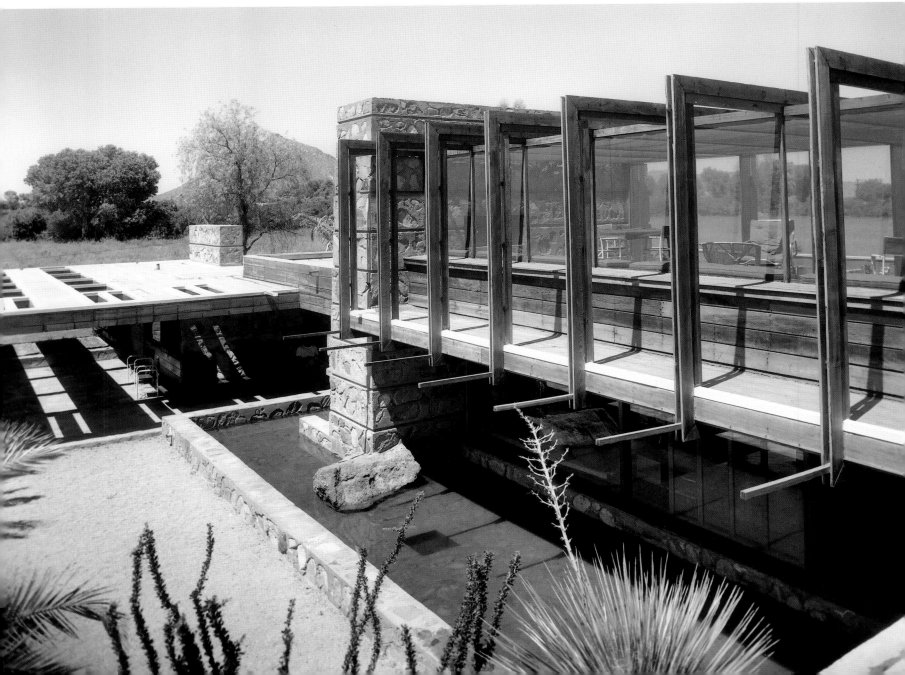

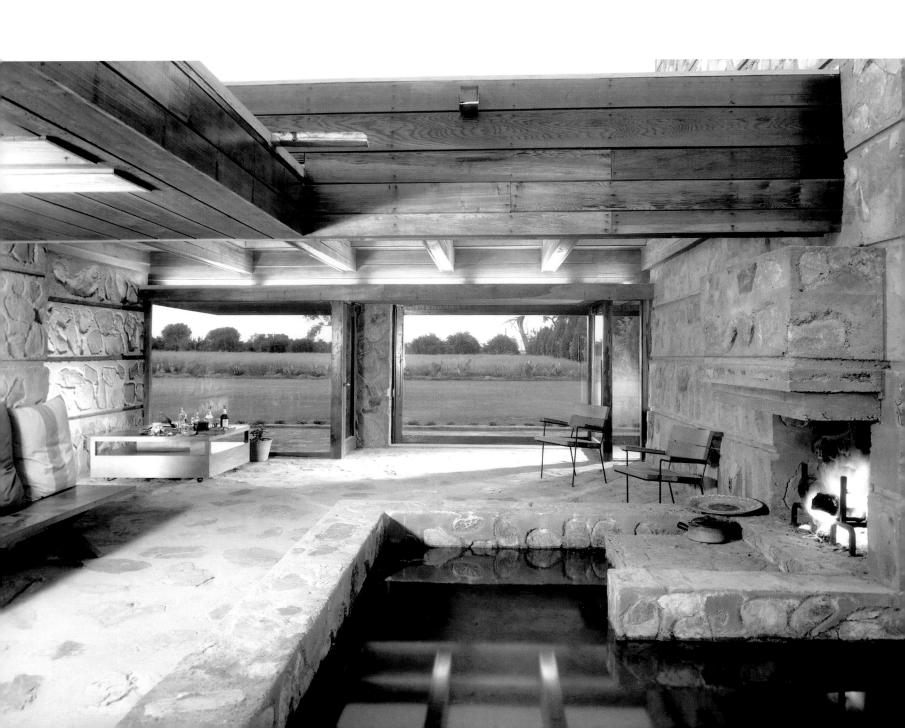

Selected Bibliography:

- Architectural Record, December 1946
- House & Garden, December 1950
- Katherine Morrow Ford and Thomas Creighton, The American House Today, New York 1951

- Henry Russell-Hitchcock and Arthur Drexler (eds), Built in USA: Post-War Architecture, New York 1952
- House & Home, February 1953
- Architectural Review, May 1957

- The Los Angeles Examiner, Pictorial Living section, March 22, 1959
- Architecture USA, by Ian McCallum, 1959
- Triglyph, Spring 1985

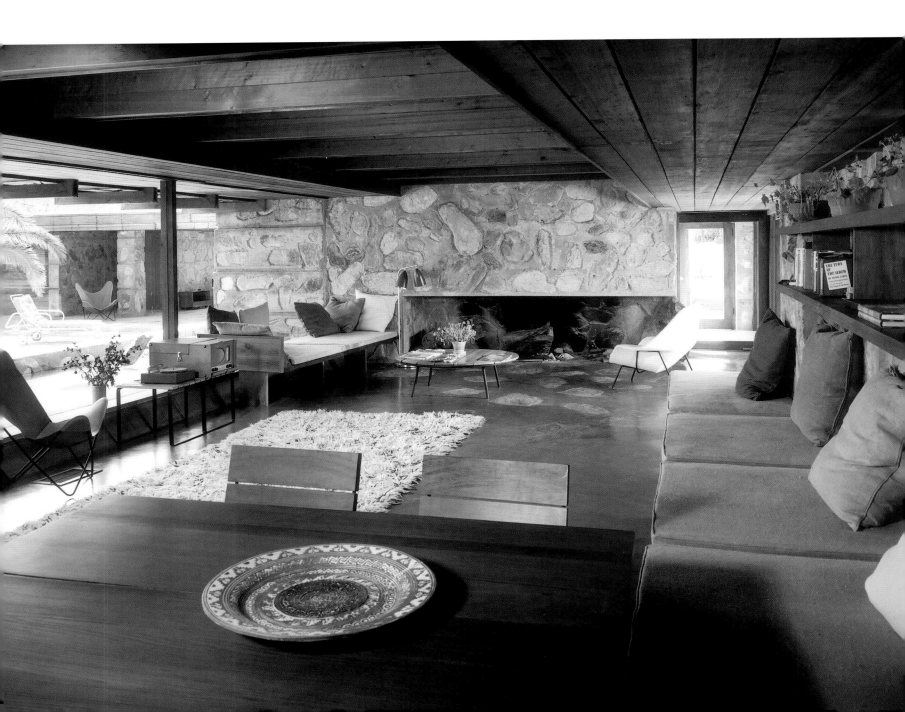

753 Richard O. Spencer
Spencer Residence, Santa Monica, California
June 9, 1950

Spencer was a product-designer strongly interested in design-ing hillside housing (see p. 099 and p. 182). On a hillside property with a 40-degree slope in the Santa Monica Canyon, he wanted to build a private residence for himself and his wife with a swimming pool, a wide patio and abundant square footage of covered space.

The residence comprises two sections joined through a partially roofed veranda. A kitchen, dining area, and a master bedroom and bath are located in the east wing. The opposite wing houses a 14-foot-high living room (open to the terrace through a 12 x 12-foot glass screen) and a study on the upper level. Next to the carport, the entry path leads from street level to the terrace, which functions as an outdoor setting for social activities.

Spencer war ein Produktdesigner, der sich auch mit der Ge-staltung von Wohnhäusern auf Hanggrundstücken beschäftigte (s. S. 099 und S. 182). An einem Steilhang (40° Gefälle) im Santa Monica Canyon wollte er für sich und seine Frau ein Haus mit all dem Komfort bauen lassen, der sonst nur auf ebe-nen Grundstücken möglich ist: Schwimmbecken, großer Patio und viel Platz. Das Haus besteht aus zwei durch eine teilweise überdachte Veranda verbundene Volumen. Im Ostflügel sind eine kleine Küche, Essplatz, Schlafzimmer und Bad unterge-bracht und nach Westen der 4,20 m hohe Wohnraum mit 3,60 x 3,60 m großer Glastür (durch die man auf die Terrasse gelangt) und einem Arbeitsplatz auf der Galerie. Neben dem Carport führt eine Treppe vom Straßenniveau zur Wohnterrasse.

Designer Spencer s'intéressait beaucoup à la conception des maisons à flanc de colline (voir p. 099 et 182). Sur un terrain du Santa Monica Canyon présentant une pente de 40°, il eut envie de construire, pour lui et sa femme, une maison qui offre le confort normalement attendu en terrain plat : une piscine, un grand patio et de nombreux espaces extérieurs abrités. La maison se compose de deux volumes réunis par une vé-randa partiellement couverte. Une petite cuisine, un coin repas, la chambre principale et sa salle de bains occupent l'aile ouest. Dans l'aile opposée, se trouvent un séjour de 4,20 m de haut qui ouvre sur une terrasse par un mur de verre de 3,60 x 3,60 m et un bureau à l'étage. Partant de l'abri aux voitures, l'allée d'accès descend de la rue vers la terrasse,

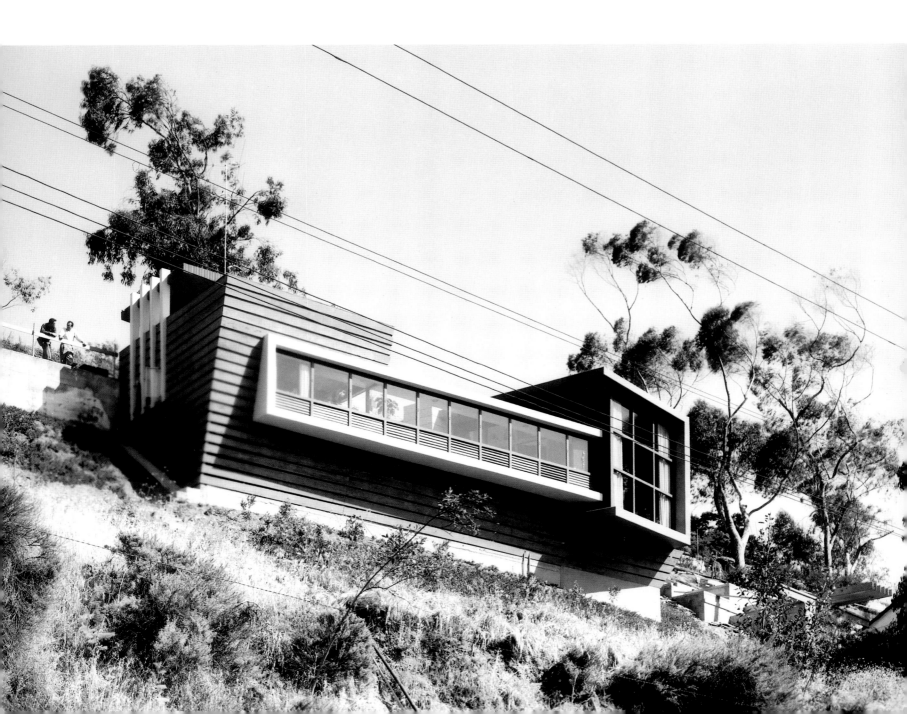

The concrete swimming pool serves as the anchor point of the house structure and was poured at the same time as the foundations. Dining areas, bedroom, living quarter and terrace jut out from the foundation.

Das Betonschwimmbecken dient als Anker der Konstruktion und wurde zusammen mit den übrigen Fundamenten vor Ort gegossen. Essplätze, Schlafzimmer, Wohnräume und Terrasse kragen von den Fundamenten aus.

conçue comme une pièce extérieure prévue pour recevoir. La piscine en béton fait partie de l'ancrage de la structure de la maison et a été coulée en même temps que les fondations. Les coins repas, la chambre, le séjour et la terrasse surplombent le terrain.

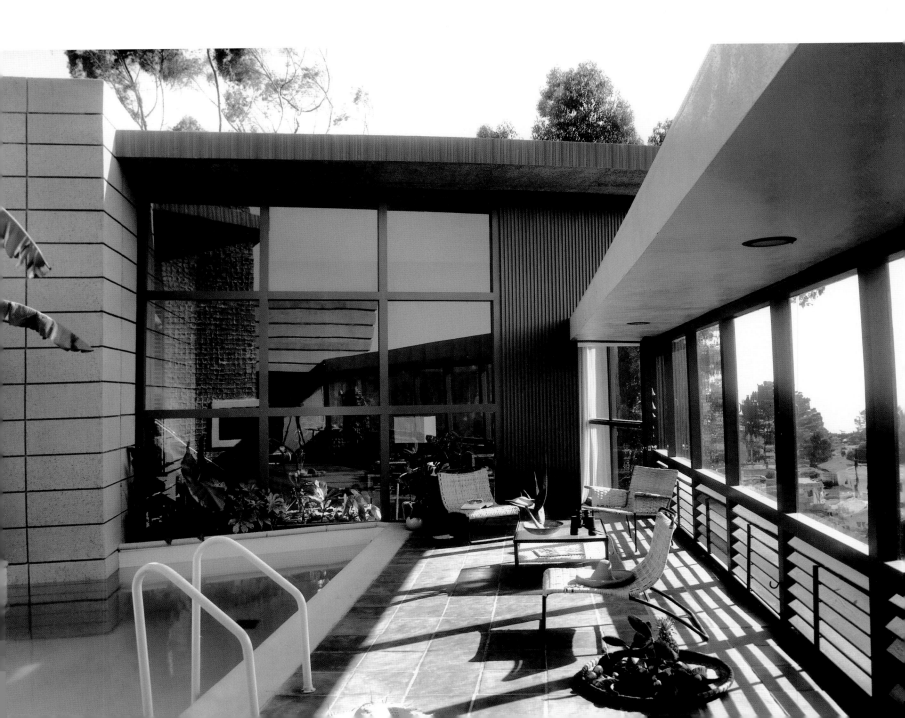

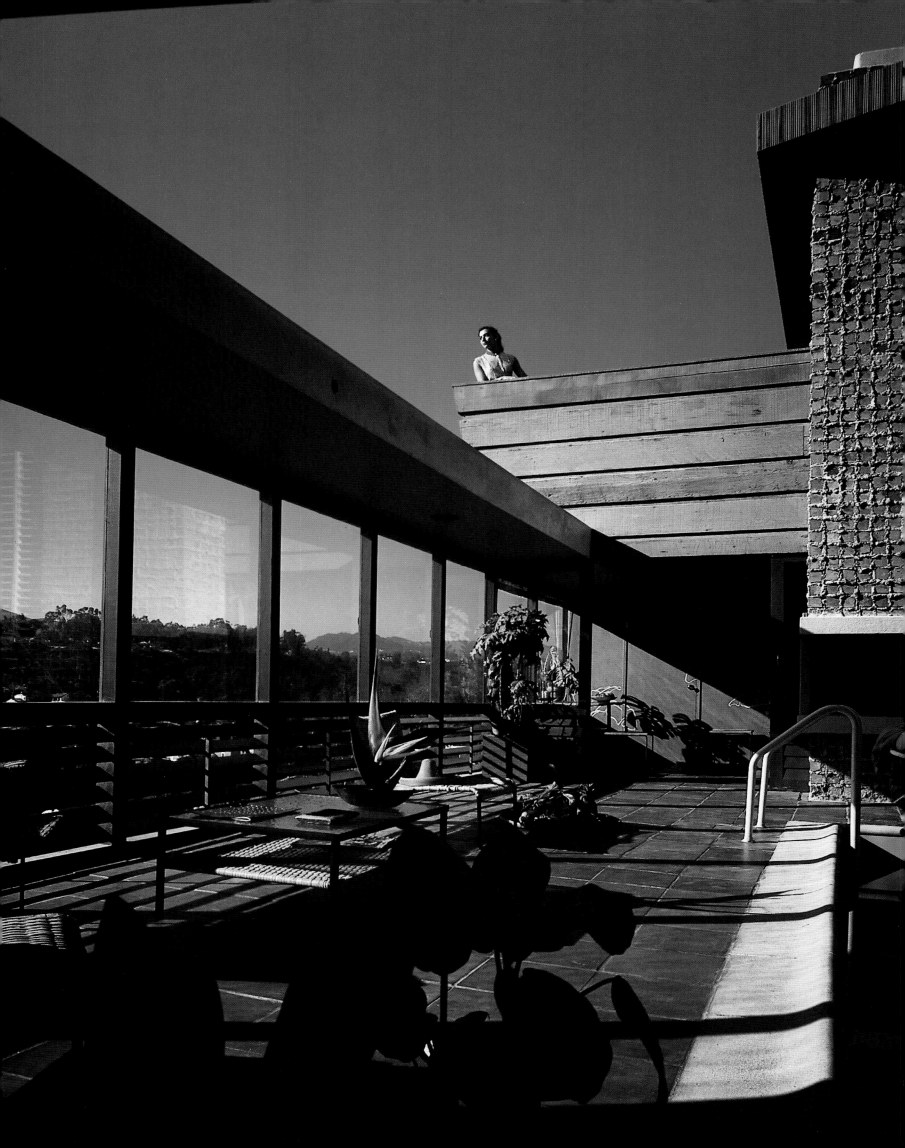

**Selected
Bibliography:**
- Los Angeles Times Home Magazine,
 August 12, 1951

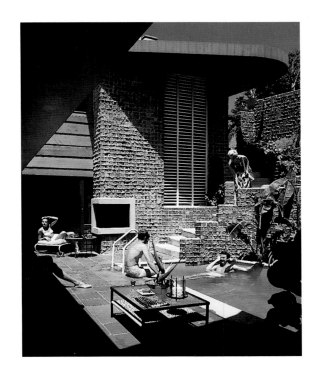

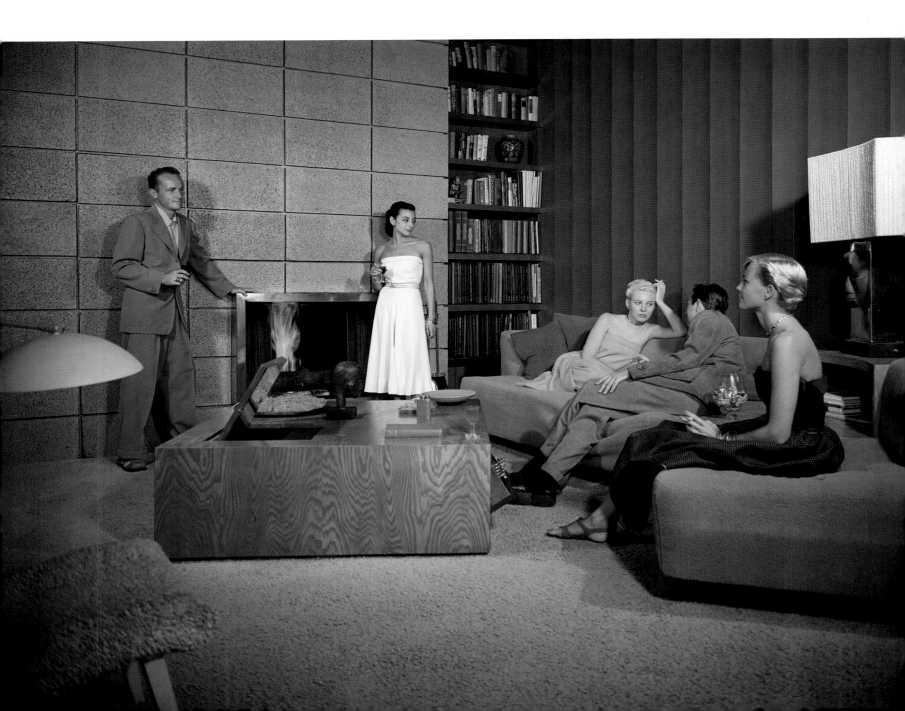

772 A. Quincy Jones, Whitney Smith, Edgardo Contini, with James Charlton and Wayne Williams Mutual Housing, Brentwood, California, July 8, 1950; August 10, 1950

In 1946, four musicians joined forces to develop an acre of land and build their own homes. It was the birth of Mutual Housing Association. Two years later, the non-profit organization counted over 500 members to be housed on 835 acres in the Santa Monica Mountains. Through questionnaires and meetings with the community members, the architects outlined a design program taking into consideration the various needs of different households. In addition to the residences, the agenda was to provide a nursery school, recreation facilities, and a community center.

Intended to preserve the natural topography of the land, 35 house types were developed, addressing the diversity of site

Im Jahr 1946 taten sich vier Musiker zusammen, um einen Morgen Land zu kaufen und darauf vier Eigenheime zu bauen. Das war die Geburtsstunde der Mutual Housing Association, einem Wohnungsbauverein. Zwei Jahre später zählte der gemeinnützige Verein bereits über 500 Mitglieder, die auf 835 Morgen Land in den Bergen von Santa Monica ein Zuhause finden sollten. Mit Hilfe von Fragebogenaktionen und Mitgliederversammlungen entwickelten die Architekten einen Siedlungsplan, der die Bedürfnisse der verschiedenen Bewohner berücksichtigte. Neben den Wohnhäusern umfasste sie einen Kindergarten, Freizeiteinrichtungen und ein Nachbarschaftszentrum.

Da die natürliche Landschaft so weit wie möglich erhalten blei-

En 1946, quatre musiciens s'associèrent pour lotir un demi-hectare de terrain et construire leurs maisons. C'était la naissance de Mutual Housing Association. Deux ans plus tard, cette association sans but lucratif comptait plus de 500 membres et construisait sur plus de 400 hectares dans les vallées et collines des Santa Monica Mountains. Des questionnaires et des réunions permirent aux architectes de définir les principes généraux du projet et de répondre à la diversité des besoins de ces multiples propriétaires. En dehors de la construction des maisons, le projet se proposait de créer une école maternelle, des équipements de jeux et un centre communautaire. Dans un esprit de préservation du site, 35 types de maisons furent

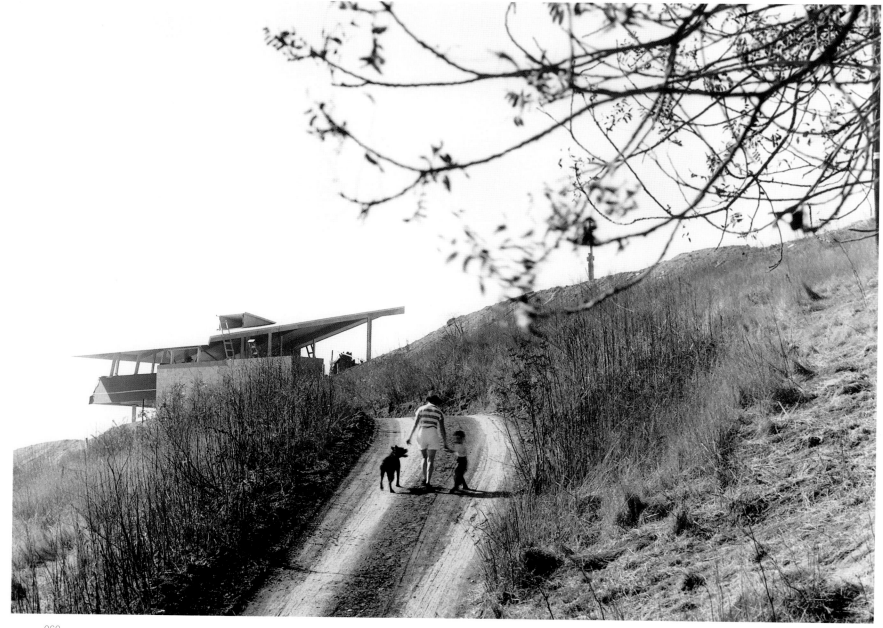

conditions listed as: hillside, gently sloping and flat lots. Concrete block footings, piers or steel beams were used to adjust the plan to the specific site conditions. On this artificial ground level, houses are wood frames, exposed post-and-beams, plank ceilings and floors, with walls of plywood, redwood panels, glass and concrete blocks.

Mutual Housing received an Honor Award from the Southern California and Pasadena Chapters of the American Institute of Architects in 1951 and an Award of Merit from the National American Institute of Architects in 1952.

The project is located on Hanley Avenue in the Brentwood area, West Los Angeles.

ben sollte, entwickelten die Architekten 35 Haustypen für Steilhang, sanft abfallende oder ebene Grundstücke. Je nach Gefälle setzten sie Betonblöcke, Pfähle oder Stahlträger als Gründungen ein, um eine ebene Fläche zu schaffen, auf der das jeweilige Haus errichtet werden konnte. Alle Häuser sind Pfosten-Riegel-Konstruktionen aus Holz und haben Dielenböden sowie holzverkleidete Decken und Redwood-getäfelte Sperrholzwände. Außerdem wurden Glas und Betonwerksteine verwendet.

1951 erhielten die Gebäude von den Sektionen Südkalifornien und Pasadena des AIA für diese Siedlung einen Honor Award und 1952 einen Award of Merit vom landesweiten AIA. Die Siedlung liegt an der Hanley Avenue in Brentwood, West Los Angeles.

conçus pour répondre à la topologie du terrain : flanc de colline, pente douce, terrain plat. Des fondations en parpaings, des contreforts ou des poutres d'acier permirent d'adapter les plans aux conditions spécifiques de chaque parcelle. Au-dessus des terrains ainsi préparés, les maisons sont construites à partir d'une ossature de bois, poteaux et poutres apparentes. Parmi les matériaux : plafonds et sols en planches, murs en contreplaqué, panneaux de bois rouge, verre et parpaings.

La Mutual Housing a reçu un Prix d'honneur des chapitres de Californie du Sud et de Pasadena de l'American Institute of Architects en 1951, et un Prix du mérite du chapitre national de l'AIA en 1952. Le projet présenté est situé Hanley Avenue, à Brentwood, West Los Angeles.

Selected Bibliography:
- arts & architecture, September 1948
- arts & architecture, March 1949
- Progressive Architecture, February 1951
- arts & architecture, January 1952
- Process Architecture, number 41, Oct.1983
- Los Angeles Conservancy, March/April 1986

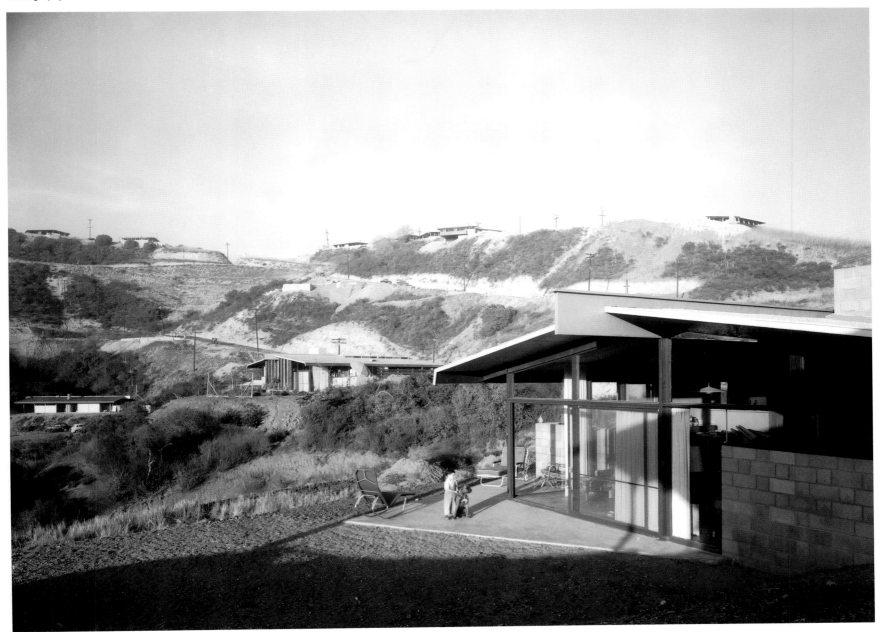

786 Douglas Honnold and John Lautner
Coffee Dan's Wilshire, Los Angeles, California
July 20, 1950

Since the post-war period, coffee shops emerged as one of the most popular building-types in modern Los Angeles. Coffe Dan's is one of the four restaurants designed by John Lautner, when he was working for Douglas Honnold.

Nach dem Krieg entwickelte sich der Coffee Shop zu einem der populärsten Bautypen in Los Angeles. Coffee Dan's ist eines von vier Restaurants, die John Lautner während seiner Tätigkeit bei Douglas Honnold entwarf.

A partir de l'après-guerre, les coffee shops deviennent l'un des types de construction les plus populaires et les plus typiques de Los Angeles. Coffee Dan's est l'un des quatre restaurants conçus par John Lautner lorsqu'il travaillait pour Douglas Honnold.

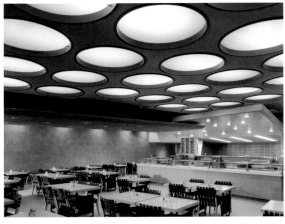

Selected Bibliography: - arts & architecture, Volume 2, number 2

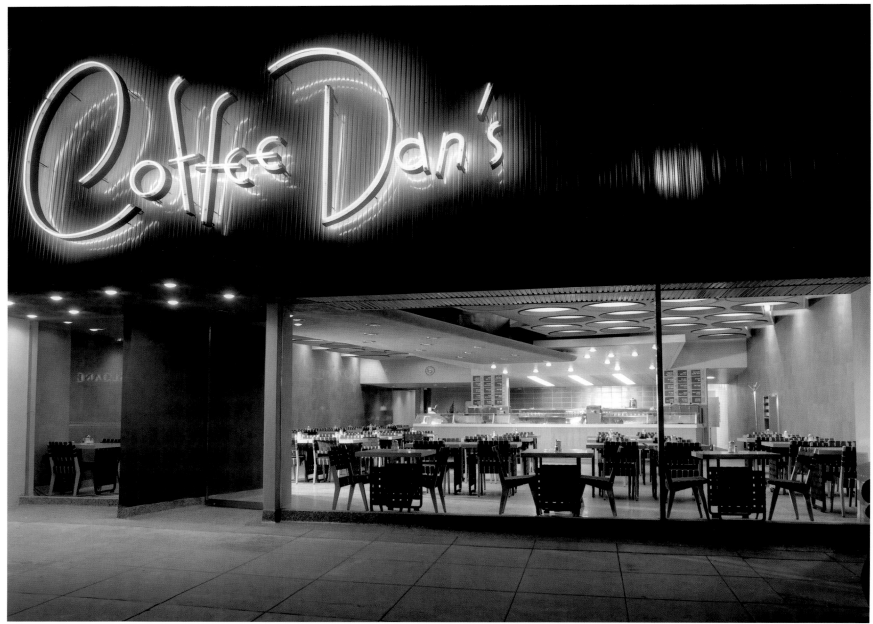

813 Douglas Honnold
Westwood Music Center, Westwood, California
July 29, 1950; October 14, 1950

Edna Larson, director of the Westwood Music Center, commissioned a structure for various musical activities.

Since the east front faces a busy street, the pavilion is oriented west and serves several purposes. It is an environment apt for indoor and outdoor recitals, but also functions as a living space for Mrs. Larson and her husband.

When the glass doors slide into the wall, the music room becomes a stage with the outdoor area available for additional seating. The ceiling geometry fans out, suggesting the form of an open theatre. A small two-room studio for music instruction is a separate building to avoid interference with the main spaces.

Material selection is a direct response to acoustical demands. The concrete block walls and paving were chosen to reflect sound waves. The wood ceiling and the furnishings were designed to be absorbent surfaces.

In ihrer Amtszeit als Direktorin des Westwood Music Center erteilte Edna Larson den Auftrag zum Bau eines Hauses für verschiedene Musikveranstaltungen. Da östlich des Grundstücks eine belebte Straße verläuft, ist der Bungalow nach Westen orientiert. Er dient nicht nur für Konzerte im Innern und im Freien, sondern auch als Wohnhaus für Mrs. Larson und ihren Mann. Wenn die Glasschiebetüren in der Wand verschwinden, wird das große Musikzimmer zur Konzertbühne und der Garten zum zusätzlichen »Parkett«. Die sich zum Garten in ein Vordach verbreiternde Raumdecke erinnert an die Form eines Amphitheaters. Eine kleine Musikschule (zwei Zimmer) ist in einem separaten Häuschen untergebracht, damit der Unterricht im großen Haus nicht stört. Die Materialwahl wurde im Hinblick auf akustische Erfordernisse getroffen. Die Betonsteinwände und Betonbodenfliesen haben gute schallreflektierende Eigenschaften, während etwa die Holzdecken schallschluckend wirken.

Edna Larson, directrice du Westwood Music Center, avait demandé à Honnold un bâtiment qui convienne à ses diverses activités musicales. Comme le terrain est limité à l'est par une rue fréquentée, le pavillon est orienté à l'ouest. Il a plusieurs fonctions : concerts donnés à l'intérieur ou en plein air, mais aussi salle de séjour. Lorsque les portes de verres coulissantes sont repoussées dans une cloison creuse, le salon de musique se transforme en scène. La cour peut être équipée de sièges. Le plafond se relève, suggérant la forme d'un théâtre ouvert. Un petit studio de musique de deux pièces pour les cours et répétitions est installé dans un bâtiment séparé pour éviter les interférences sonores avec le bâtiment principal. Le choix des matériaux répond aux contraintes acoustiques. Les murs en parpaings et le pavement ont été choisis pour renvoyer les ondes sonores, le plafond de bois et les meubles pour les absorber.

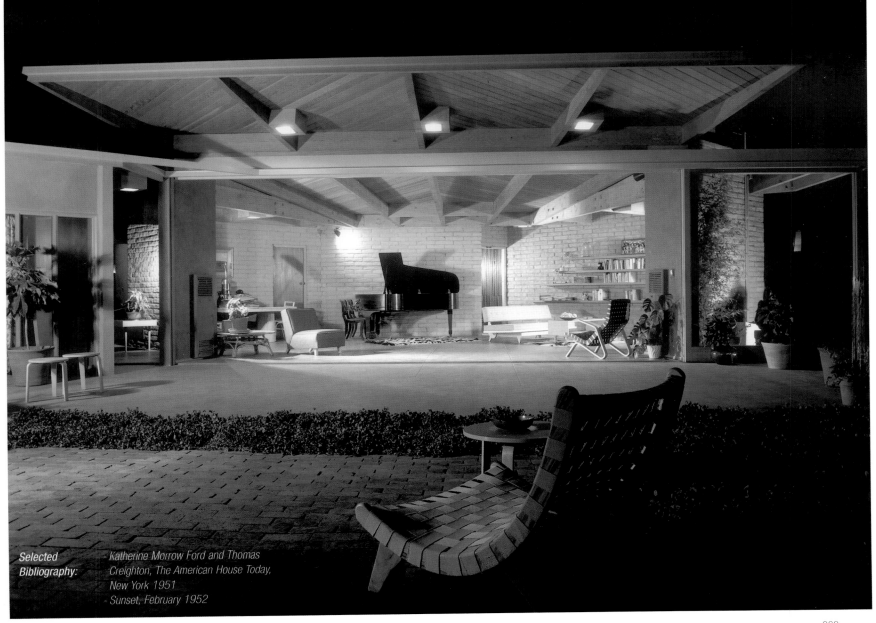

Selected Bibliography:
- Katherine Morrow Ford and Thomas Creighton, The American House Today, New York 1951
- Sunset, February 1952

796 **A. Quincy Jones**
Bel Air Garden Apartments, Los Angeles, California
August 2, 1950

The owner wanted to develop a small site of high property value and secure maximum return. After appraisal of the cost of land and construction, it was concluded that three two-bedroom units on two stories and six one-bedroom units would generate the highest income. A U-shaped plan encloses a common courtyard used as a collective entrance lobby and entertainment area for large gatherings. Service entrances and garages are located off the back street. Sunlight filters through wells in the elevated walkways and openings in the overhangs.
A system of 6-foot-tall wooden screens shields a small outdoor patio for each unit to give privacy. The bearing structure is wood frame with exterior walls in plywood and painted plaster. The architect also designed the landscaping.

Der Auftraggeber wollte ein kleines, aber wertvolles Grundstück in bester Lage bebauen und mit der Vermietung größtmögliche Renditen erzielen. Nach Schätzung der Grundstücks- und Baukosten kam man zum Schluss, drei Maisonettewohnungen mit jeweils zwei Schlafzimmern und sechs Zwei-Zimmer-Appartements würden am meisten Mieteinnahmen bringen. Das U-förmige Gebäude rahmt den gemeinsamen Eingangshof, der auch für größere Geselligkeiten genutzt wird. Die Garagen und Liefereingänge werden über eine rückseitige Zufahrt erschlossen. Sonnenlicht filtert durch Lichtschächte in den erhöhten Wegen und durch Öffnungen in den Dachüberständen. Ein System aus 1,80 m hohen Holzblenden schützt die kleinen Außenterrassen der Wohnungen vor Einblicken. Das Gebäude wurde in Holzrahmenbauweise errichtet und mit Sperrholz und farbigem Putz verkleidet. Der Architekt gestaltete auch die Grünanlagen.

Le propriétaire souhaitait tirer parti d'un petit terrain de grande valeur. Après étude financière, il décida que deux appartements de 4 pièces sur deux niveaux et un appartement de 7 pièces lui permettraient d'obtenir une rentabilité optimale. Le plan en U enferme une cour commune qui fait office de hall d'entrée collectif et peut servir à de grandes réceptions. Les entrées de service et les garages sont implantés sur la rue qui se trouve derrière le bâtiment.
La lumière naturelle est filtrée par des puits créés dans les galeries couvertes surélevées et des ouvertures dans le débord des toits. Dans chaque appartement, un système d'écrans en bois de 1,80 m de haut protège un petit patio des regards. La structure porteuse est une ossature en bois. Les murs extérieurs sont en contreplaqué et plâtre peint. L'architecte s'est également chargé des aménagements paysagés.

Selected - Architectural Record, April 1951
Bibliography: - Process Architecture, number 41,
 October 1983

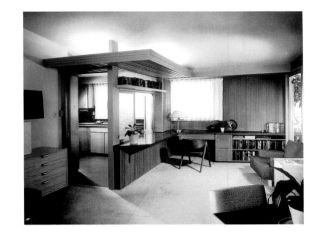

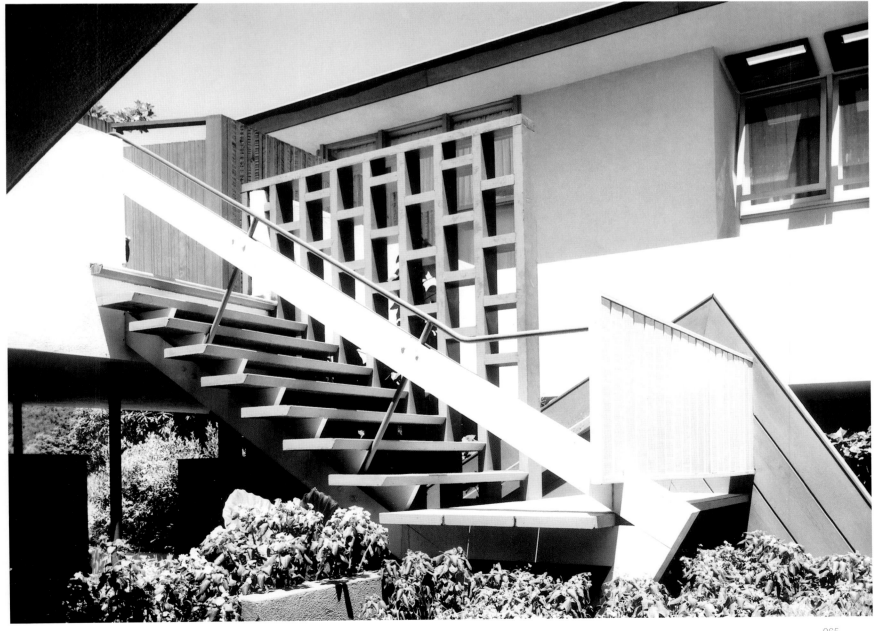

840 **Milton Caughey and Clinton Ternstrom**
Garred Residence, Los Angeles, California
October 2, 1950

A few minutes from Hollywood, the one-story residence for a news broadcaster stands on a plateau with panoramic views on all sides. The pinwheel plan has the living room at the center and the bedroom wing, kitchen-dining area and entry path branching out into the landscape.

Coming from the road below, the driveway terminates in a motor court, where a long covered porch leads to the entry. The living area, the hub of the house, is connected to the dining room and a hallway for the bedrooms through roofed terraces that open out onto the exterior.

Glass walls serve as transitional devices to connect separate sections of the house. The glazing of the living room continues into the dining area; glass screens connect the outdoor patio with the bedroom wing.

The materials reflect the design idea of merging inside and outside. Adobe brick painted gray and Douglas Fir are used for the interior and exterior walls. The brick floor of the living room continues in the roofed porch, the sleeping quarters and the entry passage. Landscaping is by Eckbo, Royston & Williams.

Einige Autominuten von Hollywood entfernt steht dieses Haus, das für einen Nachrichtensprecher entworfen wurde, auf einem Plateau mit freier Sicht nach allen Seiten. Der Wohnraum bildet den Mittelpunkt des kreuzförmigen Plans, Schlafzimmertrakt, Küche und Esszimmer sowie Zugangsweg bilden die Flügel. Die Zufahrt von der Straße mündet in einen Hof, von dem eine lange gedeckte Passage zum Hauseingang führt. Überdachte Terrassen verbinden den Wohnraum mit dem Esszimmer und dem Flur zu den Schlafzimmern und erweitern den bewohnbaren Raum ins Freie.

Auch die außen wie innen verwendeten grau gestrichenen Lehmziegel und Douglaskiefernbretter sind Ausdruck der Entwurfsabsicht, den Außen- mit dem Innenraum zu verschmelzen. Der Klinkerfußboden des Wohnzimmers setzt sich in die überdachte Veranda, den Eingangsflur und die Schlafzimmer fort. Eckbo, Royston & Williams besorgten die Gartengestaltung.

A quelques minutes d'Hollywood, cette maison à un seul niveau construite sur un plateau pour un journaliste de radio bénéficie de vues panoramiques sur toutes ses faces. Le plan en croix implante la salle de séjour au centre tandis que l'aile de la chambre, le coin-repas et la cuisine et enfin le passage d'entrée, avancent vers le jardin. Montant de la route en contrebas, l'allée d'accès se termine sur une cour d'où une longue véranda couverte mène à la porte d'entrée. Le séjour central est relié à la salle à manger et aux couloirs d'accès aux chambres par des terrasse couvertes qui dilatent l'espace intérieur vers l'extérieur.

Les murs de verre font lien entre les différentes parties de la maison. Le vitrage du séjour se poursuit dans la salle à manger et des écrans de verre fait la jonction entre le patio et l'aile de la chambre. Les matériaux traduisent ce concept de fusion dedans/dehors. Des briques d'adobe peintes en gris et du pin de Douglas tapissent les murs internes et externes. Le pavement en brique du séjour se poursuit dans la véranda, les chambres et le passage de l'entrée. Le jardin est dû à Eckbo, Royston & Williams.

Selected Bibliography: - *Los Angeles Times Home Magazine,* *February 4, 1951*

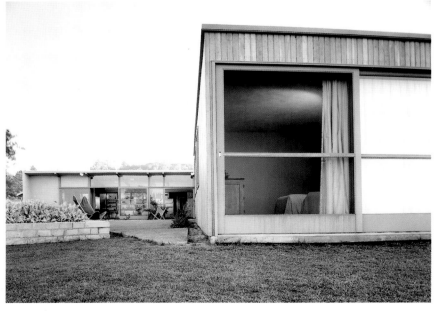

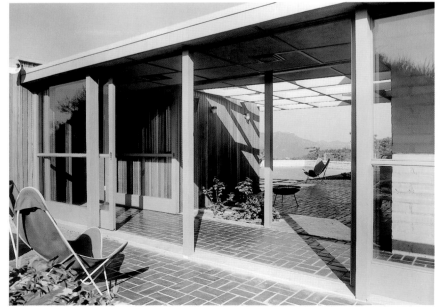

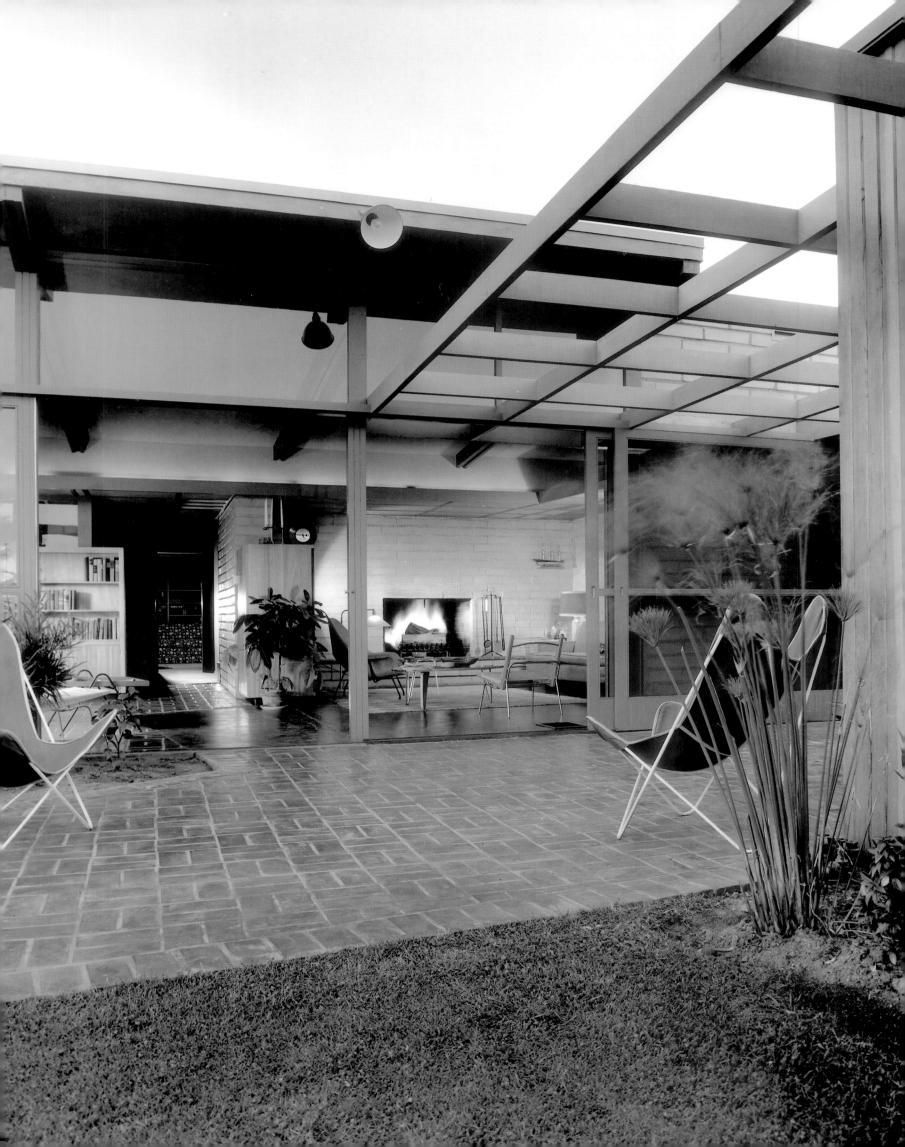

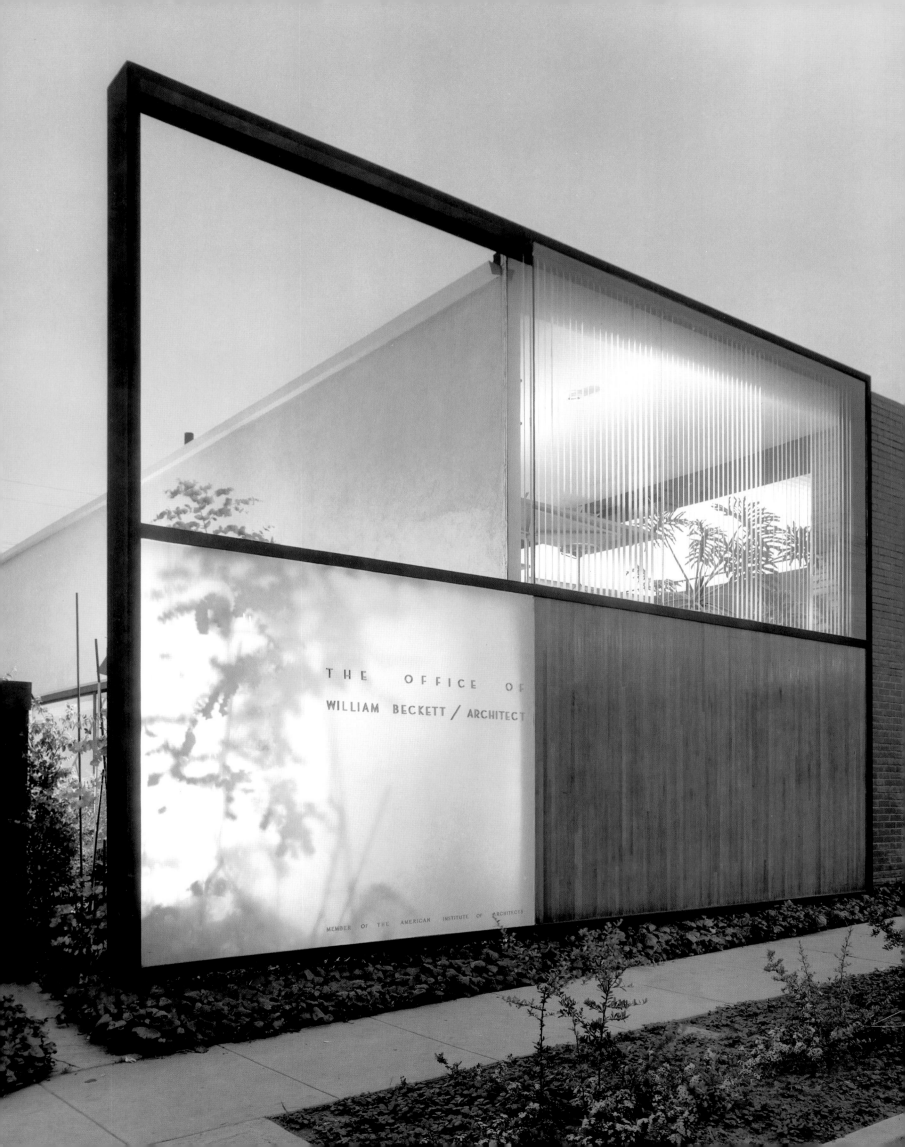

THE OFFICE OF
WILLIAM BECKETT / ARCHITECT

MEMBER OF THE AMERICAN INSTITUTE OF ARCHITECTS

887 William S. Beckett
Beckett Offices, Hollywood, California
December 18, 1950

The project received an Honorable Mention at the American Institute of Architects Awards in 1951 and a National Honor Award in 1952, and drew considerable attention in the architectural community during the 1950s. It was listed in several architecture guides up to those published most recently. When Beckett designed his office, he was only 28. Originally a boys' club called "Jill's and Jack's" located at 9026 Melrose Avenue in Beverly Hills, the two-story building was remodeled and turned into the architect's own office. The program was configured around a double-height drafting room that became the center of the architectural experience. In the remaining square footage, the reception room, conference room and open mezzanine complete the facility. By using a limited number of partitions, the architect avoided the customary physical separation between the principal and the working force, in favor of a single space. Numerous built-in cabinets suspended on thin metal supports partially screen the drafting room from the street, keeping the visual perception of the whole space clear. All the furniture was custom-designed. Next to a metal stairway on the first level, sliding glass links the interior to a narrow garden patio running parallel to the long side of the rear elevation. Through the careful orchestration of industrial materials and minimalist details, the architect shaped his vision of the modern workspace in Southern California. Outside, a steel frame seems to slide along a brick wall and extends its short facade.

20 years after its appearance in the press, the 1974 Map Guide on Los Angeles architecture published in *Architectural Design* reported that the office was owned by the architectural firm Honnold, Reibsamen and Rex. Although the structure is still standing, the exterior has been altered. In addition, its surroundings have been densely built up and the structure is barely visible from the street.

Dieses Gebäude erhielt 1951 eine lobende Erwähnung des AIA und 1952 einen National Honor Award. In den 50er Jahren fand es beträchtliche Aufmerksamkeit unter den Architekten. Es wurde in zahlreiche Architekturführer aufgenommen. Beckett war erst 28 Jahre alt, als er sein Bürogebäude entwarf. Das ursprüngliche als Jugendclub »Jill's and Jack's« genutzte zweistöckige Haus wurde zum Büro des Architekten umgebaut. Das Raumprogramm war auf einen doppelt hohen Zeichenraum konzentriert, der zum Mittelpunkt des Architekturbüros wurde. Auf der übrigen Fläche vervollständigten je ein Empfangs- und Konferenzzimmer und ein offenes Zwischengeschoss die Anlage. Indem er nur wenige Trennwände einbaute, vermied der Architekt die übliche räumliche Trennung zwischen Chef und Mitarbeitern zugunsten eines einzigen Großraums. Zahlreiche Einbauschränke, die von dünnen Metallträgern gehalten werden, schirmen den Zeichenraum von der Straße ab, ohne den Eindruck eines Gesamtraums zu stören. Alle Möbel wurden vom Architekten selbst entworfen. Neben einer Metalltreppe im ersten Stock verbindet eine Glasschiebetür das Innere mit einem kleinen Gartenhof, der parallel zur Rückfront verläuft. Durch die sorgfältige Abstimmung von industriellen Baustoffen und minimalistischen Details hat der Architekt seine Vorstellung von einem modernen Arbeitsplatz in Südkalifornien zum Ausdruck gebracht. Am Außenbau zieht sich ein Stahlrahmen an einer Ziegelwand entlang und verlängert gewissermaßen optisch die kurze Fassade. Zwanzig Jahre nach den Presseveröffentlichungen berichtete 1974 ein Architektur-Stadtplan von Los Angeles in »Architecture Design«, dass das Gebäude im Besitz des Architekturbüros Honnold, Reibsamen and Rex sei. Obwohl der Baukörper noch besteht, sind an seinem Äußeren einige Veränderungen vorgenommen worden. Außerdem ist das Umfeld inzwischen dicht bebaut, so dass das Bürogebäude kaum noch von der Straße aus sichtbar ist.

Ce projet qui reçut une mention honorable lors des A. I. A. Awards de 1951 et un National Honor Award en 1952 attira l'attention de la communauté architecturale au cours des années 1950. Il fut mentionné dans de nombreux guides d'architecture jusqu'à très récemment. Beckett n'était âgé que de 28 ans lorsqu'il le conçut. A l'origine club de garçons appelé « Jill's and Jack's » et situé 9026 Melrose Avenue à Beverly Hills, ce bâtiment de deux niveaux fut remodelé pour abriter les bureaux de l'architecte. Le programme se développait autour d'une salle de dessin double-hauteur, centre du travail de création architecturale. Une pièce de réception, une salle de conférence et une mezzanine ouverte complétaient les installations. Au moyen d'un nombre limité de cloisonnements, l'architecte évita la séparation habituelle entre le chef d'agence et ses collaborateurs au profit d'un espace unique. De nombreux meubles intégrés soutenus par de fins supports métalliques isolent en partie la salle de dessin de la rue, et dégagent visuellement la totalité de l'espace. Tous les meubles furent spécialement dessinés pour l'occasion. A côté d'un escalier en métal, au rez-de-chaussée, des panneaux de verre coulissants ouvrent sur un étroit patio-jardin qui longe la façade arrière. Par une orchestration soignée de matériaux industriels et de détails minimalistes, l'architecte a su mettre en forme sa vision d'un espace de travail moderne en Californie du Sud. A l'extérieur, une structure métallique semble glisser le long du mur de brique prolongeant virtuellement une étroite façade. Vingt ans après sa parution dans la presse, le plan-guide de l'architecture de Los Angeles publié dans *Architectural Design* précisait que ces bureaux étaient la propriété de l'agence d'architecture Honnold, Reibsamne and Rex. Bien que la structure ait été conservée, certains changements ont été apportés à l'extérieur. De plus le contexte s'est densifié et l'agence n'est plus qu'à peine visible de la rue.

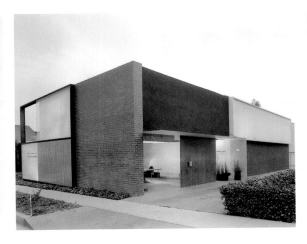

Selected Bibliography:

- Architectural Forum, June 1951
- arts & architecture, February 1952
- L'Architecture d'Aujourd'hui, December 1953
- Domus, March 1954
- Los Angeles Times Home Magazine, August 29, 1954

- L'Architecture d'Aujourd'hui, September 1957
- Douglas Honnold, Southern California Architecture 1769-1956, Los Angeles 1956
- Wolf von Eckardt (ed.), Mid-Century Architecture in America, Washington D.C. 1961
- Architectural Design, July 1974

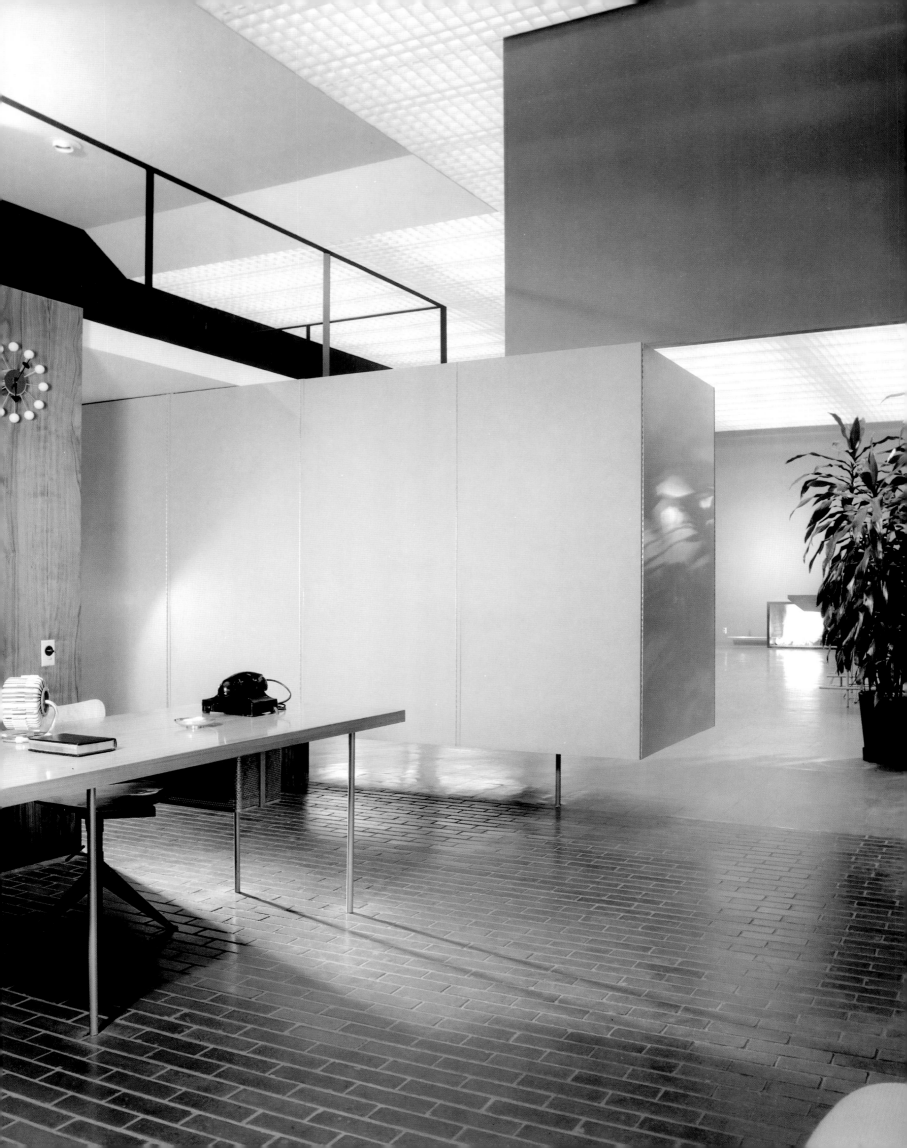

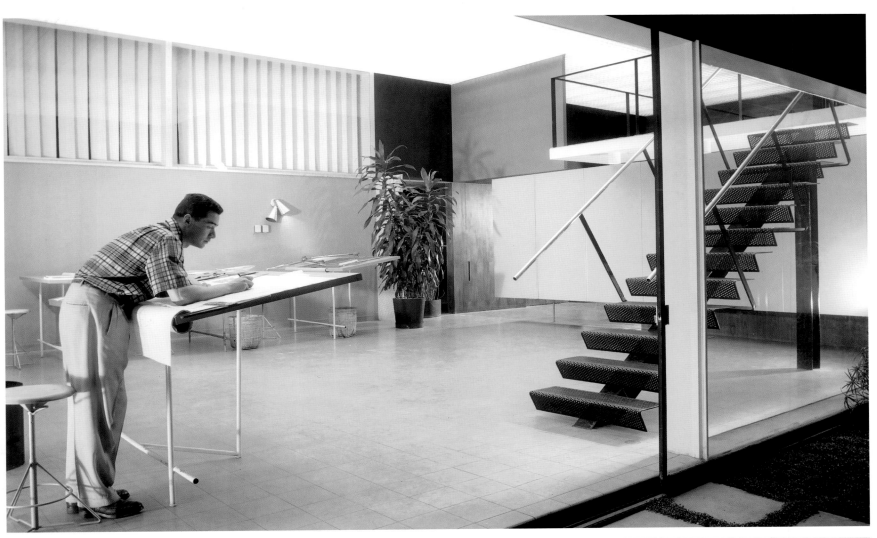

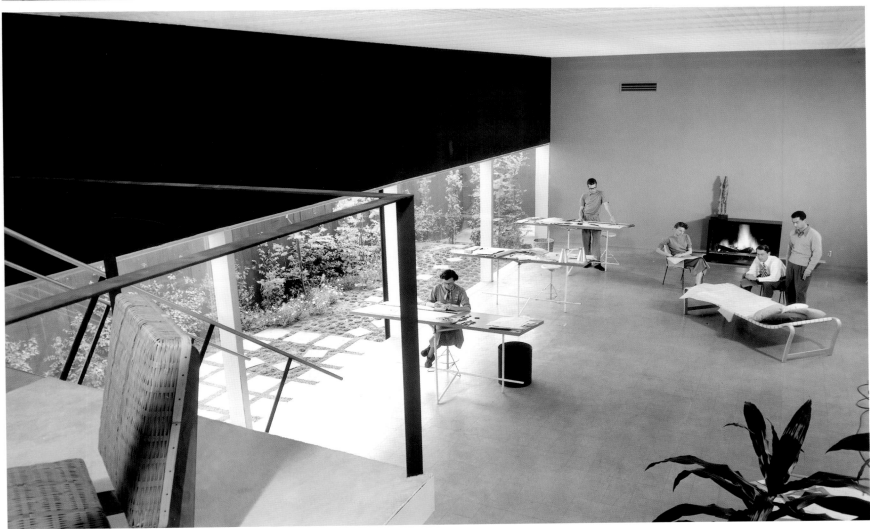

915 Sumner Spaulding and John Rex
Ekdale Residence, Palos Verdes, California
February 16, 1951

Recipient of a 1951 Honor Award from the Southern California and Pasadena Chapters of the American Institute of Architects, the Ekdale Residence was widely published in the popular and specialized press in the 1950s.

Built on a plateau of a ten-acre property in the Palos Verdes Hills, the layout of the house maximizes the panorama in four directions, framing views of the mountains beyond Pasadena, the Los Angeles basin, and the south coast of the Pacific Ocean.

The main piece of the 1,750-square-foot scheme is a 28 x 28 x 14-foot glass volume, which informally houses the lounging, dining and living room functions. This single space wraps around the kitchen, which is screened by seven-foot-high walls, thus creating the effect of a room without a ceiling within a larger room. In the overall composition, the bedroom wing steps back from the southwest side on smaller scale and is kept five feet lower than the volume, reading as an architectural appendix to the square shape.

Structurally, four walls, positioned along the diagonals of the square, support the ceiling, which tapers outward through two inverted steel trusses; the rest of the construction is composed of a wooden frame. The roof is an inverted pyramid with its apex marking in plan the exact center of the communal area. It crowns the primary volume, with a slope that extends six feet beyond the glass screen to form the overhangs.

Arch Ekdale's fascination with electronics emerges in the latest technology of the time: a push-button coffeemaker controlled from his bedside, an intercommunication system and sun lamps in the bedroom ceilings.

Easy maintenance was a major criterion in material selection. Redwood siding and fieldstone found by the owners on their land sheathe the exterior walls. Shipwrights executed the interior carpentry in birch plywood.

Das Wohnhaus der Familie Ekdale, das 1951 einen Ehrenpreis der Southern California and Pasadena Sektion des AIA erhielt, wurde häufig in der Tages- und Fachpresse der 50er Jahre publiziert. Der Entwurf des auf einem Plateau des 5 Hektar großen Besitzes in den Palos Verdes Hügeln liegenden Hauses erweitert das Panorama in vier Richtungen. Es bietet Ausblicke auf die Berge hinter Pasadena, die Bucht von Los Angeles und die Südküste des Pazifiks. Der Hauptteil des 160 m² großen Bauwerks ist ein Glaswürfel von 8,50 x 8,50 x 4,25 m Größe, in dem zwanglos die Lounge und die Ess- und Wohnbereiche untergebracht sind. Diese Raumeinheit umschließt die Küche, die von 2,10 m hohen Wänden umgeben ist, wodurch der Eindruck eines in einen größeren Raum integrierten deckenlosen Raums entsteht. In der Gesamtkomposition der Anlage springt der Schlafzimmer-Flügel in einem kleineren Maßstab von der Südwestseite zurück; er ist 1,50 m niedriger und kann als architektonische Erweiterung der quadratischen Form interpretiert werden. Konstruktiv tragen vier Wände, die entlang der Diagonale des Quadrats verlaufen, die Decke, die nach außen überkragt mit Hilfe von 2 Stahlträgern; die übrige Konstruktion besteht aus einem Holzfachwerk. Das Dach bildet eine umgedrehte Pyramide, ihre Spitze markiert im Entwurf die genaue Mitte des Wohnbereichs. Sie krönt das Hauptvolumen mit einer Neigung, die 1,80 m über die Glasschürze hinausreicht und so die Auskragung bildet. Die Faszination von Arch Ekdale für Elektronik wird im Haus deutlich in Geräten der neuesten zeitgenössischen Technologie: eine vom Bett aus (per Zeitschaltuhr) ferngesteuerte Kaffeemaschine, eine interne Haussprechanlage und Höhensonne in der Decke der Schlafzimmer. Das entscheidende Kriterium bei der Auswahl der Materialien war, dass sie pflegeleicht waren: Redwood und Feldsteine, die die Besitzer auf ihrem Grundstück gefunden hatten, verkleiden die Außenwände. Schiffsbauer führten den Innenausbau mit Birken-Sperrholz aus.

Bénéficiaire d'un Prix d'honneur des chapitres de Californie du Sud et de Pasadena de l'AIA, la résidence des Ekdale a été très souvent publiée dans la presse spécialisée et grand public des années 1950. Construite sur un petit plateau à l'intérieur d'un terrain de 5 hectares situé dans les collines de Palos Verdes, elle bénéficie de magnifiques vues dans quatre directions, sur les montagnes au-delà de Pasadena, le bassin de Los Angeles et la côte du Pacifique.

L'élément principal de cette construction de 160 m² est un cube de verre de 8,50 x 8,50 x 4,25 m qui, de façon informelle, abrite le séjour, la salle à la manger et un salon. Cet espace unique entoure la cuisine, masquée par des murs de 2,10 m de haut qui donne l'impression d'une pièce sans plafond à l'intérieur d'une pièce plus vaste. Dans la composition d'ensemble, l'aile des chambres en retrait au sud-ouest, est traitée à une échelle plus petite — hauteur réduite de 1,50 m par rapport au cube —, et se lit comme un appendice rattaché à celui-ci. Sur le plan structurel, les quatre murs, positionnés sur les diagonales du carré, soutiennent le plafond qui s'abaisse vers l'extérieur par deux fermes inversées. Le reste de la construction est à ossature de bois. Le toit est en forme de pyramide inversée dont l'apex marque le centre exact des espaces communs. Il couronne le volume principal et, par sa pente, crée un auvent de 1,80 m de profondeur au-dessus des murs de verre. La fascination d'Arch Ekdale pour l'électronique se manifeste dans les appareils d'avant-garde pour l'époque, comme une machine à café commandée du lit, un système d'Interphone et une lampe solaire au plafond de la chambre à coucher. La facilité d'entretien fut l'un des critères de sélection des matériaux. Les bardages en bois rouge et la pierre trouvée sur le terrain habillent les murs extérieurs. Des charpentiers de marine ont réalisé la charpente intérieure en contreplaqué de bouleau.

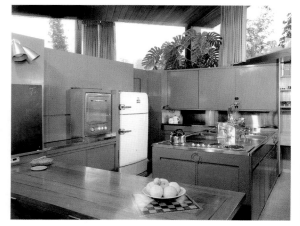

Selected Bibliography:
- arts & architecture, May 1951
- Los Angeles Times Home Magazine, December 9, 1951
- Katherine Morrow Ford and Thomas Creighton, The American House Today, New York 1951
- Architectural Record, May 1952
- Los Angeles Times Home Magazine, October 12, 1952
- Herbert Weisskamp, Beautiful Homes and Gardens in California, New York 1964

958 Thornton Ladd
Lyon Residence, Pasadena, California
May 8, 1951; August 26, 1951

Thornton Ladd was a young architectural student at the University of Southern California, when he received the commission for the Lyon Residence. The three major requirements of the owners for the rather complex site were: a house on one floor only; a passageway connecting the swimming pool at the back and the tennis court in the front of the lot without having to enter the house; living and bedroom area were to be clearly separate from the dining and service quarters. The natural setting was a hillside property covered with old oak trees which were to be preserved.

The architect positioned the house away from the street to secure privacy and developed the one-story plan along the slope. From the carport below, close to the tennis court, a stepped path with broad landings articulates the architectural promenade leading to the entry of the residence. The living room, the two bedrooms and their corresponding terraces are grouped in one structure; the dining room and the service areas are located in another structure. To link the two distinct parts of the house, Ladd designed a glass-walled bridge, whose underpass connects the lower level with the swimming pool at the back of the property. Once inside this glass volume, the dining room, pantry, kitchen and laundry are on the right, and the living room and sleeping units are on the left. At the corner of the dining room and the bridge, a rectangular trellis called "dendriform" generates formal motifs informing the design. The house has glass walls almost everywhere, staging family life among the treetops. The material palette encompasses the pale buff clay of the Roman brick, redwood for the fascia boards and the undersides of the eaves, and natural plaster for the moldings under the windows.

Thornton Ladd war noch Student der Architektur an der University of Southern California, als er den Bauauftrag für das Haus Lyon erhielt. Drei Wünsche des Bauherrn mussten auf dem unregelmäßig abschüssigen Grundstück erfüllt werden: alle Räume auf einer Ebene, eine Passage vom Schwimmbecken hinter zum Tennisplatz vor dem Haus, die nicht durch das Haus führte, und eine klare Trennung zwischen Wohn- und Schlafzimmern einerseits sowie Esszimmer und Hauswirtschaftsräumen andererseits. Außerdem sollten die alten Eichen am Hang erhalten bleiben. Ladd versetzte das Haus von der Straße in die Grundstückstiefe zurück, um es abzuschirmen und das Haus quer zum Hang zu entwickeln. Vom Carport neben dem Tennisplatz führt ein Treppenweg mit breiten Podesten hinauf zum Haupteingang. Der Wohnraum und die zwei Schlafzimmer (mit dazugehörigen Terrassen) sind in einem Baukörper zusammengefasst, Essplatz und Wirtschaftsräume in einem zweiten. Als Verbindung zwischen beiden schuf Ladd eine verglaste Brücke, unter der man vom unteren Geländeabschnitt mit Tennisplatz zum oberen Teil mit Schwimmbecken durchgeht. Wenn man die Glaspassage betritt, befinden sich Esszimmer, Anrichte, Küche und Waschküche zur Rechten, das Wohn- und Schlafhaus zur Linken. Das Haus ist fast vollständig verglast und inszeniert das Familienleben sozusagen in den Baumkronen. Die Materialpalette umfasst helle römische Verblendziegel, Redwood für die Traufkanten und Unterseiten der Dachüberstände sowie Putzmörtel für die Fenstergesimse.

Thornton Ladd était un jeune étudiant en architecture de l'Université de Southern California, lorsqu'il reçut commande de cette maison. Il devait répondre à trois exigences des propriétaires pour ce terrain compliqué : une maison sur un seul niveau ; un passage entre la piscine à l'arrière et le court de tennis à l'avant sans avoir à passer par la maison, une séparation claire du séjour et des chambres, de la salle à manger et des pièces techniques. Le cadre naturel était constitué d'un terrain au pied d'une colline et d'anciens chênes à préserver.

L'architecte plaça la maison en retrait de la rue pour la protéger des regards et développa son plan à flanc de colline sur un seul niveau. De l'abri à voitures en bas près du court de tennis, un escalier coupé de larges paliers conduit à l'entrée de la maison. La salle de séjour, les deux chambres et les terrasses correspondantes sont regroupées en un seul bloc, la salle à manger et les pièces de service dans un autre. Pour relier ces deux parties distinctes, Ladd dessina une passerelle vitrée courant une allée qui permet de se rendre à la piscine à l'arrière de la propriété. Par rapport à ce volume vitré, la salle à manger, l'office, la cuisine et la lingerie sont à droite, le séjour et les chambres, à gauche.

À l'angle du séjour et de la passerelle, un treillis rectangulaire à ramifications reprend des motifs décoratifs que l'on retrouve dans tout le projet.

La maison presque vitrée de tous côtés met en scène la vie de la famille au milieu des arbres. La palette de matériaux comprend des briques en argile claire lustrée, le bois rouge pour les acrotères et les soffites, et le plâtre naturel pour les panneaux sous les fenêtres.

Selected Bibliography:
- Los Angeles Times Home Magazine, September 2, 1951
- House & Garden, July 1952
- Architectural Review, May 1957

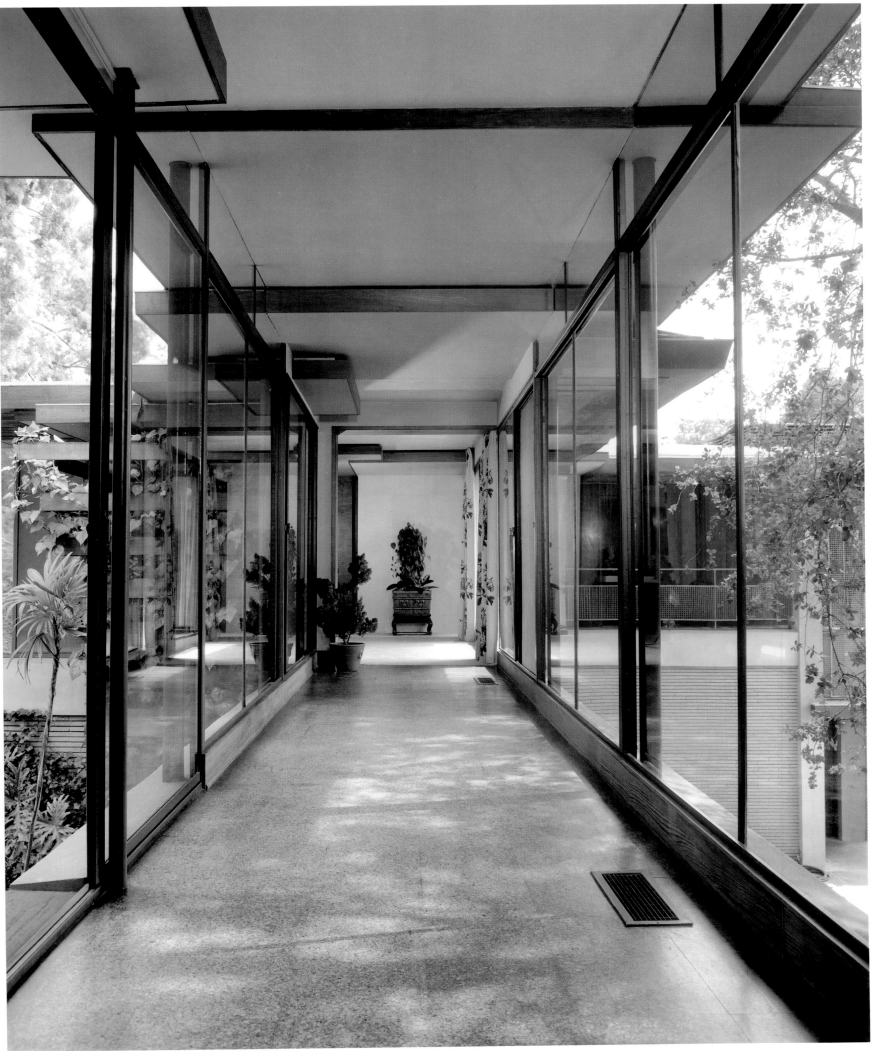

969 **Lewis E. Wilson**
Beryl Berry Agency, Los Angeles, California
May 29, 1951

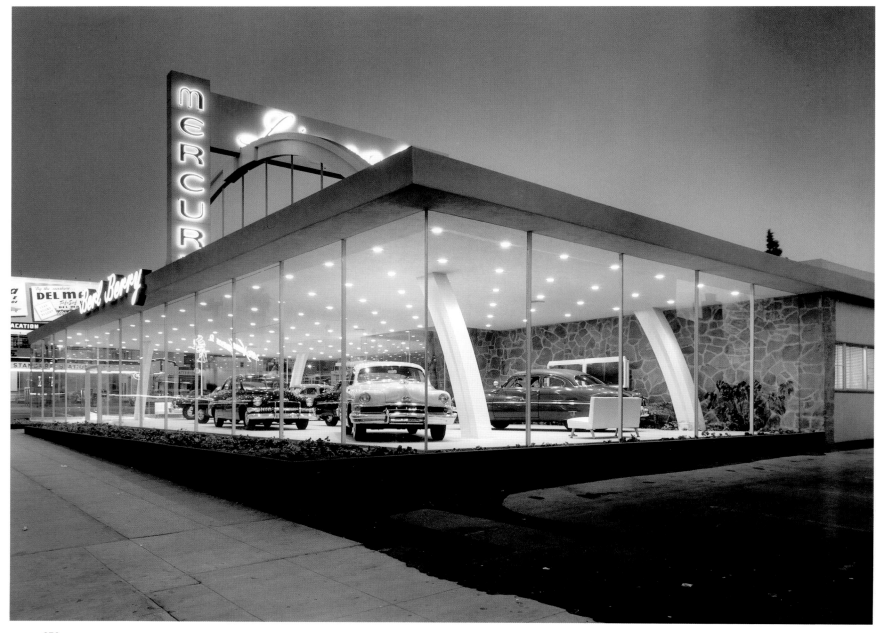

974 **Richard O. Spencer**
Space Retreat, Hollywood, California
June 4, 1951; July 10, 1951

To solve the challenge of building on steep hills, Spencer uses a laminated plywood arch to place part of the house on a 50-degree terrain. Cut in two parts and assembled on site, the 60-foot arch supports 20,000 pounds of weight. The forward suspended portion of the dwelling is made of light materials, while the other end is firmly anchored to the ground through masonry construction.

Lobby, kitchen, sleeping units and baths are on the street side. The cross-sectioning arch divides the two-story living room of the cantilevered portion generating a smaller covered area with a balcony.

Pumice blocks build the mountain side of the design, while the suspended part is of studs and stucco.

Spencer stellte sich der Herausforderung, ein Haus an einem Steilhang mit 50° Gefälle zu bauen, indem er Strebebögen aus Sperrholzlaminat einsetzte, um einen Hausteil über dem Hang in der Schwebe zu halten. Tatsächlich handelte es sich um einen 18 m langen Bogen, der in zwei Teile geschnitten und vor Ort montiert wurde. Der vorkragende Baukörper wurde zwar in Leichtbauweise konstruiert, ist aber immer noch rund 10 Tonnen schwer. Das hintere Ende ist fest im Hang verankert. Diele, Küche, Schlafzimmer und Bäder befinden sich im straßenseitigen Teil des Hauses. Der quergestellte Bogen teilt einen kleineren Balkonteil von dem vom Hang abhebenden zweige-schossigen Wohnraum ab. Bimsbetonsteine bilden die Hang-fassade des Hauses, der vorkragende Baukörper ist verputzt.

Pour répondre au défi habituel posé par la construction dans des collines escarpées, Spencer utilise un arc en contreplaqué lamellé collé pour soutenir une partie de la maison sur un terrain dont la pente atteint 50°. Livré en deux parties et assemblé sur site, cet arc de 18 m de long soutient ainsi un poids de 10 tonnes. La partie en suspension est en matériaux légers tandis que l'autre est fermement ancrée dans le terrain au moyen d'une solide maçonnerie.

Le couloir, la cuisine, les chambres et les bains donnent sur la rue. L'arc divise le séjour double hauteur et génère un petit espace couvert par un balcon. La partie de la maison reposant sur le terrain est en parpaings de ponce. La partie suspendue est construite à partir d'une ossature

Selected Bibliography: - Los Angeles Times Home Magazine, August 12, 1951

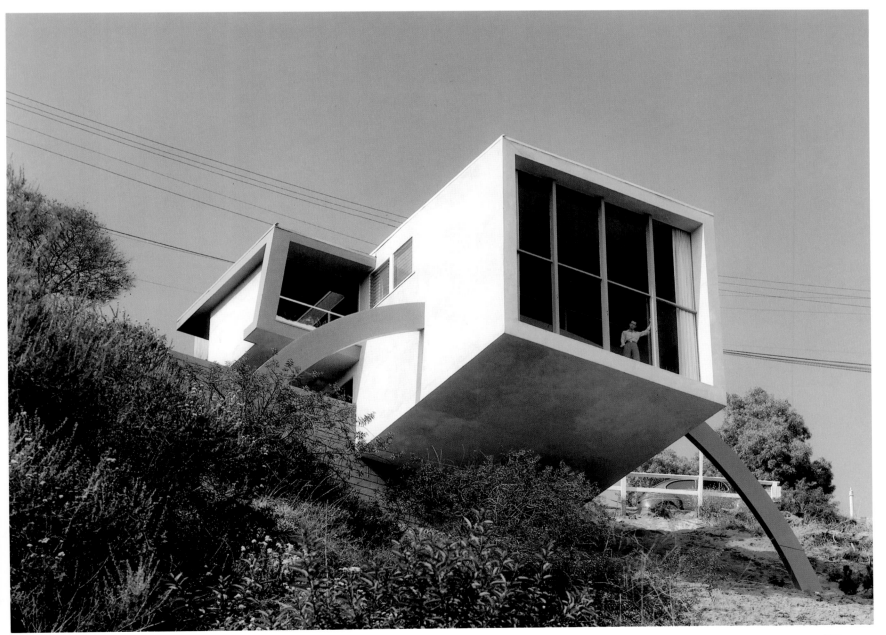

1021 Harold J. Bissner
Bissner Residence, Pasadena, California
July 1, 1951

When architects design their own residence, the project usually becomes a manifesto of their vision of modern living. For Harold J. Bissner, domestic space is integrated with nature and grants indoor privacy.

The Bissners' site is part of an old wooded estate called Chapman Woods. Built on a 100 x 190-foot lot, the house has an area of 2,000 square feet. From the outside, the front elevation appears closed off. Western cedar vertical boarding patterns the layout of the street façade. A projecting elongated box frame, containing dark green aluminum louvers, conceals the living room and bedroom hall from passers-by.

In plan, the house wraps around a large oak tree in a U-shape, delimiting a rear patio with a wooded vista as the backdrop. With the exception of the dining area, all rooms open onto a terrace filled with a variety of trees and plants: tropical ferns, aralias, India stone pine, aromatic red cedar, sycamores, and ponderosa pine. Through the front door, painted bright green, a glass-walled passage forks inside the residence at an 80-degree angle. On one side, an all-purpose room for informal activities projects into the garden and screens the working wing, which consists of a storage space, a maid's quarters and bathroom. The other wing comprises the living room, guestroom and master bedroom. Both living spaces have radiant heat in the floor slabs.

The rooftop is the combination of three sheds at different levels. A unique butterfly roof characterizes the portion of the residence on the street. This results from the intersection of the highest shed whose clerestory windows cast light into the living room and the guest bath with the shed containing the master bedroom and bath running in the opposite direction. The material palette is rich: California fieldstone for the entry path, Bouquet Canyon stone for the fireplace wall, crushed white rock for the roof, 12-inch cork tiles for the floor.

Wenn Architekten ihr eigenes Haus entwerfen, wird das Projekt gewöhnlich zu einer Manifestation ihrer eigenen Vorstellung vom modernen Leben. Für Harold J. Bissner soll der Wohnbereich sich eng mit der Natur verbinden und im Innern private Ungestörtheit gewährleisten.

Das Grundstück der Bissners ist Teil eines alten bewaldeten Besitzes, der Chapman Woods heißt. Das Haus hat eine Gesamtfläche von 185 m². Von außen wirkt die Vorderfront verschlossen. Die Verkleidung aus V-förmig angeordneten Zedernholz-Brettern prägt den Charakter der Straßenfront. Ein vorkragendes Rahmenwerk mit dunkelgrünen Aluminiumjalousien entzieht den Wohnraum und den Flur zum Schlafzimmer den Blicken der Passanten. Im Grundriss entwickelt sich der Bau U-förmig um eine große Eiche und begrenzt zugleich einen rückwärtigen Innenhof mit einem Blick auf den Wald als Hintergrund. Mit Ausnahme des Essbereichs gehen alle Räume auf eine Terrasse hinaus, die angefüllt ist mit einer Vielfalt von Bäumen und Pflanzen. Durch die leuchtend grün gestrichene Haustür führt in einem Winkel von 80° eine verglaste Passage in das Wohnhaus. Auf der einen Seite erstreckt sich ein Mehrzweckraum bis in den Garten und schirmt den Arbeitsflügel ab. Der andere Flügel umfasst den Wohnraum, das Gästezimmer und das Schlafzimmer. Beide Wohnbereiche haben Fußbodenheizung.

Das Dach ist eine Kombination aus drei Pultdächern auf verschiedenem Niveau, ein ungewöhnliches Schmetterlings-Dach charakterisiert den Teil des Hauses zur Straße hin. Das ergibt sich aus der Überschneidung von zwei in entgegengesetzte Richtungen abfallenden Pultdächern. Die Palette der Baumaterialien ist reich: verschiedene lokale Steinarten für den Eingangsweg und die Kaminwand, weißer Kies für das Dach sowie Korkfliesen für den Fußboden.

Lorsqu'un architecte dessine sa propre maison, il en fait généralement le manifeste de sa vision de la vie moderne. Pour Harold J. Bissner, l'espace domestique doit s'intégrer à la nature tout en conservant une intimité.

Le terrain fait partie d'un domaine boisé appelé Chapman Woods. Construite sur un parcelle de 30 x 58 m, la maison fait 185 m². Vue de l'extérieur, la façade principale sur rue semble fermée, mais elle est mise en valeur par un bardage vertical en cèdre monté à rainure et languette à joint en V. Un caisson allongé en projection, fermé de persiennes vert foncé, masque le séjour et le dégagement des chambres.

En plan, la maison s'enroule autour d'un énorme chêne, et sa forme en U délimite à l'arrière un patio qui donne sur les bois. A l'exception du coin-repas, toutes les pièces s'ouvrent sur une terrasse ornée de divers arbres et plantes : fougères tropicales, aralias, pin indien, cèdre rouge aromatique, sycomores et pin ponderosa. De la porte d'entré de couleur vert vif, un passage vitré s'insinue dans la maison selon un angle à 80°. D'un côté, une pièce à fonctions multiples et informelles avance dans le jardin et fait écran avec l'aile des services qui contient une pièce de rangement, une chambre de bonne et une salle de bains. L'autre aile comprend le séjour, une chambre d'amis et la chambre principale. Les pièces à vivre sont chauffées par le sol.

Le toit est la combinaison de trois sheds de niveaux différents. La partie sur rue se distingue par son toit en aile de papillon à l'intersection du shed le plus élevé dont les fenêtres hautes éclairent le séjour et la salle de bains des invités, et du shed de la chambre et de la salle de bains principale qui s'étend dans la direction opposée. La palette des matériaux est variée : pierre de Californie pour l'allée d'entrée, pierre du Bouquet Canyon pour le mur de la cheminée, rocher blanc broyé pour le toit, dalles de liège pour les sols.

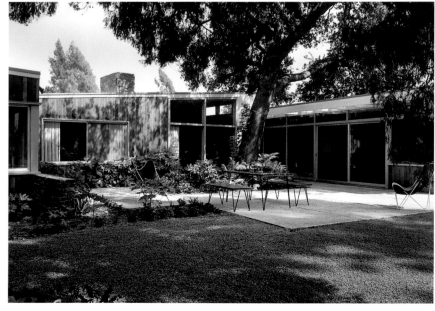
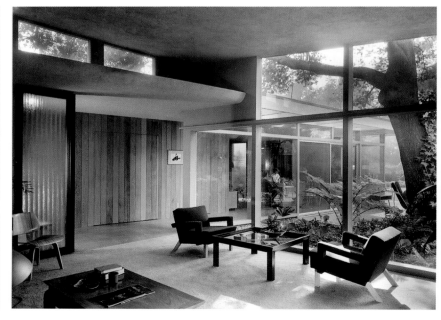

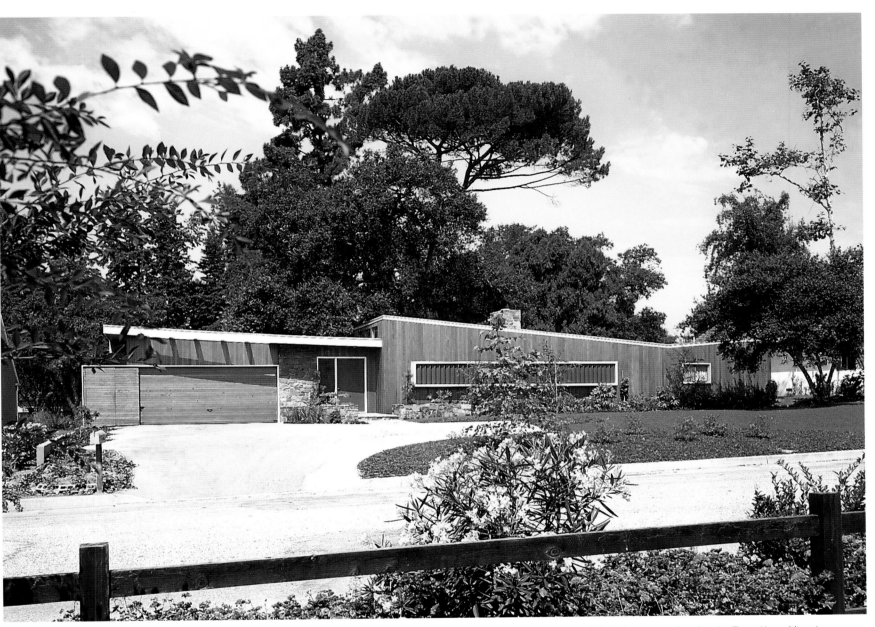

Selected Bibliography:

- Los Angeles Times Home Magazine, January 20 1952
- House & Garden, May 1952

1207 **Rodney Walker**
Sweeney Residence, Beverly Hills, California
January 8, 1952

The lot posited one main design challenge: to capture the south light in the house interior while making of the north view towards the San Fernando Valley the focal space of family life. Two ordering systems are at play in the layout to reconcile this site condition. The square shape housing the common areas seems to grow out of the sleeping quarters with a 45-degree rotation, generating a plan physically pointing north. An unconventional triangular roof on the living-dining area slopes from the high south point down to the north terrace.

Walker allocates 2,300 square feet of covered space to three bedrooms and the living area. The house sits on a concrete slab, extending out to form terraces toward the valley. From the carport, a brick-paved trail leads to the entry-garden space. Access to all bedrooms is in this area, with no exposure to the main living space.

The roof envelope is laid on an exposed 68-foot-long steel beam connecting the lowest and highest point of the structure, resulting in a 48-foot clear span in the living room and a gable glass end facing south.

Das Baugrundstück stellte den Architekten vor die schwierige Aufgabe, das Licht der Mittagssonne ins Haus zu bringen und dabei die Ausblicke nach Norden auf das San Fernando-Tal in den Mittelpunkt des Wohnerlebnisses zu stellen. Die Grundrisslösung besteht aus zwei Ordnungen: Die quadratische Fläche der Gemeinschaftsräume scheint mit einer Drehung von 45° aus dem Schlafzimmerbereich herauszuwachsen, wodurch der Plan nach Norden weist. Ein ungewöhnliches dreieckiges Dach über dem Wohn- und Esszimmer neigt sich von seinem höchsten Punkt nach unten zur Terrasse auf der Nordseite des Hauses. Walker überbaute etwa 210 m^2 mit drei Schlafzimmern und dem Wohnbereich auf einer Betonplatte, die sich über die Außenmauern fortsetzt und die Terrassenflächen auf der Talseite bildet. Vom Carport führt ein Klinkerweg zum Vorgarten vor der Haustür. Alle Schlafzimmer sind von hier aus direkt zugänglich. Die Dachdecke wird von einem zwischen dem niedrigsten und dem höchsten Punkt der Konstruktion gespannten, unverkleideten, 21 m langen Stahlträger getragen, so dass der mit einer Glasgiebelwand nach Süden versehene Wohnraum eine stützenfreie Spannweite von über 14 m hat.

Cette parcelle de terrain représentait un vrai défi : comment faire pénétrer dans la maison la lumière (du sud), tout en bénéficiant au maximum de la vue sur le San Fernando Valley, au nord. Deux dispositifs d'ordonnancement réconcilient ces attentes contradictoires. Le carré qui abrite les parties communes et les oriente vers le nord semble prolonger l'espace réservé aux chambres en effectuant une rotation de 45°. La pente du curieux toit triangulaire au-dessus du séjour-salle à manger part de son point haut, au sud, pour descendre vers la terrasse, au nord. Walker consacre 210 m^2 d'espace couvert aux trois chambres et au séjour. La maison est édifiée sur une dalle de béton, dont des extensions forment des terrasses vers lavallé. A partir de l'abri aux voitures, une allée pavée de briques conduit au jardin d'entrée. L'accès à toutes les chambres se fait par cette zone, indépendant du séjour. Le toit repose sur une poutre d'acier de 21 m de long qui relie le point haut et le point bas de l'ossature, permettant une portée de 14 m sans pilier au-dessus du séjour et un pignon de verre au sud.

Selected Bibliography: - *Los Angeles Times Home Magazine, May 1, 1955*

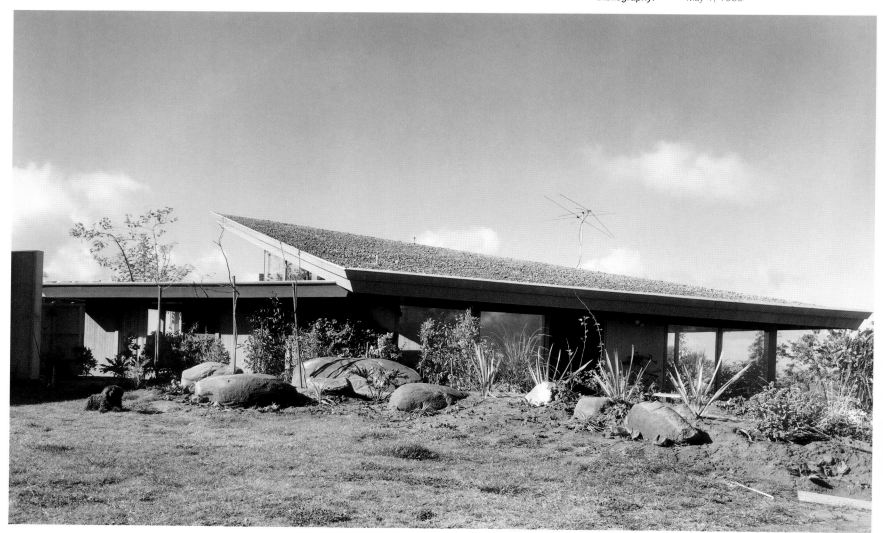

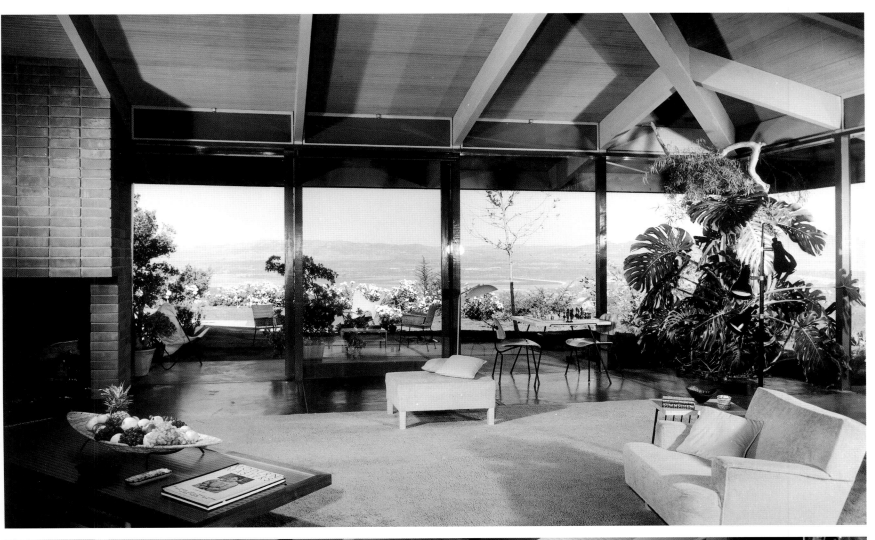

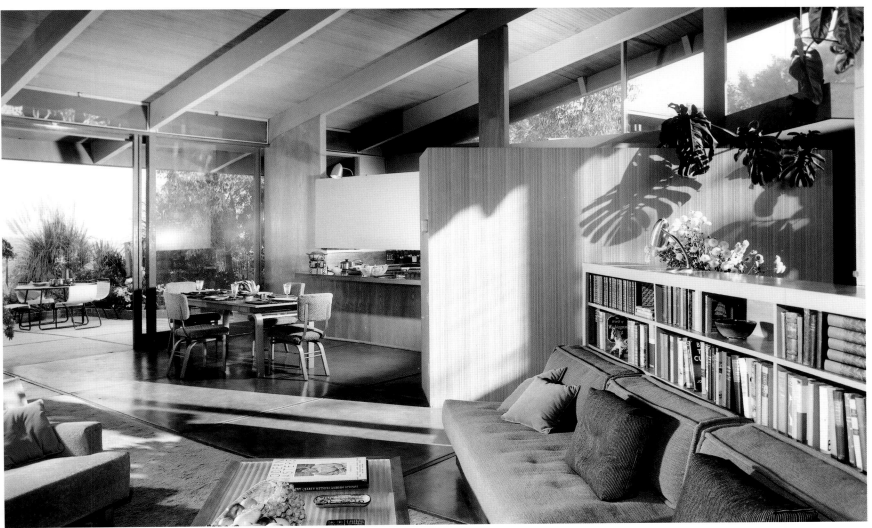

1224 **William S. Beckett**
Evans Residence, Beverly Hills, California
February 2, 1952; November 23, 1953

The topography of the site provided an ideal setting to accommodate the specifications of the owners, Raymond Evans, a composer for the movie industry, and his wife, a writer. Both artists used to work at home and needed separate studio space. In addition, the couple asked for large indoor and outdoor areas for public and more private entertainment occurring at the same time.

Beckett takes advantage of the lot's sectional condition by splitting the house on two levels. Functional sections are divided into three completely independent pavilions connected by a carport and a sloping bridge half-encased in glass. 3,898 square feet of sheltered space are subdivided, into communal zones, plus the maid unit at the upper level and sleeping quarters with study-dressing rooms at the lower level. The free-standing arc at the entrance is echoed on the opposite side of the floor plan with a curved surface acting both as internal partition of the public zone of the house and exterior wall of the kitchen. In the 24 x 40-foot living room, the sculptural fireplace separates living and dining functions. Hanging from the ceiling, the chimney looms over a triangular island of shiny Montana marble. A 19-foot-long wood cabinet is embedded in the glass wall on the lee side of the residence and displays pre-

Die Grundstücks-Topographie bot ideale Voraussetzungen zur Verwirklichung der Bauherrenwünsche. Raymond Evans komponierte Filmmusik, seine Frau war Schriftstellerin, beide brauchten separate Arbeitsbereiche. Außerdem wünschte das Paar sich viel Platz für große offizielle Empfänge und gleichzeitig stattfindende private Geselligkeit im kleineren Rahmen. Beckett nutzte das Gelände, indem er die Räume auf zwei Ebenen anlegte. Die verschiedenen Funktionen sind in drei separaten Pavillons untergebracht, die durch eine Garage sowie eine geneigte, halb verglaste Brücke miteinander verbunden sind. Die Gesamtfläche von 360 m² ist in die Wohn- und Gesellschaftsräume auf der oberen Ebene und die Schlafzimmer mit Arbeits- und Ankleideräumen auf der unteren Ebene unterteilt. Der freistehende Bogen am Eingang findet auf der anderen Seite des Hauses sein Echo in der geschwungenen Außenmauer der Küche, die zugleich die »öffentlichen« Räume umfasst. Im 7,50 x 12 m großen Wohnraum fungiert der Kamin als Raumteiler zwischen Wohnbereich und Essplatz. Der Kamin selbst hängt frei über einer dreieckigen Feuerstelle aus glänzend poliertem Montana-Marmor von der Decke. In die Glaswand auf der windgeschützten Seite des Hauses ist ein 6 m breiter Schrank integriert, in dessen Vitrine präkolumbiani-

La topographie du site offrait un cadre idéal au programme des propriétaires, Raymond Evans, compositeur de musique de cinéma et son épouse, écrivain. Chacun travaillait essentiellement à la maison et avait besoin d'un bureau à lui. De plus, ils souhaitaient de grands espaces pour que des réceptions publiques ou privées puissent se dérouler en même temps. Beckett mit à profit le profil du terrain pour répartir la maison sur deux niveaux. Les parties fonctionnelles occupent trois pavillons complètement indépendants, réunis par un abri à voitures et une passerelle inclinée protégée du vent par des panneaux de verre. Les 360 m² d'espace couverts sont divisés en parties communes au niveau supérieur ainsi que des chambres avec bureau-dressing au niveau inférieur. L'arc indépendant qui marque l'entrée se retrouve en écho à l'autre extrémité du plan dans une surface en courbe qui sert à la fois de cloisonnement interne dans la partie de réception de la maison et de mur extérieur pour la cuisine. Dans le séjour de 7,50 x 12 m, une cheminée sculpturale sépare les fonctions séjour et repas. Le conduit de cheminée est suspendu du plafond au-dessus d'un îlot triangulaire en marbre poli du Montana. Un meuble en bois de 6 m de long intégré au mur de verre permet d'exposer des sculptures précolombiennes et

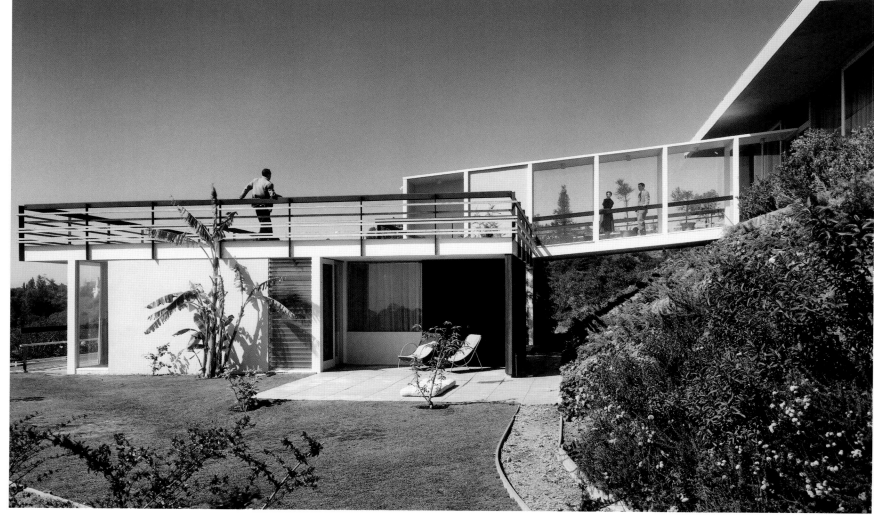

Columbian sculpture and technical equipment. In axis with the fireplace, the glassed-in bridge starting from the living area lands on the wide rooftop of the unit below. A panoramic view of Los Angeles sets the backdrop for this outdoor paved platform. Each room has a private outdoor terrace and a study alcove for work. Both the study in the main unit and the maid section can double as extra bedrooms. The house and the bridge are conventional wood framing. Finishing materials include redwood, brick, and stucco siding, plaster and cork walls.

sche Skulpturen und Werkzeuge ausgestellt sind. Auf einer Achse mit dem Kamin mündet die vom Wohnbereich ausgehende verglaste Brücke in die breite Dachterrasse des tiefer liegenden Hausteils mit Blick auf Los Angeles. Jedem Innenraum ist ein Balkon oder eine Terrasse zugeordnet, jeder hat einen Alkoven als Arbeitsecke. Haus und Brücke wurden in Holzrahmenbauweise errichtet. Als Baumaterialien wurden Redwood, Ziegelsteine, Stuckplatten, Putzmörtel und Kork (für die Wände) verwendet.

certains équipements techniques. Dans l'axe de la cheminée, la passerelle part du séjour pour descendre sur le toit-terrasse du volume inférieur, d'où l'on découvre une vue panoramique sur Los Angeles. Chaque pièce dispose d'un espace extérieur et d'un coin travail. La maison et la passerelle ont été construites à partir d'une ossature en bois. Comme autres matériaux, on a utilisé des bois rouges, de la brique, des plaques de stuc, du plâtre et un revêtement mural en liège.

Selected Bibliography:

- Los Angeles Times Home Magazine, April 24, 1955
- Katherine Morrow Ford and Thomas H. Creighton, Designs for Living, New York 1955
- Architecture Record Houses of 1956, Mid-May, June 1956
- The Los Angeles Examiner, Pictorial Living Section, May 13, 1956
- L'Architecture d'Aujourd'hui, Sept. 1957

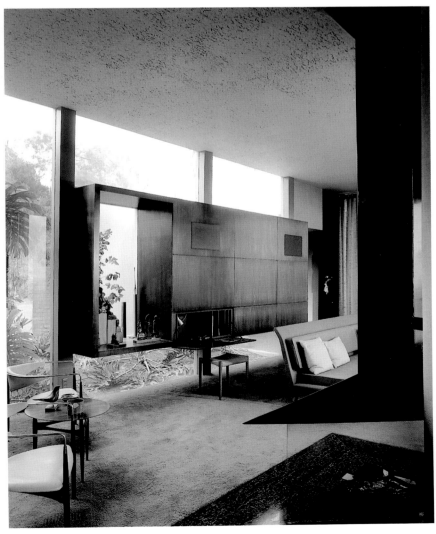

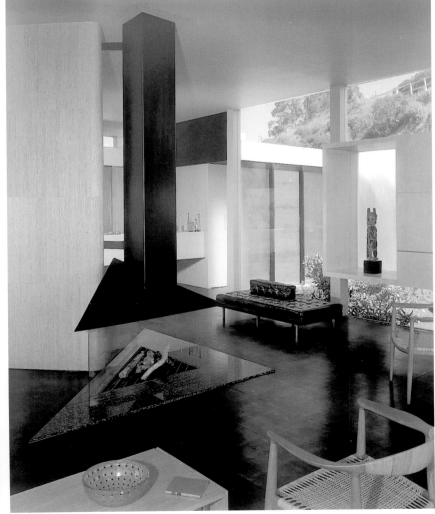

1277 Williams, Williams, Williams
Kiner Residence, Palm Springs, California
April 25, 1952

The private units and common rooms form a line along the east-west axis covering a total area of 2,300 square feet. Supported by an evenly spaced post-and-beam structure, the low gabled-roof tops the narrow strip of inhabited space. In contrast with the north facade, closed against dust storms, the residence opens south to the pool terrace and surrounding mountains.

Each room has direct access to the patio, the center of outdoor entertaining, with the kitchen within easy reach. The interiors feature many built-ins to save floor space. Master and guest bedrooms have a large bathroom and a two-way closet each between bedrooms and baths. Redwood and stone texture the walls of an informal house for Ralph Kiner, a noted baseball player at the time.

Die 212 m² großen privaten Bereiche und die Gemeinschaftsräume sind entlang der Ost-West-Achse angeordnet. Ein niedriges Giebeldach überdeckt den schmalen Streifen des bewohnten Raums. Im Gegensatz zu der geschlossenen Nordfassade, die gegen Sandstürme schützt, öffnet sich das Wohnhaus nach Süden auf eine Terrasse mit Schwimmbad und auf die umliegenden Berge. Jedes Zimmer hat direkten Zugang zum Patio, dem Mittelpunkt aller Aktivitäten im Freien, mit der Küche in Reichweite. Die Innenräume sind mit Einbauschränken ausgestattet, um Bodenfläche zu sparen. Die Eltern- und Gästeschlafzimmer haben jeweils ein großes Bad und einen beidseitig zugänglichen Schrank zwischen den Räumen. Redwood und Naturstein bestimmen die Ausstattung dieses Hauses für Ralph Kiner, der seinerzeit ein berühmter Baseball-Spieler war.

Les chambres et les pièces communes alignées sur un axe est-ouest occupent une surface de 212 m². Soutenu par des poteaux et poutres, un toit à pignon surbaissé surmonte l'étroit ruban des espaces habités. Par contraste avec la façade nord, fermée pour protéger des tempêtes de sables, la maison s'ouvre au sud vers la piscine et les montagnes environnantes. Chaque chambre possède son accès direct au patio, qui est en fait le centre de la vie en plein air, la cuisine étant à portée immédiate. Les pièces sont équipées de meubles intégrés pour réduire l'encombrement. La chambre principale et celle des invités possèdent une grande salle de bains et un placard qui s'ouvre du côté chambre et du côté bains. Le bois rouge et la pierre donnent un certain relief aux murs de cette maison construite pour Ralph Kiner, célèbre joueur de base-ball de l'époque.

Selected Bibliography: - House & Garden, August 1952

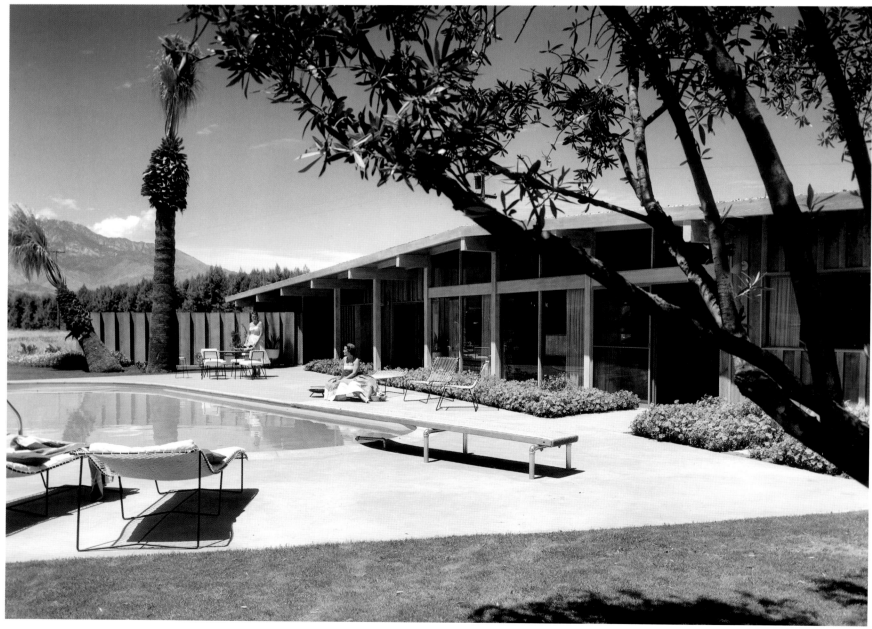

1337 Thornton M. Abell
Home Show "Californian", Los Angeles, California
February 9, 1952

Originally built as a model house for the Construction Industry Exposition in 1952, the residence was later owned by Mr. and Mrs. Kenneth Griffin of Los Angeles.

Behind a façade closed to the public street, customary in Abell's architecture, the house interior is completely transparent. Many of the rooms in the L-plan open to the large patio through floor-to-ceiling glass doors and are visible from all the other areas. At night, indoor and outdoor spaces become a single vast space, punctuated by the masonry wall of the fire-place. The patio, paved in concrete, is an outdoor living room.

On the opposite side of the house, the kitchen, the children's bedroom and the hall of the living room cluster around a smaller open area often used for informal meals.

Das ursprünglich als Modellhaus für die Bauindustrie-Ausstellung im Jahr 1952 gebaute Haus wurde später das Wohnhaus des Ehepaars Griffin in Los Angeles.

Wie üblich in den Entwürfen von Abell ist das Hausinnere hinter der zur Straße geschlossenen Fassade ganz transparent. Die meisten Räume des L-förmigen Hauses öffnen sich mit deckenhohen Glastüren zu dem großen Innenhof und sind von allen anderen Bereichen her einzusehen. Nachts verschmelzen die Innen- und Außenbereiche zu einem einzigen großen Raum, der durch die Backsteinmauer des Kamins akzentuiert wird. Der mit Betonblocksteinen gepflasterte Innenhof ist ein Wohnzimmer im Freien. Auf der anderen Seite des Hauses drängen sich die Küche, das Kinderzimmer und die Diele um einen kleinen offenen Bereich, der häufig für private Mahlzeiten genutzt wird.

A l'origine maison-modèle conçue pour la Construction Industry Exposition de 1952, cette résidence fut ultérieurement acquise par Mr. et Mrs. Kenneth Griffin de Los Angeles.

Derrière la façade fermée sur la rue, formule courante chez Abell, l'intérieur est entièrement transparent. De nombreuses pièces du plan en L ouvrent sur le vaste patio, visible de toute la maison, par des portes vitrées toute hauteur. La nuit, les espaces intérieurs et extérieurs se confondent, ponctués par le mur en maçonnerie de la cheminée. Le patio pavé de dalles de béton fait fonction de séjour extérieur. De l'autre côté de la maison, la cuisine, la chambre des enfants et le hall du séjour donnent sur un espace ouvert plus petit, souvent utilisé pour des repas informels.

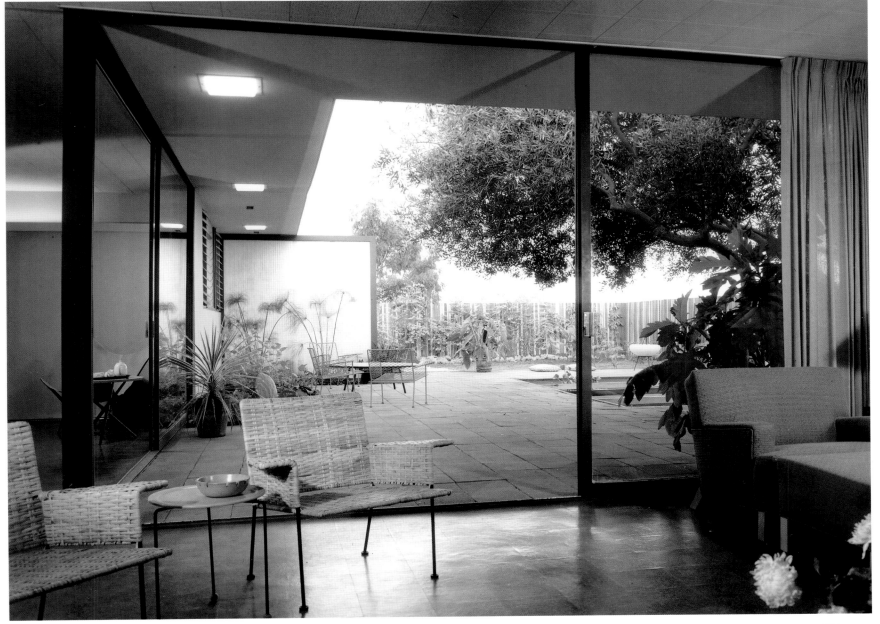

Selected
Bibliography:
- *Los Angeles Times Home Magazine,*
 "What I believe…", May 1, 1955
- *Sunset, July 1955*
- *Sunset, March 1956*

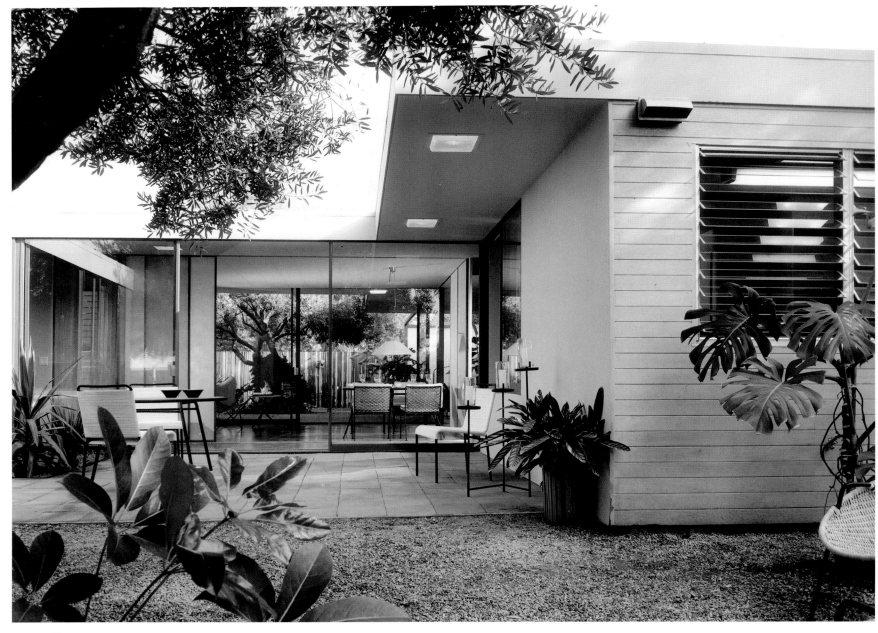

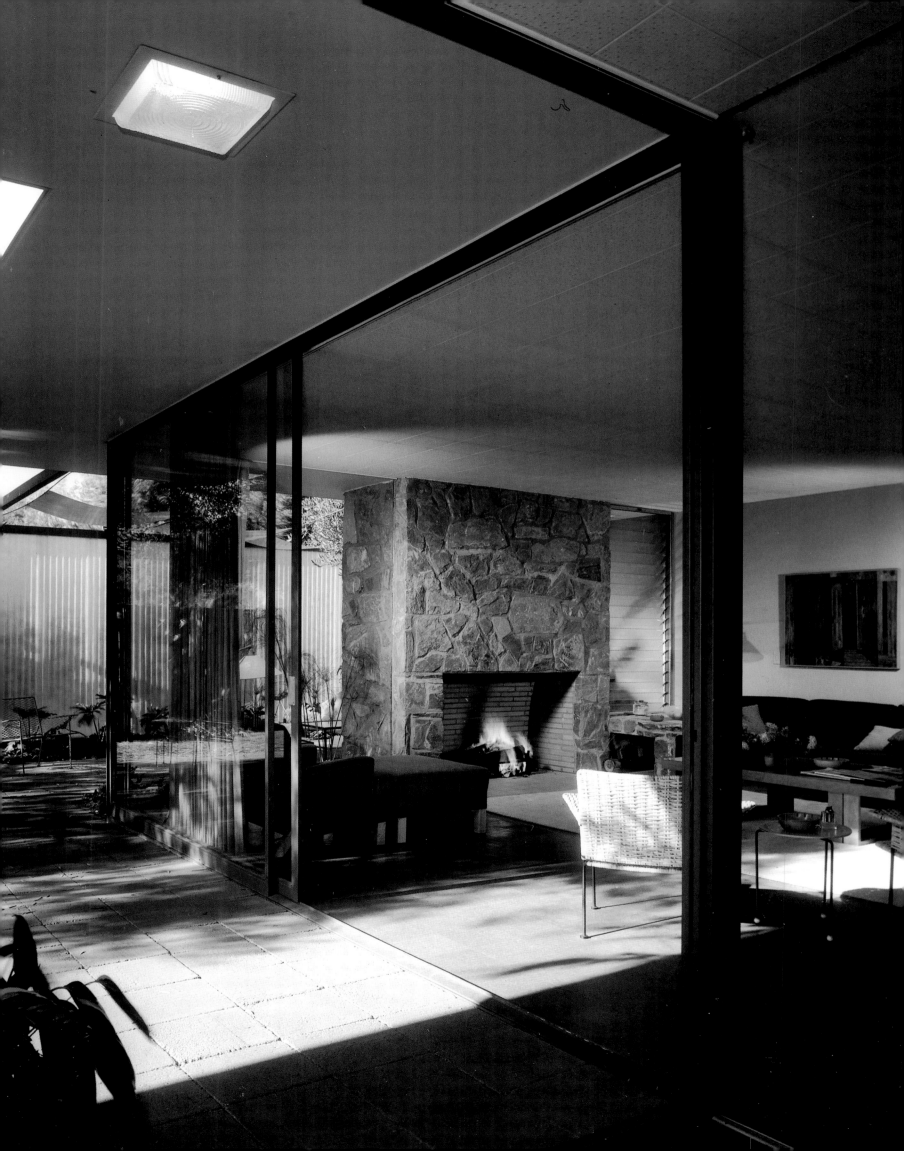

1372 **Conner and Poiezny**
Central State Hospital Nurses Dormitories, Norman, Oklahoma
October 8, 9, 1953

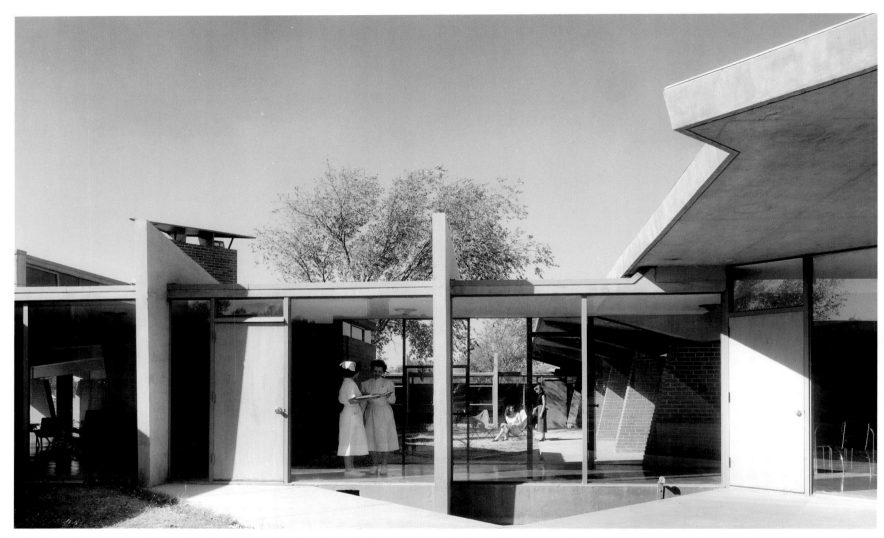

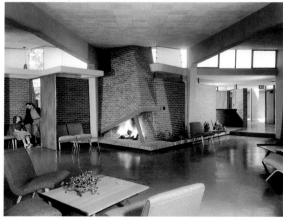

Selected Bibliography: - *Progressive Architecture, February 1954*

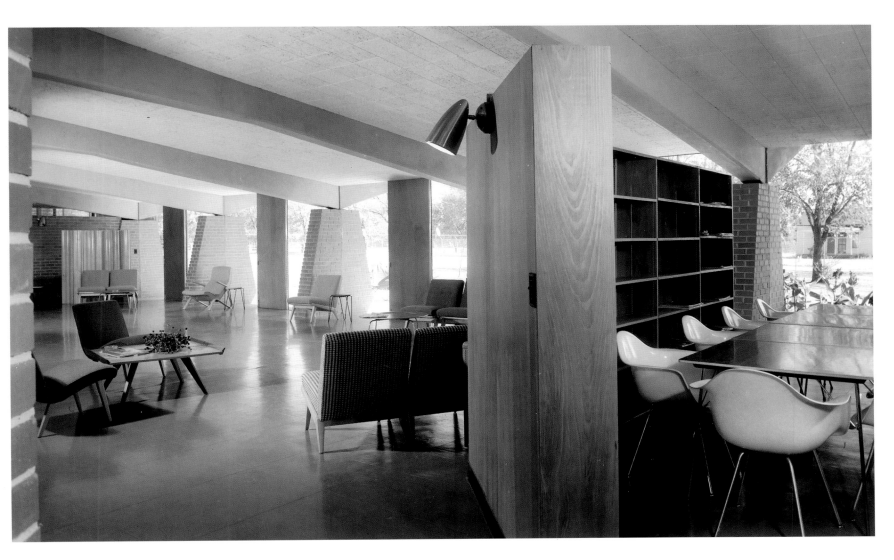

The School of Medicine of the University of Oklahoma offered at the time an elective course in psychiatric nursing, requiring a three-month-residency at a state mental institution. The class proved to be unpopular among interested applicants due to the inhospitable conditions of the Central State Hospital, selected for the training period.

To counteract these conditions, the architects designed an environment fostering reconciliation between the private needs of the community of students as well as the demands of the educational agenda. The scheme occupies a triangular parcel next to the hospital, but kept separate from it through solid brick walls and planting. Two ordering systems at a 45-degree angle from each other discipline the geometry of the complex. Parallel rows of bedroom units converge toward a central area for the communal activities. In this part, a lobby, lounge and classrooms open onto a multi-purpose court, often used for social entertaining. The lounge also provides alcoves often used for dating by the student population. In the bedroom rows, the sleeping units are offset in groups of four, creating sub-communities among students. Each room enjoys two exposures and is connected directly to an outdoor recreation area.

Die Medizinische Fakultät der Universität Oklahoma bot in den fünfziger Jahren als Wahlfach eine Ausbildung in psychiatrischer Pflege an; dazu gehörte ein dreimonatiges Praktikum in einer staatlichen psychiatrischen Anstalt. Der Ausbildungsgang fand jedoch nur wenig Interessenten, weil die »unwirtlichen« Zustände der Pflegepersonal-Unterkünfte im Central State Hospital nur zu bekannt waren. Zur Beseitigung dieses Missstands entwarfen die Architekten ein Gebäude, das die Wohnbedürfnisse der Praktikanten angemessen befriedigt und zugleich die erforderlichen Unterrichtsräume umfasst. Der Bau nimmt eine dreieckige Fläche neben dem Krankenhaus ein und ist von diesem durch Ziegelmauern und Grünanlagen getrennt. Zwei im Winkel von 45° gegeneinander versetzte Grundrisssysteme gliedern den Komplex. Parallele Reihen von Schlafzimmer laufen auf die zentralen Gemeinschaftsräume zu, die ein Foyer, einen Aufenthaltsraum und die Unterrichtsräume umfassen und sich zu einem Mehrzweckhof öffnen. Im Aufenthaltsraum befinden sich Sitznischen, in die Schüler oder Schülerinnen sich gern zurückziehen. Vier Schlafzimmer sind jeweils zu einer Gruppe zusammengefasst. Jeder Raum hat Ausblick nach zwei Seiten und direkten Zugang zum Außenraum.

L'Ecole de médecine de l'Université de l'Oklahoma proposait à l'époque un cours à option d'infirmerie psychiatrique, obligeant à resider pendant trois mois dans un asile d'aliénés. Le cours était peu populaire auprès des candidats intéressés, tant les conditions de logement du Central State Hospital où se déroulait le stage étaient médiocres.

Pour remédier à cette situation, les architectes conçurent un cadre de vie qui réconciliait les besoins de la communauté des étudiants et les contraintes du programme de formation. Le projet occupe une parcelle triangulaire, près de l'hôpital, mais séparé de lui par des murs de brique aveugles et des plantations. Deux dispositifs d'organisation, qui pivotent à 45° l'un par rapport à l'autre, articulent la géométrie du complexe. Des rangées parallèles de chambres convergent vers une zone centrale réservée aux activités communes. Là, un hall, un salon et des salles de cours s'ouvrent sur une cour polyvalente, souvent utilisée pour les réceptions. Le salon offre également des alcôves dans lesquelles les étudiants peuvent recevoir. Les chambres sont regroupées par quatre, ce qui crée des sous-groupes parmi les étudiants. Chaque pièce, qui bénéficie d'une double exposition, est directement reliée à l'aire extérieure de jeux.

1431 Frederick Liebhardt
Liebhardt Residence, La Jolla, California
January 14, 1953

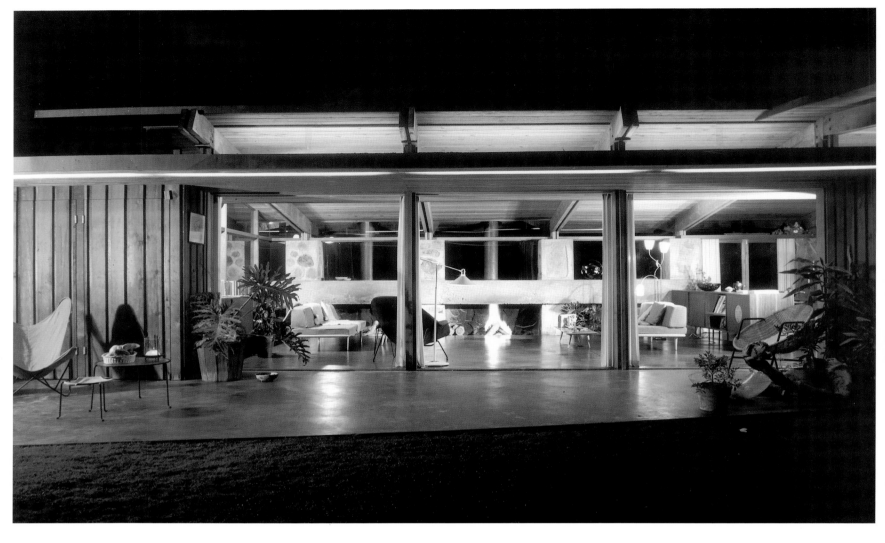

Although the area overlooks the ocean, the architect sited his own residence back from the seascape toward the canyon slope. In preserving the natural contour of the terrain, the house is configured to entertain a close relationship with the natural setting, used as an outdoor-living extension. The project is designed to meet the needs of a four-member family. The north-south axis structures the sequence of sheltered and open spaces, distributed on one level. Between the carport and the children's area, a ramp leads directly to the center of the house. Half of the square footage is apportioned to the sleeping rooms; the remaining half, sharply separate from the first, is devoted to communal activities. On the east portion of the plan, living room and kitchen form an L-shape opened through glass to the wooded hills. A long, narrow terrace extends the living quarters outdoors. Ten masonry piers made of native stone and concrete form the west elevation and support the beams holding the roof.

Obwohl man vom Grundstück aus das Meer sehen kann, hat der Architekt sein Haus zurückgesetzt an den Hang des Canyons gebaut. Indem er die natürliche Topographie des Terrains intakt ließ, schuf er ein Haus, das in enger Beziehung zur Landschaft steht und diese in den Innenraum fortsetzt. Es entstand für eine vierköpfige Familie und bietet auf einer Ebene eine Folge von überdachten und offenen Räumen in Nord-Süd-Ausrichtung. Zwischen Garage und Kinderzimmern führt eine Rampe direkt in die Mitte des Hauses. Die Schlafzimmer nehmen die Hälfte der Gesamtfläche ein, die Wohnräume die andere, deutlich abgesonderte Hälfte. Im Ostteil des Hauses bilden Wohnzimmer und Küche im Plan ein L. Sie bieten Ausblicke auf die bewaldeten Hügel. Eine lange, schmale Terrasse verlängert den Wohnraum ins Freie. Zehn Mauerwerkspfeiler aus örtlichem Naturstein und Beton bilden im Wechsel mit Glasfenstern und -türen die Westfassade und tragen die Dachkonstruktion.

Bien que le lieu donne sur l'océan, l'architecte a implanté sa propre maison le dos au paysage marin, face à un canyon. En préservant le profil naturel du terrain, le plan entretient une relation étroite avec son cadre naturel, qui devient une extension du séjour. Le projet répond aux besoins d'une famille de quatre personnes. La succession d'espaces couverts et ouverts se répartit selon un axe nord-sud sur un seul niveau. Entre l'abri aux voitures et la zone des enfants, une rampe mène directement au centre de la maison. La moitié de la surface couverte est affectée aux chambres, le reste, nettement séparé, est consacré aux activités communes. Dans la partie est, le séjour et la cuisine suivent un plan en L qui s'ouvre par des baies vitrées sur les collines boisées. Une terrasse longue et étroite prolonge le séjour vers l'extérieur. Dix contreforts de maçonnerie en pierre locale et béton rythment la face ouest et soutiennent les poutres de la charpente.

Selected Bibliography: - *Los Angeles Times Home Magazine,* March 28, 1954

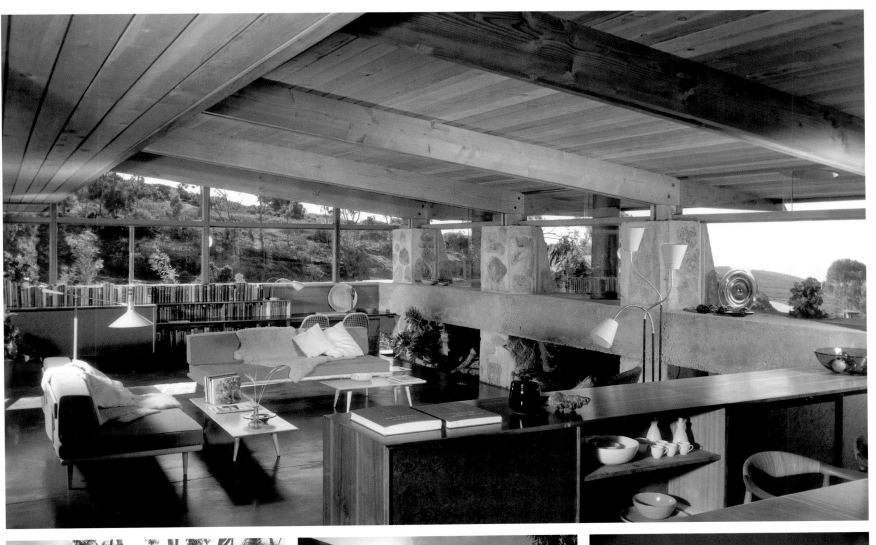

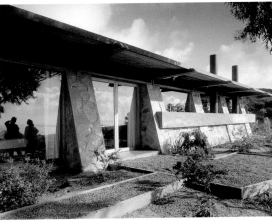

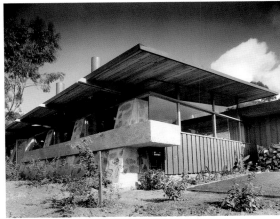

1442 Maynard Woodard
Woodard Residence, Hollywood, California
February 2, 1953

A low-pitched roof shelters three main areas: a big living-entertainment zone in the center, three sleeping units on the west end of the house, and, on the opposite end, a playroom for the children, the favorite indoor space for family life.
Since the Woodards and their two teenage sons are actively involved in various hobbies, their residence features a workshop, a darkroom, a basketball-badminton court and a pool to meet their diverse interests. In the south-oriented living room, a gable glass end facing the pool is recessed 14 feet from the roof overhang to screen out sun glare.
The house is wood post-and-beam construction with an indoor-outdoor wall in fieldstone.

Ein flaches Satteldach deckt drei Hauptbereiche: einen großen Wohnraum mit Konzertflügel in der Mitte, drei Schlafzimmer am westlichen Ende des Hauses und am östlichen Ende das Spielzimmer der Kinder – beliebter Aufenthaltsraum für die ganze Familie. Da die Woodards und ihre beiden Söhne (damals Teenager) verschiedene Hobbies pflegten, umfasst das Haus eine Werkstatt, eine Dunkelkammer, ein Spielfeld für Basketball und andere Ballspiele und eine große Terrasse mit Schwimmbecken. Der Architekt setzte die voll verglaste Giebelfassade zum Schwimmbecken um rund 4 m zurück, um die blendfreie Belichtung des Wohnzimmers sicher zu stellen. Die Pfosten-und-Riegel-Konstruktion des Hauses wird durch eine Feldsteinmauer ergänzt.

Un toit en pignon surbaissé abrite trois zones principales : une partie séjour-réception au centre, trois chambres à l'ouest et une salle de jeux pour les enfants, espace privilégié de la vie familiale
Comme les Woodard et leurs deux fils adolescents étaient passionnés de hobbies divers, la maison comprend un atelier, une chambre noire, une cour de basket et de badminton et une piscine. Dans le séjour orienté vers le sud, la façade de verre sous le pignon face à la piscine, est en retrait de 4 m par rapport à l'aplomb du toit pour mieux protéger du soleil. Construite à partir d'une ossature de montrants et de poutrelles, la maison est traversée par un mur de pierres trouvées sur place.

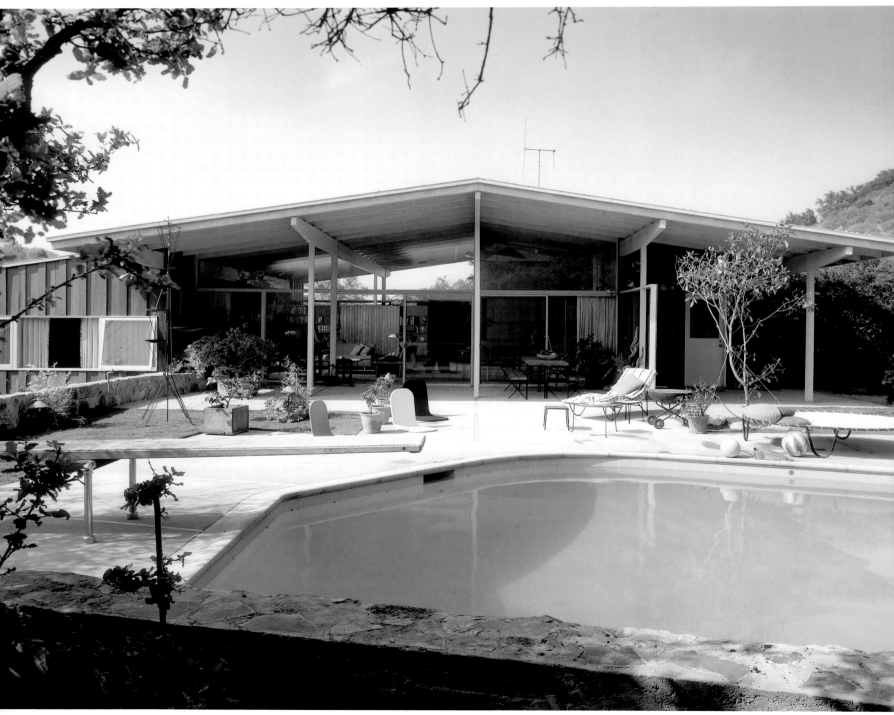

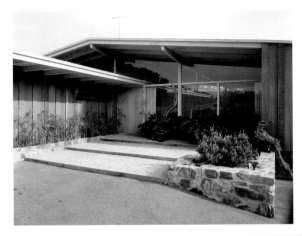
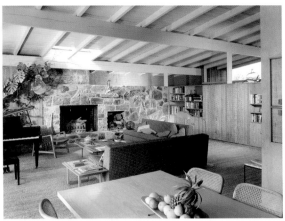

*Selected
Bibliography:* - *House & Garden, February 1955*

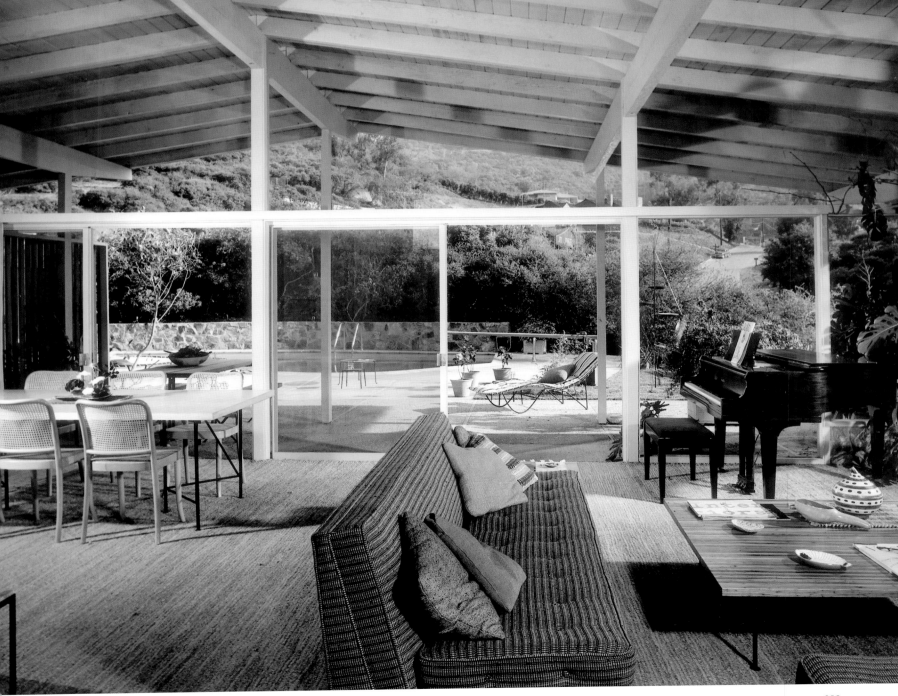

1467 **Craig Ellwood**
Zimmerman Residence, Beverly Hills, California
March 4, 1953

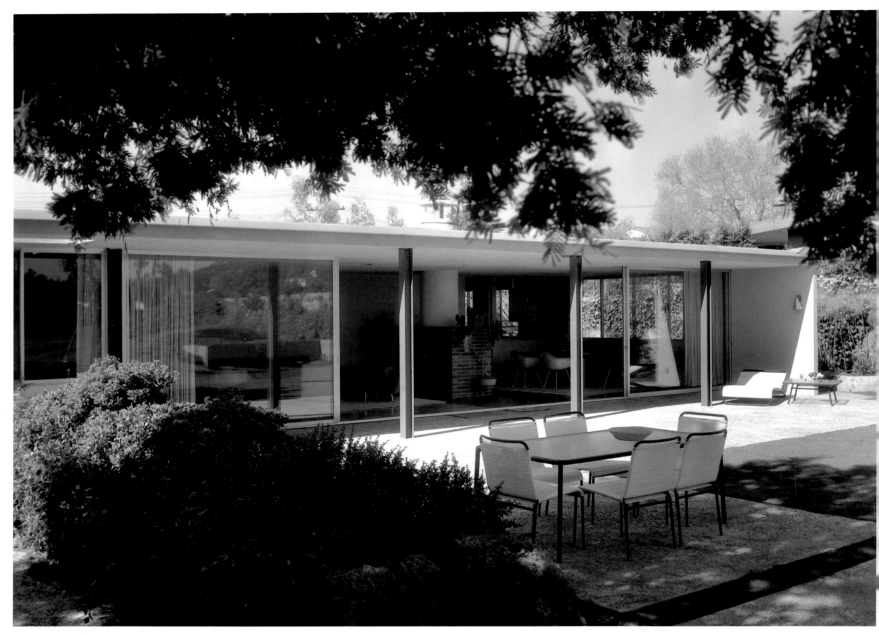

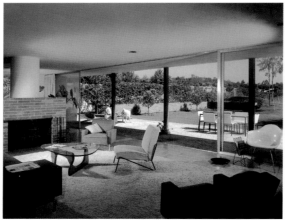

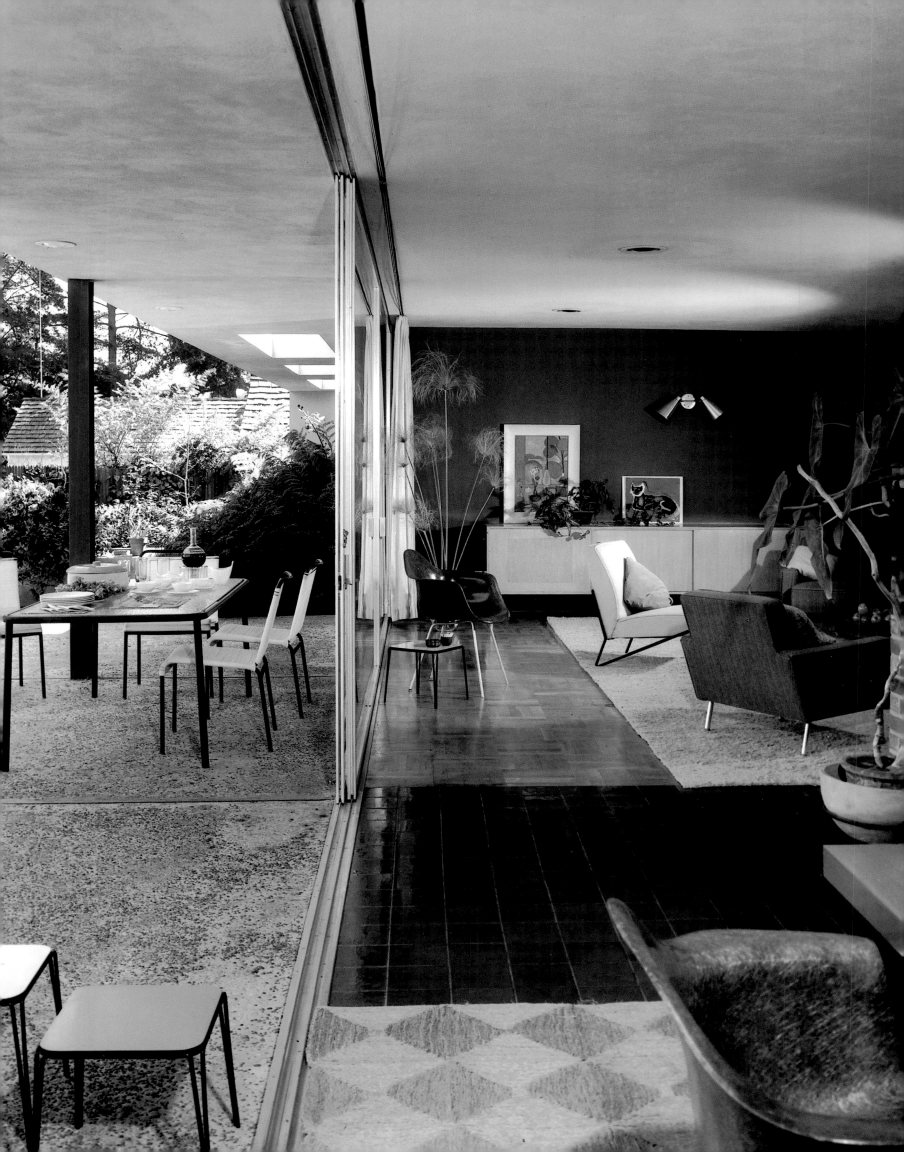

1475 **Gordon Drake**
Robert Berns Beach Home, Malibu, California
March 20, 1953

Set on a cliff 40 feet above the beach, the main design theme of this house is the transition from open sky to complete enclosure. Although entirely exposed to the ocean, the shell provides refuge from the sea breezes.

The covered space amounts to 1,170 square feet and forms an L-shape. From the garage level, a stepped walkway leads to a fenced entrance court 4 feet below. Behind the fence, protected from the elements, a brick-paved garden room provides a sheltered retreat. Positioned in the corner of the plan, a screened patio articulates the progression from the garden to the living room, framing views of the ocean visible from the back portion of the house. A glass wall stretches along the front of the living room toward the ocean to maximize the vista. A partial glass-and-plywood partition screens the deck from the wind. A continuous system of trellis ties the different sections of the house together. Beams continue from the garden room, to the screened patio, into the house and to the roof eaves of the deck toward the ocean. House interior and landscaping become inseparable.

Post-and-beam construction is laid in a five-foot-four-inch grid. Walls, light soffits, and other elements were detailed at one-half or one-quarter of this module in both directions.

The color scheme codes the layers of architectural elements: the post battens are white; the redwood beams are stained dark; the fence panels are yellow.

Hauptthema dieses Entwurfs für ein Haus auf einer 12 m über dem Strand aufragenden Steilklippe war der Übergang vom offenen Himmel zum umbauten Raum. Obwohl es sich zum Meer hin voll öffnet, bietet es doch Schutz vor Wind und Wetter. Die L-förmige überbaute Fläche beträgt 110 m². Von der Garage führt ein Treppenweg zum etwas niedriger liegenden umzäunten Eingangshof. Hinter dem Zaun befindet sich eine mit Klinkern gepflasterte windgeschützte Gartenterrasse. Im Winkel der L-Form bildet ein weiterer abgeschirmter Patio die Übergangszone vom Garten ins Wohnzimmer und rahmt den Meerblick ein, den man aus der Tiefe des Hauses durch die breite Glaswand des Wohnraums genießen kann. Eine Glas-und-Sperrholzwand gibt dem Patio Schutz vor starken Meereswinden. Ein über- und ausgreifendes Pergolagitter verbindet die unterschiedlichen Hausabschnitte miteinander, kragt vom Gartenzimmer über den Patio vor und zieht sich durchs Haus bis zur Traufkante der Terrasse mit Meerblick. So werden Innen- und Außenraum untrennbar verzahnt.

Die Pfosten-und-Riegel-Konstruktion fußt auf einem 1,60 m-Modulraster. Wände und Dachüberstände mit eingebauten Beleuchtungskörpern und andere Elemente sind jeweils um eine Hälfte oder ein Viertel dieses Moduls in beide Richtungen versetzt angeordnet. Mit dem Farbschema kodierte der Architekt die Bauelemente: die Pfosten weiß, die Riegel dunkel gebeizt, die Zaunpaneele gelb.

Erigée au sommet d'une falaise à 12 m au-dessus de la mer, cette maison joue sur l'opposition/transition entre le ciel et une enceinte complètement fermée. Bien qu'entièrement exposée à l'océan, c'est un refuge contre les vents marins. L'espace couvert représente 110 m² disposés en L. A partir du niveau du garage, une allée en escalier conduit à la cour d'entrée protégée par une clôture. Derrière celle-ci, une pièce-jardin pavée de brique offre un abri. Positionné dans un angle du plan, un patio entouré de claustras ménage un passage du jardin au séjour, tout en offrant des vues cadrées sur l'océan que l'on perçoit de la partie arrière de la maison. Un mur de verre ferme la partie avant du séjour vers le Pacifique. Un cloisonnement partiellement vitré et en contreplaqué abrite la terrasse du vent. Un système continu de treillis relie les différentes parties de la maison. Les poutres se poursuivent de la pièce-jardin au patio, traversent la maison et se prolongent sous l'auvent au-dessus de la terrasse. L'intérieur et le paysage deviennent.

L'ossature à poteaux et poutres repose sur une trame de 1,60 m. Les murs, les soffites allégés et d'autres éléments sont disposés à intervalle de moitié ou du quart de ce module, dans les deux directions. La gamme chromatique souligne la stratification des éléments architecturaux : les panneaux de latté sont blancs, les poutres en bois rouge teintées foncé, les panneaux de clôture jaunes.

Selected Bibliography:
- *Sunset, March 1954*
- *Selected Houses from Progressive Architecture, New York 1954*
- *Douglas Baylis and Joan Parry, California Houses of Gordon Drake, New York 1956*

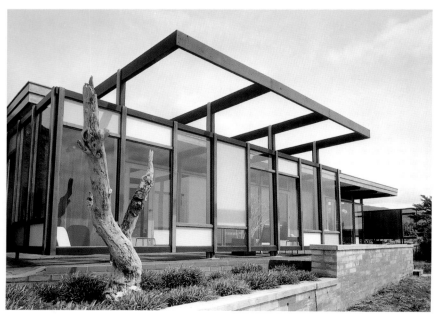
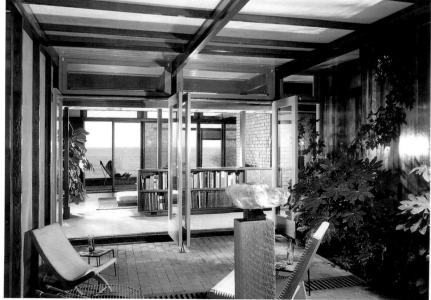

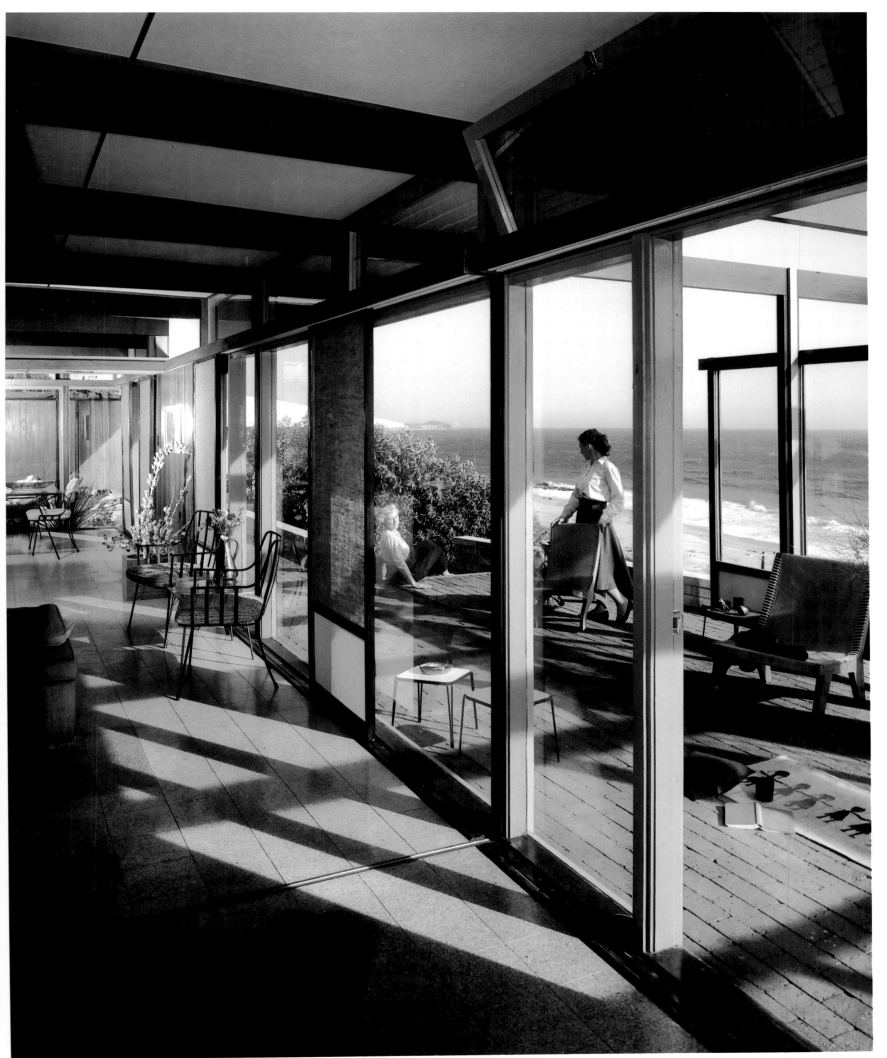

1645 Douglas Honnold and John Rex
Research House, Los Angeles, California
December 14, 1953

For over three decades, the commitment of the *Los Angeles Times Home Magazine* to advocating modern living in Southern California exposed the lay readership to a wide variety of projects concerned with new forms for domestic space. This residential prototype was the result of a collaborative effort between architects, builders and interior designers. Located at 1514 Rising Glen Road, a half-mile north of Sunset Blvd, in the Sunset Plaza area, the research house remained open to the public for 90 days. The main objective of the initiative was to make of this artifact a pedagogic tool for the community in order to expound the value of modernity in the household. Although the structure is a conventional wood frame, the house fully embraces the modern paradigm both in its plan and its

Über drei Jahrzehnte lang brachte das »Los Angeles Times Home Magazine« bebilderte Artikel über modernes Wohnen in Südkalifornien und informierte ihre Leser über neue Wohnformen. Dieses Musterhaus entstand in Zusammenarbeit des Architekten mit den Baufirmen und Innenausstattern. Es lag an der Rising Glen Road, eine halbe Meile nördlich des Sunset Boulevard im Gebiet um die Sunset Plaza. Nach Fertigstellung konnte es 90 Tage lang besichtigt werden, denn das Musterhaus sollte der örtlichen Bevölkerung als Lehrstück für modernes Wohnen dienen. Es wurde zwar in traditioneller Holzrahmenbauweise errichtet, verkörpert aber in Grundriss und städtischem Erscheinungsbild ganz das Paradigma der Architekturmoderne. Die hypothetischen Bewohner waren eine »varia-

Depuis plus de trente ans, le « Home Magazine » du « Los Angeles Times » défendait le style de vie moderne en Californie du Sud auprès du grand public à travers des projets très variés qui illustraient les nouvelles formes d'habitat.

Ce prototype de logement est né d'une collaboration entre des architectes, des constructeurs et des décorateurs. Situé à 800 m au nord de Sunset Boulevard, cette maison expérimentale resta ouverte au public pendant 90 jours. L'objectif principal était d'en faire un outil pédagogique pour mettre en valeur l'aspect économique de la maison moderne.

Bien que l'ossature soit classique, la maison est un parfait exemple de modernisme dans son plan comme dans son aspect urbain. Ses 190 m^2 sur deux niveaux étaient prévus pour

Selected Bibliography: - Los Angeles Times Home Magazine, May 16, 1954

urban appearance. The imagined occupants belong to a rather variable family format, sheltered in 2,000 square feet of covered area on two stories. From the street, the design reads solid with a few slit windows for interior lighting. The carport shades the entry path to the house, while staging the transition between public and private zones. The communal functions are at the ground level. The main sleeping quarters with a terrace facing south are on the second floor. Paneling is a major design theme in the interior and exterior. Random-width mahogany panels, acoustic ceilings, ceramic tiles and Cordova stone bricks constitute the texture of the design.

ble« Familie, deren Wohnbedarf mit knapp 190 m² auf zwei Etagen gedeckt wurde. Die Straßenfassade ist bis auf einige schmale, hohe Fensterschlitze geschlossen. Der Carport beschattet das Gartentor. Die Wohnräume befinden sich im Erdgeschoss, die Schlafzimmer der Familie mit einer nach Süden orientierten Balkonterrasse im Obergeschoss. Innen wie außen sind Wandverkleidungen ein wesentliches Gestaltungsmittel und wurden in Form von unterschiedlich breiten Mahagonipaneelen, Akustikdecken, Keramikfliesen und rechteckig behauenen Natursteinen verwendet.

une famille de nombre variable. De la rue, la maison est presque aveugle, simplement percée par quelques fenêtres verticales très étroites qui assurent l'éclairage de l'intérieur. L'abri aux voitures protège également l'allée d'accès à la maison, tout en marquant la transition entre l'espace public et le domaine privé. Les fonctions communes sont implantées au rez-de-chaussée. Les chambres principales et une terrasse face au nord occupent l'étage. L'un des principaux éléments utilisés aussi bien à l'intérieur qu'à l'extérieur est le panneau ou le lambris. Des panneaux en lattes d'acajou de largeurs variées, des carrelages en céramique et des briques en pierre participent à la palette des textures.

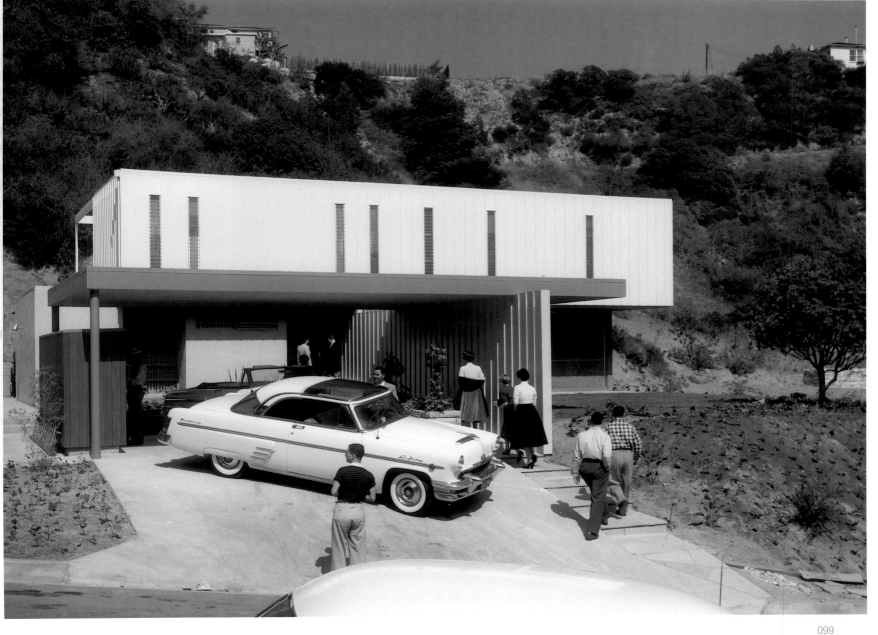

1685 **Kazumi Adachi**
Mudge Residence, Los Angeles, California
February 23, 1954

The owner, Elizabeth Mudge, was employed at the University of California Los Angeles and carried on an active social life. Her requirements were to organize a space for informal living: high ceilings, high counters, an open living kitchen, and outdoor space.

Budget constraints and the limited portion of the plot usable for building dictated the architectural solution. Adachi designed a split-level plan to create a clear separation of the working and sleeping areas and to maximize the views of the Pacific Ocean, the Santa Monica Mountains, and the city of Los Angeles in the 1,200 square-foot house.

Lifted on piers resting on foundations of concrete blocks, the residence juts out at over the steep hill. Positioned at the rear side, the entry corresponds to the intermediate landing of an interior staircase. Six steps above, there are two bedrooms, with a bath in between, overlooking the living-dining room. Six steps below, living, dining and kitchen areas, without dividing partitions, define a single space. Under the bedroom balcony, the cooking unit is a piece of freestanding furniture open to the rest of the house to allow conversation with guests. The double height of the living and dining room increases the spaciousness of the interiors. The architect offsets the structural frame by ten

Die Besitzerin, Elizabeth Mudge, war an der University of California Los Angeles beschäftigt und führte ein reges gesellschaftliches Leben. Es ging ihr bei dem Entwurf vor allem darum, dass er hinreichend Raum für eine ungezwungene Lebensart bot, also: Hohe Räume, hohe Theken, eine zum Wohnraum offene Küche und viel Außenraum. Eine begrenzte Bausumme und die nur kleine bebaubare Fläche des Grundstücks führten zu dieser baulichen Lösung. Um eine deutliche Trennung von Arbeits- und Schlafbereich zu erreichen und möglichst viele Ausblicke auf den Pazifik, die Santa Monica-Berge und die Innenstadt von Los Angeles zu gewinnen, entwickelte Adachi ein versetztgeschossiges Haus mit einer Gesamtfläche von 110 m².

Das Haus wird von Pfeilern getragen, die auf Einzelfundamenten aus Beton lagern und ragt teilweise aus dem Steilhang heraus. Der Hauseingang trifft auf das Zwischenpodest. Sechs Stufen höher befinden sich zwei Schlafzimmer mit einem Bad dazwischen. Sechs Stufen tiefer sind Wohnen, Essen und Küche ohne Unterteilungen in einem einzigen Raum zusammengefasst. Die freistehende Kücheneinheit unter dem Schlafzimmerbalkon ist nach allen Seiten offen und ermöglicht Gespräche mit Gästen. Die doppelte Höhe von Wohn- und Essraum betont die Weiträumigkeit des Hauses. Der Architekt erweiterte die tragen-

La propriétaire, Elizabeth Mudge, travaillait pour l'Université de Californie Los Angeles et menait une vie sociale très active. Son programme demandait un espace voué à une vie informelle. Elle souhaitait donc des plafonds hauts, des plans de travail à bonne hauteur, une cuisine spacieuse et ouverte et beaucoup d'espace à l'extérieur.

Les limites de son budget et le fait que seule une partie du terrain était constructible dictèrent la solution architecturale. Adachi a ainsi imaginé sur 110 m² un plan à niveaux décalés pour marquer une nette séparation entre les zones de travail et de sommeil, et optimiser les vues sur l'océan Pacifique, les Santa Monica Mountains et la ville de Los Angeles.

Surélevée sur des pilotis reposant sur des fondations en parpaings, la maison se projette en partie au-dessus de la pente. L'entrée, implantée à l'arrière, correspond au palier intermédiaire de l'escalier intérieur. Six marches plus haut, deux chambres séparées par une salle de bains, donnent sur le séjour. Six marches plus bas, le séjour, la salle à manger et la cuisine, sans cloisonnement, semblent occuper un seul grand espace. Sous le balcon de la chambre, le bloc de cuisson est un meuble indépendant ouvert sur le reste de la pièce, ce qui permet à la maîtresse de maison de poursuivre une conversation avec ses

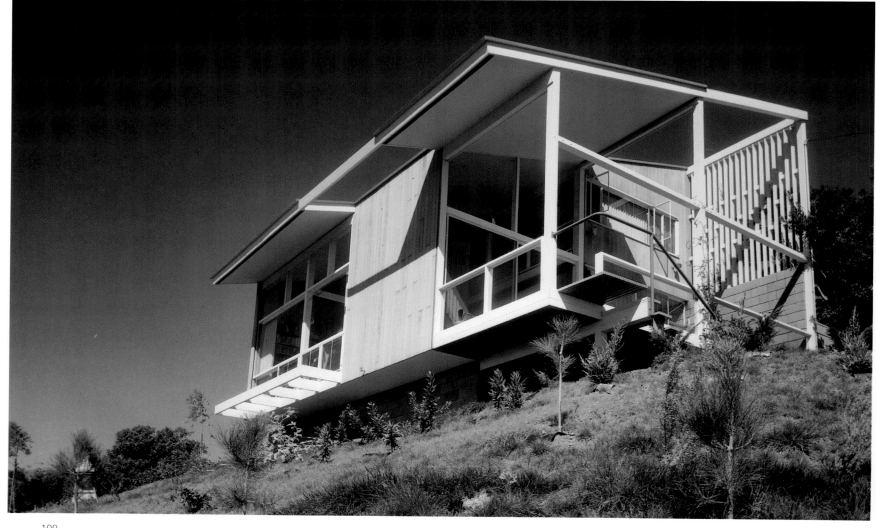

feet creating a wide sundeck shielded from the street by a wood strip lattice screen; this extends the living room's width outdoors and gives the space protection from heat and glare. The resulting side elevation displays the dramatic slope of a seemingly weightless roof. All the walls are in native California redwood. The color scheme for the interior is a mixture of bright yellow and tangerine, with muted blue and sand. Garret Eckbo was the landscape architect.

de Struktur um 3 m und erreichte dadurch eine geräumige Sonnenterrasse, die durch ein hölzernes Gitter von der Straße abgeschirmt ist; so erweitert sich der Wohnraum auch nach außen und wird vor Hitze und grellem Licht geschützt. Die Seitenansicht zeigt die dramatische Auskragung des schwerelos erscheinenden Dachs. Alle Wände bestehen aus einheimischem California Redwood. Die Innenräume sind in einer Mischung aus leuchtendem Gelb, Rot-Orange, einem blassen Blau und Sandfarbe gehalten. Landschaftsarchitekt war Garret Eckbo.

invités. La double hauteur du séjour-salle à manger accroît l'impression de volume. L'architecte laisse réapparaître l'ossature dans la terrasse couverte, isolée de la rue par un treillis, ce qui a pour effet de dilater le séjour vers l'extérieur et de le protéger de la chaleur et de la lumière. Vue latéralement, cette disposition sousligne la pente du toit qui semble d'une extrême finesse. Tous les murs sont en bois rouge de Californie. A l'intérieur, les jaunes, verts et oranges vifs s'associent aux bleus et à la couleur sable. Garret Eckbo est l'auteur du jardin.

Selected Bibliography:
- Los Angeles Times Home Magazine, May 2, 1954
- arts & architecture, October 1954

House & Garden, November 1954
- Architectural Record, June 1955

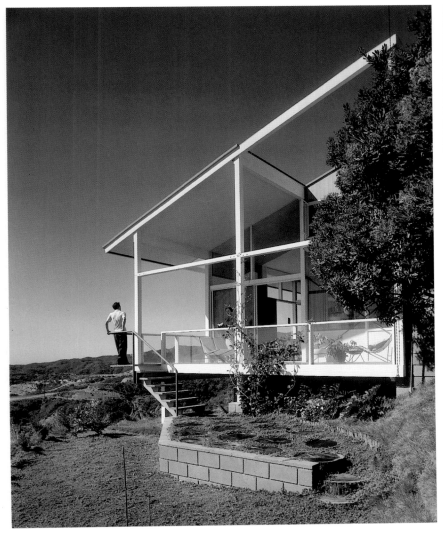

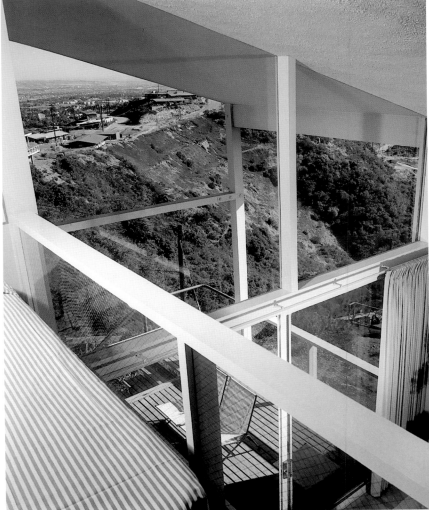

1689 **Rodney Walker**
Knauer Residence, Los Angeles, California
March 1, 1954

The main design idea was to bring the garden inside the house. From the square area of the residential unit, 30 feet per side, Walker stretches out the side walls and the roof by 15 feet to enclose a small planted patio. The deep eaves sunshade the two-story tall glass-wall between the garden room and the outside landscaping. The entry is at the upper level, where the living room, bedroom, and kitchen overlook the garden room. Stairs from the living room to the ground level are cantilevered from the wall. Downstairs, a recreation room looks out directly to the garden room. Plants grow in pots, in hanging containers, and directly from the ground. Circular pads in concrete, structurally disconnected from the house, provide a sitting area in the middle of the garden. Beach pebbles and a brick stepping path pattern the soil floor.

Hauptziel des Entwurfs war es, den Garten ins Haus zu ziehen. Vom quadratischen Grundriss des Hauses (ca. 9 x 9 m) verlängerte Walker Seitenmauern und Dach um jeweils 4,50 m, so dass sie ein Gartenzimmer umfassen. Der Dachüberstand beschattet dessen über beide Geschosse reichende Glasfassade. Die Haustür befindet sich im Obergeschoss, wo man vom Wohnraum, vom Schlafzimmer und von der Küche in das Gartenzimmer hinunterblickt. Die Treppenstufen vom Wohnzimmer nach unten ragen aus der Wand. Ein Mehrzweckraum auf der unteren Ebene grenzt an das mit Kübelpflanzen und Pflanzengondeln geschmückte Gartenzimmer. Kreisrunde Betonblöcke bilden mitten im Garten eine Sitzgruppe. Gartenwege sind mit Strandkieseln aufgeschüttet oder als Ziegelsteintreppen angelegt.

L'idée de base était ici de faire pénétrer le jardin dans la maison. A partir d'un plan carré de 9 m de côté, Walker prolonge les murs latéraux et le toit de 4,50 m pour délimiter un petit patio planté. Les profonds auvents abritent du soleil le mur vitré sur deux niveaux de haut qui sépare le jardin aménagé comme une pièce et la nature. L'entrée se fait par le niveau supérieur, là où le séjour, la chambre et la cuisine donnent sur la pièce-jardin. Du séjour au rez-de-chaussée, les escaliers sont en porte-à-faux par rapport au mur. En bas, une salle de jeux donne directement sur la pièce-jardin. Des plantes en pot sont suspendues ou poussent directement en pleine terre. Au milieu du jardin, des aires circulaires en béton forment des îlots de convivialité. Le sol est par endroits recouvert de galets de plage, et l'un des escaliers est en brique.

Selected
Bibliography: - Sunset, October 1954

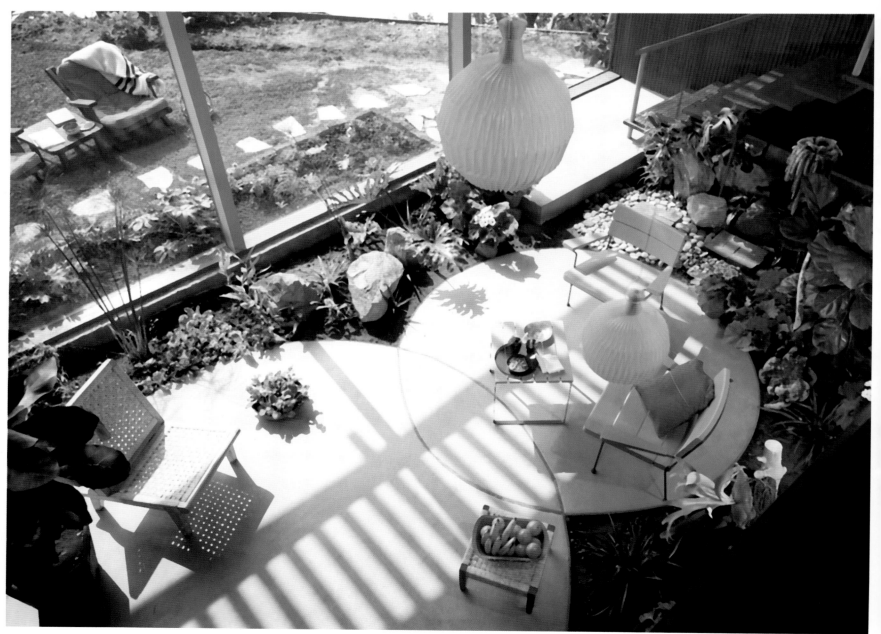

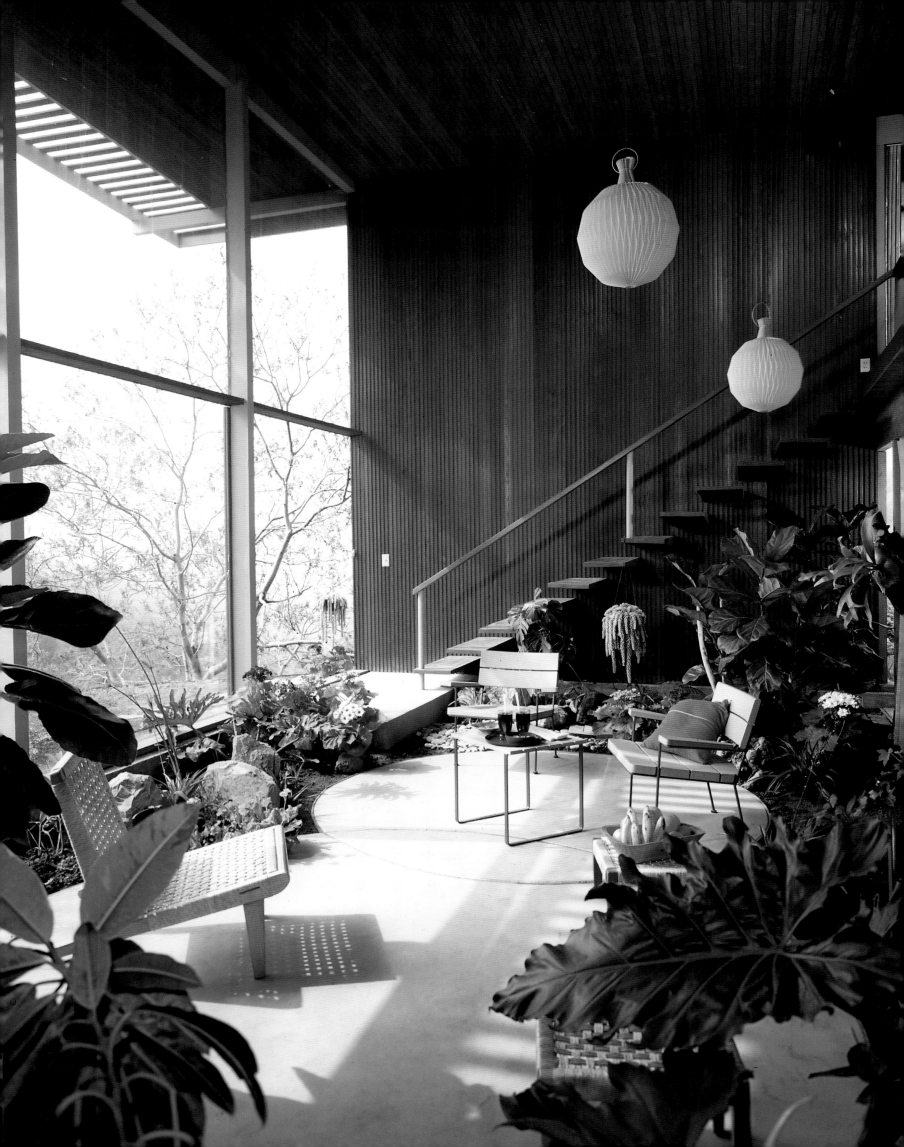

1695 Emerson Stewart Williams
Edris Residence, Palm Springs, California
March 5, 1954

The architect wanted to integrate the building with the landscape. Designed as a winter retreat for a couple spending the year between Seattle and New York, the house sits on a lot filled with giant boulders and overlooks the Coachella Valley. Through minimal site development, Stewart Williams, architect and contractor of the project, generated a flat pad and formed the pool. The plan follows an L-scheme, covering 2,800 square feet of space. A distinguishing component of the project is the asymmetrical V-profile of the roof section legible in the side elevation as well as in the interior. Suspended from a steel structure, the roof outline has its highest point outside the living room. It slopes down to the lowest point in the dining area, to fold back up over the kitchen, study and utility rooms. Sheathing is in wood throughout except for the fireplace and the west wall in native stone. Stewart Williams custom-designed all the light fixtures. Mrs. Marjorie Edris still lives in the house.

Der Architekt wollte Natur und Architektur integrieren. Das Winterhaus eines Ehepaares, das teils in Seattle, teils in New York lebt, steht auf einem mit Findlingen übersäten Grundstück mit weitem Blick in das Coachella-Tal. Mit wenig Aufwand schuf Stewart Williams, der seinen Entwurf selbst ausführte, eine flache Plattform und eine Mulde für das Schwimmbecken. Der L-förmige Grundriss umfasst 260 m² Wohnfläche. Charakteristisch ist das asymmetrische flache V-Profil des Dachquerschnitts. Der höchste Punkt der Dachsilhouette befindet sich außerhalb des Wohnzimmers; das Hängedach mit Stahltragwerk neigt sich über dem Essbereich, um sich über Küche und Wirtschaftsräumen wieder anzuheben. Die Wandverkleidungen sind aus Holz, nur die Kaminwand und die Außenmauer nach Westen sind aus Bruchsteinen gemauert. Stewart Williams entwarf alle Beleuchtungskörper speziell für dieses Haus. Mrs. Marjorie Edris bewohnt es heute noch.

L'architecte souhaitait intégrer la maison dans son paysage. Résidence d'hiver d'un couple vivant le reste de l'année entre Seattle et New York, elle se dresse sur un terrain occupé par d'énormes rochers et domine la Coachella Valley. Intervenant au minimum sur le terrain, Stewart Williams, architecte et constructeur, crée juste la surface plane nécessaire à la maison et creuse une piscine. Le plan en L couvre 260 m². Un des éléments forts de ce projet est le profil asymétrique en V de la partie du toit, qui se lit de côté mais aussi de l'intérieur. Suspendu à une ossature d'acier, le point le plus élevé du toit est en dehors du séjour. La couverture descend ensuite vers son point le plus bas, au dessus de la salle à manger, pour se replier sur la cuisine, le bureau et les pièces techniques. Le bardage est intégralement en bois, à l'exception de celui de la cheminée et du mur ouest, en pierre locale. Stewart-Williams a conçu tous les luminaires.

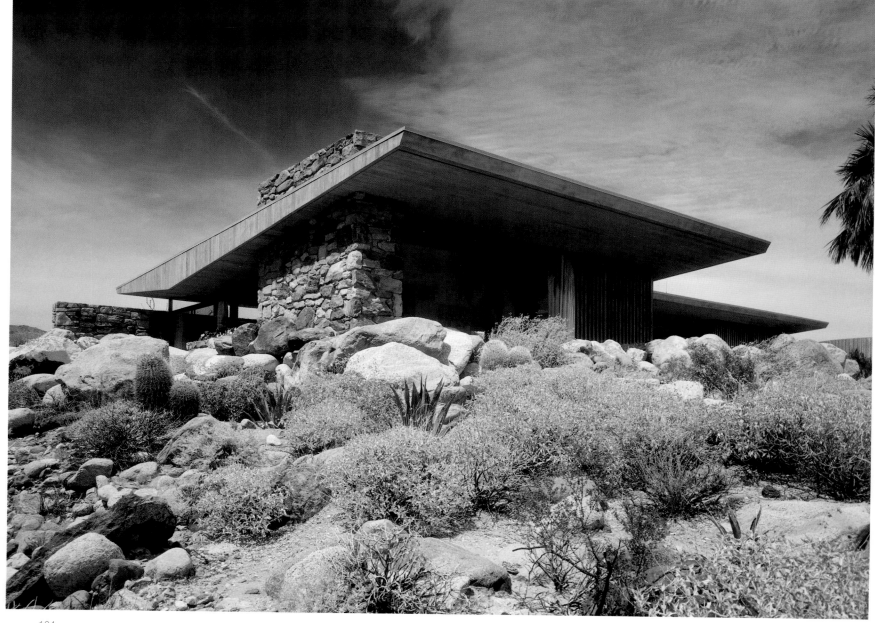

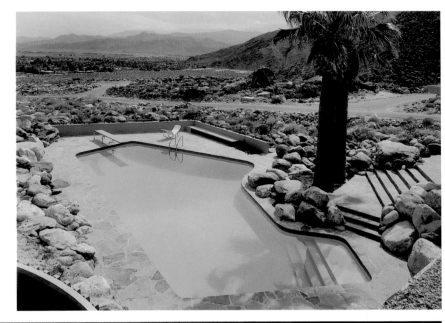

Selected *- Adele Cygelman, Palm Springs Modern,*
Bibliography: *New York 1999*

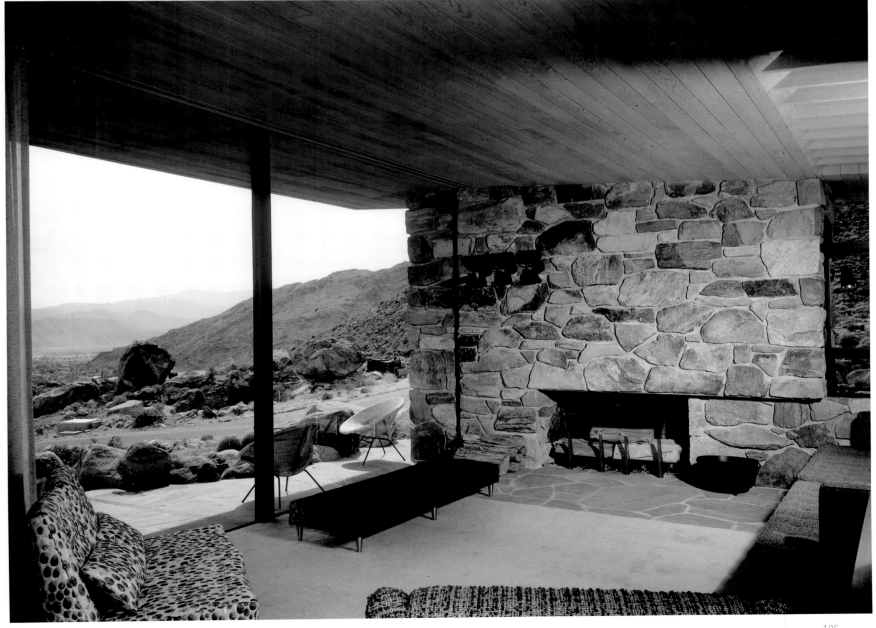

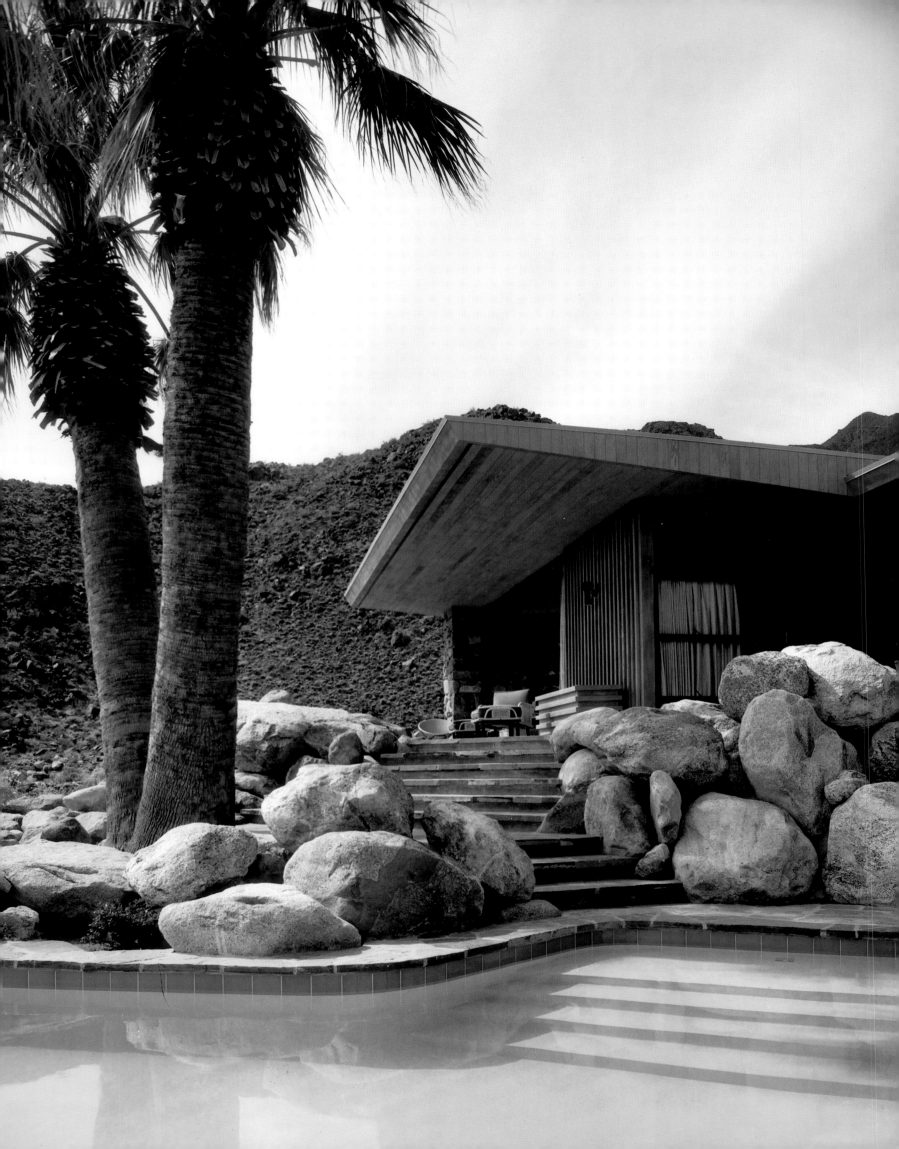

1750 A. Quincy Jones and Frederick E. Emmons
Tiny Naylors Restaurant, Los Angeles, California
May 14, 1954

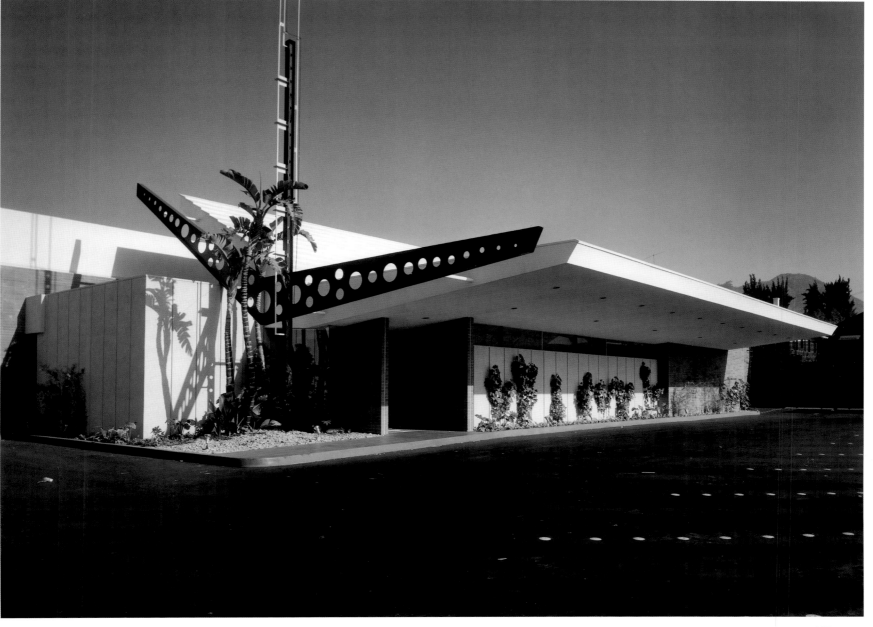

1771 Burton A. Schutt
John Harris Residence, Beverly Hills, California
June 11, 1954

The dining patio is the architectural center of the project. Entirely contained within the house, this room is designed as an inner courtyard with a roof. Sliding doors on two adjacent walls connect the living room and the cooking area. The others are solid walls in white stucco, reverberating indoor sunlight from the trellis-like roof above.

Suspended from the ceiling, a canopy shelters the table. In sharp contrast with the color of the partitions, the floor is black and white terrazzo. Potted plants of various specimens further play upon the indoor-outdoor ambiguity.

Der als Esszimmer genutzte und als überdachter Innenhof gestaltete Patio bildet den Mittelpunkt des Hauses. Schiebetüren in den Seitenwänden verbinden ihn mit dem Wohnzimmer und der Küche. Das Sonnenlicht wirft durch das Pergola-artige Dach Licht- und Schattenmuster auf die beiden anderen massiven, weiß verputzten Wände. Ein von der Decke abgehängter Baldachin beschirmt den Tisch. Im scharfen Kontrast zur Farbe der Wände besteht der Fußboden aus schwarz-weißem Terrazzo. Kübelpflanzen betonen den Charakter dieses Innen- und zugleich Außenraums.

Le patio-salle à manger est le cœur architectural de ce projet. Entièrement intégrée à la maison, cette pièce est une cour intérieure sous un toit. Sur les deux murs adjacents, des portes coulissantes relient le séjour au coin cuisine. Les autres murs aveugles, traités au plâtre blanc, réverbèrent la lumière qui tombe du toit en treillis.

Un dais est suspendu au-dessus de la table. Le sol en terrazzo noir et blanc contraste fortement avec la couleur des cloisonnements. Diverses plantes en pots contribuent à accentuer l'ambiguïté de la répartition dedans/dehors.

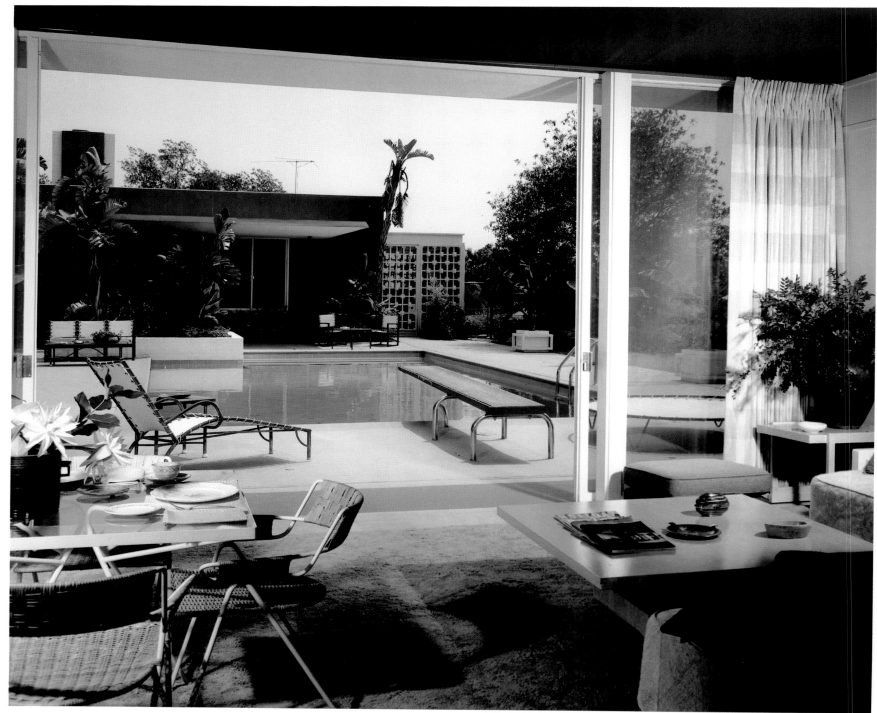

Selected Bibliography: - *House & Garden, April 1955*

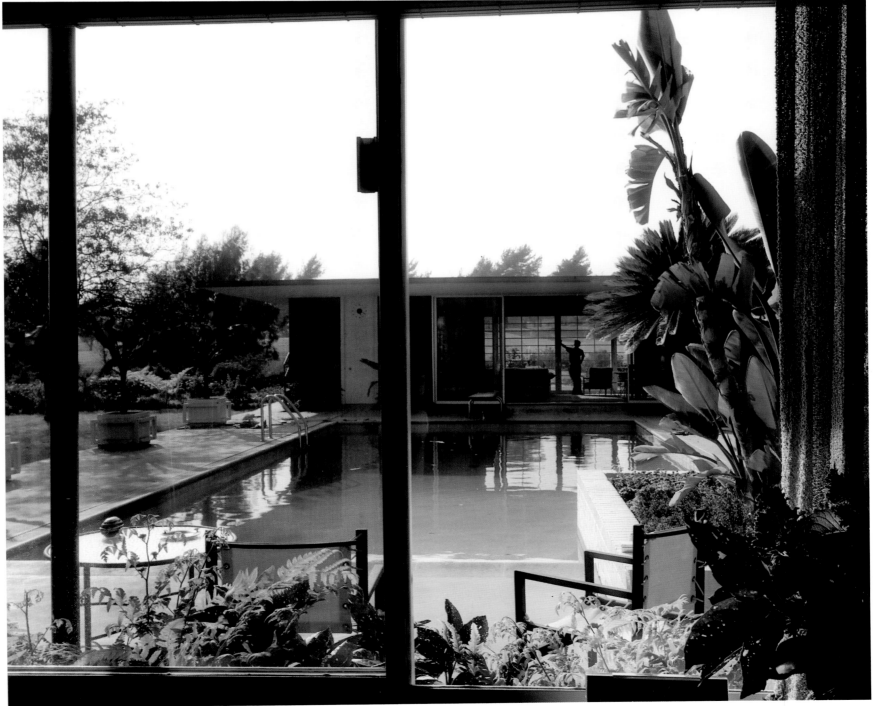

1773 **Coston & Frankfort**
Coston Residence, Oklahoma City, Oklahoma
July 15, 1954

For his own family Truett H. Coston designed an addition to an old farmhouse dating back to 1893. Shapes present in the previous scheme resonate in the tent-like structure of the latest portion. To integrate the new with the old, the architect extends the pitched roof all the way to the ground mimicking the image of the original building. Outside, the slanted plane folds upward to support a sunshade for the planted area underneath. Red lightweight trusses left exposed generate the triangular section. Sheets of two-inch-thick cork cover the upper ceiling. Direct sunlight, instead, filters through the lower part of the roof, glazed to create a small greenhouse area. A perspective of light steel frames shelter walkways and carport. Materials range from concrete for the floor slabs, to stone for the fireplace and exterior walls, to brick and redwood for the finishes.

Für seine eigene Familie baute Truett H. Coston ein altes Farmhaus von 1893 um und erweiterte es mit einem zeltartigen Anbau. Um Alt und Neu zu verbinden, zog der Architekt das Satteldach des Anbaus auf beiden Seiten bis zum Boden hinunter, und zwar in Form von Glasscheiben zwischen schlanken Metall-„Sparren", die von einer waagerecht vorkragenden Lamellenfläche beschattet werden, was so aussieht, als wäre der untere Dachabschnitt hochgeklappt. Rote Fachwerkträger bilden die Dachsparren. Die Dachunterseite ist mit ca. 5 cm dicken Korkplatten verkleidet. Direktes Sonnenlicht fällt nur durch die Scheiben des »Glashauses« in den großen Innenraum. Leichtstahlrahmen fassen Wege und Carport ein. Neben Beton (Bodenplatten) und Natursteinen (Kamin und Außenmauern) wurden Ziegelsteine und Redwood (Innenausbau) verwendet.

C'est pour sa propre famille que Truett H. Coston conçut cette extension d'une ferme de 1893. Les formes de l'ancienne construction se retrouvent en partie dans la nouvelle. Pour intégrer le neuf à l'ancien, l'architecte a prolongé le toit à double pente jusqu'au sol, dans l'esprit du bâtiment original. A l'extérieur, le plan incliné se relève pour se transformer en écran protecteur au-dessus des plantations. Les fermes apparentes en bois rouge renforcent la perception de la forme triangulaire. Le plafond est recouvert de liège de 5 cm d'épaisseur. L'éclairage naturel direct pénètre en partie basse du toit par une longue et étroite baie vitrée horizontale au-dessus d'une partie du séjour qui fait office de serre. Un portique composé de cadres légers en acier délimite les allées d'entrée et l'abri à voitures. La gamme de matériaux va du béton pour les dalles de sol à la pierre pour la cheminée et les murs extérieurs, en passant par la brique et le bois rouge pour les finitions.

Selected Bibliography: *- Architectural Record Houses of 1956, Mid May-June 1956*

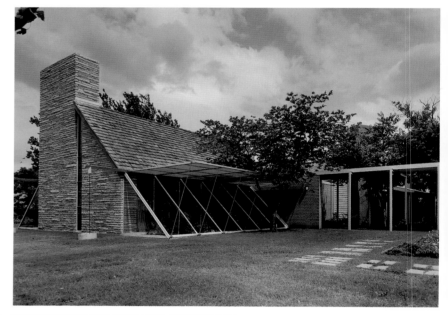

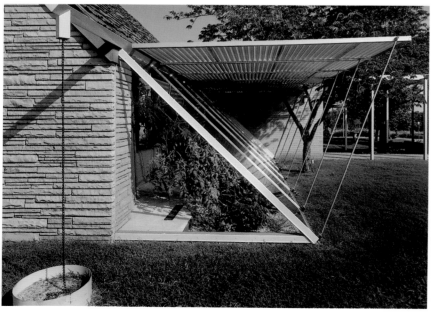

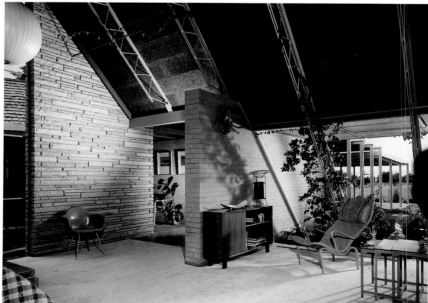

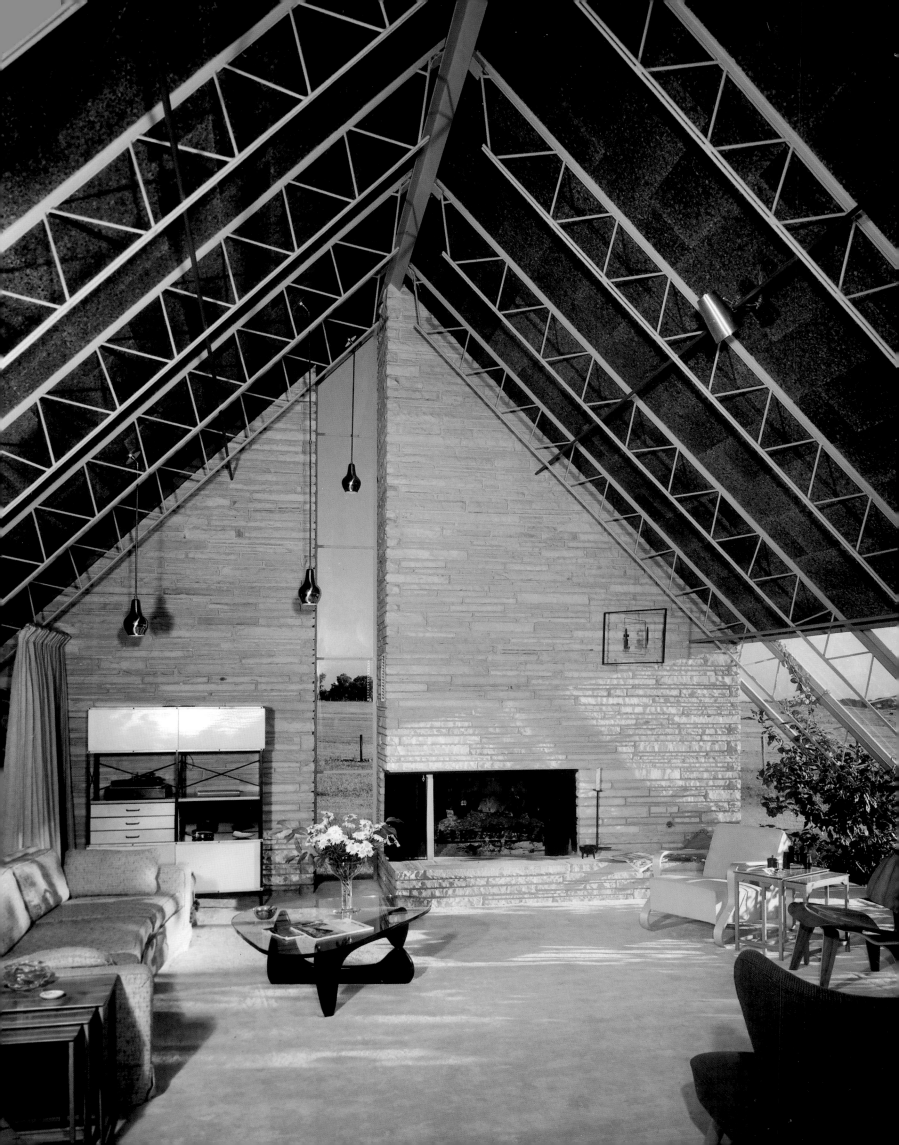

1791 Joseph Van Der Kar
Wohlstetter Residence, Los Angeles, California
July 21, 1954

The Wohlstetters, a couple with a school-age daughter, had developed musical interests. Within the restraints imposed by the budget, they wanted average-size sleeping quarters and a large common area for the study and informal performance of music.

2,100 square feet of residential space is distributed on two floors to follow the steep slope on the heavily wooded site. A breezeway links the carport to the entry on the second level. On this floor, living, dining and cooking functions coexist in a single room. The sleeping units are sound-proof and have one wall of glass each. A deck surrounds two sides of the plan to increase the living room area, while shading the long glass wall below from the southern exposure. Downstairs, a large study room opens onto the garden. Behind the fireplace wall, a guestroom can be either separate from or combine with the study to generate one large all-purpose area. Structurally, the house is wood frame on an eight-foot module. Wood is used for the cantilevered balcony, for exterior finishes and interior walls. Sliding doors are wood framed as well. The spiral stairway connecting the two floors is made of steel. Garret Eckbo was the landscape architect.

Die Musik-interessierten Wohlstetters hatten eine schulpflichtige Tochter und wünschten sich, da sie über ein begrenztes Budget verfügten, durchschnittlich große Schlafzimmer, dafür aber einen großen Raum für Hauskonzerte.
Da das Haus an einem Hang steht, verteilte der Architekt die Gesamtfläche von 193 m² auf zwei Ebenen. Ein überdachter Weg führt vom Carport zum Hauseingang im Obergeschoss. Hier befindet sich ein großer Raum mit Sitzecke, Essplatz und Küche. Die Schlafzimmer sind schallgedämmt und haben je eine Glaswand. Eine Balkonterrasse umgibt die obere Etage über Eck auf zwei Seiten und erweitert die Wohnfläche. Außerdem beschattet sie die lange Glasfront des unteren Geschosses vor der Mittagssonne. Hier öffnet sich ein großer Mehrzweckraum zum Garten. Der Bereich hinter der Kaminwand lässt sich als Gästezimmer abtrennen. Die Holzrahmenkonstruktion des Hauses basiert auf einem 2,40 m-Modul. Auch die auskragende Balkonterrasse, Fassaden- und Innenwandverkleidungen bestehen aus Holz, ebenso wie die Schiebetürrahmen. Die Wendeltreppe wurde aus Stahl gefertigt. Garret Eckbo gestaltete den Garten.

Les Wohlstetter – un couple et sa fille écolière – s'intéressaient à la musique. Dans le cadre de leur budget limité, ils souhaitaient des chambres de taille normale, mais un vaste espace commun pour l'étude et la musique.
Les 193 m² de surface consacrés à l'habitation sont distribués sur deux niveaux qui suivent la pente marquée du terrain fortement boisé. Un passage couvert relie l'abri à voitures à l'entrée implantée à l'étage, où les fonctions séjour, repas et cuisine sont regroupées en un seul volume. Les chambres sont isolées sur le plan phonique et bénéficient chacune d'un mur de verre. Une terrasse prolonge les deux façades pour accroître l'espace du séjour tandis qu'une pergola en porte-à-faux protège le mur vitré exposé au sud. En bas, une vaste salle d'étude donne sur le jardin. Derrière le mur de la cheminée, une chambre d'amis peut être soit isolée, soit réunie à la pièce précédente pour constituer un vaste espace multifonctions. La maison est construite à partir d'une ossature en bois formant une trame de 2,40 m. Le bois est également utilisé dans le balcon en porte-à-faux, les habillages extérieurs et intérieurs, les châssis des portes coulissantes. L'escalier en spirale qui réunit les deux niveaux est en acier. Le jardin a été dessiné par Garret Eckbo.

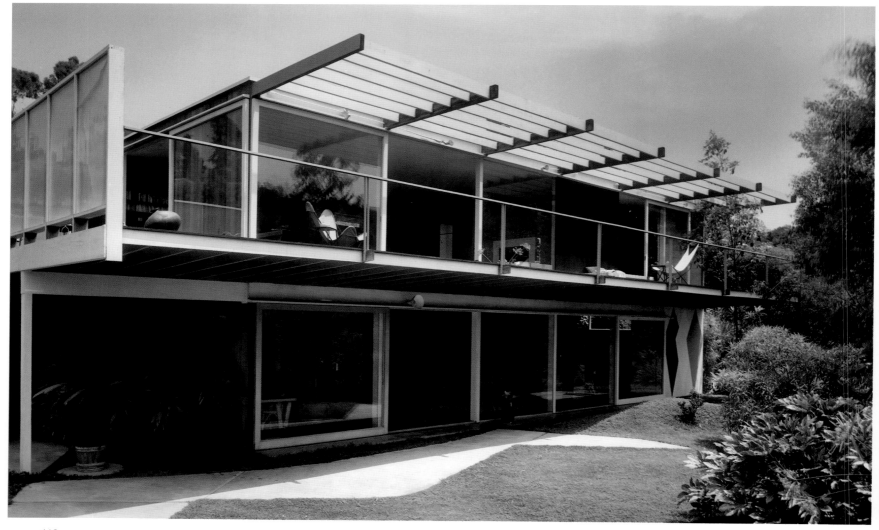

Selected Bibliography:
- *The Los Angeles Examiner, Pictorial Living Section, August 7, 1955*
- *Thomas H. Creighton and Katherine Morrow Ford, Contemporary Houses, New York 1961*

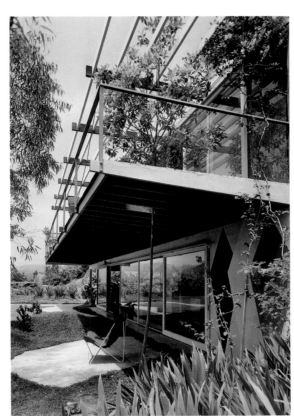

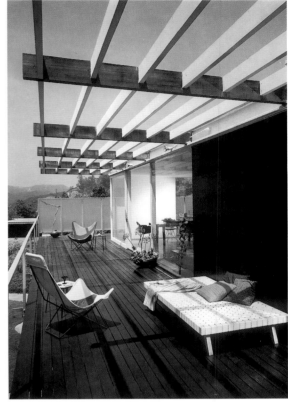

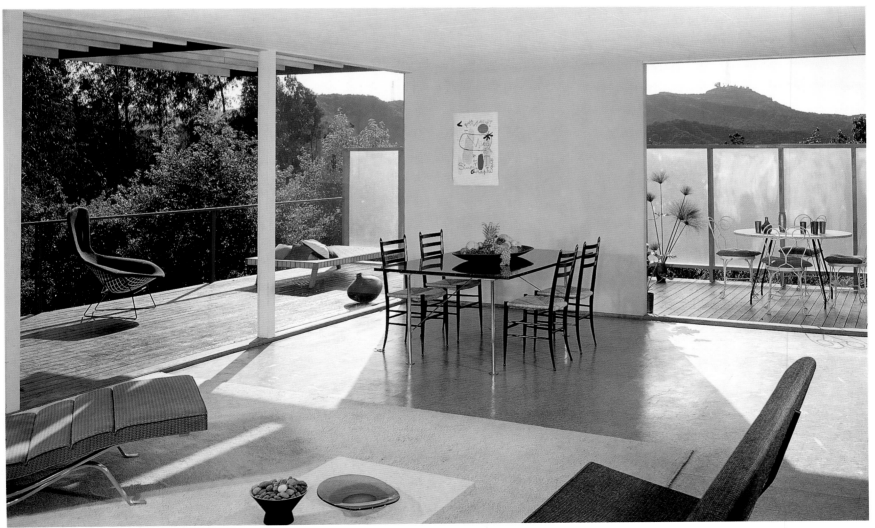

1810 **Boyd Georgi**
Georgi Residence, Pasadena, California
August 12, 1954

The design theme of the project is the blending of indoor and outdoor conditions into a seamless architectural experience. The extensive use of decks increases the amount of level area for the hillside house. A redwood platform next to the living room slides the floor level out over a 20-degree slope to incorporate an existing tree in the house setting. One of its interior walls, whose surface is patterned with ribs of battens, extends out as well, suggesting a semi-enclosed terrace.

Thema des Entwurfs war auch hier die Verschmelzung von Innen- und Außenraum zu einem »Gesamt-Bau-Kunstwerk«. Mehrere geräumige Holzdeckterrassen vergrößern den Anteil ebener Flächen auf dem Hanggrundstück. Ein großes Deck vor dem Wohnzimmer schiebt sich in den Garten hinein und umfasst dabei sogar einen Baum aus altem Bestand. Eine Innenwand – mit Latten gerippt – stößt ebenfalls in den Garten vor und bildet eine halb umschlossene Terrasse.

Le concept de ce projet joue sur le thème de la fusion intérieur/extérieur et sur l'absence de séparation perceptible. Le recours systématique aux terrasses permet d'accroître la surface plane rare sur ce terrain accidenté. Le long du séjour, une plate-forme en bois rouge surplombe une pente de 20° et incorpore un arbre existant dans l'environnement immédiat de la maison. L'un des murs intérieurs, dont la surface est rythmée par des nervures en tasseaux, se prolonge vers l'extérieur pour suggérer une terrasse semi-close.

Selected Bibliography:
- Los Angeles Times Home Magazine, May 15, 1955
- House & Home, August 1961

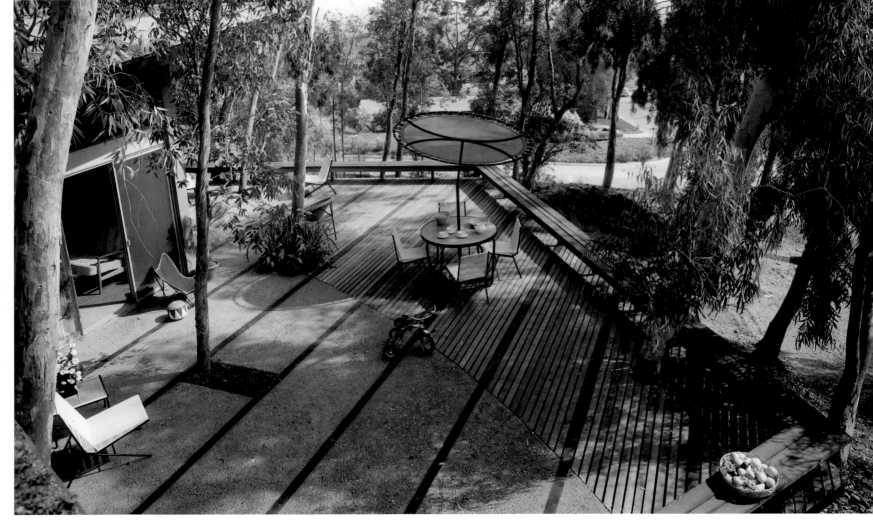

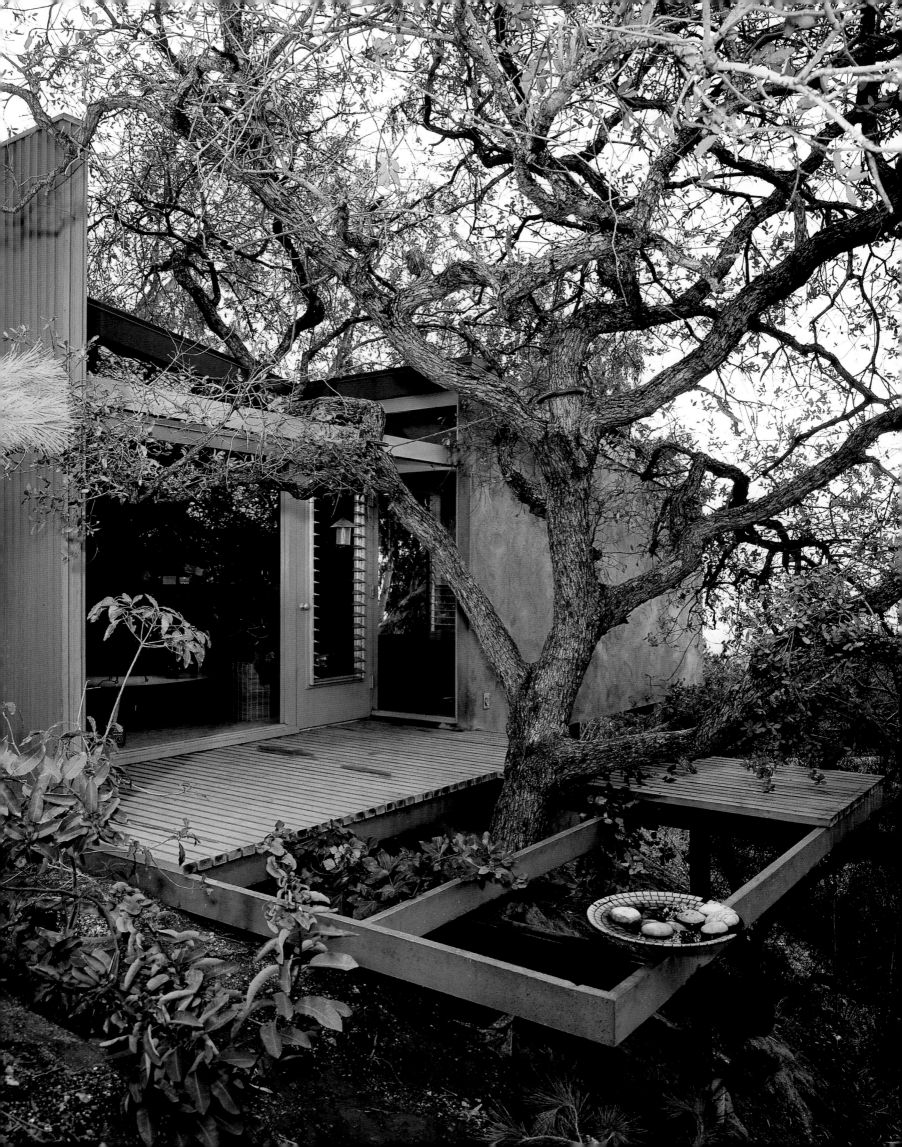

1814 George Frank Ligar
Adrian Residence, Hollywood, California
August 19, 1954

Built in 1952, the residence was designed for Louis Adrian, a conductor of light opera. Inspired by Indian shapes, the Round House, as it was known, raised the curiosity of the architectural community at the time due to its unconventional beehive-like look. It was an experiment in roof design to reduce maintenance costs.

The architect wished to provide sunlight and moonlight in the living areas within the twenty-four hour cycle. Eight concentric rings of lightweight concrete, each twelve-sided and resembling the treads of a stair, shield the interior space from direct light. The recessed risers of heat-absorbing glass admit the sunrays casting ever-changing patterns of shadow on the central stone fireplace. Its conical chimney penetrates a circular opening in the roof. A skylight visually connects the interior with the sky and reveals the texture of the chimney stonework.

Within the residence, the underside of the roof can be entirely perceived. Movable partitions between the living room and the bedroom create a single space. The geometry of the circle informs the configuration of the plan. Partially built into a hill, the central core houses a living room, two bedrooms and a bathroom. The remaining space grows in a concentric fashion. Two sections of the successive rings contain the kitchen and the carport. Interior walls, retaining walls, benches, and indoor-outdoor dining tables are in radial position in relation to the center. Ligar conceived the project, computed the bearing structure and acted as the contractor.

Das 1952 errichtete Haus wurde für den Operettendirigenten Louis Adrian entworfen. Von indianischen Tipis inspiriert, erregte das ungewöhnliche »Round House« die Neugier von Architekturkennern und -interessierten. Es stellte ein Experiment in der Gestaltung von Dächern mit geringen Instandhaltungskosten dar. Der Architekt wollte »rund um die Uhr« Sonnen- und Mondlicht in die Wohnräume bringen und entwarf ein Dach aus acht konzentrischen zwölfeckigen Leichtbetonringen, das wie eine Treppenpyramide aussieht. Durch die »Setzstufen« aus Wärmeschutzglas malt die Sonne stets wechselnde Lichtmuster auf den Natursteinkamin, dessen Abzugsschacht die zentrale kreisrunde Dachöffnung durchstößt. Ein Oberlicht eröffnet hier auch den Blick in den Himmel.

Die Unterseite des Treppendaches ist unverkleidet, seine Struktur von innen daher deutlich zu sehen. Es deckt einen großen Raum, der sich durch Stellwände in Wohn- und Schlafbereich unterteilen lässt. Die Kreisgeometrie bestimmt den Grundriss. Das an den Rundpavillon anschließende, teilweise in den Hang gebaute Haupthaus enthält ein Wohnzimmer, zwei Schlafzimmer und ein Bad. Die übrigen Räume schließen sich konzentrisch an. Zwei aufeinander folgende Teilringe beherbergen die Küche und den Carport. Innenwände, Stützmauern, Bänke und Esstische für innen und außen sind radial angeordnet – vom Mittelpunkt des Rundhauses ausgehend. Nicht nur der Entwurf stammt von Ligar, er betätigte sich auch als Statiker und ausführender Bauunternehmer.

Construite en 1952, cette maison avait été conçue pour Louis Adrian, chef d'orchestre de musique légère. Inspirée des formes indiennes, la Round House – connue sous ce nom de « maison ronde » – avait éveillé à l'époque la curiosité des professionnels par son curieux aspect de ruche. L'objectif de ce toit était de réduire la consommation d'énergie.

L'architecte voulait que la zone de séjour soit éclairée à la fois par le soleil et par la lune. Huit anneaux concentriques à douze facettes en béton léger ressemblant à un perron, protègent le volume intérieur de la lumière directe. Les bandeaux de verre entre chaque anneau sont en retrait et les rayons du soleil projettent sur la cheminée centrale en pierre un jeu de lumière qui évolue en permanence. La cheminée conique traverse le toit par une ouverture circulaire. Une verrière en partie supérieure ouvre le volume du séjour vers le ciel et met en valeur la texture du travail de maçonnerie de la cheminée.

De l'intérieur, la structure du toit est omniprésente. Des cloisonnements mobiles entre le séjour et la chambre créent un espace unique. Le plan respecte un principe de circularité. En partie creusé dans la colline, le noyau central contient le séjour, deux chambres et une salle de bains. L'espace restant se développe par anneaux concentriques. La cuisine et l'abri à voitures sont logés dans deux portions de ces anneaux. L'implantation des murs intérieurs, de ceux de soutènement, des bancs et des tables, rayonne à partir du centre. Ligar a conçu le projet, calculé la structure porteuse et réalisé la construction.

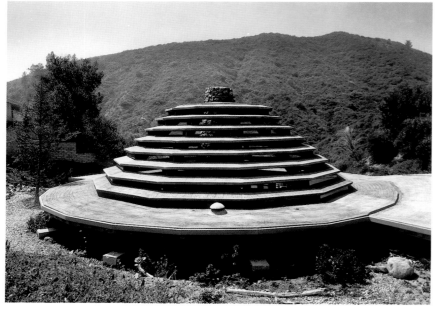

Selected Bibliography:
- *House & Home, January 1955*
- *Herbert Weisskamp, Beautiful Homes and Gardens in California, New York 1964*

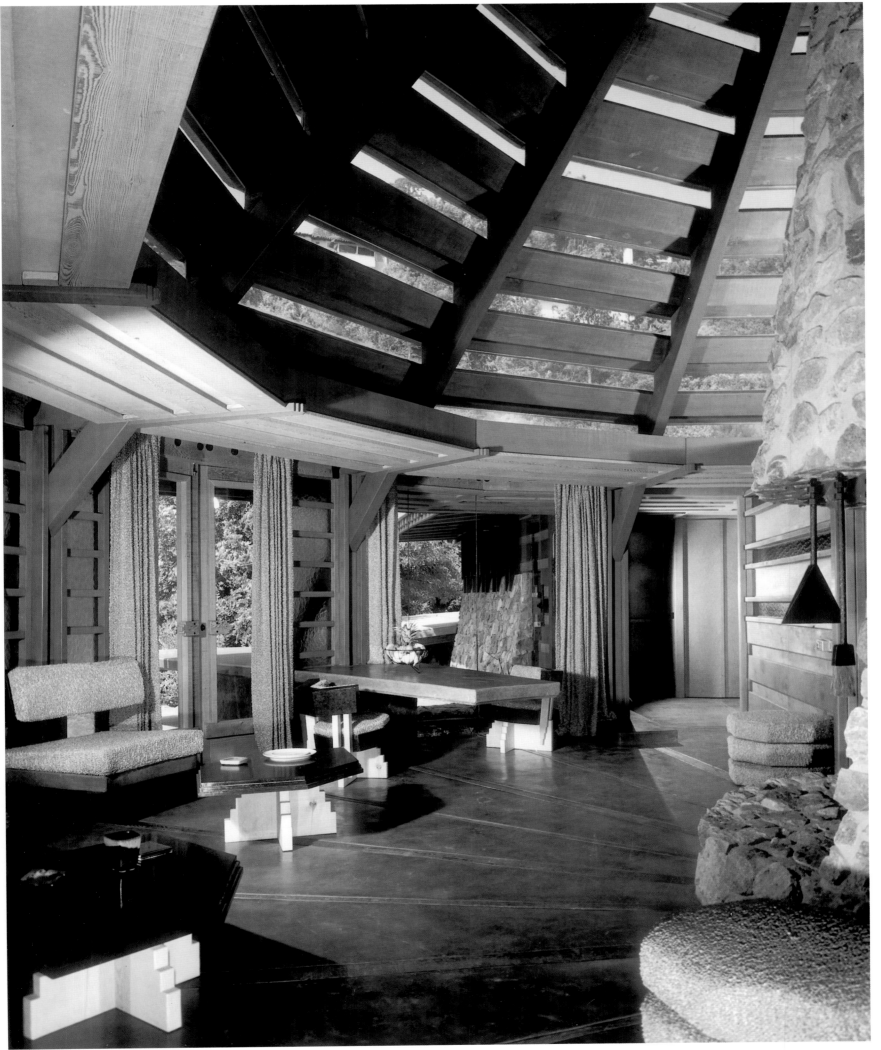

1920 A. Quincy Jones and Frederick E. Emmons
Jones Residence, Brentwood, California
January 26, 1955

Jones' own residence is a demonstrative statement about how mass-produced materials can make domestic space. Steel is chosen on technological grounds as well as architectural considerations. The first point is manifest in the assembly time. Because the material can be shop-fabricated with extreme precision, the frame was erected in three days and the 2,620 square-foot house was up in three months. The second point hinges upon the great potential steel has to generate flexible plans for informal living. In this project, functional areas merge into each other, generating essentially one big room. Storage closets, sliding partitions and full-length curtains in ceiling tracks establish soft subdivisions of the floor space into private units. Only the walls in the plumbed rooms reach the roof decking. The owner wanted the feeling of a vacation house in the city, just a few minutes away from his office. The 3.9-acre site overlooks a wooded valley and enjoys a panorama of the city. To maximize the views, the house's enclosure is primarily steel framed glass walls, with each area given its own sliding glass door opening to the outside. The red steel frame is composed of four-inch steel columns and ten-inch steel beams supporting a metal roof decking with a white underside. To avoid direct sunlight on the west elevation, the roof folds to make vertical eaves. Since gardening is the owner's hobby, the architects devoted 15% of the square footage to interior planting. Next to the main entrance left to the carport, garden strips and paving blocks penetrate into the living room reaching all the way to the master bedroom on the other side of the house. To capture natural light, the roof opens over the planting.

The design won an award in the 1956 edition of the American Institute of Architects Homes for Better Living Award (Pacific Coast and Hawaii) and an Award of Merit in 1957 from the American Institute of Architects National Chapter. Located on 1233 Tigertail Road, Brentwood (West Los Angeles), the residence burnt down in the Bel Air fire in 1963.

Jones' eigenes Haus belegt, dass man auch mit massenproduzierten Bauteilen schöne Wohnarchitektur schaffen kann. Er wählte Stahl nicht nur wegen seiner technischen Eigenschaften, sondern auch aus ästhetischen Gründen. Der erste Grund erklärt sich schon durch die Montagezeit: Da Stahlteile mit äußerster Präzision vorgefertigt werden, konnte das Stahlfachwerk innerhalb von drei Tagen und das ganze Haus mit einer Fläche von 240 m² in nur drei Monaten fertiggestellt werden. Zum Zweiten eignet sich Stahl als äußerst vielseitiges Baumaterial zur Erzeugung offener Räume, in denen sich zwanglos leben lässt. So ist das Hausinnere im Wesentlichen ein einziger großer Raum, der sich mit Hilfe von begehbaren Schränken, Schiebetüren und raumhohen Vorhängen variabel in kleinere Räume unterteilen lässt. Nur in den Sanitärräumen reichen die Wände bis zur Decke.

Der Architekt wollte mit seinem Entwurf die Anmutung eines Ferienhauses in der Stadt erzeugen, nur wenige Autominuten von seinem Büro entfernt. Vom 3,9 Morgen großen Grundstück hat man eine Panoramasicht über ein bewaldetes Tal und die Stadt. Um die schönen Aussichten einzufangen, verglaste Jones das Haus weitgehend und versah jeden Raum mit Schiebetüren zum Garten. Das rote Stahlfachwerk besteht aus 10 cm dicken Stahlstützen und 25 cm breiten Stahlträgern, die das auf der Unterseite weiß beschichtete Metalldach tragen. Auf der Westseite ist die Dachkante zur Abwehr direkter Sonneneinstrahlung heruntergeklappt. Da Jones Hobbygärtner war, verwendete er 15 % der Fläche auf Pflanzbecken und -kübel im Haus. Neben dem Hauseingang links vom Carport ziehen sich Beete und Trittsteine vom Garten durch den Wohnraum bis zum Elternschlafzimmer auf der anderen Seite des Hauses. Die Pflanzbecken werden durch Oberlichter natürlich belichtet.

1956 erhielt das Haus im Rahmen des Homes for Better Living Award des American Institute of Architects eine Auszeichnung (für den Bereich Pazifikküste/Hawaii) und 1957 einen Award of Merit des AIA. Bei dem Flächenbrand von 1963 in Bel Air brannte auch dieses Haus nieder.

La maison que Jones construisit pour lui-même est une démonstration pédagogique de la manière dont les matériaux industriels peuvent s'intégrer dans un espace domestique. L'acier est choisi ici aussi bien pour des raisons technologiques qu'architecturales. Le premier aspect est évident au vu des temps de montage. Comme le matériau se prête à une fabrication d'une extrême précision, la structure a été érigée en trois jours et les 240 m² montés en trois mois. Le second point tient à son potentiel pour la mise en œuvre de plans souples qui conviennent à une vie décontractée. Dans ce projet, les surfaces fonctionnelles fusionnent les unes dans les autres, pour créer ce qui n'est en fait qu'une très grande pièce. Les placards, les cloisons coulissantes et les rideaux toute hauteur accrochés à des tringles intégrées au plafond suffisent à délimiter quelques espaces plus privés. Seuls les murs des pièces humides touchent le plafond.

Le propriétaire voulait une maison en ville qui donne l'impression d'être en vacances, à quelques minutes de son bureau. Le terrain de deux hectares domine une vallée boisée et offre un vaste panorama sur la ville. Pour optimiser les vues, l'enceinte est essentiellement en panneaux vitrés et châssis d'acier, chaque zone disposant d'une porte coulissante ouvrant sur l'extérieur. La structure en acier patiné se compose de montants d'acier de 10 cm de côté et de poutres d'acier de 25 cm de hauteur qui soutiennent un toit en platelage à sous face blanche. Pour éviter l'exposition directe au soleil sur la façade ouest, le toit se replie en auvents verticaux. Comme les propriétaires aimaient jardiner, les architectes ont consacré 15% de la surface intérieure à des plantations. Des jardinières et un pavement partent de l'entrée principale, à gauche de l'abri à voitures, pénètrent dans le séjour et se poursuivent jusqu'à la chambre principale de l'autre côté de la maison. Des ouvertures sont ménagées dans le toit pour capter la lumière naturelle au-dessus des plantes.

Ce projet a remporté en 1956 un prix au Homes for Better Living Award de l'AIA (Côte Pacifique et Hawaii), et un prix du mérite en 1957 du chapitre national de l'AIA. Situé 1233 Tigertail Road, Brentwood (West Los Angeles), la maison a été entièrement détruite lors de l'incendie de Bel Air de 1963.

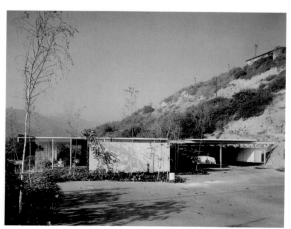

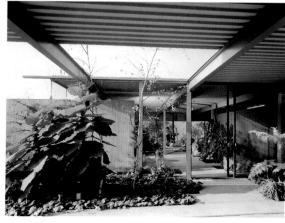

Selected Bibliography:
- Architectural Record Houses of 1956, Mid-May-June 1956
- House & Home, June 1956
- Sunset, July 1956
- arts & architecture, October 1956
- Architectural Review, May 1957
- House & Home, June 1957
- Concrete Masonry Age, June 1957
- Arts of Southern California-I Architecture, Long Beach Museum of Art, 1957
- Wolf von Eckardt (ed), Mid-Century Architecture in America, Washington D.C. 1961
- Herbert Weisskamp, Beautiful Homes and Gardens in California, New York 1964
- Process Architecture, number 41, Oct. 1983

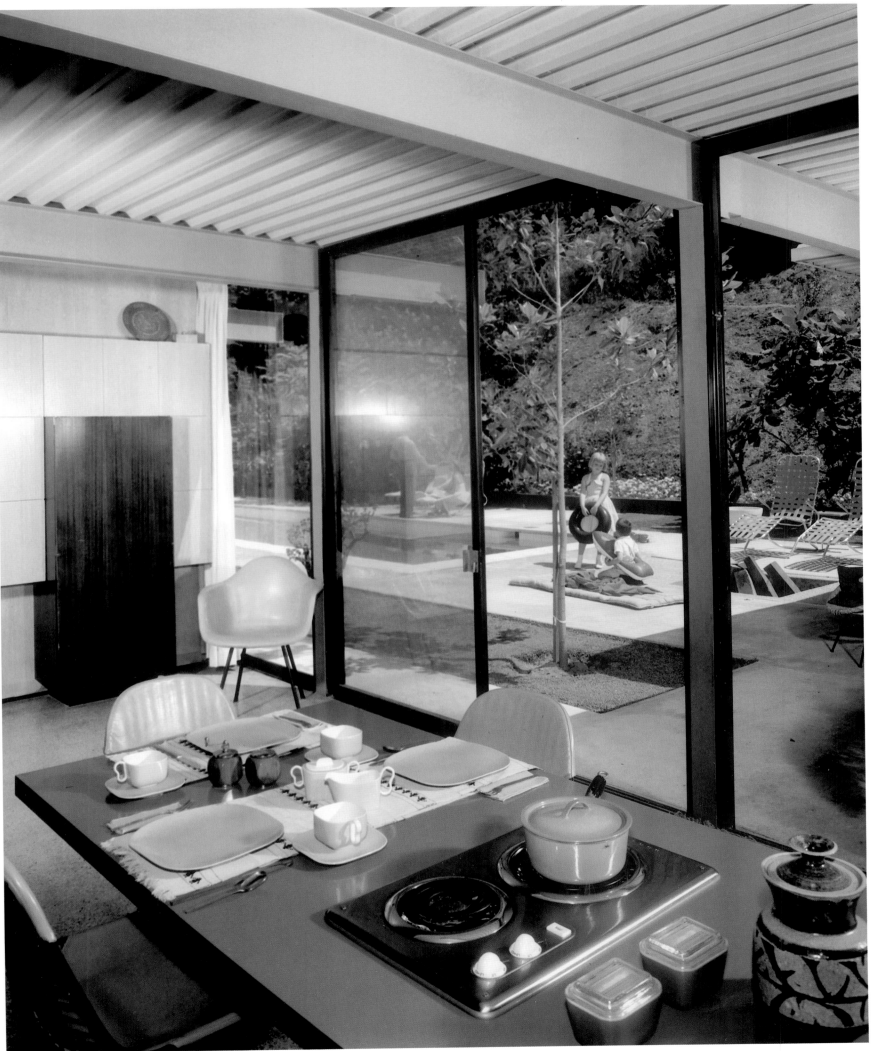

1929 **Thornton M. Abell**
Abell Offices, Brentwood, California
February 4, 1955

Movability of the entire structure and flexibility of interior space – these were the driving ideas for the architect's own office. The building was located on 654 South Saltair, in Brentwood, a district that was undergoing steady economic growth and heavy land development at the time. Due to the limited budget available, Abell decided to occupy the property with a provisional artifact to be later replaced by a more lucrative investment. To meet this goal, the architect designed a structure that could be disassembled and rebuilt on a different site, either as a work set-up or as domestic space with minimum adaptation. In this architecture, Abell explores the principles of modular design, demonstrating the strong influence of the early Mies Van der Rohe. The wood frame design complies with an ordering system based on 2·6 x 12-foot modules. Two main sections define the setting for public and private activities. The street portion is a 12 x 24 foot area accommodating a reception, secretary office and utility core. Behind this screen threshold, one 24 x 36 feet room with only two central posts becomes the background for office life. Conference and drafting rooms fit into six bays furnished with prefabricated sliding panels to provide for unrestrained spatial configurations. Fenestration is in direct response to solar orientation. The north wall, entirely in glass, opens onto a private garden. The south wall, features a narrow band of glass, while east and west elevations are solid.

The richness of the color palette affects the architectural experience of the place. The exterior redwood screen on the parking lot continues inside the reception area in lemon gold. Exposed structural members painted charcoal pattern the light green-oyster ceiling. The conference room is in violet blue. Abell's office received a 1954 National American Institute of Architects Honor Award from the Southern California Chapter of the American Institute of Architects.

Ziel des Entwurfs war ein Bürogebäude, das sich nicht nur innen variabel gliedern, sondern auch insgesamt an einen anderen Ort versetzen ließ. Es entstand in Brentwood, einer Ortschaft, die damals einen steten wirtschaftlichen Aufschwung und demzufolge einen enormen Bauboom erlebte. Weil er über ein knappes Baubudget verfügte, beschloss Abell, einen Behelfsbau zu errichten, den er später durch ein besseres Gebäude ersetzen konnte, und entwarf einen demontierbaren Bau, der sich auf einem anderen Grundstück ohne großen Aufwand entweder als Büro oder Wohnhaus erneut aufstellen lässt. Dabei untersuchte er die Prinzipien der modularen Ordnung und bewies damit, dass er unter dem Einfluss des frühen Mies van der Rohe stand. Zur Straße hin befindet sich der 3,50 x 7,50 m große Bereich mit Empfang, Sekretariat und Betriebsräumen. Dahinter schließt sich der Arbeitsbereich der Architekten an: ein großer Raum (7 x 11 m), in dem Besprechungs- und Zeichentische in sechs durch vorgefertigte Schiebetüren abgeschlossenen Kabinen aufgestellt sind. Die Platzierung der Fenster berücksichtigt den Sonnenlauf. Die voll verglaste Nordwand öffnet sich auf einen Garten. Die Südfassade weist nur ein schmales Fensterband auf, die Ost- und Westfassaden sind ganz geschlossen.

Die reichhaltige Materialpalette prägt das Architekturerlebnis. Die Redwoodverkleidung der Außenmauer am Parkplatz setzt sich im Empfangszimmer zitronenfarbig gestrichen fort. Die anthrazitgrau gestrichenen Teile der Konstruktion kontrastieren mit hellgrünen Decken. Der Konferenzbereich ist violettblau gestrichen. Abells Bürogebäude erhielt 1954 von der Sektion Südkalifornien des American Institute of Architects einen Honor Award.

La mobilité éventuelle de la structure et la flexibilité de l'espace intérieur sont les deux idées directrices qui président à la conception de cette agence d'architecture. Le bâtiment était situé 654 South Saltair, à Brentwood, commune qui connaissait à l'époque une croissance régulière et une forte pression des promoteurs immobiliers. Son budget étant limité, Abell décida d'occuper le terrain avec une réalisation provisoire qui pourrait être remplacée par un investissement immobilier plus rentable. Il conçut ainsi une structure qui pouvait être démontée et reconstruite sur un autre terrain, et transformée en bureaux ou en maison d'habitation, avec le minimum de problèmes d'adaptation. Abell explore les principes de la construction modulaire, témoignant au passage de l'influence de Mies van der Rohe à ses débuts. Deux zones principales définissent le cadre des activités commerciales et privées. Sur rue, une zone de 3,50 m x 7,50 m regroupe la réception, un secrétariat et des équipements techniques. Derrière ce seuil qui fait office de filtre, une pièce de 7 x 11 m à deux poteaux centraux constitue l'agence proprement dite. Les salles de dessin et de conférence sont logées dans six travées équipées de panneaux préfabriqués coulissants qui permettent toutes sortes de configurations. Les ouvertures ont été ménagées en fonction de l'orientation solaire. Le mur nord, entièrement en verre, s'ouvre sur un jardin privé. Le mur sud est doté d'un étroit bandeau vitré, tandis que les façades est et ouest sont aveugles.

La richesse de la palette chromatique joue beaucoup ici dans la perception architecturale. L'écran de bois rouge extérieur sur le parking se poursuit à l'intérieur de la réception de couleur or clair. Les éléments d'ossature apparents sont anthracite et le plafond vert pâle. La salle de conférence est bleu violet.

L'agence Abell a reçu un prix d'honneur en 1954 du chapitre de Californie du Sud de l'AIA.

Selected Bibliography:
- *arts & architecture, July 1954*
- *Architectural Forum, April 1955*
- *Arts of Southern California-I Architecture, Long Beach Museum of Art, 1957*
- *Pacific Architect and Builder, February 1960*

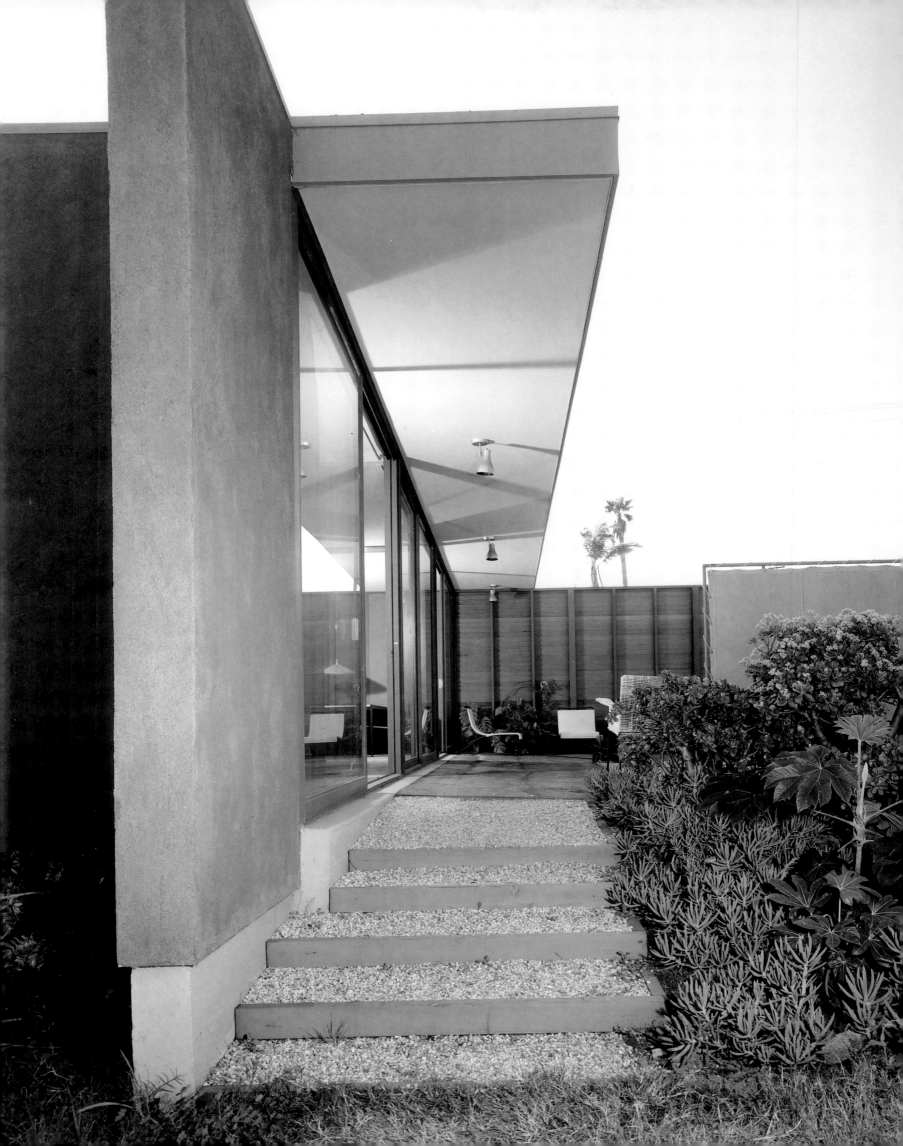

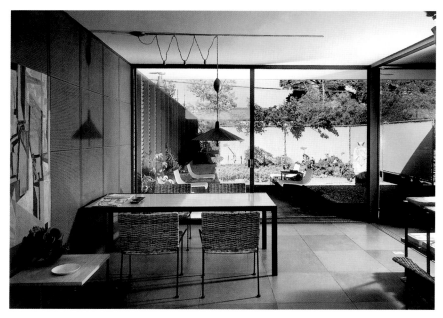
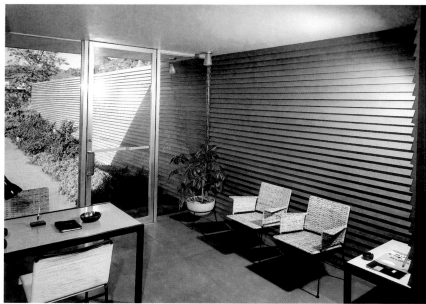
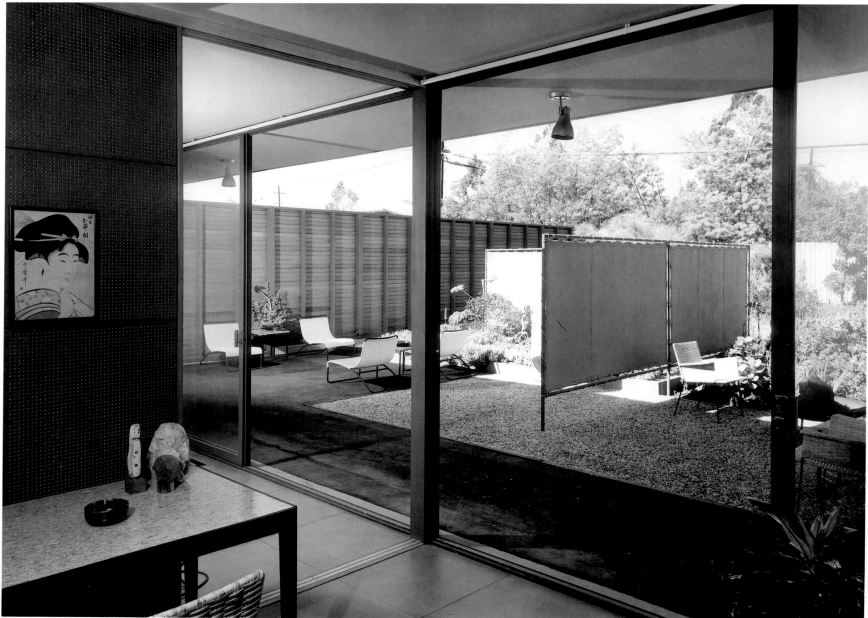

1930 Carl L. Maston
Apartments, Los Angeles, California
February 7, 1955

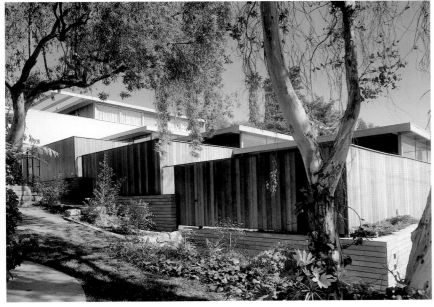
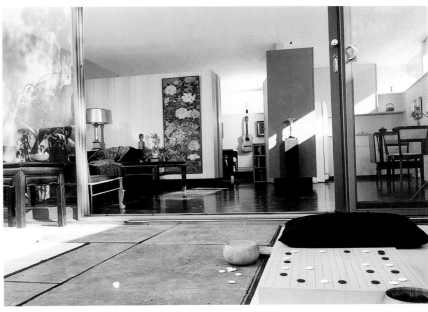

Maston acted as architect, owner and builder of this five-dwelling unit on 10567 National Boulevard in West Los Angeles. His goal was to produce a piece of real estate generating income with minimum capital investment. Developed on a hillside lot, the apartments are positioned in step-fashion. A ramp along the side of the lot provides access to the units, entered through individual garden-wall doors.

Although the covered space in each dwelling is rather limited, 600 square feet, the 20 x 14-foot garden patios increase the scale of the place. The interiors afford great flexibility through the storage closets used to partition the space as needed. Continuous clerestory windows catch the southern light.

The architect integrates indoor and outdoor through a few architectural moves: the garden fence is the same height as the room wall below the clerestory; floor and paving planes are level; the eaves of the roof are the ceiling of the outdoor extension. The typical wood frame is covered with 1 x 6-inch redwood siding. Gypsum board is used for the interior walls and ceilings.

The apartment project received an Award Citation in the 1954 Progressive Architecture Award Program and an Award of Merit in 1955 from the American Institute of Architects National Chapter.

Maston war nicht nur der Architekt, sondern auch der Besitzer und ausführende Bauunternehmer dieses Gebäudes mit fünf Wohnungen. Mit einer möglichst geringen Kapitalinvestition wollte er sich so ein regelmäßiges Mieteinkommen verschaffen. Er staffelte die Wohnungen terrassenförmig am Hang und erschloss die Anlage über eine seitliche Rampe. Die einzelnen Wohnungen sind von der Rampe aus durch Gartenpforten und Vorgärten zugänglich. Die Wohnungen sind zwar klein (55 m²), ihre Wohnfläche wird aber durch 6 x 4,50 m große Gartenhöfe erheblich erweitert. Die Innenräume können effizient und flexibel genutzt werden, weil Maston Einbauschränke als Raumteiler einsetzte. Durchgehende seitliche Oberlichter lassen Tageslicht einfallen.

Mit sparsamen gestalterischen Mitteln verband der Architekt Wohnungen und Landschaft miteinander: Der Gartenzaun ist ebenso hoch wie die Wände bis zu den Oberlichtern; Zimmerböden und Terrassenpflaster liegen auf einer Ebene; Die Dachüberstände beschirmen als Vordächer die Terrassen. Die Fachwerkmauern sind mit Redwoodbrettern verschalt, Innenwände und Decken bestehen aus Gipskartonplatten.

1954 erhielt das Appartementhaus im Rahmen des Progressive Architecture Award eine lobende Erwähnung, und 1955 einen Award of Merit vom American Institute of Architects.

Maston était l'architecte, le propriétaire et le constructeur de ce bâtiment de cinq logements. Son objectif était de tirer un revenu maximum d'un investissement minimum. Les appartements sont disposés en escalier sur un terrain des collines de Los Angeles. Une rampe latérale permet l'accès à chaque logement, via une porte ouverte dans un mur donnant sur un petit jardin. Bien que l'espace couvert soit relativement limité – 55 m² par appartement –, ce jardin-patio de 6 x 4,50 m en accroît l'échelle. Les volumes intérieurs permettent une grand souplesse d'aménagement, grâce à des placards qui font office de cloisonnements. Des bandeaux continus de fenêtres hautes sont orientés à l'ouest.

L'architecte intègre l'intérieur et l'extérieur au moyen de quelques procédés architecturaux : la clôture du jardin est de la même hauteur que le mur sous les fenêtres hautes, le sol et le pavement extérieur sont au même niveau, les débordements du toit sont une extension du plafond. L'ossature en bois est recouverte d'un bardage en bois rouge de 2,50 x 15 cm. Des panneaux de plâtre recouvrent les murs intérieurs et les plafonds.

Ce projet a reçu une citation lors du Progressive Architecture Award Program de 1954 et un prix du mérite du chapitre national de l'AIA en 1955.

Selected Bibliography:
- Progressive Architecture, January 1955
- Progressive Architecture, August 1955
- L'Architecture d'Aujourd'hui, July 1956
- Arts of Southern California-I Architecture,
 Long Beach Museum of Art, 1957
- Wolf von Eckardt, (ed.), Mid-Century Architecture in America, Washington D.C. 1961
- Schöner Wohnen, June 1963
- Los Angeles Times Home Magazine, April 19, 1964
- Architecture California, Idiom of the Fifties, November/December 1986

1989 Burton A. Schutt and William Stephenson
Moore Residence, Arcadia, California
May 25, 1955

The front of house, facing the street, displays a lath wall painted white with the entry door as its single opening. Behind the light screen a flamboyant planted area covered with an egg crate ceiling unfolds before the visitors' eyes. A ring of succulents in white crushed rock surrounds a black concrete circle. On the opposite side of the house, the glass walls of the main living zones face a private multi-leveled garden.

Vor der Straßenfassade ist eine weiß gestrichene Spalierwand angebracht; der Hauseingang bildet die einzige Öffnung in der Vorderfront. Dahinter betritt man ein blühendes Gartenzimmer. In einem Ring aus weißen Bruchkieseln um eine Kreisfläche aus schwarzem Beton wachsen Sukkulenten. Auf der anderen Seite des Hauses blickt man durch die Glaswände des Wohnraums in den auf mehreren Ebenen angelegten Garten.

La façade sur rue est composée d'un mur en lattis peint en blanc dont l'unique ouverture est la porte d'entrée. Derrière un écran, un jardin couvert de caissons à claire-voie est planté de flamboyants. Une bande de plantes grasses et de rocaille entoure un cercle de béton teinté noir. De l'autre côté de la maison, les murs des pièces à vivre donnent sur un jardin à niveaux.

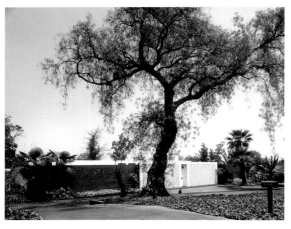
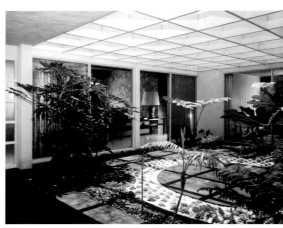

Selected Bibliography:
- *Los Angeles Times Home Magazine, May 20, 1956*
- *Los Angeles Times Home Magazine, August 9, 1959*

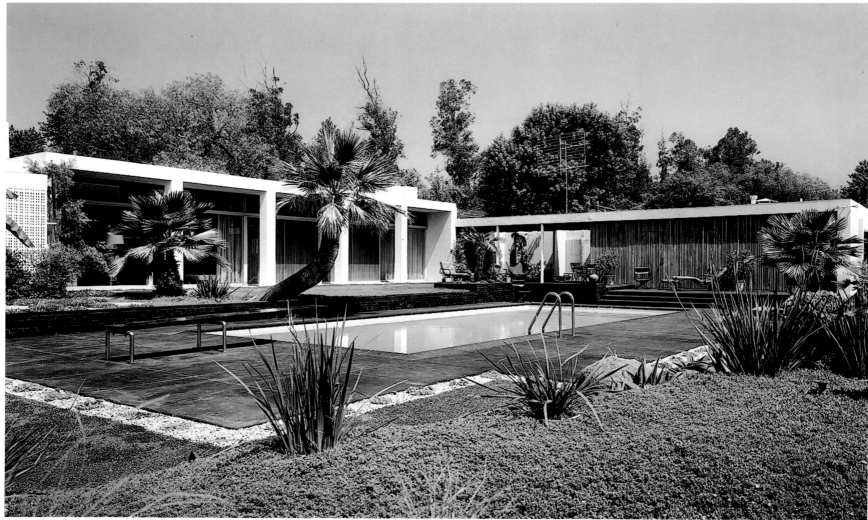

2004 John Sjoberg
Sjoberg Residence, Hollywood, California
June 21, 1955

The Danish designer situates 1,850 square feet of covered floor space on the hilly topography of the site using a split-level plan. With one end anchored to a hill, the long and narrow volume stretches along the horizon line to bridge the stepped entry path. Motor court and garage are on the lower level; a separate bedroom unit, storage space and a passageway reside on the intermediate level; a collective area and the sleeping quarters occupy the upper level.

The entrance stairs lead to the front door at the rear of the house. Inside, living, dining, kitchen and garden areas coalesce into a large communal block. The fireplace has seashells set in concrete slab. A corridor to the left of the entry leads to the master bedroom with its own private sun deck.

The bearing structure is exposed post-and-beam. The roof slants gently to create a clerestory window. Because of the plan layout, all rooms on the upper floor enjoy an unobstructed views of the wooded hills, yet avoid unwanted exposure.

Der dänische Architekt platzierte das Haus mit seinen 170 m² auf mehreren Ebenen auf der Höhe des hügeligen Grundstücks. Am einen Ende im Boden verankert, überbrückt der lange, schmale Trakt quer zum Horizont den Treppenweg zum Eingang auf der Rückseite des Hauses. Vorplatz und Garage befinden sich auf der untersten Ebene, ein separates Gästeappartement, Abstellräume und ein Korridor im Zwischengeschoss sowie die Schlafzimmer der Familie und die Gemeinschaftsräume auf der obersten Ebene. Sie umfassen das Wohn- und Esszimmer, die Küche und den Garten. Die Kaminwand aus Beton ist mit Meeresmuscheln »intarsiert«. Der Flur links neben der Haustür führt zum Elternschlafzimmer mit eigener Sonnenterrasse. Die Pfosten-und-Riegel-Konstruktion des Hauses blieb unverkleidet. Das Dach ist leicht geneigt, so dass zwischen Mauerkrone und First ein Oberlicht eingefügt werden konnte. Alle Räume auf der obersten Ebene bieten freie Sicht auf die bewaldete, hügelige Umgebung, ohne jedoch Einblicke zu gewähren.

Cette maison de 170 m² de surface couverte met à profit la topographie accidentée du terrain par le biais de niveaux décalés. Ancré dans la colline à une extrémité, le volume étroit et allongé s'étend à la manière d'une passerelle pour rattraper l'allée d'entrée en escalier. Le parking et le garage sont situés au niveau inférieur. Une chambre autonome, un volume de rangement et un passage occupent le niveau intermédiaire. Les pièces collectives et les chambres occupent le niveau supérieur. Les escaliers d'entrée mènent à la porte principale, à l'arrière de la maison. A l'intérieur, le séjour, la salle à manger, la cuisine et les jardins forment un vaste ensemble. La cheminée est habillée de dalles de béton à coquillages. Un couloir, à gauche de l'entrée, mène à la chambre principale et à son solarium privé. La structure porteuse apparente est à poteaux et poutres. Le toit s'incline doucement pour faire place à une fenêtre haute. Grâce à cette configuration, toutes les pièces de l'étage supérieur bénéficient d'une vue dégagée sur les collines boisées, tout en préservant leur intimité.

Selected Bibliography: - Los Angeles Times Home Magazine, August 14, 1955

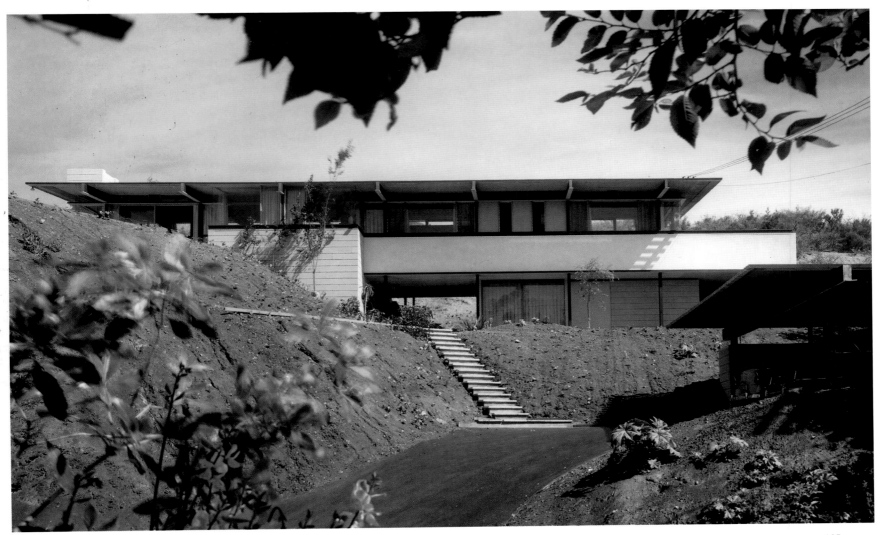

2029 Albert C. Martin
Office Building for Bethlehem Pacific Steel Corporation, Torrance, California
July 22, 1955; November 29, 1956

The headquarters of the Bethlehem Pacific Steel Corporation is a showcase for the company's products. Design concept was to articulate a syntax of steel components to demonstrate the material's flexibility. Doors, dividers, the paneling system and the roof are assembled in a rigorous architectural order to create a unified corporate identity in an urban context. The interiors exhibit a treatment of the surfaces which matches the exterior envelope. The structural steel framework which is left exposed, is further highlighted through color coding. The X-bracing in red stands out against the grayscale of the different components of the building's skin.

Das Hauptgebäude des Stahl verarbeitenden Unternehmens ist buchstäblich selbst ein Muster für dessen Fertigteilprodukte. Der Entwurf zielte darauf ab, die Stahlteile so zusammen zu setzen, dass sie die flexiblen Einsatzmöglichkeiten des Materials belegen. Türen, Raumteiler, Wandpaneele und Dach sind in streng regelmäßiger Ordnung so komponiert, dass das Ganze die Firmenidentität widerspiegelt. Die Oberflächen im Innern wurden in gleicher Weise bearbeitet wie die Fassadenteile. Das unverkleidete Stahltragwerk ist in verschiedenen Farben gestrichen, wobei die roten Kreuzverstrebungen sich deutlich von der Grauskala der diversen Fassadenteile abheben.

Le siège de cette aciérie sert de vitrine à ses produits. Le concept est ici de mettre en œuvre un vocabulaire à base d'éléments en acier pour prouver la souplesse d'utilisation de ce matériau. Les portes, les cloisons, les systèmes de panneaux et le toit sont assemblés dans un ordre architectural rigoureux pour donner une image urbaine et homogène de l'identité de l'entreprise. A l'intérieur, le traitement des surfaces est identique à celui de l'enveloppe extérieure. L'ossature en acier, laissée apparente, est soulignée par un code couleurs. Les poutrelles de raidissement en X peintes en rouge ressortent sur les divers tons de gris des composants de la peau du bâtiment.

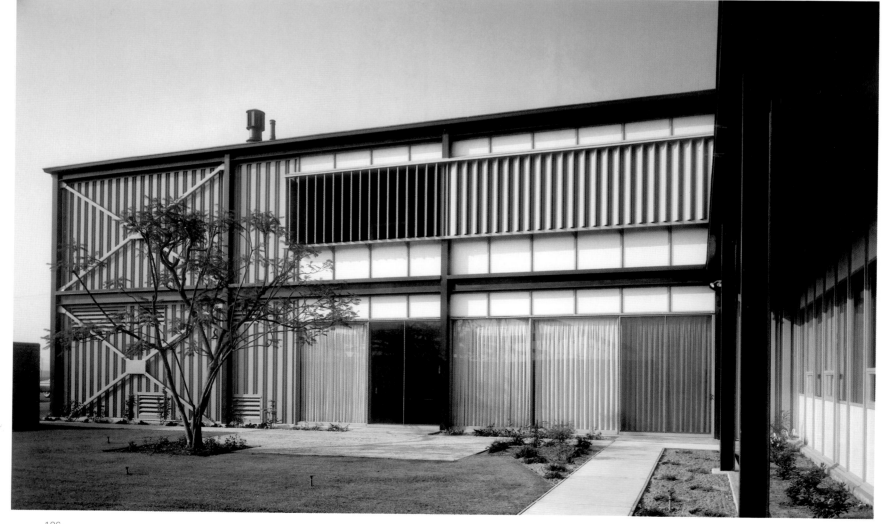

Selected *Bibliography:* - *Architectural Record, February 1957*

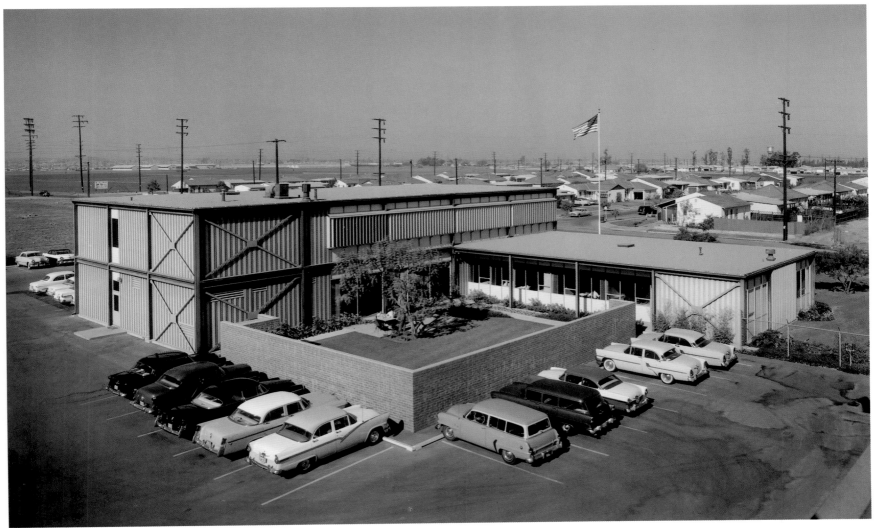

2086 Paul László
László Residence, Beverly Hills, California
October 26, 27, 1955

The living court is the center of life in the László Residence. On the street front, a solid barrier of Palos Verdes stone screens family life from view. The black overhang at the main entrance underscores the horizontal character of the elevation, yet contrasts in color with the soft beige and white of the rustic wall. Inside, all spaces converge toward the inner court with the circular pool, intended for outdoor activities and large social gatherings. The dining area flows into the living room, 60 x 20 feet in size, with floor-to-ceiling sliding doors. A covered terrace doubles the living room outside in the patio and frames

Der Wohnhof bildet im Haus des Architekten den Mittelpunkt des Familienlebens. Die Straßenfassade ist eher verschlossen und schützt das Privatleben der Lászlós; das auf der Unterseite schwarze Vordach des Hauseingangs unterstreicht die Horizontalität dieser Ansicht und bildet farblich den Kontrast zum Beige und Weiß des Rustika-Mauerwerks.
Alle Innenräume konvergieren zum Innenhof mit kreisrundem Wasserbecken; dort findet ein Großteil des Familienlebens sowie größere Feste statt. Der ca. 18 x 6 m große Wohnraum enthält einen Essbereich und öffnet sich über raumhohe Glas-

Une cour protégée et ouverte constitue le centre de la maison de Paul Laszlo. Côté rue, une massive barrière en pierre de Palos Verdes protège la vie familiale des regards extérieurs. L'auvent noir au-dessus de l'entrée renforce le caractère horizontal de la façade, tout en contrastant fortement avec les tonalités beiges et blanches du mur rustique.
A l'intérieur, tous les espaces convergent vers la cour intérieure et sa piscine circulaire, conçue pour une vie en plein air et de grandes réceptions. La salle à manger n'est pas séparée du séjour de 18 x 6 m, équipé de portes coulissantes sol-plafond.

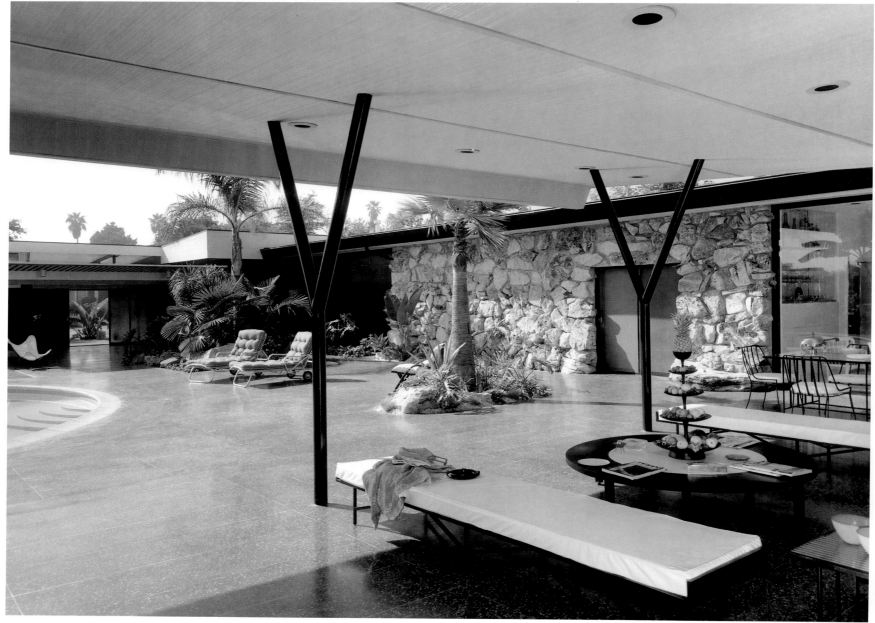

a view of the surrounding hills. The west wing of the structure is reserved for the children, who are apportioned their own outdoor play terrace.

Designed for himself and three family members, the house showcases modern commodities and various amenities. The kitchen is fully equipped and features a stainless steel table for informal dining. A monorail carries the groceries from the driveway to the kitchen.

schiebetüren zum Garten. Die überdachte Hofterrasse verdoppelt praktisch die Wohnfläche des Hauses. Der Westflügel ist den beiden Kindern vorbehalten; jedes hat vor seinem Zimmer eine eigene Terrasse.

Das Haus enthält modernste Technik: Die Einbauküche ist mit allen arbeitserleichternden Maschinen und Geräten ausgestattet, aber auch mit einem Esstisch aus Edelstahl, an dem die Familie ihre Mahlzeiten einnimmt.

Une terrasse couverte double le séjour vers l'extérieur et encadre la vue sur les collines avoisinantes. L'aile ouest est réservée aux enfants qui possèdent leur propre terrasse de jeu. Conçue pour l'architecte et les trois membres de sa famille, cette maison est une vitrine des commodités modernes et des équipements de l'époque. La cuisine est intégralement équipée d'appareils ménagers pour limiter les tâches quotidiennes et d'une table en acier pour des dîners informels. Un monorail transporte les courses de l'allée à la cuisine.

Selected Bibliography:
- arts & architecture, September 1956
- Book of Homes 12
- Architectural Digest, Volume XV, number 4

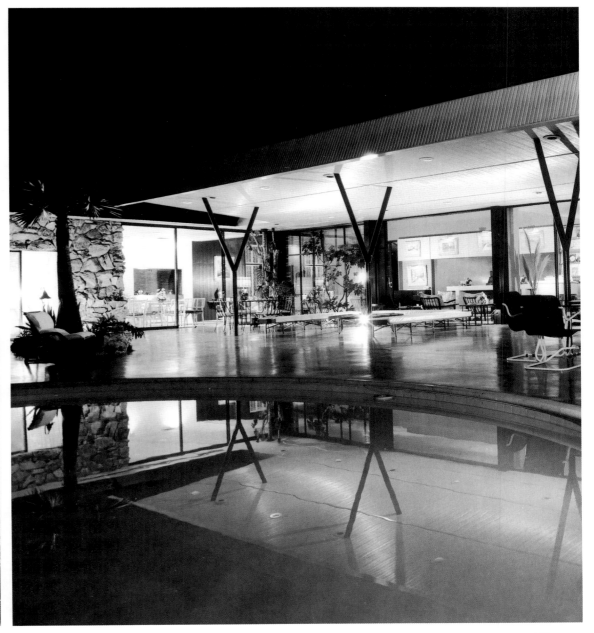

2091 **John Carr and Joseph Putnam**
Von Delden Residence, Studio City, California
November 1, 1955

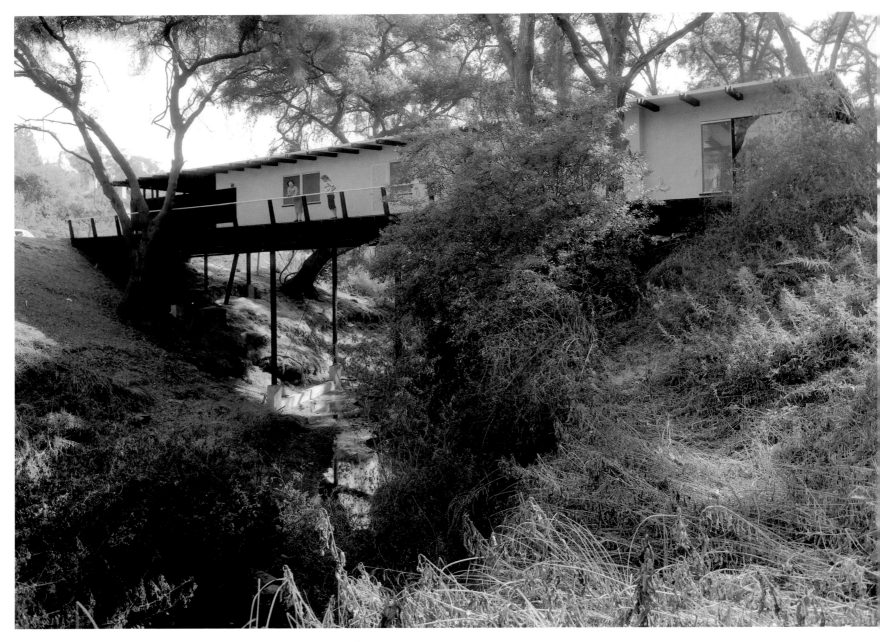

The linear structure bridges an arroyo site. Steel piers set in concrete blocks support the platform stretching across the stream running underneath. A deck, prolonging the common area outdoors, marks one end of the house. At the other end the carport area is connected to an open balcony leading to the entrance. The bridging structure has wire and wood railings for safety reasons. In 1,700 square feet, the architect distributes three bedrooms, two baths, living-dining-cooking space and a laundry room. Black and white is the color theme of the communal portion. Floor-to-ceiling fenestration incorporates large portions of the natural setting into the interior. The surrounding oak trees modulate direct sunlight.

Das langgestreckte Haus überbrückt einen Arroyo, eine von einem Bach gegrabene Schlucht. Stahlstützen in Betongründungen tragen die Bodenplatte des Hauses, das am einen Ende mit einem Terrassendeck abschließt. Am anderen Ende befinden sich die Garage und ein offener Balkon, über den man zur Haustür gelangt. Die Maschendraht-Geländer der Hausbrücke sind mit Holzhandläufen versehen. Auf der Gesamtfläche von 156 m² brachte der Architekt drei Schlafzimmer, zwei Bäder, Wohn- und Esszimmer mit Kochecke sowie eine Waschküche unter. Die Gemeinschaftsräume sind in Schwarz und Weiß gehalten. Durch raumhohe Verglasungen wird die Natur ins Haus einbezogen. Die großen Eichen um das Haus gewähren Schutz vor direkter Sonneneinstrahlung.

Enjambant un torrent à la manière d'un pant, cette maison repose sur des pilotis enchâssés dans des blocs de béton. La terrasse, qui agrandit le séjour vers l'extérieur, prolonge une de ses extrémités. De l'autre côté, l'aire de l'abri à voitures est entourée de grillages et de palisades de bois pour des raisons de sécurité. Sur 156 m² l'architecte a distribué les trois chambres, les deux salles de bains, le volume séjour/repas/cuisine et la lingerie. Le noir et le blanc se retrouvent dans toutes les parties communes. Les ouvertures sol-plafond permettent d'intégrer l'environnement naturel à l'intérieur. Les chênes environnants filtrent la lumière du soleil.

Selected Bibliography: - Los Angeles Times Home Magazine, February 5, 1956

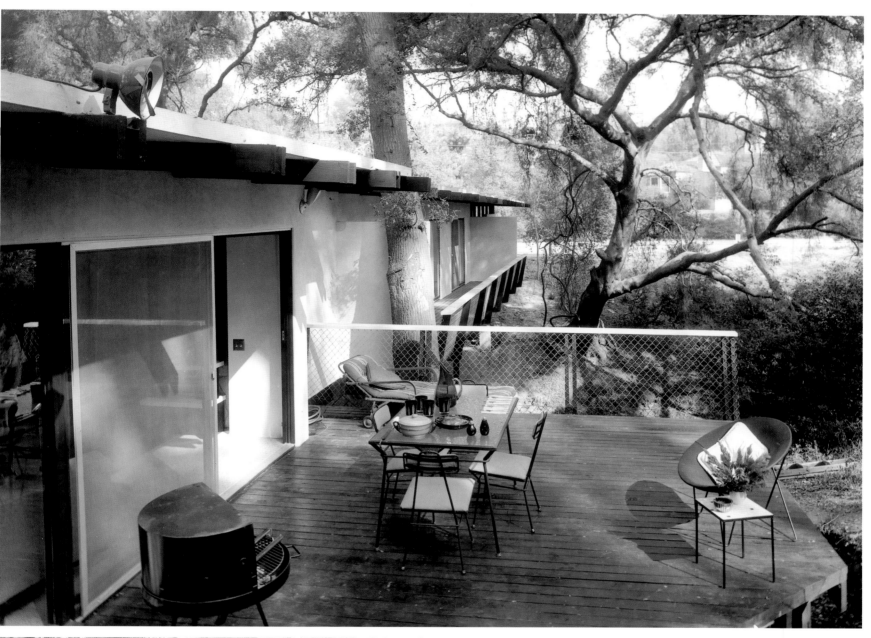

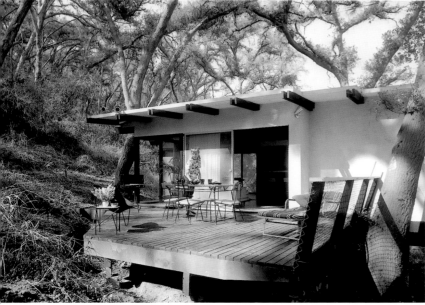

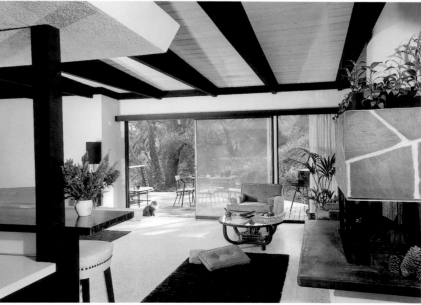

2125 Smith and Williams
Booth Residence, Beverly Hills, California
January 17, 1955

A deck above street level sets a new ground plane for the house. Wood canopies and a trellis shelter the entrance court placed in a central position within the plan. A patchwork of glass fields, wood panels and concrete block walls give material quality to the building envelope. The kitchen-guest wing and the sleeping-studio area are separated by the living-dining room. The folded structure covering this pavilion-like area results from the intersection of two gable roofs. The ceiling finish is hardwood-veneered plywood.

Ein über Straßenniveau aufgeständertes Holzdeck bildet eine neue, ebene Grundfläche für das Haus. Holzvordächer und ein Rankspalier beschatten und schützen den zentralen Eingangshof. Ein »Flickenteppich« aus Glasscheiben, Holzpaneelen und Betonwerksteinmauern bildet die Außenhülle des Hauses. Küchen- und Gästetrakt sowie Schlafzimmer- und Studiobereich flankieren das von einem flachen Kreuzdach überwölbte Wohn-Esszimmer, dessen Decke mit Hartholz-furnierten Sperrholzplatten verkleidet ist.

La maison occupe une terrasse plane surélevée par rapport à la route. Des auvents et un écran en treillis protègent la cour d'entrée implantée au centre. Un patchwork de panneaux de verre, de bois et de murs en parpaings confère une texture originale à l'enveloppe extérieure. L'aile cuisine/chambre d'amis et la chambre/studio sont séparées par le séjour. Le volume de celui-ci s'explique par l'intersection des deux toits en pignon. Les plafonds sont recouverts de contreplaqué de bois dur verni.

Selected Bibliography: - House & Home, March 1958

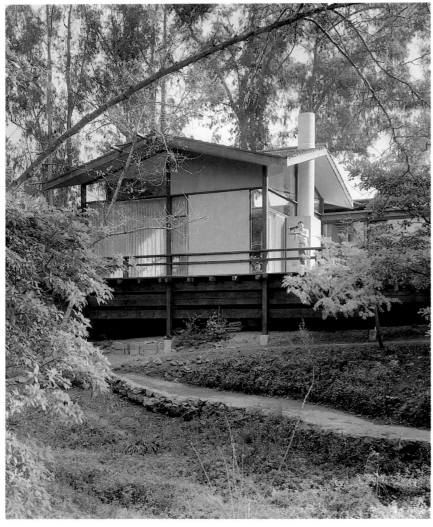

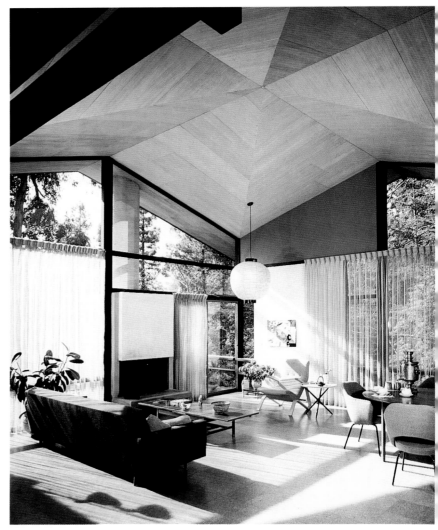

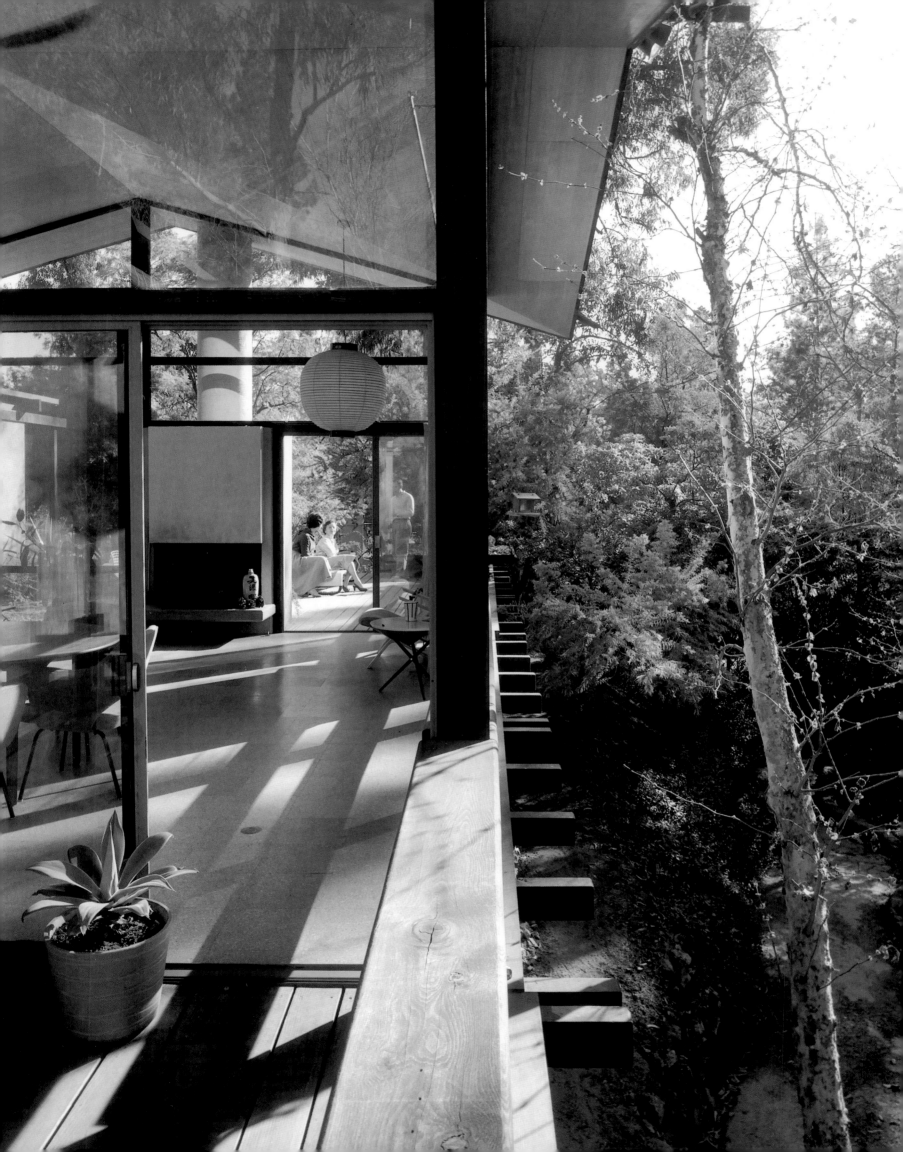

2168 Richard O. Spencer
Spencer Residence, Malibu, California
March 16, 1955

Richard O. Spencer was an industrial designer with a record of hill site houses, which required unconventional structural solutions. This project, the third of a series of custom-made homes designed for himself and his wife, was the experimental playground for the "module plan" system authored by steel fabricator Eugene Memmler. The 2,200-square-foot house was located 70 feet above the Pacific Coast Highway and close to a vanished Pacific Palisades landmark called "Castle Rock". The architectural scheme hinged upon the idea of lightness. An assemblage of a steel cage, made of pre-cut elements transported to the site, doubles the square footage available with more traditional structural systems given similar ground conditions.

The Spencer Residence appeared on the front cover of *Pictorial Living*, the Sunday section of the *Los Angeles Examiner*, a newspaper that folded in 1989. In the article, Dan MacMasters, who would later become architectural editor for the *Los Angeles Times Home Magazine* pointed out the inventiveness of the bearing structure, which provided an effective architectural option to the design of hillside housing in Los Angeles, detailing and its methods of construction, materials and all the commodities that the domestic space afforded, including a plan with dimensions. The image on the front cover portrays Mr. and Mrs. Spencer enjoying the view with binoculars while standing at the end of the 18-foot cantilevering. To underscore the challenging structural section, a woman poses right underneath the balcony and looks in the same direction as the Spencers. The Pacific coastline provides the visual backdrop for the frame outlined by the balcony and the ground. By the time the article appeared in print, the house already had new owners: Mr. and Mrs. Erwin F. Czichos. Although both articles had stressed its structural excellence, the house collapsed twenty years after its completion, allegedly due to poor assessment of the geological conditions of the soil.

Richard O. Spencer war eigentlich Industriedesigner, er hat aber auch eine Reihe von Häusern auf »unbebaubaren« Hanggrundstücken gebaut, die unkonventionelle konstruktive Lösungen erforderten. Dieses ist das dritte von mehreren Häusern, das er speziell für sich selbst und seine Frau entwarf, und eine Art Testlauf für das von dem Stahlfabrikanten Eugene Memmler entwickelte »Modulplan-System«. Spencer baute das 200 m² große Haus etwa 20 m oberhalb des Pacific Coast Highway in der Nähe des »Castle Rock« – des damaligen Wahrzeichens von Pacific Palisades. Das Entwurfsziel hieß Leichtigkeit. Ein Stahlkäfig aus vorher nach Spencers Angaben zugeschnittenen Teilen verdoppelt die Fläche, die mit den bis dato üblichen Tragwerkssystemen für ein Haus am Hang möglich gewesen wäre.

Das Haus Spencer zierte seinerzeit (wie auch im vorliegenden Band) die Titelseite des Sonntagsmagazins »Pictorial Living« des »Los Angeles Examiner«, einer Zeitung, die ihr Erscheinen 1989 einstellte. In seinem Artikel erläuterte Dan MacMasters (später Architektur-Redakteur des »Los Angeles Times Home Magazine«) die originelle Tragwerkslösung, die sich hervorragend für den Hausbau in der hügelig-bergigen Gegend von Los Angeles eignete, und machte detaillierte Angaben zur Bauweise, Gliederung (mit Grundriss-Abbildung) und Innenausstattung des Hauses. Das Titelbild zeigt Mr. und Mrs. Spencer am Rand der ca. 5,40 m auskragenden Veranda, die mit Ferngläsern den Meereshorizont absuchen. Die junge Frau links unten im Bild soll offenbar demonstrieren, welch tollkühne konstruktive Lösung dem Betrachter da vorgeführt wird. Die Horizontlinie des Pazifik bildet die Parallele zur Horizontalität des auskragenden Baukörpers und des darunter liegenden ebenen Geländeabschnitts. Als der Artikel erschien, war das Haus bereits in den Besitz von Mr. und Mrs. Erwin F. Czichos übergegangen. Die eingangs zitierten Artikel hatten die hervorragende Konstruktion gelobt, dennoch stürzte das Haus zwanzig Jahre nach Fertigstellung ein, angeblich aufgrund einer fehlerhaften Bodenfestigkeitsanalyse.

Richard O. Spencer était un designer industriel connu pour les maisons qu'il construisait dans les collines en recourant à des solutions et à des structures inhabituelles. Ce projet, le troisième d'une série de maisons conçues pour lui et sa femme, était en fait l'expérimentation du système « moduleplan » d'Eugene Memmler. La maison de 200 m² se trouvait à 20 m au-dessus de la Pacific Coast Highway, proche de « Castle Rock », un lieu connu de Pacific Palisades et aujourd'hui disparu. Par sa conception, le projet est une réflexion sur le thème de la légèreté. L'assemblage d'une cage d'acier en éléments prédécoupés, transportés et montés sur site, permit de doubler la surface au sol par rapport à ce qu'une structure plus traditionnelle aurait permis sur un terrain semblable.

La Spencer Residence fut publiée sur la couverture d'un supplément dominical du « Los Angeles Examiner » intitulé « Pictorial Living », journal qui cessa sa publication en 1989. Dans l'article, Dan MacMasters qui allait devenir le rédacteur en chef de la section architecture du « Home Magazine du « Los Angeles Time » argumentait sur l'inventivité de structure porteuse, solution efficace aux problèmes de la construction dans les collines de Los Angeles. Il fournissait de multiples détails sur les méthodes de construction, les matériaux et les commodités que cet espace permettait, et ajoutait même un plan dimensionné. L'image de la couverture montre Mr. et Mrs. Spencer admirant la vue à travers des jumelles, debout à l'extrémité du porte-à-faux de 5,40 m. Pour souligner l'audace de la structure, une femme pose sous le balcon et regarde dans la même direction que les Spencer. La côte du Pacifique, à l'arrière plan, épouse l'horizontale du balcon et du sol. A l'époque de cette parution, la maison avait déjà changé de propriétaires, les nouveaux étant Mr. et Mrs. Erwin F. Czichos. Bien que les deux articles aient magnifié l'excellence de la solution structurelle retenue, la maison s'effondra vingt ans plus tard, victime sans doute d'une étude géologique insuffisante.

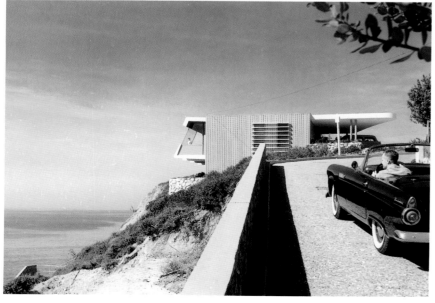
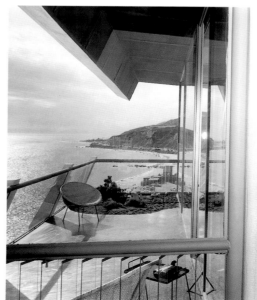

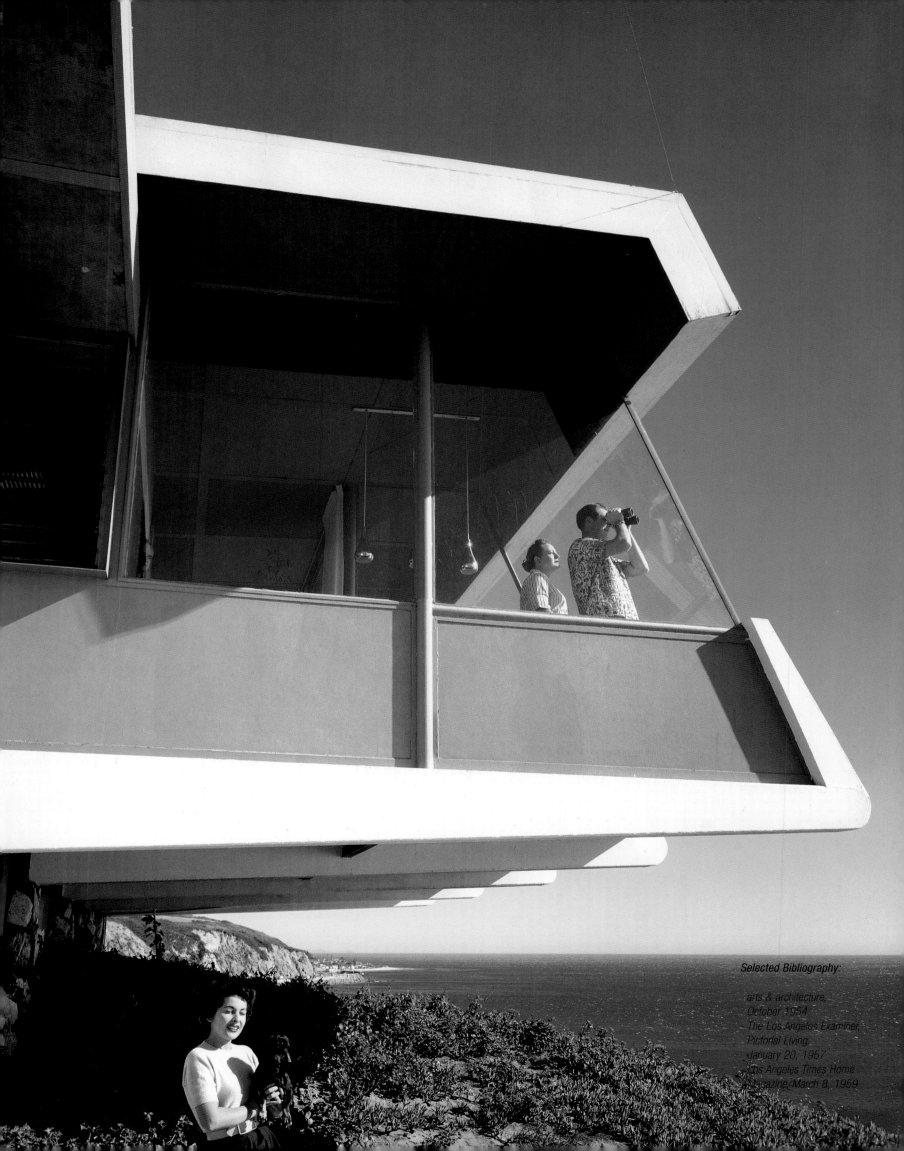

Selected Bibliography:

arts & architecture,
October 1954
The Los Angeles Examiner,
Pictorial Living,
January 20, 1957
Los Angeles Times Home
Magazine, March 8, 1959

2172 **Smith and Williams**
Wilcox Residence, Sierra Madre, California
March 21, 1956

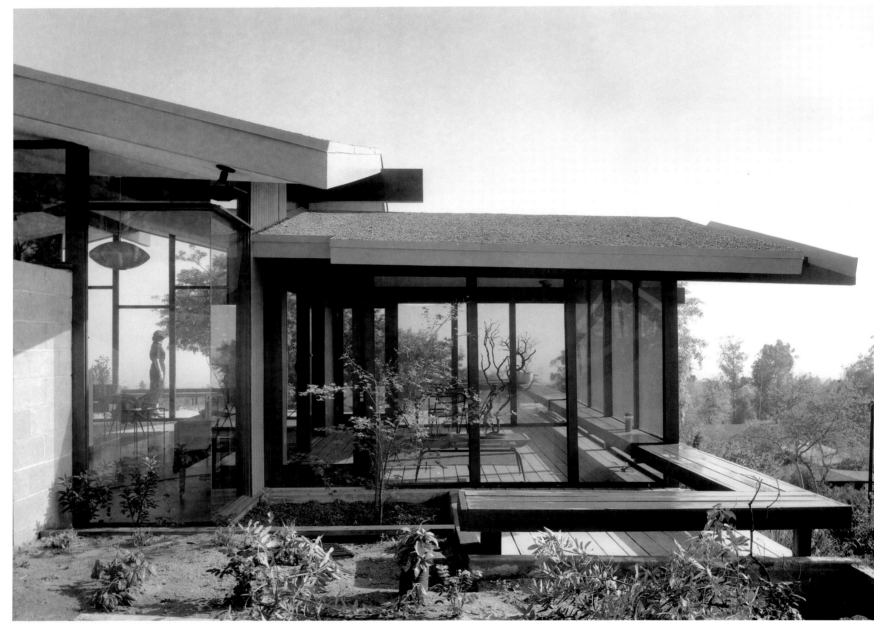

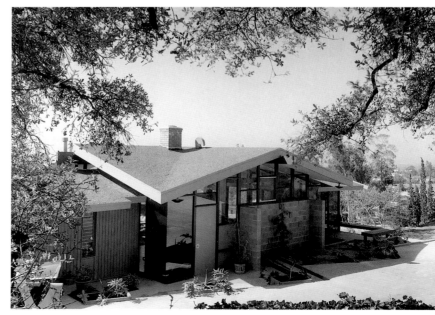

2181 A. Quincy Jones and Frederick E. Emmons
Graber Residence, SouthDown Estate, Pacific Palisades, California
April 3, 1956

This project is part of the SouthDown Estate development pursued by the Pardee-Phillips Construction Company. The developer-builders approached Jones and Emmons to design a flexible floor plan for the 21 out of 89 lots presenting terrain irregularities.

For each problem lot, the architects conducted research to map tree positions, grade changes and orientations. The Ted Graber residence epitomizes their architectural solution within a built context characterized by the presence of traditional houses. A variety of domestic functions are grouped under a single wide pitched roof, a design theme present in other Jones-and-Emmons projects (see p. 492). The street level is between three and four inches below the rear side of the lot. The carport, positioned in the lower area of the grade, articulates the entry path forming a transition between the outer world and interior space. The floor level in the house, higher than the garage area, is even throughout. A high wall gives privacy to the sleeping quarters facing the street. The tall fenestration between the roof underside and the superior edge of the exterior or wall provide air and light in the bedrooms. On the opposite side of the plan, the terrace and living room in the back enjoy a southwest exposure, protected by a steep wooded slope. Living and dining area merge into a single room, with a sliding glass door opening to the terrace. A concrete masonry fireplace, exposed sheathing, and a rafter ceiling, both painted white, texture the different surfaces of the living room.

The design won an award in the 1956 edition of the American Institute of Architects Homes for Better Living Award (Pacific Coast and Hawaii) and an Award of Merit in 1957 from the American Institute of Architects National Chapter.

Dieses Haus gehört zur Siedlung der Pardee-Phillips Construction Company auf dem Gelände des SouthDown Estate. Die Wohnungsbaufirma hatte Jones und Emmons damit beauftragt, ein Standardhaus mit variablem Grundriss für 21 von 89 Parzellen mit unebenem Grund zu entwerfen. Die Architekten beginnen jede schwierige Parzelle, um die Baumpositionen, Geländehöhen und -konturen zu kartieren. Das Haus Graber steht beispielhaft für ihre Entwurfslösung für traditionelle Einfamilienhäuser.

Die verschiedenen Wohnbereiche sind unter einem flach geneigten Dach untergebracht, ähnlich wie bei anderen Häusern von Jones und Emmons (siehe S. 492). Das Straßenniveau liegt nur geringfügig niedriger als der rückwärtige Grundstücksteil. Der Carport am unteren Parzellenrand umfasst den Zugang von der »Außenwelt« ins Hausinnere, das auf nur einer Ebene angelegt ist – etwas höher als der Carport. Eine hohe Mauer gibt den Schlafzimmern Sichtschutz zur Straße. Durch die hohen Fenster der über dieser Mauer aufragenden Giebelwand werden die Schlafzimmer natürlich belichtet und belüftet. Auf der Rückseite öffnet sich der Wohnraum mit Essecke über großflächige Fenster und Glasschiebetüren nach Südwesten; die vorgelagerte Terrasse wird von einem baumbestandenen Steilhang vor Einblicken und starken Winden geschützt. Der aus Betonwerksteinen gemauerte Kamin, Wandpaneele und Balkendecke (beide weiß gestrichen) sorgen im Wohnraum für Abwechslung.

Im Rahmen des Homes for Better Living Award für den Bereich Pazifikküste und Hawaii des AIA erhielt das Haus 1956 eine Auszeichnung und 1957 einen Award of Merit, ebenfalls vom AIA.

Ce projet fait partie du programme immobilier du SouthDown Estate réalisé par la Pardee-Phillips Construction Company. Les promoteurs avaient demandé à Jones et Emmons un plan au sol suffisamment souple pour s'adapter à 21 des 89 parcelles d'un terrain très irrégulier. Pour chaque problème, les architectes répertorièrent la position des arbres, les changements de niveaux et les orientations.

La Ted Graber Residence est l'illustration des solutions architecturales modernes pour les maisons traditionnelles. Plusieurs fonctions domestiques sont regroupées sous un unique grand toit à pignon, thème que l'on retrouve dans d'autres projets des mêmes architectes (voir p. 492). Le niveau de la rue est inférieur de 7,50 à 10 cm à celui de la façade arrière de la parcelle. L'abri aux voitures, situé en bas du terrain, sert d'articulation entre l'allée d'entrée qui fait transition entre le monde extérieur et le volume intérieur. Le niveau du sol de la maison, plus élevé que celui du garage, est parfaitement plat.

Un grand mur assure l'intimité des chambres face à la rue. Les hautes fenêtres entre la face interne du toit et la partie supérieure du mur extérieur apportent l'air et la lumière dans les chambres. A l'arrière, la terrasse et le séjour bénéficient d'une exposition sud-ouest protégée par une pente escarpée et boisée. Le séjour et la zone des repas fusionnent en une seule pièce équipée de portes coulissantes s'ouvrant sur la terrasse. Une cheminée en maçonnerie de béton, l'habillage, et le plafond de solives apparentes peintes en blanc, donnent une texture intéressante aux différentes surfaces de cette pièce.

La maison a remporté un prix lors de l'édition 1956 de l'Homes for Better Living Award de l'AIA (Côte Pacifique et Hawaii) et un prix du mérite du chapitre national de l'AIA en 1957.

Selected Bibliography:
- House & Home, June 1956
- House & Home, October 1956
- Concrete Masonry Age, June 1957

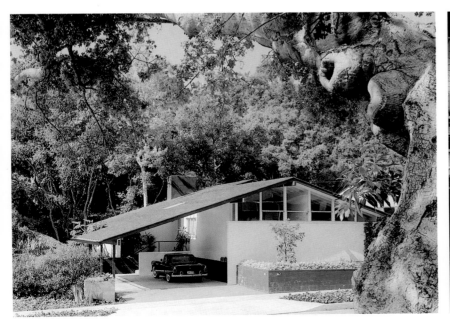
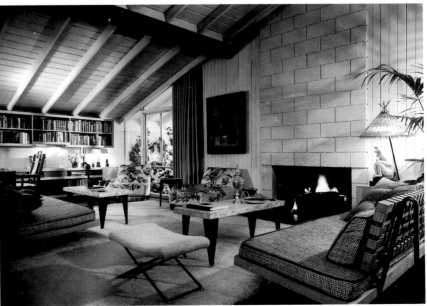

2192 John Nash Anderson
Muir Dawson Residence, Silverlake, California
April 17, 1956

This project was designed at the same time as Craig Ellwood's Smith House (1955) in West Los Angeles, whose structural solution shared strong similarities with Nash Anderson's design. A framed substructure suspended a plateau on a hillside property creating a new ground condition for the Muir Dawson Residence, yet leaving the space underneath wide open. The skinny metal supports, defining the bay-system, were laid out on a tight grid. Although single-storied, it was planned as a two-unit house on two levels. When the Los Angeles Times published the project, only the top floor had been partitioned and occupied, whereas the bottom one was still empty, but added rigidity to the load-bearing system.

A sloping ramp provided a street entrance to the residence, while securing privacy. The 850 square feet of the upper level included living and dining areas, a kitchen, two bedrooms, a bath, and a deck running along three sides of the plan. 760 square feet were apportioned for future expansion at the lower level and could be used as an extension of the upper living area, as a guest apartment or as a studio. The interior spaces open onto views of the Silverlake area. The non-bearing partitions and a bookcase divided the functional areas, keeping the house enclosure transparent to sunlight. Floors in the living area were carpeted, while the kitchen and bedrooms were tiled in asphalt.

Dieses »Pfahlhaus« wurde zur gleichen Zeit entworfen wie Craig Ellwoods Haus Smith (1955) in West Los Angeles, dessen Tragwerkslösung große Ähnlichkeit mit der dieses Hauses aufweist. Eine vom Hang auskragende Sockelplatte auf Stahlrahmenskelett bildet das ebene »Fundament« des Hauses, wobei der Raum darunter offen blieb. Die schlanken Metallstützen sind in relativ engen Abständen angeordnet und definieren die Jochfeldbreiten. Eigentlich hatte Anderson das Haus zweigeschossig geplant, zum Zeitpunkt der Publikation in der »Los Angeles Times« war jedoch nur das Obergeschoss mit Außenwänden versehen, innen ausgebaut und bewohnt, während das untere noch ein auf allen Seiten offener Raum war.

Der Zugang erfolgte über eine schräge Brücke. Die knapp 80 m² Fläche des Obergeschosses umfassten Wohn- und Esszimmer, Küche, zwei Schlafzimmer, ein Bad und den auf drei Seiten umlaufenden Holzdeck-Balkon. Die 70 m² große untere Etage war als Erweiterung der Gesamtwohnfläche, als Gästewohnung oder Arbeitszimmer vorgesehen. Vom Haus überblickt man den Bezirk Silverlake. Nicht-tragende Wände und ein Bücherregal unterteilten den Innenraum, ohne das Sonnenlicht auszusperren. Die Wohnräume waren mit Teppichboden, Küche und Schlafzimmer mit Asphaltfliesen ausgelegt.

Ce projet a été conçu en même temps que la Smith House de Craig Ellwood (1955) à West Los Angeles, ressemble fortement à ce dernier par ses structures. L'ossature en pilotis qui soutient le plateau permet de créer un nouvel espace constructible sur ce terrain en forte déclivité, tout en laissant un espace libre dans sa partie inférieure. Le squelette de poutrelles d'acier forme une trame serrée que l'on retrouve au niveau des châssis des baies vitrées. Bien que d'un seul niveau, la maison avait été prévue sur deux. Lorsque le «Los Angeles Times» la publia, seul l'étage supérieur avait été édifié, cloisonné et habité, celui du dessous restant libre, mais participant néanmoins à la rigidité du système porteur.

Une rampe relie la maison à la rue. Les 80 m² du niveau supérieur comprennent un séjour et un coin-repas, une cuisine, deux chambres, une salle de bains, et une terrasse courant sur trois côtés. Les 70 m² du niveau inférieur auraient pu servir à une extension du séjour et à un appartement pour invités ou un atelier. Les volumes intérieurs donnent sur Silverlake. Des cloisons non porteuses et des bibliothèques séparent les différentes pièces, tout en préservant la transparence de l'enveloppe. Les sols du séjour sont recouverts de moquette, ceux de la cuisine et des chambres d'asphalte.

Selected Bibliography:
- Los Angeles Times Home Magazine, August 12, 1956
- Los Angeles Examiner, Pictorial Living, June 30, 1957

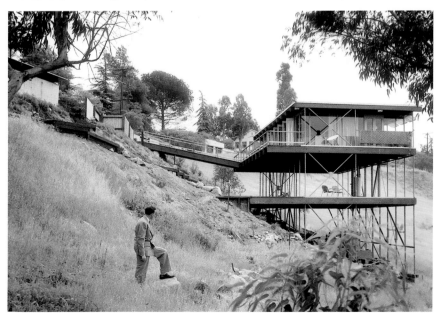
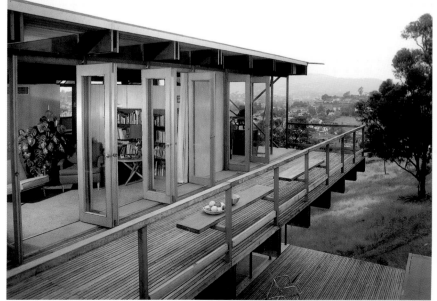

2202 Smith and Williams
Mobil Station, Anaheim, California
May 8, 1956

Four canopies, sheltering the pump areas, cluster around a single pedestrian island. The 40-square-foot roof structures are suspended from pipe columns, 16 inches in diameter, through steel cables. The gas pumps hang free of the ground on a steel beam. Located on Harbor Boulevard, at the intersection of two major boulevards, the floating umbrellas function as billboards for approaching drivers.

Vier separate Schirmdächer überspannen den Tanksäulenbereich und die zentrale Fußgängerinsel. Jedes Dach ist an Stahlkabeln von einem jeweils 40 cm dicken zentralen Pylon abgehängt. Auch die Tanksäulen hängen an einem Stahlträger, ohne den Boden zu berühren. Die schwebenden Schirmdächer an der Kreuzung von zwei Hauptverkehrsstraßen weisen Autofahrer schon von weitem darauf hin, dass sie hier tanken können.

Quatre auvents abritant les pompes sont reliés autour d'un îlot pour piétons. Les modules de 3,70 m² du toit sont accrochés par des câbles en acier à des colonnes creuses de 40 cm de diamètre. Les pompes sont surélevées du sol par des poutrelles d'acier. Situées au croisement de deux grands boulevards, ces ombrelles flottantes opèrent aussi comme une enseigne.

Selected - *Architectural Forum, August 1957*
Bibliography: - *L'Architecture d'Aujourd'hui, April-May 1959*

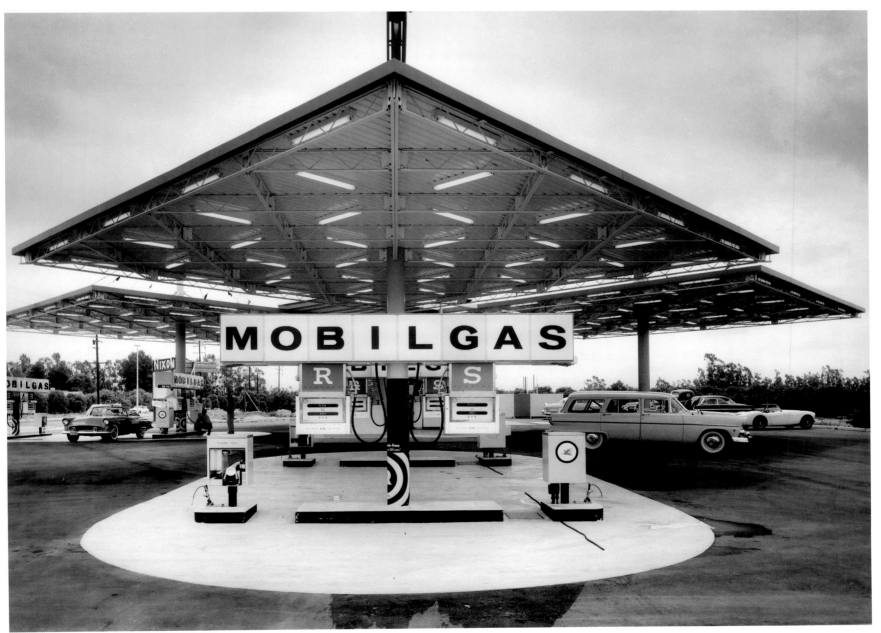

2224 Maynard Lyndon
28th Church of Christian Science, Westwood, California
June 19, 1956

The design springs from the tenets of Christian Science. Lyndon's personal exposure to the religious group (his wife was a practitioner of the Christian Science faith), made him aware of the particular needs of the community. Neither customary rituals, such as weddings and funerals, nor symbolic artwork would occupy the space of the church.

The scheme comprises two main volumes: the Sunday school, a remodeled construction previously serving as the church, and the 800-seat auditorium, which is an entirely new element. As for program requirements, the house of worship would be used only for services conducted by two Readers. Inside the auditorium, the semi-circular arrangement of the seats gently sloped toward the Reader's podium, emphasizing the dialog between the speakers and the assembly. Two inaccessible sunken gardens at either side of the enclosure, reinforce the central perspective. The ceiling, dotted with point lights, is painted black in stark contrast to the apricot color of the seating area.

The exterior loggia connecting the auditorium with the Sunday school structures the urban image of the religious complex. The loggia elevation curves to follow the site limits and has a counter-curve in the roof of the church. The portico and the concave pierced screen shielding the foyer act as buffers between the auditorium and the traffic outside.

All exterior walls are exposed concrete. The auditorium is made of reinforced concrete with steel trusses for the roof. The Southern California Chapter of the American Institute of Architects listed the Christian Science Church among the greatest examples of Los Angeles architecture created between the years 1947–1967.

Der Entwurf basiert auf den Glaubenssätzen der Christlichen Wissenschaft. Lyndons hatte diese Glaubensrichtung durch seine Frau, die ein aktives Mitglied war, kennengelernt und kannte daher die besonderen Gepflogenheiten und Bedürfnisse der Gemeinde, die weder die üblichen kirchlichen Zeremonien wie Trauungen oder Beerdigungen durchführt, noch ihre Räume mit sakraler Kunst dekoriert. Der Komplex umfasst daher zwei Hauptbaukörper: die Sonntagsschule (Umbau eines früher als Kirche genutzten Bauwerks) und das neue Auditorium mit 800 Sitzplätzen, das nur für die von zwei Vorlesern gehaltenen Gottesdienste genutzt werden sollte. Die im Halbrund angeordneten Sitzreihen senken sich zum Podium ab und weisen so auf den zwischen Rednern und Zuhörern stattfindenden Dialog hin. Zwei abgesenkte und für die Gemeinde unzugängliche »Gärten« zu beiden Seiten des Auditoriums verstärken die auf die Mitte des Podiums zulaufende Perspektive. Die mit Punktstrahlern ausgestattete nachtschwarze Decke bildet einen kraftvollen Kontrast zu den aprikosenfarbigen Sitzen.

Die Loggia zwischen Auditorium und Sonntagsschule strukturiert das städtische Erscheinungsbild des Sakralbau-Ensembles. Die Krümmung der Loggia folgt der Grundstücksgrenze, und das Auditoriumdach bildet eine gegenläufige Krümmung. Der Portikus und die konkave Lochwand vor dem Foyer fungieren als Pufferzone zwischen Saal und stark befahrener Straße. Alle Außenmauern bestehen aus Sichtbeton, die Konstruktion des Auditoriums aus Stahlbeton und Stahldachträgern. Die Sektion Südkalifornien des AIA hat die Christian Science Church in die Liste der hervorragendsten Baudenkmäler in Los Angeles aus der Zeit von 1947 bis 1967 aufgenommen.

Ce projet s'inspire directement des principes de la secte de la Christian Science. Comme l'épouse de Lyndon appartenait à cette communauté l'architecte connaissait très bien ses besoins spécifiques. Les rituels habituels, comme les mariages et les enterrements, et les œuvres d'art symboliques n'avaient pas leur place dans ce lieu de culte.

Le plan comprend deux volumes principaux : l'église du dimanche, une construction remodelée qui avait auparavant servi de lieu de culte, et un auditorium de 800 places, entièrement nouveau. Celui-ci sert exclusivement au culte animé par deux « lecteurs ». À l'intérieur, la disposition semi-circulaire des sièges en pente douce vers le podium des lecteurs met en valeur le dialogue entre ceux-ci et l'assemblée. De chaque côté de l'enceinte, deux jardins en creux inaccessibles renforcent l'orientation centrale de la perspective. Le plafond ponctué de points lumineux est peint en noir et contraste avec la couleur abricot des sièges.

La loggia extérieure qui relie l'auditorium à l'école structure fortement l'image urbaine de ce complexe religieux. La façade incurvée reproduit le contour du terrain, tandis que la toiture suit une courbe opposée. Le portique et l'écran perforé qui abritent le foyer jouent un rôle de tampon entre l'auditorium et la circulation automobile. Tous les murs extérieurs sont en béton brut. L'auditorium est en béton armé et la charpente en acier. Le chapitre de Californie du Sud de l'AIA mentionne la Christian Science Church parmi les plus importantes réalisations architecturales à Los Angeles pour la période 1947–1967.

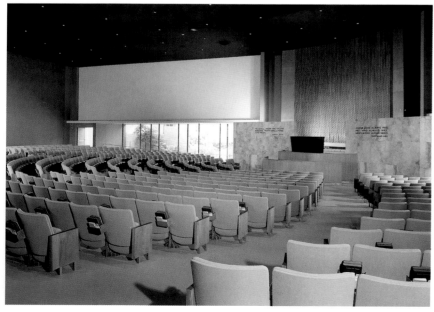

Selected Bibliography:
- Progressive Architecture, October 1956
- Interiors, December 1957
- Architectural Grand Prix, Los Angeles 1967
- Contemporary Backgrounds, Exhibition Catalog, Berkeley 1993

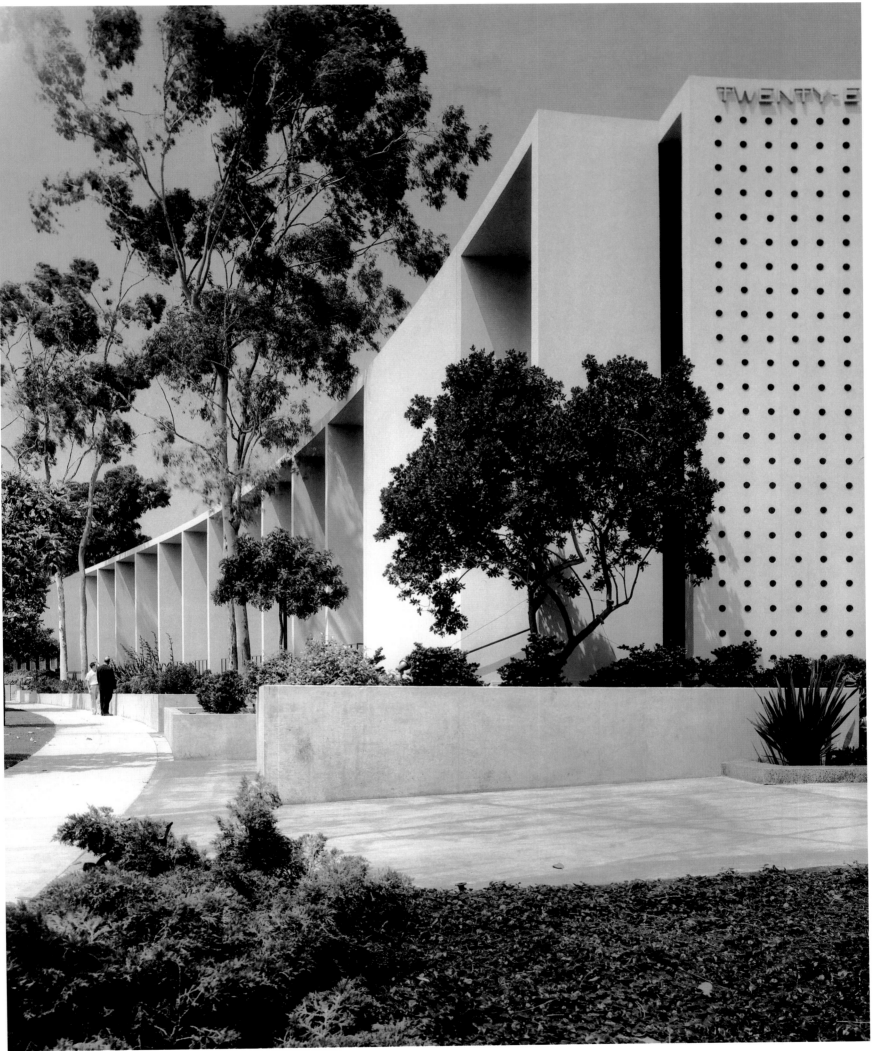

2244 Cliff May
May Residence, Los Angeles, California
August 12, 1956

Cliff May championed the most popular post-and-beam version of the California Ranch House in the Post-War period. His own residence achieved the House & Garden Hallmark in 1957 and was hailed as the model for the American suburban home rooted in the Spanish Californian tradition.

The modern rendition of this building-type had the following characteristics: single-story architecture without changes of level between interior and exterior spaces; a sprawling plan with free-flowing living spaces; outdoor patios as continuation of the interiors; indoor passageways; low-pitched roofs suggesting the idea of shelter; and economy of materials.

The May Residence stood out for its grand scale. 7,000 square feet of covered areas stretched over the flat part of a 20-acre property in Sullivan Canyon, four minutes from the owner's office on Sunset Boulevard. The site was covered with plants and trees of various species which the architect tried to preserve and integrate into the plan. May grouped the living activities into five distinct areas: entrance, guest wing, living-dining room, kitchen and children's wing, and master bedroom wing. Nine patios extended the different areas of the house.

A low overhang shaded the entry path from the carport. The hallway merged into a 1,600 square-foot living room, matched by the main terrace of similar size on one side and another generous open space on the other. This space could hold as many as 200 guests. Adjacent to the living-dining area, the kitchen had a central position in the layout and buffered the sleeping areas.

Materials gave a quasi-rustic look to the residence. The interior walls were either pine planking painted white or plaster finished. The ceiling was a decorative and inexpensive two-inch-pine split along grain to add texture. Almost every room had quarry tile flooring, including the patios.

In der Nachkriegszeit baute Cliff May eine Reihe der beliebtesten Versionen des kalifornischen Rancherhauses. Sein eigenes Haus erhielt 1957 die »House & Garden Hallmark«, eine Auszeichnung, die einer Goldmedaille gleichkommt, und galt als Modell für das in der spanisch-kalifornischen Tradition stehende amerikanische Einfamilienhaus. Die moderne Fassung dieses Haustyps wies folgende Merkmale auf: Bungalow ohne Höhenunterschied zwischen Innen und Außen, frei fließende, großzügige Innenräume, Wohnterrassen und Patios, Innenpassagen, flache Satteldächer und sparsam eingesetzte Materialien.

Das Haus May ist schon allein aufgrund seiner Größe ein besonders herausragendes Beispiel: Es umfasst eine Fläche von 645 m^2 auf dem ebenen Teil eines 20 Morgen großen Landbesitzes im Sullivan Canyon, vier Autominuten entfernt vom Büro des Architekten am Sunset Boulevard. May bemühte sich, den Baumbestand und die Vegetation des Geländes zu erhalten und in das Haus einzubeziehen. Er gliederte die überbaute Fläche in fünf Bereiche: Eingang, Gästetrakt, Wohn-Esszimmer, Küche und Kinderzimmer, Elternschlafzimmer. Neun Höfe und Terrassen erweitern die Wohnflächen ins Freie. Ein niedriger Dachüberhang schützt den Weg vom Carport zur Haustür. Die Eingangshalle geht in den knapp 147 m^2 großen Wohn-Essraum über, an den sich im Garten die fast ebenso große Hauptterrasse auf der einen und eine zweite großzügige Terrasse auf der anderen Seite anschließen. Die angrenzende Küche nimmt die Mitte des Grundrisses ein und bildet die Pufferzone zwischen Wohnbereich und Schlafzimmern. Die Materialien verleihen dem Haus eine rustikale Anmutung. Die Innenwände ließ May entweder verputzen oder mit weiß gestrichenen Kiefernholzbrettern verschalen. Die Deckenverkleidungen bestanden aus schmalen Kiefernholzlatten, die – entlang der Maserung gespalten – eine interessantere Oberfläche ergaben. Fast jeder Raum war mit Natursteinplatten ausgelegt, einschließlich der Terrassen.

Après la guerre, Cliff May s'était fait le défenseur d'une version « poteaux et poutres » de la maison style « California Ranch ». Sa propre résidence fut distinguée dans le « House & Garden Hallmark » de 1957 et applaudie comme un modèle de maison de banlieue américaine qui avait su trouver des racines dans la tradition espagnole californienne. Cette version moderniste de ce type de construction présentait les caractéristiques suivantes : construction sur un seul niveau, espaces intérieurs et extérieurs au même niveau, plan étalé, espaces de séjour à circulation libre, patios extérieurs prolongeant l'intérieur, passages intérieurs couverts, toit en pignon surbaissé suggérant une idée d'abri, économie des matériaux. La May Residence est remarquable par son échelle. Les surfaces couvertes représentent 645 m^2, implantés sur la partie plate d'une propriété de dix hectares dans Sullivan Canyon, à quatre minutes de l'agence de l'architecte sur Sunset Boulevard. Le terrain était surchargé de plantes et d'arbres d'espèces diverses que May essaya de conserver et d'intégrer dans son plan. Il regroupa les fonctions en quatre zones distinctes : entrée, aile des invités, séjour-salle à manger, cuisine et aile des enfants, aile de la chambre principale. Neuf patios prolongeaient ces différentes zones. Une avancée de toit surbaissée sépare l'allée de l'entrée qui part de l'abri à voitures. Le hall d'entrée donne sur un séjour de 147 m^2, auquel correspondent une terrasse principale de surface équivalente d'un côté et un autre vaste espace ouvert de l'autre. Celui-ci pouvait accueillir plus de 200 invités. Adjacente au séjour-salle à manger, la cuisine occupe une position centrale et protège la zone des chambres. Les matériaux donnent une apparence quasi rustique à l'ensemble. Les murs intérieurs sont soit habillés de planches de pin, soit peints en blanc ou finis au plâtre. Le plafond, décoratif et économique, est en lattes de pin coupées dans le sens de la veine. Chaque pièce ou presque possède un sol en terre cuite, y compris les patios.

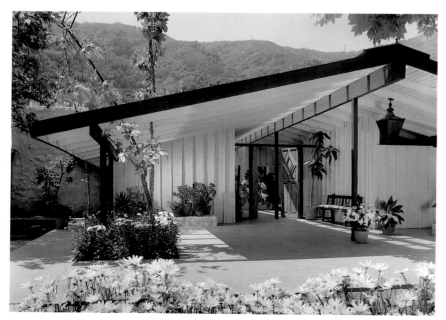

Selected Bibliography:
- House & Garden, February 1957
- House & Garden's Book of Building, Spring-Summer 1957
- House & Home, September 1957
- Sunset, February 1958

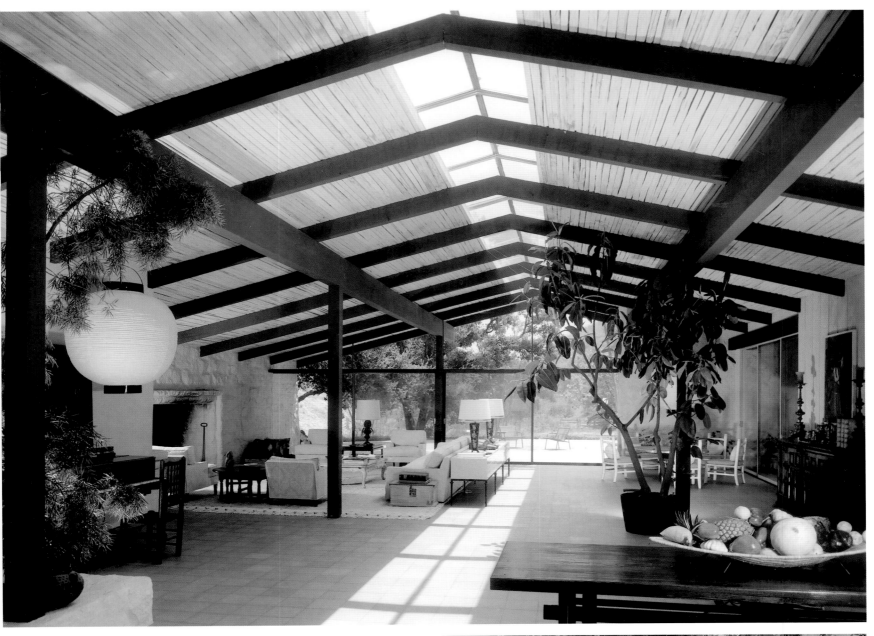

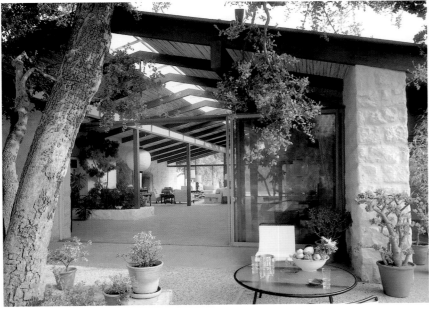

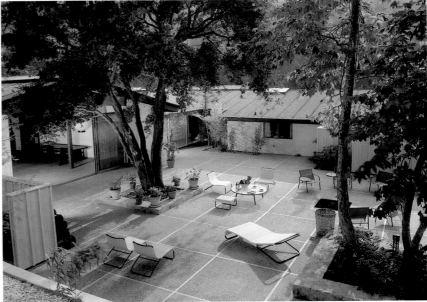

2368 Dan Saxon Palmer and William Krisel
Alexander Residence, Smoke Tree Valley Estate, Palm Springs, California
March 21, 22, 1957

The Alexander Residence is one of the 66 tract houses of the "Smoke Tree Valley" estate, a development project designed for a flat site. Great attention was paid to tone down the tract look as it had been standardized in the building industry. Intended as a weekend or second home for a family residing elsewhere, each unit is 1,600 square feet in size, and zoned in three bedrooms, two bathrooms plus a 30-foot living room with fireplace. Pools and patio areas enhance outdoor living. The architects generate numerous permutations from the typical single floor template to add variety to the residential complex. Some of the variations include: change in orientation and fenestration; "flopping" of the plan; diversity of rooflines; reversal of the location of the bath and air-conditioning; and mixed materials for the exterior finishes. The structural system is post-and-beam, with non-bearing interior walls.

Das Haus Alexander ist eines von 66 Siedlungshäusern im Flachland des Smoke Tree Valley. Große Sorgfalt wurde darauf verwendet, das übliche einförmige Erscheinungsbild der standardisierten Fertighäuser derartiger Siedlungen zu vermeiden. Jedes Haus war als Wochenendhaus bzw. Zweitwohnsitz für eine Familie gedacht und umfasste drei Schlafzimmer, zwei Bäder und einen großen Wohnraum mit offenem Kamin auf insgesamt knapp 150 m². Gartenterrasse und Schwimmbecken bieten sich zum Wohnen und Entspannen an der frischen Luft an. Aus dem Regelgrundriss entwickelten die Architekten zahlreiche Varianten, um die Siedlung abwechslungsreicher zu gestalten, indem sie die Häuser verschieden ausrichteten, die Fenster veränderten, den Grundriss umdrehten, andere Dachkonturen entwarfen oder unterschiedliche Fassadenverkleidungen wählten. Die Häuser entstanden in Pfosten-und-Riegel-Bauweise und haben nicht-tragende Innenwände.

La résidence Alexander est l'une des 66 maisons individuelles du domaine de «Smoke Tree Valley», projet de promoteur réalisé sur un terrain plat. Le souci des architectes fut de gommer l'aspect standardisé de ces maisons produites en série. Maison de week-end ou résidence secondaire pour familles, chacune mesure 150 m² et est divisée en trois chambres, deux salles-de-bains et séjour de 9 m de long équipé d'une cheminée. Des bassins et un patio améliorent l'environnement immédiat. Les architectes étudièrent de multiples variations par rapport au plan de base pour donner un peu de variété à ce complexe. Parmi ces variantes : changement d'orientation et de fenêtrage, «assouplissement» du plan, diversification des profils des toits, inversion de l'implantation de la salle de bains et air conditionné, diversification des matériaux de finitions extérieurs. L'ossature est à poteaux et poutres, les murs intérieurs ne sont pas porteurs.

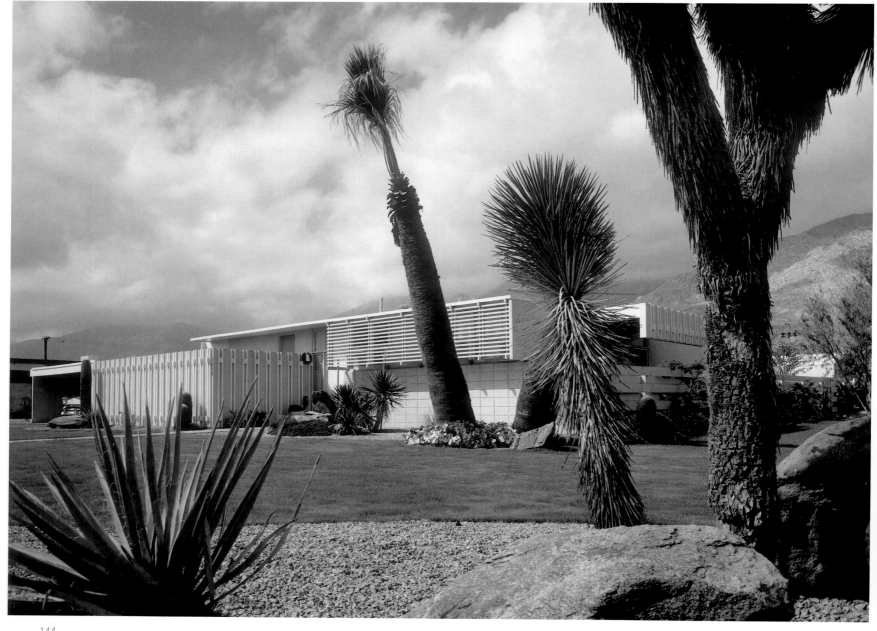

Selected - Progressive Architecture, March 1958
Bibliography: - Arts of Southern California-I Architecture,
 Long Beach Museum of Art, 1957

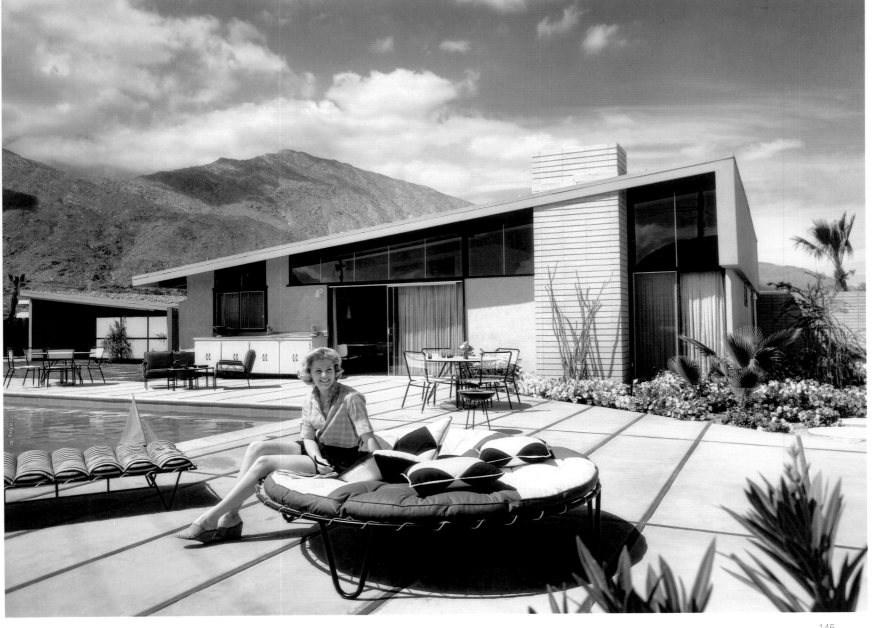

2402 William S. Beckett
Fenn Residence, Fresno, California
May 23, 1957

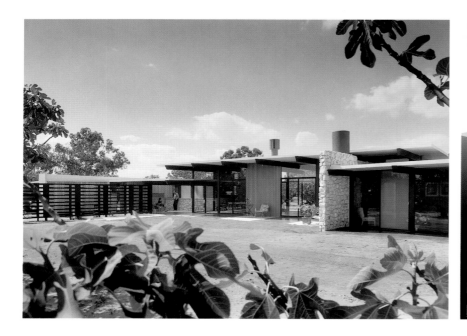

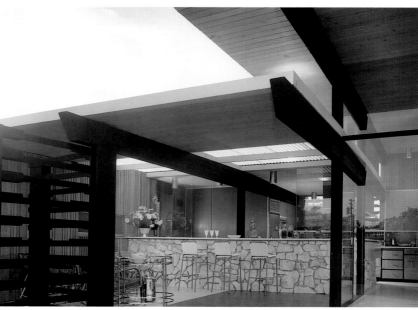

This residence meets the demands of a young couple and their three children. On a plot of land harbouring an old fig tree grove, the architect crafted a domestic setting for informal while afforcing personal space for each occupant. To protect the family from the summer heat, Beckett suspends a flat shelter on a structural cage shading the communal areas. Floor-to-ceiling glass sheets between the posts on both sides make the living and dining room transparent all the way through. The long beams extend beyond the roof acting as independent architectural elements.

The entry pierces a plaster wall, which is windowless and private from the street side. Behind this monolithic threshold, family life unfolds in a pavilion-like construction divided in two portions. In the first wing, the communal space reaches out to the landscape, blurring the separation between interior and exterior. The sleeping areas, by contrast, cluster around the more solid volume of the second wing. The diamond-like fireplace virtually separates the living room from the dining area.

The checkered paving, all terrazzo, makes visible the ten-foot module that disciplines the plan layout. In contrast to the underlying grid, the master bedroom follows a 10-degree rotation. According to the clients' specifications, redwood was the principal material for the interior and exterior walls. The interplay between redwood, glass and stone is a distinctive character of the architecture. Avocado and pumpkin yellow paints, and black, yellow and white stain define the color scheme of the house.

Das Haus entstand für ein junges Ehepaar mit drei kleinen Kindern auf einer Parzelle, die zu einem alten Olivenhain gehörte. Der Architekt schuf Räume für ein zwangloses Familienleben, aber auch je einen geschlossenen Raum als »Rückzugsgebiet« für jedes Familienmitglied. Zum Schutz gegen die Sommerhitze hängte Beckett einen flachen Baldachin in einen Skelettrahmen, der den Wohnräumen Schatten bietet. Raumhohe Verglasungen zwischen den Pfosten zu beiden Seiten machen das Wohnzimmer im wahrsten Sinne des Wortes »durchsichtig«. Die langen Deckenträger verlängern sich über die Dachkante hinaus als selbständige architektonische Elemente.

Der Hauseingang durchstößt eine zur Straße hin fensterlose Putzmauer. Hinter dieser monolithischen Schwelle vollzieht sich das Familienleben in einem zweiteiligen Bungalow. Im ersten Flügel befinden sich die mit Terrassen in die Landschaft ausgreifenden Wohnbereiche, während die Schlafzimmer im kompakteren zweiten Baukörper untergebracht sind. Der rhombenförmige Kamin fungiert als Raumteiler zwischen Wohnbereich und Essecke. Das großflächige Karomuster der Terrazzoböden lässt das 3 m-Modul des Grundrissrasters erkennen. Aus diesem rechtwinkligen Raster ist das Elternschlafzimmer um 10° herausgedreht. Auf Wunsch der Bauherren wurde Redwood als Hauptmaterial für Innen- und Außenwände eingesetzt. Das Wechselspiel aus Redwood, Glas und Naturstein verleiht dem Haus große Ausdruckskraft. Das Farbschema umfasst Avocado-Grün, Kürbis-Gelb, sowie dazu passend schwarze, gelbe und weiße Lasuren für die Holzflächen.

La maison a été conçue pour un jeune couple et ses trois enfants. Sur une parcelle plantée d'un bosquet d'oliviers anciens, l'architecte a créé un cadre agréable pour une vie familiale sans contrainte, tout en assurant un espace de vie suffisant à chacun de ses occupants. Pour protéger des désagréments de la chaleur estivale, Beckett recouvre d'un toit plat une structure en forme de cage qui abrite les espaces communs. Des panneaux de verre sol-plafond pris dans la trame assurent une transparence totale au séjour et à la salle à manger. Les longues poutres qui prolongent le toit agissent comme des éléments architecturaux autonomes.

Sur la rue, l'entrée est découpée dans un mur crépi sans fenêtre. Derrière ce seuil monolithique, la vie familiale se déroule de façon décontractée dans un volume de type pavillon divisé en deux parties. Dans la première aile, l'espace commun est dilaté vers l'environnement naturel, abolissant la séparation dedans/dehors. Les chambres sont réunies dans le volume plus massif de la deuxième aile. La cheminée en forme de diamant sépare virtuellement le séjour de la salle à manger. Le pavement en damier, tout en terrazzo, reprend la trame de 3 m de côté qui rythme le plan. La chambre principale pivote cependant de 10° par rapport à cette trame. A la demande du client, le bois rouge est le principal matériau des murs intérieurs et extérieurs. Le jeu entre le bois rouge, le verre et la pierre donne une grande vigueur à cette architecture. La gamme chromatique est composée de peintures jaune potiron et vert avocat, et de glacis noirs, jaunes et blancs.

Selected Bibliography:
- L'Architecture d'Aujourd'hui, September 1957
- arts & architecture, May 1960

2410 **Rex Lotery**
Schacker Residence, Beverly Hills, California
June 7, 1957

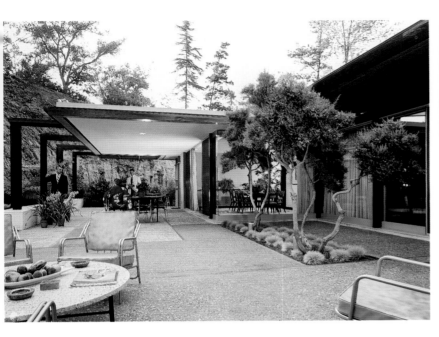 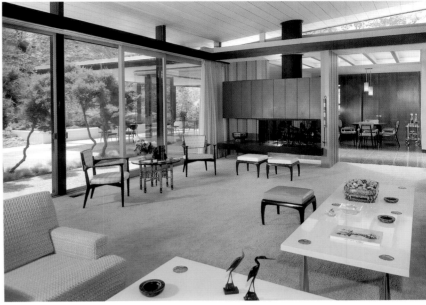

Active socializing was a significant component in the owners' routine. A middle-aged couple living alone required a domestic setting for two types of entertainment: small groups events and large gatherings.

The architect's solution was a cascade of social spaces of variable size. On the elevation toward the driveway oriented north, a glass-enclosed gallery introduces the guests to a space geared for gregarious interaction. Starting from the entry, a sequence of communal zones unfolds to accommodate various formats: a garden room connects to the dining room, which opens to a veranda for outdoor dining, linked to a larger terrace, accessible from the living and the sitting rooms. All these areas can be either used separately or joined together. Two distinct sections divide the house: one comprises the living room, dining room, covered dining terrace and garden room; the other has a sitting room with two bed alcoves, dressing rooms, and baths at either ends.

The glass plane of the front gallery folds toward the terrace with a sharp angle reaching the beginning of the sloping roof, which seems to be floating above the living room. A high slope with a grove of eucalyptus trees at the top shelters the west exposure of the rear of the house. Construction is a wood frame, with concrete slab floor, stone and vertical cedar siding on the exterior. Floors are finished in terrazzo or carpeted. The Schacker Residence won an Award of Merit in the 1957 edition of the Western Home Awards.

Im Leben der Bauherren – ein kinderloses Ehepaar in den besten Jahren – wurde Gastlichkeit groß geschrieben. Sie brauchten daher ein Haus, das sich sowohl für Abendessen im kleinen Kreis als auch für große Gesellschaften eignete.

Zu diesem Zweck schufen die Architekten eine Folge geräumiger Salons und Gartenterrassen. Von der nach Norden gelegenen Vorfahrt gelangen die Gäste über eine verglaste Eingangsgalerie in diese Räume: An ein Gartenzimmer schließt sich das Esszimmer an, das seinerseits den Zugang auf eine überdachte Terrasse eröffnet, die Platz für mehrere Esstische bietet. Diese »Veranda« geht in die größere Gartenterrasse vor den Wohnräumen über. Alle Räume lassen sich entweder getrennt oder zusammen nutzen, wobei Wohn- und Esszimmer, Veranda und Gartenzimmer den einen Teil des Hauses bilden und ein Salon mit zwei Schlafnischen, Ankleideräumen und Bädern den anderen. Die Glasfront der Eingangsgalerie reicht bis zur Terrasse und stößt an die Traufkante des über dem Wohnbereich »schwebenden« geneigten Daches. Ein hoher mit Eukalyptusbäumen bestandener Hang schützt die Westfassade vor Wind und Wetter. Die Konstruktion (Holzrahmenfachwerk) steht auf einer Betongründungsplatte, die Fassaden sind mit Naturstein und lotrecht verlegten Zedernholzbrettern verschalt. Die Bodenbeläge bestehen entweder aus Terrazzo oder Teppichboden. Das Haus Schacker erhielt 1957 im Rahmen der Western Home Awards einen Award of Merit.

Les propriétaires, un couple en retraite, menaient une vie mondaine active. Ils souhaitaient un cadre moderne qui leur permette de recevoir de petits groupes d'amis ou de donner de grandes réceptions.

La solution de l'architecte prend la forme d'une cascade d'espaces de réception de dimensions variées. Sur la façade côté allée d'entrée, une galerie à parois de verre introduit les invités dans un espace propice aux présentations. A partir de l'entrée, une succession de zones communes de différentes tailles se déploie : une pièce-jardin prolonge la salle à manger qui s'ouvre sur une véranda sous laquelle on peut également dîner, et qui est reliée à une vaste terrasse accessible du séjour et des salons. Toutes ces pièces et espaces peuvent être utilisés séparément ou réunis. La maison est divisée en deux parties distinctes : l'une comprend le séjour, la salle à manger, la terrasse couverte pour les repas et la pièce-jardin, l'autre possède un salon avec deux alcôves où l'on peut dormir, des dressings et des salles de bains des deux côtés. Le panneau de verre de la galerie d'entrée s'abaisse en angle aigu vers la terrasse et rejoint l'extrémité du toit en pente douce qui semble flotter au-dessus du séjour. Un remblais planté en son sommet d'un bosquet d'eucalyptus protège la façade ouest à l'arrière de la maison. La maison est construite a partir d'une ossature en bois, sur dalle de béton, avec habillage en pierre et un bardage verticale en cèdre. Les sols sont en terrazzo ou moquettés. La Shacker Residence a remporté un prix du mérite aux Western Home Awards 1957.

Selected Bibliography:
- Sunset, October 1957
- Book of Homes 15
- Architectural Record, July 1958

2416 Mario Corbett
Spaulding Residence, Pacific Palisades, California
June 17, 1957

Mario Corbett was a San Francisco-based architect hailed by *LIFE* magazine as a representative of the Bay Area Style. In this Southern Californian commission, he shapes a curvilinear silhouette for the house to preserve an existing 60-year-old planted redwood grove. Arranged on three levels to follow the topography of the site, the structure accommodates the needs of a family of four. The plan curves in the carport and the children's room, straightens in the collective spaces and the master bedroom. Two patios flank the living-dining areas for outdoor family activities. An exterior path steps up to reach the terrace used as an entry court giving access to the living room. Inside, a corridor provides interior circulation to the separate levels. The geometry of the fenestration is echoed in the paneling of the partitions. The skylight above the glass wall of the living area extends to fill the entire length of the living room.

Mario Corbett war ein in San Francisco ansässiger Architekt, den das Magazin »LIFE« als Vertreter des sogenannten Bay-Area-Stils würdigte. Dieses Einfamilienhaus für eine vierköpfige Familie in Südkalifornien baute er mit geschwungenen Umrissen um die 60 Jahre alten Redwood-Bäume auf dem Grundstück herum und legte es der Topographie folgend auf drei Ebenen an. Im Bereich von Garage und Kinderzimmer ist die Außenfassade gekrümmt, während sie sich bei den Wohnräumen und dem Elterschlafzimmer begradigt. Zwei Wohnhöfe flankieren den Wohn-Essraum. Ein Gartenweg führt über Stufen zur höherliegenden Terrasse, die zugleich als Eingangshof zum Wohnbereich und zum Haus überhaupt fungiert. Innen führt ein Korridor zu den verschiedenen Ebenen. Die Geometrie der Fenster wird in den gläsernen Raumteilern aufgegriffen. Die Glasfront des Esszimmers ist in das Dach fortgesetzt, so dass über die ganze Länge des Wohnraums ein Oberlichtband entsteht.

Mario Corbett, architecte à San Francisco, avait été présenté par le magazine « LIFE » comme parfait exemple du style de la Bay Area. Pour cette commande en Californie du Sud, il imagina un profil curviligne pour préserver un bosquet de bois rouge sexagénaire. Etagée sur trois niveaux pour respecter la topographie du terrain, la maison répond aux besoins d'une famille de quatre personnes. Le plan s'incurve au niveau de l'abri aux voitures et de la chambre des enfants et retrouve son caractère rectiligne dans les espaces communs et la chambre principale. Deux patios flanquent la zone de séjour et des repas. Une rampe extérieure s'élève vers la terrasse qui fait fonction de cour d'entrée à côté du séjour. A l'intérieur, un corridor assure la circulation entre les différents niveaux. La géométrie du fenêtrage fait écho avec les panneaux des cloisonnements. Le mur de verre de la salle à manger se replie vers le toit pour former une longue verrière sur toute la longueur du séjour.

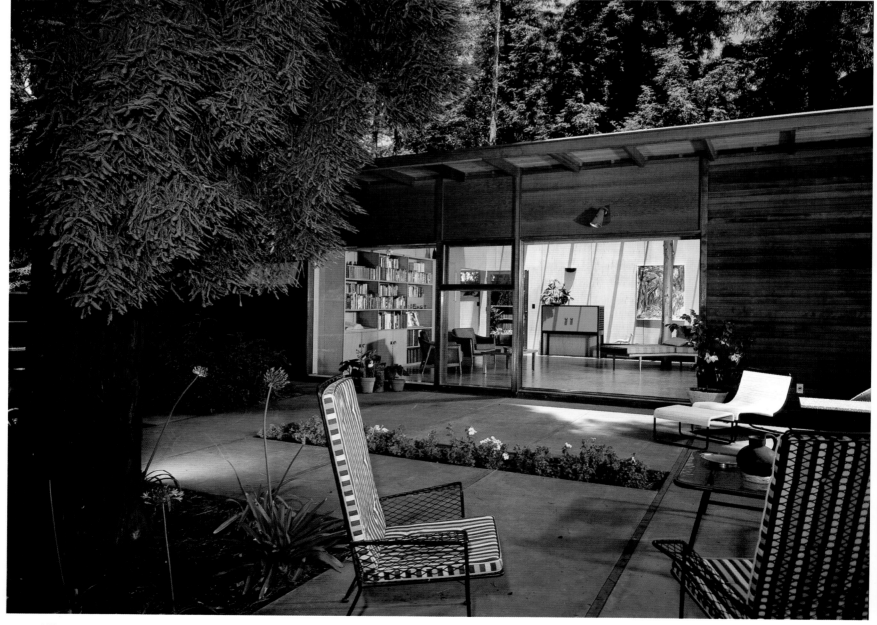

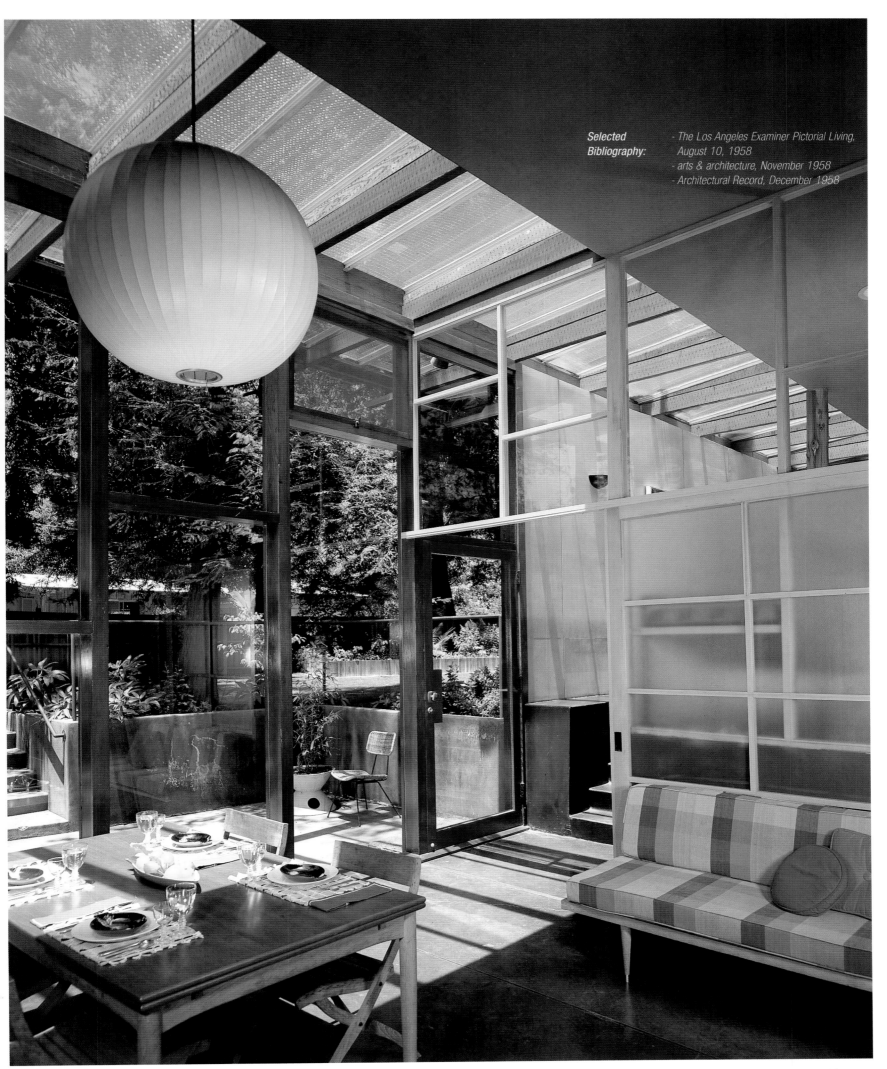

Selected
Bibliography:
- The Los Angeles Examiner Pictorial Living,
 August 10, 1958
- arts & architecture, November 1958
- Architectural Record, December 1958

2422 William S. Beckett
Cooper Residence, Beverly Hills, California
June 28, 1957

Cypress boards of variable widths pattern the walls and the underside of the roof of the family room. Flooring material is random-width oak and stained black board. To increase the scale of this area, the ceiling reaches the ridge of the roof, following its slope. The bar counter continues its circle beyond the glass line for indoor-outdoor service.

Unterschiedlich breite Zypressenholzbretter bedecken die Wände und Decken des Familienwohnzimmers, das mit verschieden breiten Eichendielen und schwarz gebeizten Brettern ausgelegt ist. Die Decke folgt der Steigung des Daches bis zum First und lässt den Raum geräumiger wirken als er eigentlich ist. Die ringförmige Bar setzt sich durch die Glaswand nach draußen fort, so dass sie auch von der Terrasse aus genutzt werden kann.

Des planches de cyprès de diverses largeurs donnent un rythme aux murs et aux faces internes du toit du séjour familial. Les sols sont en lattes de chêne de largeurs variées et de planches teintées noir. Pour accroître l'échelle de cette pièce, le plafond touche l'arête du toit et suit la pente de celui-ci. Le bar poursuit le cercle qui part de l'intérieur de l'autre côté du mur de verre pour permettre le service à l'extérieur.

Selected Bibliography: - House & Garden, February 1960

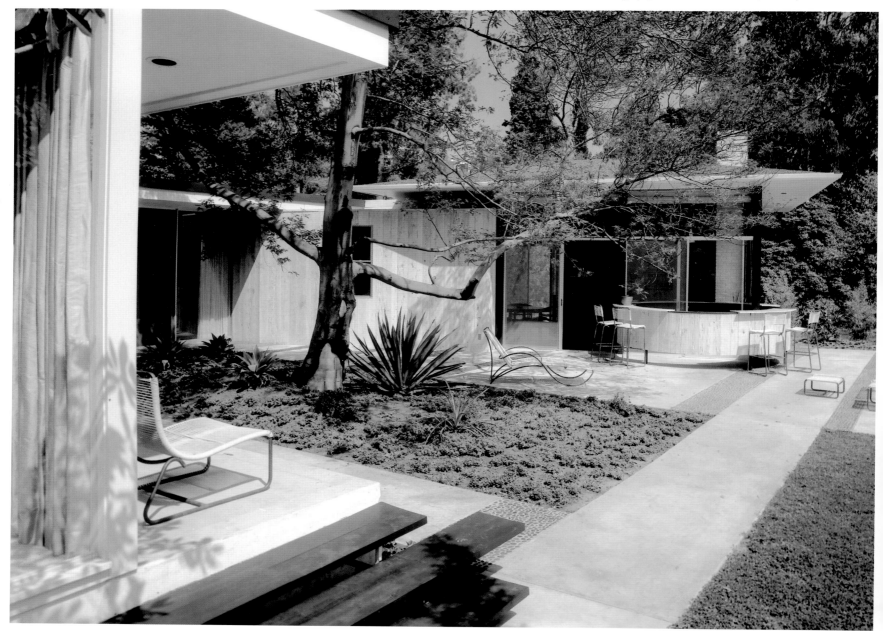

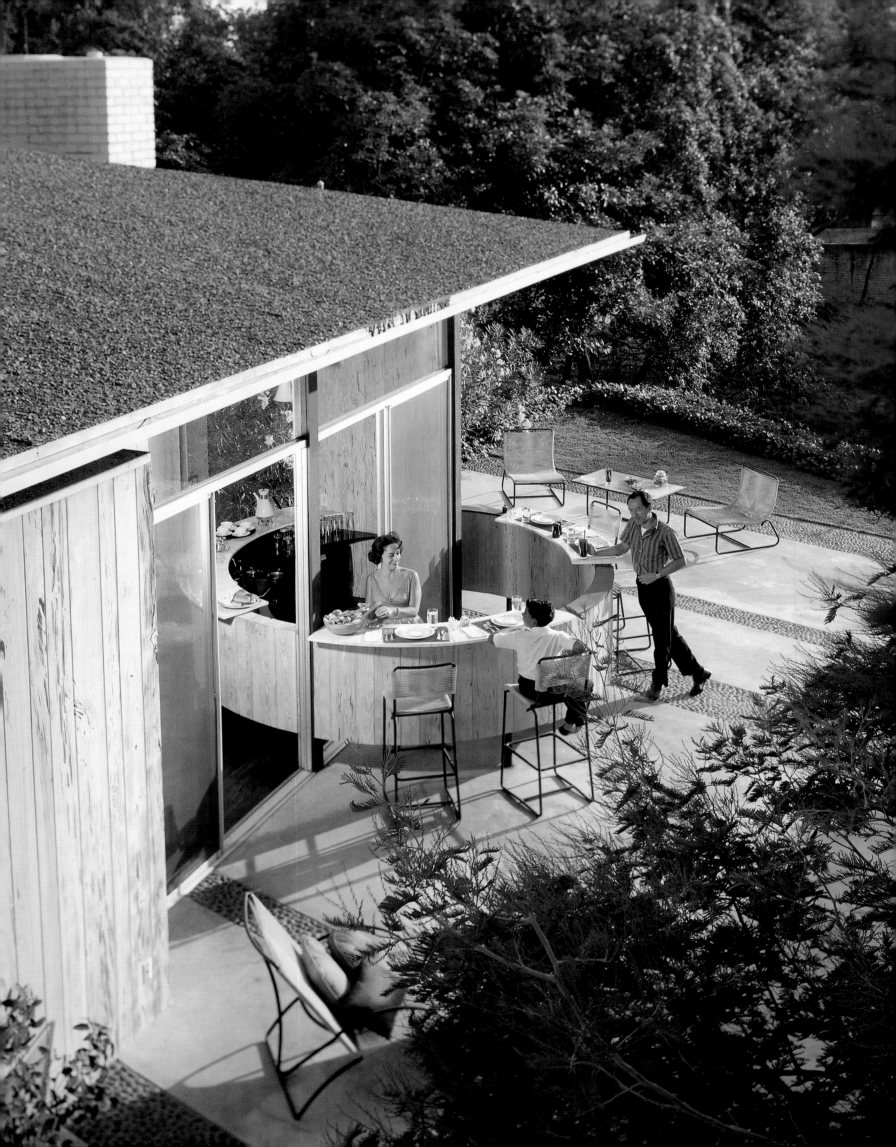

2455 Carl L. Maston
Dunham Residence, Pasadena, California
July 30, 1957

The clients, a couple with one child, wanted to preserve the natural setting of their property. Originally the site was part of a much larger estate. Once the land was subdivided, the remaining portion presented a richly planted garden with several oak trees, a wide variety of shrubs and a millpond.

Maston positions the larger volume of the residence in the center of the parcel along the east-west axis. On the lower level, the main living areas extend outdoors and blend into the surrounding landscape. Upstairs the sleeping areas occupy a vantage-point overlooking the pond and the neighboring hills. The second story bridges over part of the ground floor, creating a covered terrace for the dining room toward the pool.

The ample gesture of the roofline parallels in scale the contours of the topography. Surfaces of glass meet the underside of the canopy to further underscore its presence in the natural scenery. The load-bearing structure is post-and-lintel wood framing. North and south elevations display rectangular fields of fixed-glass and painted wood panels of Douglas fir. For the exterior walls redwood planking is alternated with natural field stone walls. Walnut plywood is the primary component for the interior finish. In 1956, the Dunham Residence won a Progressive Architecture Design Award in the residential category.

Die Bauherren (ein Ehepaar mit Kind) wollten die natürliche Vegetation auf ihrem Grundstück erhalten, Teil eines ehemals großen, dann parzellierten Gutshofes. Das Gartengrundstück war außer mit Kiefern mit vielen verschiedenen Ziergehölzen und alten Eichen bewachsen und umfasste einen Mühlteich.

Maston stellte den größeren Baukörper des Hauses mit Ost-West-Orientierung in die Mittel der Parzelle. Die Hauptwohnräume auf der unteren Ebene gehen fließend in den Garten über und verbinden das Haus mit der Landschaft. Von den Zimmern im Obergeschoss blickt man auf den Mühlteich und die benachbarten Hügel. Die obere Etage überbrückt teilweise das Erdgeschoss und bildet so das Dach der Terrasse zwischen Esszimmer und Schwimmbecken im Garten.

Das weit ausgreifende Satteldach geht auf die Topographie ein und überspannt den auf der ganzen Breite voll verglasten Wohnraum. Das Holztragwerk besteht aus Pfosten und Riegeln. Die Fassaden nach Norden und Süden sind jeweils mit Rechteckfeldern gegliedert (Glas und farbig gestrichene Douglaskiefernpaneele). Die übrigen Fassadenflächen sind mit Redwoodbrettern oder Feldsteinmauerwerk verkleidet. Im Innenausbau wurde vor allem Nussbaum-furniertes Sperrholz verwendet. 1956 erhielt das Haus Dunham in der Kategorie Wohnhäuser einen Progressive Architecture Design Award.

Les clients – un couple et un enfant – souhaitaient préserver le cadre naturel de leur propriété. A l'origine, le terrain faisait partie d'un domaine beaucoup plus vaste. Le lotissement avait laissé une parcelle comprenant un jardin planté de nombreux chênes, de buissons variés et un étang.

Maston a placé le volume le plus important au centre de la parcelle sur un axe est-ouest. Au niveau inférieur, les pièces de séjour s'ouvrent sur l'extérieur et se fondent dans le paysage environnant. Au niveau supérieur, les chambres bénéficient de la vue sur l'étang et les collines avoisinantes. L'étage forme pont au dessus du rez-de-chaussée, créant une terrasse couverte pour la salle à manger qui donne sur l'étang.

Le geste généreux du toit suit le profil du terrain. Les panneaux de verre qui remplissent l'espace entre les baies et la couverture accentuent la présence de celle-ci. La structure porteuse est une ossature à piliers et linteaux en bois. Les façades nord et sud sont fermées par des baies vitrées fixes et des panneaux de pin de Douglas peints. Pour les murs extérieurs, le bardage de bois rouge alterne avec la pierre naturelle. Le contreplaqué de noyer est le principal matériau intérieur.

En 1956, la Dunham Residence a remporté un prix de l'Architecture Progressive dans la catégorie résidences privées.

Selected Bibliography:
- Progressive Architecture, January 1956
- arts & architecture, June 1956
- Progressive Architecture, May 1958

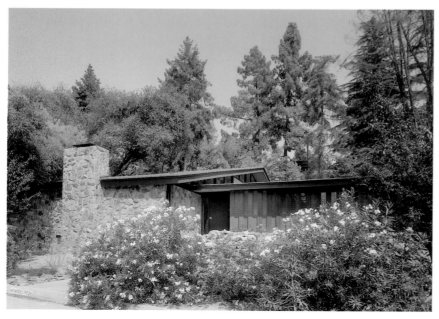
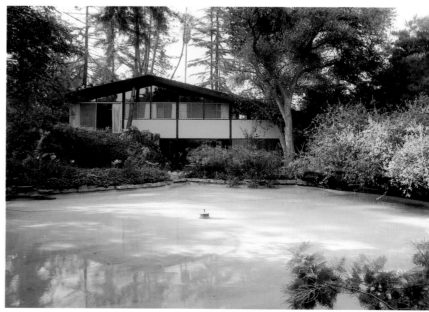

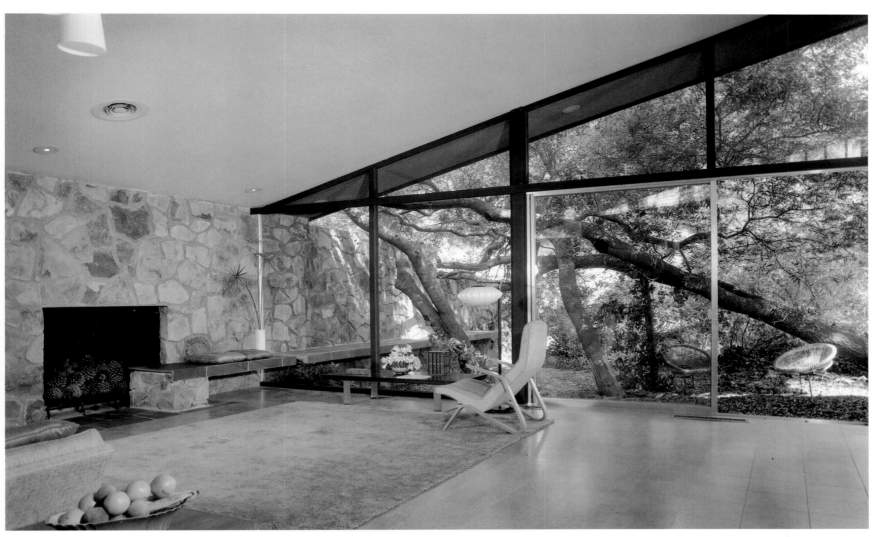

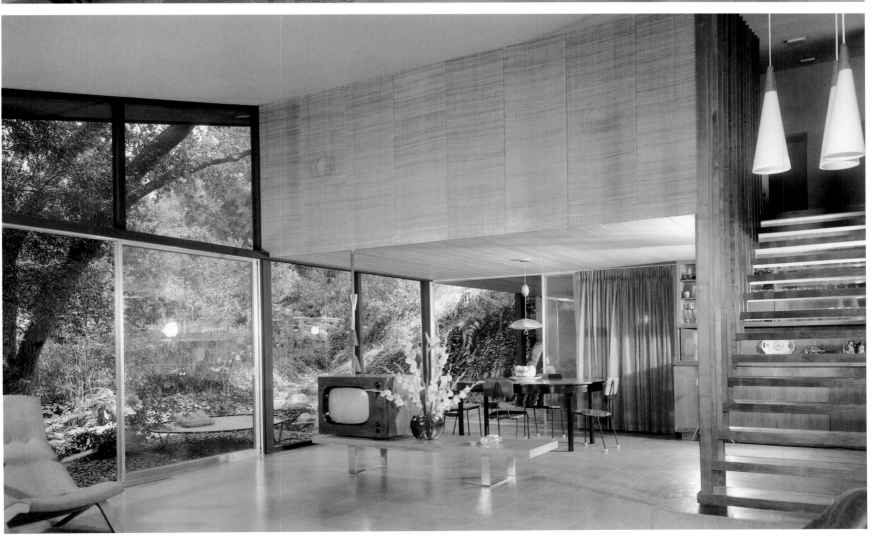

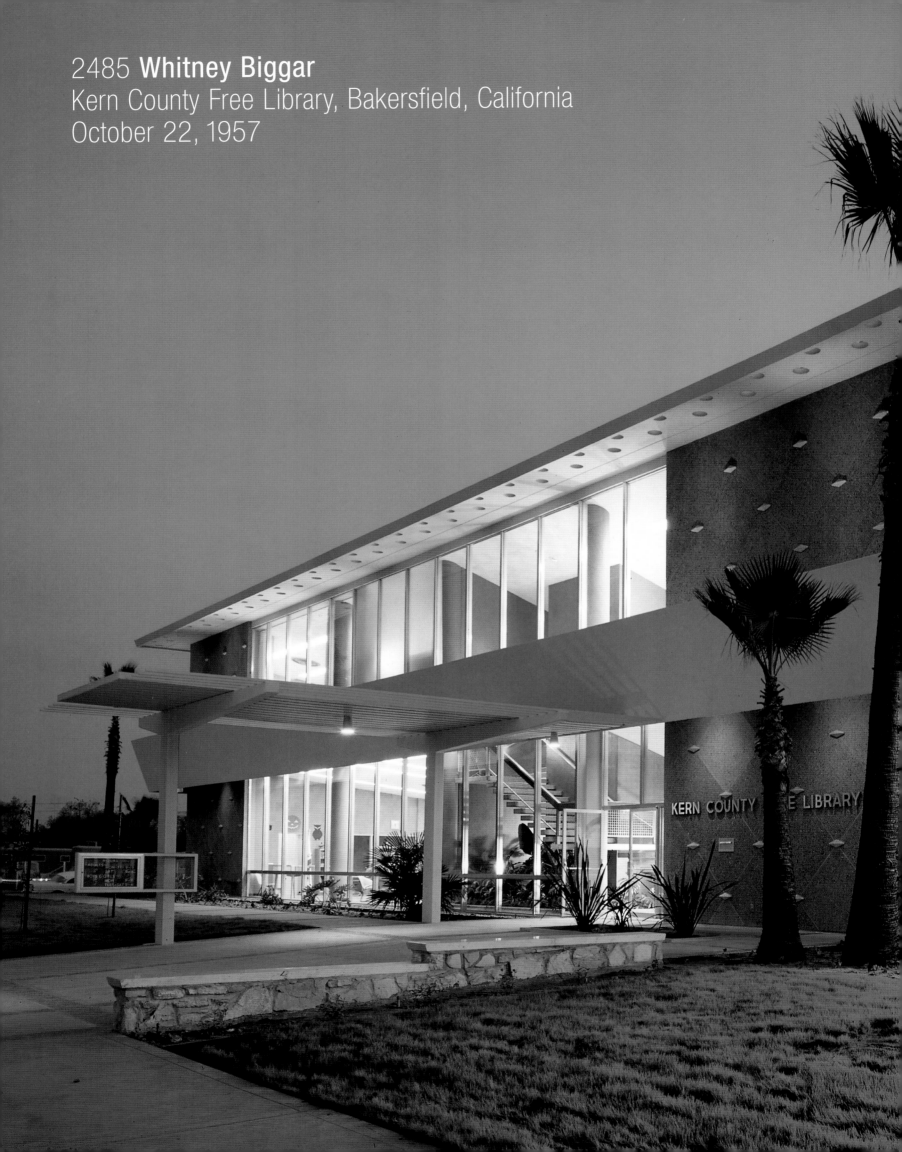

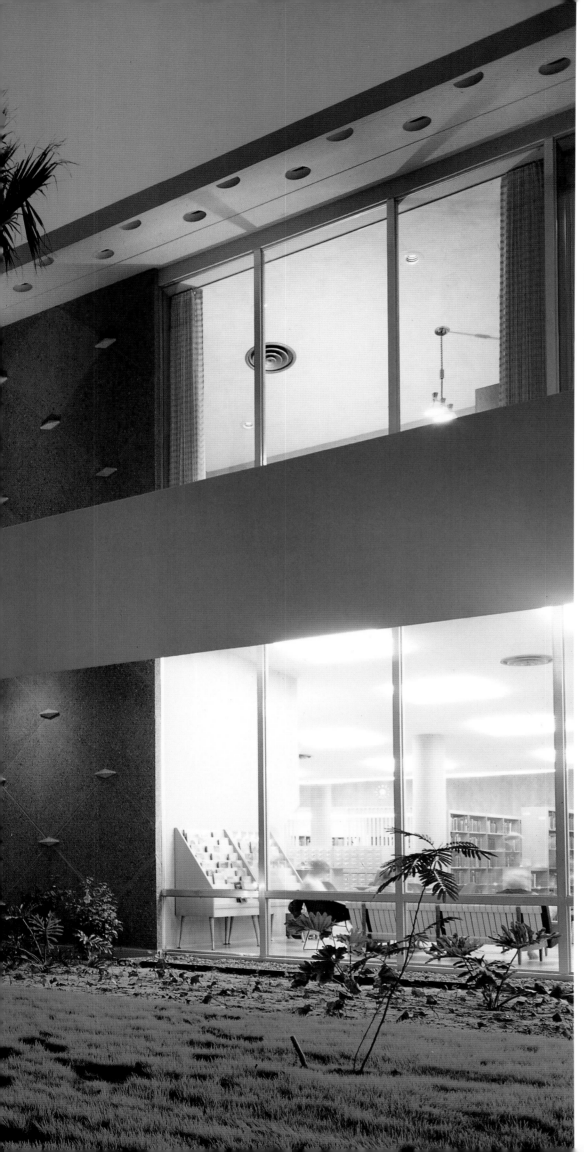

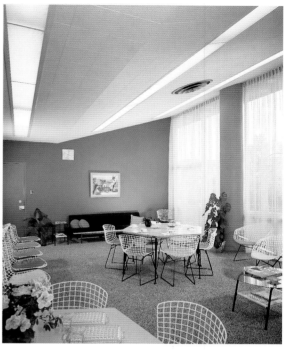

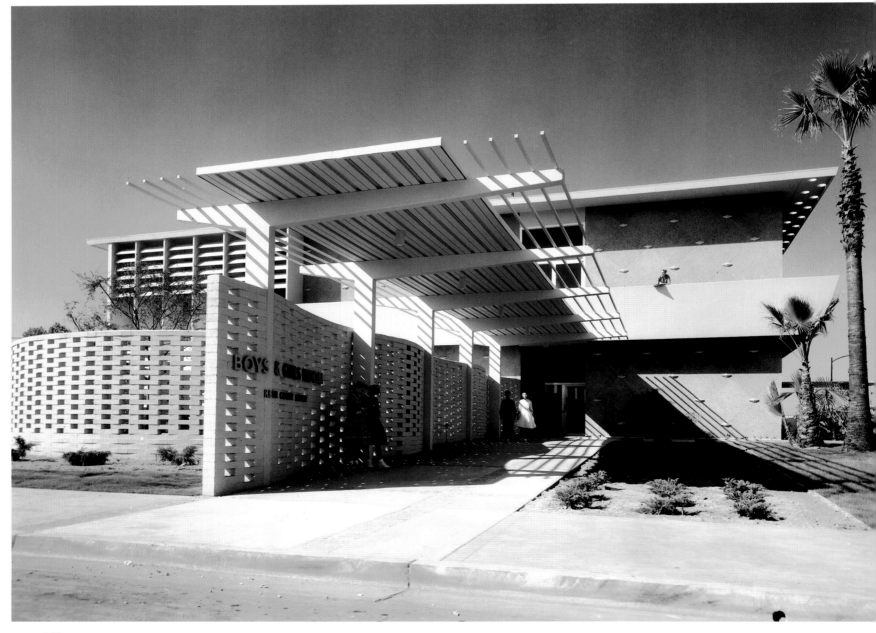

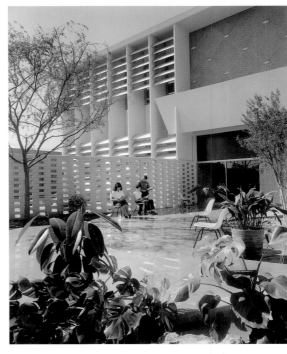

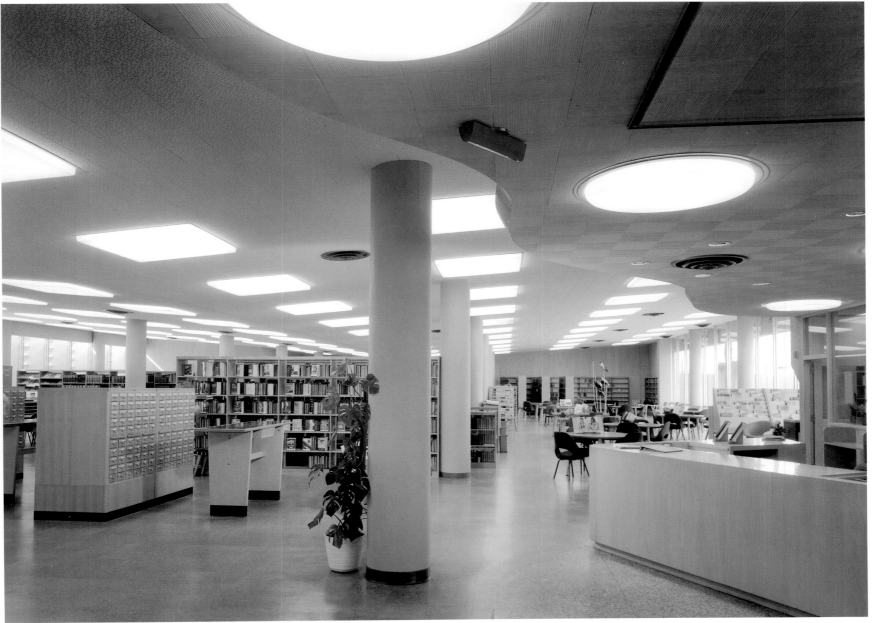

2505/2551 **Paul László**
McCullogh Motors, Office and Showroom, Los Angeles, California
November 28, 1957; December 7, 1957

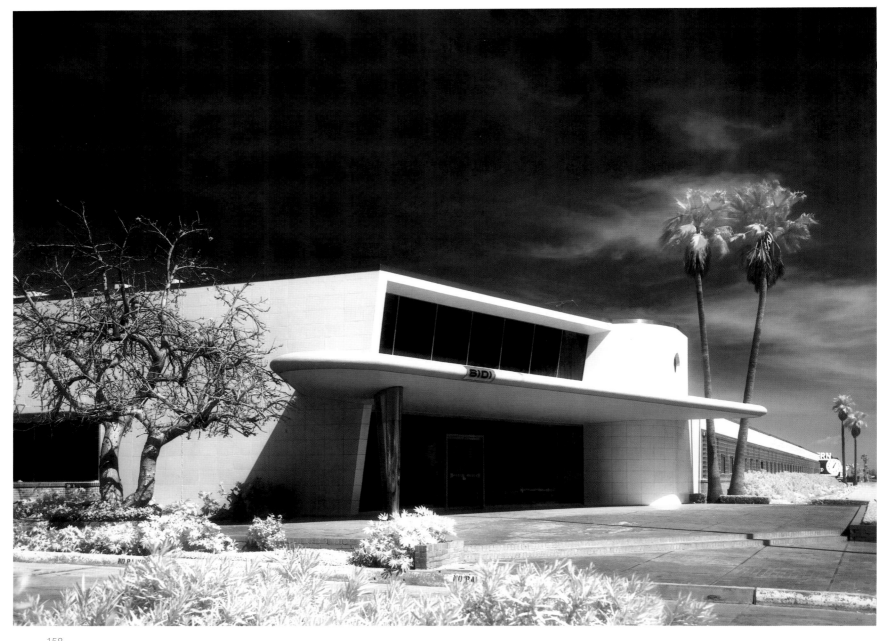

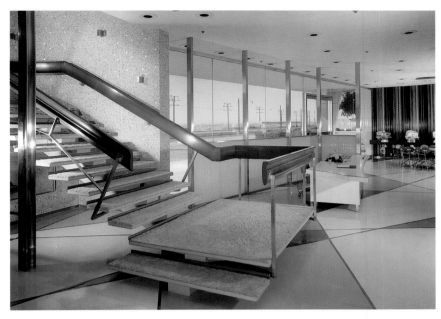

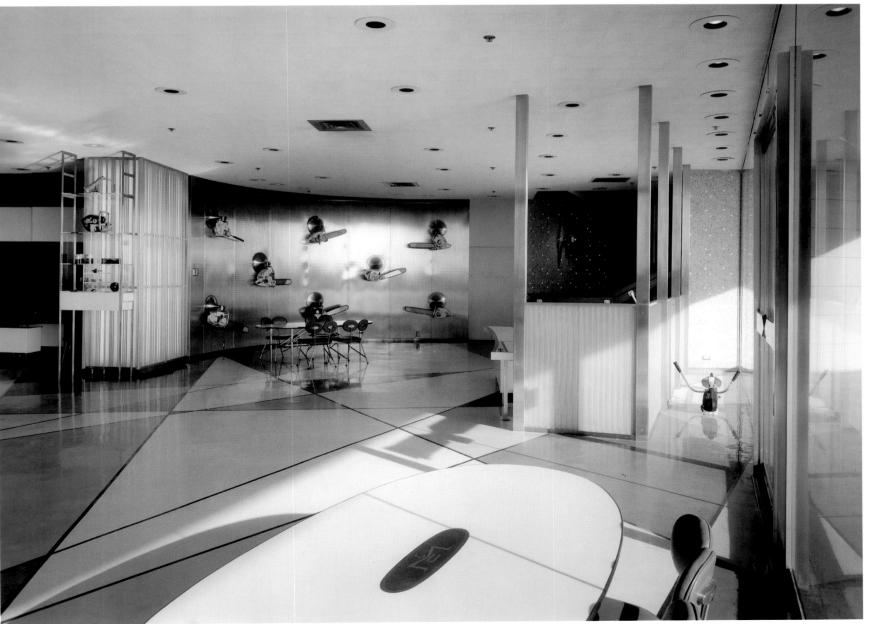

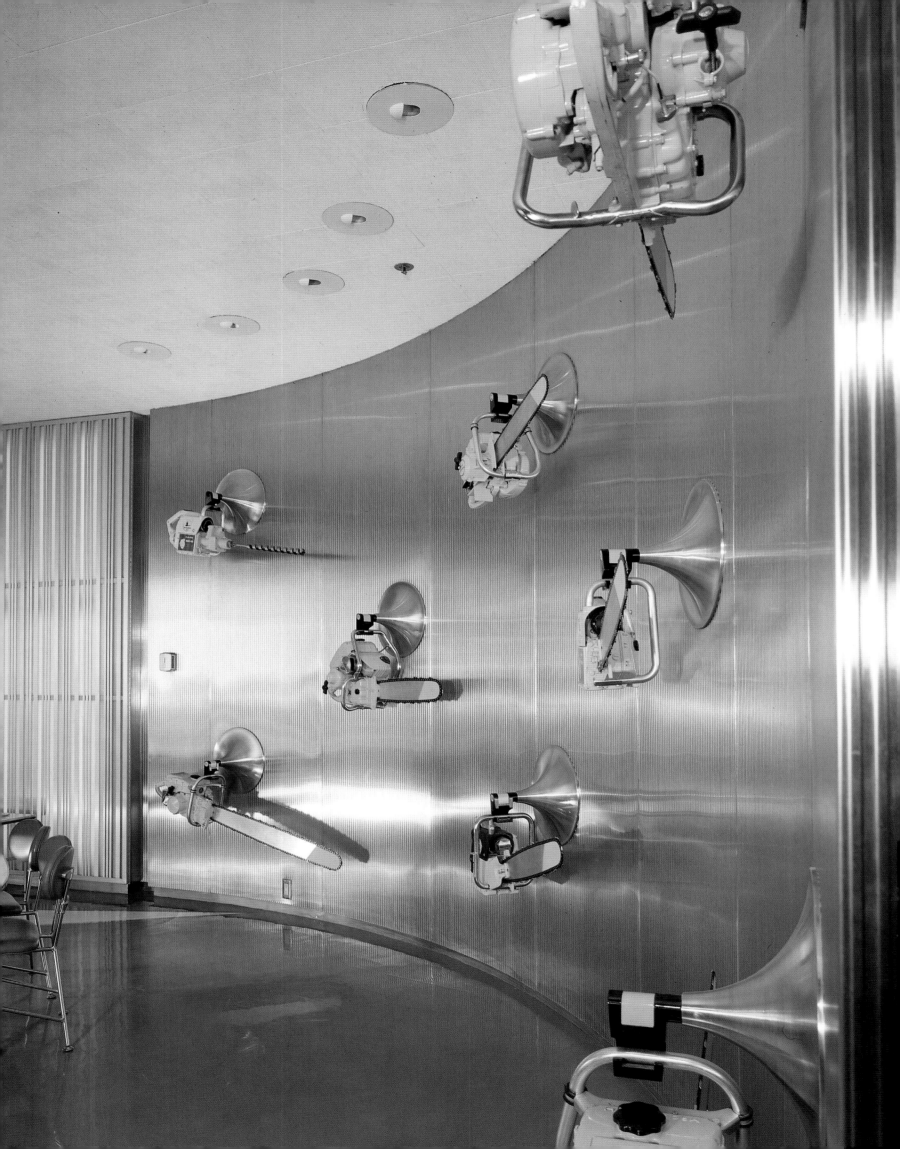

2507 **Pereira & Luckman**
Union Oil Building, Los Angeles, California
November 30, 1957

With this project, Pereira took the first step toward the design of a "central city" for Los Angeles, envisioned as a new urban organization connected to a nexus of surrounding neighborhoods. The Union Oil Building is the first large-scale scheme "over spilling" the Downtown Los Angeles quadrant defined by the Harbor Freeway, the Santa Monica Freeway, and the Hollywood Freeway. The complex is situated on 461 South Boylston Street, off 5th Street, and is still standing.

A four-level parking garage for 1,400 cars occupies the entire basement of the complex and becomes the podium for an urban scene. The diamond-like shape of the main tower dominates an inner rectangular courtyard framed by two low wings on its sides. Through the extensive use of a grid of thin aluminum louvers evenly screening the east and west facades from sunlight, the exterior elevations exhibit the strong influence of Le Corbusier's Ministry of Education and Health in Rio de Janeiro (1938–1943). The design received a 1960 Triennial Honor Award Program from the Southern California Chapter of the American Institute of Architects and was listed among the most important examples of Los Angeles architecture built between the years 1947–1967.

Mit diesem Projekt unternahm Pereira den ersten Schritt zu einem neuen Zentrum für Los Angeles, gedacht als neuartiger Verbund mit den umliegenden Stadtvierteln, denn das Gebäude der Union Oil ist der erste städtische Großbau, der das gesamte Areal zwischen Harbor Freeway, Santa Monica Freeway und Hollywood Freeway umfasst. Der Komplex steht unweit der 5th Street an der South Boylston Street Nr. 461.

Ein Parkhaus für 1 400 Autos nimmt die vier Tiefgeschosse des Ensembles ein und wird zum Podium, auf dem sich das städtische Geschehen entfaltet. Das im Grundriss rhombenförmige Hauptgebäude ragt über einem rechteckigen Innenhof auf, der von zwei niedrigeren Gebäuderiegeln flankiert wird. Ein regelmäßiges Fassadengitter aus schmalen Aluminiumlamellen beschattet die Fenster von Ost- und Westfassade, so dass diese stark an Le Corbusiers Ministerium für Bildungswesen und Gesundheit in Rio de Janeiro (1938–1943) erinnern.

1960 wurde der Entwurf von der Sektion Südkalifornien des AIA mit einem Triennial Honor Award ausgezeichnet und in die Liste der wichtigsten Bauten aus der Zeit von 1947 bis 1967 in Los Angeles aufgenommen.

Cette réalisation de Pereira marque la première étape du projet de « Central City » à Los Angeles, nouvelle organisation du centre urbain réuni aux quartiers avoisinants. L'Union Oil Building est le premier grand projet à déborder du carré du « Downtown », déterminé par le Harbor Freeway, le Santa Monica Freeway et l'Hollywood Freeway. Ce complexe est situé 461 South Boylston Street, non loin de 5th Street. Un parking de 4 niveaux pour 1 400 voitures occupe la totalité du soussol. C'est la plaque tournante d'une mise en scène urbaine. La tour principale en forme de diamant domine la cour intérieure rectangulaire fermée sur les côtés par deux ailes basses. Par leurs lames d'aluminium horizontales qui protègent du soleil les façades est et ouest et les extérieurs témoignent d'une forte influence de Le Corbusier, et en particulier de son ministère de l'Education et de la Santé de Rio de Janeiro (1938–1943). Ce projet a reçu un prix d'honneur lors de l'attribution de prix triennaux du chapitre de Californie du Sud de l'AIA en 1960. Il est mentionné parmi les plus importantes réalisations architecturales de Los Angeles édifiées de 1947 à 1967.

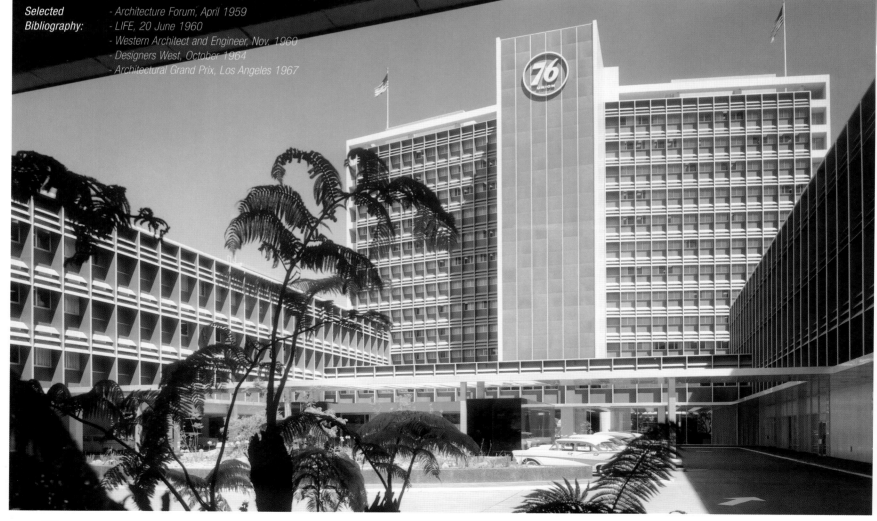

Selected Bibliography:
- *Architecture Forum, April 1959*
- *LIFE, 20 June 1960*
- *Western Architect and Engineer, Nov. 1960*
- *Designers West, October 1964*
- *Architectural Grand Prix, Los Angeles 1967*

2540 Arthur F. O'Learly
O'Learly Residence, Hollywood, California
February 26, 1958

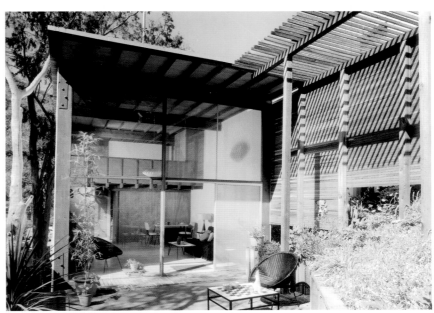

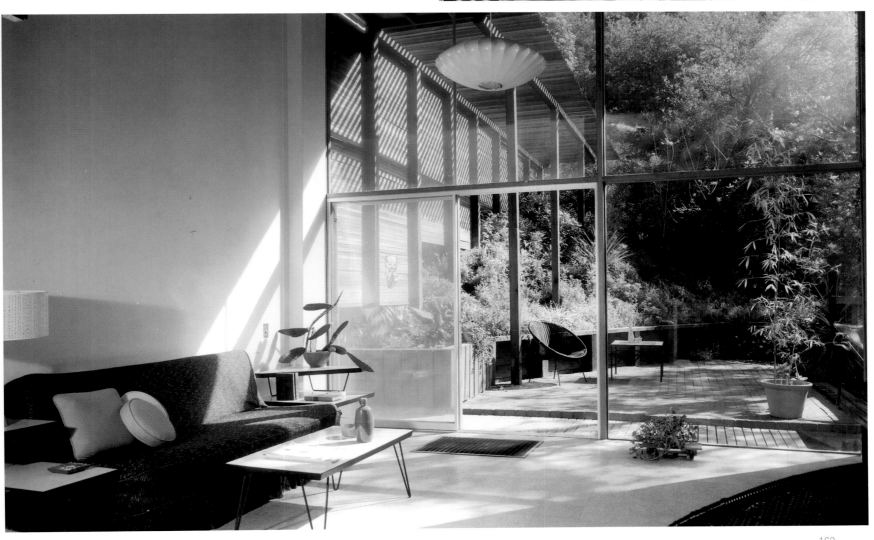

2510 Smith and Williams
Union Service Center, Los Angeles, California
December 7, 1957

This project was the forerunner of the office for the Community Planners (see p. 255). The structural cage of the building affords great diversity of functions under a single continuous roof. Trusses on steel posts outline the envelope enclosed with glass surfaces.
The design received an Award of Merit from the National Chapter of the American Institute of Architects in 1958.

Dieser Entwurf war der Vorläufer des Community Planners-Gebäudes (siehe S. 255). Die konstruktive Hülle des Kunden-dienstzentrums bot Platz für viele verschiedene Funktions-bereiche unter einem gemeinsamen Dach. Fachwerkträger auf Stahlstützen umreißen das Innenvolumen; die Fassaden bestehen aus Glas. Der Entwurf erhielt 1958 einen Merit Award des American Institute of Architects.

Ce projet est antérieur aux bureaux des Community Planners (voir p. 255). Le principe de structure à ossature interne permet de réunir des fonctions très diverses sous un toit continu. Les poutres en fronton reposant sur des montants d'acier mettent en valeur la forme de l'enveloppe fermée de parois de verre. Ce projet a reçu un prix du mérite du chapitre national de l'AIA en 1958.

Selected Bibliography: - Wolf von Eckardt (ed.), Mid-Century Architecture in America, Washington D.C. 1961

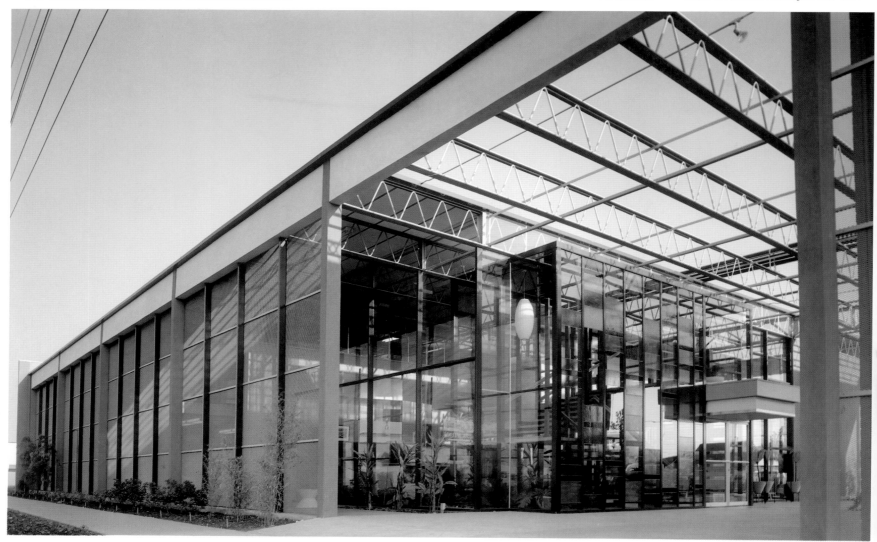

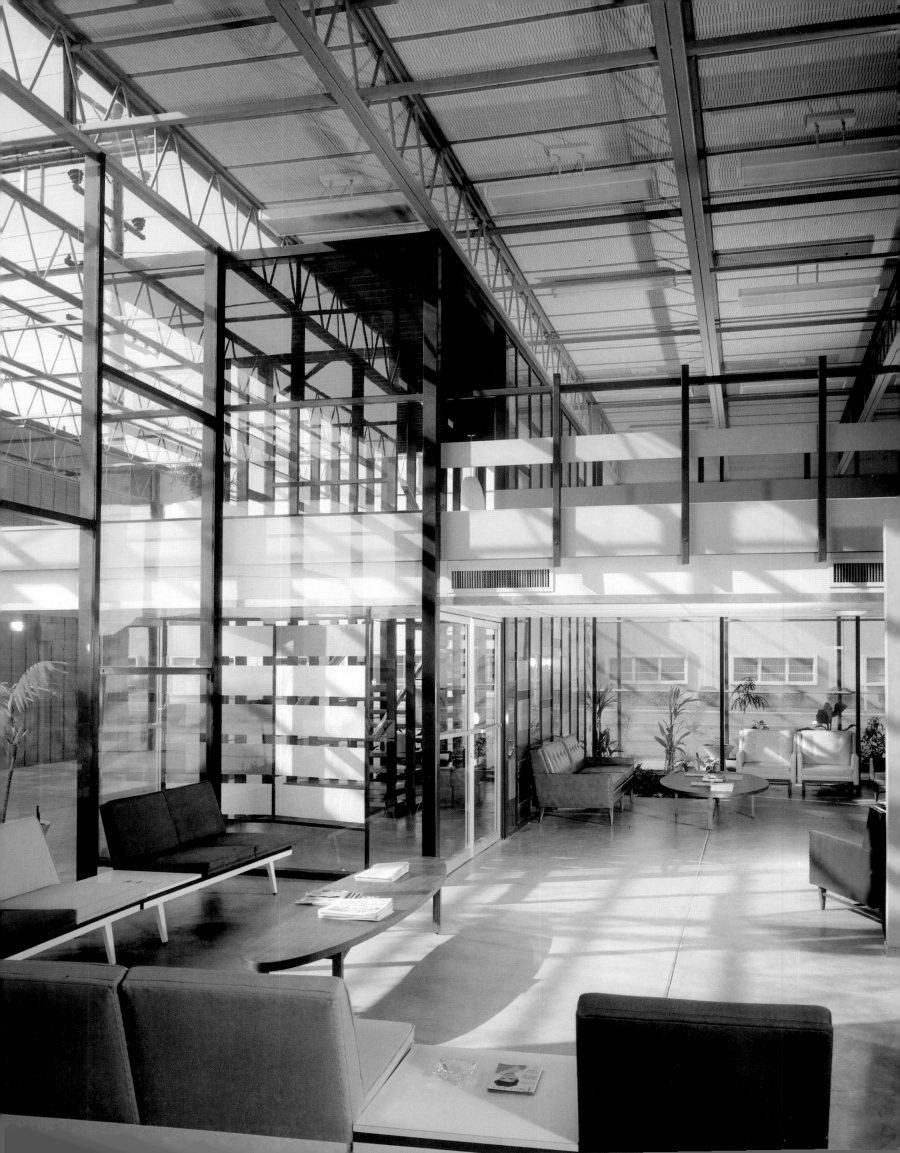

2520 Pereira & Luckman
Robinson's Specialty Shop, Palm Springs, California
January 13, 1958

To take full advantage of the site, located at the corner of a busy intersection in Palm Springs, the client asked for a project that maximized the view of the goods from the streets. For this branch of the J. S. Robinson Company, a West Coast specialty shop, the architects designed a stage where the shopping experience was presented as a public spectacle. Vast glass areas on the street frontages made the entire structure a showroom for the merchandise.

Because of the grade in the building lot, the temple-like store sits on a terraced base establishing a new ground level. On this "stylobate", an ordered set of lean pipe columns holds the roof, composed of light steel trusses. The plan features two distinct zones in the interiors: the 14-foot-tall sales area and the 10-foot-tall service area. In the main elevation, the non-load-bearing exterior wall corresponding to the service area penetrates the interior of the sales area and catches the shadows

Der Auftraggeber, die J. S. Robinson Company, wünschte für eine Ladenfiliale an der Ecke einer belebten Straßenkreuzung in Palm Springs ein Gebäude mit großen Schaufenstern. Deshalb entwarfen die Architekten eine Art Bühne, auf der den Kunden durch große Schaufenster zur Straße das »Einkaufserlebnis« vorgeführt wurde.

Da das Grundstück leicht anstieg, stellten sie – in Anlehnung an einen griechischen Tempel – den eingeschossigen »Konsum-Tempel« auf einen terrassierten Sockel, eine moderne »Krespis«, auf deren »Stylobat« schlanke Rohrstützen das Stahlfachwerkdach in die Höhe halten. Im Grundriss erkennt man zwei deutlich voneinander abgegrenzte Bereiche: den 4,20 m hohen Verkaufsraum und die 3 m hohen Nebenräume, deren nicht-tragende Außenwand ins Innere des Verkaufsraums vorstößt, der vom tiefen Dachüberstand beschattet wird. Das Rhombenmuster der golden eloxierten Traufblechkante wiederholt sich auch

Pour profiter au maximum de la situation de son terrain en bordure d'un carrefour très fréquenté de Palm Springs, le client souhaitait un projet qui mette ses vitrines en valeur. Les architectes conçurent cette succursale de la J. S. Robinson Company, magasin spécialisé de la Côte ouest, comme une scène sur laquelle faire ses achats devenait un spectacle. Les vastes surfaces vitrées sur rue font de l'ensemble un véritable showroom. Du fait de la déclivité du terrain, le magasin est édifié sur une terrasse aménagée qui crée un nouveau niveau. Au-dessus de ce stylobate artificiel, une architecturé de fines colonnes cylindriques soutient le toit, dont la charpente est en poutres d'acier légères. Le plan répartit l'espace en deux zones distinctes : la surface de vente de 4,20 m de hauteur, et une surface consacrée aux services, de 3 m de haut. En façade principale, le mur extérieur (non porteur) qui correspond à la zone des services pénètre à l'intérieur du magasin, abrité par l'important surplomb

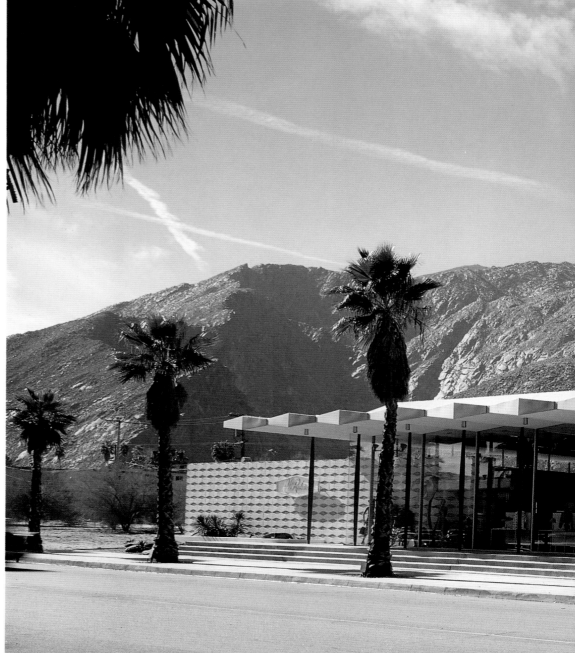

Selected Bibliography:
- *AIA Journal, July 1958*
- *Architectural Forum, March 1959*
- *Western Architect and Engineer, November1960*
- *Wolf von Eckardt (ed.), Mid-Century Architecture in America, Washington D.C. 1961*

cast from the deep roof overhang. The horizontal pattern of diamond shapes is a recurring theme throughout the building. This design element is present both in the gold anodized aluminum fascia of the roof and in the special tiles of marble and quartz aggregate used for the cladding of the exterior walls. Above the center of the sale store, a three-foot-deep clerestory in the roof increases the amount of daylight. Long and narrow adjustable slots in the acoustical tile ceiling diffuse the tempered air. The project received a 1958 First Honor Award from the American Institute of Architects National Chapter and a 1960 Triennial Honor Award Program from the American Institute of Architects Southern California Chapter. Raymond Loewy designed the interiors.

an den Marmortafeln mit Quartzeinschlüssen der Außenfassaden und an anderen Stellen des Gebäudes. In der Mitte des Verkaufsraums sorgt ein 90 cm tiefes seitliches Oberlicht unter dem Dach für mehr Tageslicht. Durch lange, schmale Lüftungsschlitze mit verstellbaren Lamellen wird der Raum mit Frischluft versorgt und eine angenehme Raumtemperatur erzeugt. 1958 wurde das Gebäude vom American Institute of Architects mit einem First Honor Award ausgezeichnet, und 1960 mit dem Triennial Honor Award der Sektion Südkalifornien des AIA. Raymond Loewy gestaltete die Innenräume.

du toit. Le motif horizontal en pointe de diamant d'aluminium doré de l'acrotère fait le tour du bâtiment. Il se retrouve dans les carrelages en agrégat de marbre et de quartz spécialement fabriqués pour le parement des murs extérieurs. Au-dessus du centre du magasin lui-même, une fenêtre haute de 90 cm de haut ménagée dans le toit améliore l'éclairage naturel. L'air conditionné est diffusé au travers de fentes longues et étroites de dimensions réglables pratiquées dans le plafond acoustique. Ce projet a reçu le premier prix d'honneur du chapitre national de l'AIA en 1958, et un prix d'honneur triennal du chapitre de Californie du Sud de l'AIA. Les aménagements intérieurs sont dus à Raymond Loewy.

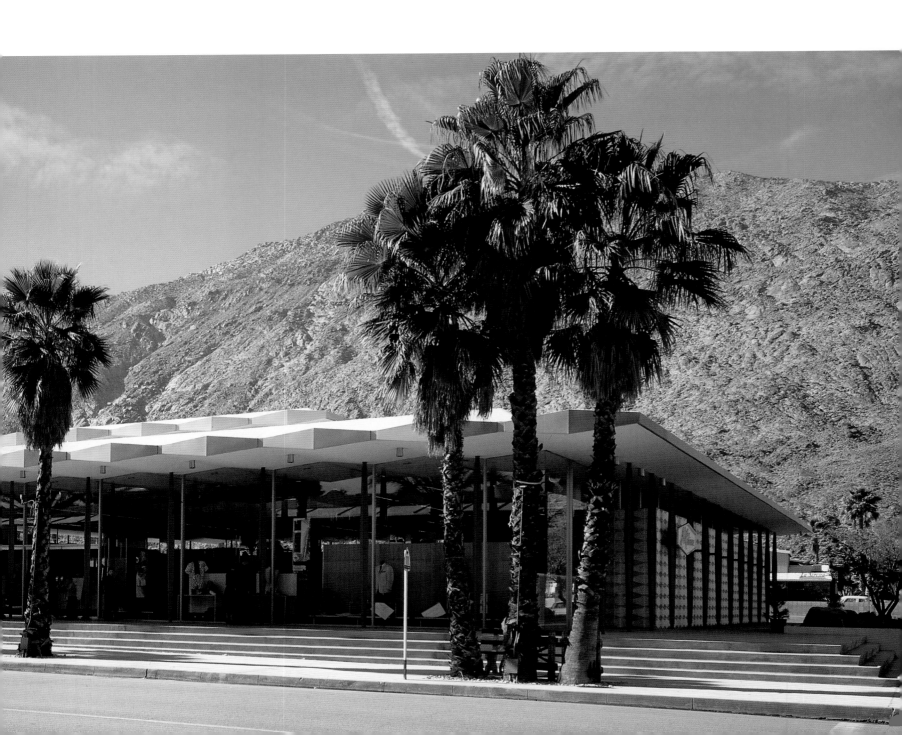

2521 Carl L. Maston
Addison Residence, Ventura, California
January 13, 1958

Built on a small hillside lot, the 1,950-square-foot residence was designed for a family of four. The clients listed several program specifications: a space for informal living with no change of levels between indoor and outdoor areas; independent access for the bedroom of their two college-age sons; and a private terrace at the rear of the residence. Against the steep bank of the site, Maston positions two tall retaining walls, located at the edge and the lee side of the property, to establish a new ground level. The dominant architectural element of the overall design is its structural skeleton. In particular, the Douglas fir post-and-beam system defines the regulating geometry of the layout, carport and terrace included. Seven load-bearing frames made of 3 x 12-inch beams are evenly spaced on a 6-foot interval. Firmly anchored on the masonry wall at the back of the lot, the joists extend all the way through the house interior to its opposite end, bending vertically through 3 x 6-inch posts, in a spider-leg manner.

A stepped entry path penetrates a partially sheltered patio, where a floor-to-ceiling glass screen marks a virtual separation from the interior. But the transparency of this almost invisible partition and the continuation of the outdoor brick floor indoors, both suggest integration between the courtyard and the communal area. Two zones clearly divide private and collective functions. Living-dining room and kitchen open to the sundeck and the southwest views, with a sheltered studio behind the massive fireplace as the only private section. In sharp contrast, the bedroom wing is closed off.

Panels of redwood, plywood, asbestos cement board, translucent plastic, and clear glass fill the space between the framing in both exterior and interior.

Das Haus mit einer Gesamtfläche von 180 m² entstand für eine vierköpfige Familie auf einem kleinen Hanggrundstück. Die Bauherren wünschten sich einen Wohnraum auf einer Ebene mit einer Balkonterrasse (die einen zwanglosen Wechsel von drinnen nach draußen ermöglichen würden), einen separaten Hauseingang zum Zimmer der beiden Söhne im College-Alter und eine abgeschirmte Gartenterrasse auf der Rückseite des Hauses. Maston ließ am oberen und unteren Teil des Hangs zwei massive Stützmauern bauen, um darauf eine ebene Grundfläche zu errichten. Das Tragwerksystem ist das beherrschende Gestaltungsmittel, besonders die Pfosten und Riegel aus Douglaskiefernholz, welche die Grundrissgeometrie – einschließlich Carport und Terrasse – definieren: sieben tragenden Rahmen aus rund 7,50 x 30 cm dicken Balken in Abständen von jeweils 1,80 m, die in der rückseitigen Backsteinmauer verankert sind und über der Balkonterrasse auf der anderen Seite des Hauses auskragend den Dachüberstand stützen und, in der Art eines »Spinnenbeins« (Richard Neutras Erfindung) abknickend, den Balkon tragen.

Ein Treppenweg führt von der Straße in einen teilweise umschlossenen Hof, in dem eine haushohe Glaswand den Übergang zum Hausinnern markiert. Diese fast unsichtbare Trennwand und der sich von außen nach innen fortsetzende Klinkerboden suggerieren die Verschmelzung von Vorhof und Wohnbereich im Haus. Wohnzimmer und Küche öffnen sich zum Sonnenbalkon und zur Aussicht nach Südwesten. Ein Arbeitszimmer hinter der massiven Kaminwand ist in diesem Teil des Hauses der einzige geschlossene Raum, während der Schlafzimmertrakt einen abgeschlossenen Bereich bildet.

Platten aus Redwood, Sperrholz, Asbestzement und transluzentem Kunststoff sowie Klarglasscheiben bilden die Ausfachungen zwischen den Querrahmen.

Edifiée sur un petit terrain à flanc de colline, cette maison de 180 m² fut conçue pour une famille de quatre personnes. Ses propriétaires voulaient un vaste espace de séjour, sans différence de niveau entre l'intérieur et l'extérieur, un accès extérieur indépendant de l'entrée principale pour les chambres des deux fils collégiens et une terrasse privée à l'arrière. Perpendiculairement à l'escarpement, Maston place deux hauts murs de soutènement, l'un en bordure de parcelle l'autre face au vent pour créer une terrasse plane. Ce squelette constitue l'élément architectural dominant. Un réseau de poteaux et de poutres en pin de Douglas matérialise la trame du plan de la maison, de l'abri aux voitures et de la terrasse. Sept cadres porteurs faits de poutres de 7,50 x 30 cm sont disposés à intervalle régulier de 1,80 m. Fermement ancrées au mur de maçonnerie du fond de la parcelle, les poutres traversent toute la maison et se prolongent à l'extérieur avant de plonger à la verticale vers le terrain, à la manière de « pattes d'araignées ».

Une allée en escalier pénètre dans un patio en partie couvert, séparé visuellement de l'intérieur par un écran de verre sol-plafond. La transparence de ce cloisonnement presque invisible et la continuation du sol en brique de l'extérieur vers l'intérieur, fait fusionner la cour et les pièces de séjour. Les fonctions privées et collectives sont clairement réparties en deux zones. Le séjour-salle à manger et la cuisine ouvrent sur le solarium orienté sud-ouest, tandis qu'un atelier fermé est aménagé derrière la cheminée massive. Par contraste, la zone des chambres semble presque repliée sur elle-même.

Des panneaux de bois rouge, de fibrociment, de plastique translucide et de verre clair servent de remplissage entre les cadres, tout en donnant une certaine personnalité aux façades aussi bien extérieures qu'intérieures.

Selected Bibliography:
- House & Home, November 1960
- Architectural Record, May 1961

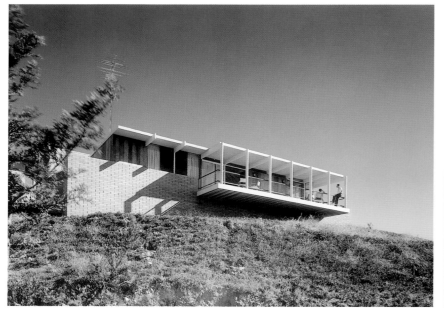 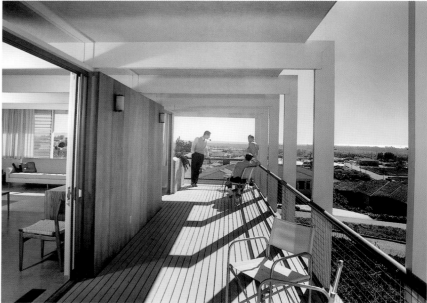

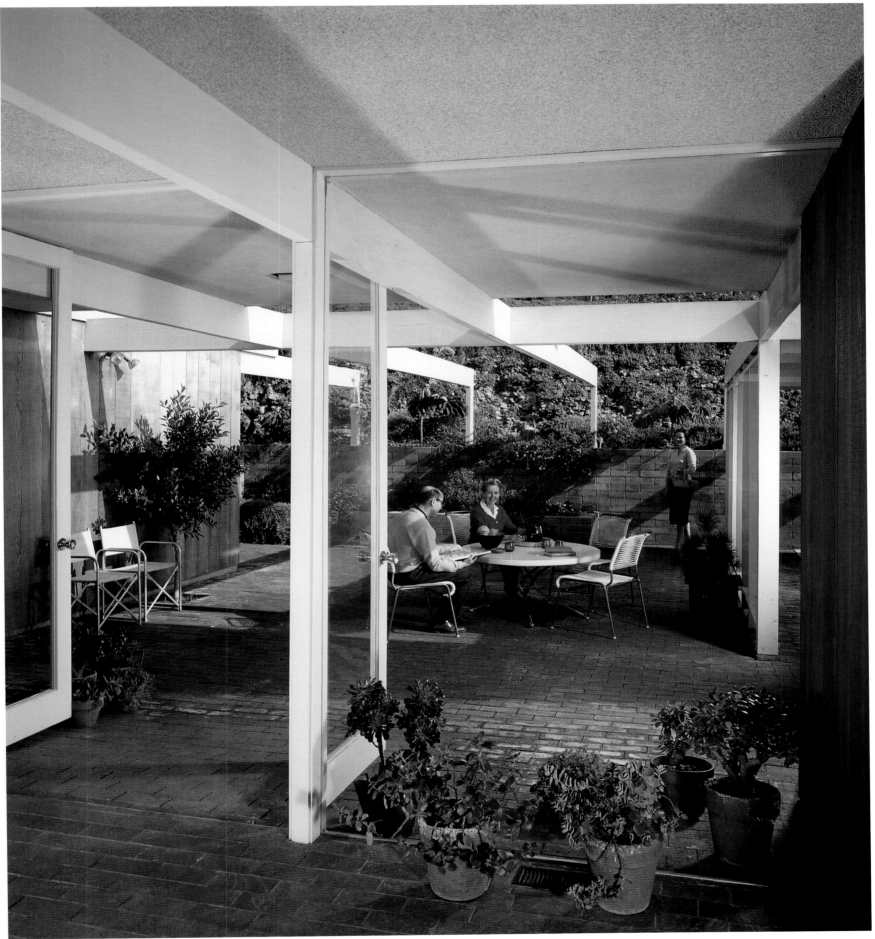

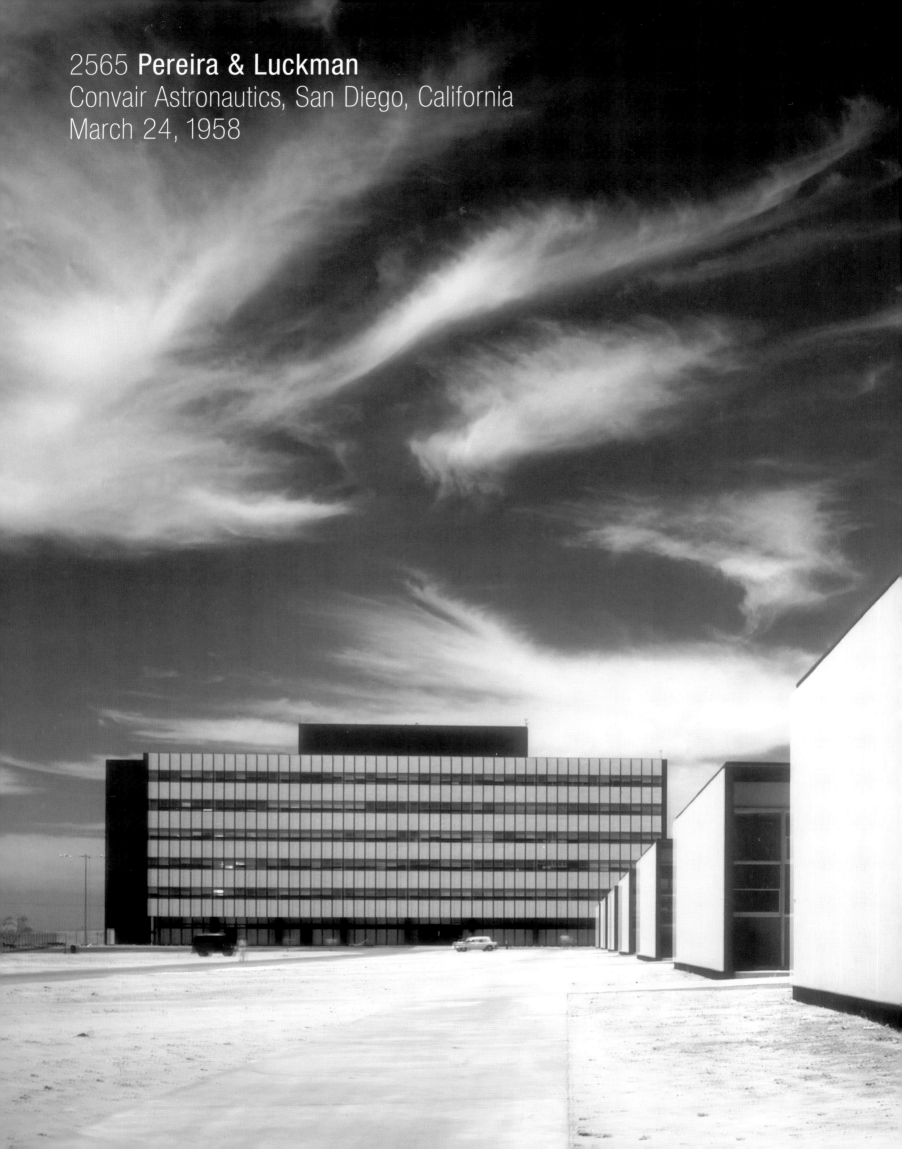

2565 **Pereira & Luckman**
Convair Astronautics, San Diego, California
March 24, 1958

When it was built, this large-scale complex was the biggest modern plant for scientific research, design and production of long range missiles and space vehicles in the country. Designed to provide complete flexibility and future expansions, the Convair Astronautics was realized in two years on non-urbanized land for 7,500 employees.

Two six-story buildings for administration, fourteen one-story structures for research and a large manufacturing area follow a "waffle" pattern in plan to secure privacy and maximize air and light conditions for each volume. Outside walkways define the circulation system, replacing internal hallways. The ground level of both the administration and the engineering buildings

Dieser große Gebäudekomplex der Convair Astronautics war seinerzeit die größte moderne Forschungs-, Entwicklungs- und Produktions-Anlage für Langstreckenraketen und Raumfähren der USA. Sie war als vollkommen flexibler und erweiterbarer Bau geplant. Er entstand innerhalb von zwei Jahren »auf der grünen Wiese« und bot Arbeitsplätze für 7 500 Angestellte.

Zwei sechsstöckige Bürogebäude, vierzehn eingeschossige Forschungslaboratorien und eine große Werkshalle folgen im Grundriss einer Art Waffelmuster, so dass die Einzelbauten vor Einblicken geschützt sind und von optimalen natürlichen Belüftungs- und Lichtverhältnissen profitieren. Anstelle von Innenfluren erschließen Außenwege die Gebäude. Die Erdgeschosse

Ce vaste complexe pour 7 500 employés fut à un certain moment la plus importante installation de recherche, de conception et de fabrication de missiles longue portée et de véhicules spatiaux du pays. D'une grande flexibilité et conçu en prévision d'une future extension, il fut construit en deux ans sur un terrain vierge.

Deux immeubles de cinq étages pour l'administration, quatorze bâtiments d'un seul niveau pour la recherche et un vaste hall de production sont répartis selon un plan en gaufrier pour assurer l'autonomie et optimiser l'éclairage et l'aération naturels de chaque volume. Des passages couverts extérieurs servent aux circulations et remplacent les couloirs intérieurs. Le rez-de-

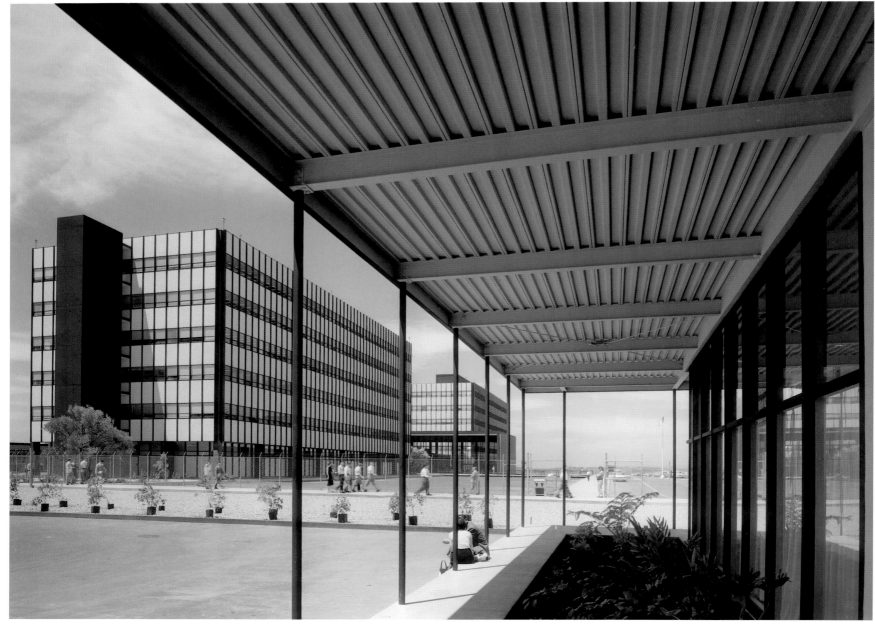

entertain maximum contact with the public for employment, industrial relations and purchasing purposes. The lobby of the two-story reception center between the towers exhibits a 245-foot vinyl-tiled spiral ramp, anchored to the ceiling with aluminum rods, which gives access to the conference room on the second floor as well as to the administration and engineering buildings.

The load-bearing structure of the manufacturing building is made of heavy steel trusses with concrete and metal walls. Light steel trusses with concrete and glass walls define the shell of the engineering laboratories.

der Verwaltungs- und Entwicklungsgebäude sind für lebhaften Publikumsverkehr ausgestattet: Hier fanden zum Beispiel Personaleinstellungen, Treffen zwischen Betriebsführung und Gewerkschaftern und Verkaufsgespräche statt. Das Foyer des zweigeschossigen Empfangsgebäudes zwischen den Bürobauten enthält eine 75 m lange Wendelrampe, die mittels Aluminiumstäben von der Decke abgehängt ist und zum Konferenzraum sowie zu den übrigen Gebäuden führt. Das Tragwerk der Produktionshalle besteht aus schweren Stahlfachwerkträgern mit Beton- und Metallausfachungen. Leichtere Stahlfachwerkträger, ausgefacht mit Beton und Glas, bilden das konstruktive Gerüst für die Forschungs- und Entwicklungslabors.

chaussée des immeubles de l'administration et de l'ingénierie est ouvert pour favoriser les contacts avec le public (personnel, relations publiques, achats).
Le hall du centre de réception de deux niveaux de haut (entre les tours) est doté d'une rampe spiralée de 75 m de long en dalles de vinyle, suspendue au plafond par des câbles d'aluminium. Elle donne accès à une salle de conférence à l'étage ainsi qu'aux bâtiments de l'administration et de l'ingénierie.
La structure porteuse du hall de construction est composée de lourdes poutres d'acier et de murs en béton et métal. Des poutres d'acier légères et des murs de verre et de béton constituent l'enveloppe extérieure des laboratoires d'ingénierie.

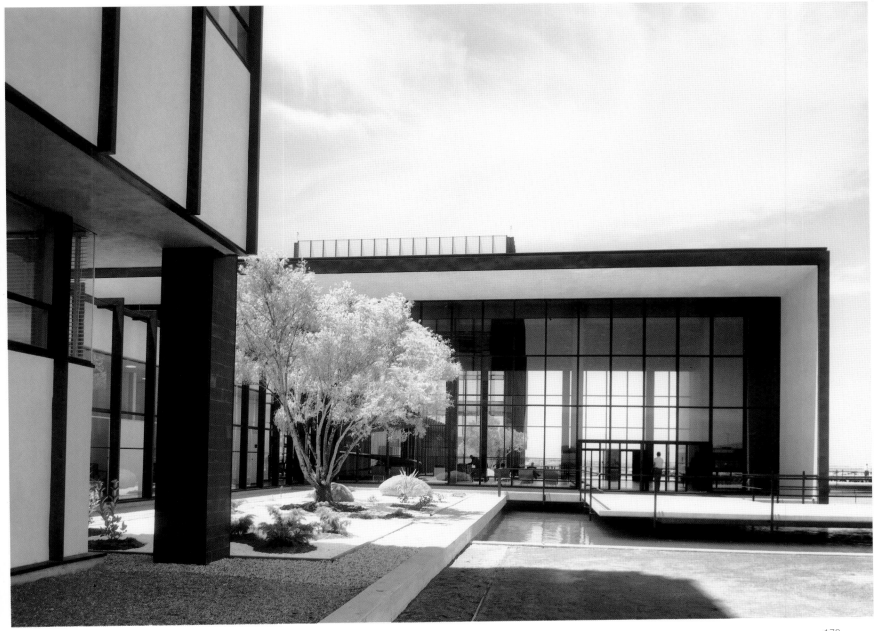

Selected - arts & architecture, December 1958
Bibliography: - L'Architecture d'Aujourd'hui, April-May 1959

2567 Smith and Williams
Shoreline House, Orange County, California
March 26, 1958

The Shoreline House was a demonstration project built for the Orange County Fair in 1958. Its purpose was to demonstrate how experimental building techniques and industrial materials could meet the demands of modern domestic space. Lifted above foundations, the residence featured multilevel wood decks and an interior pool that triples its living area. In plan, two identical rectangular volumes each arranged on two sides of a large reflecting pool, sheltered 1,000 square feet of private and communal zones. One rectangle enclosed living room and kitchen; the other housed bedroom and bathroom. The long and narrow perspective of the entry bridge crosscutting both spaces functioned as a corridor and gave new scale to the project. Two open platforms extended over the pool and contained the dining room plus additional living areas. On the opposite side of the central court, the sunken tub of the bathroom unit also projected over the pool with a screen made of wood sticks and stained glass to secure privacy.

The thin post-and-beam structure of the wood frame was left exposed, generating an effect of lightness. Wood surfaces, mostly Douglas fir, were stained for easy maintenance. Solid wood paneling and glass floor-to-ceiling planes in blue and

Das Shoreline House entstand als Musterhaus für die Orange County Fair des Jahres 1958, eine regionale Handelsmesse. Es sollte unter Beweis stellen, dass die neu entwickelten Bautechniken und vorgefertigten Bauteile alle Erfordernisse des modernen Hauses erfüllen konnten. Das komplett aufgeständerte Haus umfasste Holzdecks auf mehreren Ebenen und ein Wasserbecken im Innern, die die Wohnfläche praktisch verdreifachten. Im Plan (Gesamtfläche 93 m²) bestand es aus zwei identischen Rechtecken zu beiden Seiten des Beckens. Der eine Bereich enthielt den Wohnraum und die Küche, der andere Schlafzimmer und Bad. Eine lange, schmale Brücke durchquerte als Korridor beide Hausteile. Zwei offene Terrassen – die eine der Essplatz, die andere ein zusätzlicher Wohnraum – überbrückten das Wasserbecken. Auf der anderen Seite des zentralen Hofes kragte die versenkte und durch eine Wand aus Holzstäben und Buntglas abgeschirmte Badewanne über dem Wasserbecken aus. Die schlanke Pfosten-und-Riegel-Konstruktion aus Holz blieb unverkleidet und erzeugte den Eindruck von Leichtigkeit. Die gebeizten, pflegeleichten Holzoberflächen bestanden überwiegend aus Douglaskiefer. Massive Holzwände und raumrohe Glasscheiben in Blau- und Weißtönen bildeten

La Shoreline House est un projet d'exposition construit pour la Foire du comté d'Orange en 1958. Son objectif était de montrer comment des techniques de construction expérimentales et des matériaux industriels pouvaient répondre aux besoins domestiques contemporains. Surélevée sur ses fondations, la maison était entourée de plates-formes de bois de niveaux différents et d'un bassin intérieur qui triplait la surface d'habitation. En plan, deux volumes rectangulaires identiques, disposés sur deux côtés d'un grand bassin, offraient les 93 m² nécessaires aux pièces communes et aux chambres. Le premier contenait le séjour et la cuisine, l'autre la chambre et la salle de bains. Une longue et étroite passerelle traversant ces deux espaces jouait le rôle de couloir tout en donnant une échelle particulière au projet. Deux plates-formes ouvertes passant par-dessus le bassin contenaient la salle à manger et les autres espaces de séjour. De l'autre côté de la cour centrale, la baignoire en creux de la salle de bains protégée par une claustra en bois et en verre teinté surplombait le bassin. Les minces poteaux et poutres de l'ossature en bois laissés apparents donnaient une impression de légèreté. Les plans verticaux intérieurs étaient essentiellement en pin de Douglas teinté pour faciliter l'entre-

white colors form the exterior walls. The translucent glass help to modulate light and control the view. Vaulted metal mesh forms on the rooftop shield the interior from sun glare and heat. Shoji screens enclose different zones. The Shoreline House received a 1959 Merit Award from the American Institute of Architects Pasadena Chapter.

die Außenfassaden. Dieses transluzente Glas dämpfte das Tageslicht und fungierte zum Teil auch als Sichtschutz. Gewölbte Drahtgitterstreifen über dem Dach beschatteten das Haus und wehrten die Sonnenhitze ab. Shoji-Papierwände umschlossen verschiedene Bereiche. 1959 wurde das Shoreline House von der Sektion Pasadena des American Institute of Architects mit einem Merit Award ausgezeichnet.

tien. Des panneaux de bois massif et des panneaux de verre sol-plafond de couleur bleue ou blanche habillaient les murs extérieurs. Le verre translucide contribuait à moduler l'éclairage naturel et à contrôler la vision dans les deux sens. Au-dessus du toit, des voûtains en fin grillage métallique protégeaient l'intérieur du soleil et de la chaleur. Des écrans shoji séparaient les diverses zones. Cette maison reçut un prix du mérite du chapitre de Pasadena de l'AIA en 1959.

Selected Bibliography:
- arts & architecture, September 1958
- Architectural Record, February 1960
- Book of Homes 17, 1960

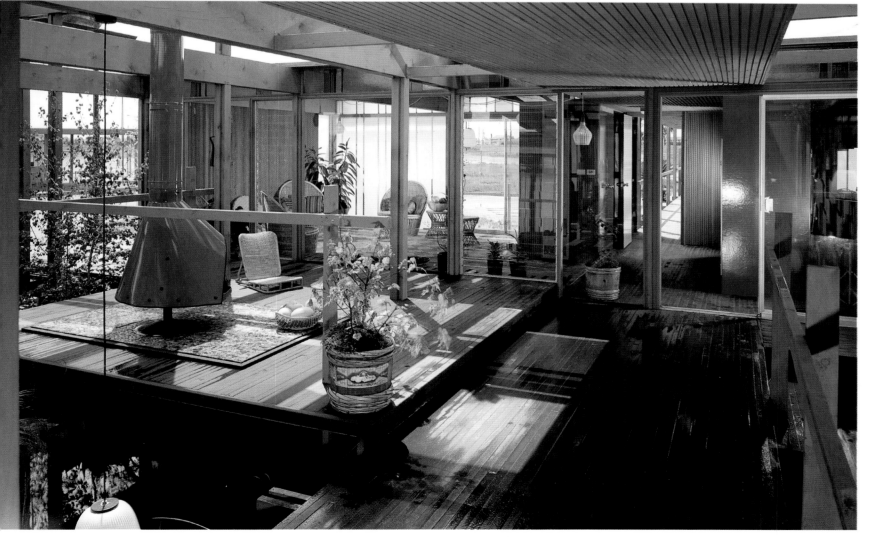

2575 **Carl L. Maston**
Bauer Residence, Santa Barbara, California
April 9, 1958

The living-dining and the sleeping areas form two distinct units. The residence opens onto a carefully designed garden and the surrounding landscape. Indoor and outdoor areas blend into a seamless space, with each room framing wide views of the greenery.

An entry path steps down to a gate fencing a semiprivate terrace and leads to the hub of the house. Inside, a low brick fireplace wall partially divides the entry from the living room, yet the space is still perceived as a single room.

The low-pitched roof of the living room floats on a 27-foot-long glass screen. Deep roof overhangs shade the exterior walls and emphasize the horizontals of the house. From the garden, the eye penetrates the interiors and catches views of the landscape on the opposite side of the dwelling. The plan stretches over 2,830 square feet of space and reaches 91 feet in length. Since the short side of the lot faces the access road, the architect positioned the driveway and garage in that elevation to provide privacy for domestic life.

Zwei deutlich unterscheidbare Einheiten bilden den Wohn- und Essbereich und den Schlafzimmertrakt. Das Haus öffnet sich zum sorgfältig gestalteten Garten und zur Landschaft. Innen- und Außenräume gehen nahtlos ineinander über; alle Räume sind großzügig verglast und bieten Ausblick ins Grüne. Der Zugangsweg führt über Treppen zum Gartentor der halb abgeschirmten Terrasse und zum Mittelpunkt des Hauses. Im Innern trennt eine niedrige Backsteinkaminwand den Eingangsbereich nur teilweise vom Wohnzimmer, so dass der Eindruck eines durchgehenden großen Raums nicht geschmälert wird. Die leicht geneigte Decke des Wohnraums scheint über der 8 m breiten Glasfront zu schweben. Tiefe Dachüberhänge beschatten die Außenfassaden und betonen die niedrige Horizontalität des Hauses. Vom Garten blickt man durch das ganze Haus hindurch in die Landschaft auf der anderen Seite. Der 30 m lange Baukörper hat eine Grundfläche von 260 m². Die Schmalseite des Grundstücks liegt an der Straße, daher platzierte der Architekt Zufahrt und Garage auf dieser Seite des Hauses.

Le séjour-salle à manger et les chambres sont implantés dans deux unités distinctes. La maison s'ouvre sur un jardin bien dessiné dans un environnement naturel. Le dedans et le dehors fusionnent en un espace continu, chaque pièce bénéficiant d'une vue cadrée sur la verdure.

L'allée d'entrée descend vers une porte qui ferme une terrasse semi privée et mène au coeur de la maison. A l'intérieur, le mur de brique surbaissé de la cheminée sépare en partie l'entrée du séjour, même si l'espace reste perçu comme une seule pièce. Le toit à pignon bas qui surplombe le séjour semble flotter au-dessus d'une paroi de verre de 8 m de long. De profonds auvents protègent le mur extérieur et soulignent l'horizontalité de la maison. Du jardin, le regard pénètre à l'intérieur de la maison et perçoit même le paysage situé de l'autre côté. L'ensemble a une superficie de 260 m² et mesure 30 m de long.

Comme la largeur de la parcelle qui donne sur la rue est réduite, l'architecte y a implanté l'allée d'accès et le garage pour mieux protéger l'intimité de la maison.

Selected Bibliography: - House & Home, November 1958

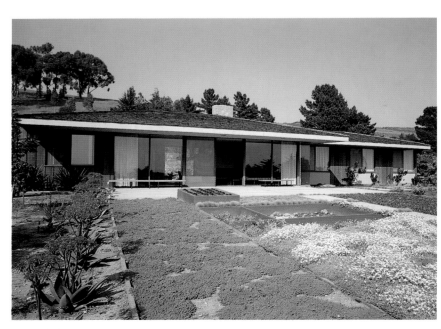

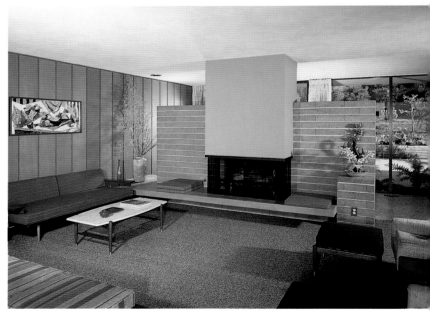

2601 David Hyun
Haddad Residence, Los Angeles, California
May 8, 1958

Under the structure of a low-pitch roof, a mixture of covered areas and open spaces generates an intimate domestic setting in the city for the family of William G. Haddad, builder of his own residence.

In conjunction with the landscaping designed by Eckbo, Royston and Williams, the architect gives a terrace to each room of the house, tripling outdoors the 2,000 square feet of actual covered area. In particular, a play yard next to the kitchen and a garden patio adjacent to the living-dining area afford opportunities for outdoor living. Rooms are arranged in sequence on both sides of a corridor. Beams are left exposed throughout the different parts of the house, giving architectural continuity to the space.

Unter einem flach geneigen Dach bietet eine Mischung aus gedeckten und offenen Räumen eine intime Häuslichkeit inmitten der Großstadt für die Familie des Bauunternehmers William G. Haddad, der den Entwurf natürlich selber ausführte.

In Zusammenarbeit mit den Gartengestaltern Eckbo, Royston & Williams wies der Architekt jedem Raum eine eigene Terrasse zu, so dass die Wohnfläche im Garten dreimal so groß ist wie die des Hauses von rund 185 m². Vor allem der Kinderspielplatz neben der Küche und der Gartenhof im Anschluß an das Wohn-Esszimmer bieten viele Möglichkeiten des Lebens im Freien. Die Räume sind zu beiden Seiten eines Gangs aneinandergereiht. Im ganzen Haus sind die Deckenbalken freigelegt und sorgen für gestalterische Kontinuität.

En pleine ville, sous un toit à faible pente, le rapprochement de zones couvertes et d'espaces ouverts offrait un cadre domestique intime à la famille de William G. Haddud, le constructeur de la maison.

De concert avec l'aménagement de l'extérieur conçu par Eckbo, Royston & Williams, l'architecte a doté chaque pièce d'une terrasse, triplant vers l'extérieur les 185 m² couverts. Une cour de jeu près de la cuisine et un patio-jardin adjacent au séjour-salle à manger offrent de multiples possibilités de vie en plein air. Les pièces sont disposées en séquence des deux côtés d'un couloir. Les poutres, apparentes dans toute la maison, assurent une continuité architecturale à l'ensemble.

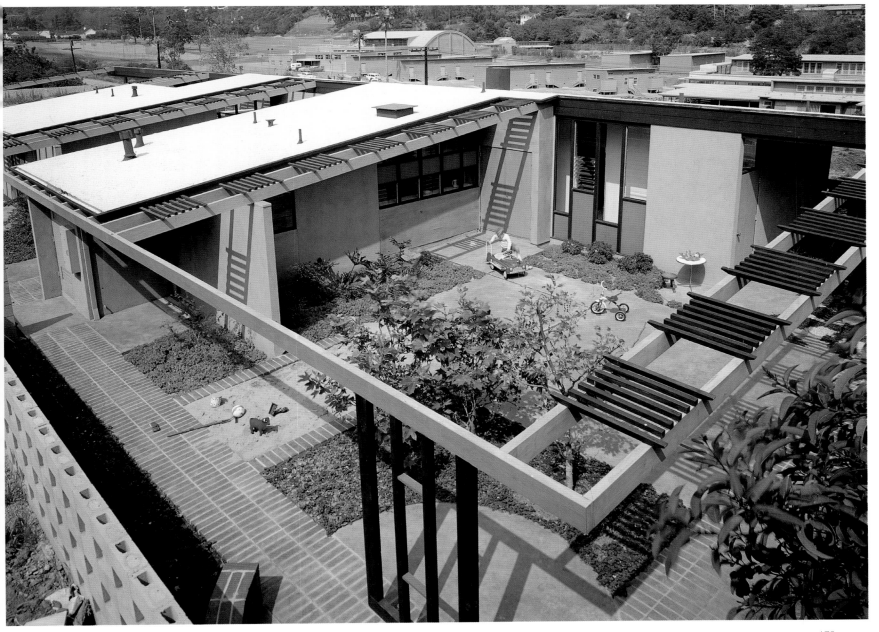

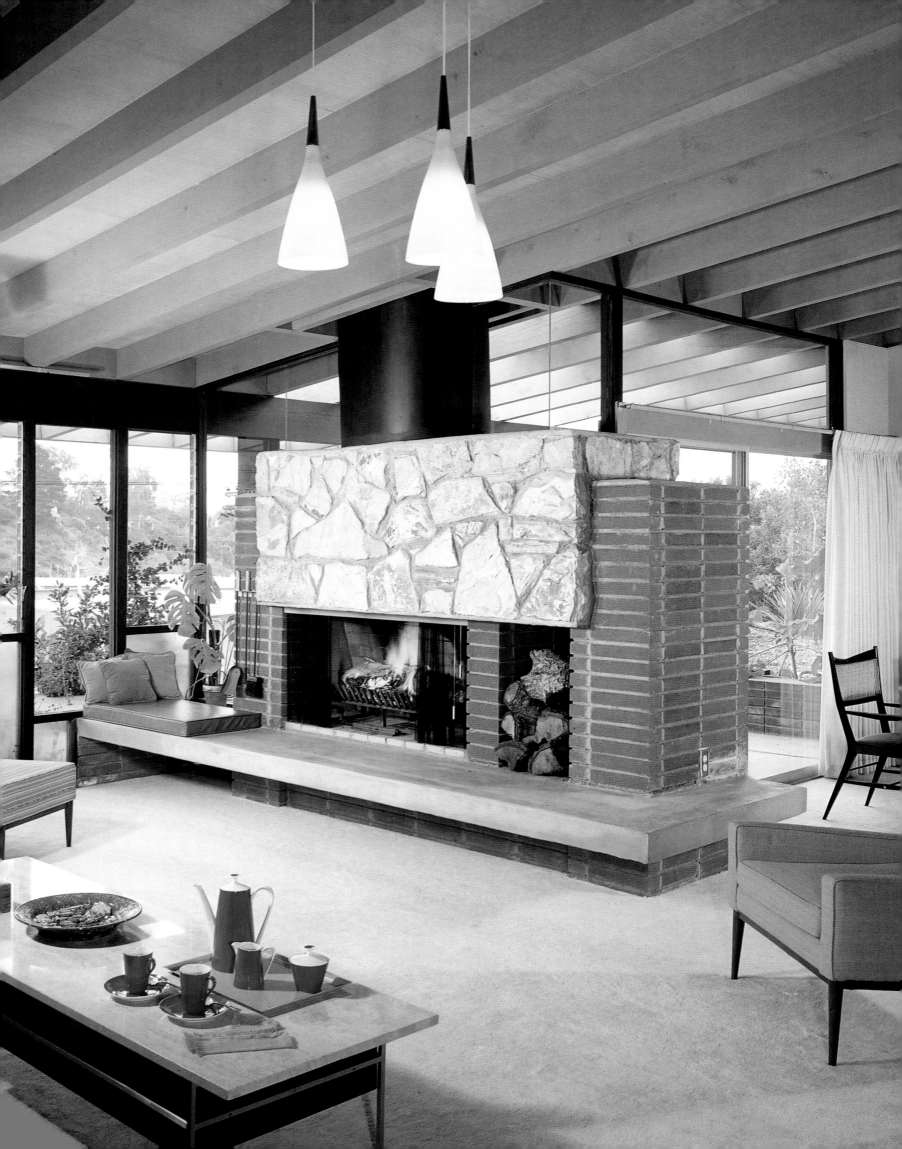

Selected Bibliography: - Los Angeles Times Home Magazine, August 3, 1958

2603 Joseph Johnson
Leeds Residence, Pasadena, California
May 23, 1958

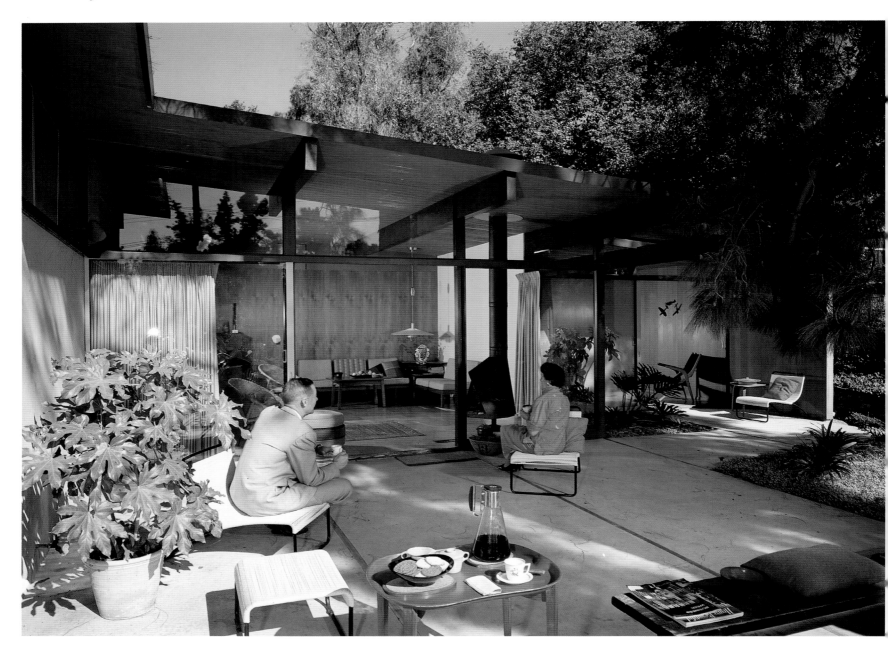

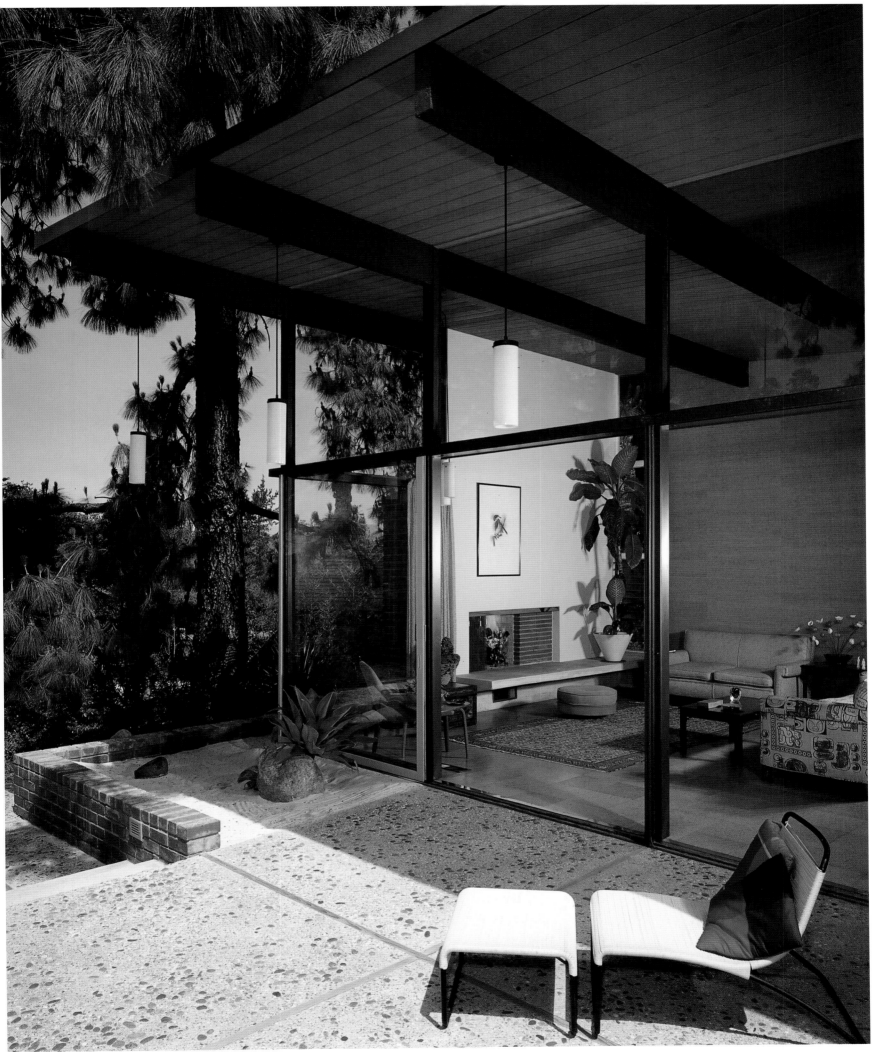

2650 Adrian Wilson Associates
Convention Center, Las Vegas, Nevada
August 18, 1958

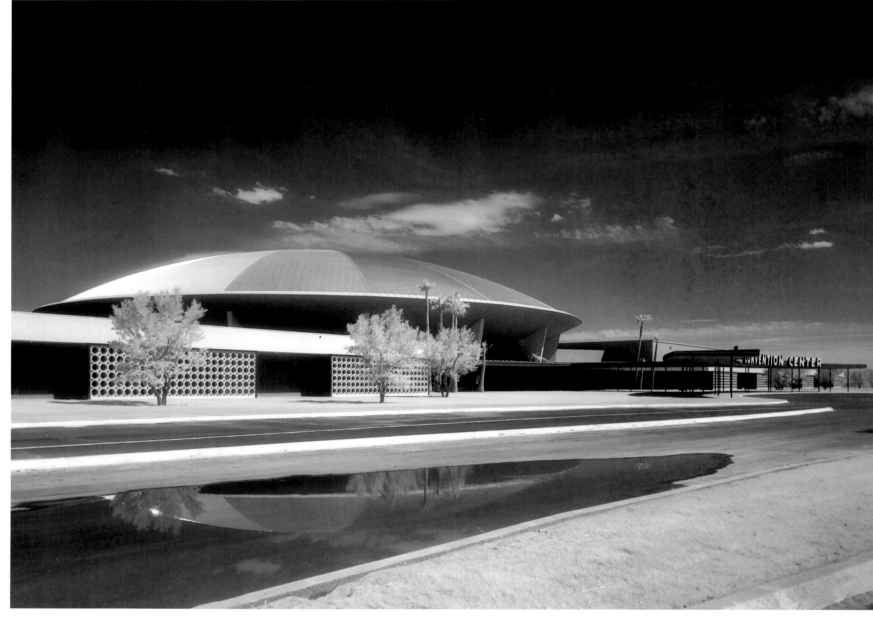

In the wake of Las Vegas' economic development in the 50s, the Clark County Fair and Recreation Board undertook a large development program to include the city in the national business circuit.

The site was a 40-acre property at Desert Inn Road and Paradise Valley Road, once the location of a racetrack. The distinguishing feature of the architecture was the unique mushroom-shaped aluminum roof dominating the volumetric composition. The dome was 316 feet in diameter. 16 arched steel trusses, each six feet deep and weighing six tons, were connected to a tension and compression ring that defined its structure. Beneath the cupola, the assembly hall was designed for very diverse types of gathering, with a seating capacity of 8,500 people. The entire ceiling under the dome was suspended below the roof for acoustical and air conditioning considerations. The exhibit wing housed display facilities and trade areas.

Zu Beginn der wirtschaftlichen Entwicklung von Las Vegas in den 50er-Jahren hatte sich der »Clark County Fair and Recreation Board« ein großes Bebauungsprogramm vorgenommen, um die Stadt in den wirtschaftlichen Kreislauf einzubeziehen. Der Standort war ein 162 000 Quadratmeter großes Grundstück zwischen Desert Inn Road und Paradise Valley Road, auf dem Gelände einer früheren Rennbahn. Das charakteristische Merkmal des Gebäudes war das ungewöhnliche pilzförmige Aluminiumdach, das die Baumasse beherrschte. Die Kuppel hatte einen Durchmesser von 100 m. 16 gebogene Stahlbinder, jeweils 1,80 m tief und 6 Tonnen schwer, waren mit einem Zug- und Druckring verbunden und bildeten so das Tragwerk. Der Kongresssaal unterhalb der Kuppel war für verschiedenartigste Versammlungen geeignet und bot Sitzmöglichkeit für 8 500 Menschen. Die Decke unter der Kuppel war zur Verbesserung der Akustik und Klimatisierung von der Dachkonstruktion abge-

A l'occasion de l'essor que connut Los Angles au cours des années 1950, la Foire du comté de Clark et le Comité des Fêtes se lancèrent dans un vaste programme de développement pour améliorer l'intégration de la ville à l'activité économique nationale. Un ancien champ de course de 20 hectares au carrefour de Desert Inn Road et de Paradise Valley Road fut retenu. L'élément le plus caractéristique de ce centre de congrès est son toit d'aluminium en forme de champignon. Ce dôme mesurait 100 m de diamètre. 16 fermes en arc d'acier, chacune de 1,80 m d'épaisseur et pesant 6 tonnes, étaient assemblées en un anneau en tension et compression pour constituer l'ossature. Sous la coupole, la salle prévue pour 8 500 personnes était conçue pour divers types de réunions. Pour améliorer l'acoustique et la climatisation, le plafond a été suspendu à la charpente du toit. L'aile de la foire accueillait des installations commerciales et d'exposition. La longueur totale du

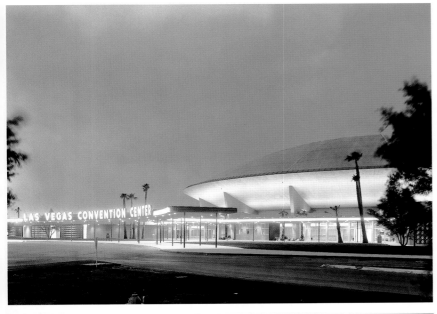
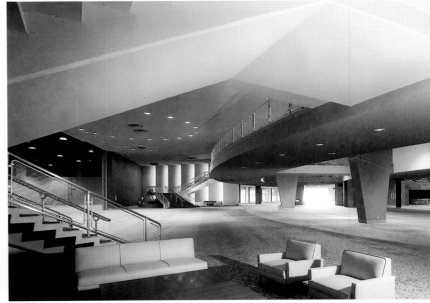
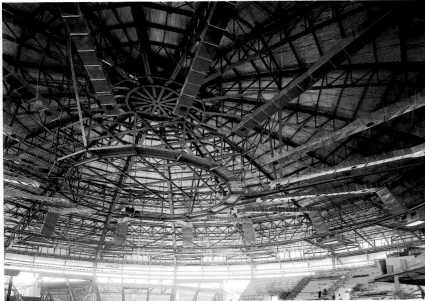
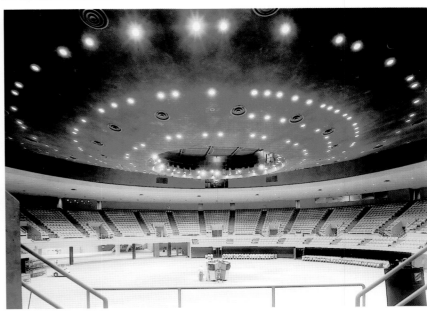

The overall length of the project was 1,000 feet. Over a thousand sheets of 0.40-inch anodized corrugated aluminum with a four-inch rib formed the cladding of the dome's exterior surface. Structurally, part of the load-bearing walls was masonry curtain walls. The floors were primarily metal decks except for the main level designed in concrete for the heavy loads of temporary shows. Automatic movable partitions in aluminum soundproofing separated the interior spaces. 2 x 4-foot grid-paneling patterned the high ceilings and covered the mechanical ducts.

hängt. Der Ausstellungstrakt enthielt entsprechende Installationen und Verkaufsbereiche. Die gesamte Länge des Projekts betrug 300 m. Über tausend Platten aus 1 cm starkem eloxiertem Well-Aluminium bildeten die Verkleidung der Kuppel-Außenfläche. Die tragenden Wände waren zum Teil mit Ziegeln verkleidet. Die Geschossdecken waren vorwiegend Stahlkonstruktionen, außer im Hauptgeschoss, dort waren sie aus Stahlbeton für schwere Belastung bei wechselnden Ausstellungen. Mechanisch betriebene Faltwände mit einer Schallschutzbekleidung aus Aluminium unterteilten die Innenräume. Ein Lamellengitterrost gliederte die Deckenuntersicht und deckte die Versorgungsleitungen ab.

bâtiment atteignait 300 m. Le dôme était recouvert de plus de 1000 feuilles d'aluminium ondulé anodisé de 1 cm d'épaisseur. Les murs porteurs alternaient avec des murs-rideaux en maçonnerie. Les plateaux étaient essentiellement des plates-formes métalliques à l'exception du niveau principal qui était en béton, pour supporter des charges importantes lors des expositions temporaires. Des cloisonnements à commande automatique en aluminium et isolants phoniques divisaient les espaces intérieurs. Les plafonds qui masquaient les divers conduits techniques étaient habillés de panneaux de 0,60 x 1,20 m.

Selected Bibliography:
- Architect and Engineer, August 1958
- John Peter (ed.), Aluminum in Modern Architecture, New York 1960

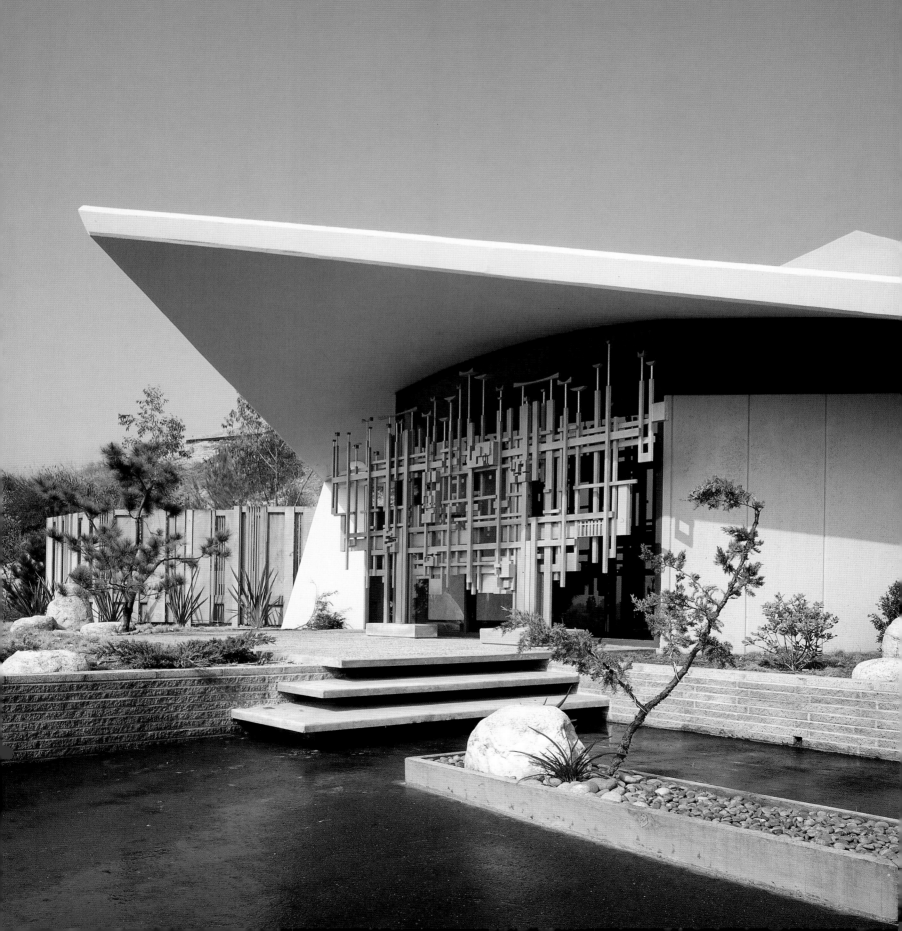

This studio-office for an advertising consultant was in the Eagle Rock District of Los Angeles. Located on three acres of land, it was the first building in a "research park" conceived by the owner, James Real and others.

The adventurous solution for the canopy caught the attention of the press and led to a Merit Award from the American Institute of Architects Pasadena Chapter in 1959. The roof was composed of four equal hyperbolic paraboloids on four exterior columns. Outlining a square profile, it spanned an octagonal plan. Each surface was poured on forms made from straight timber planking and was two inches thick except for the edge areas. This was the first shell structure approved by the Los Angeles building department. The Pacific Bridge Company, which specialized in large-scale structures, made a research laboratory out of this project to highlight how construction techniques could be adopted to create highly sculptural forms that were financially competitive solutions.

Four distinct sections comprised the plan for a total of 2,500 square feet: an office space, a conference room, a drafting area and services. Sheltered by a corner overhang, the access cut the interior diagonally. The enclosure walls were pre-cast concrete and recessed from the roof perimeter. Indirect sunlight entered through the underside window of the canopy structure and reverberated in the interiors. The wooden screen at the entry and the artwork were by Jan de Swart.

Dieses Gebäude einer Werbeagentur entstand im Eagle Rock-Bezirk von Los Angeles auf einem 3 Morgen großen Gelände und war der erste fertige Bau im »Experimentierpark« des Agentur-Besitzers James Real und anderer Eigentümer.

Das eigenwillige, weit auskragende Dach erregte die Aufmerksamkeit der Presse und brachte dem Bau 1959 einen Merit Award der Sektion Pasadena des American Institute of Architects ein. Das Dach bestand aus vier gleich großen hyperbolischen Paraboloiden (zweifach gekrümmte Schalen) auf vier Außenstützen und umschrieb ein Quadrat über einem achteckigen Baukörper. Die vier jeweils ca. 5 cm dicken, an den Rändern etwas dünneren Dachdecken wurden an Ort und Stelle in Bretterverschalungen gegossen. Es war das erste vom Bauamt Los Angeles genehmigte Betonschalendach überhaupt. Die auf Großbauvorhaben spezialisierte Pacific Bridge Company nutzte dieses Projekt als Versuchsobjekt für plastische Bauformen auf der Grundlage neuer und noch dazu wirtschaftlicher Bautechniken.

Die Gesamtfläche von 230 m^2 war in vier Abteile gegliedert: Büro, Konferenzraum, Zeichensaal, Nebenräume (Haustechnik, Sanitär, etc.). Der Zugang liegt unter den Dachüberständen. Indirektes Tageslicht fällt durch die Oberlichter zwischen Außenmauer und Dachschale ins Innere. Jan de Swart entwarf die Holzwand am Eingang und zeichnete verantwortlich für die künstlerische Ausstattung.

Cet atelier-bureau construit pour un consultant publicitaire se trouvait dans le quartier d'Eagle Rock à Los Angeles sur un terrain de 1,5 hectare. C'était la première réalisation d'un « Research Park » créé par le propriétaire James Real et ses associés. Cette « tente » audacieuse attira l'attention de la presse et valut à ce projet un prix du mérite du chapitre de Pasadena de l'AIA en 1959. Le toit se composait de quatre paraboloïdes hyperboliques de dimensions égales, reposant sur quatre piliers rejetés en périmétrie. Carré vu de profil, il était en fait octogonal. Chaque élément avait été coulé dans des coffrages en planches brutes de sciage et mesurait 5 cm d'épaisseur hors tout. Ce fut la première coque de béton homologuée par le département de la construction de Los Angeles. La Pacific Bridge Company, spécialisée dans les structures de grandes dimensions, fit de ce projet un laboratoire pour montrer à quel point certaines techniques de construction pouvaient donner naissance à des formes sculpturales tout en restant économiquement compétitives.

Quatre sections distinctes occupent le plan intérieur de 230 m^2 : un bureau, une salle de conférence, une salle de dessin et des pièces techniques. A l'abri d'un surplomb en angle, l'entrée coupe l'intérieur en diagonale. Les murs de l'enveloppe sont en béton préfabriqué en retrait par rapport au toit. La lumière naturelle pénètre indirectement par des ouvertures vitrées entre les murs et la « tente » et se réverbère à l'intérieur. L'écran de bois de l'entrée et les œuvres d'art étaient de Jan de Swart.

Selected Bibliography:
- arts & architecture, December 1958
- Architectural Forum, August 1959
- Architectural Record, February 1960

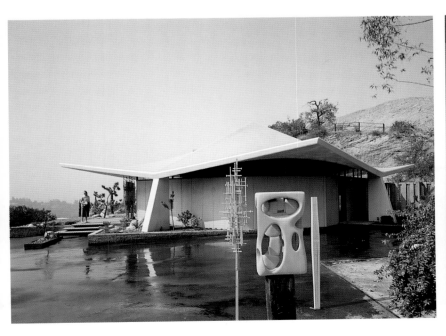

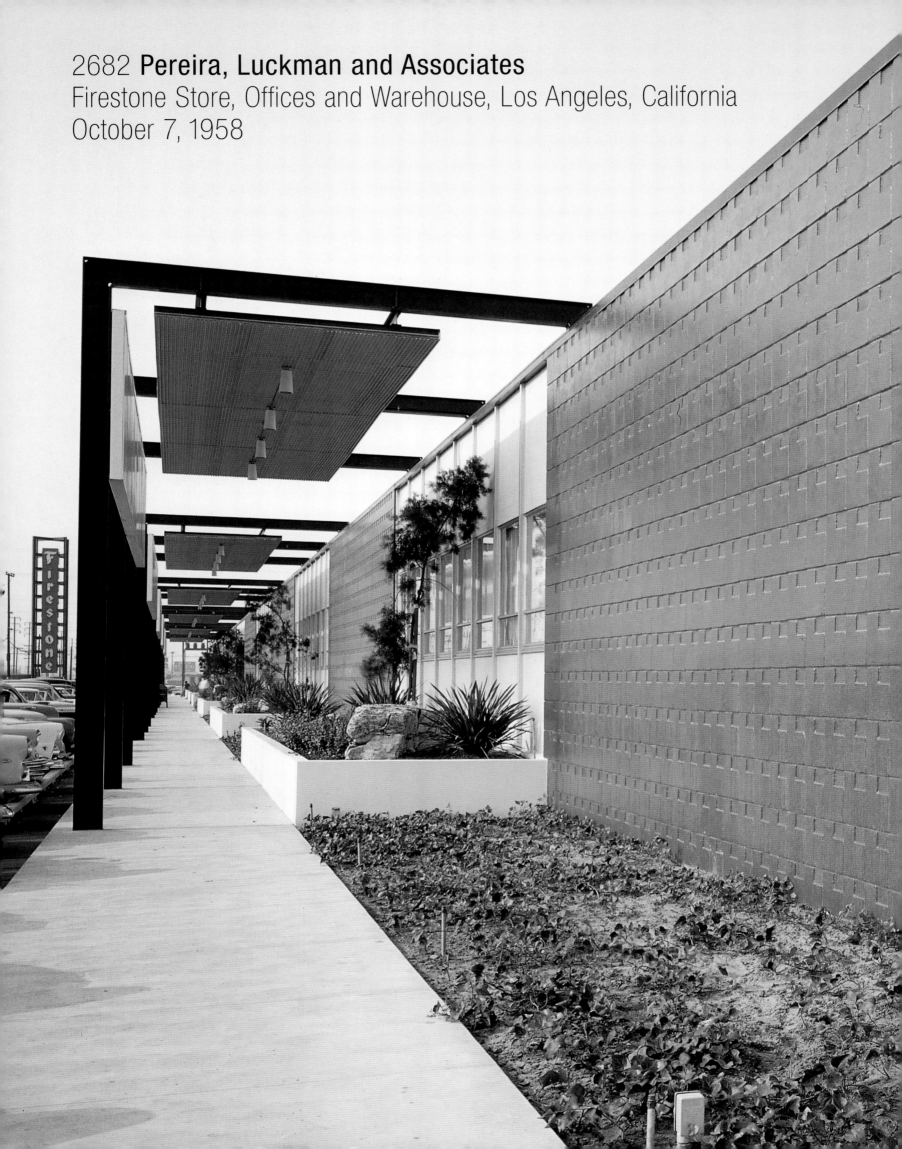

2682 **Pereira, Luckman and Associates**
Firestone Store, Offices and Warehouse, Los Angeles, California
October 7, 1958

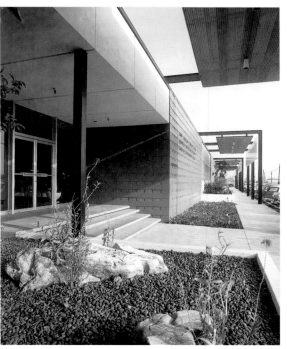

2693 Henry Hester
Gleich Residence, San Diego, California
October 22, 1958

Through the design-build formula, Hester crafts a space that blends the boundaries between indoors and outdoors. Starting from the street access, one long and narrow line of rooms runs the full length of the site. The living-dining area and the master bedroom grow perpendicularly off the mid- and endpoint of the longitudinal volume into the landscape. Each room opens to the pool area and large garden, both contained between the octogonal wings of the house. The sunken area of the living room adds a new experience of scale on this flat site. Brick paving unites the circular living room with the garden area, doubling its square footage outdoors.

In 1960, the Gleich Residence received an Honorable Mention in the Homes for Better Living Awards program sponsored by the American Institute of Architects in cooperation with *House & Home* and *LIFE* magazine, and an Award of Excellence in the Honor Awards program held by the San Diego Chapter of the American Institute of Architects.

Hester setzte seinen Entwurf selber um und schuf Räume, in denen die Grenzen zwischen Innen- und Außenraum verschwimmen. Ausgehend von der Zufahrt an der Straße durchdringt ein langes, schmales »Rückgrat« das Grundstück in seiner ganzen Länge. Wohn- und Esszimmer sowie Schlafzimmer treten im rechten Winkel zum Mittelteil und zum Ende des langgestreckten Baukörpers in die Landschaft vor. Jeder Raum öffnet sich zum großen Garten mit Schwimmbecken, der von diesen Flügeln umfasst wird. Der abgesenkte Teil des Wohnraums sorgt für ein abwechslungsreiches Wohnerlebnis. Der durchgehende Klinkerboden des kreisrunden Wohnraums und der Terrasse verbindet Haus und Garten.

Im »Homes for Better Living«-Wettbewerb des American Institute of Architects (in Zusammenarbeit mit »House & Homes« und »LIFE«) wurde das Haus Gleich 1960 belobigt; im gleichen Jahr erhielt es einen Award of Excellence von der Sektion San Diego des AIA.

Le concept retenu par Hester permettait d'aménager un espace tout en gommant les limites entre le dedans et le dehors. A partir de l'entrée sur rue, une longue succession de pièces peu profondes se déploie sur toute la longueur du terrain. La zone séjour-repas et la chambre principale forment une saillie perpendiculaire à cet axe, à mi-longueur et en extrémité. Chaque pièce ouvre sur le bassin et le grand jardin, tous deux contenus entre les ailes perpendiculaires. La partie en creux du séjour crée un espace convivial à jart. Un pavement en brique relie le séjour circulaire au jardin, doublant vers l'extérieur la surface du premier.

En 1960, la Gleich Residence a reçu une mention honorable à l'occasion des Homes for Better Living Awards, sponsorisés par l'AIA en collaboration avec «House & Garden» et «LIFE» et un prix d'excellence aux prix d'honneur organisés par le chapitre de San Diego de l'AIA.

Selected Bibliography:
- House & Home, June 1960
- House & Home, September 1960
- Pacific Architect & Builder, August 1960

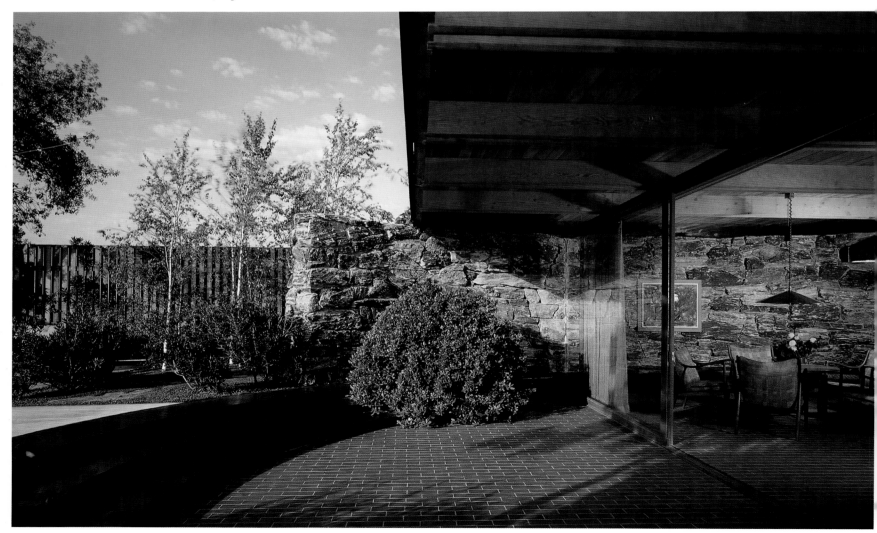

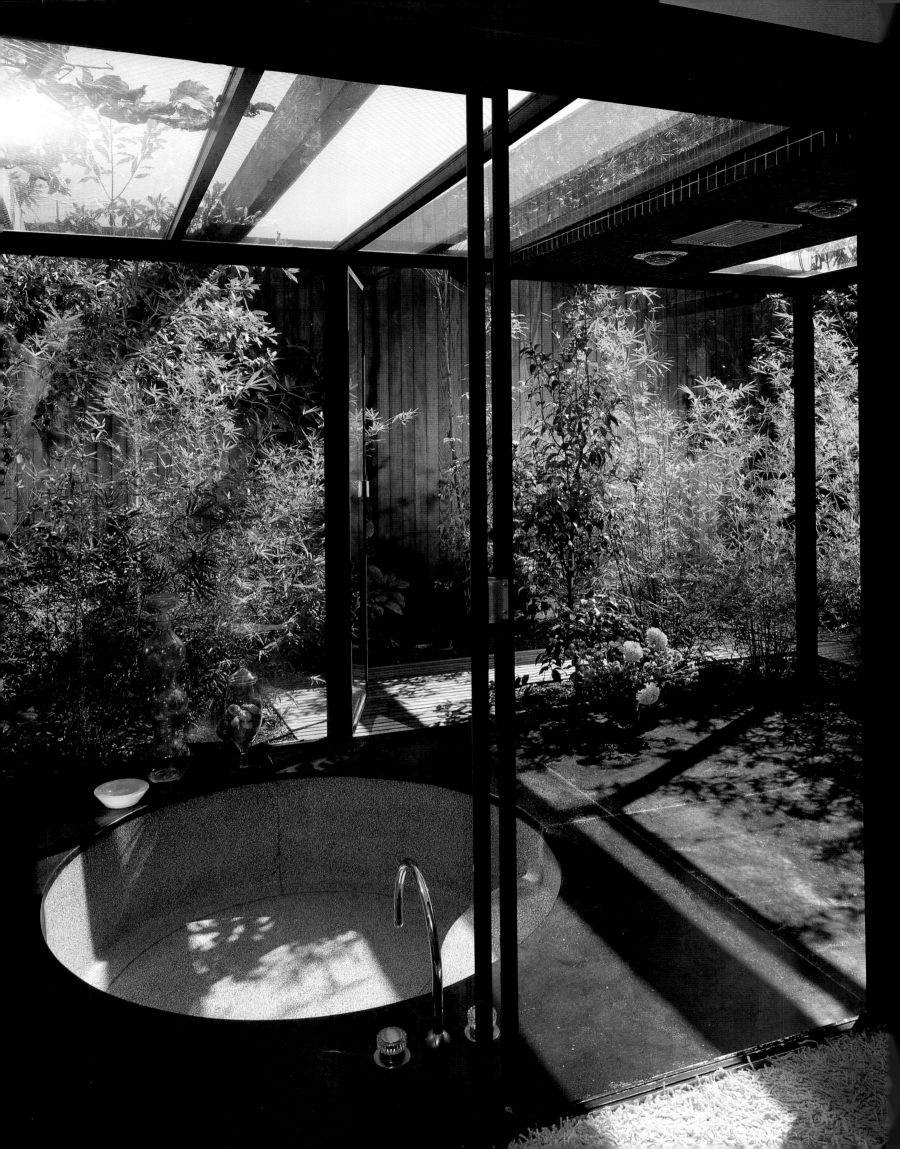

2732 **Theodore T. Boutmy**
Mammoth Mountain Inn, Mammoth Mountain, California
December 20, 21, 22, 1958

The project location is a popular ski resort at an altitude of 2,900 m. An A-frame rectilinear structure housing the recreational and dining facilities crosscuts a three-story volume containing the guestrooms. Their point of intersection houses a full-height meeting area corresponding to the hub of the hotel. The balcony of the bar on the second floor bridges over the street to cover the lobby and reception area below.

Der Hotelbau steht in einem beliebten Skiurlaubsort auf einer Höhe von 2 900 m. Ein relativ steiles Satteldach aus weit heruntergezogenen dreieckigen Dachdecken überspannt die mit Sitzecken ausgestattete Empfangshalle, an die sich zu beiden Seiten rechtwinklig die dreigeschossigen Gästezimmerflügel anschließen. Die Bargalerie im Obergeschoss überbrückt den straßenseitigen Zugang zur Empfangshalle.

Cet hôtel a été construit dans une grande station de ski à 2 900 m d'altitude. Une structure en forme de A abrite la salle à manger et les salons au milieu d'un bâtiment de trois niveaux avec une partie affecté aux chambres tandis que le hall occupe toute la hauteur. A leur point d'intersection, se développe un hall toute hauteur, centre de l'hôtel. Le balcon du bar au premier étage forme un auvent qui abrite l'entrée et la réception.

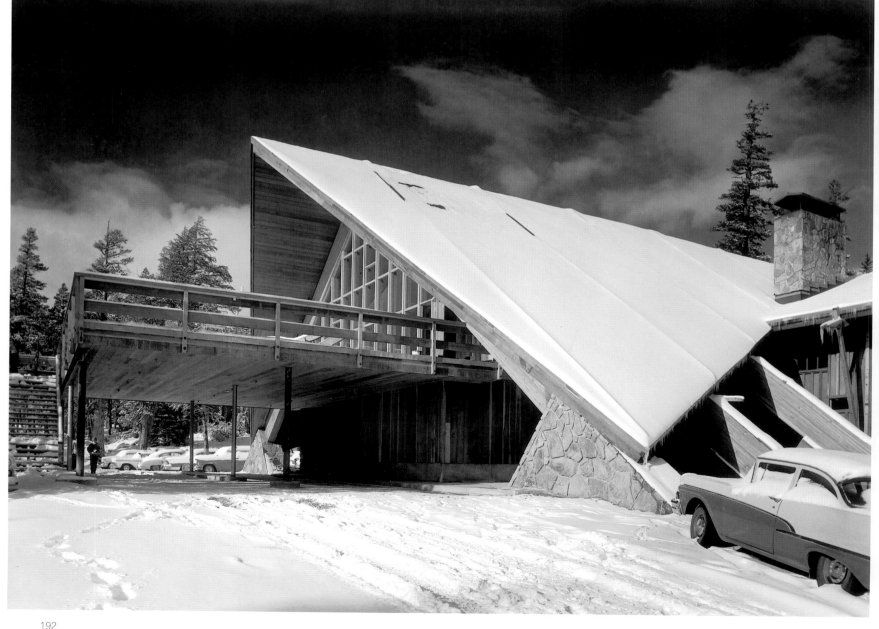

Selected
Bibliography:
- *Arkitekten, June 1961*

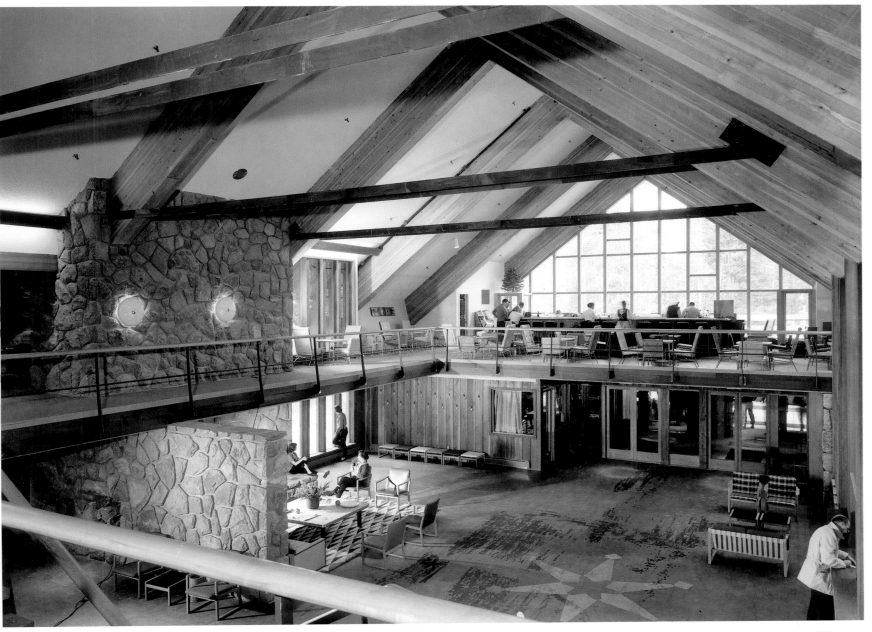

2761 Buff, Straub and Hensman
Recreation Pavilion, Mirman Residence, Arcadia, California
February 3, 1959

Recipient of the Honor Award from the Pasadena Chapter of the American Institute of Architects in 1960, this recreation pavilion was an adjacent, yet distinct element of the family's main residence. Dr. and Mrs. Ben Mirman had three children and commissioned the architects to design a multi-purpose entertainment facility geared to the needs of both adults and children and encouraging communal activity. Several game areas for outdoor sports (a court for badminton, basketball, volleyball; a shuffleboard playground; a ping pong table; a swimming pool; and a tree house) and an exterior living room for social venues provide the stage for various forms of interaction. Within a 69 x 113-foot space, six rectangles of diverse sizes are placed side by side to generate a visually fluid, seamless space throughout the entire site. Changes in floor levels suggest functional separations sheltered under a single roof. A minimum number of partitions defines the openness of the layout. The core of the facility is fully equipped with built-in commodities: kitchen, bar, fireplace, barbecue, dining table and part of the seating are permanent fixtures of a setting organized around the interplay of indoor and outdoor.

Through the economy of materials, the architects identify the functional fields in the design. Two raised wooden platforms, the entry and lounge decks used as built-in seating areas for both courts and lounge, float above the lowered brick floor of the pavilion. The walls, in either bricks or plywood, are carefully placed in the corners of the primary rectangular shapes of the project. Based on an eight-foot module, the charcoal brown post-and-beam structure in stained Douglas fir opens to the playing courts and the garden. The flat, continuous ceiling in unstained Douglas fir becomes the unifying architectural element of diverse activities.

Dieser Pavillon grenzte an das Hauptwohnhaus der Familie, bildete aber dennoch eine separate Einheit. 1960 wurde er von der Sektion Pasadena des American Institute of Architects mit einem Honor Award ausgezeichnet. Die Mirmans hatten drei Kinder und beauftragten die Architekten mit dem Bau einer »Freizeit-Anlage«, in der Erwachsene und Kinder verschiedene gemeinsame Aktivitäten entwickeln konnten. Dazu gehören mehrere Bereiche: ein Spielfeld für Federball, Basketball oder Volleyball, ein Ping-Pong-Tisch, Schwimmbecken und Baumhaus sowie eine Wohnterrasse. Auf einem Grundriss von 20 x 35 m sind sechs verschieden große Rechtecke nebeneinander angeordnet, so dass die Räume optisch nahtlos ineinander fließen. Unterschiedliche Fußbodenniveaus markieren die einzelnen Funktionsbereiche unter dem gemeinsamen Dach. Der Gesamtraum ist mit nur wenigen Trennwänden unterteilt. Der Gebäudekern umfasst die Küche, die Bar, den offenen Kamin, Grillplatz und Esstisch mit Bänken als feste Einbauteile. Mit sparsamen Mitteln haben die Architekten die verschiedenen Funktionsbereiche definiert. Zwei erhöhte Holzpodeste (Eingangs- und Wohnbereich) »schwimmen« auf dem abgesenkten Klinkerboden des Pavillons und werden als Einbausitze am Rand der Spielfelder und im Wohnbereich genutzt. Die Wände (entweder aus Ziegelmauerwerk oder Sperrholz) sind exakt auf den Ecken des Grundrasters platziert, das auf einem 2,50 m-Modul basiert. Die geschwärzte Pfosten-und-Riegel-Konstruktion aus Douglaskiefernholz öffnet sich zu den Spielfeldern und zum Garten. Die durchgehende Flachdecke aus naturbelassenem Douglaskiefernholz bildet das buchstäblich übergreifende und alle Aktivitäten zusammenfassende architektonische Element.

Récompensé par le prix d'honneur du chapitre de Pasadena de l'AIA en 1960, ce pavillon était adjacent à la résidence principale de ses propriétaires. Les Mirman avaient demandé aux architectes de concevoir un bâtiment polyvalent consacré aux sports et aux loisirs, tant de leurs enfants que d'eux-mêmes. Plusieurs aires de jeux de plein air (badminton, volley-ball, basket-ball, jeu de galet, ping-pong, piscine, sans compter une cabane dans un arbre) et un « séjour extérieur » pour recevoir offrent un cadre à diverses activités en commun. A l'intérieur d'un rectangle de 20 x 35 m, six rectangles de différentes tailles sont disposés côte à côte pour générer un espace fluide, sans interruption apparente, qui occupe la totalité du terrain. Les changements de niveaux suggèrent la diversité des fonctions réunies sous un même toit. Les cloisonnements en nombre très limité sont répartis dans un plan très ouvert. Le noyau du pavillon est doté d'équipements intégrés qui s'insèrent dans le jeu incessant entre le dedans et le dehors : cuisine, bar, cheminée, barbecue, table des repas et une partie des sièges.
L'économie des matériaux employés aide les architectes à identifier les fonctions. Deux plates-formes de bois surélevées, à l'entrée et dans le salon, servent de banquettes fixes pour le salon et la cour et semblent flotter au-dessus du sol de brique du pavillon. Les murs, qu'ils soient en brique ou en contreplaqué, sont implantés avec soin aux angles du rectangle de base. Construite selon une trame de 2,50 m, l'ossature à poteaux et poutres en pin de Douglas teinté brun noir s'ouvre sur les aires de jeux et le jardin. Le plafond horizontal continu en pin de Douglas naturel sert de toile de fond aux diverses activités.

Selected Bibliography:
- *Los Angeles Times Home Magazine, September 25, 1960*
- *Western Architect and Engineer, November 1960*
- *Architectural Record, August 1963*

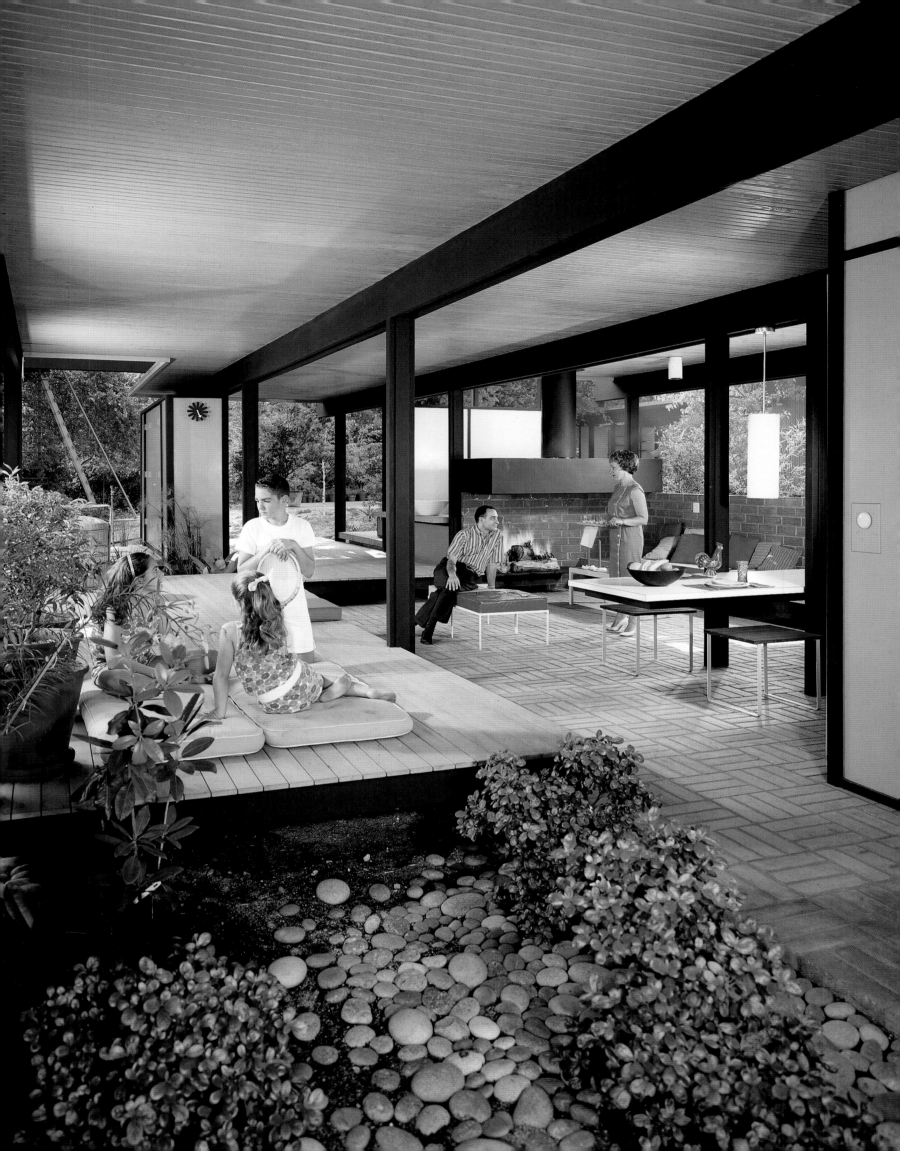

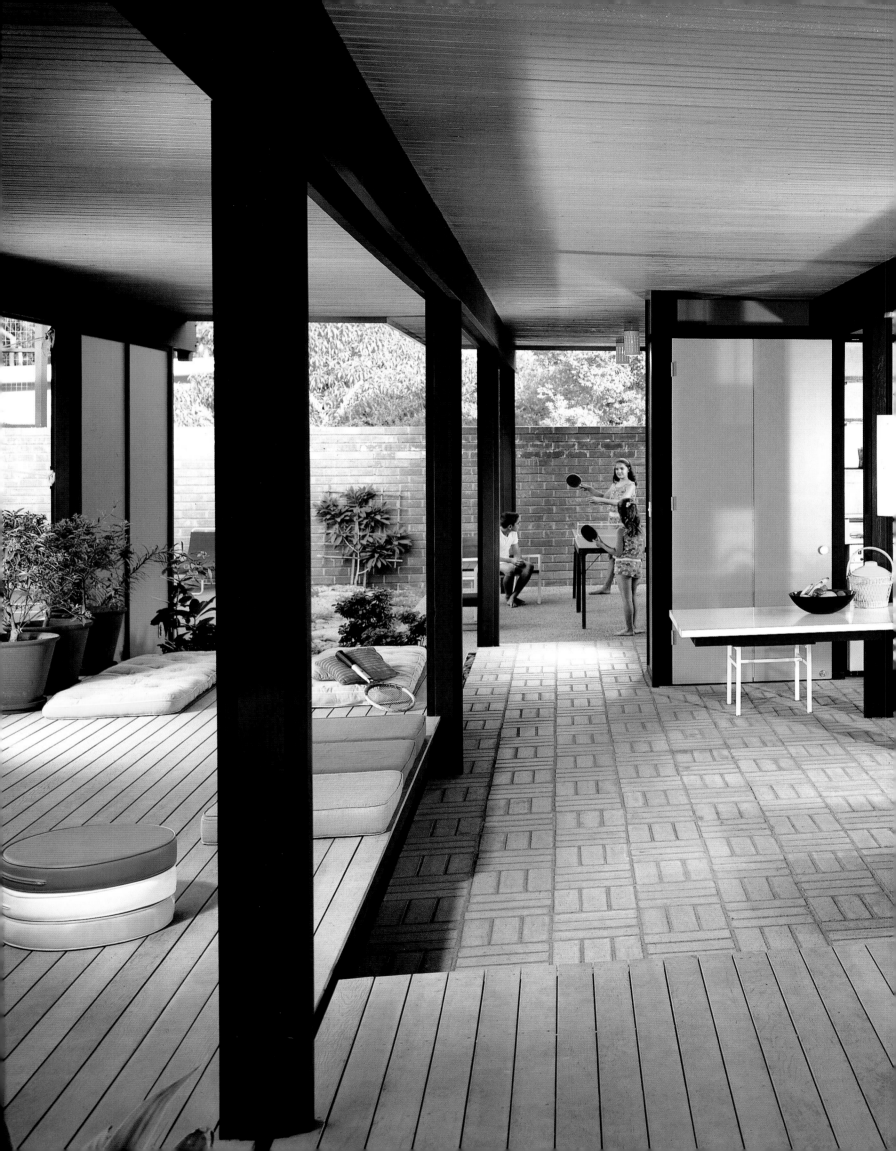

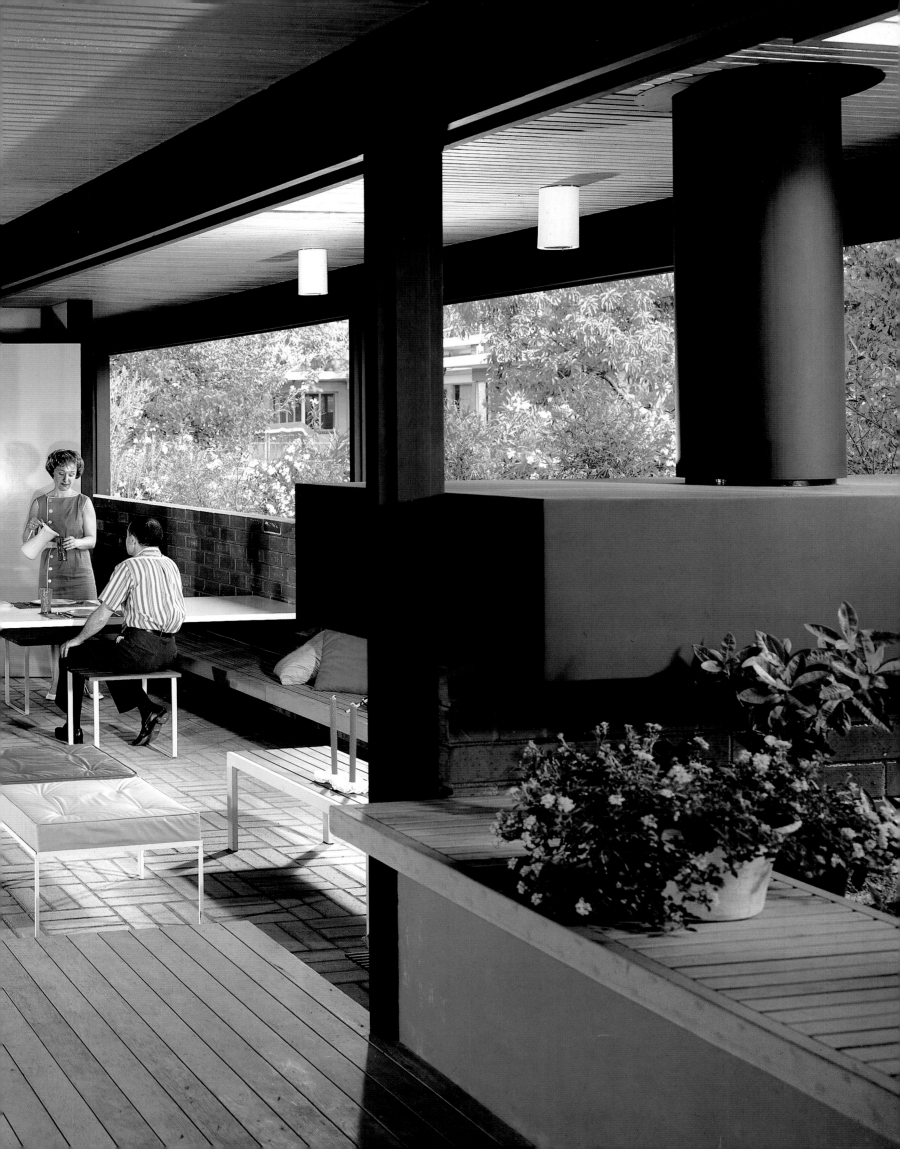

2762 Buff, Straub and Hensmann
Edwards Residence, Beverly Hills, California
February 4, 1959

The design meets the demands of a household going through a transitional period. The family make-up comprised a couple with two young daughters in college. Two different agendas coexist in the plan layout: the needs of the offspring regularly coming back to the house, and the imminent scenario of the parents' life in the post-child-raising years.

The narrow ledge on the building lot dictates the elongated geometry of the house. Each room has a panorama of the surroundings and a visual relationship with the outdoor pool. A multipurpose area in the center of the residence stages communal activities. At its opposite ends, the architects situate the private bedrooms of owners and their daughters, each with their outdoor annexes. When the children are away, their wing gets converted into a guesthouse, with an additional room used as a painting and pottery studio. A long porch paved with rosy beige pebbled concrete stretches the living-dining-cooking area out into the pool zone. The interior has a Japanese flavor, explicit in the use of closets with shoji-doors and in the detailing of the garden. A Merit Award went to the Edwards Residence from the American Institute of Architects Pasadena Chapter in 1959.

Der Entwurf erfüllte die Bedürfnisse einer Familie, die sich in einer Übergangsphase befand: Die zwei Töchter des Ehepaars Edwards besuchten bereits das College und kamen nur noch ab und zu nach Hause, das Haus musste also Zimmer für sie bereit halten, aber auch die Bedürfnisse des später allein lebenden Ehepaares berücksichtigen.

Das schmale Stück Flachland des Grundstücks gab die langgestreckten Umrisse des Hauses vor. Jeder Raum bietet eine Panoramasicht in die Umgebung und Blick auf das Schwimmbecken im Garten. Der Mehrzweckraum in der Mitte des Hauses ist Mittelpunkt des Familienlebens. Die Architekten platzierten das Elternschlafzimmer auf dessen einer Seite und die Schlafzimmer der Töchter auf der anderen und statteten sie jeweils mit eigenen Terrassen aus. Bei Abwesenheit der Töchter werden ihre Zimmer in eine Gästewohnung mit einem als Atelier und Keramikstudio genutzten zusätzlichen Raum verwandelt. Eine lange, mit rosa-beigefarbenen Waschbetonplatten ausgelegte Veranda verlängert den Wohn-, Ess- und Küchenbereich bis zum Schwimmbecken ins Freie. Die Innenausstattung lässt an japanische Häuser denken, besonders die Shoji-Wände der begehbaren Schränke und die Grünpflanzenbereiche. Das Haus Edwards erhielt 1959 von der Sektion Pasadena des American Institute of Architects einen Merit Award.

Ce projet répond aux besoins d'une famille qui traversait une période de transition. Le couple et ses deux filles, qui allaient au collège, souhaitaient un cadre de vie adapté, qui prenne en compte le retour périodique des enfants à la maison et, pour le futur, leur départ définitif.

L'étroitesse de la parcelle de terrain a dicté le plan. Chaque pièce bénéficie du panorama sur l'environnement et donne sur la piscine. Au centre, un espace multifonctions offre un cadre aux diverses activités familiales. Les chambres et leurs prolongements extérieurs se trouvent à l'extrémité opposée. Lorsque les enfants partent, leurs chambres se transforment en maison d'amis et en une pièce supplémentaire qui sert d'atelier de peinture et de poterie.

Une longue véranda pavée de dalles en petits galets de tonalité rosée prolonge le séjour-salle à manger vers la piscine. L'architecture témoigne d'influences japonaises dans le style décoratif intérieur, comme le montrent les placards à écrans shoji, ou certains détails du jardin. Un prix du mérite a été décerné à cette résidence par le chapitre de Pasadena de l'AIA en 1959.

Selected *Bibliography:* - *Architectural Record, February 1960*
 - *House & Garden, November 1961*

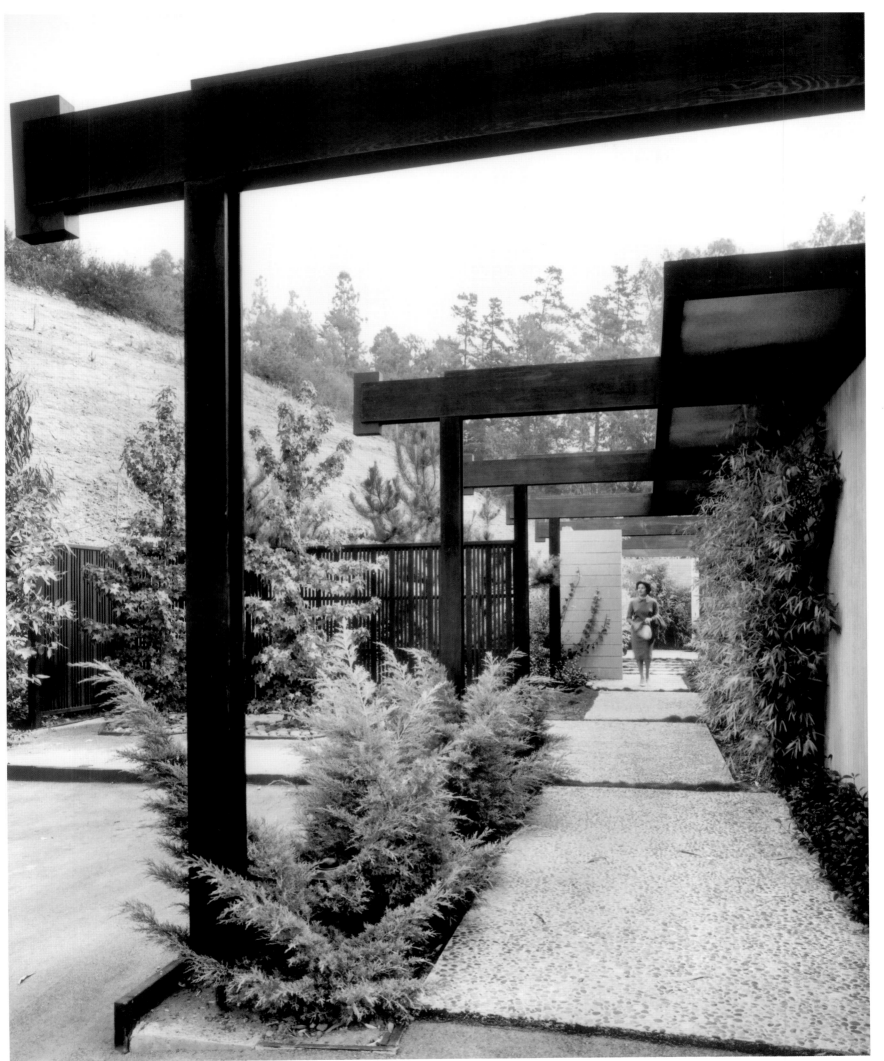

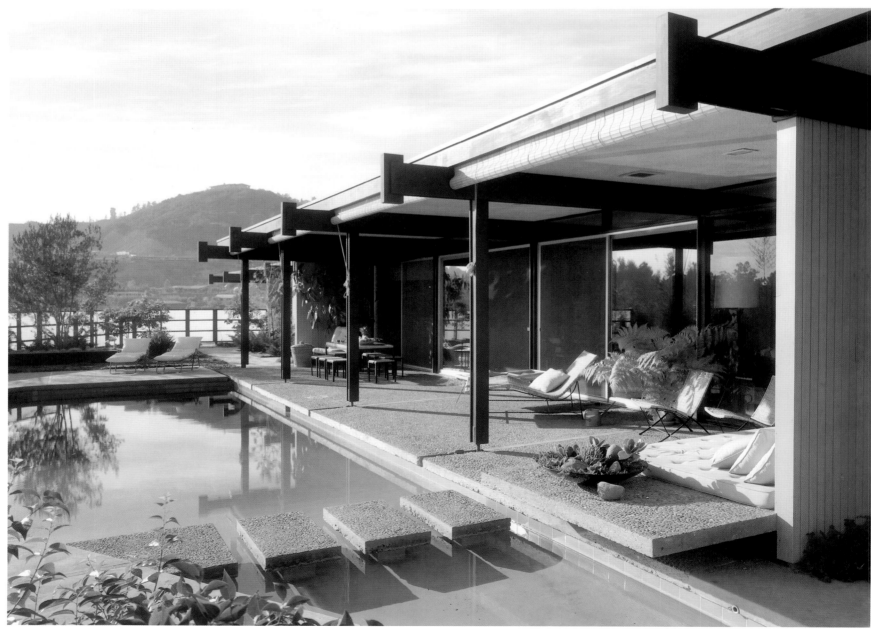

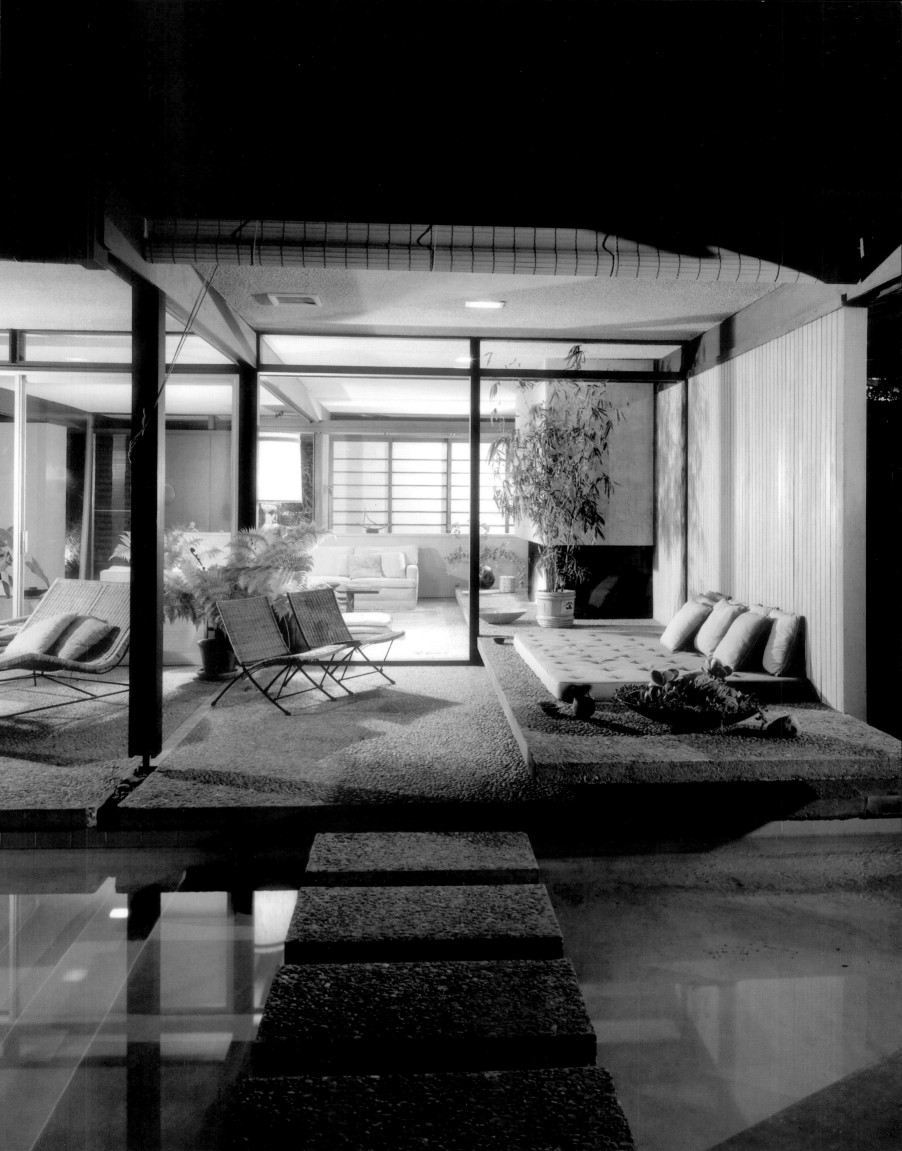

2799 William S. Beckett
Beckett Residence, Beverly Hills, California
March 24, 1959

Previously owned by the Franks family, the building was extensively remodeled by the owner-architect. Keeping the same scale, Beckett stripped off all the references to classical architecture present in the original construction, and superimposed on the main facade a two-story-high screen patterned with rectangular panels. Behind the frame, the interior features very luxurious of materials. The bathroom turns into an exercise of style on its own terms. The space exhibits eight square feet of bathtub and shower tiled with a glass mosaic. In addition compartmentalized toilets and dressing rooms for each partner are clad in white marble and gold-plated tiles.

Das Haus hatte zuvor der Familie Franks gehört, Beckett baute es für sich und seine Familie völlig um. Er beseitigte zum Beispiel sämtliche Anzeichen von klassischer Architektur und setzte eine zweigeschossige Blendwand aus hochrechteckigen Paneelen vor die Eingangsfassade. Das Hausinnere stattete er mit luxuriösen Materialien aus. Das Badezimmer stellt eine ganz eigene Stilübung dar: Es enthält eine gewaltige Badewanne und eine mit Glasmosaiksteinen gekachelte Duschzelle. Die beiden WCs und Ankleidezimmer neben dem Schlafzimmer des Ehepaares sind mit weißem Marmor und vergoldeten Kacheln ausgekleidet.

Ancienne propriété de la famille Franks, cette maison a été entièrement remaniée par Beckett devenu son propriétaire. Conservant la même échelle, il élimina toute référence à l'architecture classique encore présente dans le projet original et surimposa à la façade un écran sur deux niveaux composé de panneaux rectangulaires décalés.
Derrière cet écran, un grand luxe de matériaux agrémente l'intérieur. La salle de bains est un véritable exercice de style : baignoire et cabine de douche décorées d'une mosaïque de verre. Les toilettes sont indépendantes et les deux dressings recouverts de marbre blanc et de carrelage doré.

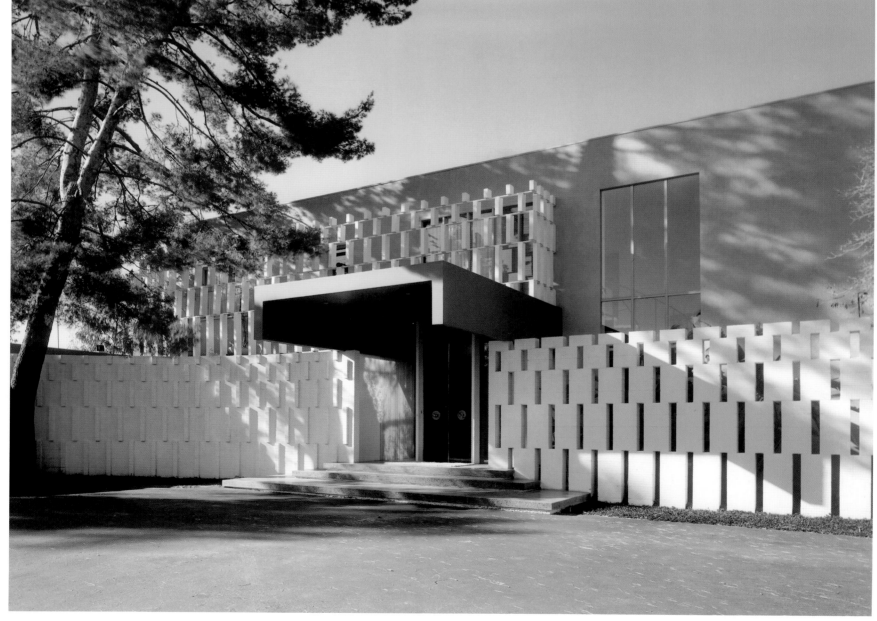

Selected Bibliography:

- L'Architecture d'Aujourd'hui, September 1957
- Los Angeles Times Home Magazine, February 14, 1960

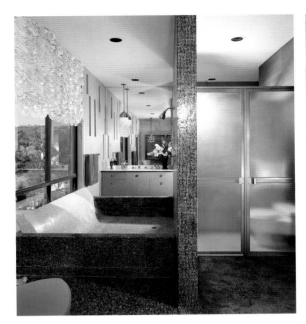

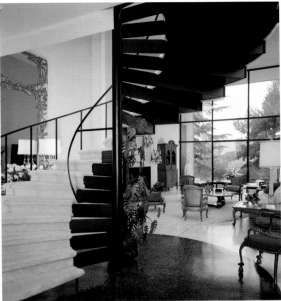

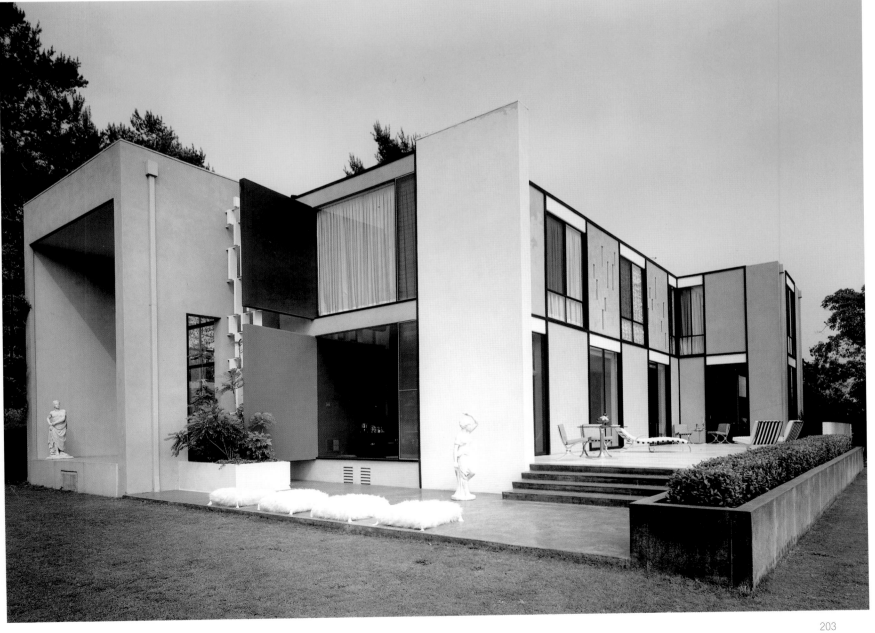

2817 **Val Powelson**
Indian Wells Country Club, Palm Springs, California
May 11, 1959

The linear building grows along the east-west axis against the rugged backdrop of the San Jacinto Mountains, shielded from the breezes and the desert sun. Raised 4 feet from the ground, the floor level is parceled out into a golf store, locker rooms, lounge area and a restaurant for 75 people. To clear the interior space of structural supports, the flat roof is suspended from exposed frames in stained laminated wood at narrow intervals. The circulation system is based on an outdoor walkway connecting the various areas to the verandas at either end of the structure.

Das gerade, lange Gebäude entwickelt sich auf der Ost-West-Achse vor der schroffen San Jacinto-Bergkulisse, abgeschirmt vor starken Winden und der sengenden Wüstensonne. Der um 1,20 m vom Boden aufgeständerte Bau umfasst Golfzubehör-lager, Umkleiden, Aufenthaltsraum und ein Restaurant für 75 Gäste. Um einen stützenfreien Innenraum zu schaffen, hängte der Architekt das Flachdach von dicht aufeinander folgenden unverkleideten Schichtholzrahmen ab. Ein Gartenweg verbindet die verschiedenen Clubbereiche mit je einer Veranda an beiden Stirnseiten des Gebäudes.

Linéaire, la construction se développe sur un axe est-ouest, à l'abri des vents et du soleil du désert, avec les San Jacinto Mountains pour toile de fond. Surélevé de 1,20 m par rapport au sol, le rez-de-chaussée est réparti entre une boutique de golf, des vestiaires, une zone salon et un restaurant de 75 places. Pour dégager l'espace intérieur de toute structure, le toit plat est suspendu aux poutres apparentes très rapprochées qui forment la charpente en bois lamellé-collé teinté. Les circulations se font par une allée extérieure qui réunit les diverses zones d'activité aux vérandas situées aux deux extrémités.

Selected Bibliography: - Pacific Architect & Builder, April 1960

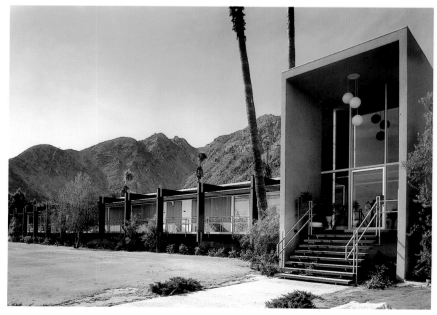

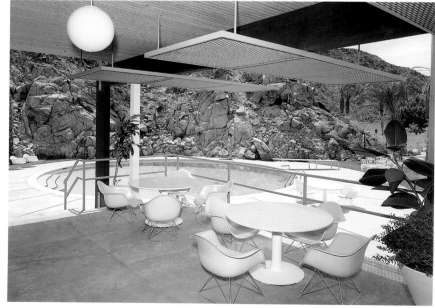

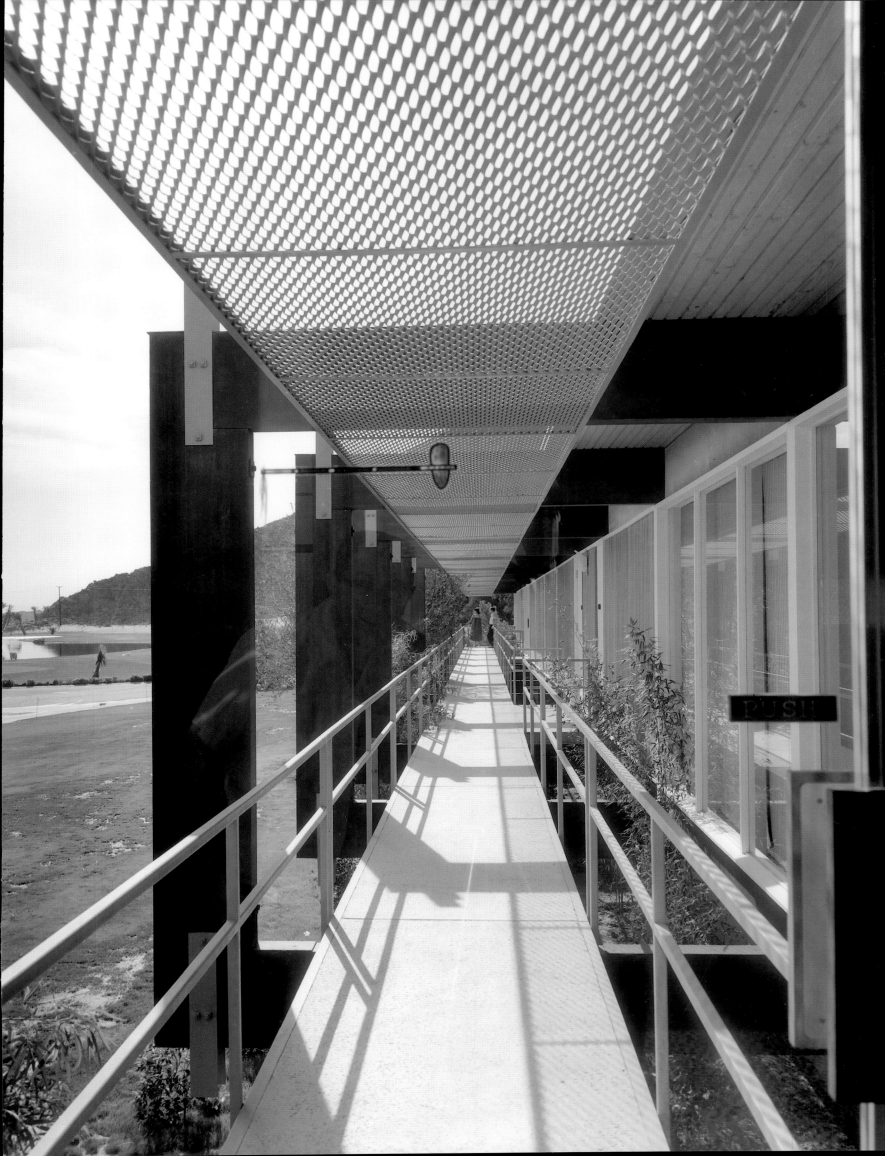

2998 Carl L. Maston
Medical Building, Ventura, California
June 1, 1960

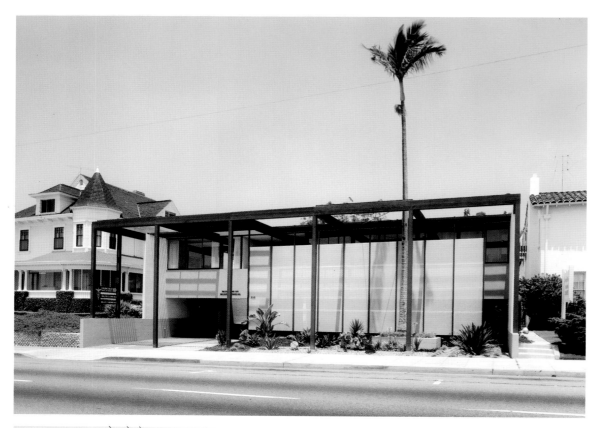

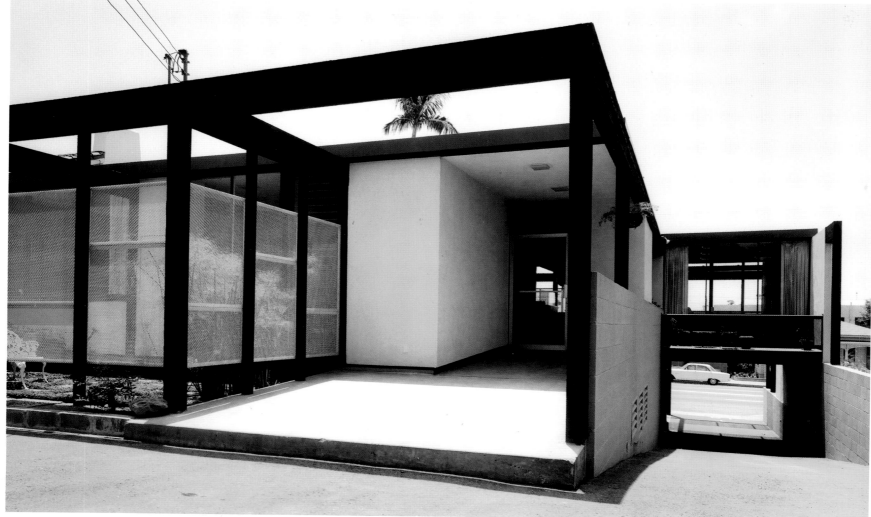

2868 Robert Skinner
Skinner Residence, Beverly Hills, California
October 9, 10, 1959

The complex topography of the land posited a challenging design problem. The Beverly Hills restrictions prescribed a 1,800-square-foot house for the owners' property, 80 x 140 feet in size. Yet, the flat portion of the lot was on a sandbank seven feet above the street level and much smaller in square footage than authorized.

Following the site's contours, Skinner's solution was to split the living functions on a stepped plan into two levels, to stake out three main sections. On the street front, the lower horizontal part of the parcel allows for the carport, the two-story entry piece in glass, and a double-height volume for the architect's office, independent from the house. Upstairs, the sunken living room, the dining section with adjoining patio and the kitchen define the recreational domain of the residence. Toward the rear hill, the master bedroom and the sleeping quarters for their two children are apportioned outdoor spaces comparable in extent to the covered area of each. Through this design strategy, the built residence reaches 1,950 square feet.

Skylights above the studio produce unexpected lighting effects that reverberate in the collective zone. The resulting back light singles out the fireplace wall, amplifying its architectural role in the living room.

The customary wood frame is finished with different natural redwood grades contrasted with white stucco and a yellow fascia in the exterior walls. 1 x 6-inch panels are uniformly used for siding and interiors. Plaster surfaces contrast with warm woods of walls and ceiling. Both the garden and the open spaces underscore the rectangular geometry of the house. Eckbo, Dean and Williams were the landscape architects. The project won a Merit Award in the Triennial Honor Award Program from the American Institute of Architects Southern California Chapter in 1960.

Das unregelmäßige Grundstück stellte den Architekten vor eine schwierige Aufgabe. Aufgrund der in Beverly Hills geltenden Bestimmungen durfte der Grundriss des Hauses auf dem 24 x 42 m großen Grundstück eine Fläche von 165 m² nicht überschreiten. Der flache Teil der Parzelle auf sandigem Untergrund ca. 2 m über dem Straßenniveau war jedoch viel kleiner. Indem er den Grundstückskonturen folgte, legte Skinner die Räume abgestuft auf zwei Ebenen an: auf dem flachen Grundstücksabschnitt zur Straße hin den Carport, die zweistöckige verglaste Eingangshalle und das separate, ebenfalls doppelgeschossige Arbeitsstudio des Hausherrn, auf der oberen Ebene den leicht abgesenkten Wohnraum, das Esszimmer mit angrenzendem Patio und die Küche, und zum Hang nach hinten hinaus das Elternschlafzimmer und die beiden Kinderzimmer – offene Räume mit insgesamt ungefähr der gleichen Fläche wie das restliche Haus. Auf diese Weise erzielte Skinner eine Wohnfläche von 180 m². Dachoberlichter im Studio sorgen für überraschende Lichteffekte, die sich auch noch in den Wohnräumen auswirken und zum Beispiel die Kaminwand optisch hervorheben.

Die Standard-Holzrahmenkonstruktion ist mit Redwood in verschiedenen Qualitäten und Ausführungen verkleidet, die Innenwände sind weiß verputzt und mit gelben Deckenleisten abgesetzt, die Decken und Dachüberstände mit Brettern verschalt. Der von Eckbo, Dean and Williams gestaltete Garten und die Terrassen betonen die rechtwinklige Geometrie des Hauses. Die Sektion Südkalifornien des American Institute of Architects zeichnete es 1960 mit einem Merit Award aus.

La topographie complexe du terrain posait un vrai problème de conception. La réglementation de Beverly Hills prescrivait par ailleurs pour ce terrain de 24 x 42 m, une maison de 165 m². Cependant, la partie plane de la parcelle était une étroite zone sableuse surélevée de 2 m par rapport à la rue.

La solution de Skinner suit les contours du terrain et sépare les diverses fonctions au moyen d'un plan sur deux niveau décalés organisé en trois parties. Côté rue, la partie basse du terrain permet de loger l'abri à voitures, l'entrée en verrière sur deux niveaux, et un volume double hauteur pour le bureau de l'architecte, indépendant de la maison. Plus haut, le séjour en creux, la salle à manger, son patio adjacent et la cuisine définissent la zone de la vie familiale. Vers l'arrière et la colline, la chambre principale et les chambres des deux enfants sont prolongés par des espaces ouverts presque égaux à la surface couverte. Cette stratégie permet d'obtenir une surface construite de 180 m². Des verrières au-dessus de l'atelier produisent des effets. de lumière insolites qui animent et soulignent l'architecture du mur de la cheminée.

L'ossature bois classique est habillée de bois rouge de différentes tonalités qui contrastent avec l'enduit blanc et l'acrotère jaune. Des lattes servent au bardage intérieur et extérieur. Les surfaces plâtrées contrastent avec la chaleur du bois des murs et du plafond. Le jardin et les espaces ouverts soulignent l'aspect orthogonal de la maison. Eckbo, Dean and Williams sont les auteurs du jardin. Ce projet a remporté un prix du mérite lors des prix triennaux du chapitre de Californie du Sud de l'AIA en 1960.

Selected Bibliography:
- Book of Homes 15
- arts & architecture, October 1959
- House & Garden, May 1960
- Pacific Architect and Builder, November 1960
- Western Architect and Engineer, November 1960

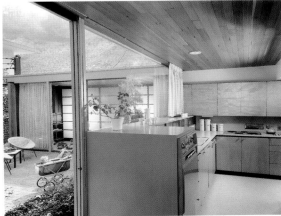

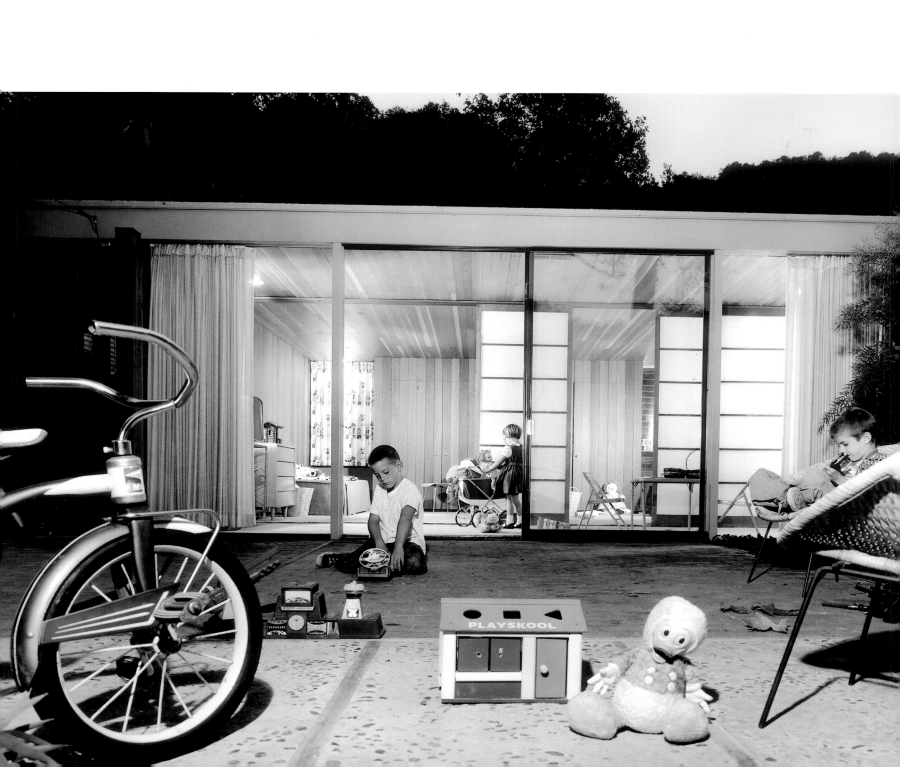

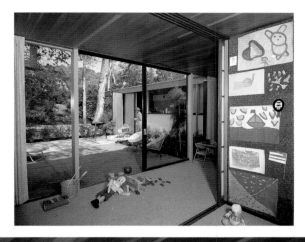

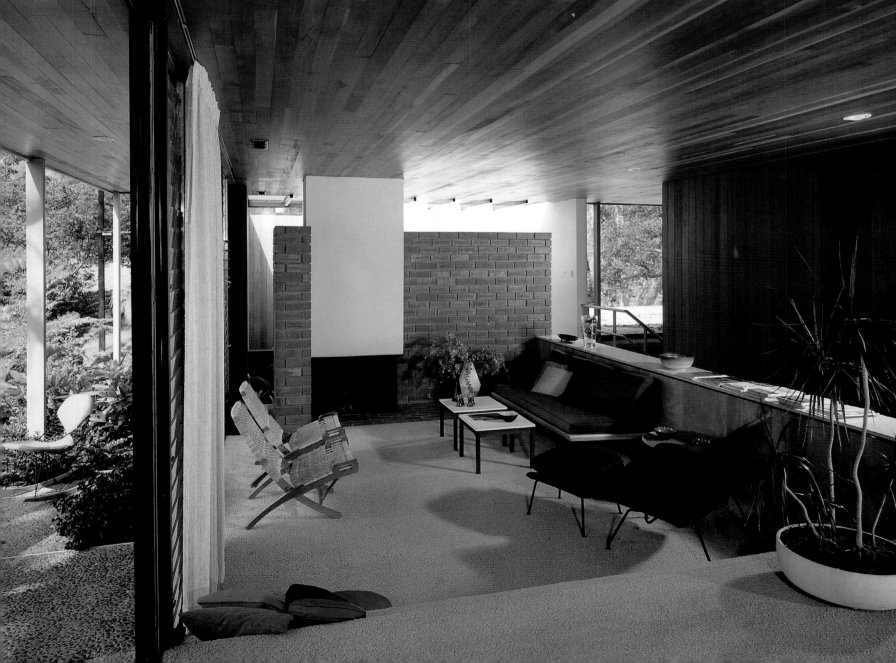

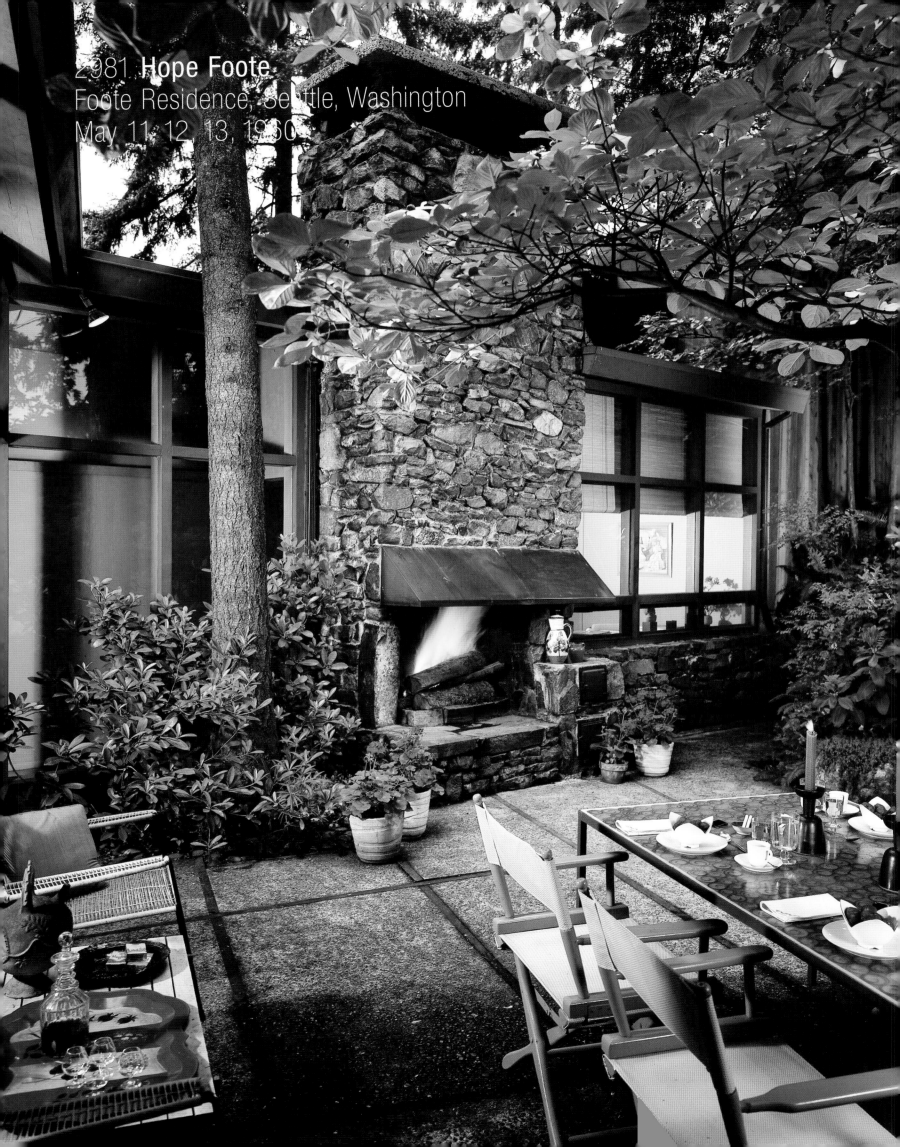

2981 **Hope Foote**
Foote Residence, Seattle, Washington
May 11, 12, 13, 1930

The owner was the former head of the Design Department of the University of Washington. The hub of the house is the protected terrace with an outdoor fireplace. The beach tree in the patio shades the area during the summer time and shows the colors of autumn when the season changes.

Der Bauherr war ein ehemaliger Dekan des Fachbereichs Design der University of Washington. Die geschützte Wohnterrasse mit Außenkamin bildet den Dreh- und Angelpunkt des Hauses. Die hier stehende Buche gewährt im Sommer Schatten und zeigt sich im Herbst in den prächtigsten Farben.

Le propriétaire était l'ancien responsable du département de design de l'Université de Washington. Le cœur de la maison est la terrasse protégée équipée d'une cheminée extérieure. Le bouleau du patio protège celui-ci en été et annonce l'automne par ses changements de couleur.

Selected Bibliography: - *Los Angeles Times Home Magazine, November 2, 1969*

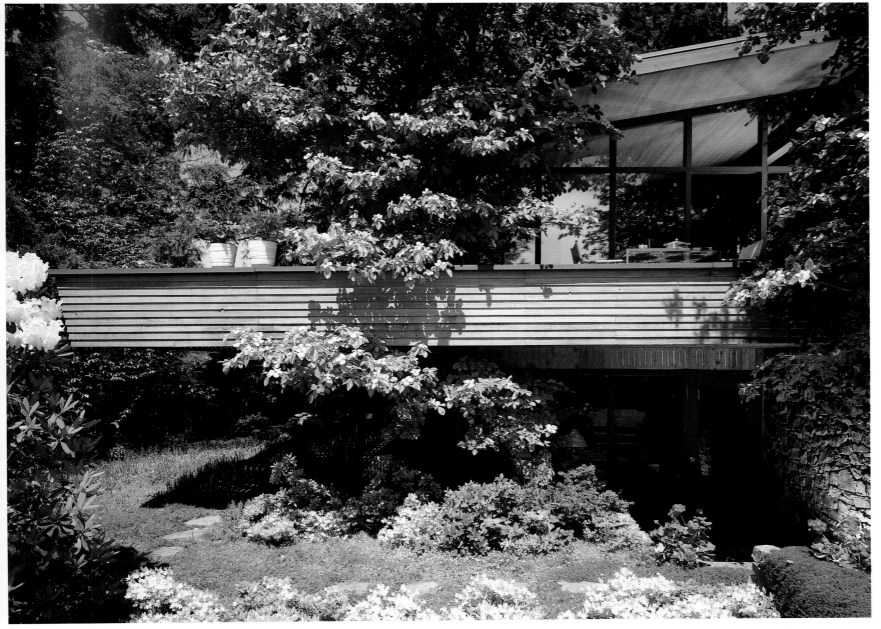

3037 Raymond Kappe
Hayes Residence, Sherman Oaks, California
July 29, 1960

Under a low-pitched roof, the boundaries between indoors and outdoors blur. Terraces and wooded decks continue the living functions beyond the rectangular plan of the house. Each room is provided with outdoor space. The roof beams prolong the wall line over the open areas to support a wood lattice made of 2 x 2-inch and 2 x 6-inch members. In the course of the day, the sunlight filtering through the lattice pattern creates a complex geometry of shadows, which in the late afternoon, hours, shield entirely shades the glass wall of the living room. To create a clerestory window, the roof ridge is raised three feet from the even horizontal section of the walls, allowing for wide views of the setting from the interior. With the exception of the fireplace in exposed bricks, all the partitions are plastered in white, forming a stark contrast with the dark-stained framing elements. In the program requirements, the owners listed a study convertible to another bedroom, a family room-guest

Die von einem weiten, flachen Satteldach überspannten Räume des Hauses lassen die Grenzen zwischen Innen und Außen verschwimmen: Jedem Raum sind Terrassen oder Holzdecks vorgelagert, welche die Wohnfläche des längsrechteckigen Hauses mit einer Grundrissfläche von 186 m² erweitern. Die Dachbalken kragen weit über die Fassaden aus und tragen ein Lattengitterwerk mit breitem geschlossenem Überstand. Im Laufe des Tages filtert Sonnenlicht durch das Lattenwerk, am Spätnachmittag beschattet dieses die Glasfront des Wohnraums. Um ein seitliches Oberlicht einfügen zu können, hob Kappe das Dach um 90 cm an. Mit Ausnahme der Klinkerverblendung des Kamins sind alle Innenwände weiß verputzt und kontrastieren so mit den dunkel gebeizten Tragwerksteilen. Die Bauherren hatten sich unter anderem ein auch als Gästezimmer dienendes Arbeitszimmer und ein vom Schlafzimmertrakt und der offenen Küche mit Frühstückstheke abgeschiedenes Familienzimmer

Sous ce grand toit à faible pente, les frontières entre le dedans et le dehors sont brouillées. Des terrasses et des planchers de bois prolongent l'habitat vers l'extérieur. Chaque pièce se voit dotée de son propre espace extérieur. Les poutres de la charpente se prolongent au-dessus des espaces ouverts et soutiennent un treillis poutre en bois. Au cours de la journée, le soleil filtré par cette structure génère un jeu géométrique complexe d'ombres, qui protège le mur de verre de la salle de séjour en fin d'après-midi. Afin de laisser la place à un bandeau de fenêtres hautes, l'arête du toit est relevée de 90 cm par rapport aux murs qui restent horizontaux pour permettre une vue originale sur l'environnement naturel. A l'exception de la cheminée en briques apparentes, toutes les cloisons sont en plâtre blanc qui contraste avec les éléments structurels en bois foncé. Les propriétaires avaient demandé dans leur programme, un bureau convertible

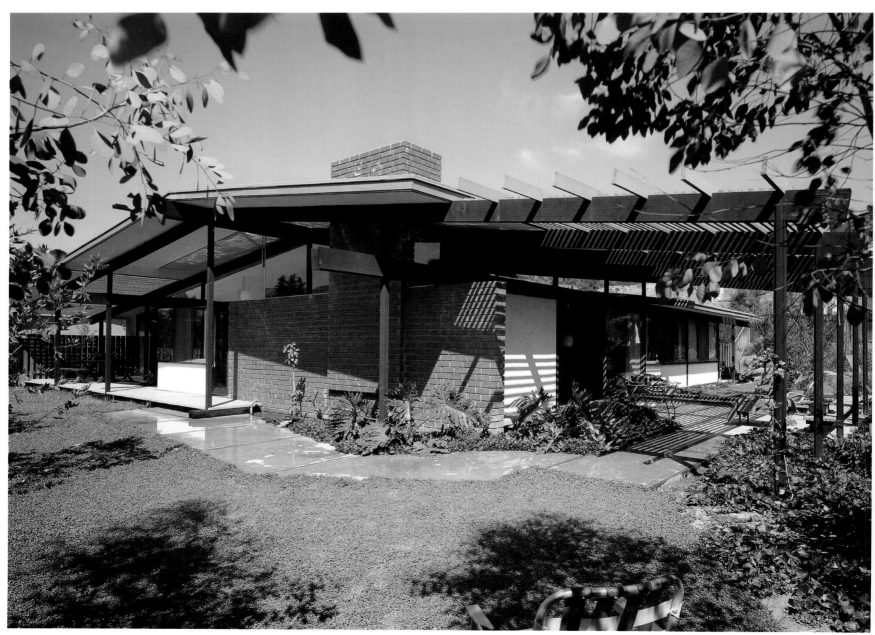

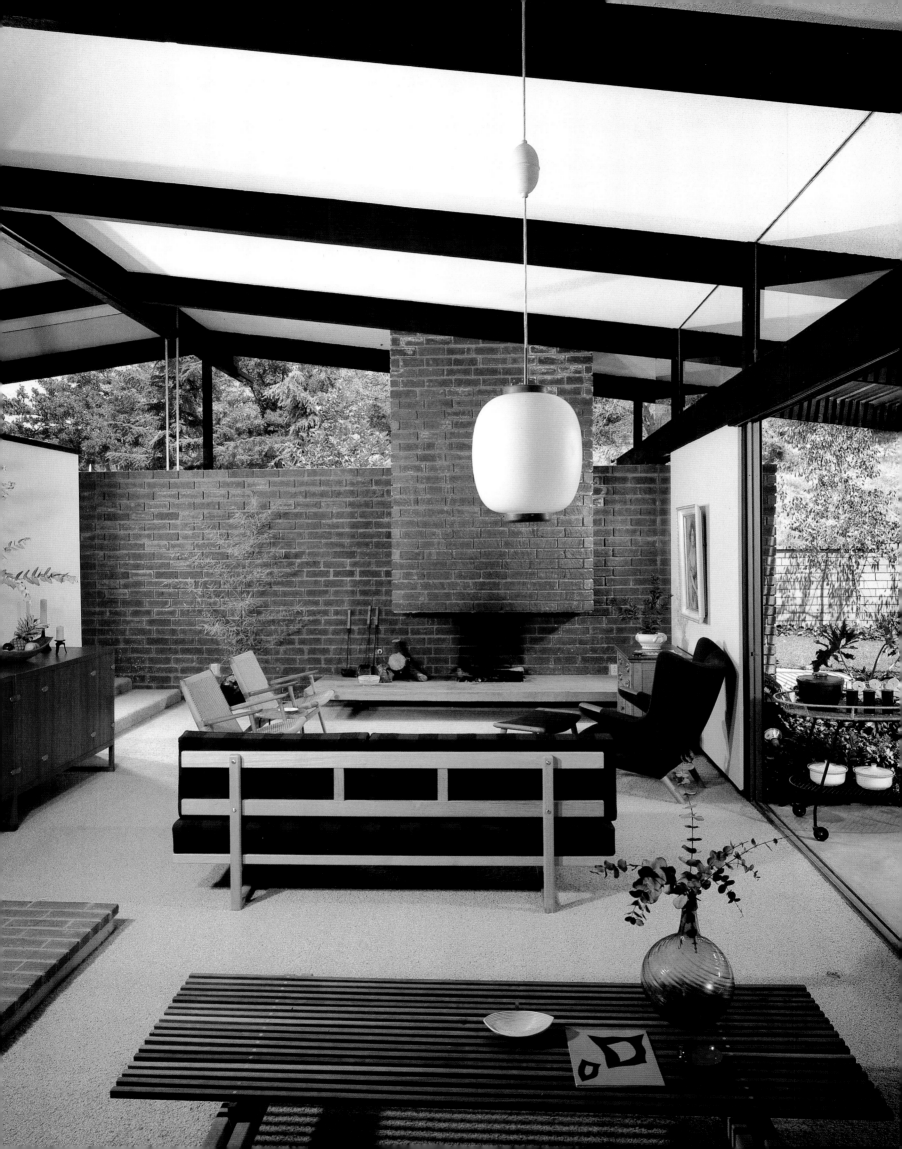

room separate from the bedroom wing, and an open kitchen with a large counter. The entry corridor crosscuts the 2,000-square-foot interior, dividing the collective areas from the private quarters.

(ebenfalls für Gäste nutzbar) gewünscht. Der Eingangsflur zieht sich durch das ganze Haus und trennt die Wohnräume vom Schlafzimmerbereich.

en chambre, un séjour familial, un chambre d'amis séparée de l'aile des chambres et une cuisine ouvert avec un large comptoir. Le couloir d'entrée sépare les zones communes et les zones privatives de cette maison de 186 m².

Selected Bibliography:
- *Western Architect and Engineer, October 1960*
- *House & Home, November 1960*
- *Architecture California, Idiom of the Fifties, November/December 1986*
- *Michael Webb, Themes and Variations. House Design. Ray Kappe, Victoria 1998*

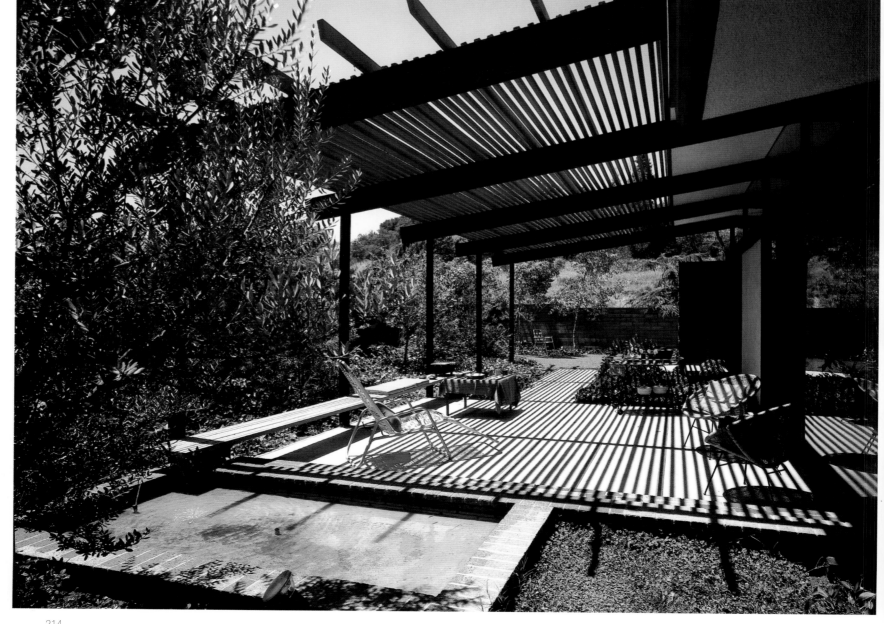

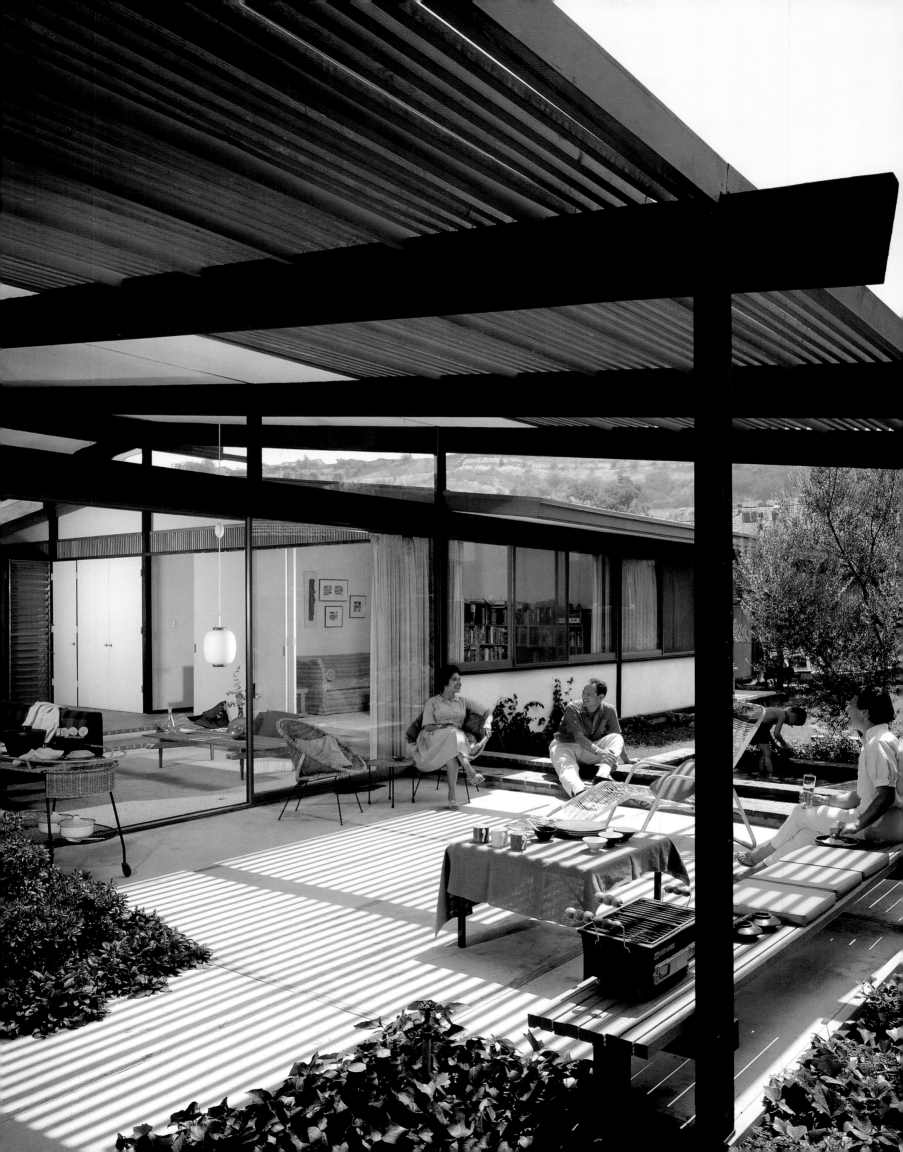

3045 **Risley and Gould**
Magnavox, Torrance, California
September 23, 1960

The project received an Honor Award in the 1960 edition of the Triennial Honor Award Program from the American Institute of Architects Southern California Chapter.

1960 zeichnete die Sektion Südkalifornien des American Institute of Architects das Projekt mit einem Merit Award aus.

Ce projet a reçu prix d'honneur aux prix triennaux du chapitre de Californie du Sud de l'American Instiute of Architects.

Selected Bibliography:
- *Western Architect and Engineer, November 1960*
- *Building Progress, September 1964*

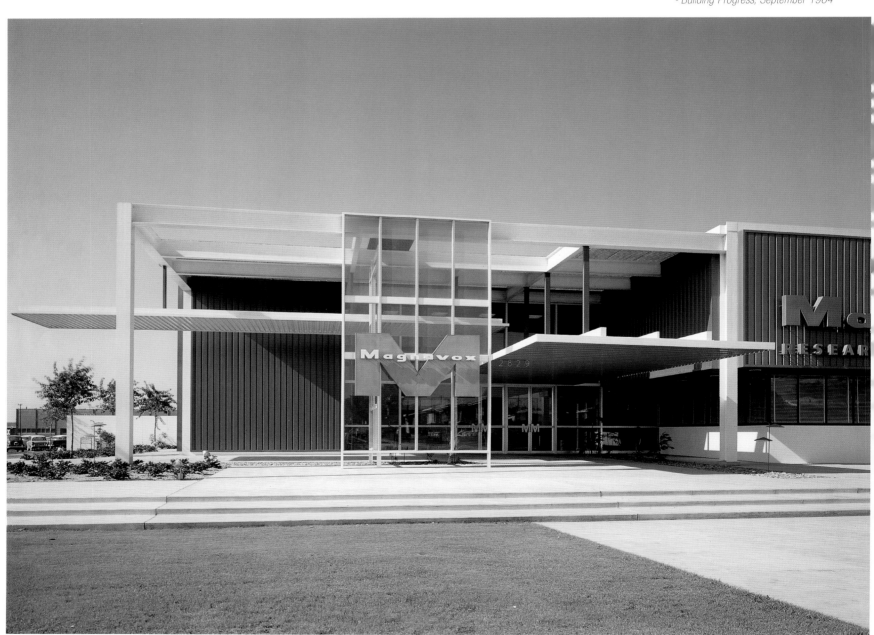

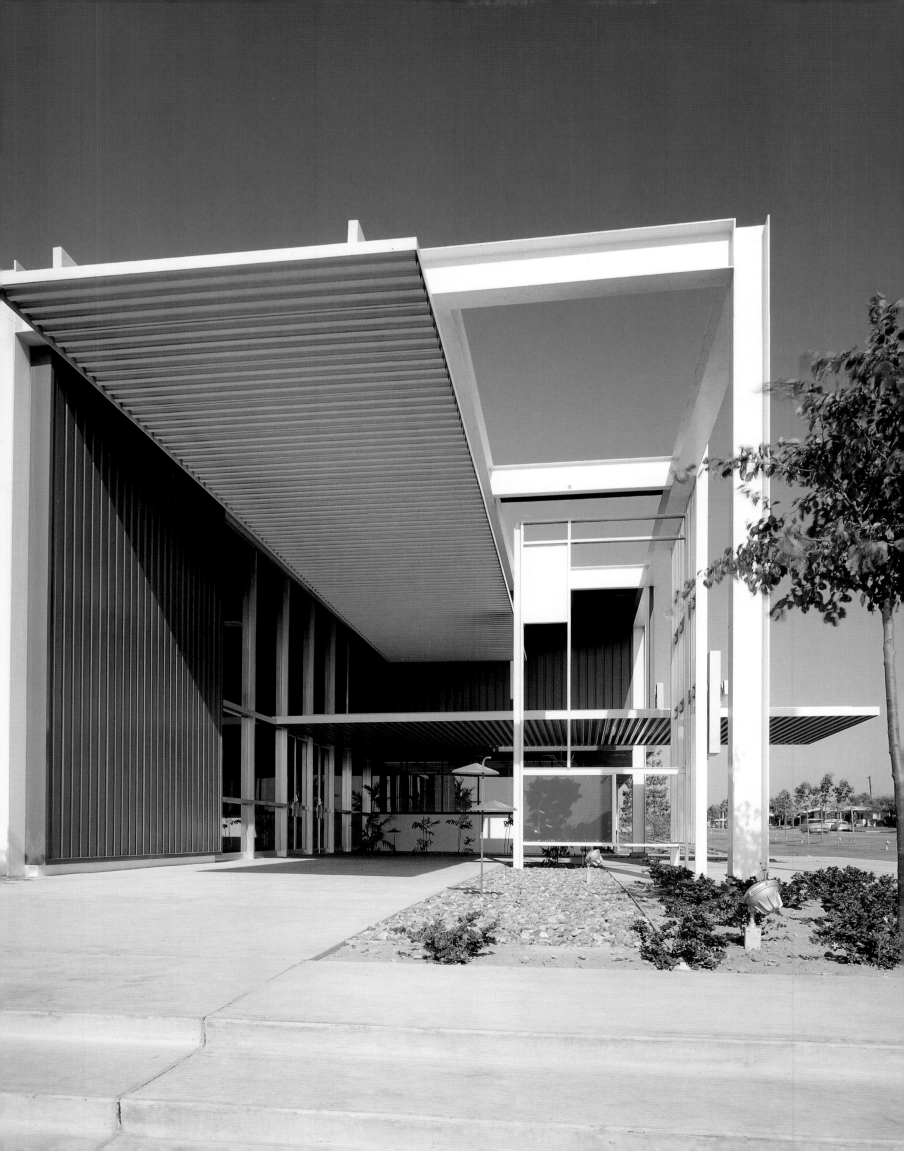

3073 **Harold Levitt**
Horton House, Bel Air, California
October 3, 4, 1960

A complex circulation system connects a set of glass pavilions raised a few feet above the ground. The house is transparent on all sides; interior and exterior promenades offer views of the natural environment. In this use of large glass surfaces throughout the residence, the architect plays out the theme of the interpenetration of indoors and outdoors.

The building plot is a pad containing a high garden wall of an old estate on the mountain side, and a steep descent toward the valley side. When approaching the house, the visitors are welcomed in a large parking area where an entrance platform displays a major architectural component in the project: the elevated walkway. From this platform a long perspective penetrates the entire length of the house with its vanishing point in the distant landscape. Three sleeping units are clustered around the entry court, followed by the kitchen-living-dining section, which offers views on three sides. At the far end, the master bedroom can be accessed through the living room, the exterior redwood deck on the east end of the plan, or through the living terrace. Variations in ceiling height in the sequence of rooms provide diversity of scale in the domestic space. The organic design of the garden and the pool on the north side becomes the center for family and social entertainment.

Ein komplexes Erschließungsnetz verbindet mehrere aufgeständerte Glaspavillons miteinander, so dass das Haus von allen Seiten »durchlässig« ist, weil es von inneren und äußeren Promenaden durchkreuzt und begleitet wird. Mit Hilfe großflächiger Verglasungen inszeniert der Architekt die wechselseitige Durchdringung von Innen- und Außenraum im ganzen Haus. Das Grundstück besteht aus einer ebenen Terrasse am Hang und einem Steilhang zum Tal. Wenn Besucher sich dem Haus nähern, gelangen sie zunächst in einen großen Hof mit Autostellflächen, wo ein Podest vor dem Hauseingang ihnen bereits ein Hauptelement des Entwurfs vorführt: den erhöhten Gehweg. Vom Podest kann man durch das ganze Haus bis zum Fluchtpunkt in der Landschaftsferne blicken. Drei Schlafzimmer sind um den Eingangshof gruppiert, gefolgt vom Trakt mit Wohn- und Esszimmer sowie angrenzender Küche, der sich auf drei Seiten zur Aussicht öffnet. Am anderen Ende dieses Hausteils befindet sich das durch den Wohnraum, vom Terrassendeck auf der Ostseite oder über die Wohnterrasse zugängliche Hauptschlafzimmer. Unterschiedliche Deckenhöhen sorgen für räumlich-maßstäbliche Abwechslung im Haus. Der »organisch« gestaltete Garten mit Schwimmbecken wird zum Mittelpunkt familiärer und gesellschaftlicher Anlässe.

Un système complexe de circulations réunit cet ensemble de pavillons surélevés de quelques dizaines de centimètres par rapport au sol. La maison s'ouvre sur son cadre naturel dans toutes les directions via des passages intérieurs et extérieurs. Le recours à de vastes baies vitrées permet à l'architecte de jouer sur le thème de l'interpénétration du dedans et du dehors. La partie construite s'élève sur un plateau fermé du côté de la montagne par un haut mur appartenant à une ancienne résidence et limité par une pente abrupte côté vallée. Les visiteurs sont accueillis par un vaste parking au bout duquel une plate-forme d'entrée sert de point de départ à l'un des principaux éléments architecturaux du projet : l'allée surélevée. De la plate-forme, le regard traverse la maison sur toute sa longueur jusqu'au point de fuite dans le lointain. Les trois chambres sont réunies autour de la cour d'entrée, suivies par la partie cuisine-séjour-salle à manger ouverte vers l'extérieur sur trois côtés. A l'autre extrémité, la chambre principale peut être atteinte par le séjour, la terrasse en bois rouge côté est, ou la terrasse du séjour. Des variations de hauteurs de plafond dans la succession des pièces instaurent une échelle différente dans la partie familiale. La conception organique du jardin et de la piscine offre un cadre animé à la vie familiale comme aux réceptions.

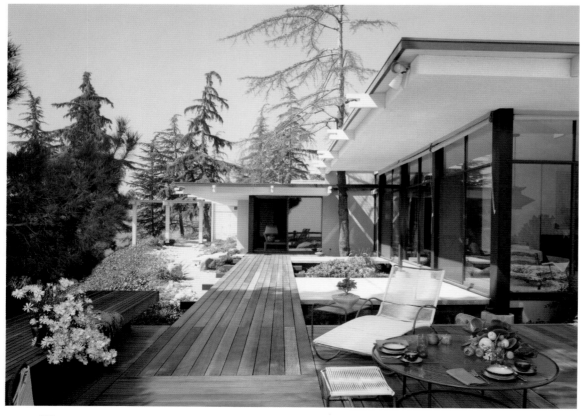

Selected
Bibliography: *- House & Garden, July 1961*

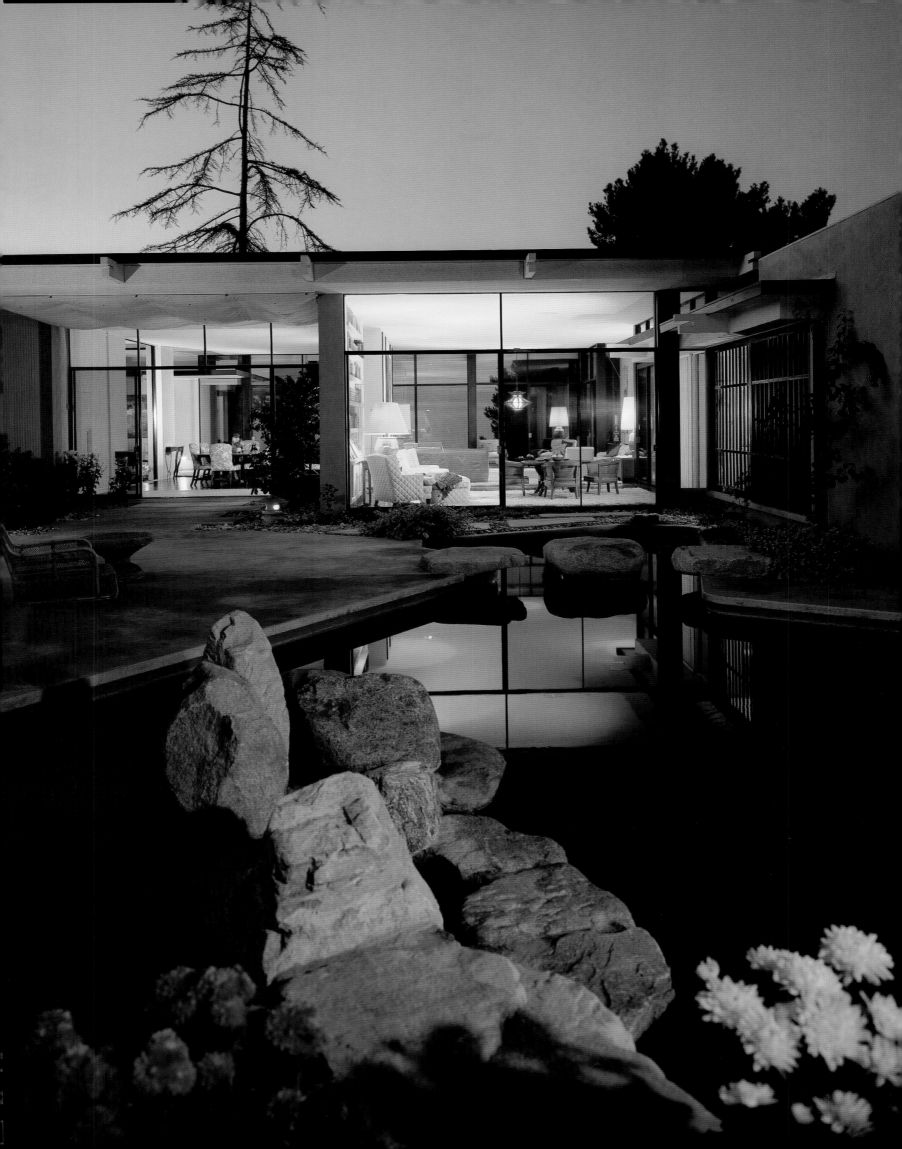

3177 **Jon P. Antelline**
Antelline Residence, San Diego, California
April 26, 1961

When Jon Antelline designed this residence for his family, he was only 19 years old. The project is an investigation of circular geometry both in plan and in landscaping.

Positioned at the top of a 3.5 acre site and surrounded by a grove of eucalyptus trees, the house is developed on three levels to follow the land contours. For the upper portion, the variation of floor elevations establishes function-definition. The sleeping quarters are raised a few steps above a circular living area; the studio, bath, and guest room are on the lower floor. Wooden decks connect the bedroom wing to the pool and patio. Concrete slabs and wood frame define the basic shell, whereas the frame of the roof is made of laminated beams stained walnut. Interior wall paneling and cabinet work is mahogany. Antelline also designed tables and chairs in the dining area.

Als Jon Antelline dieses Haus für seine Familie baute, war er erst 19 Jahre alt. Der Entwurf ist – was Grundriss und Gartengestaltung anlangt – im Grunde eine Studie zur Geometrie des Kreises. Antelline platzierte das Haus im oberen Teil eines 14 000 m² großen Geländes inmitten von Eukalyptusbäumen und legte es entsprechend der Topographie auf drei Ebenen an: die Schlafzimmer auf der oberen – einige Stufen höher als der kreisrunde Wohnraum –, das Arbeitsstudio sowie Bad und Gästezimmer auf der untersten Ebene. Holzdecks verbinden den Schlafzimmertrakt mit Gartenhof und Schwimmbecken. Die Grundkonstruktion besteht aus Betonplatten und Holzrahmen, der Dachstuhl aus nussbaumfarben gebeizten Schichtholzbalken. Das Haus ist mit Mahagonitäfelungen und -einbauschränken ausgestattet. Antelline entwarf auch die Tische und Stühle für die Essecke.

Lorsque Jon Antelline conçut cette résidence pour sa propre famille, il n'était âgé que de 19 ans. Le projet est né d'une recherche sur le cercle, aussi bien dans son plan que dans l'aménagement du paysage. Située au sommet d'un terrain de 14 000 m² et entourée d'un bois d'eucalyptus, la maison comprend trois niveaux qui suivent les contours du sol. Pour la partie supérieure, la variation des niveaux correspond à la répartition des fonctions. Les chambres dominent de quelques marches le séjour circulaire. Le studio, la salle de bains et la chambre d'amis se trouvent au niveau inférieur. Des platesformes de bois réunissent l'aile des chambres à la piscine et au patio. La structure en coquille est constituée de dalles de béton et d'une ossature en bois, tandis que la charpente est en poutres de noyer lamellé collé et teinté. Le lambrissage des murs intérieurs et la menuiserie sont en acajou. Les tables et les sièges de la salle à manger ont été dessinés par Antelline.

Selected
Bibliography:
- *San Diego & Point Magazine, February 1966*
- *Designers West, June-July 1968*

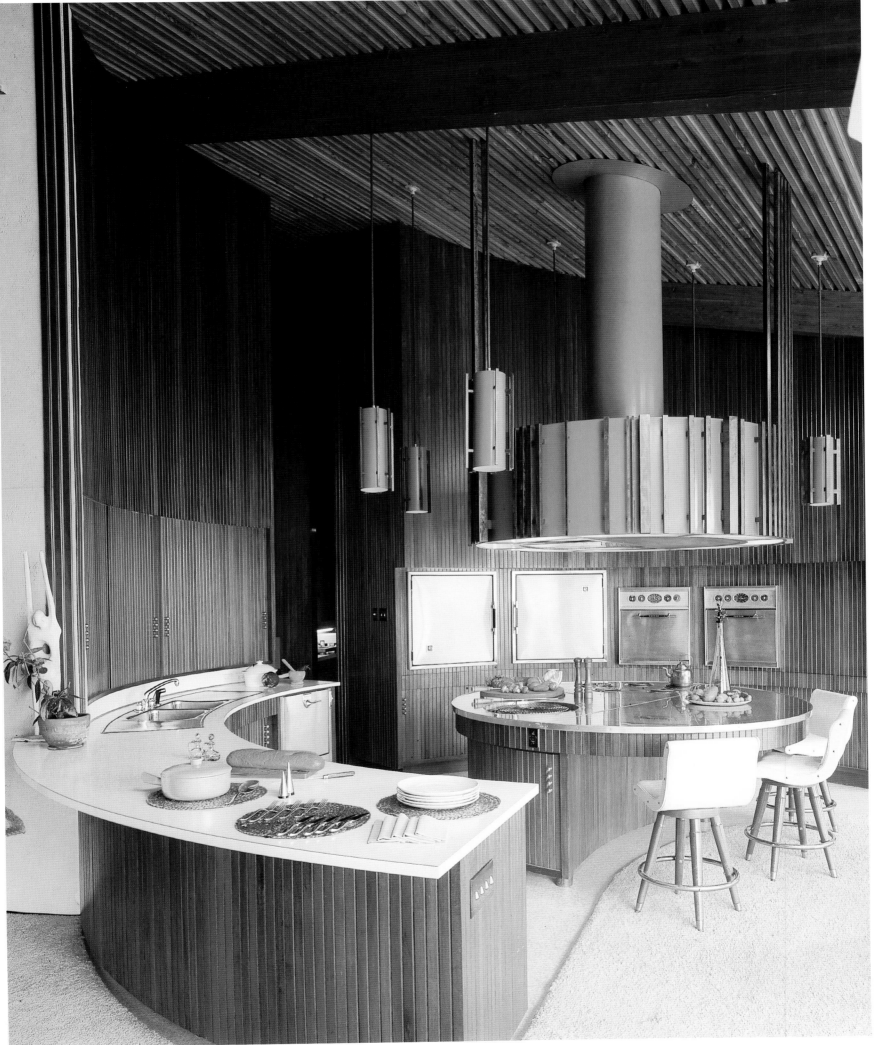

3181 Frederick Liebhardt and Eugene Weston III
Islandia Hotel and Restaurant, Mission Bay, San Diego, California
April 27, 1961

During the late 1950s, San Diego experienced an upsurge in construction, resulting, among many other initiatives, in the Mission Bay project, a 6,400-acre aquatic park for public and private recreational use. Smith and Williams, architects, and Eckbo, Dean & Williams, landscape architects, authored the master plan of the entire development.

Within this grand scheme, the hotel and the restaurant located in the Quivira Basin, next to the ocean were commissioned to Liebhardt and Weston. Due to land restrictions, the two structures were separated with the restaurant being positioned on piling above the water. Raised three feet above the ground, the two hotel wings contain 120 rooms and suites distributed on two floors. Individual stairs give access to the decks of the ground floor rooms on both sides. Rooms on the second floor are entered through a central passageway featuring slatted cupolas for light and cross-ventilation. The central plan of the restaurant is composed of seven hexagons, with the biggest

Ende der50er-Jahre erlebte San Diego einen Bauboom, der unter anderem den Freizeit- und Ferienpark auf einem 6 400 Morgen großen Areal in Mission Bay hervorbrachte. Die Architekten Smith and Williams und die Landschaftsplaner Eckbo, Dean & Williams entwickelten gemeinsam den Generalplan, Liebhardt und Weston wurden mit dem Bau des Hotels und Restaurants an der Quivira-Bucht beauftragt.

Da die baugesetzlich zulässige Überbauungsfläche knapp bemessen war, mussten Hotel und Restaurant getrennt werden, letzteres steht auf Pfählen im Wasser. Die beiden um etwa 90 cm aufgeständerten zweigeschossigen Hotelflügel enthalten insgesamt 120 Zimmer und Suiten. Die Zimmer im Erdgeschoss sind beidseits der Gebäudeflügel jeweils über einige Stufen und eine vorgelagerte Balkonterrasse zugänglich; die Gästezimmer im Obergeschoss werden über einen Mittelgang erschlossen, der über große Oberlichter belichtet und belüftet wird. Der Grundriss des Restaurants besteht aus sieben Hexagons, wobei

A la fin des années 1950, San Diego connut une explosion du marché de l'immobilier, d'où sortit, entre autres, le projet de Mission Bay, parc aquatique de 3200 hectares à vocation à la fois publique et privée. Smith and Williams, architectes, et Eckbo, Dean & Williams, architectes-paysagistes furent chargés du plan directeur de l'ensemble. Dans le cadre de ce projet, Liebhardt et Weston reçurent commande de l'hôtel et du restaurant du Quivira Basin, en bordure de l'océan.

Le terrain manquant, les deux constructions sont séparées et le restaurant a été monté sur pilotis au-dessus de l'eau. Surélevées de 90 cm par rapport au sol, les deux ailes de l'hôtel contiennent 120 chambres et suites réparties sur deux niveaux. Des escaliers indépendants donnent accès des deux côtés aux terrasses des chambres du premier niveau. Les chambres à l'étage sont desservies par un passage central à lanterneaux à lames de bois qui assure la ventilation et l'éclairage. Le plan central du restaurant se compose de sept hexagones, le plus

one in the center housing a bar and cocktail lounge. Of the surrounding hexagons, four contain dining spaces, one is occupied by the kitchen and one is used as an office.

die Bar das mittlere bildet. Vier der übrigen Sechsecke enthalten die Restaurantbereiche, in einem ist die Küche und im letzten das Büro untergebracht.

grand, au centre, abritant le bar et une salle pour les cocktails, les quatre autres contenant les salles à manger, la cuisine, et les bureaux.

Selected Bibliography:
- *Pacific Coast Record, August 1961*
- *Architecture/West, September 1962*
- *Architectural Record, October 1964*

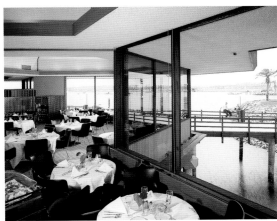

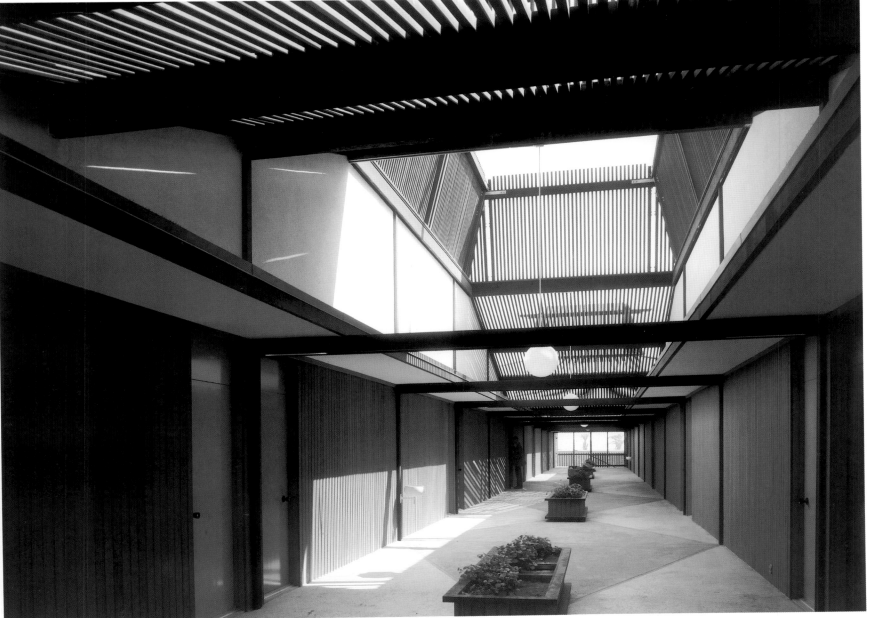

3192 Murray, Jones, Murray
Sigma Nu Fraternity, University of Tulsa, Oklahoma
May 10, 1961

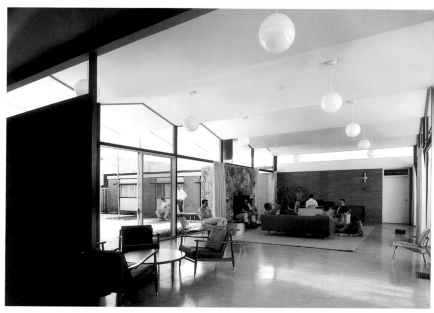

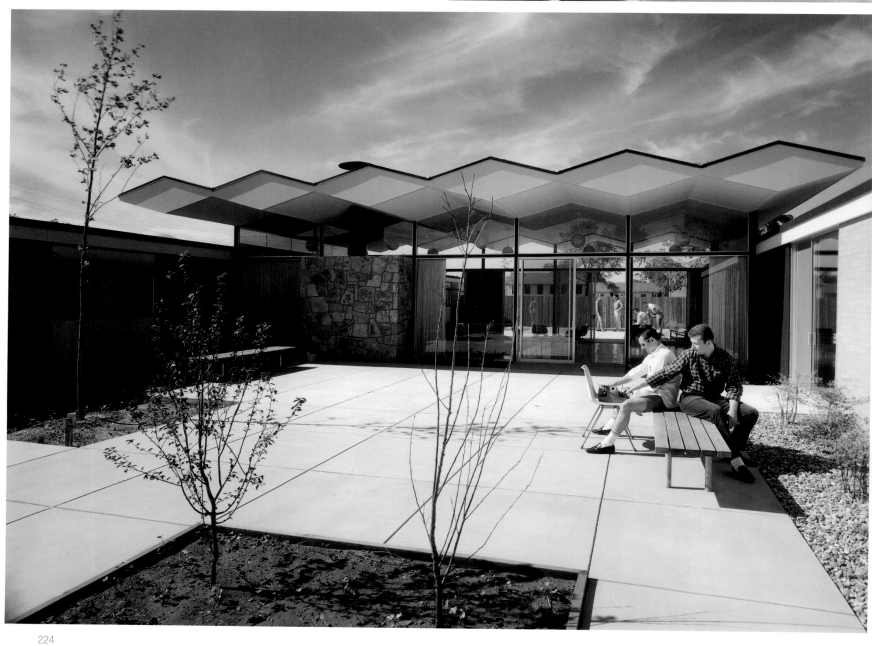

3194 Crites & McConnell
Crites Residence, Cedar Rapids, Iowa
May 13, 14, 1961

On a sloped terrain in the woods, the architects designed a narrow steel framework on a 12-foot square module to lift the main living space from the ground. The plan is based on a nine-square scheme, the sleeping quarters and the kitchen occupying one module. Toward the downhill side, glass walls surround three sides of the living-dining area, cantilevering out from a 12 x 36-foot rectangular base zoned with a study room and a screened area. Accessible from a bridge on the uphill side, the residence features a vaulted ceiling on the central staircase connecting the two floors. Walnut sheathing patterns the walls between the steel posts. The National Chapter of the American Institute of Architects accorded the project a 1963 Honorable Mention.

Für ein bewaldetes Hanggrundstück entwarfen die Architekten ein schlankes Stahlgerüst, basierend auf einem ca. 3,50 m messenden Quadratraster, um den Wohnbereich vom Boden abzuheben. Der Grundriss umfasst neun Quadrate; Küche und Schlafzimmer nehmen je ein Quadrat ein. Der von einem rechteckigen Fundament vorkragende, teilweise unterteilte Wohnbereich mit Arbeitszimmer ist zum Tal hin auf drei Seiten raumhoch verglast. Vom oberen Hang gelangt man über eine Brücke zur Haustür. Das zentrale Treppenhaus ist mit Tonnengewölben gedeckt. Die Wandausfachungen zwischen den Stahlpfosten haben eine Nussbaumtäfelung. Das American Institute of Architects zeichnete das Haus 1963 mit einer Belobigung aus.

L'ossature d'acier qui reste très visible se dresse sur un terrain en pente. Le principal espace de séjour est surélevé par rapport au sol. Le plan repose sur une trame de neuf carrés de 3,50 m de côté. Les chambres et la cuisine occupent chacune un module. Côté pente, des parois de verre ferment le séjour-salle à manger sur trois côtés, en porte-à-faux à partir d'un bloc rectangulaire qui regroupe le bureau et la véranda. Accessible par une passerelle côté colline, la maison est dotée d'un plafond voûté au-dessus de l'escalier central qui réunit les deux niveaux. Entre les poteaux, les murs sont habillés de noyer. Le chapitre national de l'American Institute of Architects a décerné une mention honorable à ce projet en 1963.

Selected Bibliography:
- *House & Home, January 1963*
- *David Gebhard and Gerald Mansheim, Buildings of Iowa, New York 1993*

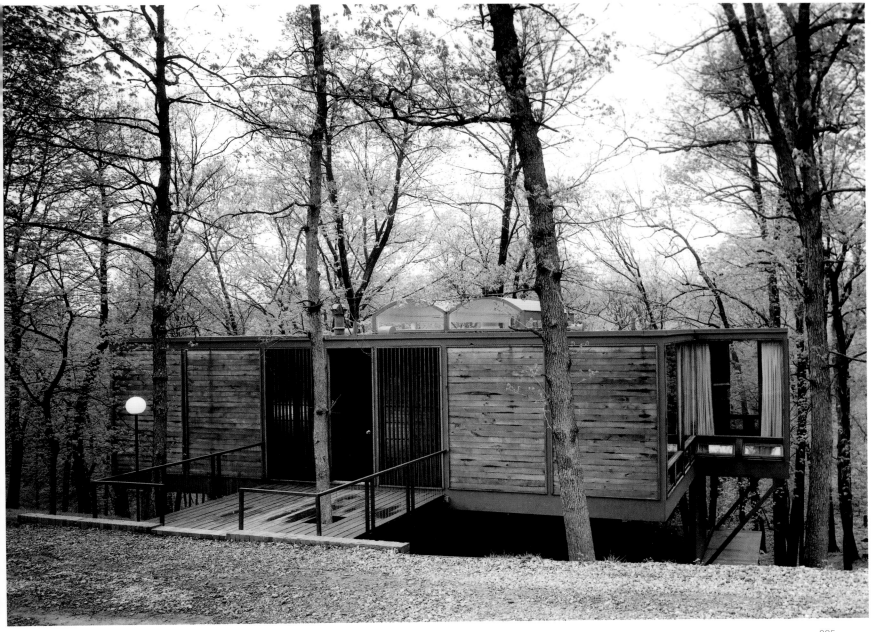

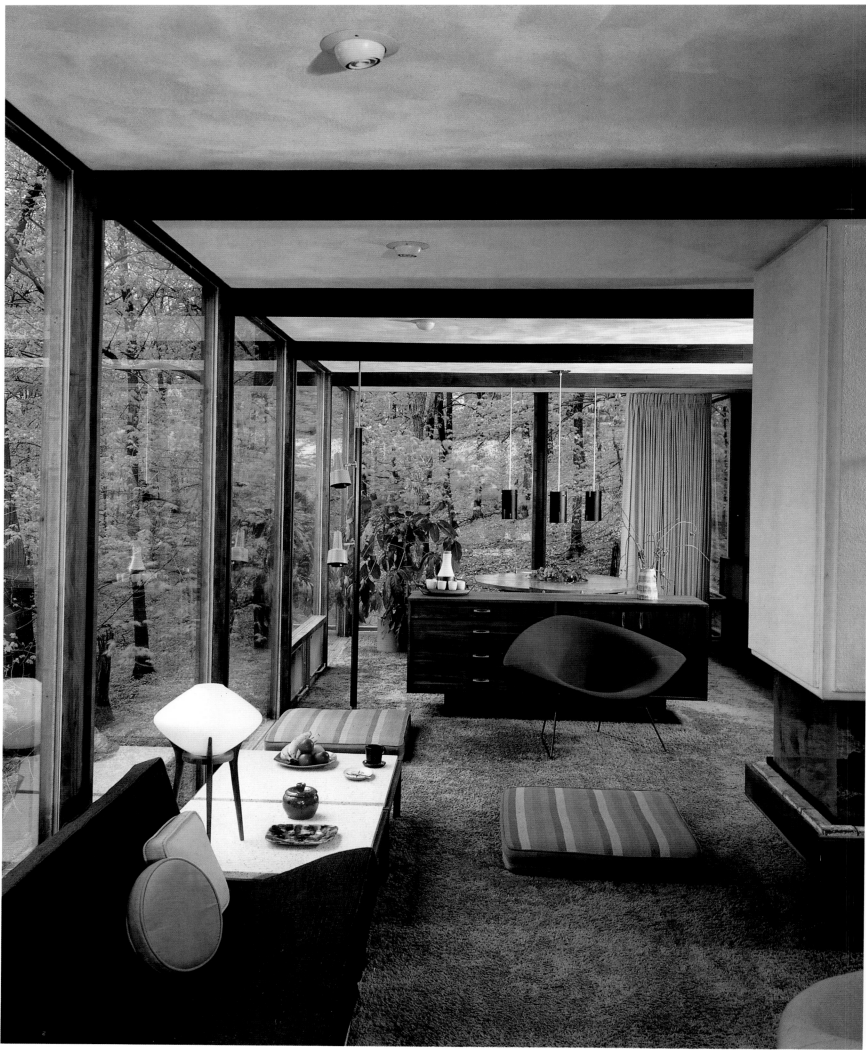

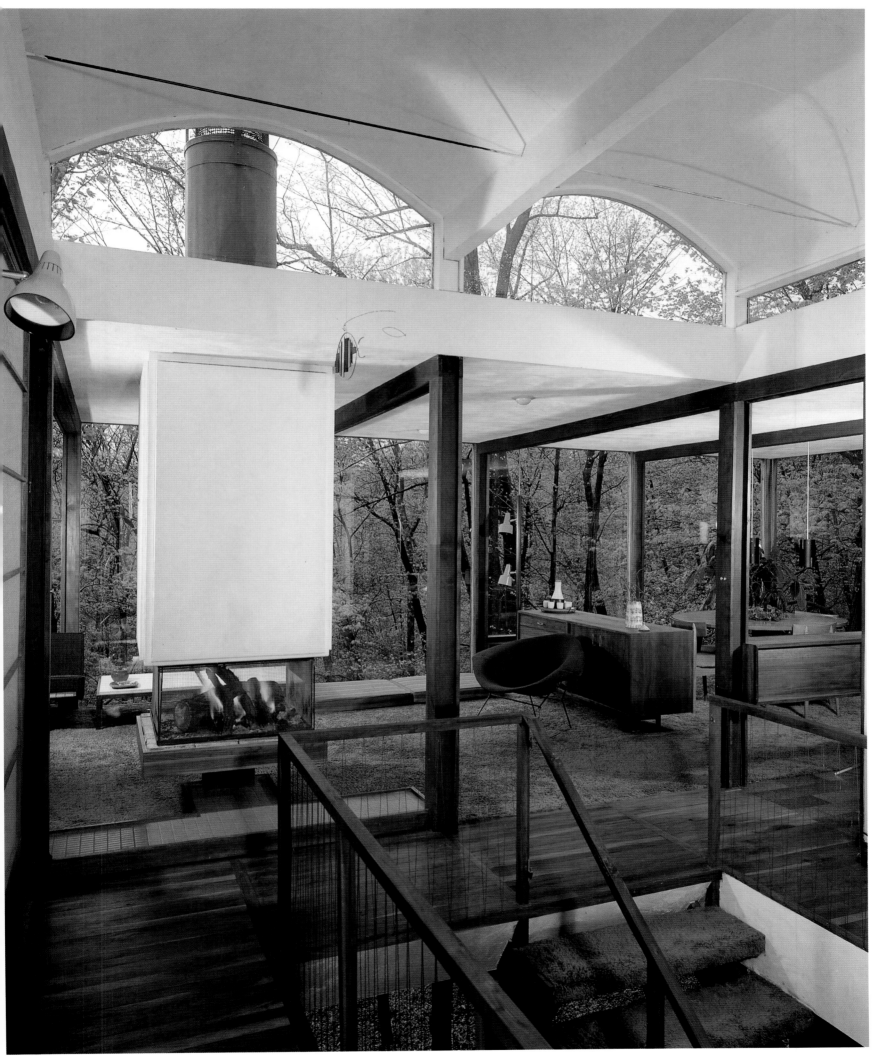

3202 Crites & McConnell
Seiberling Residence, North Liberty, Iowa
May 15, 1961

The Seiberling Residence won an Honorable Mention in the Homes for Better Living Program sponsored by the American Institute Architects, *House & Home*, and *LIFE* magazine. Although the project received national recognition in the professional circles, neither the *AIA Journal* nor *LIFE* magazine ran any articles on it. An abstract written by the architects, found in Shulman's archive, reports that the single-family residence was designed for the Head of the Department of Art at Iowa University, situated on a 40-acre site six miles from the nearest city, and was completed in the fall of 1961. The owner, an art historian, required a space that would reconcile customary domestic demands with the display of artwork from his extensive collection. A programmatic requirement was the incorporation of the technological knowledge of the time into the design concept. Seiberling's cruciform plan was not new in Crites & McConnell's residential architecture, frequently designed for rural sites. Throughout their schemes, this configuration was used to provide separation of functions. Typically the center of the cross was reserved for the communal space, often double-height,

Das Haus Seiberling erhielt eine lobende Erwähnung des Programms »Homes for Better Living«, das vom American Institute of Architects und den Zeitschriften »House and Home« und »LIFE« gefördert wurde. Obwohl das Projekt Anerkennung unter amerikanischen Architekten fand, haben weder die Zeitschrift des AIA noch »LIFE« je einen Artikel darüber veröffentlicht. Ein von den Architekten verfasster Text, der sich in Shulmans Archiv befindet, berichtet, dass das Einfamilienhaus für den Leiter des Fachbereichs Kunst der Universität von Iowa entworfen wurde. Es liegt auf einem 20 Hektar großen Grundstück, 10 km entfernt von der nächsten Stadt und wurde im Herbst 1961 fertiggestellt. Der Besitzer, ein Kunsthistoriker, wünschte hinreichend Wohnraum und darüber hinaus Ausstellungsräume für seine umfangreiche Sammlung. Alle Bereiche sollten auf dem neuesten Stand der Technik sein.

Der kreuzförmige Grundriss des Hauses war nicht ungewöhnlich in der Wohnhaus-Architektur von Crites & McConnell und diente zur Trennung der Funktionsbereiche. Typischerweise – wie auch beim Haus Seiberling – war das Zentrum des Kreuzes dem Ge-

La résidence Seiberling obtint une mention honorable du programme Homes for Better Living sponsorisé par le AIA, « House & Home » et « LIFE ». Bien que le projet ait bénéficié de la reconnaissance nationale des professionnels, ni le journal de la AIA ni le magazine « LIFE » ne lui consacrèrent un article. Un résumé écrit par les architectes, trouvé dans les archives de Shulman, rapporte que la résidence destinée à une famille fut dessinée pour le directeur du Department of Art de l'Université d'Iowa. Située sur un terrain de 20 ha à près de 10 km de la ville la plus proche, elle fut achevée à l'automne 1961. Le propriétaire, un historien d'art, avait besoin d'un endroit satisfaisant les besoins domestiques habituels et qui lui permettrait d'exposer son importante collection d'œuvres d'art. Le programme prévoyait d'intégrer le savoir technologique de l'époque dans le concept.

Le plan cruciforme de Seiberling n'est pas une nouveauté dans l'architecture résidentielle de Crites & McConnell, et il était fréquemment mis à contribution dans les sites ruraux. Vu sa forme, la configuration séparait les fonctions. De manière caracté-

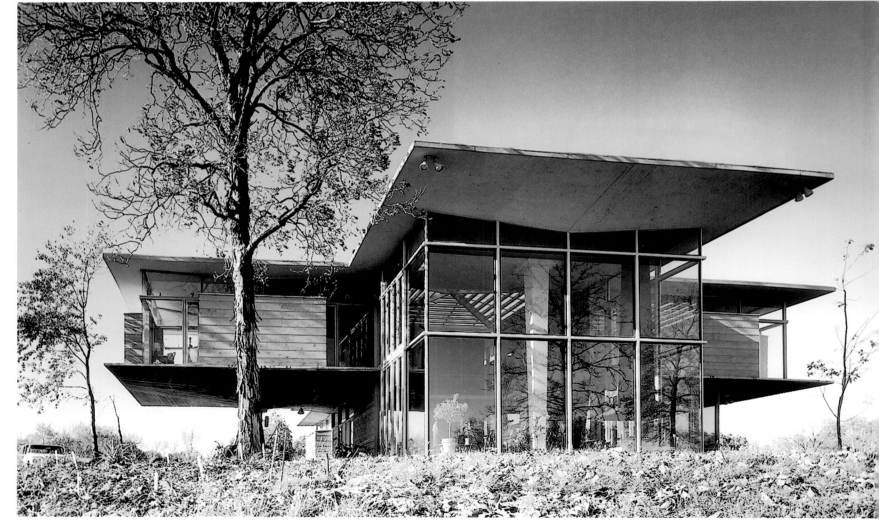

while the arms branching out from it delineated private zones. This design model shaped the Seiberling layout to the letter. Although its characteristic sculptural forms belonged to the line of investigation of corrugated structures and shells pursued during the 50s and 60s, this work was raised to a Frank Lloyd Wright pitch. Both the terminal solutions of the arms and the seven concrete umbrellas shwow a striking similarity with the cantilevered volume jetting out of one of the extremities of Wingspread and the structural mushrooms of the Johnson Wax designed by Frank Lloyd Wright a few years earlier.

The Seiberling Residence was praised for its technological merits. The four hyperbolic-paraboloid sections constituting each concrete umbrella were supported at their centers by slender steel posts. A wood-framed, translucent skylight covers the center section of the house.

meinschaftsbereich vorbehalten, oft mit doppelter Deckenhöhe, während die abzweigenden Arme die Individualbereiche enthielten. Auch wenn die charakteristischen skulpturalen Formen in die Reihe der Versuche mit Wellblechkonstruktionen und Schalenbauweisen in den 50er- und 60er-Jahren gehören, erreicht dieser Entwurf Wright'schen Rang. Sowohl die Abschlüsse der Kreuzarme als auch die sieben Beton-Schirme haben eine verblüffende Ähnlichkeit mit dem auskragenden Bauteil, der aus einem der Flügel des Wingspread Hauses herausspringt, und mit den Pilzstützen des Johnson Wax Baus, die Frank Lloyd Wright wenige Jahre zuvor entworfen hatte.

Das Haus Seiberling wurde wegen seiner technologischen Vorzüge gerühmt. Die vier hyperbolisch-paraboloiden Abschnitte, die die Schirme bilden, wurden jeweils in der Mitte von schlanken Stahlstützen getragen. Ein holzgerahmtes Oberlicht liegt über dem Mitteltrakt des Hauses.

ristique, le centre de la croix était réservé à l'espace commun, souvent double-hauteur, alors que les branches abritaient les zones privées. Ce dessin donnait littéralement sa forme au plan de la résidence. Bien que sa forme sculpturale caractéristique soit dans la ligne de recherche des structures ondulées et des coquilles poursuivie durant les années 1950 et 1960, ce projet atteint une dimension wrightienne. La solution trouvée pour la terminaison des bras et les sept parapluies en béton présente une similitude frappante avec le volume en porte-à-faux partant de l'une des extrémités de Wingspread et les structures en forme de champignons de la Johnson Wax dessinés par Frank Lloyd Wright quelques années plus tôt.

La résidence fut louée pour ses qualités technologiques. Les quatre sections hyperboliques-paraboloïdes constituant chaque parapluie de béton étaient soutenues en leur centre par des poutres d'acier élancées, une lucarne translucide dans un cadre de bois recouvre la section centrale de la maison.

Selected Bibliography:
- House & Home, November 1962
- Los Angeles Times Home Magazine, August 19, 1973

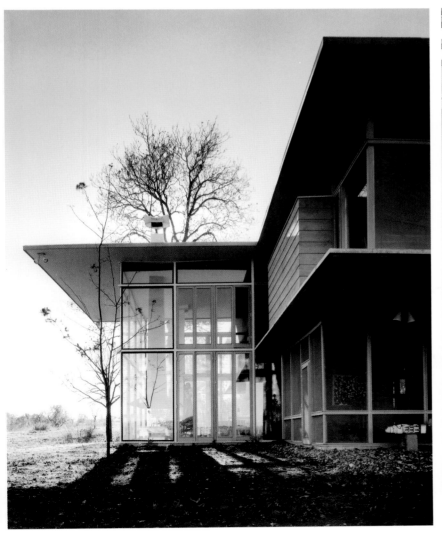

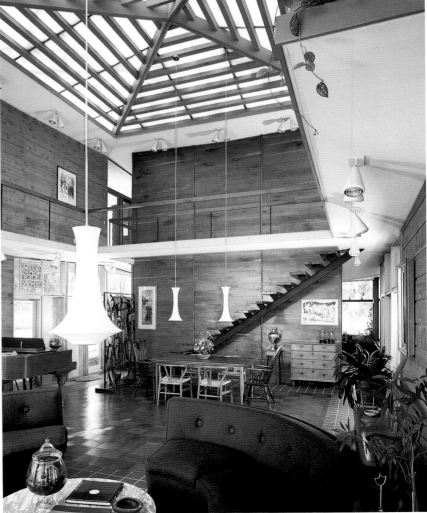

3205 David Fowler
Davis Pavilion, Lake Arrowhead, California
June 3, 1961

Hundreds of feet away from the main residence, this summer shelter overlooks a lake in the San Bernardino Mountains. Four masonry columns hold a pitched shingled roof with an open peak. Underneath the canopy, a glass box is rotated 45 degrees with the corners projecting out of the roof outline. The interior floor is made of 2 x 6-foot redwood planking, spaced 3/8 inch apart to drain rain and snow entering from the roof peak and projecting corners. The dressing room is walled on two sides with sand-colored concrete blocks.

Dieses Sommerhäuschen steht in einigem Abstand zum Wohnhaus der Familie Davis an einem See in den San Bernardino-Bergen. Vier Mauerwerkspfeiler tragen ein schindelgedecktes Dach, das in der Mitte offen ist. Darunter ist ein ebenfalls offener Glaskasten um 45° gedreht, so dass die Ecken unter dem Dach vorspringen. Der Innenraum ist mit Redwood-Brettern ausgelegt; in den knapp 1 cm breiten Fugen versickert das durch die unverglasten vorspringenden Ecken und die Dachöffnung eindringende Regen- oder Schmelzwasser. Die Umkleidekabine hat auf zwei Seiten sandfarbene Betonsteinmauern.

A quelques dizaines de mètres de la résidence principale, ce bungalow d'été domine un lac dans les San Bernardino Mountains. Quatre piliers en maçonnerie soutiennent un toit à pignon recouvert de bardeaux dont la partie centrale reste ouverte. Sous cet abri, une boîte de verre pivote de 45° par rapport aux angles et, ce faisant, déborde du toit. Le sol intérieur est en plancher de bois rouge espacées de 1 cm pour évacuer l'eau et la neige qui pénètrent par l'ouverture du toit et les parties saillantes. Le dressing-room est protégé par deux murs sur deux côtés élevés en parpaings de béton.

Selected Bibliography:
- Sunset, April 1962
- Architectural Record, August 1963

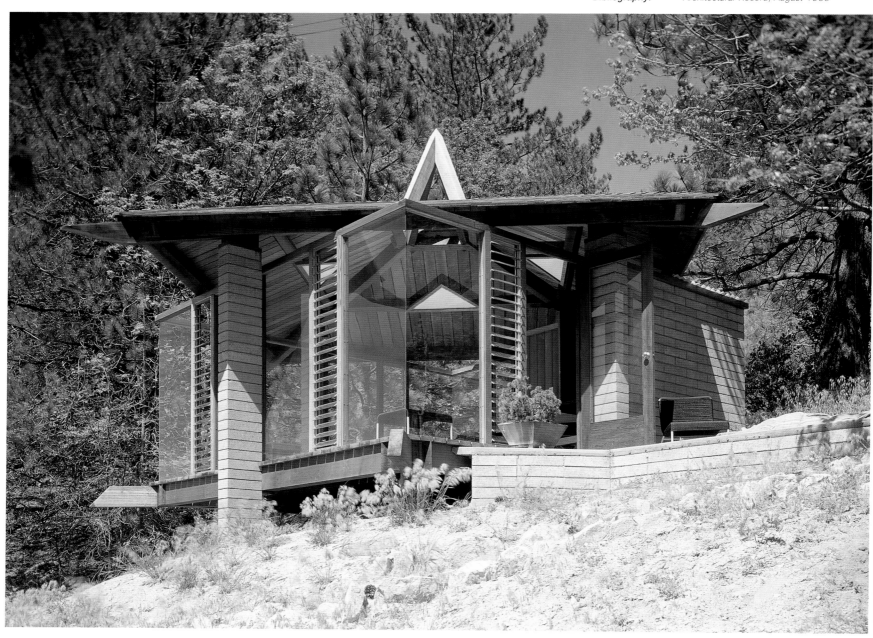

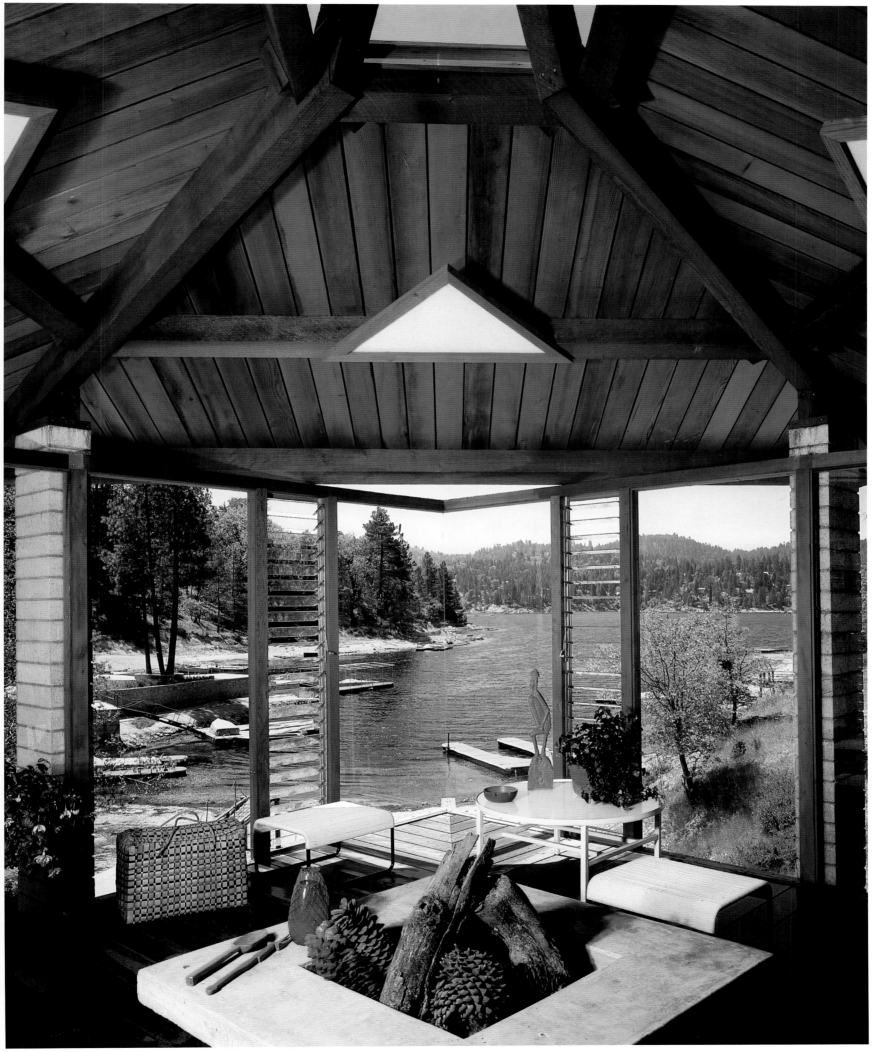

3215 Buff, Straub and Hensman
Thomson Residence, Pasadena, California
June 19, 1961

Although the residence is only 1,358 square feet, the open plan and the generous area of decks dramatically change the scale of the project. The hillside lot contained seven oak trees that the Thomsons wanted preserved.

Entry to the residence is from the intermediate landing of the stairway connecting the two levels of the living scheme. Double-height kitchen-dining area, living room, den and large decks built around two oak trees occupy the bottom floor. Enclosed by sliding translucent screens, the sleeping quarters on top open to the space below. A deck extends the master bedroom outdoors. Excepting the den, every room overlooks the two-story space and the view through its transparent wall. Construction is a post-and-beam framing system based on four 13-foot-4-inch modules. Three of them form the house enclosure. The fourth on the east side is left open for the terrace and deck. The house received an Honor Award in the 1961 edition of the Western Home Award sponsored by the American Institute of Architects and *Sunset* magazine.

Obwohl das Haus nur rund 125 m² umfasst, verändern der offene Grundriss und die großzügigen Terrassendecks ganz entscheidend die Wahrnehmung seiner Dimensionen. Die Thomsons wollten die sieben ausgewachsenen Eichen auf dem Hanggrundstück erhalten. Der Zugang erfolgt vom Podest auf halber Höhe der Außentreppe zwischen den beiden Geschossen. Die zweigeschossige Wohnküche, der Wohnraum, die Bibliothek und eine große, um zwei Eichen herumgebaute Holzterrasse befinden sich im Erdgeschoss. Die Schlafzimmer bilden die Galerie-Ebene der Wohnküche, öffnen sich nach innen über transluzente Glasschiebetüren und bieten Ausblicke durch die Glasfront dieses großen Raums. Dem Elternschlafzimmer ist eine weitere Außenterrasse vorgelagert. Bis auf die Bibliothek öffnet sich jeder andere Raum des Hauses zur zweigeschossigen Wohnküche. Das Haus ist eine Pfosten-Riegel-Konstruktion auf einem 4 m-Raster. Drei Rasterfelder umreißen die Grundfläche des Hauses. Das vierte auf der Ostseite umfasst die große Holzterrasse. 1961 erhielt das Haus in einem vom American Institute of Architects und der Zeitschrift »Sunset« gemeinsam ausgelobten Wettbewerb eine Belobigung.

Bien que cette résidence ne fasse que 125 m² de surface, son plan ouvert et ses généreuses terrasses modifient de manière spectaculaire la perception que l'on a de son échelle. Le terrain situé dans les collines de Pasadena possédait sept chênes que les Thomson souhaitaient conserver.

L'entrée se fait par un palier intermédiaire sur l'escalier qui réunit les deux niveaux. Une zone de cuisine-salle à manger double hauteur, le séjour, un petit salon et une vaste terrasse aménagée autour de deux des chênes occupent le niveau inférieur. A l'étage, les chambres fermées par des écrans translucides dominent l'espace de vie. Une terrasse prolonge la chambre principale vers l'extérieur. A l'exception du petit salon, chaque pièce donne sur le grand volume double hauteur et bénéficie d'une vue au travers de son mur de verre. La maison est construite à partir d'une ossature de poteaux et poutres comprenant quatre modules de 4 m de côté. Trois d'entre eux représentent l'emprise au sol de la maison au sens propre. Le quatrième, côté est, est laissé ouvert et abrite une véranda et la terrasse. La maison a reçu un prix d'honneur du Western Home Award 1961 de l'American Institute of Architects et « Sunset » magazine .

Selected Bibliography:
- Western Architect and Engineer, Sept. 1961
- Sunset, October 1961
- Los Angeles Times Home Magazine, November 12, 1961
- Herbert Weisskamp, Beautiful Homes and Gardens in California, New York 1964

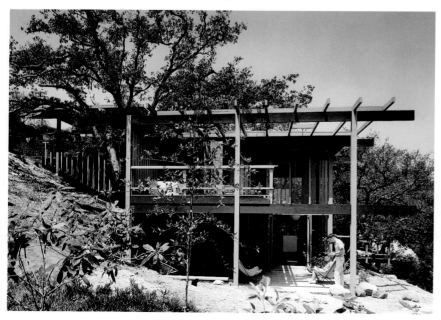
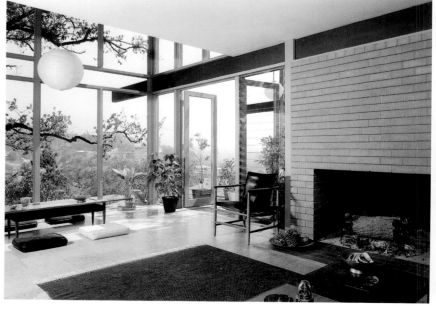

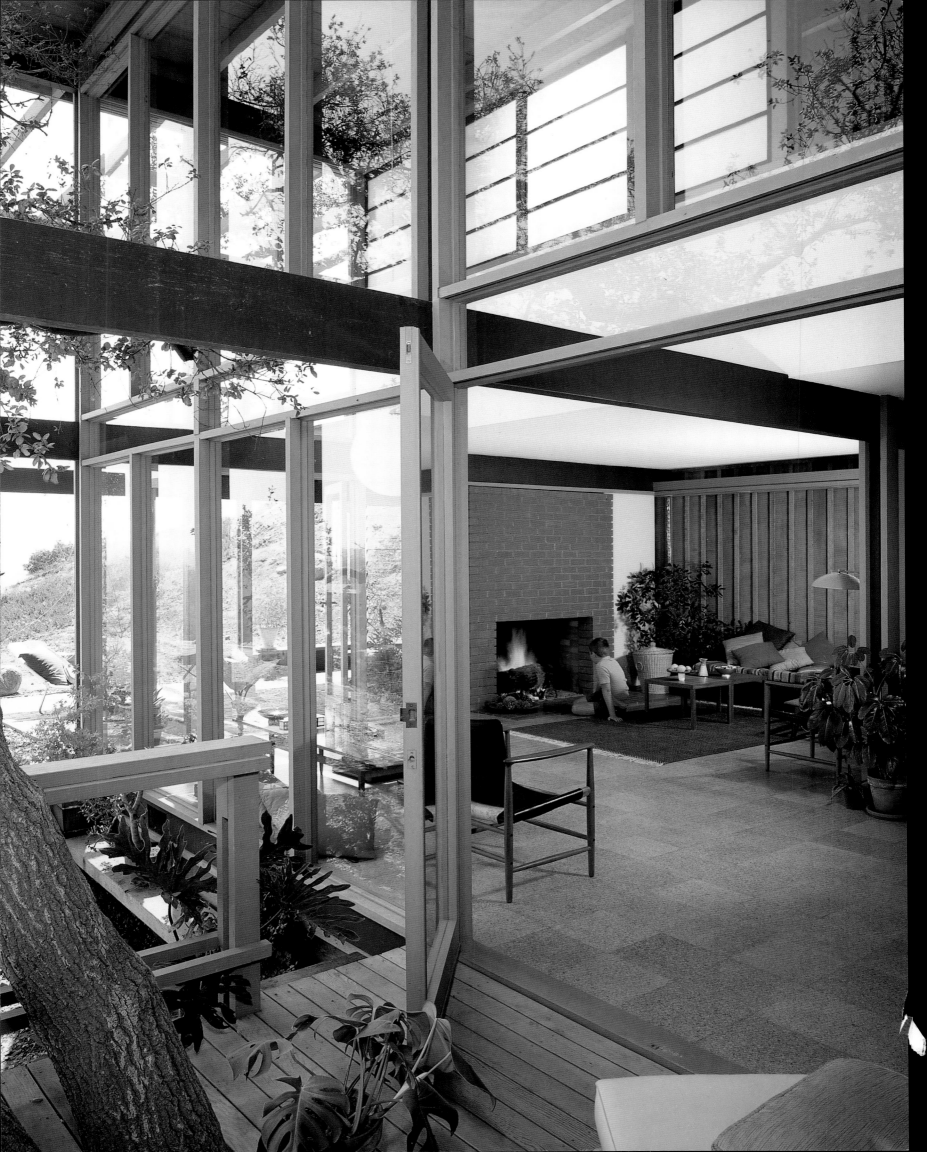

3225 **Henry Hester**
Jerome Residence, La Jolla, California
June 25, 1961; December 3, 1961

The owner, Gerald Jerome, was a San Diego interior decorator, and worked very closely with the architect on his own residence built on an interstitial site. A residual from an adjacent property, the narrow lot is only 25 feet wide and 165 feet deep. Hester arranged two concrete shells in sequence, spaced 15 feet from each other. Due to the volume of traffic on the street front, the principal living areas are located in the rear of the lot. The street-side building is an eleven-foot wide guesthouse with a garage at the lower level. In the back, the 17-foot-wide main section accommodates two stories of residential space. In between, an outdoor terrace half-level above the street joins the two structures. The entry to the house is located on the raised terrace. On the main floor, a dining and kitchen area precedes a study room in the back that opens to a rear garden. A curved staircase leads to the living and master bedroom on the upper level with an unobstructed view of the ocean. In section, a 10-foot vertical module defines the proportion of doors, windows and walls. The Jerome Residence won an Honor Award in the 1961 edition of the Western Home Awards.

Gerald Jerome war ein Raumausstatter aus San Diego und arbeitete eng zusammen mit dem Architekten seines eigenen Hauses, das auf einer extrem schmalen, vom Nachbargrundstück abgeteilten Parzelle (ca. 8 x 50 m) entstand. Hester entwarf zwei hintereinander liegende Betonschalenkörper mit einem Zwischenabstand von rund 4,50 m. Aufgrund des starken Straßenverkehrs vor dem Haus brachte er die Wohnräume der Familie im hinteren Gebäude unter; das vordere ist ein 3,30 m breites Gästehaus mit Tiefgarage. Das 5 m breite Wohnhaus ist zweigeschossig. Zwischen den beiden Baukörpern fügte Hester eine erhöhte Terrasse ein (auf halber Geschosshöhe vom Straßenniveau). Im Hauptgeschoss befinden sich die Essecke und Küche und im hinteren Teil ein Arbeitszimmer, das sich zum Garten öffnet. Eine geschwungene Treppe führt zum Wohnraum und zum Schlafzimmer im Obergeschoss, die freie Sicht auf den Pazifik bieten. Der Querschnitt basiert auf einem hochrechteckigen Raster von ca. 3 m, das die Fenster-, Türen- und Wandproportionen bestimmt. 1961 erhielt das Haus Jerome eine Belobigung im Rahmen der Western Home Awards.

Gerald Jerome, décorateur à San Diego, travailla sur ce projet en étroite collaboration avec Hester. Maison construite entre deux autres sur une petite parcelle de terrain de 8 x 50 m prise sur la propriété adjacente, son plan se répartit en deux coquilles de béton, successives et espacées l'une de l'autre de 4,50 m. Pour se protéger du bruit de la circulation, les principales zones de séjour sont repoussées en fond de parcelle. Le bâtiment sur rue est une maison d'amis de 3,30 m de large sous laquelle est glissé le garage. A l'arrière, le volume principal de 5 m de large comporte deux niveaux. Les deux constructions sont reliées entre elles par une terrasse extérieure, d'un demi-niveau au-dessus de celui de la rue, sur laquelle s'ouvre l'entrée. Au niveau principal, la salle à manger et la cuisine précèdent le bureau qui donne sur le jardin à l'arrière. Un escalier en courbe conduit au séjour et à la chambre principale situés à l'étage, d'où l'on bénéficie d'une vue dégagée sur l'océan. Les proportions des portes, des fenêtres et des murs sont harmonisées par un module vertical de 3 m de haut. La Jerome Residence a remporté un prix d'honneur aux Western Home Awards de 1961.

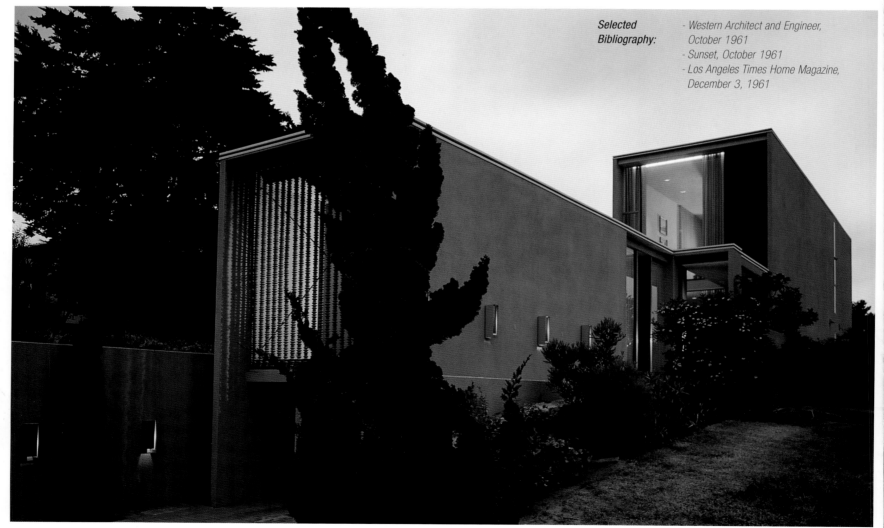

Selected Bibliography:
- *Western Architect and Engineer, October 1961*
- *Sunset, October 1961*
- *Los Angeles Times Home Magazine, December 3, 1961*

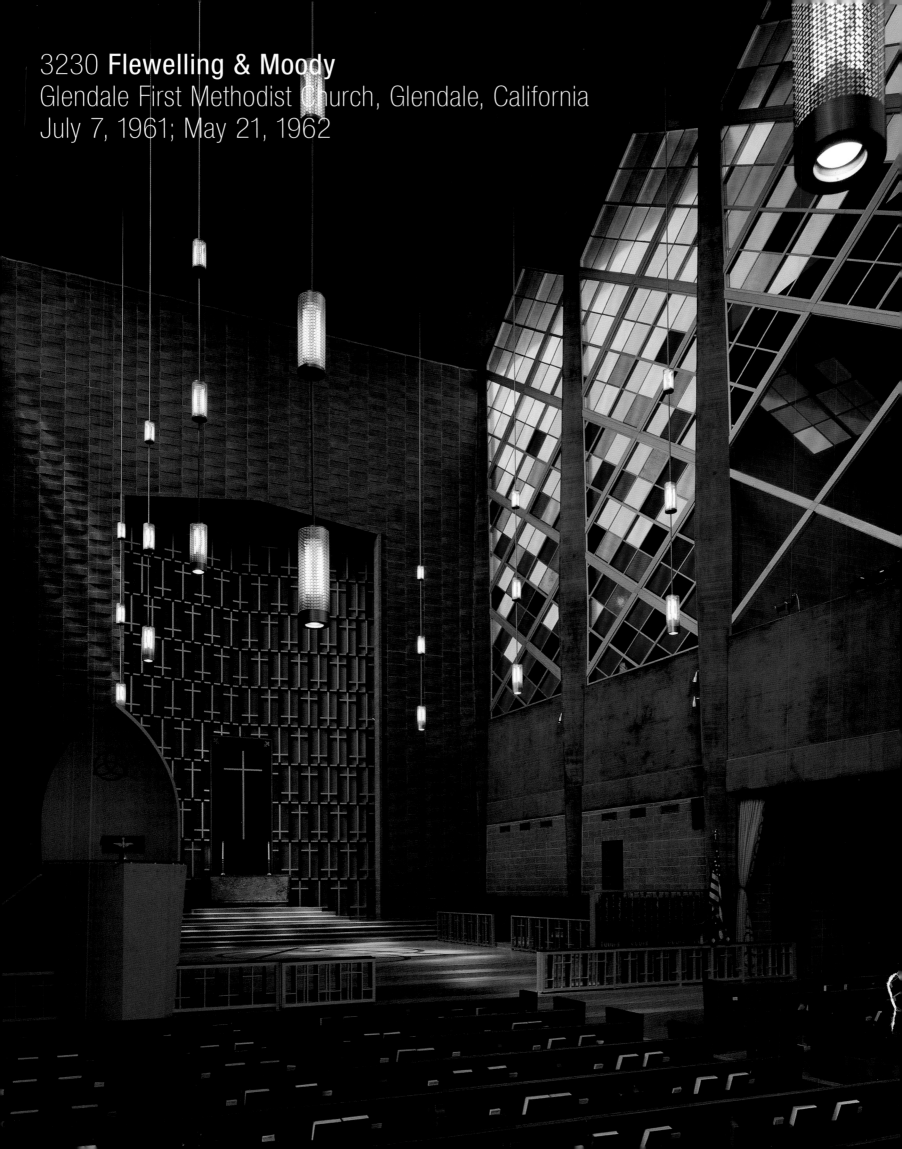

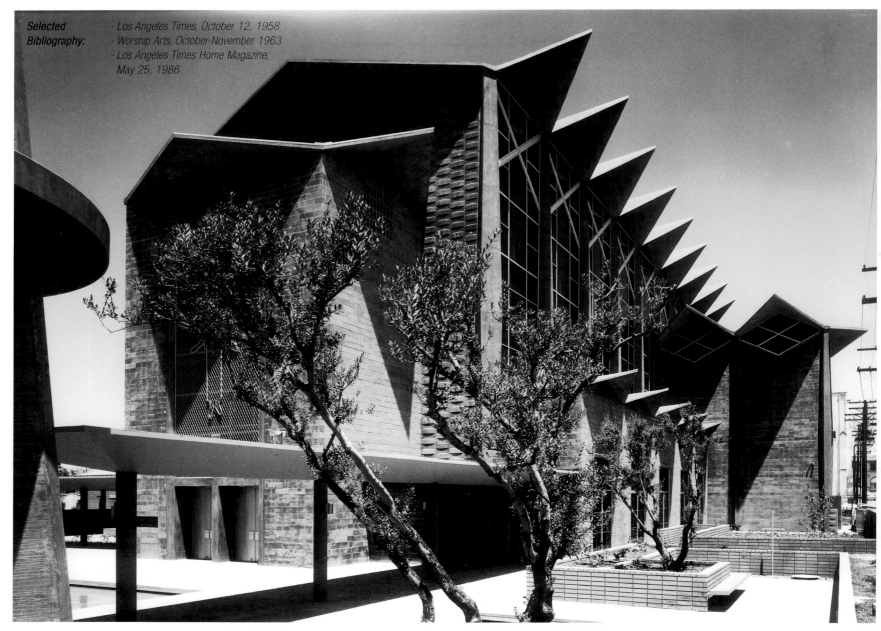

Selected
Bibliography:
- Los Angeles Times, October 12, 1958
- Worship Arts, October-November 1963
- Los Angeles Times Home Magazine,
May 25, 1986

For the congregation and the pastor, Gothic style was the urban identity of Glendale First Methodist, since their second church, built in 1917. They commissioned a space with a cathedral feeling; the architects responded with a modern statement. Walter Moody had been a member of the religious community since the 30s, and Flewelling was the son of a Methodist minister. Their personal background provided them with the intimate knowledge essential to meet the requirements of the religious program without indulging in historical revivals. A year and a half of designing efforts and eleven plans preceded the built solution. The sanctuary is at the corner of Broadway and Kenwood Street, one block south of the church's old headquarters, and was designed to seat 1,340 people. Gothic symbolism permeates the cruciform plan, the concrete columns, the floor and furniture, and the double glass walls. Yet the architectural language is contemporary. For the folded surface of the 270-ton roof, the architects used pre-stressed technology. The structur-

Für die Methodisten-Gemeinde von Glendale und ihren Pfarrer war der neogotische Baustil seit der Vollendung des zweiten Kirchenbaus im Jahr 1917 untrennbar mit der Identität ihrer Kirche verbunden. Sie wünschten sich einen Bau, der wie eine Kathedrale wirken würde. Was sie bekamen, war moderne Architektur. Walter Moody war seit den 30er-Jahren Gemeindemitglied und Flewelling der Sohn eines Methodistenpfarrers. Beide wussten sie also genau, welche Elemente in einer Methodistenkirche nicht fehlen durften, waren aber dabei keineswegs historistisch geneigt. Die Entwurfsarbeiten nahmen – mit elf Revisionen – insgesamt anderthalb Jahre in Anspruch. Die moderne Kirche steht an der Kreuzung von Broadway und Kenwood Street, einen Straßenblock südlich der alten Kirche, und sollte 1 340 Gläubigen Sitzplätze bieten. Die gotische Symbolik ist immer noch spürbar: im kreuzförmigen Grundriss, in den Betonsäulen und Doppelglaswänden, im Fußbodenbelag und Gestühl. Dennoch ist der Kirchenbau sichtlich modern. Das 270 Tonnen

Pour la congrégation et le pasteur de la First Methodist Church de Glendale, le style gothique était celui qui convenait le mieux, depuis qu'il avait été choisi pour la construction de leur second lieu de culte en 1917. Alors que les commanditaires souhaitaient un espace évoquant une cathédrale, les architectes répondirent par un manifeste de modernité. Walter Moody était membre de cette église depuis les années 1930, et Flewelling fils de pasteur méthodiste. Leur expérience personnelle leur donnait donc une connaissance approfondie et essentielle des contraintes d'un tel projet, et pouvait leur éviter de tomber dans un style historicisant. Il fallut un an et demi de réflexion et onze propositions avant d'arriver au projet final. Le sanctuaire, situé à un bloc au sud de l'ancienne église, peut contenir 1 340 personnes assises. Le symbolisme gothique se retrouve en partie dans le plan cruciforme, les piliers en béton, le sol, le mobilier et les murs de verre à double vitrage. Le langage architectural n'en est pas moins contemporain de la période de construction.

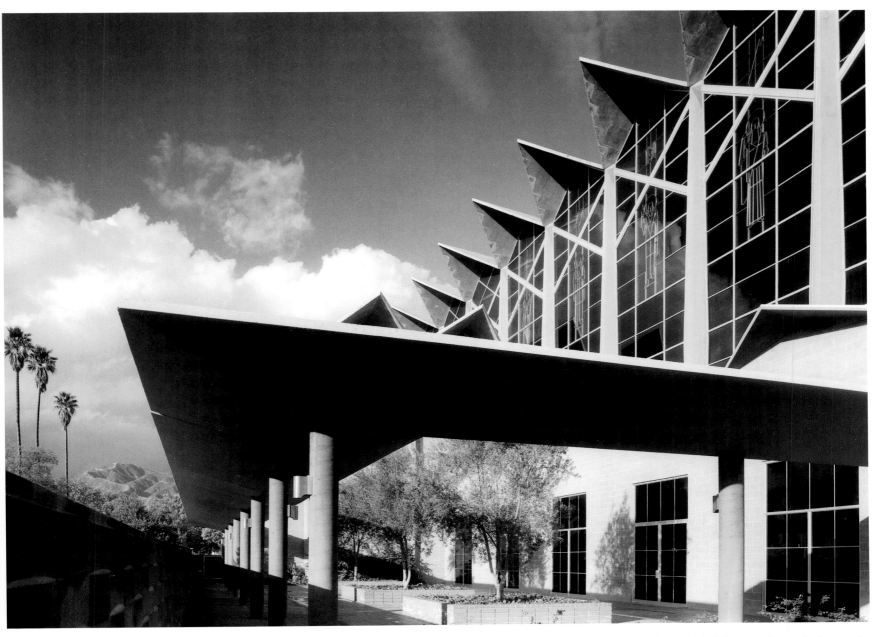

al scheme channels the load to the center of the supporting columns. Steel slip cables reinforce the roof plates. Each 68-foot-high column is assembled and formed on the site. The Trilon, a 112-foot-high three-legged tower, modifies the skyline of Glendale.

The glasswork was the result of a collaboration between John Wallis, of Wallis-Walley Glass Studio of Pasadena, and the architects. A glass-patterned surface of 150 x 40 feet characterizes each side of the nave and chancel. An exterior layer of neutral density glass mutes the interior colored fields, ranging from blue at the entrance, to violet, to gold over the altar. In 1992, the American Institute of Architects Pasadena and Foothill Chapter bestowed an Award of Merit to the project.

schwere Faltdach ließen die Architekten in Vorspannbauweise errichten. Die Lastableitung erfolgt durch die Mitte der 21 m hohen Stützen, die auf der Baustelle montiert und gegossen wurden. Der sogenannte Trilon, ein etwas über 34 m hoher dreibeiniger Turm, veränderte die Stadtsilhouhette von Glendale radikal. Die Glasfenster stellen eine Gemeinschaftsarbeit von John Wallis und den Architekten dar. Zu beiden Seiten des Hauptschiffs und des Altarraums befindet sich je eine 45 x 12 m große, mit farbigen Glasplättchen gemusterte Glaswand. Eine Außenscheibe aus Grauglas dämpft die Leuchtkraft der Buntglasstücke auf der Innenseite, die am Eingang in Blautönen erstrahlen, dann in Violett übergehen und um den Altar golden schimmern. 1992 erhielt der Bau von der Sektion Pasadena und Foothill des American Institute of Architects einen Award of Merit.

Pour le toit à plis cassés de 270 tonnes, les architectes eurent recours à une technologie de précontrainte. Les forces se répartissent entre les piliers. Des câbles d'amarrage renforcent les plaques qui composent le toit. Chaque pilier de 21 m de haut fut assemblé sur place. Le Trilon, clocher tripode de 34 m de haut transforma la silhouette du centre de Glendale. Les murs vitrés sont le produit de la collaboration de John Wallis et des architectes. La nef et le chœur sont clos par une paroi vitrée de 45 x 12 m. Le verre extérieur est neutre tandis que le verre intérieur décline une gamme de couleurs allant du bleu de l'entrée à l'or de l'autel en passant par le violet. En 1992, le chapitre de Pasadena et Foothill de l'AIA décerna son prix du mérite à ce projet.

3281 Crites & McConnell
Tucker Residence, Cedar Rapids, Iowa
October 14, 1961

The 1,584-square foot house sits on the steepest portion of a 50 x 150-foot lot, fully shaded by the natural growth of large existing trees. The domestic functions are distributed in a two-story structure of post-and-beam framing. Detached from the house, the carport shields a small landscaped entry court leading to the center of the plan. The zoning of the first floor consists of the master bedroom, and the children's room in the front with a storage space and a bathroom at the back. A wooden walkway connects the master bedroom with an outdoor deck built on the garage's roof. Two freestanding panels of plastic-coated plywood protect the privacy of both bedrooms from entry path and street. Adjacent to the entry, a central stairway takes the guests to the collective areas and an additional sleeping unit on the second floor. Two short bridges link the living and dining areas to the back of the sloping lot, but the main openings of the house face a north.

Das zweigeschossige Haus (eine Pfosten-Riegel-Konstruktion mit 146 m² Fläche) steht auf dem Steilhangabschnitt eines 15 x 45 m großen Grundstücks, das von alten Bäumen beschattet wird. Die separate offene Garage bildet die Sichtschutzbarriere des kleinen begrünten Eingangshofs, der bis zur Mitte des Grundrisses reicht. Im ersten Stock sind nach vorne Eltern- und Kinderzimmer untergebracht, nach hinten Bad und Abstellraum. Ein Holzbohlenweg führt vom Elternschlafzimmer durch den Garten zur Dachterrasse auf der Garage. Zwei kunststoffbeschichtete Stellwände schützen beide Schlafzimmer vor Einblicken vom Zugangsweg und von der Straße. Vom Eingang führt eine zentrale Treppe in die Wohnräume und das Gästezimmer im zweiten Stock. Zwei nah am Hang verlaufende kurze Brücken verbinden Wohn- und Essbereich im hinteren Teil des Hauses. Die größten Fenster und Glastüren des Hauses weisen nach Norden.

Cette maison de 146 m² se dresse sur la partie la plus abrupte d'une parcelle de 15 x 45 m, entièrement ombragée par un bosquet de grands arbres. Les fonctions domestiques sont distribuées sur les deux niveaux de la construction à ossature de poteaux et poutres. Détaché de la maison, l'abri aux voitures protège une petite cour d'entrée paysagée qui introduit au centre du plan. Le rez-de-chaussée comprend la chambre principale et celle des enfants à l'avant, ainsi que des espaces de rangement et une salle de bains sur l'arrière. Une allée recouverte de plancher relie la chambre principale à une terrasse aménagée sur le toit du garage. Deux panneaux isolés de contreplaqué plastifié assurent l'intimité des deux chambres par rapport à l'entrée et à la rue. Adjacent à l'entrée, un escalier central conduit les visiteurs aux pièces communes et à une chambre supplémentaire à l'étage. Deux courtes passerelles relient le séjour et la salle à manger à l'arrière de la parcelle, vers le plat du terrain, mais les principales ouvertures de la maison sont néanmoins orientées au nord.

Selected Bibliography: - House & Home, September 1962

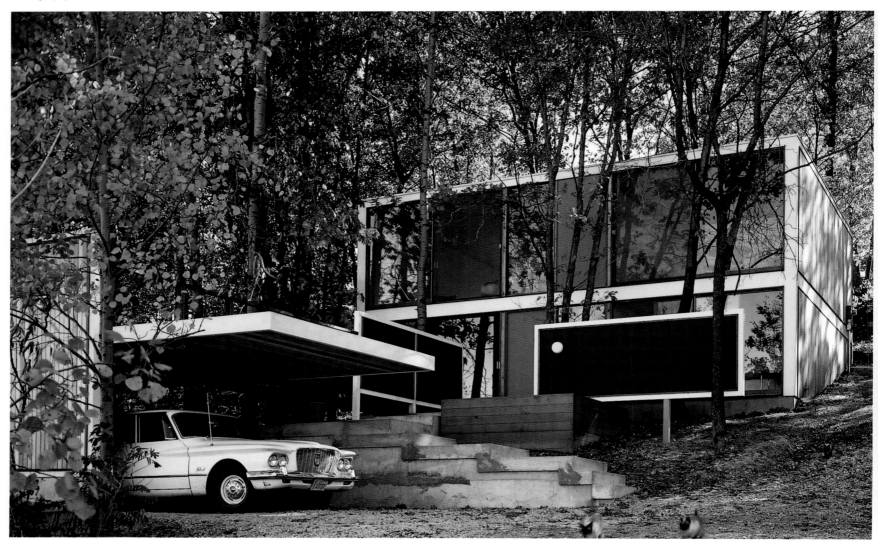

3288 Kistner, Wright and Wright
Cerritos Junior College and Gymnasium, Norwalk, California
November 6, 1961

Entirely contained within a square, the pinwheel plan of the steel frame library consists of a core from which the four main rooms spread to the four compass directions. The center of the plan houses a display area with a depressed browsing circle in the middle, and is covered with four barrel vaults perpendicular to each other. The peripheral volumes contain a reading and a reference room of equal size; small conference facilities; and an audio-visual department. Indented courts on each side increase the natural lighting in the inner parts of the library.

Vom Kernbereich des in ein Quadrat eingeschriebenen Grundrisses weisen vier Trakte in die Himmelsrichtungen. Im Zentrum des Stahlgebäudes – einer Bibliothek – befindet sich ein Ausstellungsraum mit einem abgesenkten Lesebereich in der Mitte und vier im rechten Winkel zueinander angeordneten Tonnendächern. An der Gebäudeperipherie sind ein Lesesaal und ein Saal mit Nachschlagewerken, kleine Konferenzräume und eine Audio-Video-Abteilung untergebracht. Einspringende Fassadennischen erlaubten den Einbau zusätzlicher Fenster zur besseren natürlichen Belichtung der Bibliothek.

Entièrement contenu dans un carré, le plan en croix de l'ossature d'acier consiste en un noyau d'où partent les quatre salles principales orientées selon les points cardinaux. Au centre, sous quatre voûtes en berceau perpendiculaires, se trouve une aire d'exposition autour d'une espace circulaire en creux. Les volumes périphériques contiennent une salle de lecture et de documentation de tailles identiques, de petites salles de conférence, et le département audiovisuel. Des cours découpées de chaque côté permettent l'implantation de fenêtres supplémentaires qui éclairent l'intérieur de la bibliothèque.

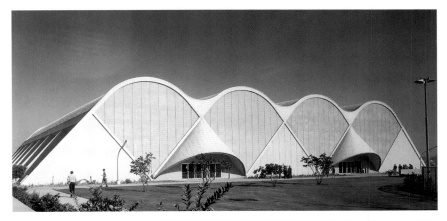

Selected
Bibliography: *- arts & architecture, October 1963*

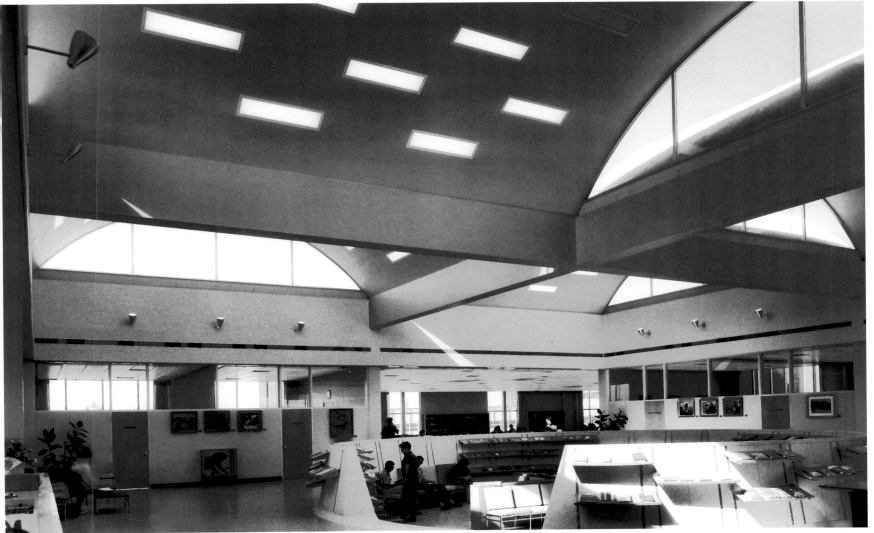

3348/3399 **Pereira & Associates**
Pereira Residence, Los Angeles, California
February 20, 1962

This residence stands as a demonstrative statement of the architect's commitment to the tenets of International Style. Within the confines of a 17,000-square-foot lot, located in the Hancock Park District, an old residential section of Los Angeles, a seven-foot perimeter wall establishes a sharp division between the busy heart of the city and the domestic privacy. The site was formerly a garden of the house next door. As a result, the 4,500-square-foot house was designed such as to preserve the many existing palm trees.

From the street entrance, the stretched perspective magnifies the scale of the place. Walking the entry path along an L-shaped pool with a painted black bottom, a statue becomes the focus of the visitor's gaze. Indoor and outdoor areas merge into a spatial continuum in line with the Southern Californian residential models. While the house's overall layout is openly modernist in the modular arrangement of the diverse functions, its elevation nevertheless has a classical flavor. The temple-like living room, raised on a two-stepped base, completes the still outdoor landscape framed by the disposition of the benches around the pool.

In the pavilion containing the living room, a conversation pit surrounds a sculptural metal fireplace and continues into the out-

Das Haus Pereira verkörpert das Engagement des Architekten für den so genannten International Style. Es steht im Hancock Park Distrikt, einem alten Wohnviertel von Los Angeles, auf einem 1 580 m² großen Grundstück, das durch eine 2 m hohe Mauer vor dem Lärm der Großstadt und vor Einblicken geschützt ist und früher der Garten des Nachbarhauses war. Die großzügige Villa (ca. 420 m²) wurde mit Bedacht so platziert und gestaltet, dass die vielen alten Palmen erhalten blieben. Vom Straßentor gesehen wirkt das Haus noch größer, als es tatsächlich ist. Auf dem Weg zum Eingang, an einem L-förmigen Schwimmbecken mit schwarz gestrichenem Boden entlang, wird eine antike Büste auf einem Sockel für die ankommenden Besucher zum attraktiven Blickfang. Innen- und Außenbereiche verschmelzen entsprechend dem südkalifornischen Wohnmodell zu einem räumlichen Kontinuum. Die modulare Gliederung des Hauses nach Funktionen ist zwar ganz modern, von außen vermittelt das Haus aber klassische Anklänge: Der um zwei Treppenstufen erhöhte Baukörper des Wohnraums erinnert zum Beispiel auch aufgrund seiner Verglasungspfosten ein wenig an einen Tempel. Innen ist der freistehende offene Kamin mit plastisch geformter Metallabzugshaube von einem abgesenkten Sitzbereich umgeben, der in die Außenterrasse übergeht. Diese

La Résidence Pereira témoigne de l'adhésion de l'architecte aux principes du Style international. Aux limites d'un terrain de 1 580 m², situé dans le Hancock Park District, quartier résidentiel ancien de Los Angeles, un mur de 2 m de haut marque une séparation nette entre le centre-ville et la sphère privée. La parcelle était jadis occupée par un jardin botanique qui appartenait à la maison voisine. La nouvelle maison (420 m²) s'efforça de préserver de nombreux palmiers existants.

A partir de l'entrée sur rue, une longue perspective magnifie l'échelle de l'ensemble. Lorsque le visiteur emprunte l'allée le long de la piscine en L, au fond peint en noir, son regard tombe sur un buste romain placé au point de fuite. Le dedans et le dehors s'interpénètrent en un continuum spatial dans l'esprit du modèle californien du sud. Si le plan général de la maison est franchement moderniste dans sa répartition modulaire des fonctions, son élévation n'est pas sans évoquer les canons classiques. La situation du vaste séjour, élevé sur un soubassement à deux marches à la manière d'un temple, parachève la mise en scène extérieure, cadrée par la disposition des bancs autour de la piscine.

Dans le pavillon de séjour, un coin conversation en creux aménagé autour d'une cheminée sculpturale en métal se poursuit

Selected Bibliography:
- Newsweek, "A Personal View", May 7, 1962
- House & Garden, October 1962
- House & Home, January 1964
- Architecture/West, May 1964
- Designers West, May 1966
- Designers West, June 1966
- Designers West, June 1967

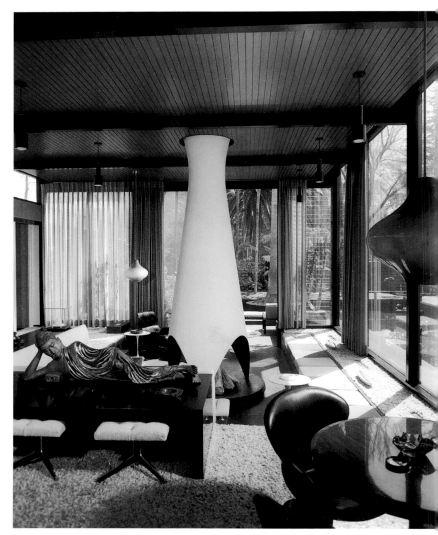

side terrace. This deck, partially enclosed with walls displaying art objects on built-in shelves, reads as an interior without a roof. The two wings of the house contain two sides of the dining room; combined with two interior patios, they make it possible to sent 125 gutests for dinner. Exterior materials are black frame, warm beige stucco and orange trimmed wood louvers. Under the carport floor, there is an egg-shaped bomb shelter. Pereira's reputation for large-scale designs may have inhibited public recognition of his own residence. The house seems an isolated episode in his career, and was not followed by similar endeavors in terms of scale and building type. Today, the residence is still standing, but the steel frame, originally black, is painted white. The house received little coverage in the specialized press, and has consequently been neglected; it has never been listed in an architectural guide.

ist zum Teil von niedrigen Mauern umgeben, an denen auf Wandregalen Kunstwerke ausgestellt sind, so dass der Platz wie ein Innenraum ohne Decke wirkt. Der zweiflügelige Teil des Hauses enthält (quer) zwei Bereiche des Esszimmers, das sich (längs) in einen von zwei Innenhöfen flankierten Raum fortsetzt, so dass man bis zu 125 Tischgäste aufnehmen kann. Die Außenfassaden bestehen aus schwarzen Rahmenkonstruktionen, beigefarbenen Zementputzflächen und orangefarben abgesetzten Holzlamellenjalousien. Unter der Garage wurde ein im Plan eiförmiger Luftschutzbunker eingebaut. Pereiras Reputation für Großbauvorhaben mag die öffentliche Anerkennung für sein eigenes Haus überschattet haben. Es erscheint als Einzelfall in seinem Gesamtwerk, dem keine vergleichbaren Bauten folgten, und steht noch immer, allerdings mit inzwischen weiß gestrichenen konstruktiven Teilen. Aufgrund der spärlichen Presseberichte ist es vom Fachpublikum kaum wahrgenommen und auch in keinen Architekturführer aufgenommen worden.

vers la terrasse. Celle-ci, en partie close de murs, sert de lieu d'exposition à divers objets d'art disposés sur des plans-étagères intégrés qui donnent l'impression d'une pièce intérieure sans toit. Les deux ailes de la maison abritent chacune une partie de la salle à manger, tandis que les deux patios intérieurs permettent de recevoir jusqu'à 125 invités pour un dîner assis. A l'extérieur, l'ossature est peinte en noir, les plans sont recouverts d'un enduit beige et les volets de bois accessoirisés en orange. Sous l'auvent aux voitures a été creusé un abri antiatomique de forme ovoïde. La réputation que Pereira s'était acquise à travers ses grands projets a sans doute occulté l'intérêt du public pour sa demeure privée. Celle-ci semble un épisode isolé dans sa carrière, et il ne réalisera plus aucun projet résidentiel de cette échelle. Peu publiée à l'époque, elle n'a pas laissé d'empreinte particulière auprès des professionnels, et ne figure dans aucun guide d'architecture.

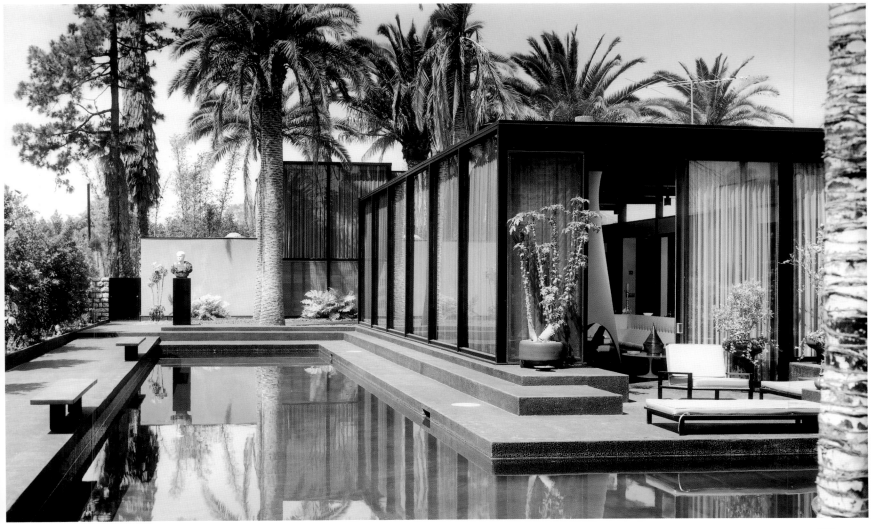

3378 Bernard Judge
Judge Residence, Hollywood, California
April 30, 1962

When *LIFE* magazine published the photograph of the skeleton of the dome against a glittering night view of Los Angeles on a double-page, the project was presented as the icon of a technological future.

In the late 1950s, Buckminster Fuller delivered a lecture at the University of Southern California, where Bernard Judge was a student. Fascinated by the geodesic frames, the young architect, who was about to get married at the time, contacted Fuller to build such a structure for his own home. He was referred to one of Fuller's students living in Los Angeles, who donated to Judge the aluminum framework of a geodesic dome 45 feet in diameter previously manufactured in Canada. With the help of Henrik De Kanter, a Dutch designer for Douglas Aircraft who provided the land, and a few fellow students from the University of Southern California, the architect constructed the residence. Judge labeled this project the "Triponent House", a residential prototype of great adaptability. He established a distinction between the skin (envelope) and the rest of the house. The former, whose purpose is to shield the interior from the elements, can be fabricated locally to accommodate particular climatic conditions. The latter can be mass-produced and shipped to the site.

The dome was located on Beachwood Drive in the Hollywood Hills and sheltered a garden and two floors containing all the functions. Anchored to the foundations, made with eleven concrete piers, steel "quadrupeds" supported wood platforms exposing the a hexagonal shape. Entry, kitchen, dining room and master bedroom were on the lower deck, the living room and two studios on the upper deck. Both were connected to a pre-fabricated mechanical core and mutually accessible through a spiral staircase.

Heat control was a primary concern in the design. The hill blocked the sun from the west. A fixed sunshade, with a silvery coating on the outside to reflect the sunrays, protected an opening 12 foot in diameter at the top of the dome. The wires, radiating from short poles on the aluminum ribs carried loads in tension. The underside of the aluminum frame had wood ribs onto which 5-mm-thick Mylar foil was stapled. To obtain the building permit from the municipal department, Judge had to perform empirical tests to prove the structural stability of the skeleton. The architect lived in the house for one year. A few years later it was dismantled and shipped to the Smithsonian Institution.

Als das Magazin »LIFE« das Foto der Kuppelkonstruktion des Hauses Judge vor dem Hintergrund des nächtlich beleuchteten Los Angeles auf einer Doppelseite zeigte, präsentierte sie das Haus als Ikone einer Technik-geprägten Zukunft.

Ende der 50er-Jahre hatte Buckminster Fuller an der University of California – an der Judge damals studierte – einen Vortrag gehalten. Der junge Architekt war fasziniert von dessen geodätischen Kuppeln; da er bald heiraten wollte, bat er Fuller, ein solches Haus für ihn und seine Frau zu bauen. Fuller verwies ihn an einen seiner Schüler, der in Los Angeles lebte und Judge das Aluminiumskelett einer in Kanada gefertigten geodätischen Kuppel mit einem Durchmesser von knapp 14 m überließ. Mit Hilfe von Henrik de Kanter, einem holländischen Flugzeugdesigner bei Douglas Aircraft, der das Grundstück zur Verfügung stellte, und einigen Studienkollegen konnte Judge schließlich das von ihm so genannte »Triponent House« realisieren, ein äußerst anpassungsfähiges Musterhaus. Judge unterschied zwischen der »Haut« (oder Hülle) und den übrigen Strukturen des Hauses. Die »Haut« schützt das Innere vor Wind und Wetter und lässt sich unter Berücksichtigung der örtlichen Klimabedingungen auf der Baustelle errichten. Die Teile des Innenausbaus können praktisch auf der ganzen Welt massenproduziert und zur Baustelle transportiert werden.

Die Kuppel wurde am Beachwood Drive in den Hollywood Hills errichtet und überdachte einen Garten und zwei Geschosse mit sämtlichen Wohn- und Schlafbereichen. Sie wurde mittels »vierfüßigen« Stahlklammern in elf Betongründungspfeilern verankert, die auch die sechseckigen Holzgeschossdecken trugen. Eingangsbereich, Küche, Essplatz und Schlafzimmer befanden sich auf der unteren Etage, Wohnraum und zwei Arbeitszimmer auf der oberen Ebene. Beide waren durch einen vorgefertigten Haustechnikkern und eine offene Wendeltreppe verbunden.

Die Temperaturregulierung war ein Hauptanliegen des Entwurfs. Der Hang schützte die Kuppel vor der Spätnachmittags- und Abendsonne. Ein festes Sonnensegel – außen silbern reflektierend beschichtet – beschattet eine Öffnung (Durchmesser ca. 3,60 m) um den Kuppelscheitelpunkt. Das Segel wurde von Drähten getragen, die ihrerseits unter Zugspannung an kurzen Stäben auf den Aluminiumrippen befestigt waren. Die Aluminiumrahmen waren auf der Innenseite mit Holzleisten versehen, auf die 5 mm dicke Sonnenschutzfolien geheftet wurden. Um die Baugenehmigung zu bekommen, musste Judge die Tragfähigkeit des Kuppelskeletts mit empirischen Versuchen beweisen. Der Architekt bewohnte das Haus etwa zwölf Monate lang. Einige Jahre später wurde es abgebaut und zur Smithsonian Institution verbracht.

Publiée par «LIFE» en double-page, la photographie de ce dôme squelettique devant le panorama nocturne illuminé de Los Angeles, fut présentée comme l'icône même d'un futur technologique prometteur.

A la fin des années 1950, Buckminster Fuller avait donné une conférence à l'Université de Californie du Sud, où étudiait Bernard Judge. Fasciné par les dômes géodésiques, le jeune architecte, qui allait se marier, contacta Fuller afin d'utiliser ce principe de construction pour sa propre maison. Fuller l'orienta sur un de ses étudiants qui vivait à Los Angeles, et qui offrit à Judge la structure d'aluminium d'un dôme géodésique de 14 m de diamètre fabriqué au Canada. Avec l'aide d'Henrik de Kanter, designer néerlandais qui travaillait pour Douglas Aircraft et fournit le terrain, et de quelque amis étudiants, l'architecte put se lancer dans la construction de sa maison. Judge baptisa son projet la «Triponent House», prototype résidentiel à grande adaptabilité au site. Il fit une distinction entre la peau (l'enveloppe) et le reste de la maison. La première, dont la fonction est de protéger l'intérieur des éléments extérieurs pouvait être fabriquée localement pour s'adapter aux conditions climatiques. La seconde devait être fabriquée en série pour le monde entier et expédiée sur le lieu de montage.

Le dôme se dressait sur un terrain de Beachwwod Drive dans les collines d'Hollywood. Il abritait un jardin et deux niveaux contenant toutes les fonctions. Ancrés aux fondations composées de onze piles de béton, des «quadrupeds» d'acier soutenaient des plates-formes en bois de forme hexagonale. L'entrée, la cuisine, la salle à manger et la chambre principale se trouvaient en bas, le séjour et deux ateliers occupaient l'étage. Les deux niveaux étaient réunis par un noyau technique préfabriqué et reliés par un escalier en spirale.

Le contrôle de la température était essentiel. Si la colline protégeait du soleil couchant, un écran fixe revêtu d'un matériau argenté renvoyait les rayons solaires, et abritait une ouverture de 3,60 m de diamètre au sommet du dôme. Un réseau de câbles radiants à partir de colonnettes fixées sur les nervures d'aluminium supportait les contraintes de traction. La partie intérieure de l'ossature d'aluminium était habillée de plinthes en bois sur lesquelles étaient fixées un film de mylar de 5 mm d'épaisseur. Pour obtenir son permis de construire, Judge dut réaliser quelques tests empiriques pour prouver la stabilité structurelle de son ossature. L'architecte vécut un an dans cette maison. Quelque années plus tard, elle fut démontée et remise au Smithsonian Institution.

Selected Bibliography:
- LIFE, June 20, 1960
- Los Angeles Times Home Magazine, July 1, 1962
- Herbert Weisskamp, Beautiful Homes and Gardens in California, New York 1964

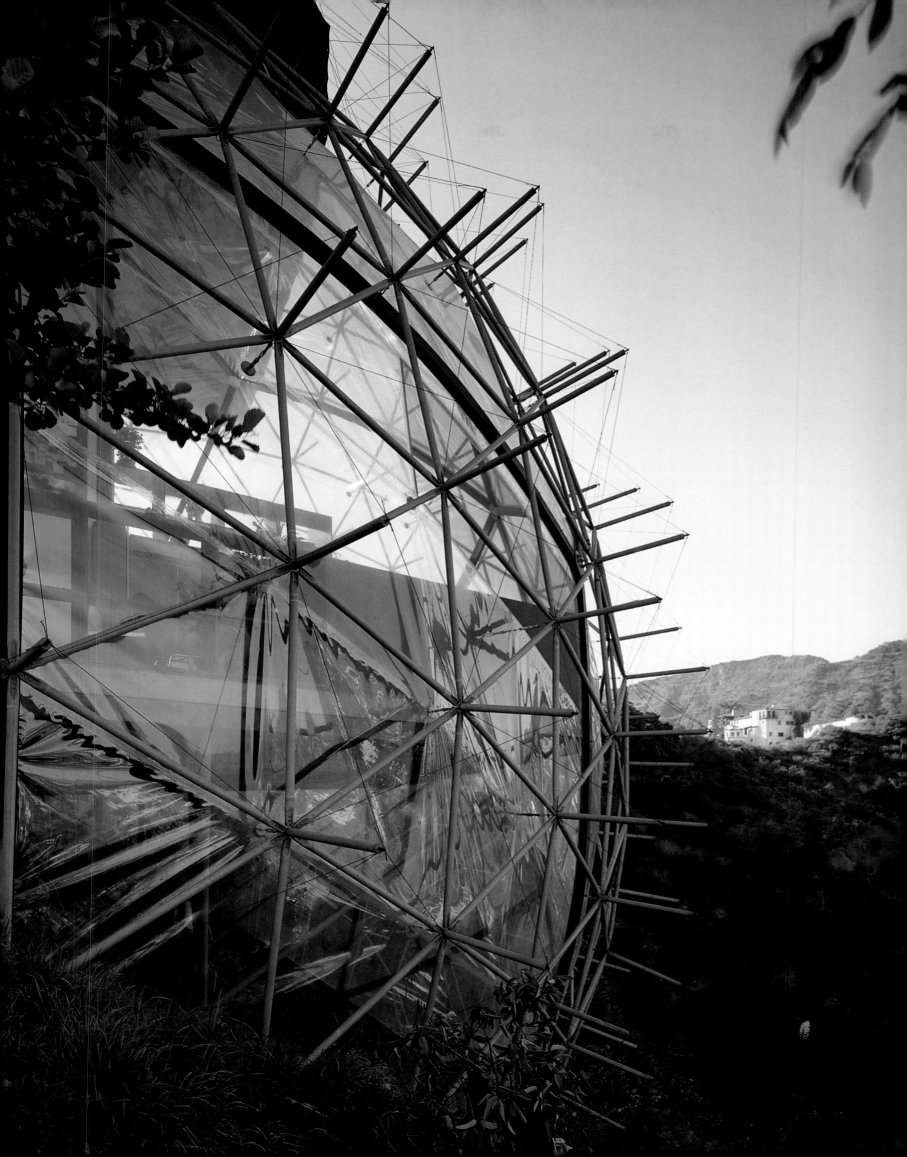

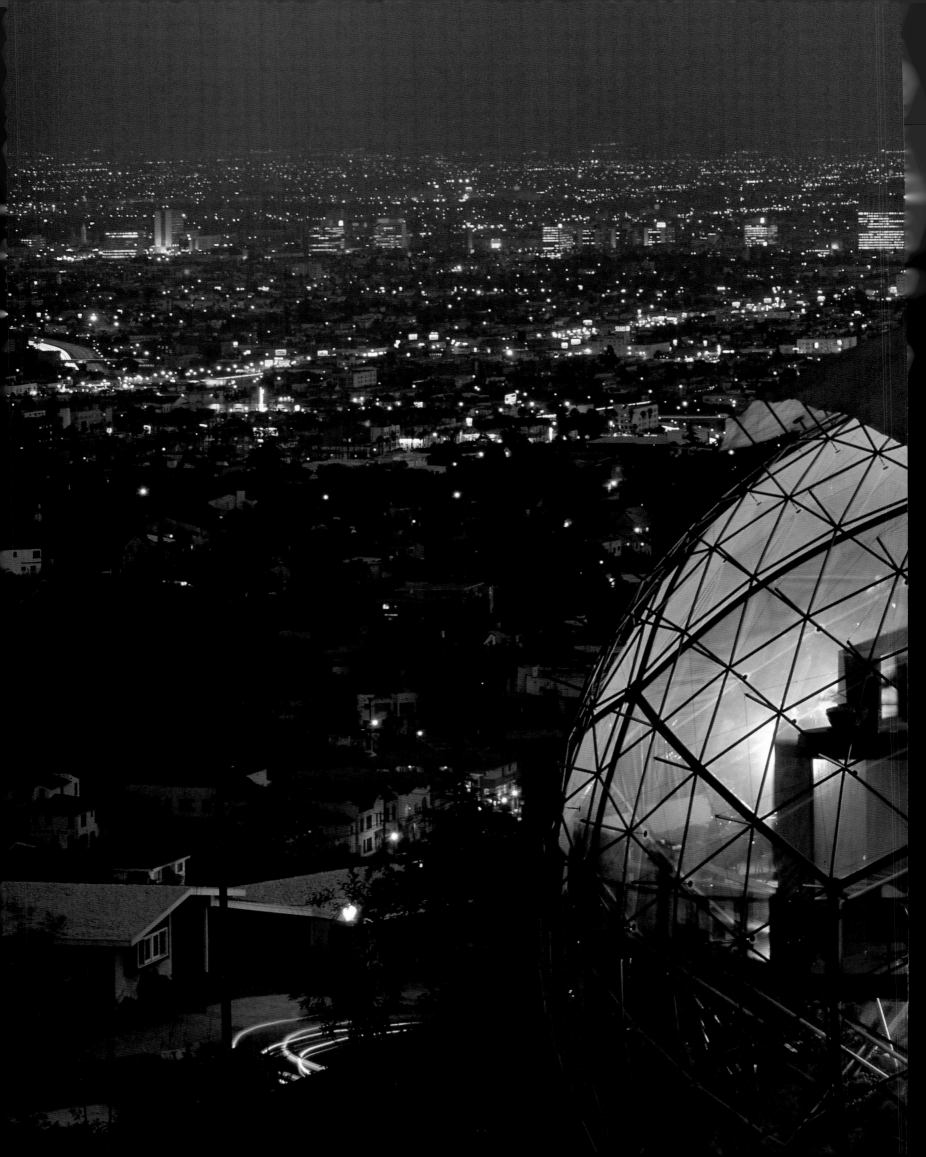

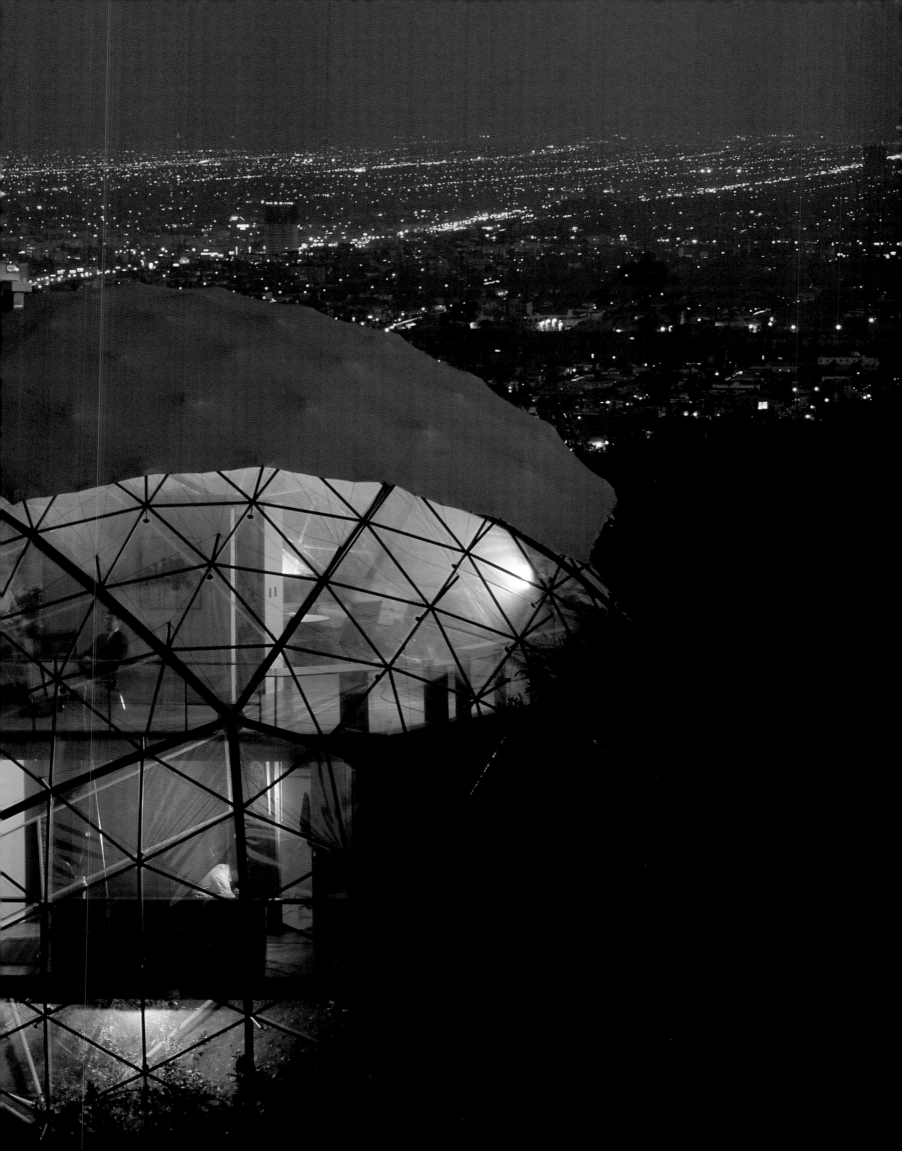

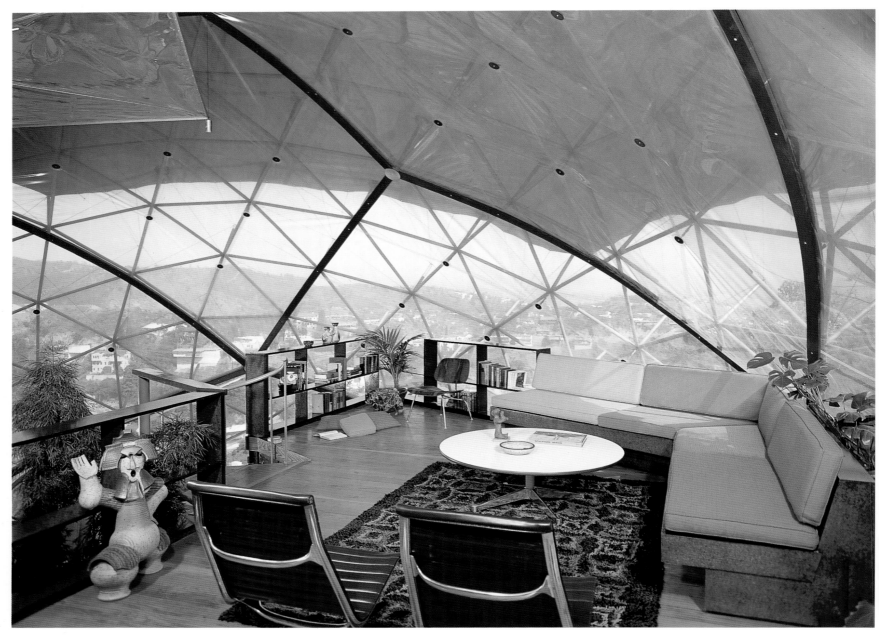

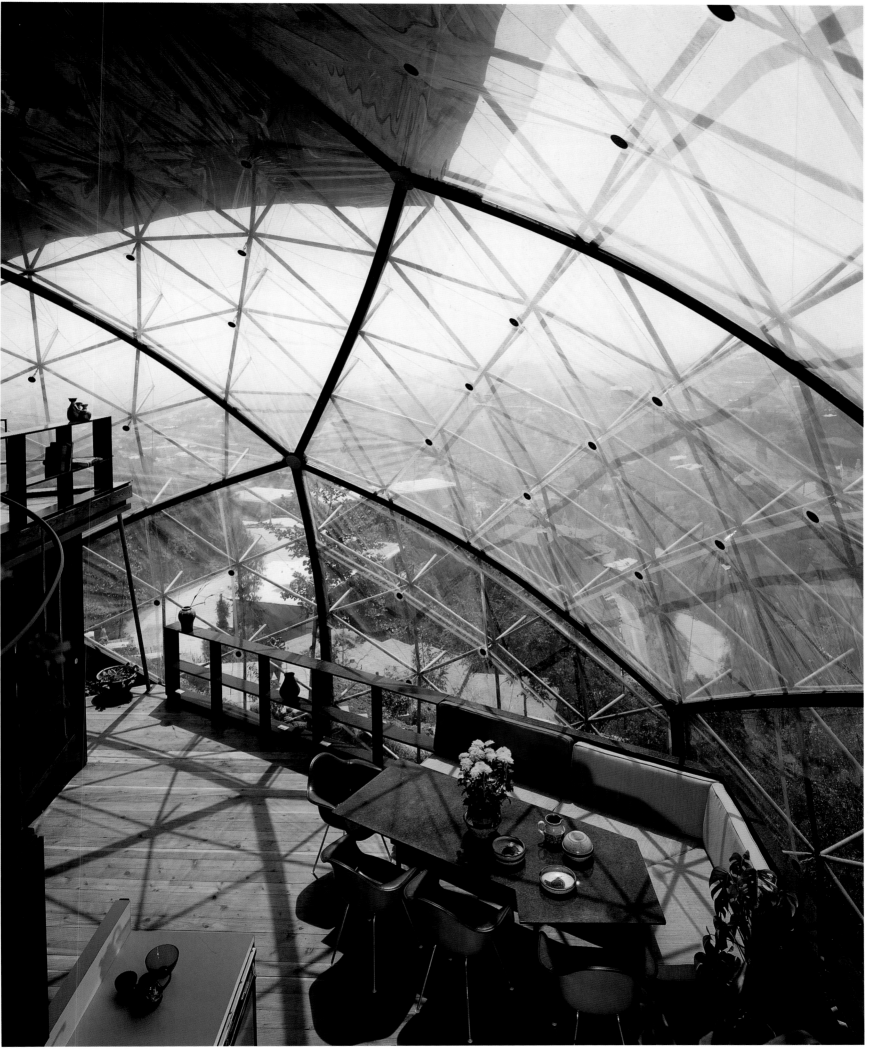

3445 Carl L. Maston
Hillside Town House, Los Angeles, California
November 4, 1962

Building residences on hillside lots is a customary design challenge in Los Angeles. The architect had one primary goal: to preserve the character of the hill. His response to the 45-degree slope of the site was to conceive the entire project as a retaining wall. Contrary to the common practice of leveling the site or building on stilts, the architect wanted to integrate the project to the site. Walls and floor slabs in reinforced concrete buttress each other to retain the earth wrapping around three sides of the structure. On a small lot (about 1/5 of an acre), Maston designed a 2,050-square-foot structure combining privacy and space within a crowded city suburb. Designed for the architect and his wife, the residence develops vertically on three levels. From the access road, it appears closed at the bottom and open at the top. A two-story-high windowless wall rises along the frontage of the property and serves as a partial base for the glass-walled top floor. The driveway at the first level filters the entry, located in the rear wall, where a stairwell leads to the sleeping quarters on the second level. A sundeck suspended above the driveway screens the two bedrooms from the street. The communal spaces are on the top level, comprising a studio, and glass-walled dining and living areas opening onto a terrace and a small pool. A continuous skylight running along the rear wall brings daylight to the back of the house. A divider, low enough to make the entire the ceiling visible, screens the studio and kitchen from the dining area. Change of levels between the dining and the living area dramatizes the space.

Materials are left exposed in their natural state to add textural quality. Concrete was poured in situ, in forms of 1 x 6-inch horizontal boards. Front and side walls are sandblasted. The planked ceiling of the top floor is of re-sawn redwood boards spaced half an inch apart. The floor and terrace is of flint acid brick laid without mortar joints over electric radiant heating coils. The American Institute of Architects Southern California Chapter bestowed an Honor Award on this residence in 1964.

Wohnhäuser auf Hanggrundstücken sind eine für Los Angeles typische architektonische Herausforderung. In diesem Falle wollte der Architekt den Charakter des 45° abfallenden Hügelgeländes erhalten, indem er den Bau als Stützmauer konzipierte. Im Gegensatz zu der üblichen Praxis, ein Hanggrundstück zu planieren oder den Bau auf Stelzen zu stellen, integrierte der Architekt das Gebäude in das Gelände.
Wand- und Bodenplatten aus Stahlbeton stützen sich gegenseitig und nehmen den Druck des Erdreichs auf. So gelang es Maston, auf dem kleinen Grundstück von 1 000 m² einen geräumigen Bau von 190 m² zu entwerfen und dennoch in einem dichtbewohnten Vorort die Privatsphäre zu erhalten. Das für den Architekten und seine Frau entworfene Wohnhaus entwickelt sich auf drei Ebenen. Von der Zufahrt aus erscheint es im unteren Teil verschlossen und öffnet sich nach oben. Die zweigeschossige fensterlose Straßenfront dient zum Teil als Sockel für das verglaste Obergeschoss. Die Zufahrt führt zum rückwärtigen Eingang, von wo aus ein Treppenhaus zu den oberen Schlafräumen führt. Ein Sonnendeck über der Zufahrt schirmt die beiden Schlafzimmer gegen die Straße ab. Das Studio und die verglasten Ess- und Wohnräume im Obergeschoss öffnen sich auf eine Terrasse und einen kleinen Pool. Ein Fensterband an der rückwärtigen Wand sorgt für Tageslicht in den hinteren Raumbereichen. Ein Raumteiler, der den Blick auf die gesamte Decke freigibt, trennt Studio und Küche vom Essbereich. Unterschiedliche Fußbodenhöhen in Ess- und Wohnzone verstärken die Raumwirkung.
Die Materialien wurden in ihrem natürlichen Zustand belassen. Der Beton wurde vor Ort gegossen, Front- und Seitenwände wurden sandgestrahlt. Die Decke über dem obersten Geschoss ist mit sägerauhen Redwoodbrettern verkleidet, die mit einem Abstand von 1 cm verlegt sind. Der Ziegelbelag im Innern und auf der Terrasse wurde ohne Mörtel über einer Fußbodenheizung verlegt. Die Southern California Sektion des AIA verlieh dem Haus Maston 1964 einen Ehrenpreis.

Construire sur une parcelle à flanc de colline est un défi courant à Los Angeles. Le premier objectif de l'architecte était ici de préserver le caractère de la colline. Confronté à une pente de 45°, il conçut la totalité de son projet comme un mur de soutènement massif. Contrairement à la pratique habituelle de surélévation sur pilotis, il souhaitait s'intégrer totalement au site. Les dalles des sols et des murs en béton armé contiennent les sols qui cernent la structure sur trois côtés.
Sur cette petite parcelle d'à peine 1000 m², Maston a réussi à édifier une maison de 190 m², à la fois spacieuse et intime, au centre d'une banlieue densément peuplée. Conçue pour lui-même et son épouse, la maison s'élève verticalement sur trois niveaux. Vue de la route d'accès, elle paraît fermée à sa base, et ouverte en sa partie supérieure. Un mur aveugle de deux niveaux de haut s'élève en bordure de la propriété et sert en partie de soubassement au niveau supérieur vitré. La courte allée d'accès au rez-de-chaussée filtre l'entrée située sur le mur arrière d'où un escalier mène aux chambre implantées au premier étage. Les espaces de séjour se trouvent au deuxième étage. Ils comprennent un bureau, un séjour-salle à manger derrière un mur de verre qui ouvre sur une terrasse, et une petite piscine. Une verrière continue court le long du mur arrière et éclaire le fond des pièces. Un cloisonnement, assez bas pour que le visiteur perçoive le plafond dans son intégralité, sépare le bureau et la cuisine du coin-repas. Le changement de niveaux entre le séjour et ce coin-repas anime l'espace.
Les matériaux sont laissés apparents, dans leur état et leur texture naturels. Le béton a été coulé sur place dans des coffrages en planches horizontales de 2,5 x 15 cm. Les murs de façade et latéraux ont été sablés. Le plafond latté de l'étage supérieur est en planches de bois rouge rescié, espacées de 1 cm. Le sol et la terrasse sont en brique à silex posée sans mortier apparent sur des serpentins de chauffage central. Le chapitre de Californie du Sud de l'AIA a décerné à la Maston Residence un prix d'honneur en 1964.

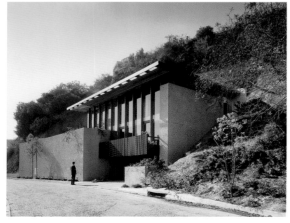
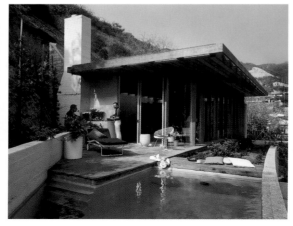
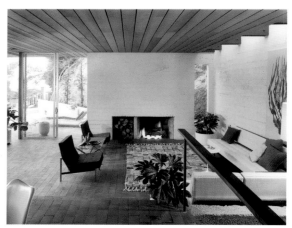

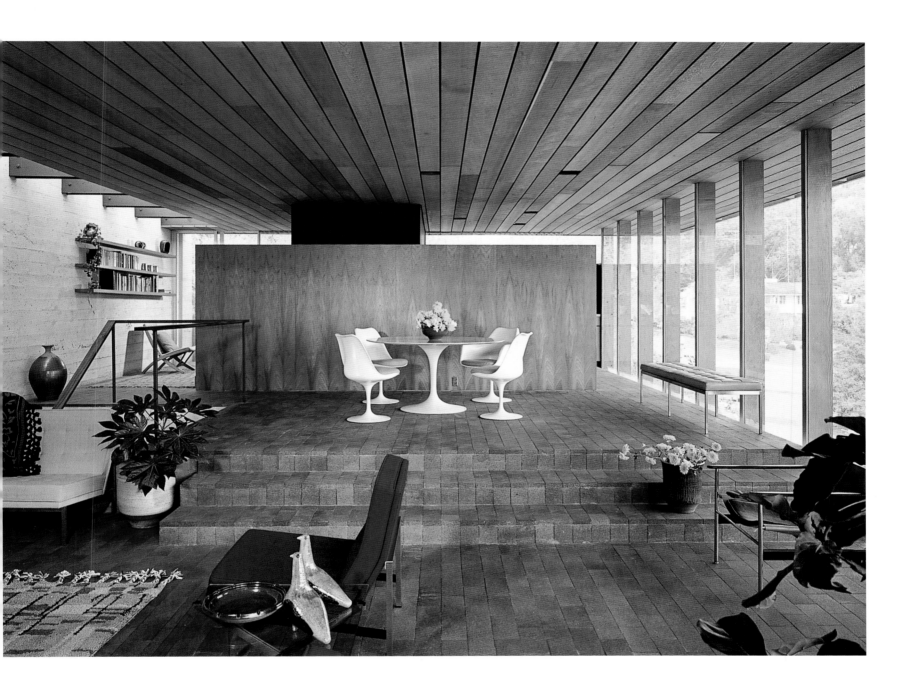

Selected - arts & architecture, July 1962 - Architecture West, April 1964 - California Living, August 30, 1964
Bibliography: - arts & architecture, February 1963 - House Beautiful's Building Manual, - Planning and Landscaping Hillside Homes,
 - Progressive Architecture, May 1963 Spring-Summer 1964 Menlo Park, California 1965

3452 Crites & McConnell
Shive Residence, Solon, Iowa
November 11, 1962

When the Shives initially hired the architects, they wanted a vacation retreat for their family of four. After the completion of the project, they decided to move permanently into their lakefront residence. The wooded property is positioned on the shore of Lake MacBride in the Coraville-MacBride area.

Two boxes connected by a glass-walled bridge are lifted on concrete piers to raise the horizon within the house toward the lake view. Windowless on the south side for privacy, the lakeside elevation facing north is entirely covered with glass. The dining room and kitchen, with independent access from the main entrance, are separate from the living area, and a study on the lower level. Upstairs four bedrooms are distributed in the two wings. From the living room, a deck juts out in front of the house, offering an unobstructed view of the lake. The three solid sides of the construction are patterned diagonally with western red cedar sheathing. Grilled wood cages enclose balconies and doors open for cross ventilation. In 1963, the National Chapter of the American Institute of Architects accorded the residence a Merit Award.

Der erste Auftrag, den die Shives erteilten, betraf den Entwurf und Bau eines Ferienhauses für die vierköpfige Familie. Als das Haus am See fertig war, beschlossen sie, ständig dort zu wohnen. Das bewaldete Anwesen liegt am Lake MacBride bei Coraville-MacBride. Zwei durch eine verglaste Brücke verbundene Kästen auf Betonpfeilern bieten Ausblick auf den See. Auf der Südseite zeigt sich das Haus geschlossen, auf der Nordseite ist es vollständig verglast. Esszimmer und Küche sind von der Eingangsdiele aus zugänglich, Wohnraum und ein Arbeitszimmer befinden sich auf einer unteren Ebene. Im Obergeschoss der beiden »Kästen« sind die Schlafzimmer untergebracht. Vom Wohnraum stößt ein Terrassendeck in den Garten vor und bietet einen freien Blick auf den See. Das Haus ist auf drei Seiten mit schräg angeordneten Brettern verkleidet. Die Balkone haben Holzgitterbrüstungen, und das Haus lässt sich durch Fenstertüren durchlüften. 1963 erhielt es eine Auszeichnung vom American Institute of Architects.

Au départ, les Shive souhaitaient faire construire une maison de vacances pour leur famille de quatre personnes. Une fois le projet réalisé, ils décidèrent de s'y installer de façon permanente. Le terrain boisé se trouve en bordure du Lac Macbride dans la région de Coraville-MacBride. Deux boîtes reliées par une passerelle à parois de verre sont montées sur des piles de béton, ce qui permet une meilleure vue sur le lac. Si la façade au sud est aveugle, pour mieux protéger l'intimité familiale, celle donnant au nord sur le lac est entièrement vitrée. La salle à manger et la cuisine, à accès indépendant de l'entrée principale, sont séparées de la salle de séjour et du bureau au rez-de-chaussée. A l'étage, quatre chambres occupent les deux ailes. Du séjour, une terrasse avance pour offrir une vue dégagée sur le lac. La construction aveugle sur trois côtés est recouverte d'un bardage en cèdre rouge posé en diagonale. Les balcons sont fermés par un treillis de bois et les portes ouvertes permettent une ventilation croisée. En 1963, le chapitre national de l'American Institute of Architects a décerné à cette maison un prix spécial.

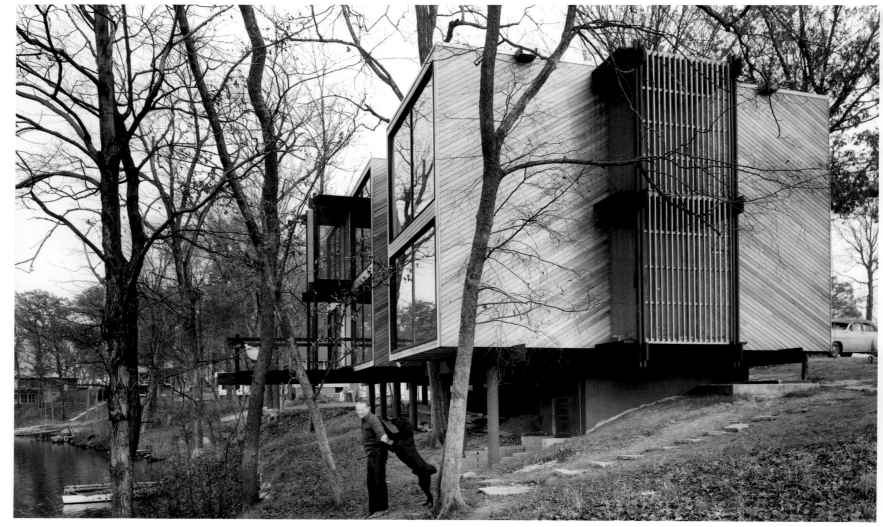

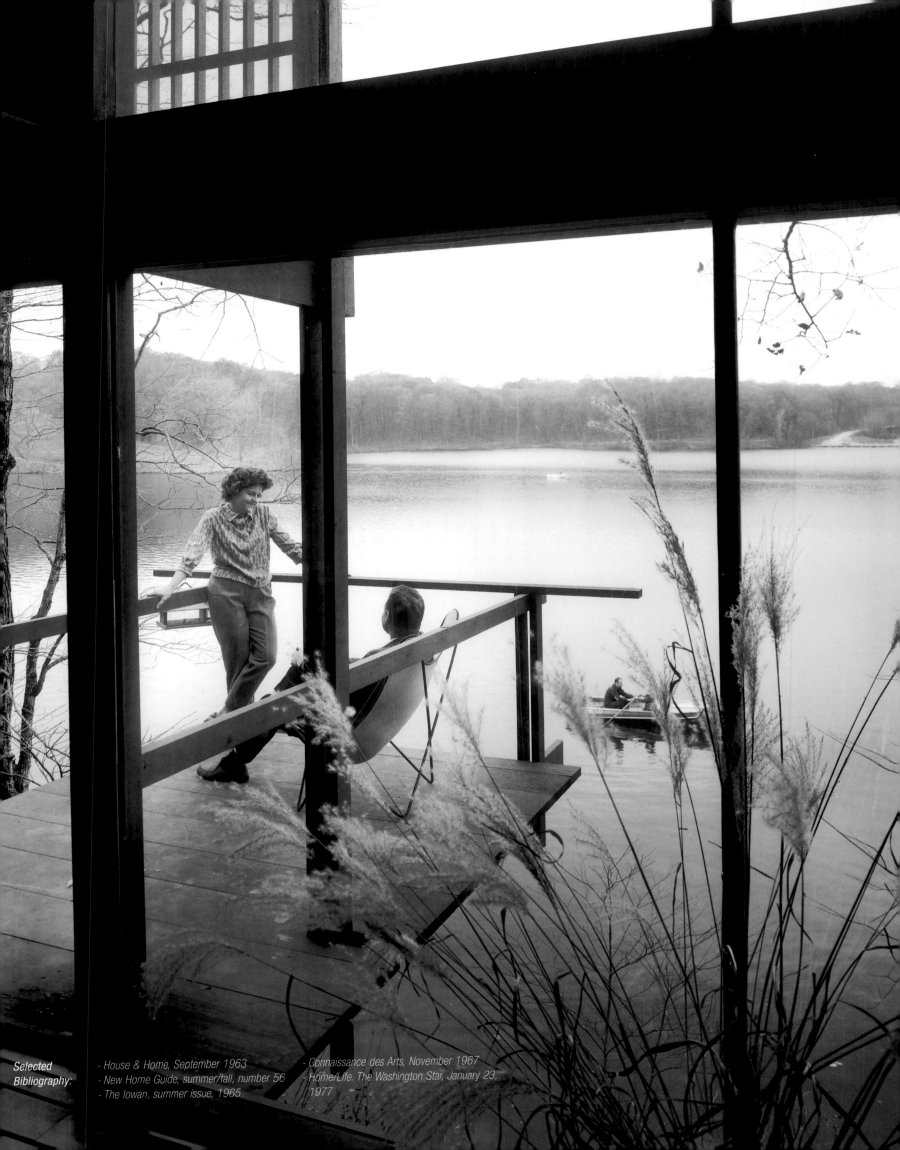

Selected
Bibliography:
- House & Home, September 1963
- New Home Guide, summer/fall, number 56
- The Iowan, summer issue, 1965
- Connaissance des Arts, November 1967
- Home/Life. The Washington Star, January 23, 1977

3467 Frederick Liebhardt and Eugene Weston III
duPont Residence, Del Mar, California
December 11, 1962

When the duPonts commissioned this project to the archi-
tects, they specified various features to meet their needs and
those of their four children. Since the owners had a rather
active social life, they wanted provision of space for small and
large gatherings and asked for a domestic setting where life
and play could coexist.

Among the list were: a space to exhibit their collection of
antique firearms, a darkroom, a swimming pool, a maid's
room, and ping pong and outdoor recreational zones for the
children to be supervised directly from the inside of the house.
Private and public activities unfold in split-level areas under-
neath thin, folded plate roofs. Large sections of the house are
enclosed with glass, giving the space deep transparency and an
uninterrupted view of the underside of the folded plates. Exter-
ior and interior walls in wood siding secure the sleeping quar-
ters privacy.

Als Charles duPont und seine Frau die Architekten mit dem Bau
ihres Hauses beauftragten, übergaben sie ihnen eine lange Liste
ihrer Anforderungen und der Bedürfnisse ihrer vier Kinder. Da
sie aktiv am gesellschaftlichen Leben von Del Mar teilnahmen,
brauchten sie Räume für größere und kleinere Gruppen von
Gästen, und außerdem einen Ausstellungsraum für ihre Samm-
lung historischer Feuerwaffen, eine Dunkelkammer, ein
Schwimmbecken, ein Zimmer für die Hausangestellte und im
Garten Ping-Pong-Tische und Freizeitflächen für die Kinder, die
vom Haus aus zu sehen sein sollten. Die Familien- und Gesell-
schaftsräume sind auf verschiedenen Ebenen in logischer Abfol-
ge angeordnet, die Faltdächer sind mit dünnem Blech gedeckt.
Geräumige Bereiche sind auf allen Seiten vollständig verglast
und verleihen dem Innenraum eine bis in die Tiefe reichende
Transparenz da, wo er von dem Faltdach durchgehend über-
wölbt wird. Die Schlafzimmerwände sind dagegen außen wie
innen mit Holz verkleidet.

Quand les duPont commandèrent ce projet aux architectes, ils
établirent la liste des nombreux équipements dont leurs enfants
et eux avaient besoin. Menant une vie sociale active, ils souhai-
taient un espace suffisant pour des réceptions grandes ou pe-
tites et un cadre qui facilite la coexistence entre la vie familiale
et les jeux des enfants.

Sur cette liste figuraient également une collection d'armes à
feu anciennes, une chambre noire, une piscine, une chambre
de service, un espace de jeu et de ping-pong pour les enfants
qui devaient pouvoir être directement surveillés de la maison.
Les activités privées ou de réception trouvent leur place dans
un plan qui s'articule autour de niveaux différents sous de
minces toits aux structures prismatiques. De vastes sections de
la maison sont vitrées, ce qui crée un effet de profondeur et de
transparence dans les espaces couverts par les plis du toit. Les
murs intérieurs et extérieurs habillés d'un lattis de bois assurent
l'intimité de la partie dévolue aux chambres.

Selected
Bibliography: - *Architecture/West, April 1964*

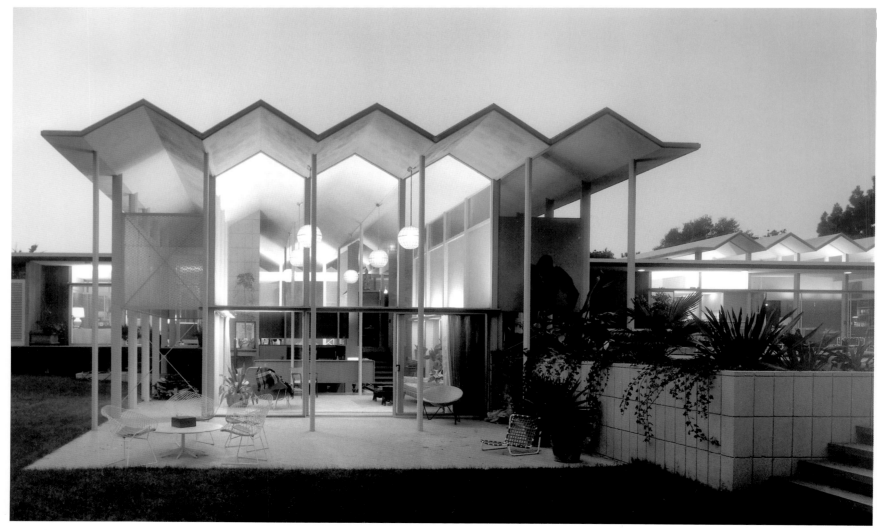

3491 Buff, Straub and Hensman
Roth Residence, Beverly Hills, California
February 11, 1963

Although the two-story residence is only 1,596 square feet in size, the exposed framework and the use of double height in the entry and in the two main-floor areas give the architecture a grand scale. In section, the structure is anchored on one end to a ledge, while the opposite end reaches a pad on a lower level. From the carport on the upper level, the owners can either walk through an indoor bridge leading to the bedroom suite which opens on both sides to double-height spaces or step down to the main entry on the bottom floor. Past the foyer, the living room features a steel fireplace suspended on long chains from the roof beams. The lumber posts of the framework are made of two 3 x 4-inch studs with 2 x 6-inch beams in-between. In 1964, the project received an Award of Merit from the National Chapter of the American Institute of Architects.

Obwohl dieses zweigeschossige Einfamilienhaus insgesamt nur 148 m² umfasst, wirkt es aufgrund der sichtbaren Konstruktionselemente sowie der zweigeschossigen Bereiche im Hauptgeschoss (Eingangshalle und zwei Räume) sehr großzügig. Der Querschnitt zeigt, dass das Haus mit einem Ende in einem Felsvorsprung verankert ist, während es mit dem andern auf einem tiefer liegenden Streifen Flachland steht. Vom Carport auf der oberen Ebene gelangen die Bewohner entweder über eine Innenbrücke in das nach beiden Seiten offene Schlafzimmer und von dort in die doppelgeschossigen Räume, oder sie gehen eine Außentreppe hinunter zum Haupteingang auf der unteren Etage. Hinter der Eingangsdiele betritt man gleich den Wohnraum, in dem eine Stahlfeuerstelle an langen Ketten von den Dachbalken abgehängt ist. Der Dachstuhl ruht auf zwei 5 x 10 m dicken, mit Querbalken verstrebten Holzpfosten. 1964 wurde das Haus vom American Institute of Architects mit einem Award of Merit ausgezeichnet.

Bien que cette maison sur deux niveaux ne mesure que 148 m², la mise en évidence de sa structure et l'utilisation d'un principe de double-hauteur pour l'entrée et les espaces principaux lui assurent une échelle nettement plus impressionnante. En coupe, elle est ancrée d'un côté dans une assise rocheuse, tandis que son autre extrémité repose sur un appui en contrebas. De l'abri à voitures du niveau supérieur, les occupants peuvent soit entrer dans l'aile de la suite principale ouverte des deux côtés sur les espaces communs double-hauteur par une passerelle intérieure, ou descendre vers l'entrée principale. L'entrée franchie, la salle de séjour met en scène une cheminée d'acier suspendue par de longues chaînes aux poutres de la charpente. Les piliers de bois de l'ossature se composent de deux poteaux de 5 x 10 cm enserrant une poutre de 5 x 15 cm.
En 1964, ce projet a reçu un prix spécial du chapitre national de l'American Institute of Architects.

Selected Bibliography:
- *House & Home, October 1964*
- *House & Home, November 1966*

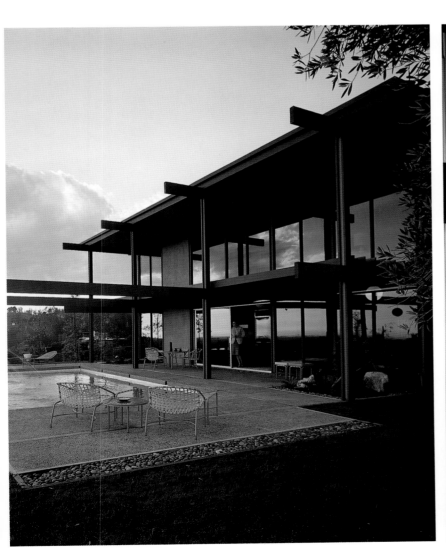

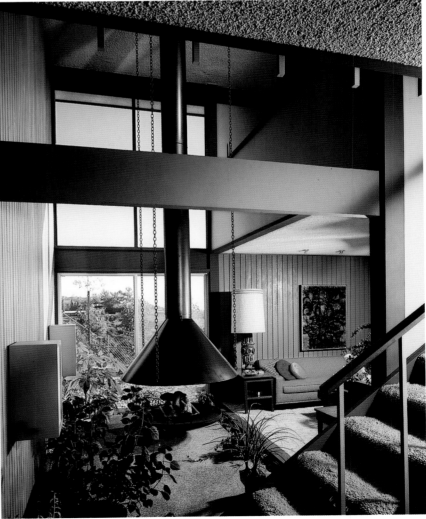

3478 **Young & Remington**
Harbor Savings and Loan Association, San Pedro, California
January 8, 1963

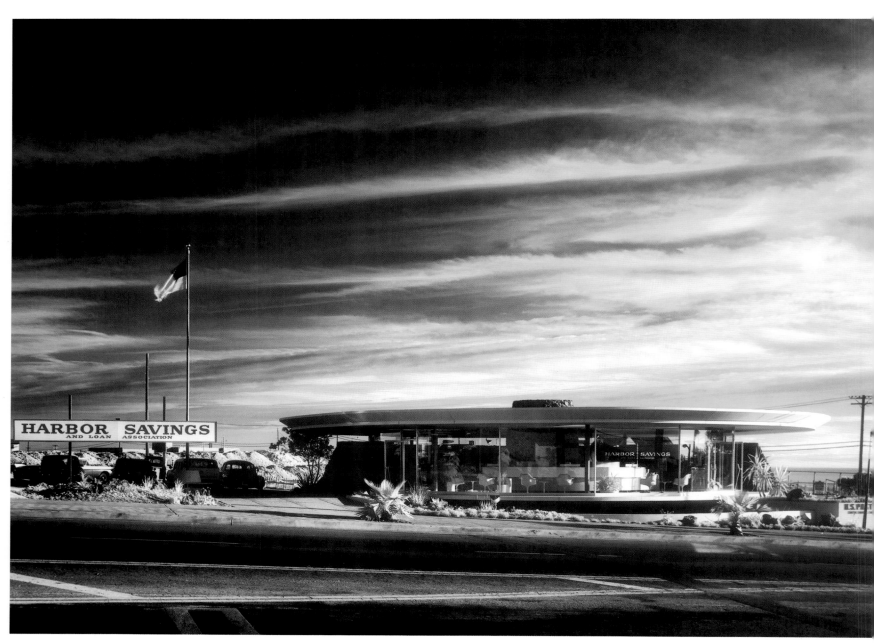

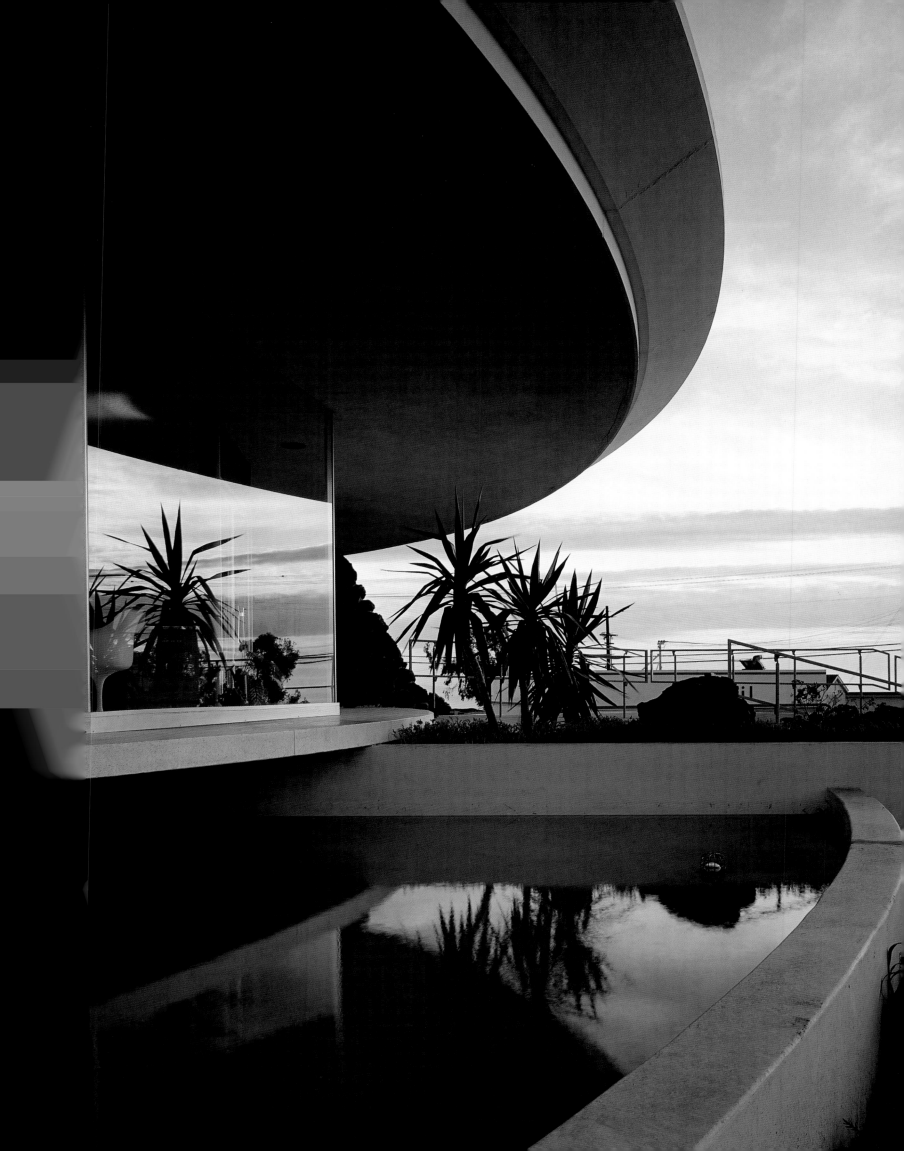

3480 Hester and Jones
Jones Residence, Del Mar, California
January 11, 1963

Selected
Bibliography:
- Architecture/West, September 1962
- Architectural Record Houses of 1963
- House & Home, September 1963
- arts & architecture, October 1963

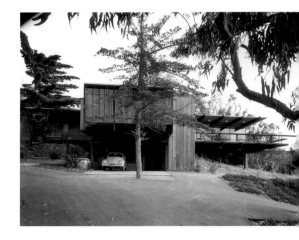

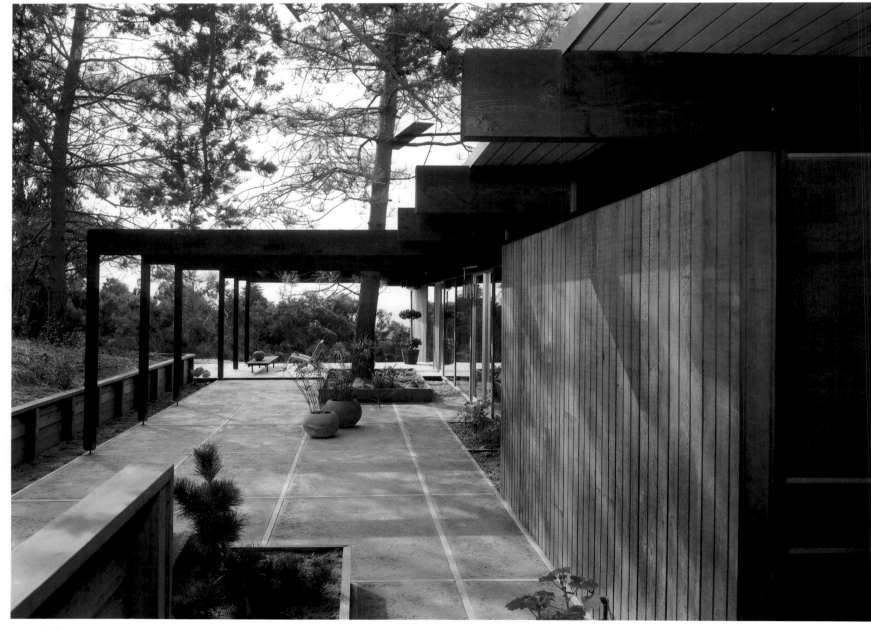

From the driveway, the house appears very large in scale, though it is only 1,600 square feet in size. The architect weaves the plan into an existing grove of trees and gives an outdoor extension to each room. Resting partially on the carport and the utility room, the residence is developed on one level. The common areas blend into one big room with decks and terraces on three sides leaving options for future expansion. Orientation and planting ensure the privacy of the bedroom wings.

In 1962, the San Diego Chapter of the American Institute of Architects gave the house an Award of Excellence, and in 1963, the project received national recognition with an Honorable Mention from the American Institute of Architects.

Von der Zufahrt aus gesehen wirkt das Haus sehr groß, umfasst insgesamt aber nur knapp 150 m². Der Architekt entwickelte den Grundriss zwischen den auf dem Grundstück vorhandenen Bäumen und fügte jedem Innenraum eine Außenterrasse an. Die von der ganzen Familie genutzten Räumlichkeiten befinden sich alle auf einer Ebene, ruhen teilweise auf dem Carport und Wirtschaftsraum und münden alle in einem großen Raum mit Balkonen und Terrassen auf drei Seiten, der spätere Erweiterungen zulässt. Die Schlafzimmer sind so ausgerichtet und von Vegetation umgeben, dass sie vor Einblicken geschützt sind.

1962 erhielt das Haus einen Award of Excellence von der Sektion San Diego des American Institute of Architects, und 1963 eine Belobigung vom zentralen American Institute of Architects.

Vue de son allée d'accès, cette maison semble vaste bien qu'elle ne couvre que 150 m². L'architecte a littéralement tissé son plan à l'intérieur d'un bosquet d'arbres et accolé à chaque pièce une extension vers l'extérieur. Reposant en partie sur l'abri à voitures et une pièce de service, la maison s'étend sur un seul niveau. Les parties communes sont réunies en une grande pièce qui se prolonge par des terrasses sur trois côtés, ce qui permet également d'envisager une extension future. L'orientation et des plantations de végétaux protègent l'intimité de la partie réservée aux chambres. En 1962, le chapitre de San Diego de l'American Institute of Architects a attribué à cette réalisation son Prix d'Excellence, et en 1963, l'American Institute of Architects lui a décerné une mention honorable.

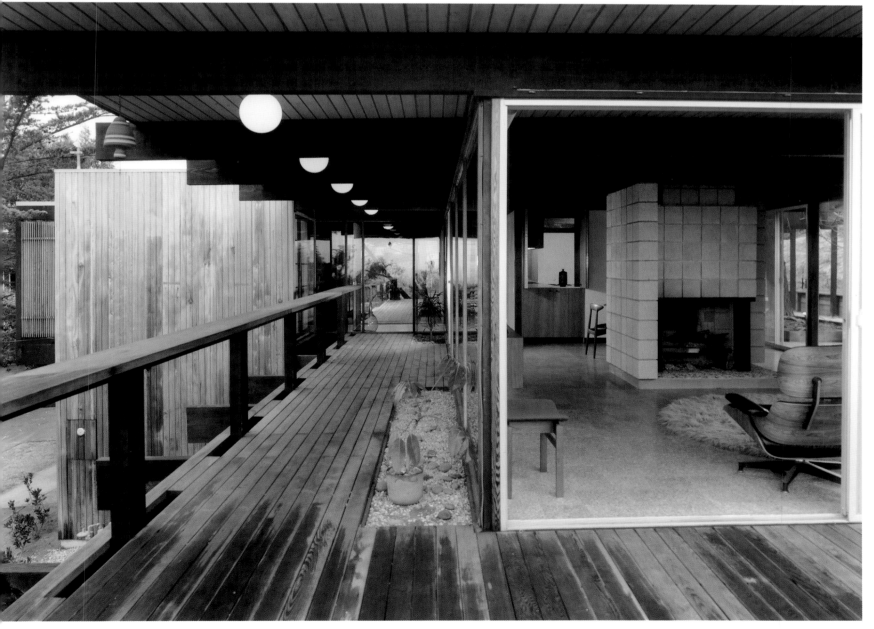

3496 William F. Cody
Cannon Residence, El Dorado Country Club, Palm Springs, California
February 20, 1963

The Cannon Residence is part of the Eldorado Country Club, comprising residential units scattered around the golf courses. Mr. and Mrs. Robert Cannon, a couple living in Los Angeles, used to go to Palm Springs for weekends and summer vacations. Cody angles the orientation of the house in relation to the geometry of the lot, marking the diagonal on the ground with a long entry hall paved neatly with Spanish quarry tiles, which ends on the south-west side at a pool. Here, a 12-foot deep steel porch screens the living room windows, which offer an 180-degree view of the golf courses. In 1963, the Southern California Chapter of the American Institute of Architects bestowed Cody an award for the Cannon Residence.

Das Haus ist eines von mehreren Wohnhäusern auf dem Gelände des Eldorado Country Club. Mr. und Mrs. Robert Cannon, ein Ehepaar aus Los Angeles, verbrachten die Wochenenden und Sommerurlaube für gewöhnlich in Palm Springs. Cody richtete das Haus der Geometrie des Grundstücks entsprechend aus und markierte die Diagonale mit einer langgestreckten Eingangshalle, die er mit spanischen Natursteinplatten auslegen ließ und an deren Südwestseite er das Schwimmbecken anschloß. Hier ist den Wohnzimmerfenstern eine rund 3,60 m tiefe Stahlveranda vorgelagert; von hier bietet sich eine Panorama-Aussicht auf den Golfplatz. 1963 erhielt Cody für dieses Haus eine Auszeichnung von der Sektion Südkalifornien des American Institute of Architects.

La Cannon Residence fait partie de l'Eldorado Country Club qui compte plusieurs maisons réparties autour d'un terrain de golf. Ses propriétaires, Mr. et Mrs. Robert Cannon, étaient un couple de Los Angeles qui passait ses week-ends et ses vacances d'été à Palm Springs. Cody a orienté la maison en fonction de la situation de la parcelle et marqué au sol l'axe diagonal, un long hall d'entrée soigneusement pavé de dalles de terre cuite qui se poursuivent jusqu'à l'extrémité sud-est de la maison et la piscine. Là, une véranda en acier de 3,60 m protège les baies de la salle de séjour, qui donnent sur le terrain de golf. En 1963, le chapitre de Californie du Sud de l'American Institute of Architects a décerné un prix à cette résidence.

Selected Bibliography:
- Los Angeles Times Home Magazine, December 1, 1963
- Los Angeles Times Home Magazine, December 8, 1963
- Home/Life. The Washington Star, January 23, 1977
- Adele Cygelman, Palm Springs Modern, New York 1999

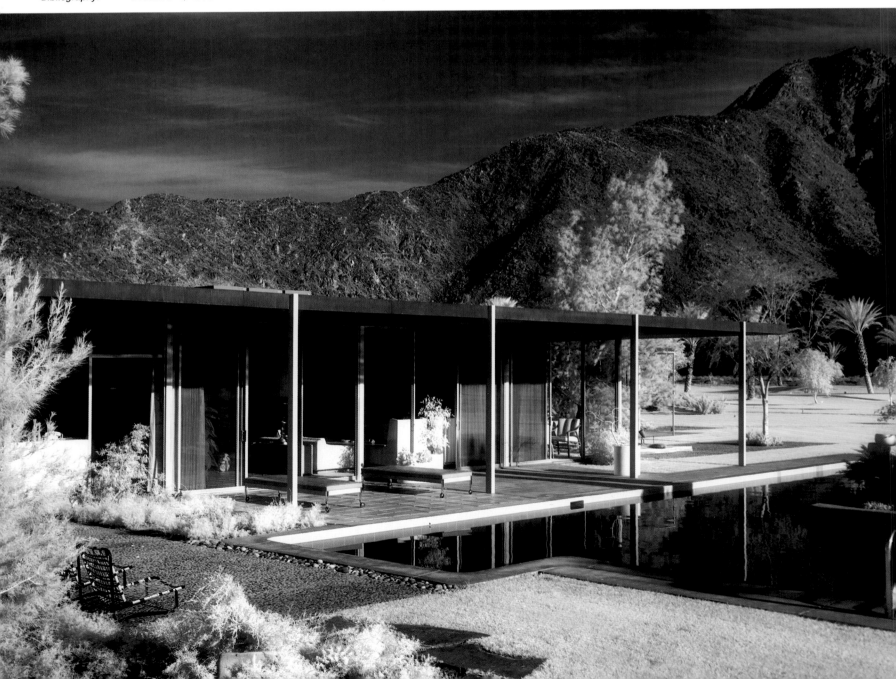

3522 Gregory Ain and James H. Garrott
Atkinson Residence, Big Sur, California
April 16, 17, 1950

Standing isolated on a cliff overlooking the Pacific Ocean, the house opens the common areas to the panorama of the coastline. The overwhelming ocean vista is framed by a partial glass wall on the more enclosed side of the residence to provide a sense of shelter.

Allein, auf einem Steilhang über dem Pazifik, öffnet sich das Haus mit einer voll verglasten Fassade in den Wohnräumen zur phantastischen Aussicht über Küsten- und Meereslandschaft,. Die vom Meer abgewandte Fassade ist dagegen geschlossener und sorgt für das Gefühl des Geschütztseins.

Isolée sur une falaise au-dessus de l'océan Pacifique, la maison s'ouvre de toutes ses parties communes vers la côte. Ce panorama omniprésent est cadré par un mur partiellement vitré sur le côté tandis que la face antérieure est plus fermée, pour assurer une sensation de protection.

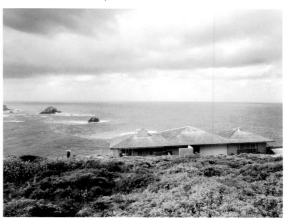

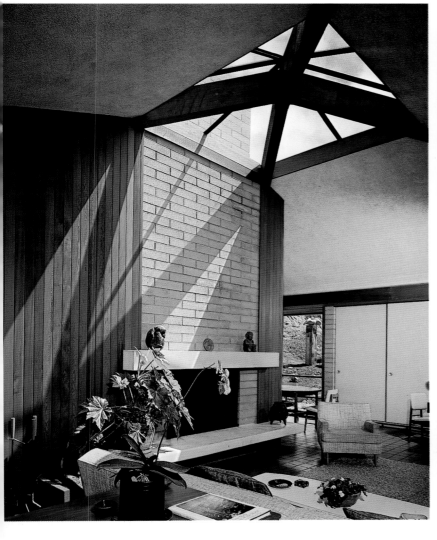

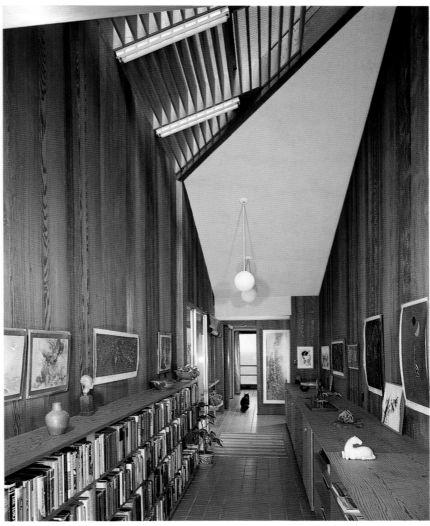

Selected Bibliography: - Los Angeles Times Home Magazine, April 26, 1964

3528 **Bailey, Bozalis, Dickinson and Roloff**
State Capitol Bank, Oklahoma City, Oklahoma
May 9, 1963

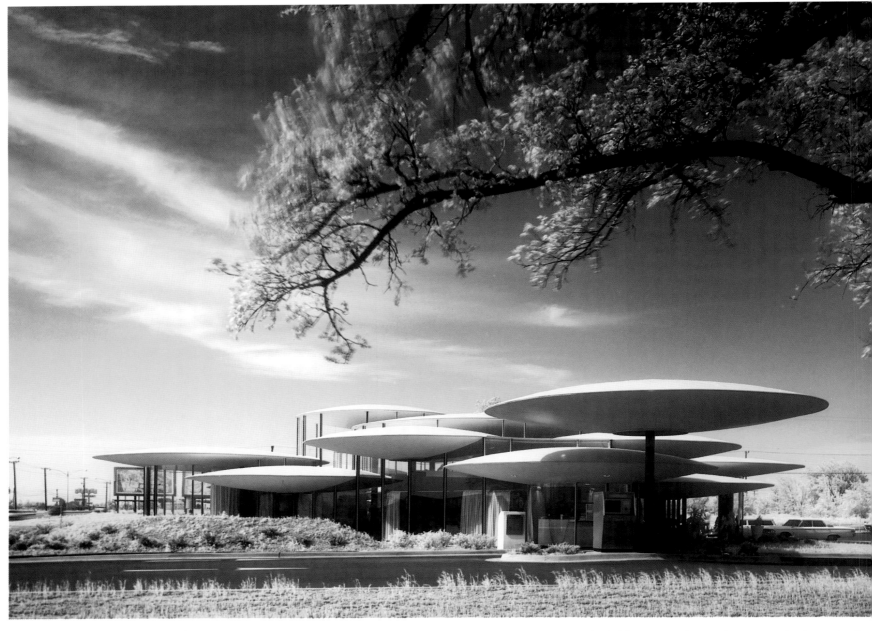

The local community labeled this structure the "flying saucer bank". Its unconventional look caught the attention of national newspapers as well as popular magazines, and increased business for the financial institution. Seventeen hollow saucers positioned at different levels float on transparent surfaces of glass and plexiglass. Individual steel columns support the white circular disks made of pre-cast concrete reinforced by steel ribs. Ranging from 39 to 27 feet in diameter, the round canopies shade 12,000 square feet of banking area, and 14,000 square feet of rental office.
Directly from their cars, customers could communicate with tellers via closed-circuit TV, conducting business transactions through a pneumatic tube system.

Im Volksmund heißt das Gebäude mittlerweile »Fliegende-Untertassen-Bank«. Sein ungewöhnliches Erscheinungsbild erregte die Aufmerksamkeit der überregionalen Tageszeitungen und Publikumszeitschriften und verschaffte der Bank dadurch sogar höhere Umsätze. Siebzehn »Schalen« schweben – gegeneinander höhenversetzt – auf transparenten Wänden aus Glas oder Plexiglas. Einzelne Stahlsäulen tragen die weißen, runden Scheiben aus Betonfertigteilen, die mit Stahlrippen ausgesteift sind. Im Durchmesser zwischen 12 und 8 m breit, überdachten und beschatten sie rund 1100 m² Bankflächen und 1300 m² Büroflächen für andere Firmen. Kunden können mit dem Auto vorfahren und über Schalter mit Videoausstattung direkt mit den Kassierern verhandeln. Unterlagen und Geld werden über ein Rohrpostnetz hin- und hergeschickt.

Les habitants des environs avaient surnommé cette construction « la banque des soucoupes volantes ». Son aspect peu commun attira l'attention des journaux nationaux et des magazines grand public, et contribua au développement de cet établissement bancaire. 17 « soucoupes » creuses, placées à différents niveaux, flottent au-dessus de plans transparents en verre et en Plexiglas. Des colonnes d'acier soutiennent ces disques en béton armé renforcé par des nervures d'acier. De 8 à 12 m de diamètre, ces dais circulaires abritent 1100 m² d'installations bancaires et 1 300 m² de bureaux à louer.
De leur voiture, les clients peuvent communiquer avec les guichets via un circuit de télévision, et effectuer des transactions par un système de tubes pneumatiques.

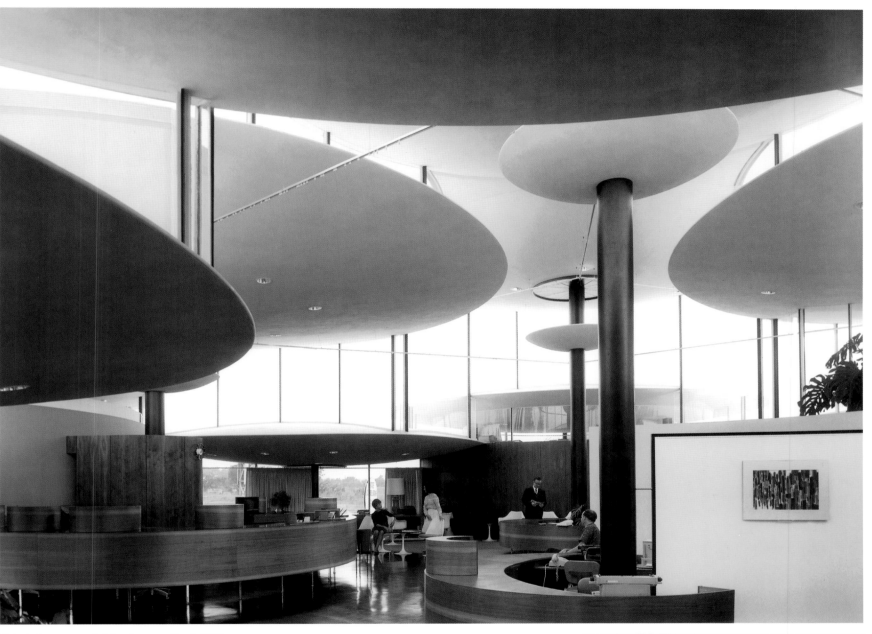

Selected Bibliography: *- Building Progress, March 1966*

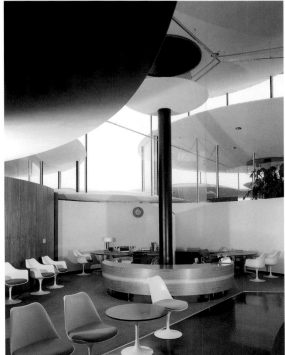

3529 **Murray, Jones and Murray**
St. Patrick Church, Oklahoma City, Oklahoma
May 9, 1963

The church is the result of a collaborative effort between the architects and the structural engineer, Felix Candela. In a busy suburban area of Oklahoma City, the designers developed a solid box-like structure made out of freestanding tilt-up concrete walls cast on both sides and separated by redwood louvers. Inside, ten concrete umbrellas on square piers are structurally independent of the exterior walls and cover a 120 x 180-foot area. Between the columns, glass panels enclose the space of a nave containing pews for 500 people. Narrow skylights between the umbrellas are the only sources of natural light. This reverberates on the concrete surfaces of the outer enclosure which features a procession of angels, cast in molds, on all four sides. Parishioners can reach the altar from the outer aisles through sliding doors.
In 1962, the North American Liturgical Conference awarded the church the Cardinal Lercaro Gold Medal. In 1963, the National

Die Kirche ist das Gemeinschaftswerk der Architekten und des Tragwerksplaners Felix Candela. Für eine belebte Vorstadtgegend von Oklahoma City entwarfen sie einen kompakten, kastenartigen Bau aus schrägen, parallel freistehenden Betonpaneelen und Redwoodlamellenfeldern. Im etwa 36 x 54 m umfassenden Kirchenraum stehen zehn einzelne Beton-»Schirme« auf quadratischen Eckpfeilern. Diese bilden die Pfosten für die Glashülle des Hauptschiffs, in dem Kirchenbänke für rund 500 Personen stehen. Schmale Oberlichter zwischen den Betonschirmen sind die einzigen Tageslichtquellen. Das natürliche Licht fällt auf die Außenwände aus Beton und den umlaufenden Relief-Fries mit Engelsfiguren. Durch Schiebetüren gelangen die Gemeindemitglieder über die Seitengänge zum Altar. 1962 erhielt der Kirchenbau die Cardinal Lercaro Goldmedaille der North American Liturgical Conference, und 1963 eine Auszeichnung von der

Cette église, édifiée dans une banlieue animée d'Oklahoma City, est le fruit d'un travail en commun des architectes et de l'ingénieur Felix Candela. Ensemble, ils ont édifié une structure aveugle en forme de boîte avec deux murs latéraux autoportants en béton coulé et relevé sur place, séparés par des lames de bois rouge. A l'intérieur, dix parapluies de béton posés sur des socles carrés et structurellement indépendants des murs permettent de couvrir une surface de 36 x 54 m. Entre les piliers, des panneaux de verre délimitent l'espace de la nef meublée de bancs pour 500 fidèles. Les étroites verrières entres les parapluies sont les seules sources d'éclairage naturel qui se réverbère sur les surfaces de béton de l'enceinte externe, ornée d'une procession d'anges moulés sur les quatre côtés. Les fidèles peuvent atteindre l'autel à partir des nefs latérales par des portes coulissantes. En 1962, la North American Liturgical Conference a décerné à cette église la médaille d'or Cardinal

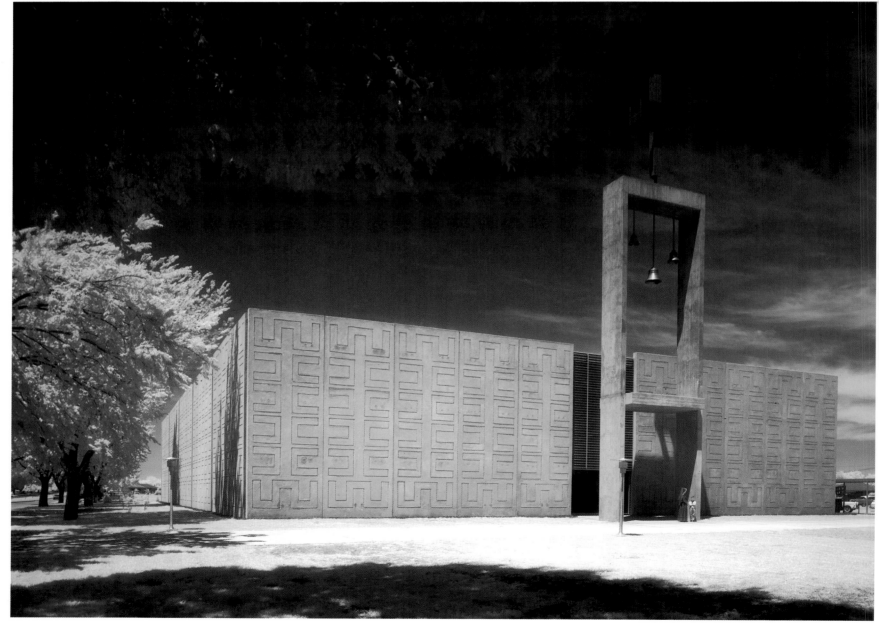

Selected
Bibliography:
- *Architectural Forum, January 1963*
- *Progressive Architecture, November 1963*

Council of Churches and the Church Architectural Guild of America bestowed an award to the project.

Church Architectural Guild (Kirchbaumeistergilde) des National Council of Churches.

Lercaro. En 1963, le National Council of Churches et la Church Architectural Guild of America ont primé ce projet.

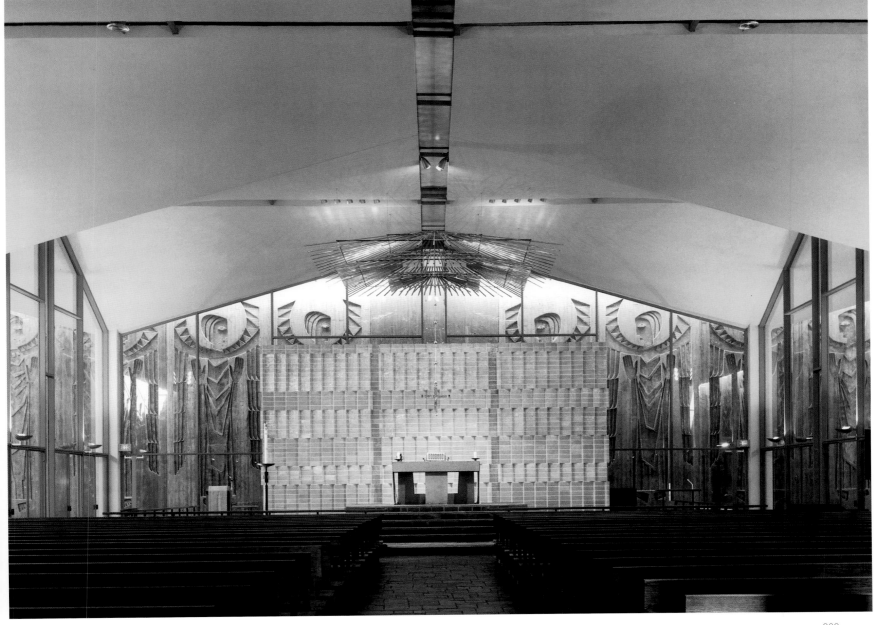

3561 **Richard H. Dodd**
Dodd Residence, Irvine Cove, Laguna Beach, California
June 4, 1963

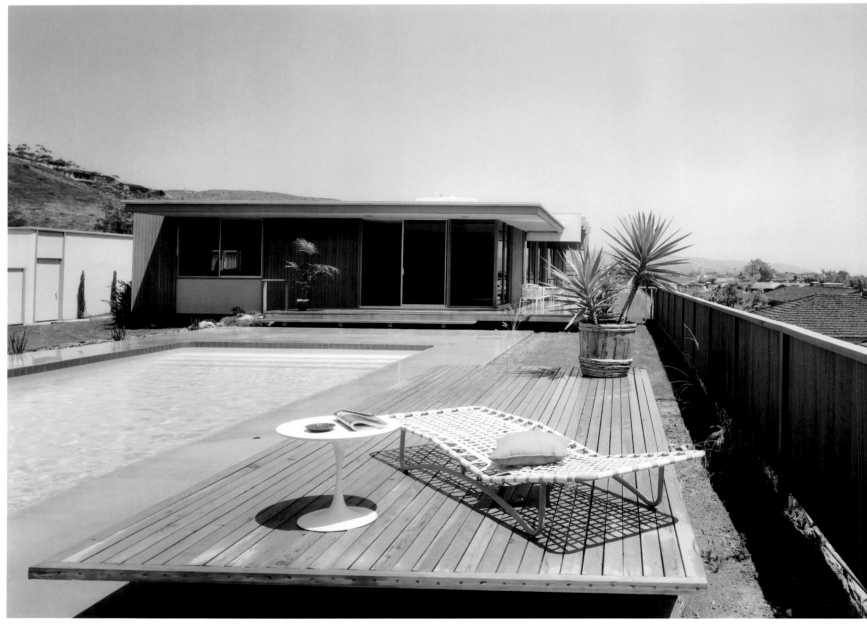

Intended as a speculative project, the residence sprawls over a wide lot in an upper class neighborhood. To shield the house from the noise of a nearby highway, the street elevation is composed of solid planes receding toward the back of the lot, following the sweeping access road. A perspective of frames virtually encloses the entry walk, which enters at right angles, making the ocean view its vanishing point. A four-foot module disciplines the geometry of the space. The floor level is lifted a

Das als Investorenprojekt entstandene Haus nimmt eine große Fläche auf einem ausgedehnten Grundstück in einer vornehmen Wohngegend ein. Die Straßenfassade besteht aus massiven Mauern. Der gekrümmten Vorfahrt folgend treten sie in die Grundstückstiefe zurück und fungieren zugleich als Schallschutzbarriere gegen den Lärm der in der Nähe verlaufenden Autobahn. Der Weg zum Haus scheint fast vollständig von Querrahmen umschlossen, die im rechten Winkel zum Hauskör-

Projet spéculatif, cette résidence se déploie sur un vaste terrain dans un quartier très bourgeois. Pour protéger la maison du bruit de la route voisine, la façade sur rue est composée de plans aveugles décalés vers le fond de la parcelle en suivant la courbe de l'allée d'accès. Une perspective composée de cadres délimite virtuellement le passage de l'entrée qui s'insère perpendiculairement dans le plan rectangulaire, faisant ainsi de la vue sur l'océan le point de fuite de l'ensemble.

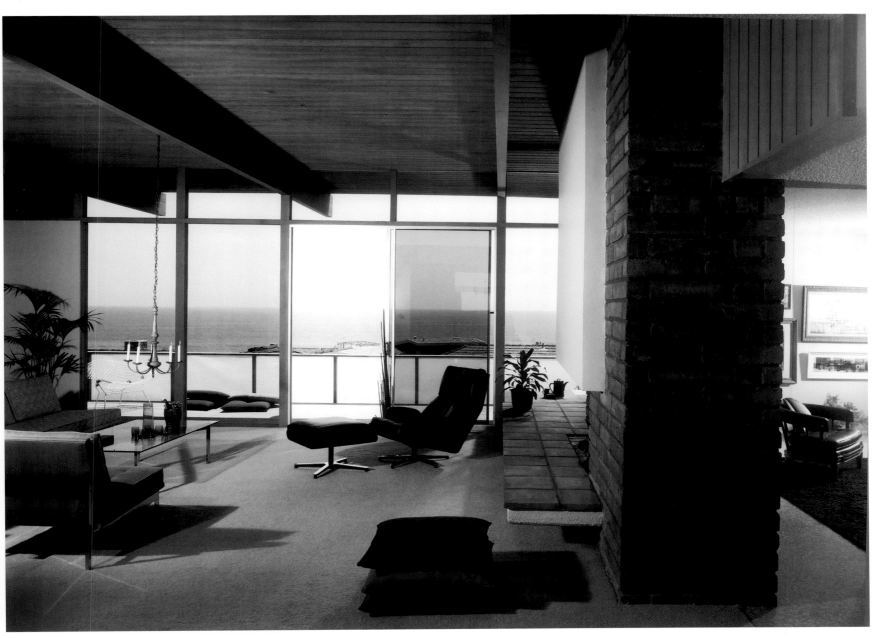

few inches off the ground to capture the surrounding land-scape, while giving the structure a pavilion-like appearance. The distribution of the domestic functions is standard: the bedroom wing in one half of the residence; the collective spaces on the other. Stucco panels, brick walls and redwood screens give material quality to the partitions in the house and garden.

per stehen – mit dem Meerblick als Fluchtpunkt. Ein 1,20 m-Raster diszipliniert die räumliche Geometrie. Das Geschossnive-au des Bungalows liegt etwas höher als der Erdboden, damit man von dort den vollen Überblick über die Landschaft hat. Die Innengliederung ist konventionell: auf der einen Seite die Schlafzimmer, auf der anderen die Wohnräume. Verputzte Wandflächen, Ziegelmauerwerk und Redwoodtäfelung bestim-men die Atmosphäre der Innenräume und des Gartens.

Une trame de 1,20 m organise l'espace. Le rez-de-chaussée est surélevé de quelques centimètres par rapport au sol pour obtenir une meilleure vue sur le paysage, tout en donnant à la construction un aspect de pavillon. La distribution des fonctions domestiques est classique : l'aile de la chambre d'un côté, les espaces collectifs de l'autre. Des panneaux de plâtre enduit, des murs de brique, et des écrans de bois rouge confèrent une qua-lité matérielle aux cloisonnements entre la maison et son jardin.

Selected
Bibliography: - arts & architecture, December 1963

3568 Robert Skinner
Bernard Residence, Los Angeles, California
June 18, 1963

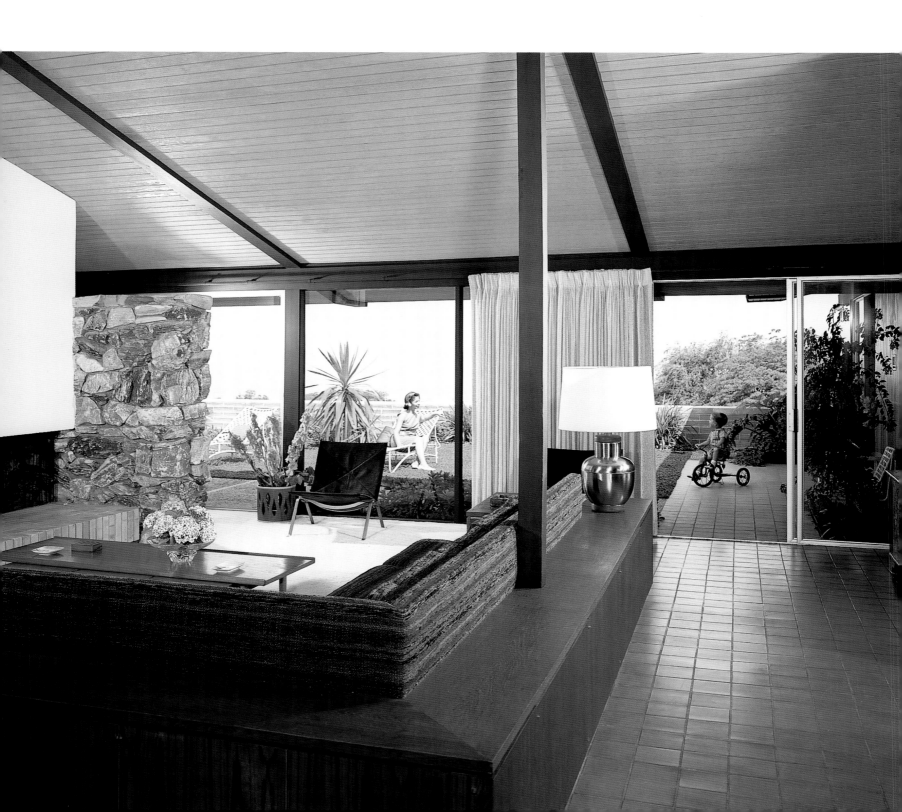

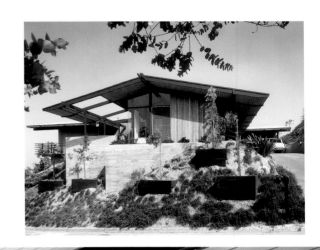

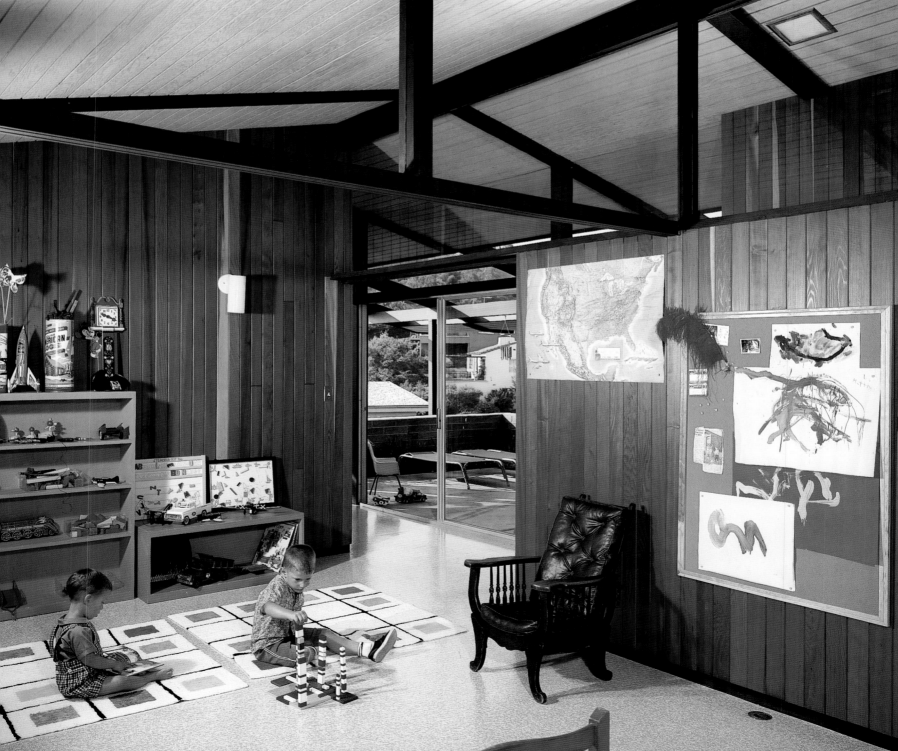

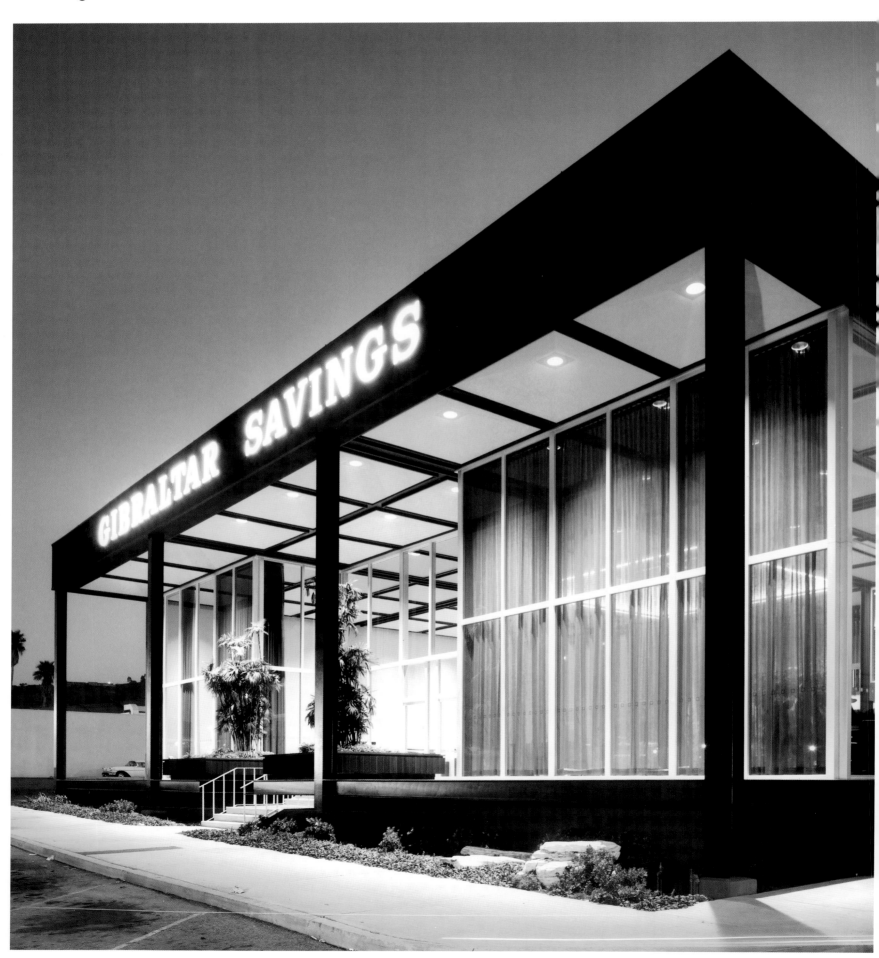

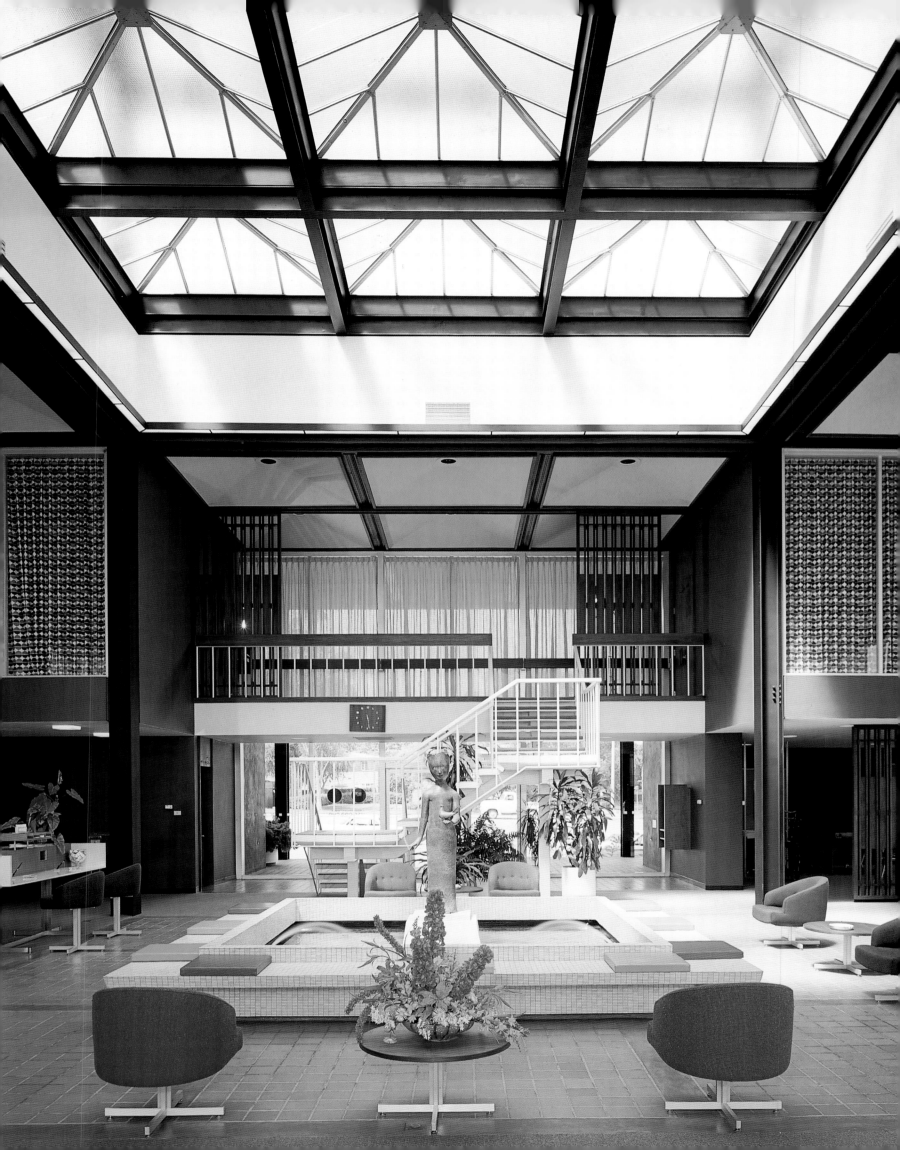

3633 Flewelling & Moody
Robert L. Frost Memorial Auditorium, Culver City, California
November 1, 1963

Size and shape of the site, budget constraints and acoustical requirements inform the design for this auditorium. Its unique concrete form originates from a combination of folded and shell structural systems, topics of central interest in engineering culture during the 50s and 60s. The building sits on a wedge-shaped lot in Culver City and resembles a seashell or a fan. To minimize cost, the architects opted for the use of repetitive forms. Eleven arched elements converge at the crown junction to form a folded dome buttressed by a gigantic thrust poured in place. Each arc was pre-cast on the ground and measures 125 feet in length, 32 feet 6 inches wide at the base and four feet wide at the top. The highest point of the structure is 50 feet from the ground. The auditorium is designed for a 1,319-seating capacity. Its enclosure, in the architects' opinion, is meant to make the sound waves flow, as opposed to bounce, along the constantly changing surface, since the sound source projects the wave parallel to the surrounding surfaces. A cylinder of masonry accommodates stagecraft facilities, rehearsal rooms and an equipment room. In 1994, the American Institute of Architects Pasadena and Foothill Chapter bestowed an Award of Merit to the project.

Größe und Form des Baugeländes, ein knappes Budget und die Forderung nach guter Akustik bestimmten den Entwurf. Das einzigartige Betonvolumen stellt eine Kombination von Falttragwerk und Schalenbau dar – beides Lösungen, die im Bauingenieurwesen der 50er- und 60er-Jahre von zentralem Interesse waren. Die Konzerthalle für 1 319 Besucher steht auf einem keilförmigen Grundstück und erinnert an eine Jakobsmuschel oder einen Fächer. Um Kosten zu sparen, entschieden sich die Architekten für regelmäßig wiederholte Formen. Elf Bögen treffen im Scheitelpunkt in 15 m Höhe aufeinander und tragen ein Dachfaltwerk mit gewaltigen Betonstrebepfeilern. Jeder 38 m lange, am Fußpunkt 10 m und am Scheitelpunkt 1,20 m breite Betonbogen wurde vor Ort gegossen und dann in Position gehoben. Die Architekten gestalteten die Wände so, dass die Klangwellen an den unregelmäßigen Oberflächen entlangfließen statt abzuprallen, da die Klangwellen parallel zu den Wänden in den Raum projiziert werden. Ein Mauerwerkszylinder umfasst die Bühne, Probenräume und Bühnentechnikraum. 1994 erhielt der Bau eine Auszeichnung von der Sektion Pasadena & Foothill des American Institute of Architects.

La taille et le contour du terrain, comme les contraintes budgétaires et acoustiques expliquent l'aspect original de cette réalisation. Son étonnante forme est née de l'alliance entre les formes fluides et les coques en béton, thème esthétique et technique qui intéressait les professionnels des années 1950 et 1960. Le bâtiment élevé sur un terrain en angle fait penser à une tortue de mer ou à un éventail. Pour réduire les coûts, les architectes ont opté pour un principe de répétition. Onze arcs convergent à un point de jonction pour créer un dôme étayé par un gigantesque contrefort coulé *in situ*. Chaque arc est préfabriqué et mesure 38 m de long, 10 m de large à sa base, et 1,20 m à son sommet. Le point le plus élevé est à 15 m au-dessus du sol. L'enveloppe de l'auditorium d'une capacité de 1 319 sièges est conçue pour laisser s'écouler les ondes sonores le long de surfaces évolutives, les ondes sonores étant renvoyées parallèlement à la coquille. Un bâtiment cylindrique abrite les équipements de scène, les salles de répétition et une salle technique. En 1994, le chapitre de Pasadena et Foothill de l'AIA a décerné à ce projet un prix du mérite.

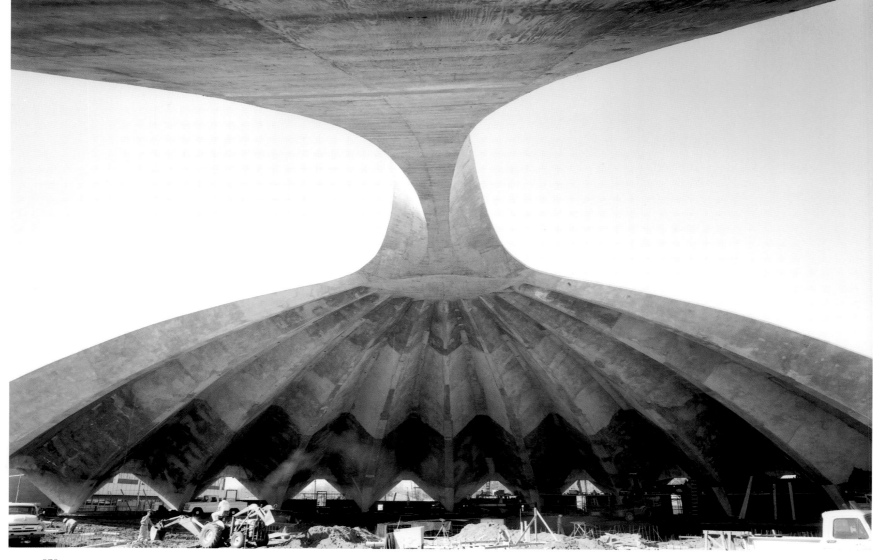

Selected - arts & architecture, May 1964
Bibliography: - The Architect & Building News,
 December 8, 1965

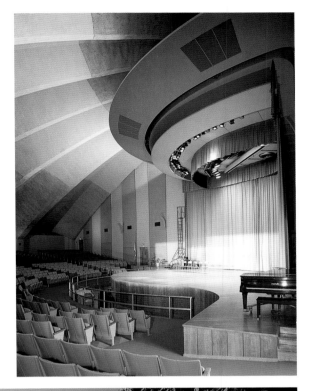

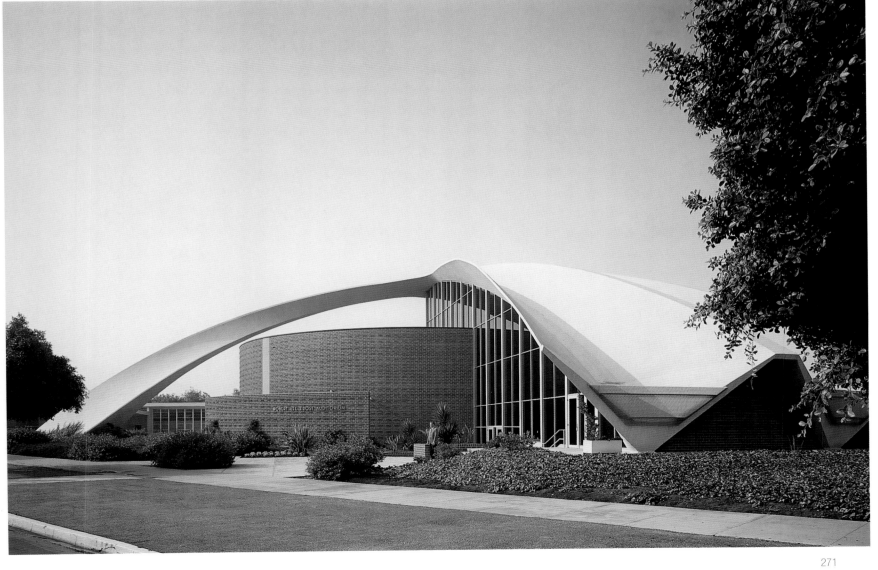

3682 William C. Muchow Associates
First National Bank, Loveland, Colorado
March 30, 31, 1964

The clients wanted to be represented in the city's fabric through a monumental design differing in character from any commercial structure in the local community.
In response to this challenge, Muchow crafted a fortress-like construction highly disciplined through an architectural order of bricks on all four sides. The bank rests on a podium projecting over a narrow band of white pebbles, reminiscent of classical architecture. The plan is a square block with offices arranged on the outer edges on two levels and a two-story hall in the center. An intricate system of brick piers and fins forms the load-bearing brick wall of the exterior envelope. The composite design of the facades consists of two levels of floor-to-ceiling piers: those on the inner level are spaced on an eight-foot module; those on the second level are positioned at irregular intervals on the outermost portion of the wall section. Perpendicular to both are lateral fins with glass in-between. Inside, four piers, composed of four smaller columns, fan out above to hold up the roof.
In 1964, the bank received an Honor Award in the Western Mountain Regional American Institute of Architects competition, and in 1965, it won an Honor Award from the Colorado Chapter of the American Institute of Architects.

Die Auftraggeber wollten sich mit einem monumentalen Bau im Stadtgefüge darstellen, der sich von den üblichen Büro- und Geschäftshäusern des Ortes deutlich abheben sollte.
Muchow nahm diese Herausforderung an und schuf eine Art Festung mit streng gegliederten Backsteinfassaden. Das Bankgebäude auf quadratischem Grundriss steht auf einem Podium, das sich aus einem schmalen umlaufenden Streifen weißer Kiesel erhebt, und erinnert an klassizistische Architektur. Die Büros sind auf zwei Ebenen um die zweigeschossige zentrale Halle angeordnet. Die tragenden Außenmauern stellen eine ausgeklügelte Mischung aus Backsteinpfeilern und Mauerwerksrippen dar, basierend auf zwei hintereinander liegenden Ebenen raumhoher Pfeiler. Die Abstände zwischen den hinteren, breiteren Pfeilern betragen jeweils etwa 2,40 m, die schlanken vorderen Stützen sind in unregelmäßigen Abständen angeordnet. Auch die Laibungen der Glasfenster werden von vertikalen Mauerrippen gebildet. Im Innern tragen vier Pfeiler das Dach. Sie bestehen jeweils aus vier gebündelten Säulen, die sich an der Spitze nach außen neigen.
1964 wurde das Bankgebäude von der Sektion Western Mountain Region des American Institute of Architects mit einem Honor Award ausgezeichnet; 1965 erhielt es den Honor Award der Sektion Colorado des AIA.

Le client souhaitait affirmer sa présence par un projet monumental différent des immeubles commerciaux environnants.
Pour répondre à cet enjeu, Muchow a conçu une construction de style forteresse dont la rigueur s'exprime par un ordre architectural strict traité en brique et décliné sur les quatre façades. Rappelant l'architecture classique, le bloc carré constitué par la banque repose sur un socle qui avance sur une bande étroite de galets blancs. Les bureaux sont installés en périphérie autour d'un hall central qui s'élève sur deux niveaux. Un système complexe de pilastres et de briques nervurées constitue le mur porteur de l'enveloppe extérieure. Le motif composite des façades se compose de deux rangs de piliers allant du sol au plafond. Ceux de la première rangée sont espacés selon un rythme modulaire de 2,40 m, ceux de la seconde rangée s'alignent à intervalles irréguliers vers l'extérieur. Les bandes horizontales sont séparées par des ouvertures vitrées. A l'intérieur, quatre piliers composés de quatre colonnes s'évasent en éventail à leur sommet pour soutenir le toit.
En 1964, cette banque a reçu un Prix d'honneur lors du concours du Western Mountain Regional American Institute of Architects et en 1965, un prix d'honneur du chapitre du Colorado de l'American Institute of Architects.

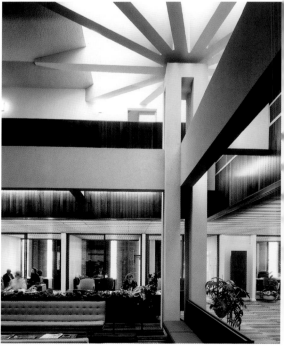

Selected Bibliography:
- *Progressive Architecture, July 1964*
- *Architecture/West, February 1965*
- *Building Progress, June 1968*

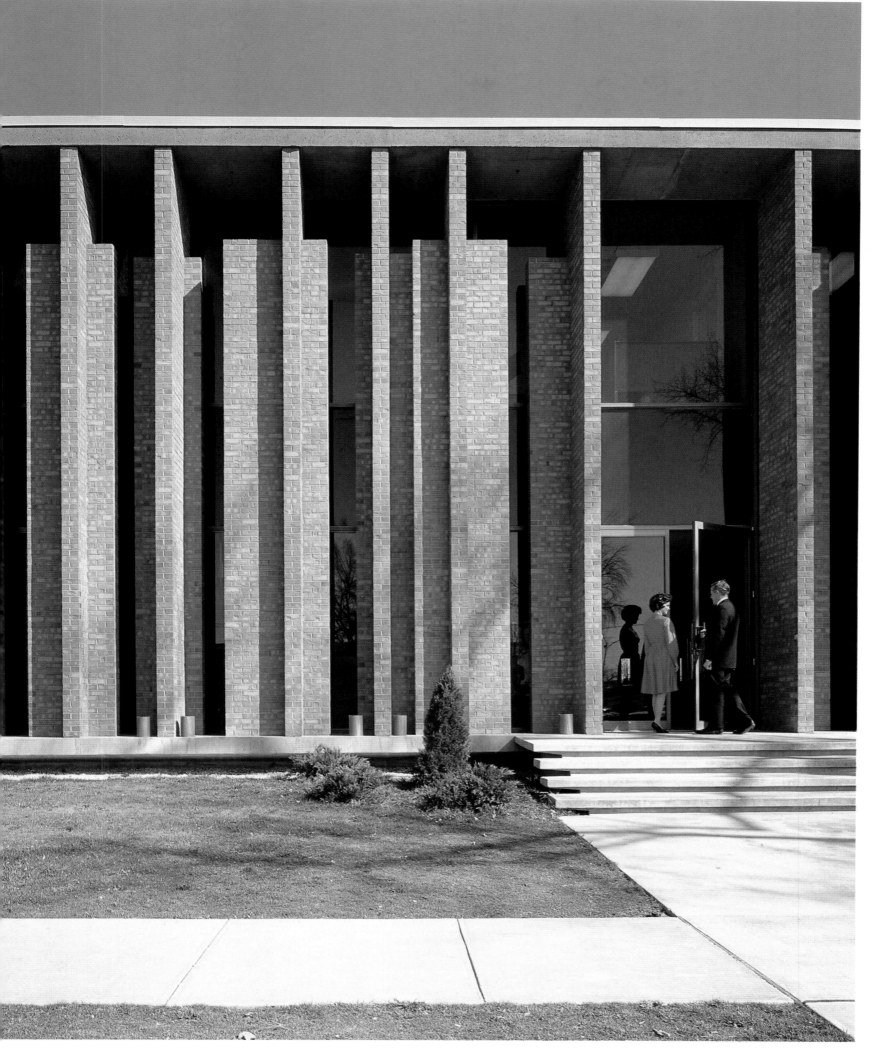

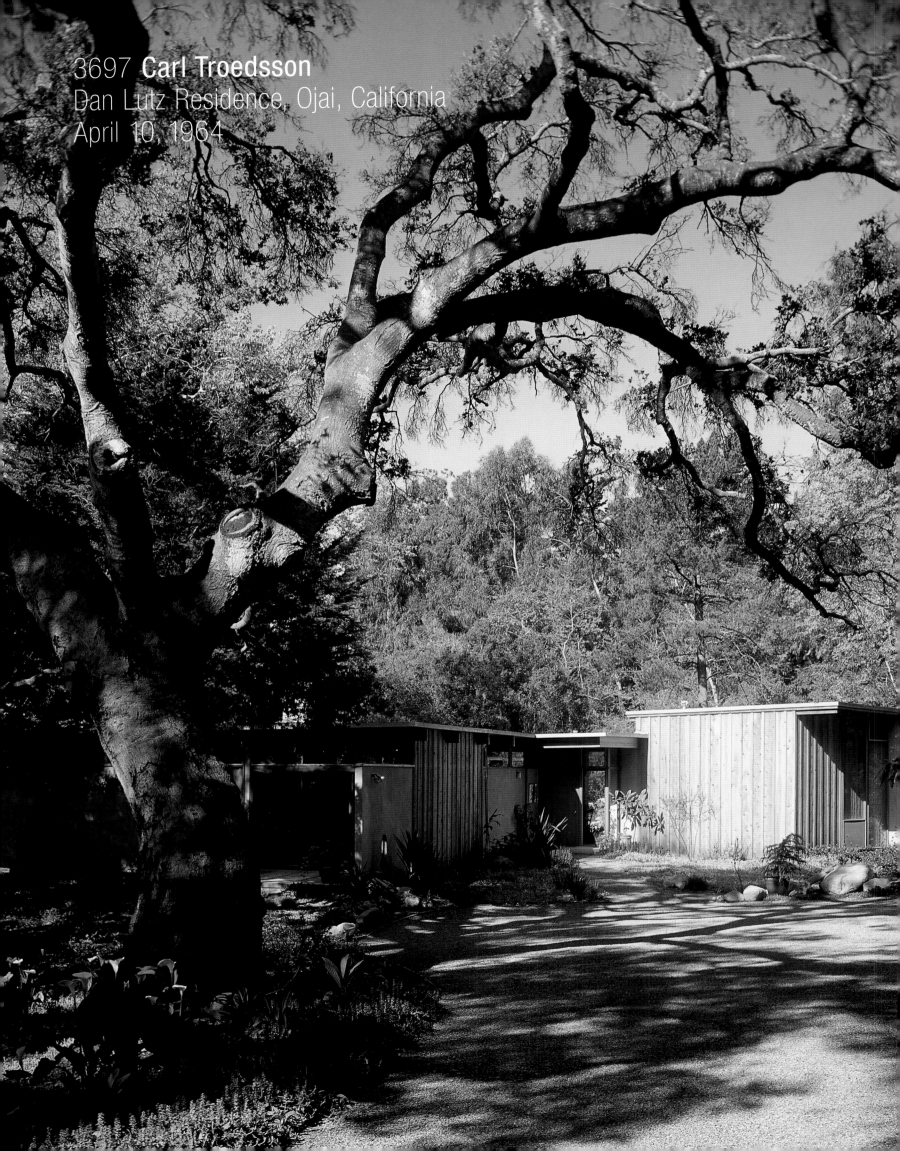

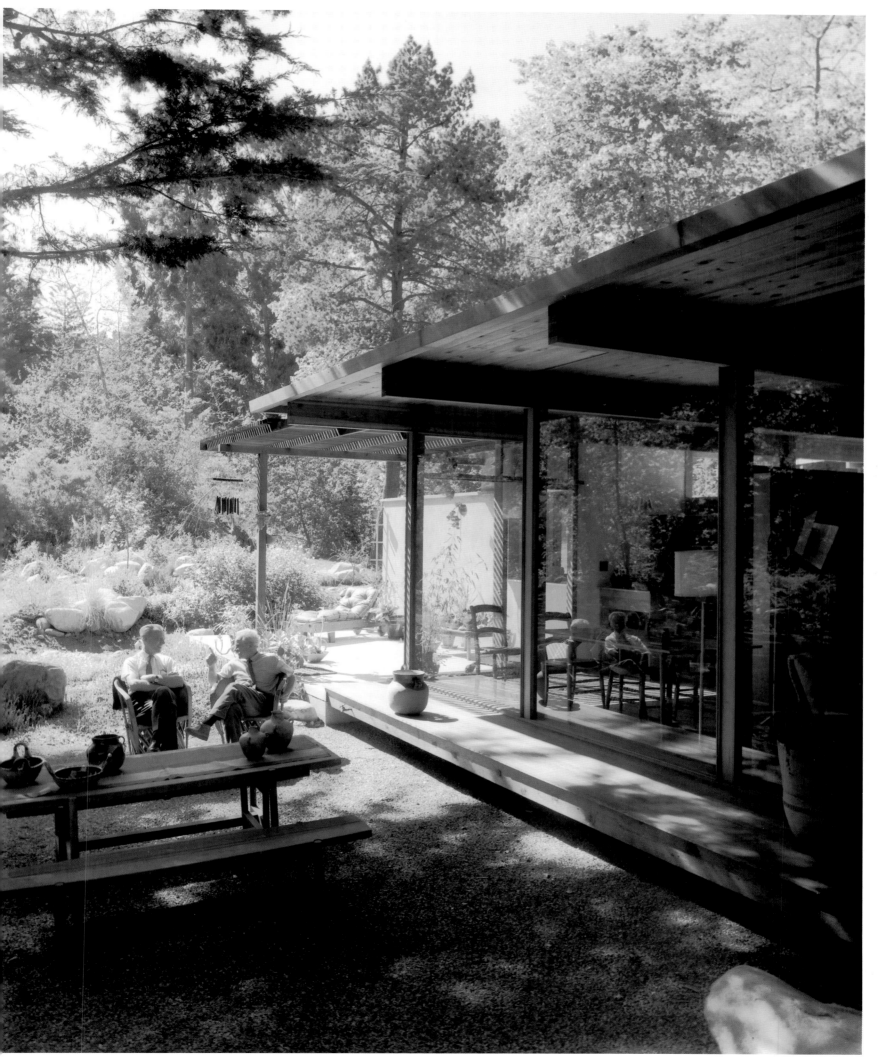

Polsky Residence, Beverly Hills, California
April 20, 1964

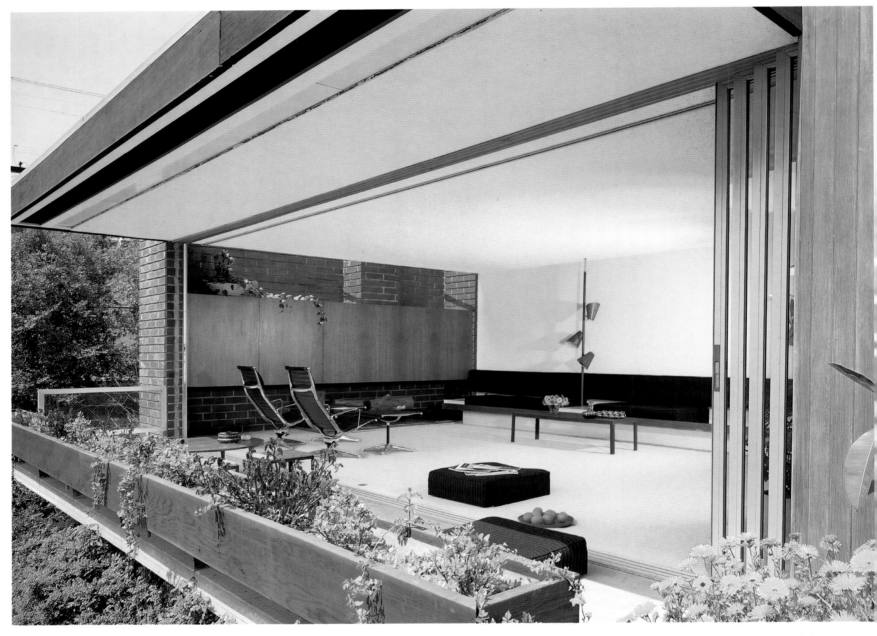

The house occupies a property filled with mature vegetation. To make a square level area, part of the building plot is cut from the adjacent hillside. Designed to accommodate the needs of a young couple and their two children, the house is subdivided in a few multipurpose areas of variable configurations. Kitchen and family eating area share a patio in common with the dining room. The dining area can be used separately or joined to the living room by movable sliding partitions to form a bigger common space. The house won an award in the 1965 edition of the Awards Program sponsored by the Nebraska Chapter of the American Institute of Architects.

Das Haus für ein junges Ehepaar mit zwei Kindern entstand auf einem Hanggrundstück mit altem Baumbestand und üppiger Vegetation. Um ein quadratisches Stück Flachland zu gewinnen, ließ Polsky einen Hügel teilweise abtragen. Das Haus umfasst nur wenige unterschiedlich geschnittene Mehrzweckräume. Die Wohnküche teilt sich einen Gartenhof mit dem Wohnzimmer. Der Essplatz kann entweder separat genutzt werden oder lässt sich durch Schiebetüren mit dem Wohnzimmer zu einem größeren Raum vereinen. 1965 erhielt das Haus eine Auszeichnung von der Sektion Nebraska des American Institute of Architects.

La maison occupe un terrain recouvert d'une végétation ancienne. Afin de disposer d'une surface carrée sur un même niveau, une partie de l'emprise au sol a été creusée dans le flanc de la colline. Conçue pour un jeune couple et ses deux enfants, cette résidence est subdivisée en plusieurs zones multifonctions de configuration variable. La cuisine et le coin-repas familial sont à cheval entre un patio avec la salle à manger qui peut être réunie au séjour. Des cloisonnements coulissants permettent d'agrandir les espaces. La maison a remporté un prix lors du Awards Program 1965 du chapitre du Nebraska de l'American Institute of Architects.

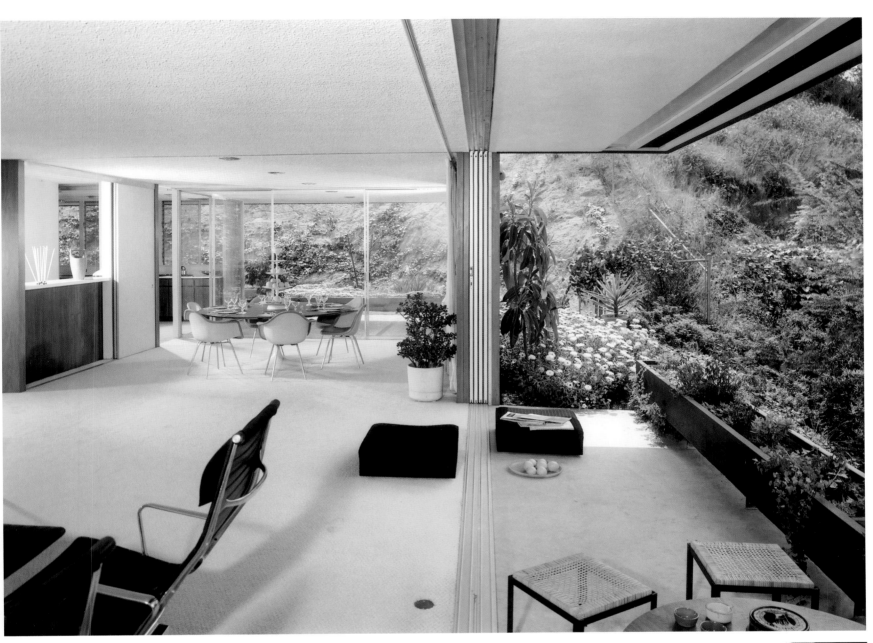

3706 **Carl L. Maston and Edward R. Niles**
Apartment House, Gardena, California
May 5, 1964

The primary objective of the design was to provide complete individual privacy for the 14 units within a unified urban image. On the street front, the strong axial composition of the plan visually locks a perspective of double-height wood frames between two windowless walls. A distinguishing feature of the apartment complex is the articulation of the transition between the public and private sphere. The main entrance in the center leads to a controlled passageway providing off-street access to each unit. Along the semi-private corridor, two common patios afford the community of tenants opportunities for social interaction. Low brick walls and two-story-high partitions surround the 200-square-foot private entry court of each apartment. Every unit has two bedrooms, one or two baths, a patio and exposure on two sides. The total covered area is 1,120 square feet distributed on two levels. In 1965, the project won an Honorable Mention from the Southern California Chapter of the American Institute of Architects.

Hauptanliegen des Entwurfs war die vollkommen blickgeschützte Anlage der 14 Wohneinheiten in einem einheitlich gestalteten städtischen Komplex. Zur Straße bietet die Achsen-symmetrische Komposition den Anblick zweigeschossiger Holzrahmen zwischen zwei fensterlosen Wänden. Ein wesentliches Merkmal des Gebäudes ist die Gliederung des Übergangs zwischen öffentlichem Raum und Privatbereichen. Der Haupteingang in der Mitte führt von der Straße in eine Passage, die Zugang zu den einzelnen Wohnungen gewährt. Entlang diesem halb privaten Gang bieten zwei Höfe Gelegenheit zu zwanglosen Treffen der Mieter. Niedrige Ziegelmauern und doppelgeschossige Trennwände umgeben die Eingangsterrassen (19 m^2) der Wohneinheiten mit je zwei Schlafzimmern, einem oder zwei Bädern, einem Innenhof und Öffnungen nach zwei Seiten. Die Gesamtwohnfläche beträgt jeweils 104 m^2, verteilt auf zwei Ebenen. 1965 wurde die Anlage von der Sektion Südkalifornien des American Institute of Architects mit einer Belobigung ausgezeichnet.

L'objectif de départ de ce projet était d'édifier 14 logements bien protégés, présentant une image urbaine homogène. Sur la rue, la composition axiale symétrique offre une perspective ouverte sur une enfilade de poteaux de bois entre deux murs aveugles. Un des aspects les plus remarquables de cet ensemble d'appartements est l'articulation de la transition entre les espaces publics et privés. L'entrée principale — au centre — conduit à une allée clairement délimitée qui donne accès à chaque appartement. Le long de ce passage semi-privé, deux patios communs permettent les échanges entre les occupants. Des murets de brique et des cloisons sur deux niveaux entourent la cour privée de 19 m^2 accolée à chaque logement. Chacun de ceux-ci possède deux chambres, une petite salle de bains et un patio et bénéficie d'une double exposition. La surface totale est de 104 m^2, distribués sur deux niveaux. En 1965 ce projet s'est vu attribuer une mention honorable par le chapitre de Californie du Sud de l'AIA.

Selected Bibliography:
- arts & architecture, July 1964
- House & Home, July 1965
- L'Architecture d'Aujourd'hui, Feb.-March 1966
- Building Progress, February 1969
- Architecture California, Idiom of the Fifties, November/December 1986

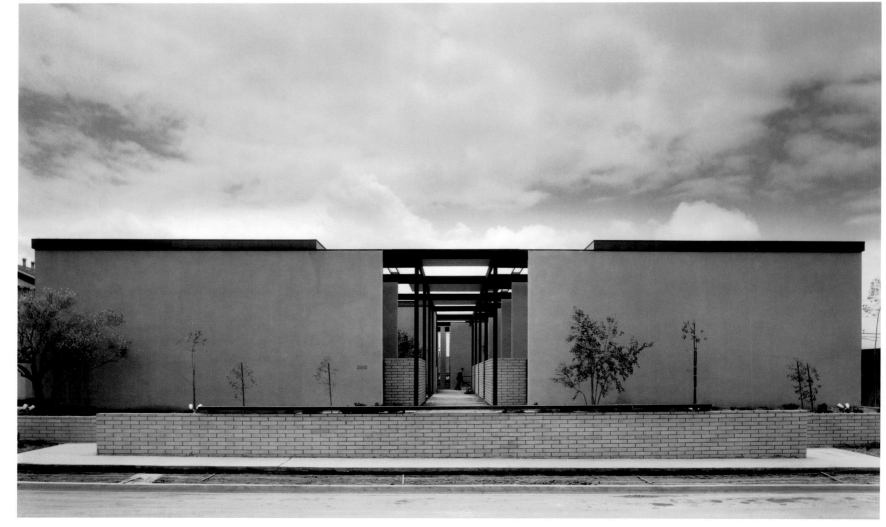

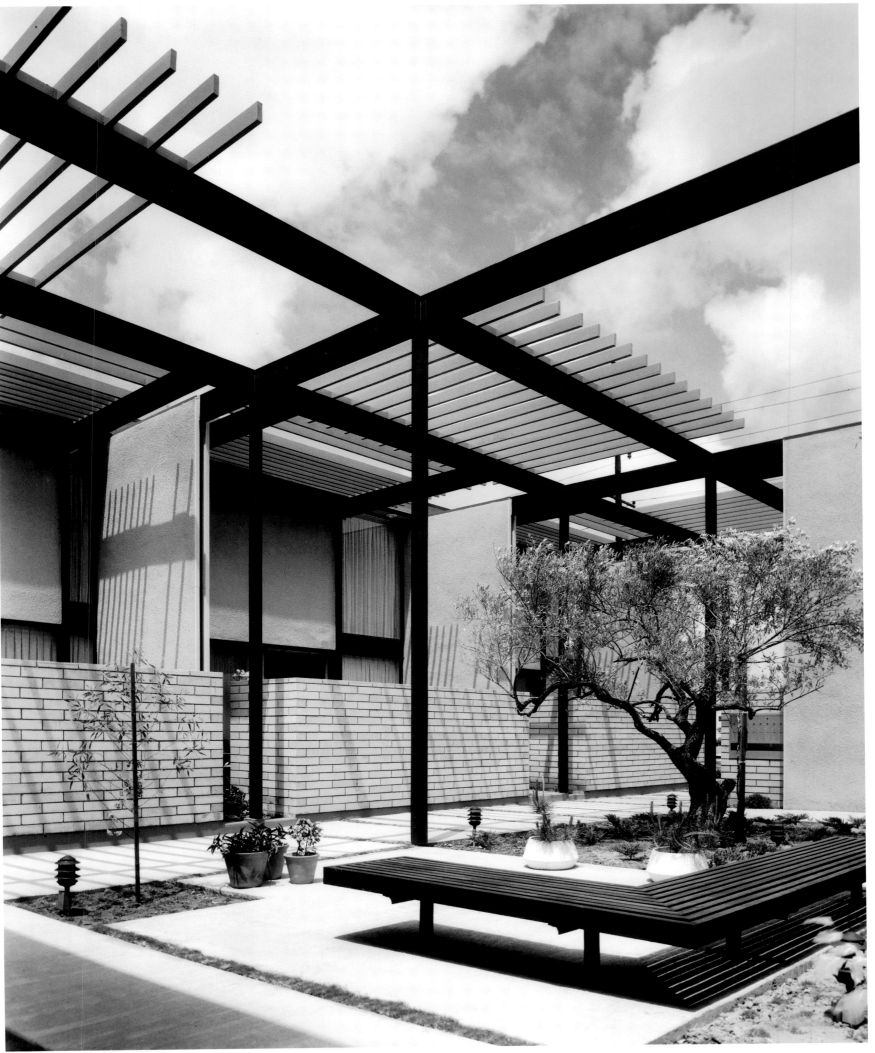

3710 Pereira & Associates
Prudential Federal Savings and Loan Bank, Salt Lake City, Utah
May 11, 12, 13, 1964

Within the urban context of downtown Salt Lake City, Pereira detailed a six-story banking facility with two levels below ground. The tripartite structural cage endows the building, both internally and externally, with a monumental scale relative to the surrounding structures.

A shaded central area attracts customers to the interior of the bank, passing a full-height garden entrance, which exhibits a 120-foot-high sculpture. The artwork shows 100 bronze seagulls in flight, representing those that saved the crops of the region's first settlers from the aggression of the locusts. The dominant architectural element in the U-shaped plan is the 50 x 20-foot central void topped by a big skylight. All the floors overlook the inner courtyard, supported by columns hung from a horizontal truss system which forms part of the structure of the skylight. The black granite counter for the teller stations snakes into the lobby. On the top floor, the upper lounge area is connected to the roof garden and covered by an arcade of structural members.

Im Zentrum von Salt Lake City baute Pereira ein Bankgebäude mit sechs Ebenen, zwei davon Tiefgeschosse. Die dreiteilige Konstruktion passt sich in ihrer Monumentalität den Nachbarbauten an.

Ein zentraler schattiger Bereich lockt die Kunden ins Innere der Bank. Zuerst passieren sie einen über die gesamte Höhe des Gebäudes reichenden Eingangsgarten, in dem eine 36 m hohe Skulptur aufgestellt wurde. Sie stellt 100 Möwen im Flug dar – Symbol für eine Schar Seemöwen, die einst die Ernte der ersten Siedler der Region vor einer Heuschreckenplage bewahrten. Das beherrschende Element des Bankgebäudes auf U-förmigem Plan ist das zentrale Atrium mit einer Fläche von ca. 15 x 6 m und einem großen Oberlicht. Alle Innenräume überblicken diesen Raum; die Geschossdecken sind von einem horizontalen Fachwerksystem abgehängt, in das auch das Oberlicht eingearbeitet ist. Die Schaltertheke aus schwarzem Granit »schlängelt sich« in die Schalterhalle. Vom obersten, von Tragwerksbögen überwölbten Aufenthaltsbereich gelangt man in den Dachgarten.

C'est dans le contexte urbain du centre de Salt Lake City, que Pereira a créé cette banque de six niveaux dont deux en sous-sol. Une structure tripartite en cage confère à cet immeuble une échelle monumentale perceptible aussi bien à l'intérieur que par rapport aux constructions voisines.

Une zone d'accès centrale protégée du soleil oriente les clients vers l'intérieur de la banque. Pour ce faire, ils traversent un jardin d'entrée orné d'une sculpture en bronze de 36 m de haut représentant une centaine de mouettes en vol, symbole de celles qui sauvèrent les récoltes des premiers colons de la région d'une attaque de sauterelles. L'élément architectural dominant du plan en forme de U est le vaste vide central de 15 x 6 m surmonté d'une énorme verrière. Tous les plateaux donnent sur la cour intérieure, délimitée par des piliers qui rejoignent à leur sommet un assemblage de poutres horizontales appartenant à la structure de la verrière. Le plan de granit noir des guichets serpente à travers le hall. Au dernier étage, un vaste salon implanté sous des arceaux de poutrelles métalliques se prolonge par une terrasse-jardin.

Selected Bibliography: - *The Architectural Digest, Fall 1964*

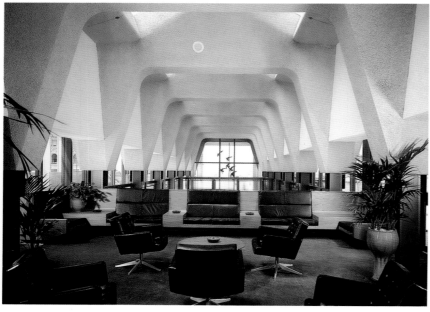

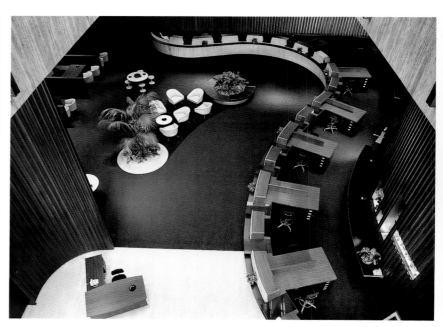

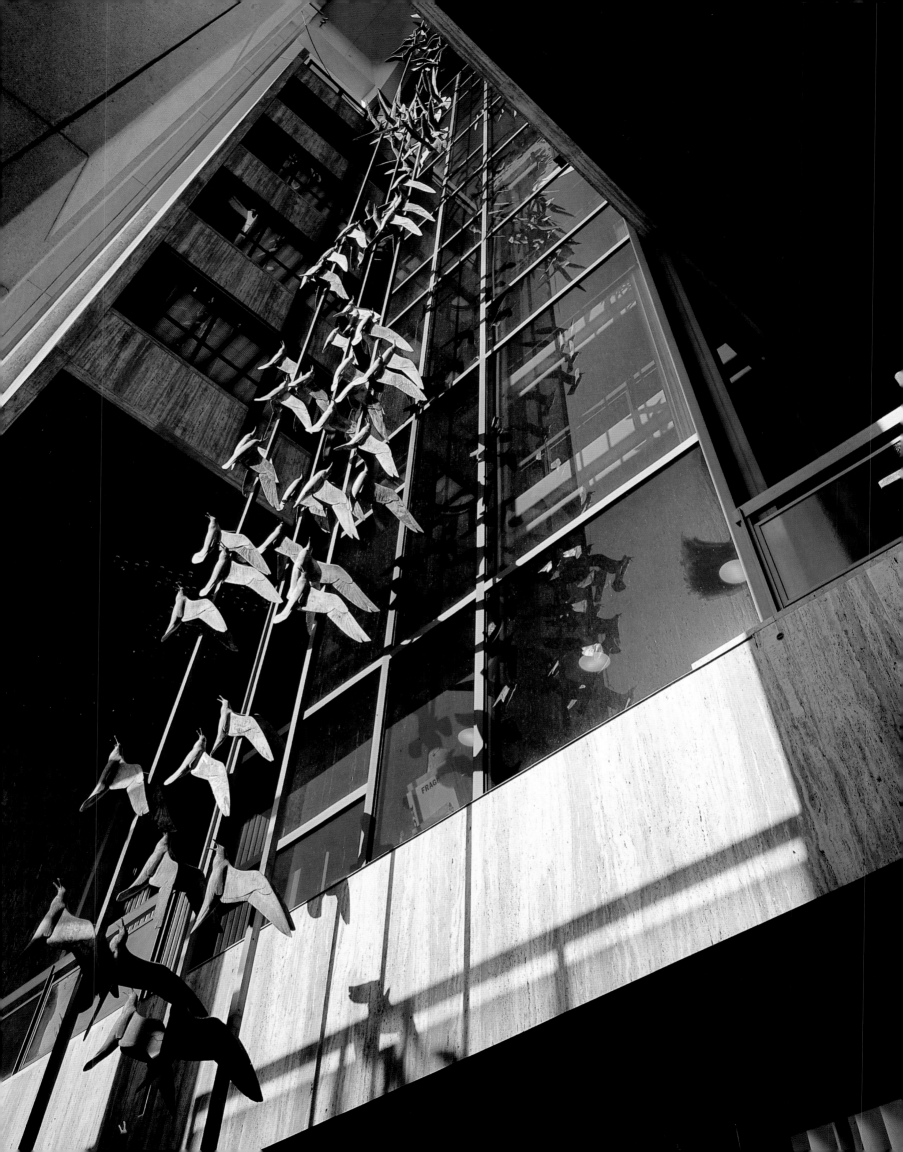

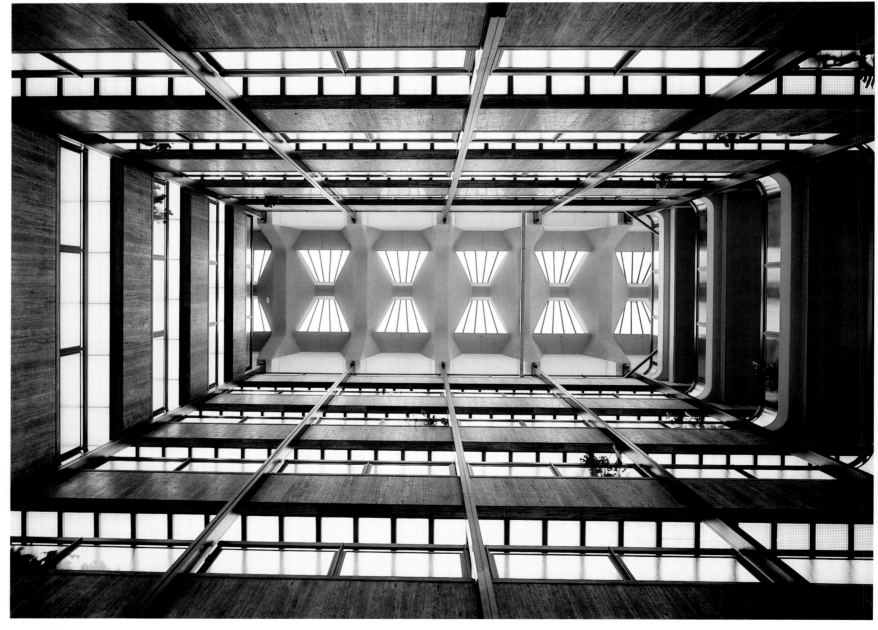

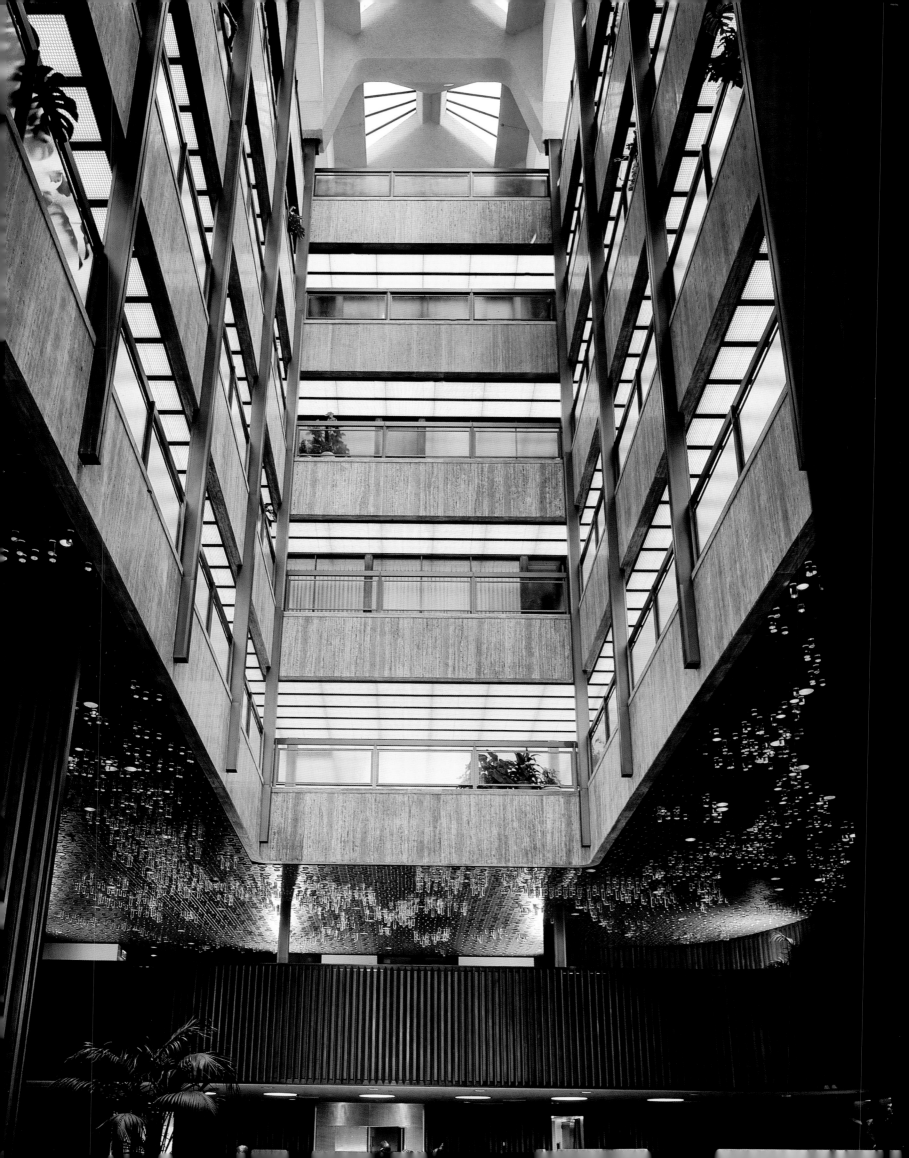

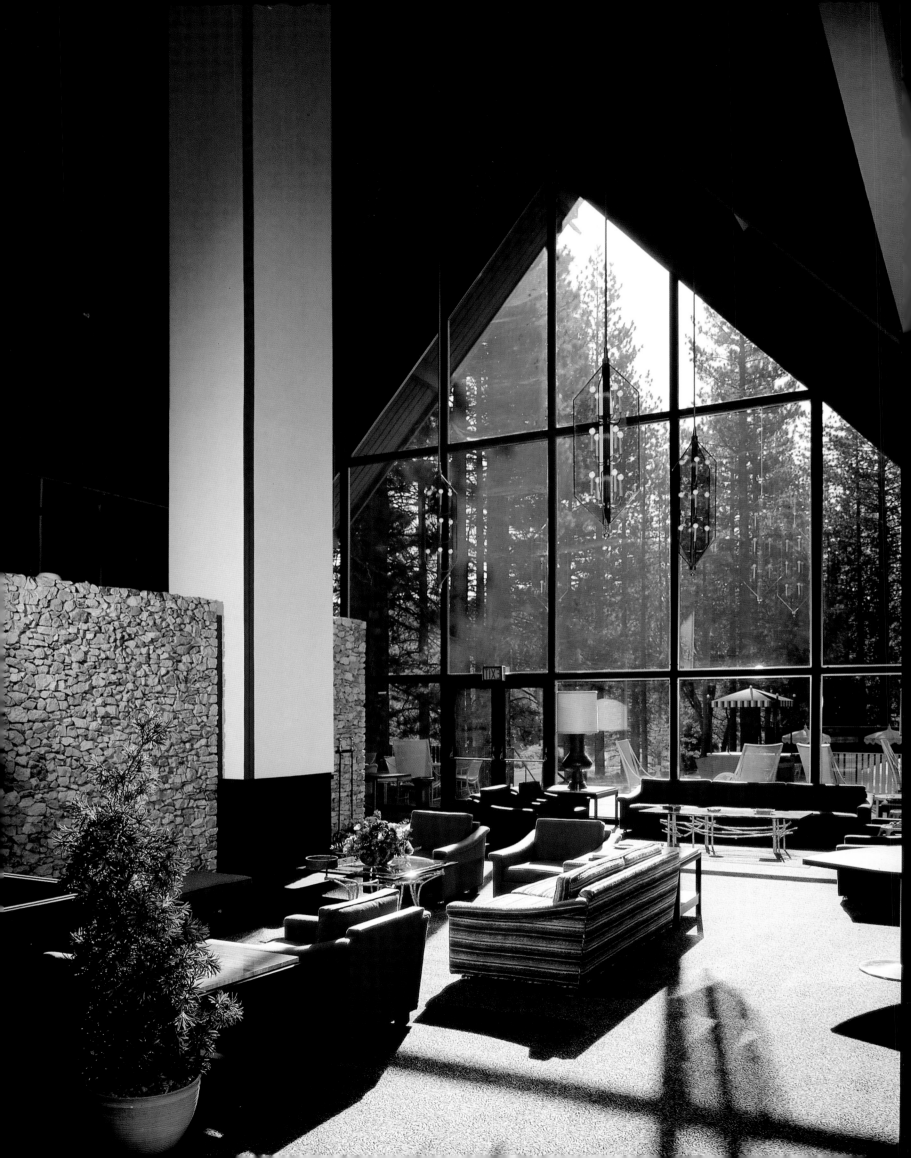

3805 Crites & McConnell
Crites Residence, Cedar Rapids, Iowa
November 14, 15, 1964

Widely celebrated in the popular and specialized press, the Crites Residence was bestowed a 1965 American Institute of Architects Honor Award. Privacy and outdoor space for all family members were the two primary objectives of the project. In the 3,000 square feet of living space, the architect gives a deck to every room of the house. The cruciform plan built on a square module generates an assemblage of horizontal and vertical slabs, giving rise to a small-scale cityscape. The crowd of tall, thin trees on the site informs the vertical quality of the architecture. The choice of materials and the articulation of the layout integrate the building into the wooded landscape. From a private road, a walkway accesses the narrow entrance on the first floor, which is devoted to communal activity. Here, the inner and outer living rooms are two distinct double-height volumes encircling the fireplace. On the second floor, the three children are each given a room with a small balcony and a rather large outdoor platform on the carport roof. The master suite on the third floor opens onto a deck facing south, which overlooks the children's outdoor space.

Due to a limited construction budget, the house is a showcase for different low-cost applications of wood. The bearing structure is a conventional timber post-and-beam system. Rough-sawn commercial-grade cedar for outside walls is left unfinished to weather to the color of the surrounding trees. Inside, the cedar boarding is sanded smooth and occasionally juxtaposed with wide surfaces of white sheet-rock, while walnut parquet covers the living room floors. Large fields of glass frame portion off the surrounding landscape, establish a closer proximity to nature and provide a background for interior views.

Das Haus Crites wurde nicht nur von der Publikums- und Fachpresse gelobt, sondern erhielt 1965 auch einen Honor Award vom AIA. Hauptintentionen des Entwurfs waren die Wahrung der Privatsphäre und »Wohnen im Freien«. Jedem Raum des fast 280 m² umfassenden Hauses ist also ein Balkon oder eine Terrasse vorgelagert. Auf einem kreuzförmigen Grundriss mit quadratischem Raster bilden horizontale und vertikale Boden- und Wandplatten zusammen eine Art kleiner Stadtsilhouette. Die hohen Bäume auf dem Grundstück regten zur Vertikalität der Architektur an. Materialwahl sowie Grundrissgliederung integrieren das Haus in die Waldlandschaft. Von einer Privatstraße führt ein Fußweg zum schmalen Eingang im Erdgeschoss, in dem die offene Veranda und das Wohnzimmer zwei doppelstöckige Räume um den offenen Kamin bilden. Im Obergeschoss hat jedes der drei Kinder ein Zimmer mit kleinem Balkon; eine relativ große Dachterrasse liegt über dem Carport. Die Zimmer der Eltern im zweiten Obergeschoss öffnen sich zu einer nach Süden orientierten Balkonterrasse mit Blick auf die Balkone und die Dachterrasse der Kinder. Aufgrund eines begrenzten Baubudgets stellt das Heim der Crites eine Art Musterhaus für den preisgünstigen Einsatz von Holz dar. Das Tragwerk ist ein herkömmliches Pfosten-Riegel-System. Grob gesägte Zedernbretter (sonst für Gewerbebauten verwendet) als Fassadenverkleidung blieben unbehandelt, damit sie sich im Lauf der Zeit durch Verwitterung der Farbe der umstehenden Bäume anpassen. Im Innern wurden die Bretter glatt geschmirgelt und an einigen Stellen neben große Flächen weißer Natursteinplatten gesetzt. Der Wohnbereich ist mit Nussbaumparkett ausgelegt. Große Glasfenster bieten Ausblicke in die Landschaft und sorgen für Naturnähe.

Largement publiée et célébrée dans la presse grand public et spécialisée, la résidence des Crites reçut un prix d'honneur de l'AIA en 1965. L'intimité ainsi que des espaces extérieurs pour chaque membre de la famille constituaient les deux objectifs principaux de ce projet de 280 m². L'architecte a réussi à doter chaque pièce d'une terrasse. Sur la base d'un module carré, le plan cruciforme génère un assemblage de dalles verticales et horizontales qui donne à la maison une silhouette très urbaine. L'abondance de grands arbres sur le terrain amplifie cette impression de verticalité. Le choix des matériaux et l'articulation générale contribuent à intégrer la construction dans son environnement boisé. A partir de la route privée, une allée donne accès à l'entrée étroite située au rez-de-chaussée consacré aux activités familiales. Les séjours intérieur et extérieur forment deux volumes double hauteur distincts autour de la cheminée. A l'étage, les trois enfants disposent chacun d'une chambre dotée d'un petit balcon et d'une assez grande terrasse aménagée au-dessus de l'abri aux voitures. Au deuxième étage, la suite principale s'ouvre sur une terrasse orientée au sud qui surplombe celle des enfants. Le budget étant limité, la maison est littéralement une vitrine des différentes utilisations économiques du bois. La structure porteuse, est constituée d'un système conventionnel de poteaux et poutres. Le cèdre de qualité courante utilisé à l'extérieur est laissé brut de sciage pour vieillir naturellement et prendre la couleur des arbres environnants. A l'intérieur, des lambris de cèdre sablé alternent avec les revêtements en pierre naturelle blanche, le parquet du séjour est en noyer. De vastes panneaux de verre renforcent la proximité de la nature et constituent le fond des perspectives intérieures.

Selected Bibliography:
- LIFE, January 15, 1965
- House and Home, June 1965
- AIA Journal, July 1965
- arts & architecture, January 1966
- L'Architecture d'Aujourd'hui, Feb.-March 1966
- Connaissance Des Arts, March 1966
- Wood, August 1966
- Polytechnisch Tijdschrift, October 27, 1967

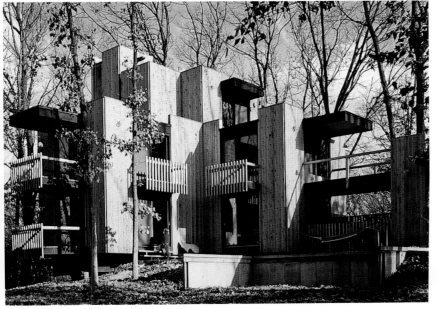
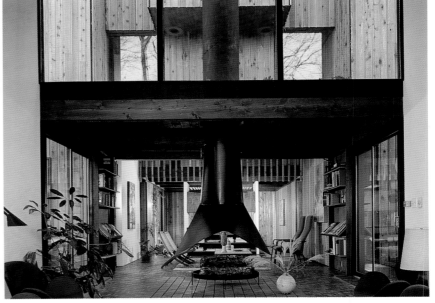

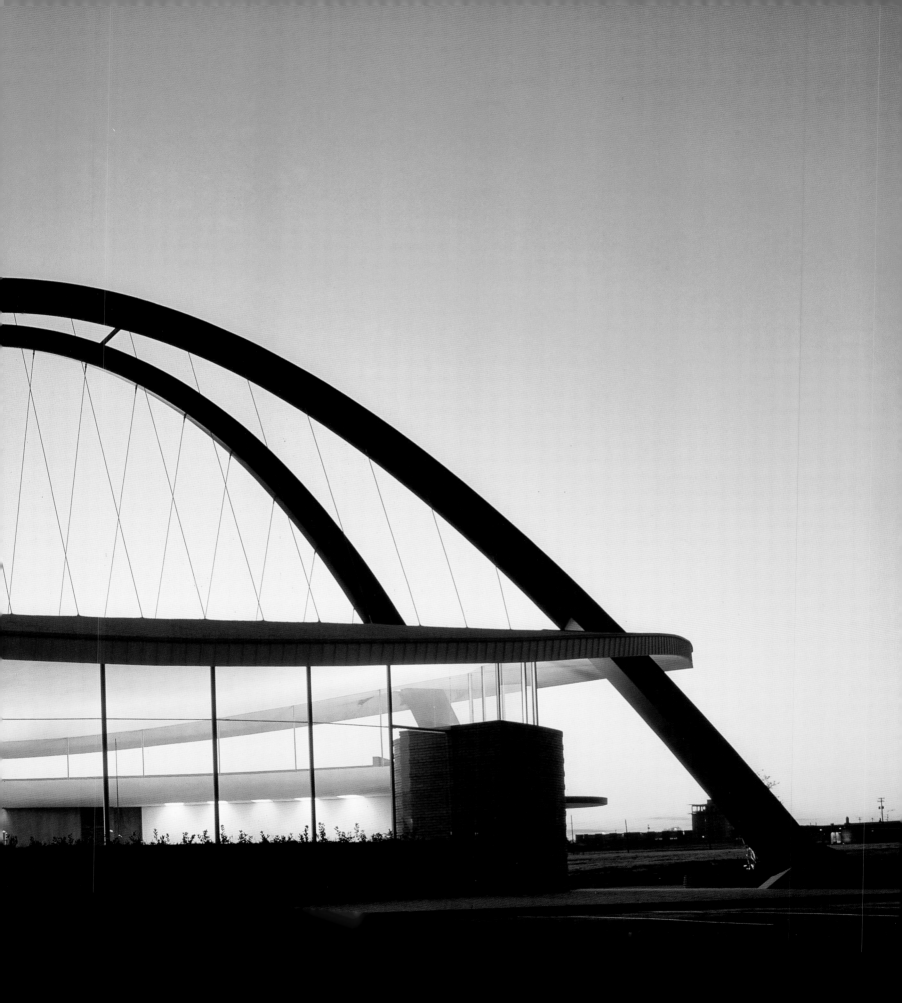

3830 **Sidney Eisenstadt**
Temple Mount Sinai, El Paso, Texas
January 10, 1965

Standing on the crest of a low hill in the desert, the synagogue has three functions: to be a house of study, a house of assembly, and a house of prayer. The religious complex works also as a social center for the local community. Against the mountain backdrop, a slanted shell of concrete rises from a solid rectangular base of stone walls.

Dieser Synagogenbau auf einem flachen Hügel in der Wüste dient gleichzeitig als Ort des Lernens, der Versammlung und des Gottesdienstes. Außerdem erfüllt das Ensemble die Funktion eines Bürger- und Nachbarschaftszentrums. Vor dem Hintergrund der Bergkulisse erhebt sich das plastisch geformte Betonschalendach aus einem massiven steinernen Kastensockel.

Au sommet de la crête d'une petite colline, en plein désert, cette synagogue remplit une triple fonction d'étude, de réunions et de culte. Elle fait également office de centre social pour la communauté locale. Sur un fond des montagnes, la coque de béton inclinée s'élève au-dessus d'un soubassement rectangulaire massif en pierre.

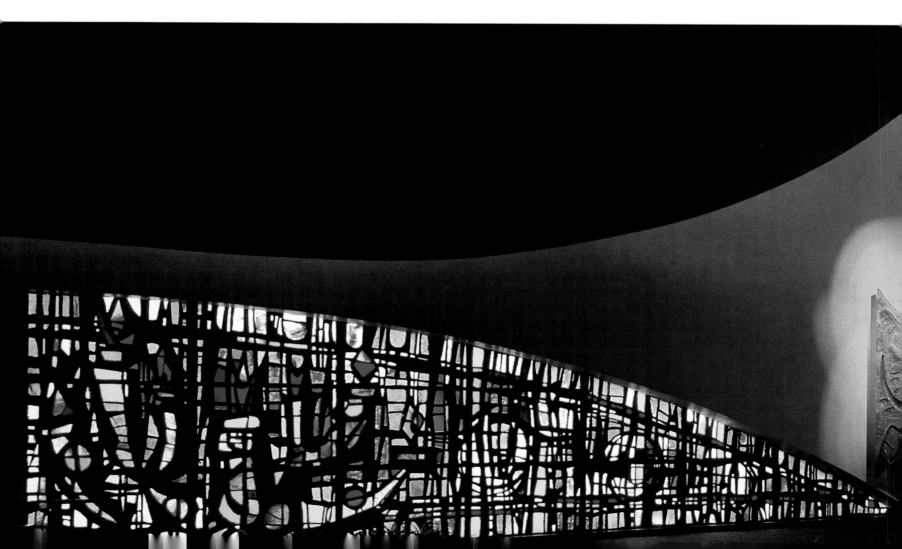

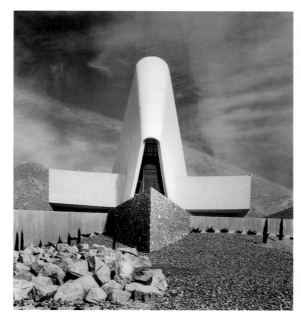
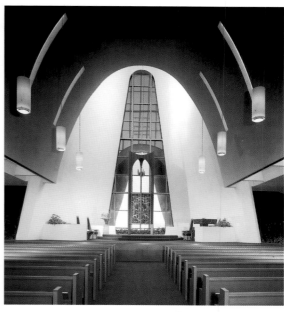

Selected
Bibliography: *- Building Progress, August 1968*

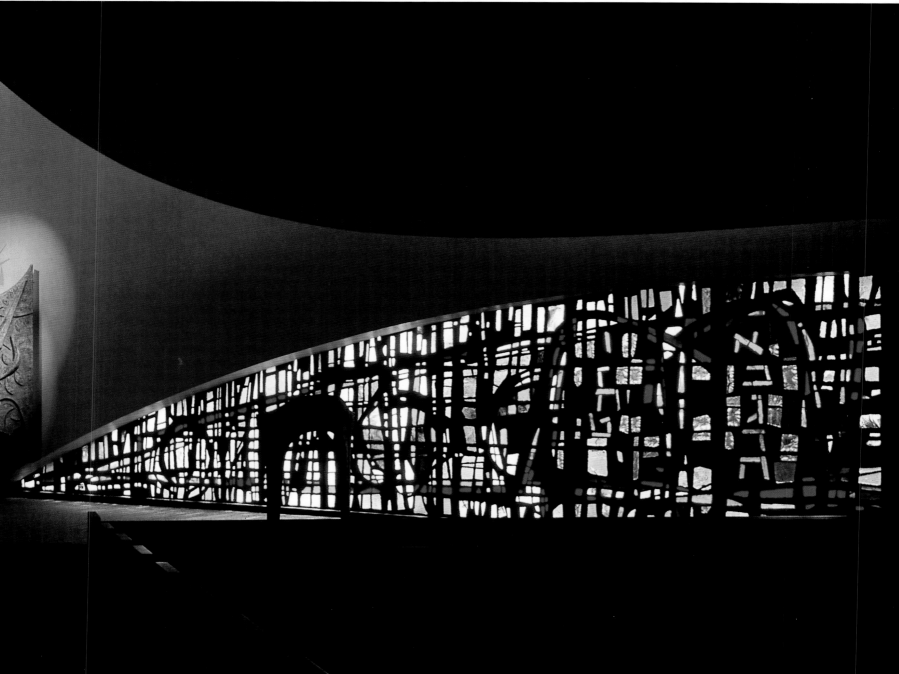

3832 **Robbin & Railla**
Price Residence, Encino, California
January 12, 1965

The internal organization of the house loosely follows an H-scheme and is structured around a rectilinear corridor serving public and private areas. Complying with the owners' request, the architects operated a clear separation between the parents' sleeping area and the children and guest zones, in order to favor their independent use. Communal activity centered on a swimming pool, a visual focus for all the rooms looking toward the patio. The parents' bedroom is connected to the children's area through the living room, which opens both to the street and a lounging terrace. Each space has a patio aimed at blurring the distinction between indoor and outdoor space. Landscaping plays a major role in the Price project. A Japanese-style flowerbed, symmetrically arranged, is aligned with the main entrance, and plants, especially those placed along the corridor, consistently establish spatial experiences. While the configuration of the layout reveals a direct lineage to the Case Study House Program, the architects used conven-

Die H-förmige Raumanordnung im Innern dieses Hauses wird erschlossen von einem geraden Korridor, der sowohl zu den öffentlichen wie zu den privaten Bereichen führt. Dem Wunsch des Eigentümers entsprechend sorgten die Architekten für eine klare Trennung des Elternschlafzimmers von den Kinder- und Gästezimmern, um eine möglichst große Unabhängigkeit für alle zu erzielen. Alle gemeinschaftlichen Tätigkeiten konzentrieren sich auf ein Schwimmbad, Blickfang für alle auf den Innenhof hinausgehenden Räume. Das Elternschlafzimmer ist mit dem Bereich der Kinder über den Wohnraum verbunden, der sich sowohl zur Straße als auch zu einer Liegeterrasse öffnet. Jeder Bereich hat einen Patio, der den Unterschied von drinnen und draußen verwischen soll.

Eine wichtige Rolle bei der Price Residence spielt die Landschaftsgestaltung. Ein symmetrisch angeordnetes, japanisch anmutendes Blumenbeet ist auf den Hauseingang ausgerichtet, und Pflanzen unterstützen das Raumerlebnis wie etwa entlang

Cette maison suit un plan en H structuré autour d'un couloir rectiligne qui dessert les zones de séjour et les chambres. Pour répondre à la demande des propriétaires, les architectes ont clairement séparé la chambre des parents de celles des enfants et des invités afin d'assurer l'indépendance de chacun, tout le monde se retrouvant néanmoins autour de la piscine, point focal de toutes les chambres qui donnent sur le patio. Celle des parents est reliée à la zone des enfants par le séjour qui donne à la fois sur la rue et une terrasse. Chaque espace possède son propre patio, ce qui a pour effet d'estomper la distinction entre le dedans et le dehors. L'aménagement de l'environnement joue un rôle majeur. Une plate-bande fleurie de style japonais est disposée symétriquement à l'entrée principale, et la végétation accentue la perception de l'espace, notamment par les plantations en bordure du long couloir. Si la configuration du plan montre un lien direct avec le Case Study House Program, les architectes ont en recours à une construction traditionnelle en

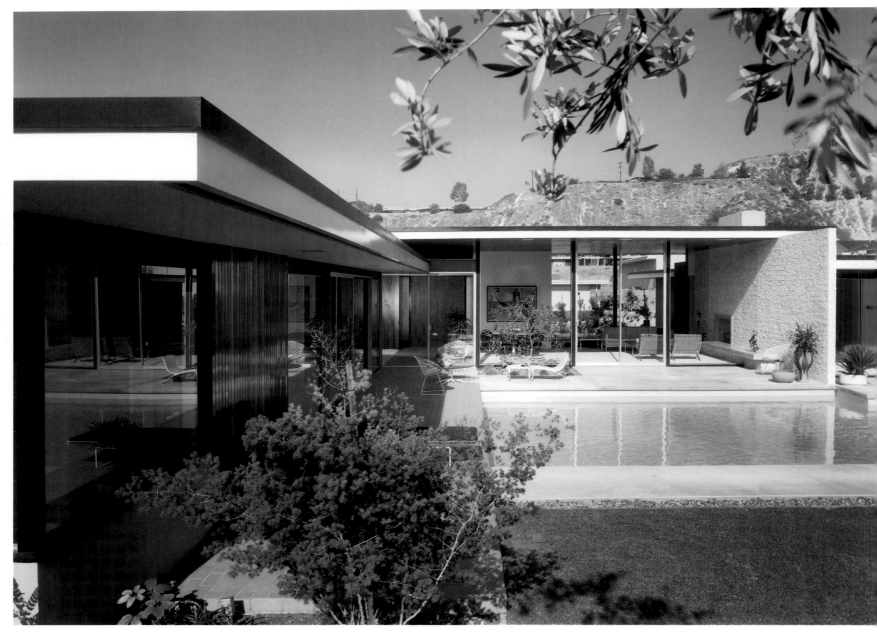

tional wood stud construction instead of a steel frame. The Price Residence is an early accomplishment in the career of Robbin & Railla, whose partnership lasted only four years. Shulman maintains that both architects were inspired by the work of Richard Neutra, whose influence is noticeable in the formal language defining the spatial attributes of the residence. The adoption of large areas of glass screens, the continuity of indoor and outdoor spaces, the identification of different functional zones through flat roofs placed at different heights and the modularity of the plan are some of the architectural features that place the house squarely in the California Modernist tradition.

dem Korridor. Während die Gliederung des Entwurfs eine direkte Verbindung zu den Erfahrungen des Case Study House-Programms erkennen lässt, haben die Architekten eine konventionelle Holz-Stützen-Konstruktion anstelle eines Stahlskeletts angewandt. Das Haus Price ist eine frühe Arbeit von Robbin & Railla, deren Partnerschaft nur vier Jahre bestand. Shulman weist darauf hin, dass beide Architekten beeindruckt waren von Richard Neutra, dessen Einfluss deutlich wird in der Formensprache, der die räumlichen Elemente des Hauses folgen. Große Glaswände, das Ineinanderübergehen von Innen- und Außenbereichen, die Verdeutlichung unterschiedlicher Funktionsbereiche durch Flachdächer verschiedener Höhe und der modulare Charakter des Grundrisses sind einige Merkmale der Kalifornischen Moderne.

bois au lieu de l'acier. La Price Residence est l'une des premières réalisations de la carrière commune de Robbin & Railla qui se séparèrent au bout de quatre ans seulement. Shulman maintient que les deux architectes s'inspiraient du travail de Richard Neutra, dont l'influence est notoire dans la définition formelle des attributs spatiaux de la maison. L'adoption de vastes plans de verre, la continuité intérieur/extérieur, l'identification des différentes zones fonctionnelles par des toitures planes de différentes hauteurs et la modularité du plan, figurent parmi les quelques caractéristiques qui inscrivent cette maison dans la tradition moderniste californienne.

Selected Bibliography:
- arts & architecture, May 1965
- Bauen & Wohnen, December 1965

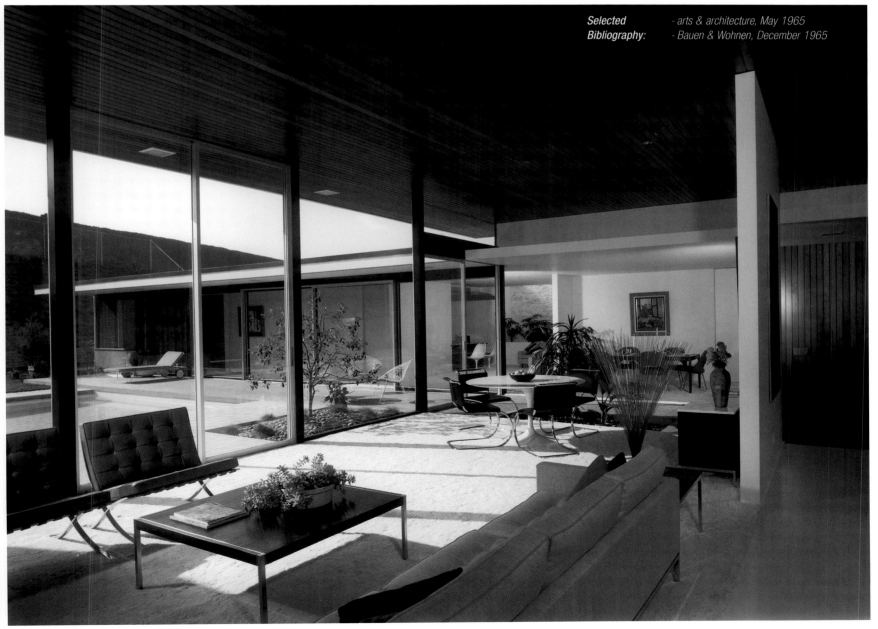

3833 **Robbin & Railla**
Browder Residence, Burbank, California
January 26, 1959; January 13, 1965

Bordered by a busy avenue, the corner lot is situated at the edge of a block in an old suburb of Burbank and measures 35 x 105 feet. Deed restrictions, a nine-foot setback on the avenue frontage and a four-foot setback on the inner side narrow the building site to a 22-foot-wide strip. A concrete block wall on the long side of the lot structures the urban image of the dwelling. Behind the windowless screen, family life unfolds sheltered from the public eye and outside traffic. An eight-foot module calibrates the interval between the beams that extend beyond the wall line giving a tight spatial rhythm to the architecture. The redwood volume on the second floor appears to sit on top of the beams, with a clerestory window between them. The residence meets the needs of a family of three within a rectangular area 22 x 24 feet in size. A total area of 1,098 square feet accommodates the living scheme. Starting from the entry on the corner side, a path parallel to the wall on the street front intersects in sequence the living room, the kitchen and dining area, an enclosed courtyard, a workshop and utility room, to end in the motor court on the opposite side. On the second floor, the sleeping units have wide windows onto the surrounding vistas. Sliding glass panels connect the kitchen-dining area with the patio, enhacing the apparent scale of the design.

Das 10,50 x 32 m große Grundstück an einer stark befahrenen Hauptstraße bildet die Eckparzelle eines Straßenblocks in einem älteren Vorort von Burbank. Aufgrund von Auflagen des Liegenschaftsamtes musste der Bauabstand zur Grundstücksgrenze an der Hauptstraße etwa 2,70 m und zum Blockinnenbereich 1,20 m betragen, was die bebaubare Fläche auf 6,60 m Breite einschränkte. Die Betonstein-Mauer an der Länsseite des Grundstücks verleiht dem Haus städtischen Charakter, während die geschlossenen Flächen die Bewohner vor Einblicken und dem Verkehrslärm schützen. Das mit Redwood verkleidete Obergeschoss scheint aufgrund der Oberlichter des Erdgeschosses auf den Dachbalken zu schweben, die über die Außenmauern hinausragen.
Das Einfamilienhaus auf fast quadratischem Grundriss (6 x 7 m) mit einer Gesamtfläche von 100 m² entstand für eine dreiköpfige Familie. Vom Eingang in der Grundstücksecke durchquert man parallel zur Straßenfassade Wohnraum, Küche, Esszimmer, Innenhof sowie den Werkstatt- und Wirtschaftsraum, um zum Garagenhof am anderen Ende des Hauses zu gelangen. Die Schlafzimmer im Obergeschoss bieten Ausblicke durch große Fenster. Der Durchgang zwischen Küche und Esszimmer lässt sich mit Schiebeglastüren schließen; der Innenhof erweitert den Umfang des Hauses.

En bordure d'une avenue très fréquentée, le terrain de 10,50 x 32 m se trouvait à l'angle d'un bloc dans une banlieue ancienne de Burbank. La réglementation d'urbanisme imposait un retrait de 2,70 m par rapport à l'avenue et de 1,20 m côté bloc, rétrécissant d'autant la surface constructible, réduite à une bande de 6,60 m de large seulement. Un mur en parpaings sur la façade longue, donne à la maison une image plus urbaine. Derrière cet écran aveugle, la vie familiale se déroule à l'écart des regards et de la circulation. Les poutres espacées de 2,40 m se prolongent au-delà de l'enveloppe extérieure, ce qui confère à l'ensemble un rythme tendu. Le volume en bois rouge de l'étage semble reposer sur ces poutres, séparées par une fenêtre haute.
La maison (6 x 7 m, 100 m² habitables) a été conçue pour une famille de trois personnes. Partant de l'entrée à l'angle du terrain, un couloir parallèle au mur donnant sur la rue longe successivement le séjour, la cuisine et la salle à manger, une cour fermée, un atelier et une pièce de rangement, pour se terminer sur la cour des voitures à l'opposé. Les chambres de l'étage sont dotées de grandes fenêtres. Des panneaux vitrés coulissants relient la zone cuisine-repas au patio, ce qui accroît l'échelle perçue.

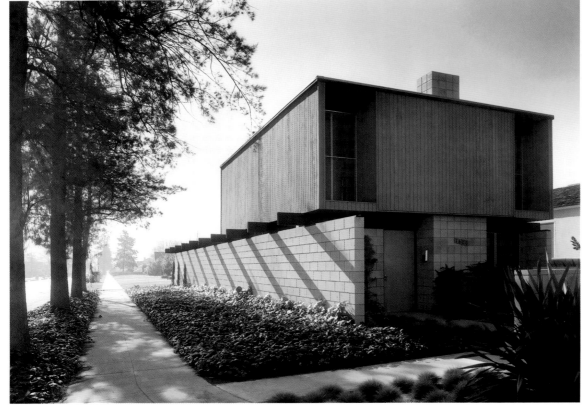

Selected Bibliography:
- *Los Angeles Times Home Magazine, August 15, 1965*
- *Architectural Record Houses of 1966*

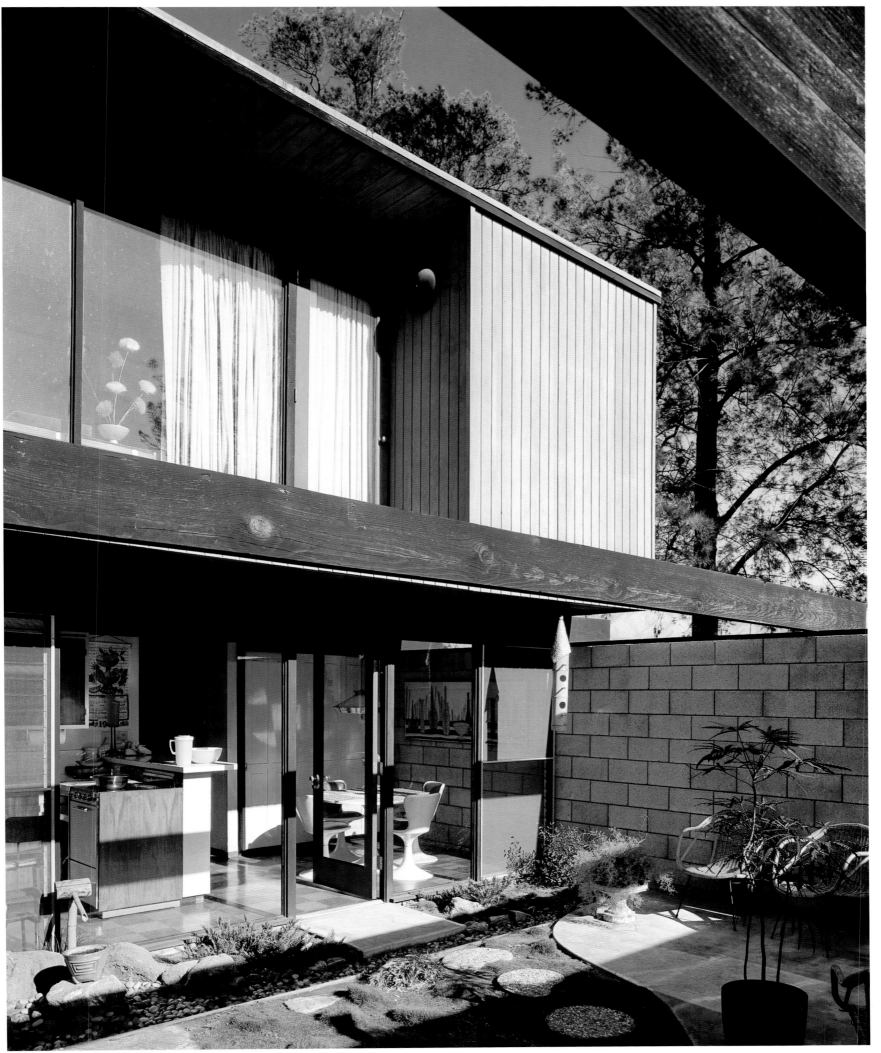

3854 **William Wallace Reid**
Reid Residence, Santa Monica, California
March 30, 1965

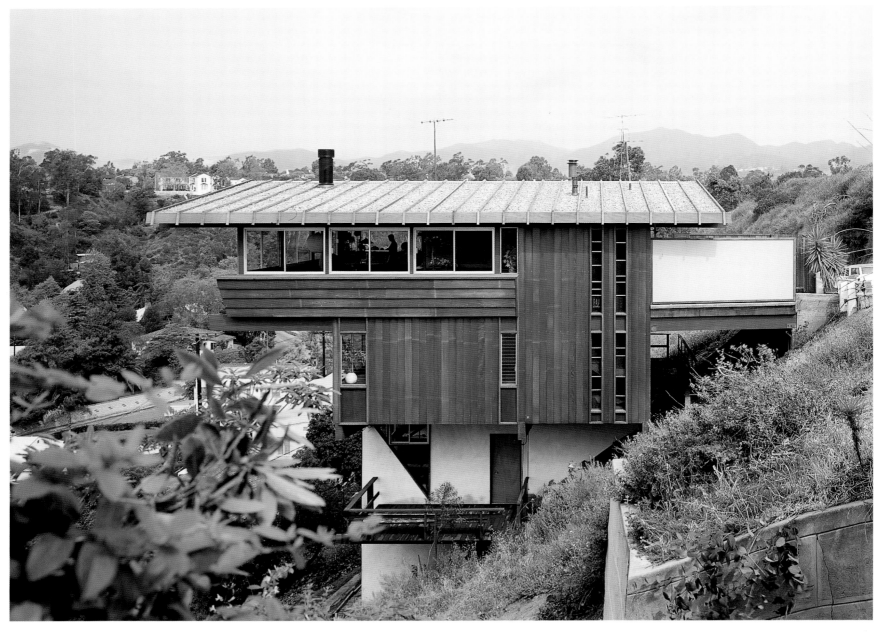

For his own residence, the architect ventured a bold structural solution to develop a hillside lot with a 40-degree slope. Pilings 40 feet tall secure a foothold for the three-level house fastened to the slope by a bridge to the street level above.
Access is from the upper level which juts out 8 feet toward the valley side to provide a spacious living room, where a ribbon window provides an unobstructed 180-degree view of the surrounding. Three bedrooms are housed on the middle level,

Bei seinem eigenen Haus konnte der Architekt eine kühne Lösung realisieren, um es auf einem Hanggrundstück mit 40° Gefälle zu errichten: 12 m hohe Pfähle sorgen für feste Verankerung des dreigeschossigen Hauses, das über eine Brücke auf der obersten Ebene vom Straßenniveau zugänglich ist. Die oberste Geschossdecke kragt zum Tal hin um rund 2,40 m über die unteren vor und bietet somit Platz für ein geräumiges Wohnzimmer. Von dort hat man eine ungehinderte Panorama-

Pour sa propre résidence édifiée sur une parcelle au flanc d'une colline en pente de 40°, l'architecte a adopté une solution audacieuse. Des pieux de fondation de 12 m de haut assurent l'assiette de l'ensemble qui s'élève sur trois niveaux. Une passerelle la relie par son sommet à la rue. L'accès s'effectue par le niveau supérieur qui s'avance de 2,40 m vers la vallée pour créer une spacieuse salle de séjour dans laquelle un bandeau de fenêtres offre une vue à 180° sur le paysage. Trois

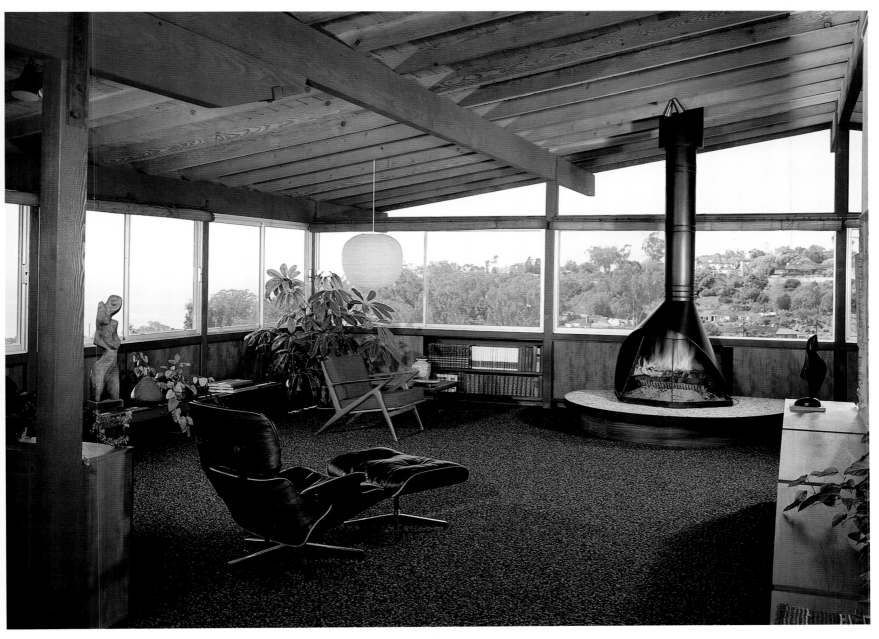

while the owner's studio is located on the bottom floor. The triangular windows reveal the geometry of the load-bearing structure. The section and main elevation of the house is textured with rough-sawn redwood siding.

Despite the limited size of the base, 24 x 24 feet, the available covered area amounts to 2,200 square feet.

sicht in die Umgebung. Drei Schlafzimmer nehmen die mittlere Etage ein, das Büro des Architekten die unterste. Die dreieckigen Fenster verdeutlichen die Geometrie des Tragwerks. Die Hauptfassade (parallel zum Querschnitt) ist mit grob gesägten Redwoodbrettern verschalt. Trotz der kleinen Grundfläche (7,30 x 7,30 m) umfasst das Haus 204 m².

chambres occupent le niveau intermédiaire, tandis que le bureau du propriétaire est implanté au niveau inférieur. La forme triangulaire des fenêtres fait apparaître la géométrie de l'ossature porteuse. La façade principale, parallèle à la coupe transversale de la maison, est revêtue d'un bardage grossier en bois rouge. Malgré les dimensions limitées de la base – 7,30 x 7,30 m –, la surface couverte utile atteint 204 m².

Selected Bibliography:
- Better Homes & Gardens, Home Building Ideas for 1966
- Los Angeles Times Home Magazine, November 26, 1967

3887 **Barry J. Moffit**
Waxman Residence, Studio City, California
June 18, 1965

The architect angles the buildings to the east-west property lines, to maximize the amount of outdoor space and catch deeper views. Following the land contours of the sloped lot, the house's domestic program is distributed on a cascade of levels. Located in the lower section are the bedrooms and the utility area; the master bedroom is placed upstairs connecting directly with the living room and the kitchen, as specified by the owners. A study room is located on the uppermost level. The spaces are interlocked with each other and connected by short staircases. Despite the residence's vertical organization, the ceiling plane stretches the geometry of the architectural masses horizontally. The structure is standard wood-framing with redwood siding.

Der Architekt richtete das Haus auf die in Ost-West-Richtung verlaufenden Grundstücksgrenzen aus, um den Gartenraum bestmöglich nutzen und weitere Ausblicke bieten zu können. Der Geländeneigung folgend, schuf er eine »Kaskade« von Räumen: unten Schlafzimmer und Wirtschaftsräume, oben das Elternschlafzimmer mit direktem Anschluss an Wohnraum und Küche. Auf der obersten Ebene befindet sich ein Arbeitszimmer. Die Räume fließen ineinander und sind jeweils durch wenige Stufen miteinander verbunden. Obwohl das Haus in der Vertikale organisiert ist, streckt die durchgehende Innenraumdecke die Bauvolumen auch in der Horizontalen. Die Konstruktion besteht aus Standard-Holzrahmen, das Haus ist mit Redwoodbrettern verschalt.

L'architecte a repoussé les constructions aux limites est-ouest de la propriété pour optimiser l'utilisation du terrain et permettre des perspectives plus intéressantes. Le programme d'habitation est réparti sur une cascade de niveaux qui suivent les contours du terrain en pente. Les chambres et les pièces de service sont implantées dans la partie inférieure. Au sommet, la chambre principale est directement reliée au séjour et à la cuisine, à la demande du propriétaire. Un bureau occupe le niveau le plus élevé. Les espaces sont imbriqués les uns dans les autres et réunis par quelques marches. Bien que l'organisation générale soit verticale, l'enfilade des plafonds génère une impression d'horizontalité. L'ossature est en bois, le bardage en cœur de bois rouge.

Selected Bibliography:
- Los Angeles Times Home Magazine, November 28, 1965
- arts & architecture, January 1967

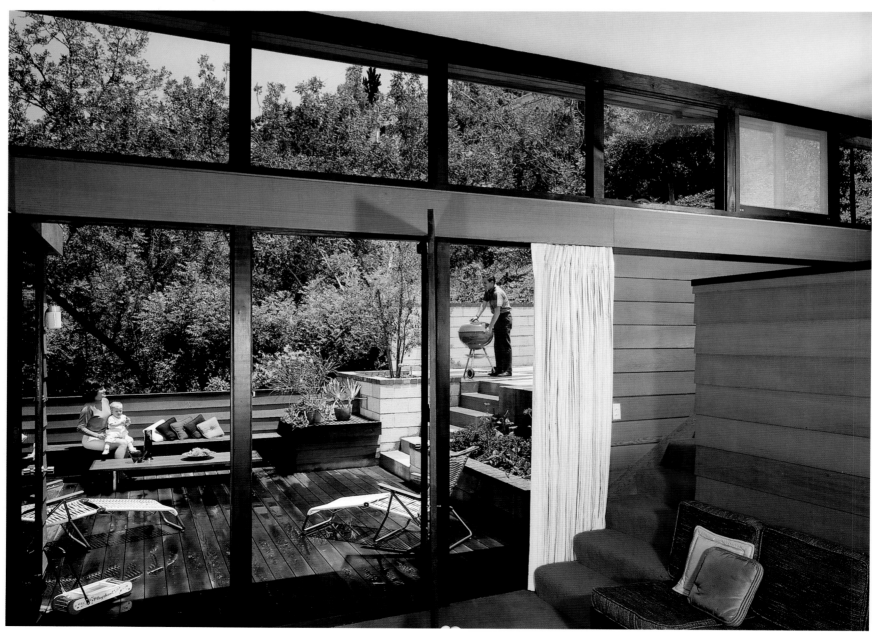

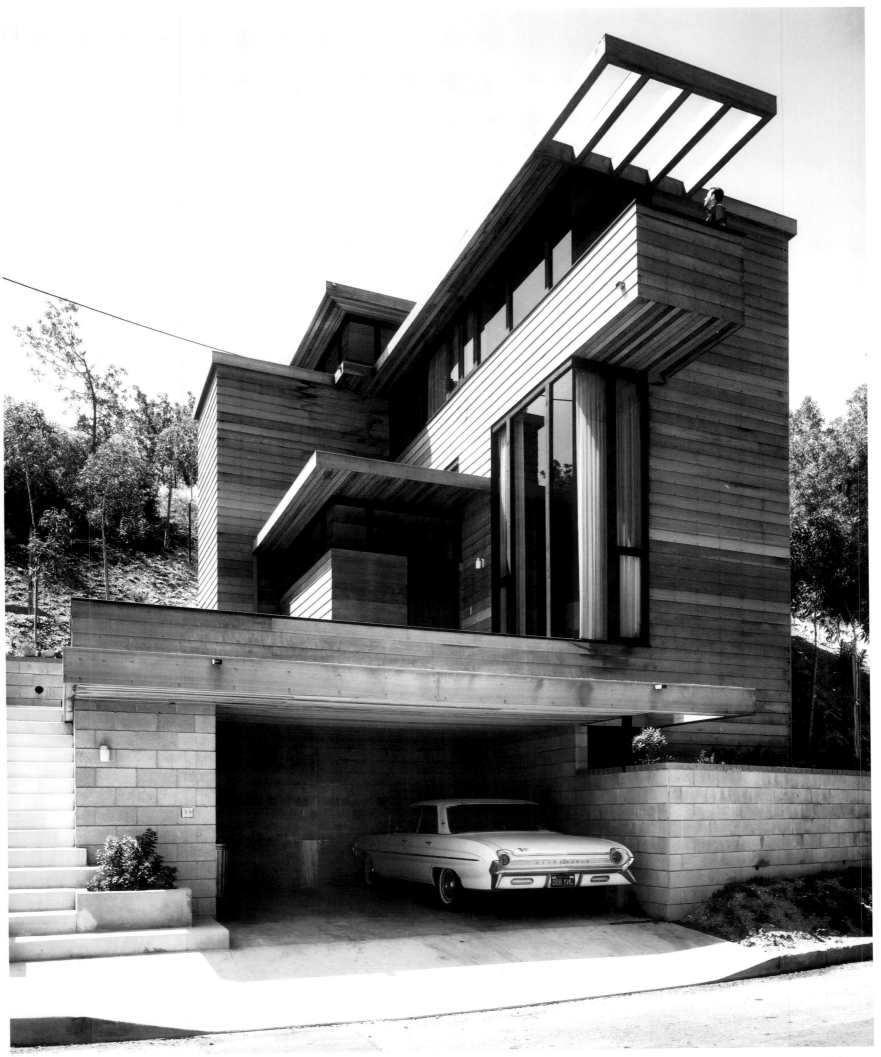

3894 Albert C. Martin and Associates
Department of Water and Power, Los Angeles, California
July 1, 1965; September 13, 1965

In the book entitled *Los Angeles. The Architecture of Four Ecologies*, architectural historian Reyner Banham refers to the Department of Water and Power (DWP) as "the only gesture of public architecture that matches the style and the scale of the city". Hailed by the popular and professional press from the outsets as a city landmark, the office building has received numerous architectural awards. Among them, there is the 1967 Honor Award by the Southern California Chapter of the American Institute of Architects, as one of the twelve most distinguished buildings constructed in the Southern California area (Santa Barbara to San Diego). The building also won the Architectural Grand Prix, as part of "the greatest Los Angeles architecture created between the years 1947–1967."

The 17-story headquarters is built on a 16-acre site at the western end of the Civic Center in downtown Los Angeles. Prior to its current arrangement, the DWP was dispersed in six downtown office buildings and in a few other locations. The program for the project was specified through the criteria of the space-utilization analysis, an operative strategy combining space planning with economic forecasting to increase efficiency. In plan, the functional scheme follows fairly traditional principles: a core

In dem Buch »Los Angeles. The Architecture of Four Ecologies« bezeichnet der Architekturhistoriker Reyner Banham das Department of Water and Power (DWP) »als das einzige öffentliche Gebäude, das dem Maßstab und der Bedeutung der Stadt entspricht«. Das Bürogebäude, das von der Tages- und Fachpresse seit Mitte der 60er-Jahre als ein Wahrzeichen der Stadt gepriesen wurde, erhielt zahlreiche Architektur-Preise, darunter 1967 den Honor Award der Sektion Südkalifornien des AIA als eines von zwölf hervorragenden Bauten in der Region zwischen Santa Barbara und San Diego und den Architectural Grand Prix als ein Beispiel der »bedeutendsten Architektur, die in Los Angeles zwischen 1947 und 1967 geschaffen wurde«.

Das 17 Stockwerke hohe Verwaltungsgebäude steht auf einem 8 Hektar großen Grundstück am westlichen Rand des Civic Center im Zentrum von Los Angeles. Bevor dieser Bau errichtet wurde, war das DWP verstreut auf sechs innerstädtische Bürogebäude und auf einige andere Orte. Das Raumprogramm des Bauwerks folgte einer Raumnutzungs-Analyse, einem Verfahren, bei der sich Raumplanung mit wirtschaftlichen Prognosen verband, um die Effektivität zu steigern. Der Funktionsplan folgt weitgehend traditionellen Grundsätzen: Die Versorgungsleitun-

Dans le livre intitulé « Los Angeles. The Architecture of Four Ecologies », l'historien d'architecture Reyner Barnham qualifie le Département de l'Eau et de l'Energie (DWP) de « seul geste d'architecture publique, qui corresponde au style et à l'échelle de la ville ». Salué par la presse professionnelle et le grand public comme un des plus intéressants monuments de la ville depuis le milieu des années 1960, cet immeuble de bureaux a reçu de nombreux prix. Parmi eux, le prix d'honneur du chapitre de Californie du Sud de l'AIA pour « l'un des plus remarquables bâtiments édifiés en Californie du Sud (de Santa Barbara à San Diego). Il a également remporté le Architectural Grand Prix décerné à « l'une des plus importantes réalisations architecturales des années 1947–1967 ».

Ce siège social de 17 niveaux est édifié sur un terrain de huit hectares à l'extrémité ouest du Civic Center, dans le centre de Los Angeles. Le DWP était auparavant réparti entre six immeubles du centre-ville et quelques autres adresses. Le programme fut mis au point après une analyse d'utilisation de l'espace, stratégie opérationnelle qui combine la planification de l'espace et la prévision économique pour en améliorer l'efficacité. En plan, le schéma fonctionnel respecte des prin-

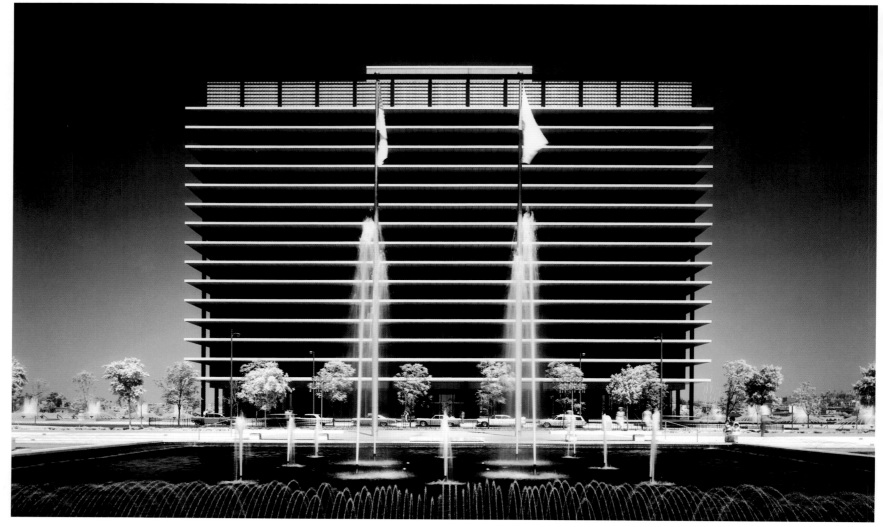

of services in the middle and office space on the perimeter. 880,000 square feet gross floor area, distributed on fifteen levels, provides office space for 3,200 employees. The interior space is based on a four-foot-two-inch module. The siting of the tower reads like a neoclassical statement. Erected on a three-story parking pedestal, it stands isolated in the middle of a 625 x 350-foot reflection pool and commands the attention as an urban monument. Whether driving or walking, one always experiences the building visually from the bottom up. Water and light are the recurring elements in the project. At night, the tower resembles an out-of-scale light fixture. During the day, the pool reflects the sunrays onto the underside of the horizontal concrete canopies cantilevered twelve feet beyond the exterior steel columns. Inside, the spiral stairway of stone, steel, and wood leads from the cafeteria to the main level.

gen liegen in der Mitte und der Bürobereich am äußeren Rand. Die Gesamtfläche von 82 000 m², verteilt auf 15 Geschosse, bietet Büroraum für 3 200 Angestellte. Der Innenraum basiert auf einem 1,25 m-Modul. Die Platzierung des Gebäudes mutet neoklassizistisch an. Auf einem dreistöckigen Parksockel steht er wie ein Monument isoliert in der Mitte eines 190 x 107 m großen reflektierenden Wasserbeckens. Beim Fahren wie im Gehen erlebt man das Gebäude visuell immer von unten aufsteigend. Wasser und Licht sind die stets wiederkehrenden Elemente dieses Bauwerks. Nachts ähnelt der Turm einem überdimensionalen Leuchtkörper. Tagsüber reflektiert das Wasser die Sonnenstrahlen auf die Unterseite der Betonvordächer, die 3,60 m über die äußeren Stahlrahmen auskragen. Innen führt eine Wendeltreppe aus Stein, Stahl und Holz von der Cafeteria zum Hauptgeschoss.

cipes assez traditionnels : noyau de services au centre et bureaux en périmétrie. Les 82 000 m² de surface utile brute, distribués sur 15 niveaux permettent d'accueillir 3 200 employés. Les aménagements intérieurs reposent sur une trame de 1,25 m. La façade suit un ordre néoclassique. Erigé sur un soubassement de trois niveaux consacré aux parkings, cette immeuble monumental se dresse isolé au milieu d'un bassin de 190 x 107 m. Que ce soit en voiture ou à pied, le premier contact visuel avec l'immeuble se fait toujours en contre-plongée. L'eau et la lumière sont omniprésentes. La nuit, la tour ressemble à un gigantesque luminaire. De jour, le bassin réfléchit le soleil sur les faces internes des pare-soleil de béton en porte-à-faux de 3,60 m par rapport aux montants d'acier. A l'intérieur, un escalier en spirale en dalles acier et bois, relie la cafétéria au niveau principal.

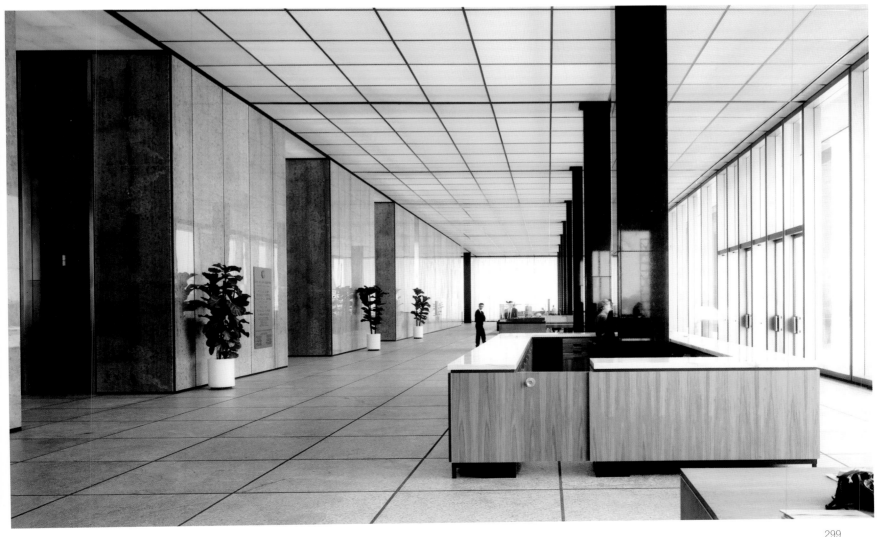

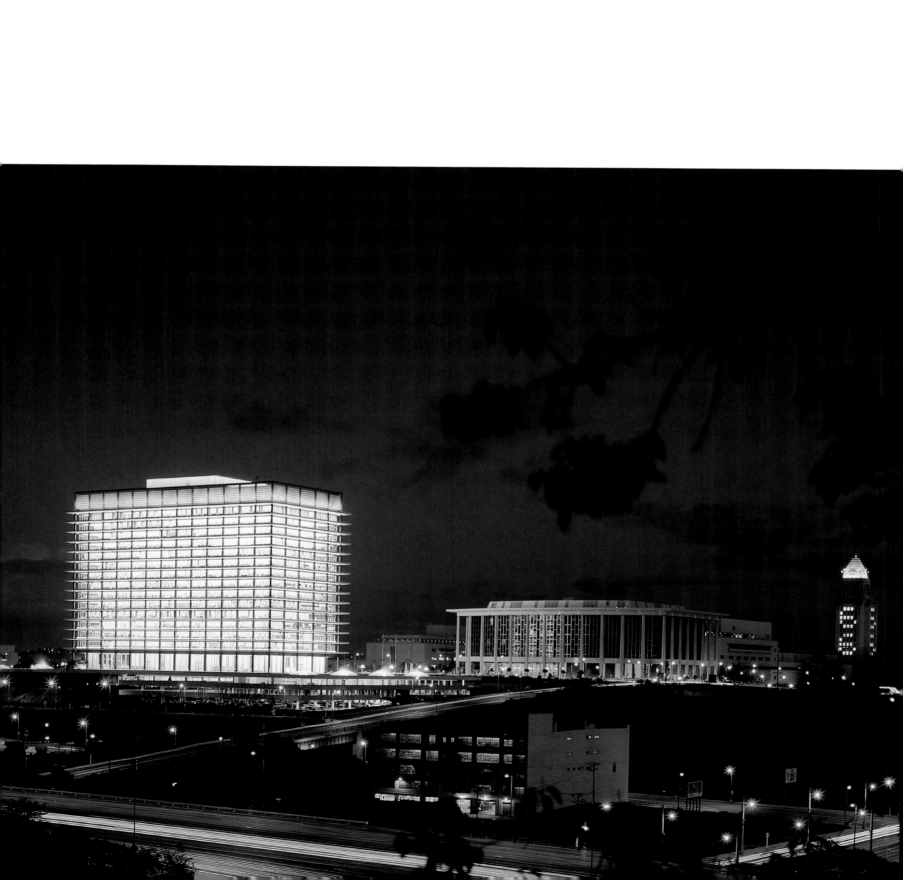

Selected Bibliography:
- The American City, June 1964
- The American City, March 1966
- Progressive Architecture, March 1966
- Architecture/West, June 1966
- Los Angeles Times West Magazine, February 19, 1967
- Architecture/West, March 1967
- Architectural Grand Prix, Los Angeles 1967
- Designers West, January 1968
- Post Earthquake Analysis: San Fernando Earthquake of February 9, 1971, The Department of Water and Power Headquarters Building, Los Angeles, California, in: Structural Engineers Association of Southern California, Los Angeles 1972

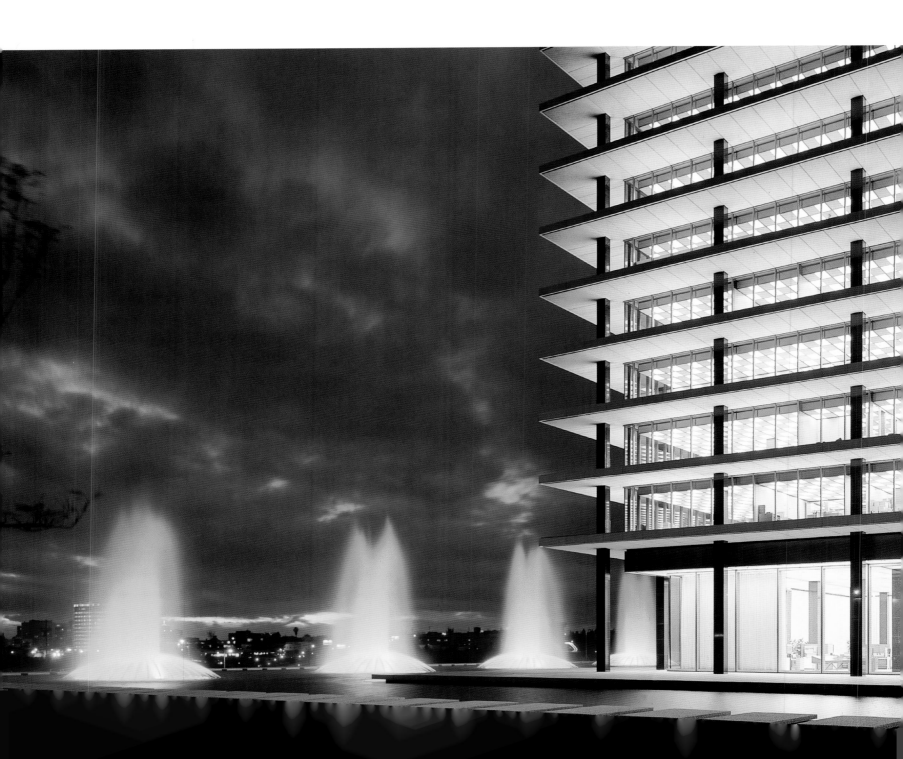

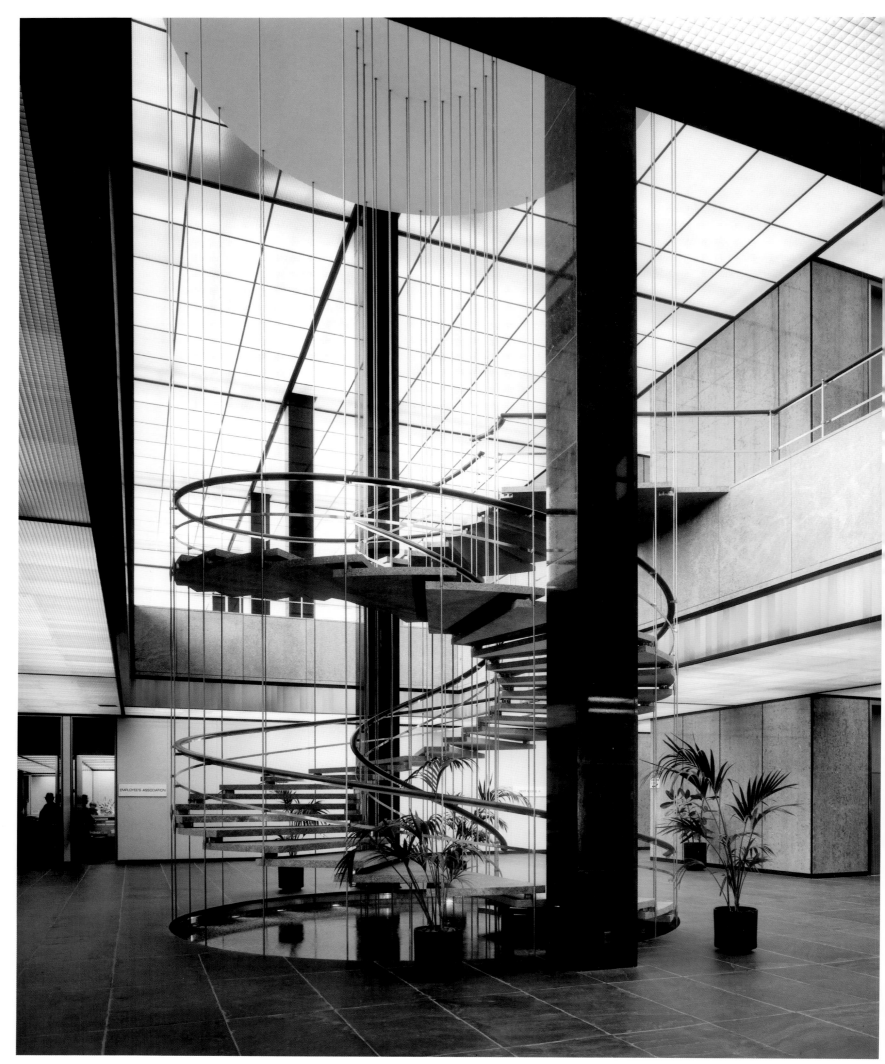

3899 Edward A. Grenzbach
Staude Residence, Hollywood, California
July 15, 16, 1965

The residence is designed as an exhibition space for the client's art collection. Showcased on two floors, the artwork collected over 30 years includes mobiles by Alexander Calder and paintings by Maurice de Vlaminck. The owner, Marguerite Brunswig Staude, was a renowned sculptor. Her studio is located on the second level. The living room is 20 feet tall and glass-walled toward the sheltered patio with a pool and a garden. The entry garden was designed by Garret Eckbo.

Das Haus sollte vor allem als Ausstellungsgalerie für die Kunstsammlung der Bauherrin dienen. Auf zwei Etagen sind in Vitrinen die in 30 Jahren gesammelten Kunstwerke ausgestellt, daneben hängen Mobiles von Alexander Calder und Gemälde von Maurice de Vlaminck. Die Eigentümerin, Marguerite Brunswig Staude, war selbst eine bekannte Bildhauerin; ihr Atelier befindet sich im Obergeschoss. Der Wohnraum ist 6 m hoch und zum Garten mit geschütztem Patio und Schwimmbecken voll verglast.

Cette résidence a été conçue pour abriter la collection d'art que la cliente a réunie en 30 ans. Les œuvres présentées sur deux niveaux comprennent entre autres des mobiles d'Alexander Calder et des peintures de Maurice de Vlaminck. La propriétaire, Marguerite Brunswig Staude, était un sculpteur renommé dont l'atelier se trouvait au second niveau. La salle de séjour haute de 6 m donne par un mur de verre sur un patio orné d'un bassin et un jardin. Garret Eckbo a créé le jardin de l'entrée.

Selected Bibliography: - Los Angeles Times Home Magazine, October 10, 1965

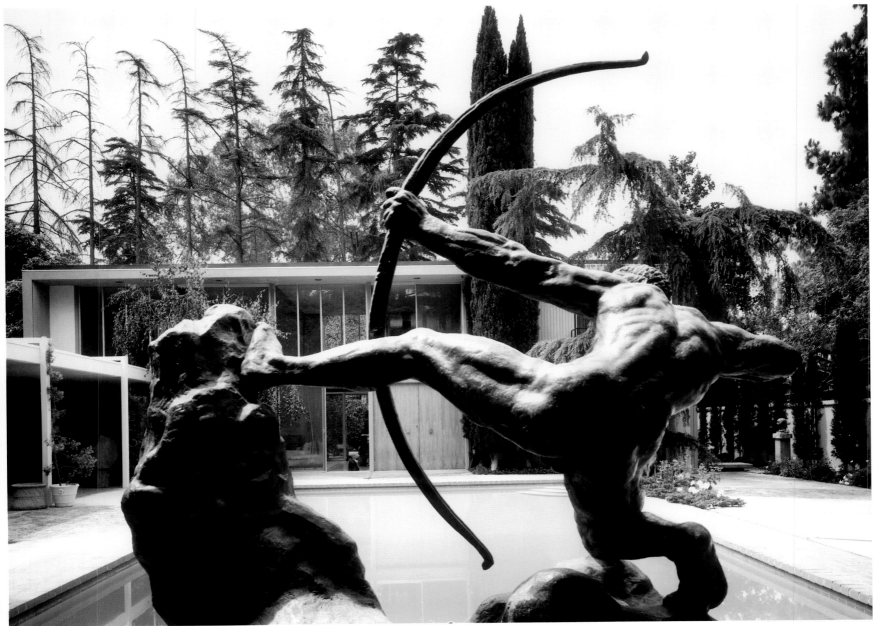

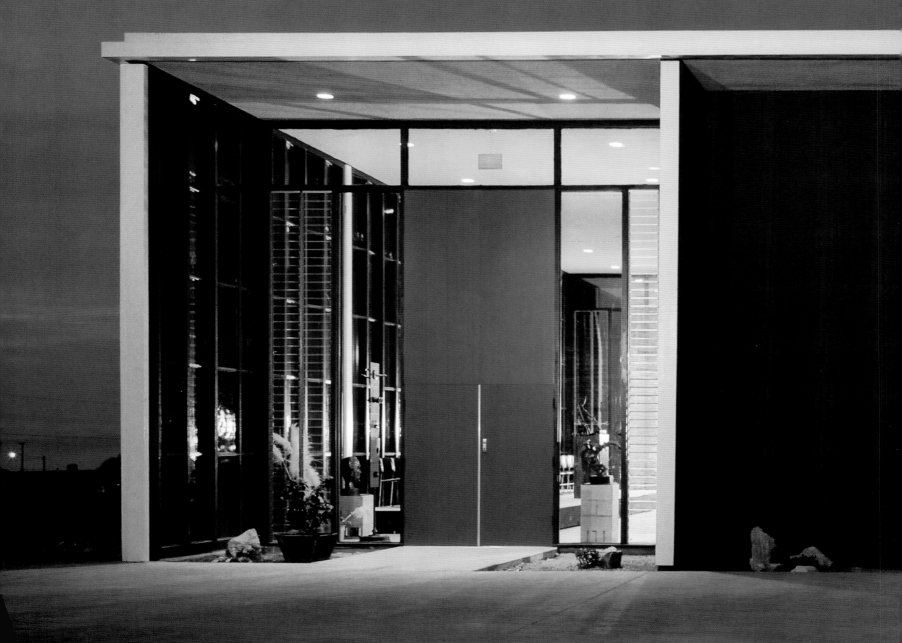

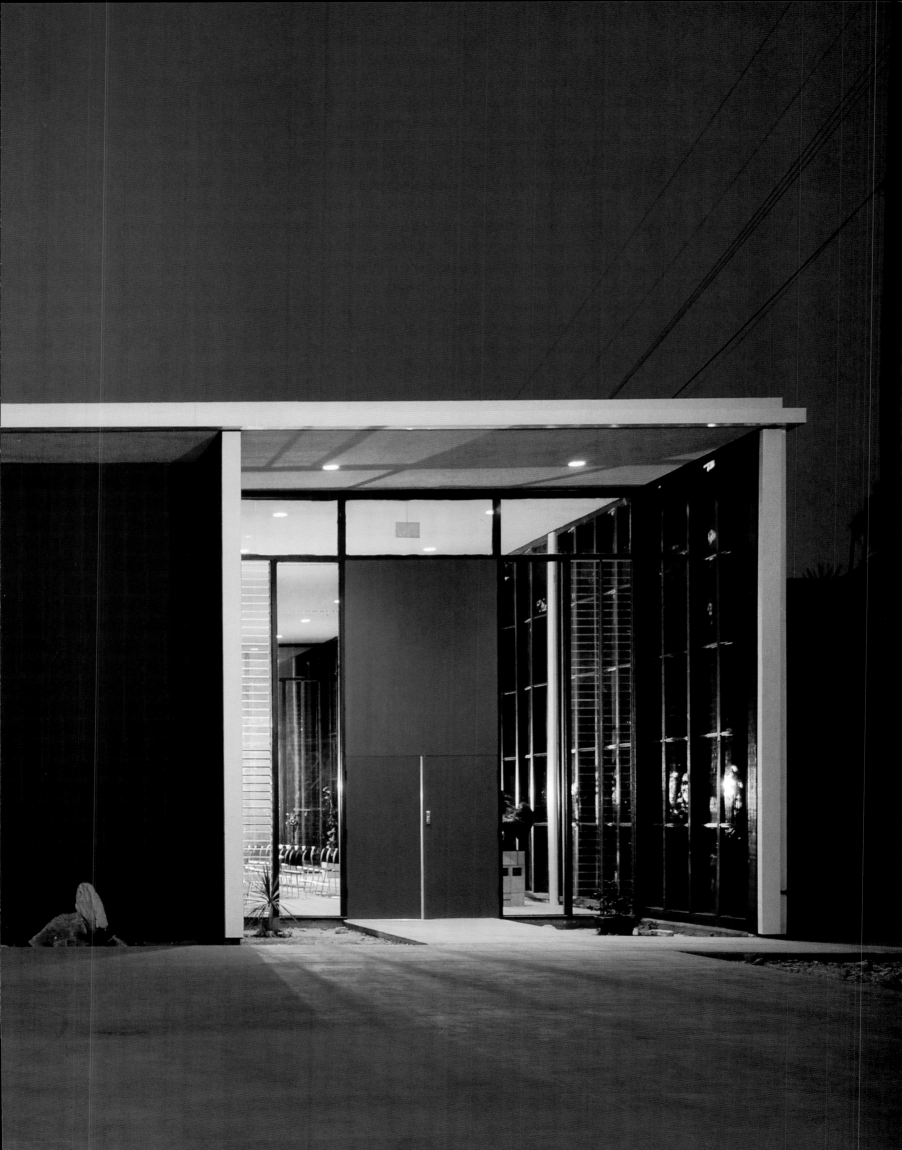

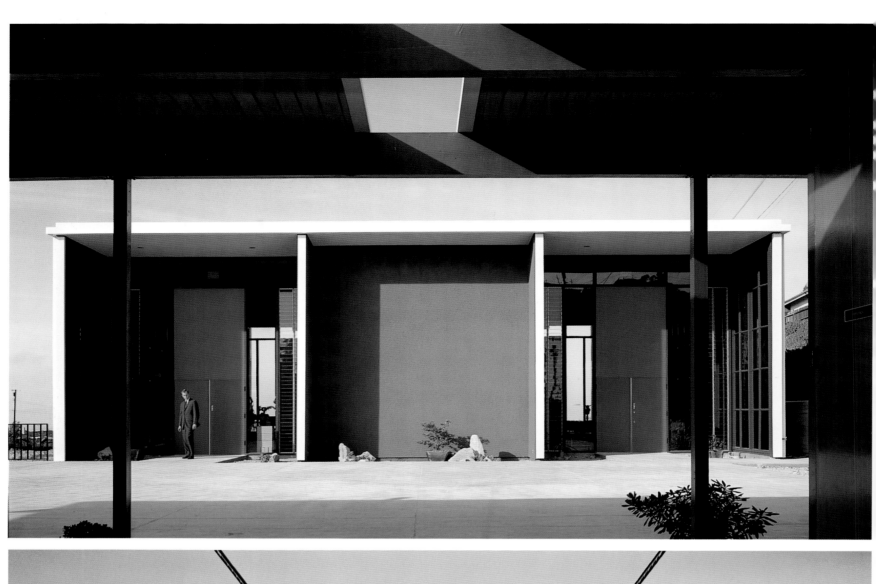

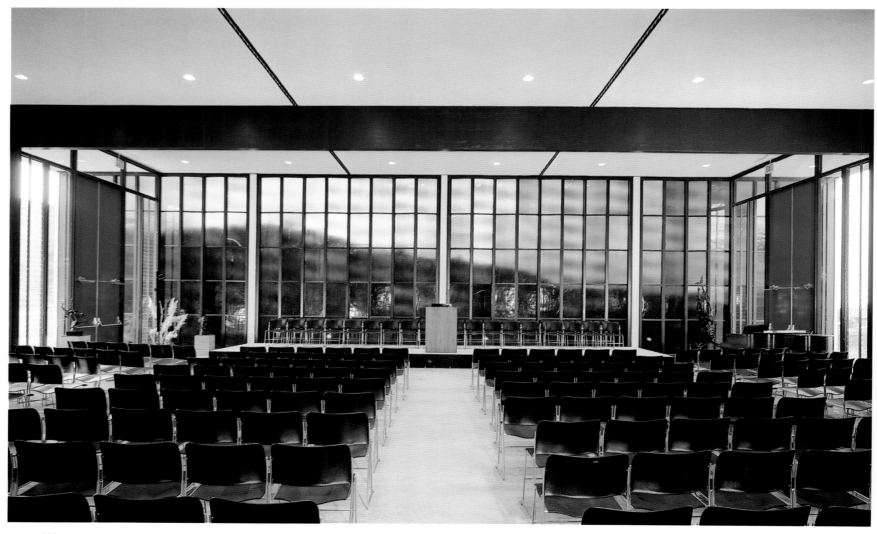

3958 **Buff & Hensman**
Nicolait Residence, Palos Verdes, California
November 9, 1965

Building codes in the Palos Verdes Estates contributed a rather distinct character to the area. The architects incorporated that mood into the design of a residence for a couple and their two teenage children. The site, windy and foggy at times, is a slope facing the Santa Monica Bay. The owners wished their home to have a minimum impact on the surrounding natural setting. A workshop and a storage room on the lower level form the structural base for the development of a single-level plan. Based on four-foot module, the house is U-shaped and wraps around a sheltered patio. The eastern wing is occupied by the children's units, a multi-purpose room and the kitchen. On the opposite wing the entry is flanked by the master suite on one end and the garage toward the hillside. In the middle section, the living room has the horizon set toward the Malibu Mountains, while the dining area opens to the covered loggia and the indoor garden. Quarry-tile paving suggests architectural continuity between entry hall, dining room and loggia. The spiral driveway parallels the entrance walk which curves down from the roadway.

Aufgrund der in Palos Verdes geltenden Baugesetze bietet dieses Wohnviertel ein charakteristisches Erscheinungsbild, das die Architekten in ihrem Entwurf für eine vierköpfige Familie berücksichtigten. Das manchmal windgepeitschte und in Nebel gehüllte Grundstück liegt an einem Hang oberhalb der Bucht von Santa Monica. Die Nicolaits wünschten ein Haus, das sich so unauffällig wie möglich in die Landschaft einfügen würde. Ein Ladengeschäft mit Lagerraum auf der unteren Etage bildet den Sockel, auf dem der Wohnbungalow errichtet wurde. Das im Plan auf einem 1,20 m-Modul basierende Haus bildet ein U um einen geschützten Patio. Im Ostflügel sind die Kinderzimmer, ein Mehrzweckraum und die Küche untergebracht, im Westflügel wird der Hauseingang vom Elternschlafzimmer mit Meerblick und der Garage am Hang flankiert. Das Wohnzimmer im Mitteltrakt bietet Ausblick auf die Berge von Malibu, während das Esszimmer sich zur überdachten Loggia und dem bepflanzten Innenhof öffnet. Böden aus Natursteinplatten sorgen für gestalterische Kontinuität zwischen Eingangsdiele, Esszimmer und Loggia. Die geschwungene Zufahrt von der Straße bildet zugleich den Fußweg zum Haus.

La réglementation de la construction des Palos Verdes Estates impose un caractère assez particulier à ce domaine. Les architectes l'ont intégré à ce projet de résidence pour un couple et ses deux jeunes enfants. Le site en pente, venteux et brumeux par moments, se trouve face à la baie de Santa Monica. Les propriétaires souhaitaient que l'impact de la maison sur son cadre naturel soit réduit au minimum. Un atelier et une pièce de rangement au niveau inférieur constituent la structure de base sur laquelle se repose la partie habitable construit selon une trame de 1,20 m. Le plan est en forme de U qui entoure un patio protégé. Une aile est occupée par les chambres des enfants, une pièce polyvalente et la cuisine, l'aile opposée par l'entrée, la suite principale d'un côté et le garage orienté vers la colline de l'autre. Au centre, la salle de séjour jouit du panorama des Malibu Mountains, tandis que la salle à manger s'ouvre sur une loggia couverte et sur le jardin intérieur. Des dalles de terre cuite identiques dans le hall d'entrée, la salle à manger et la loggia suggèrent une continuité architecturale. Une allée en courbe pour voitures et piétons descend de la rue à la maison.

Selected Bibliography: - *Los Angeles Times Home Magazine, May 22, 1966*

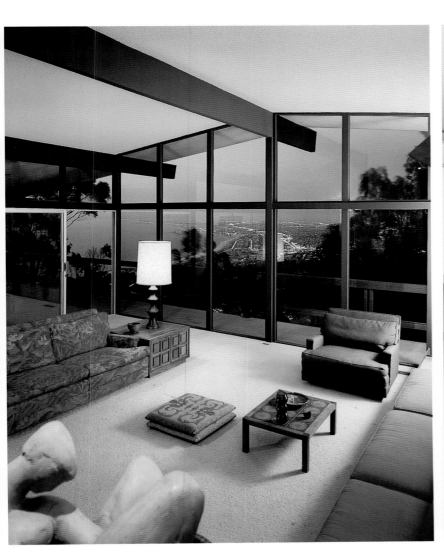

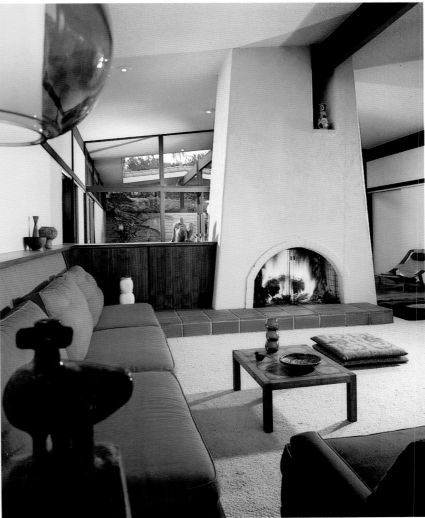

3988 A. Quincy Jones
Jones Residence, "The Barn", Los Angeles, California
February 11, 1966

Selected
Bibliography:
- *Los Angeles Times Home Magazine, May 22, 1966*
- *Progressive Architecture, May 1966*
- *Process Architecture, number 41, October 1983*

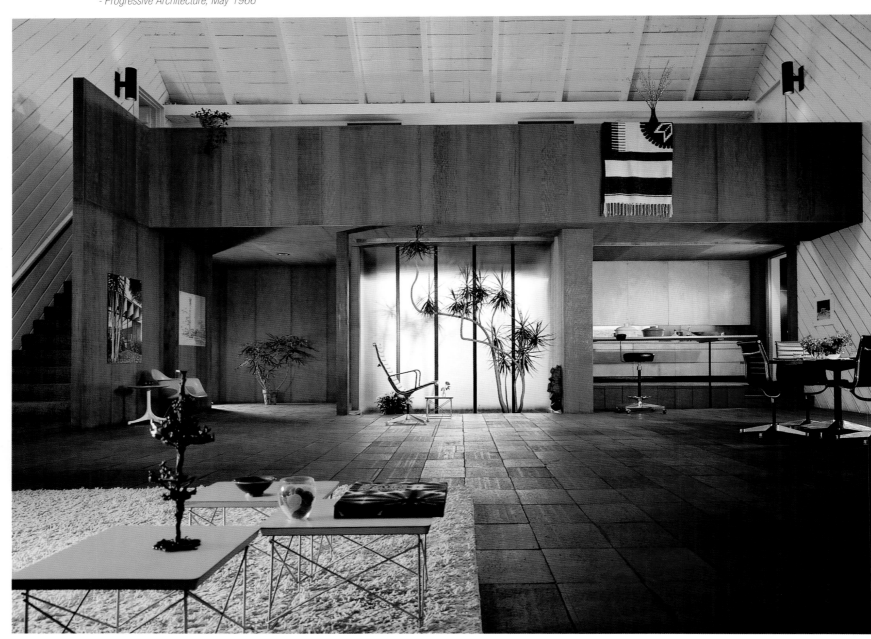

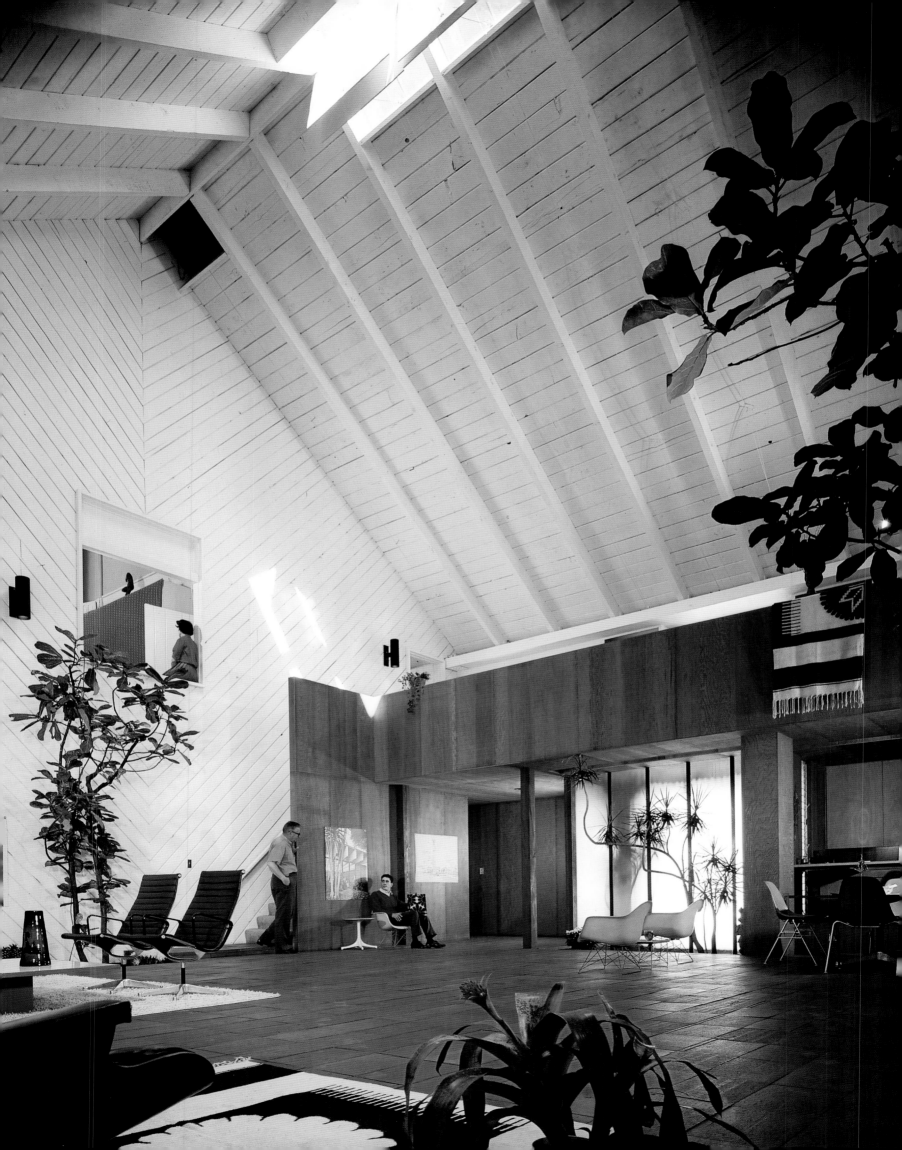

Jones referred to his third house (see p. 021 and 164) as the "Barn", due to its resemblance to New England barns. Standing on a commercial 45 x 125-foot property adjacent to Century City, the residence was only a few miles away from Jones and Emmons' main office on the Santa Monica Boulevard. Originally the Barn was a photography studio, whose construction dated back to 1950–1951. Jones' remodeling leaves the load-bearing structure largely untouched but clears many internal partitions to free 6,500 square feet of space for his residence and home studio.

In sharp contrast to the understated street front, like that of to a typical wood frame construction, the interior exhibits a grand hall, which functions as the hub of the house. Jones, who combined his professional practice with teaching design at the University of Southern California, used to meet here, four times a week, with ten architecture students. The double-height stu-

Sein drittes Haus (siehe S. 021 und 164) nannte Jones »Scheune«, weil es große Ähnlichkeit mit den Bauernscheunen Neu-Englands aufwies. Es entstand auf einem ca. 14 x 38 m großen Grundstück, nur wenige Meilen entfernt von Jones und Emmons' Hauptbüro am Santa Monica Boulevard. Ursprünglich war die »Scheune« ein Fotostudio, das 1950–1951 gebaut wurde. Beim Umbau ließ Jones das Tragwerk weitgehend unberührt, entfernte aber zahlreiche Trennwände, um großzügige Innenräume auf insgesamt 600 m² zu schaffen, die auch sein Arbeitszimmer umfassten.

Zur Straße hin wirkt der Bau wie ein typisches schlichtes Holzhaus, das Innere enthält jedoch einen riesigen Raum, der den Mittelpunkt des Hauses bildet. Jones, der neben seiner Tätigkeit als selbständiger Architekt an der University of Southern California lehrte, versammelte hier vier Mal in der Woche zehn Architekturstudenten. Der zweigeschossige Raum (ca. 9 x 12 m und

Jones appelait sa troisième maison (voir p. 021 et 164) la « Grange », en référence aux granges de Nouvelle-Angleterre. Edifiée sur un terrain de 14 x 38 m adjacent à Century City, elle ne se trouvait qu'à quelques kilomètres de l'agence principale de Jones et Emmons sur Santa Monica Boulevard. A l'origine, c'était un studio de photographe construit en 1950–1951. Le travail de rénovation de Jones a laissé la structure porteuse pratiquement intacte, mais éliminé de nombreux cloisonnements internes pour libérer les près de 600 m² nécessaires à son habitation et à son bureau.

Par contraste avec la discrète façade sur rue, qui rappelle les constructions traditionnelles à ossature en bois, l'intérieur révèle un énorme hall, cœur fonctionnel de la maison. Jones, qui en dehors de son travail d'agence enseignait la conception à l'Université de Californie du Sud, avait l'habitude de réunir ici, chaque semaine, une dizaine de ses étudiants. Le volume de

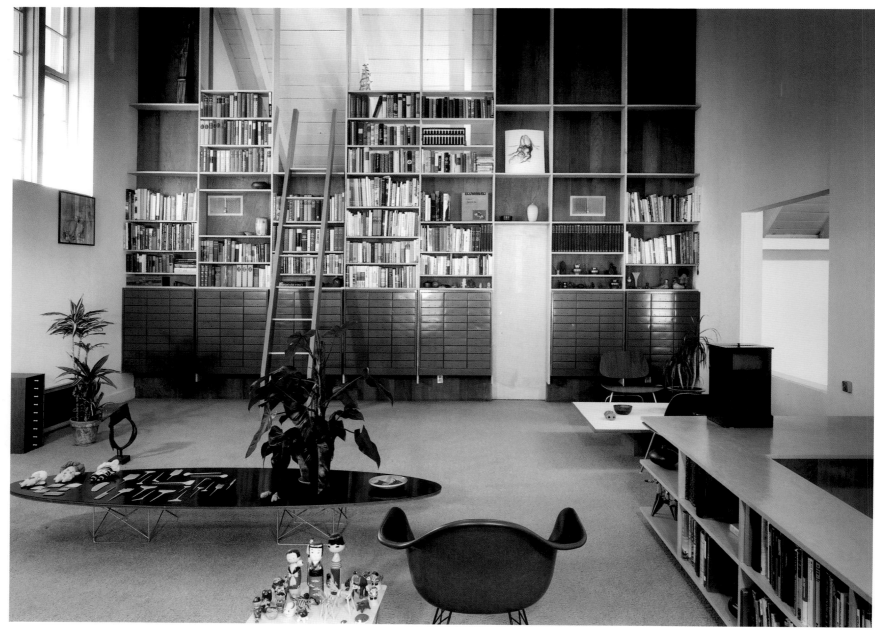

dio space, 30 x 40 square feet and 30 feet high at the ridge beam, is used for large gatherings and can accommodate up to 50 people. Slides and movies are projected against the white interior walls from the balcony ledge at the second level. The living-dining areas, the office and a private outdoor patio occupy the entire first floor. On the upper level, the balcony separates the sleeping zones from Jones' own studio and a drafting room. On the second level, the window of the master bedroom looks across the large studio to the window in the drafting room. The two internal facades in the big hall generate a quasi-urban experience. Four adjustable vents installed at the ridge roof together with large glazed surfaces at the entry alcove provide the main source of light in the main-studio. Resawn redwood boards painted white pattern the exterior facade and the interior elevation.

9 m hoch unter dem Firstbalken) wurde für größere Versammlungen mit bis zu 50 Personen genutzt. Dias und Filme wurden von der Galerie im Obergeschoss auf die gegenüberliegende weiße Wand projiziert. Wohn- und Esszimmer, Büro und ein privater Innenhof nehmen das gesamte Erdgeschoss ein. Die Galerie im Obergeschoss liegt zwischen Jones' Büro und einem Zeichensaal auf der einen und den Schlafzimmern auf der anderen Seite. Durch ein Fenster in der Innenwand des Schlafzimmers blickt man durch die Halle auf das Fenster des Zeichensaals. Auf diese Weise bieten die Innenfassaden der großen Halle einen quasi städtischen Blickhorizont. Vier verstellbare verglaste Lüftungsklappen am First sowie die großen Glasflächen des Windfangs am Eingang bilden die Haupt-Tageslichtquellen in der großen Halle. Weiß gestrichene Bretter dienen als Verkleidung von Wänden, Decken und Außenfassaden.

9 x 12 x 9 m de haut au faîtage, servait ainsi à des réunions nombreuses et pouvait recevoir jusqu'à 50 personnes. Des diapositives et des films étaient projetés sur les murs blancs à partir du balcon. La partie séjour/salle à manger, le bureau et un patio extérieur privé occupent la totalité du rez-de-chaussée. Au niveau supérieur, le balcon sépare les chambres du bureau de Jones et de son atelier de dessin. La fenêtre de la chambre principale donne sur le grand hall et vers l'atelier de dessin. Quatre ouvertures aménagées en bordure du faîtage et une grande ouverture vitrée dans l'alcôve de l'entrée constituent les principales sources d'éclairage du hall. Un bardage en bois rouge peintes en blanc donnent une texture particulière à la façade extérieure et à l'intérieur.

4001 Richard Dorman and Associates
Seidenbaum Residence, Los Angeles, California
March 21, 1966; April 12, 1966

The program requirements and the geology of the site above Sherman Oaks were primary factors in the final solution for the Seidenbaum residence. On one side, the poor soil conditions of the bank further increased the customary challenge of developing hillside land in Los Angeles. On the other, the owner, a *Los Angeles Times* columnist, and his wife, a sculptor, needed a place where they could pursue their professional interests undisturbed by their children's activities. Four pavilions, labeled "pods" by the architect, defer a house opening to the San Fernando Valley panorama and giving its back to the access road. The center two were joined on the same level, while the other two, at either end, were lower and detached. The house, 2,650 square feet in size, held three bedrooms, a family room, a living room and a kitchen. In plan, the studio, master bedroom and bathroom formed a separate unit located opposite the children's wing; the main living areas occupied the center of the scheme. The dramatic cantilever of the house sheltered the outdoor space for sculpting and jutted out over part of the swimming pool.

Since the house was oriented to the north, very little daylight came from the ceiling windows. On the peaked roofs, the architect placed south-facing clerestory windows to capture the sun

Das vom Bauherrn gewünschte Raumprogramm und die geologische Beschaffenheit des Grundstücks oberhalb von Sherman Oaks waren die bestimmenden Entwurfsfaktoren, wobei der instabile Hangboden die Aufgabe des Architekten erschwerte. Der Bauherr, Kolumnist der »Los Angeles Times«, und seine Frau, eine Bildhauerin, brauchten jedoch ein Zuhause, in dem sie ihren beruflichen Interessen ungestört von den Aktivitäten der Kinder nachgehen konnten. Der Architekt schuf vier separate Baukörper – er taufte sie »Kapseln« –, die sich zur weiten Aussicht in das San Fernando-Tal öffnen und von hinten von der Straße erschlossen werden. Die beiden in der Mitte waren auf der gleichen Ebene miteinander verbunden, die zwei seitlichen niedriger angelegt. Das 246 m² umfassende Haus enthielt drei Schlafzimmer, einen Familienraum, Wohnzimmer, Küche und das Atelier, das zusammen mit Elternschlafzimmer und Bad einen separaten Bereich bildete. Die Wohnräume befanden sich in der Mitte des dramatisch vom Hang auskragenden Hauses, welches so das Schwimmbecken (teilweise) und den Platz überdeckte, auf dem die Hausfrau im Freien an ihren Skulpturen arbeitete.

Da das Haus nach Norden orientiert war, erhielt es nur wenig Tageslicht durch die Dachoberlichter. Deshalb fügte der Archi-

Le contenu du programme et la géologie du terrain sont les principaux facteurs qui expliquent la solution retenue pour la maison des Seidenbaum. D'un côté, la nature du sol de ce terrain en pente rendait la tâche de l'architecte plus difficile ; de l'autre, le propriétaire, journaliste au « Los Angeles Times » et son épouse, sculpteur, avaient besoin d'un lieu où travailler sans être gênés par les activités de leurs enfants. Quatre pavillons, baptisés « cosses » par l'architecte, constituent la maison qui donne sur la vallée de San Fernando et tourne le dos à la route d'accès. Les deux éléments centraux sont réunis sur un même niveau, tandis que les deux autres, de chaque côté, sont implantés un peu en contrebas et séparés. La maison de 246 m² comprend trois chambres, un séjour familial, un salon-séjour et une cuisine. En plan, l'atelier, la chambre principale et sa salle de bains constituent un ensemble autonome à l'opposé de l'aile des enfants. Les principaux espaces de séjour occupent le centre du projet. Le spectaculaire porte-à-faux de la maison abrite en partie basse un espace extérieur réservé à la sculpture et qui surplombe une partie de la piscine.

La maison étant orientée au nord, l'architecte ouvrit des fenêtres hautes vers le sud, la lumière se réverbère sur les murs intérieurs. L'ossature et les habillages sont en bois, selon les

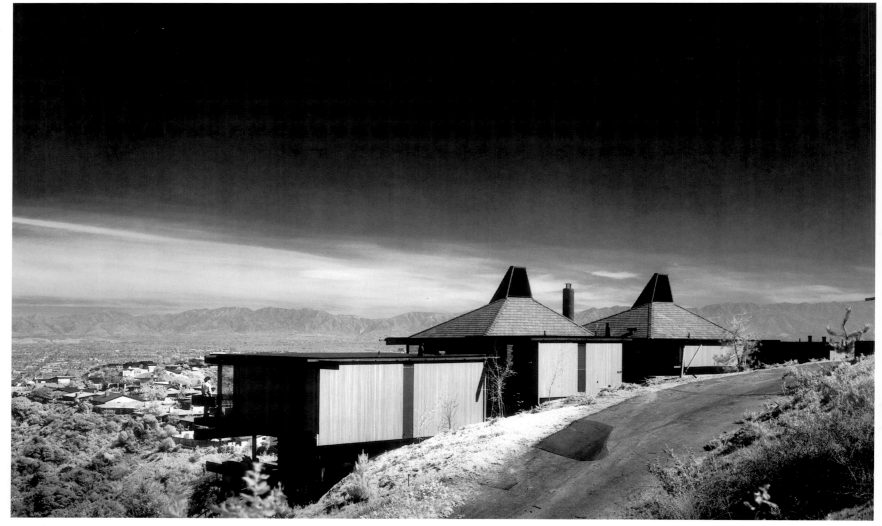

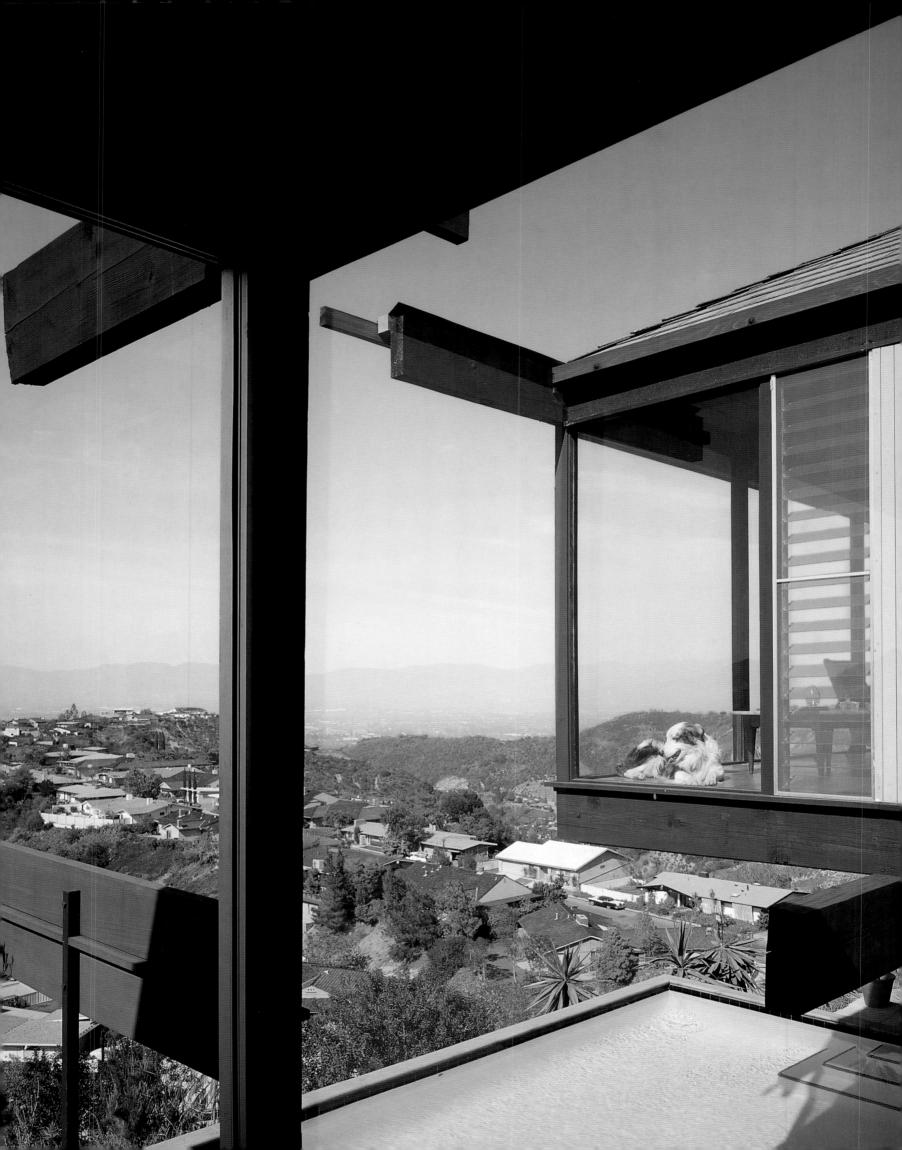

and reverberate the light in the interiors. Structure and finish were of wood, following to the the owners' requirements. Douglas fir was selected for the post-and-beam framing. Oak for all floors was finished in a charcoal stain. Redwood was used for the decks, the handrail and the exterior siding. Plaster was a code requirement on the structure's underside.

The Southern California Chapter of the American Institute of Architects listed the Art Seidenbaum Residence among the greatest Los Angeles pieces of architecture created between the years 1947–1967.

tekt seitliche Oberlichter in die nach Süden geneigten Dachflächen ein. Der Bauherr hatte ein Holzhaus gewünscht. Für die Pfosten-und-Riegel-Konstruktion verwendete Dorman Douglaskiefer, für die Holzdecks, Handläufe und Fassadenverkleidungen Redwood. Aufgrund der örtlichen Bestimmungen musste die Unterseite des Hauses verputzt werden.

Die Sektion Südkalifornien des American Institute of Architects führt das Haus Art Seidenbaum in der Liste der hervorragendsten Bauten in Los Angeles aus der Zeit von 1947–1967.

souhait des propriétaires : l'ossature à poteaux et poutres en pin de Douglas, les parquets en chêne teinté noir, les terrasses, la balustrade et les habillages extérieurs en bois rouge. La réglementation obligeait à recouvrir de plâtre les faces internes de l'ossature.

Le chapitre de Californie du Sud de l'AIA a classé la Seidenbaum Residence parmi les plus importantes œuvres architecturales édifiées à Los Angeles de 1947 à 1967.

Selected Bibliography:
- arts & architecture, February 1965
- Los Angeles Times Home Magazine, May 22, 1966
- Architectural Record Houses of 1967
- Architectural Grand Prix, Los Angeles 1967

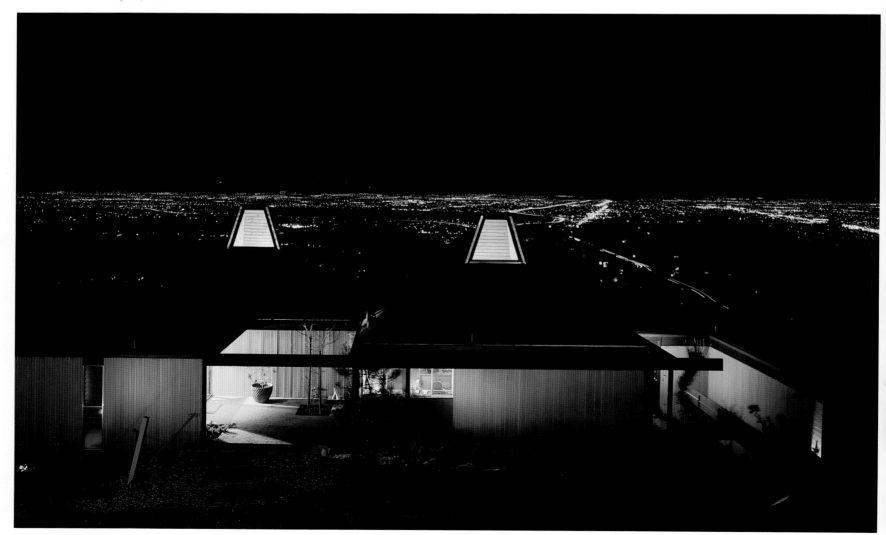

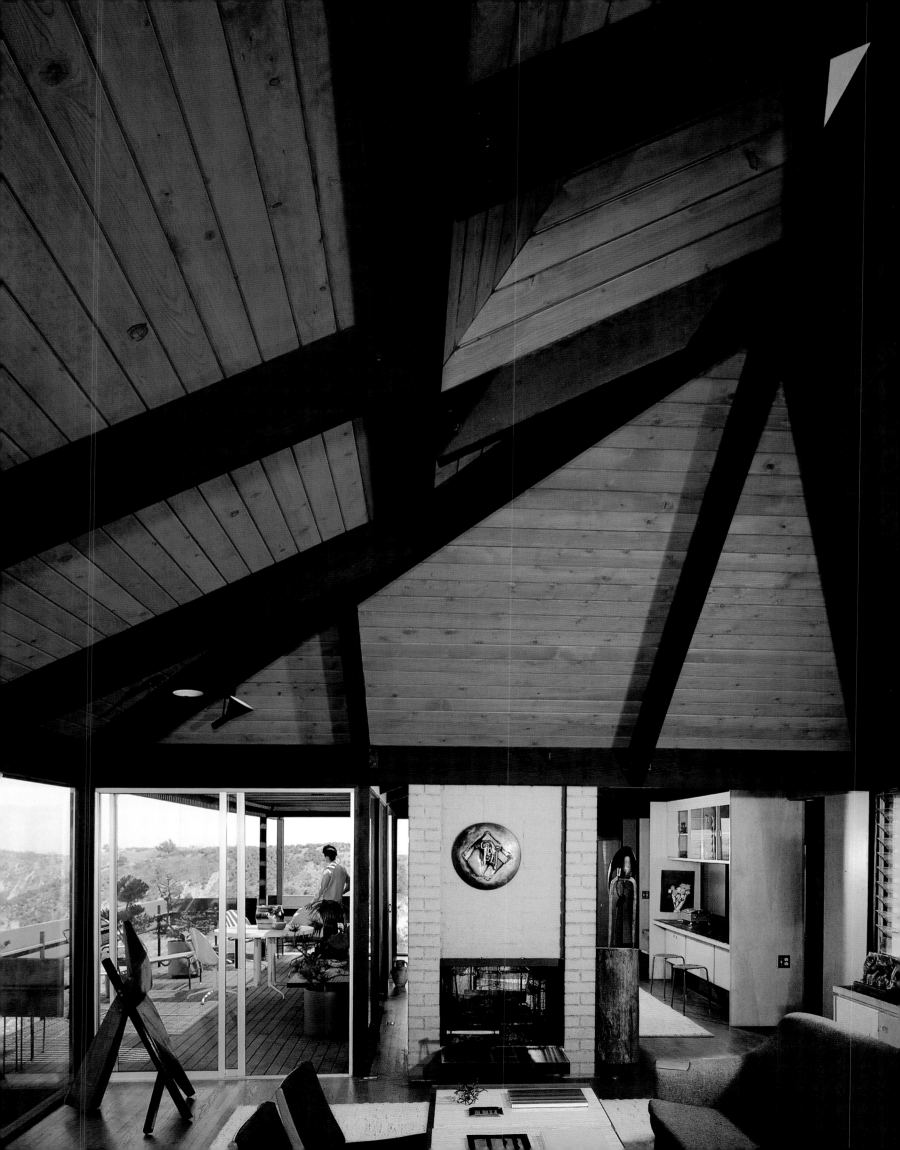

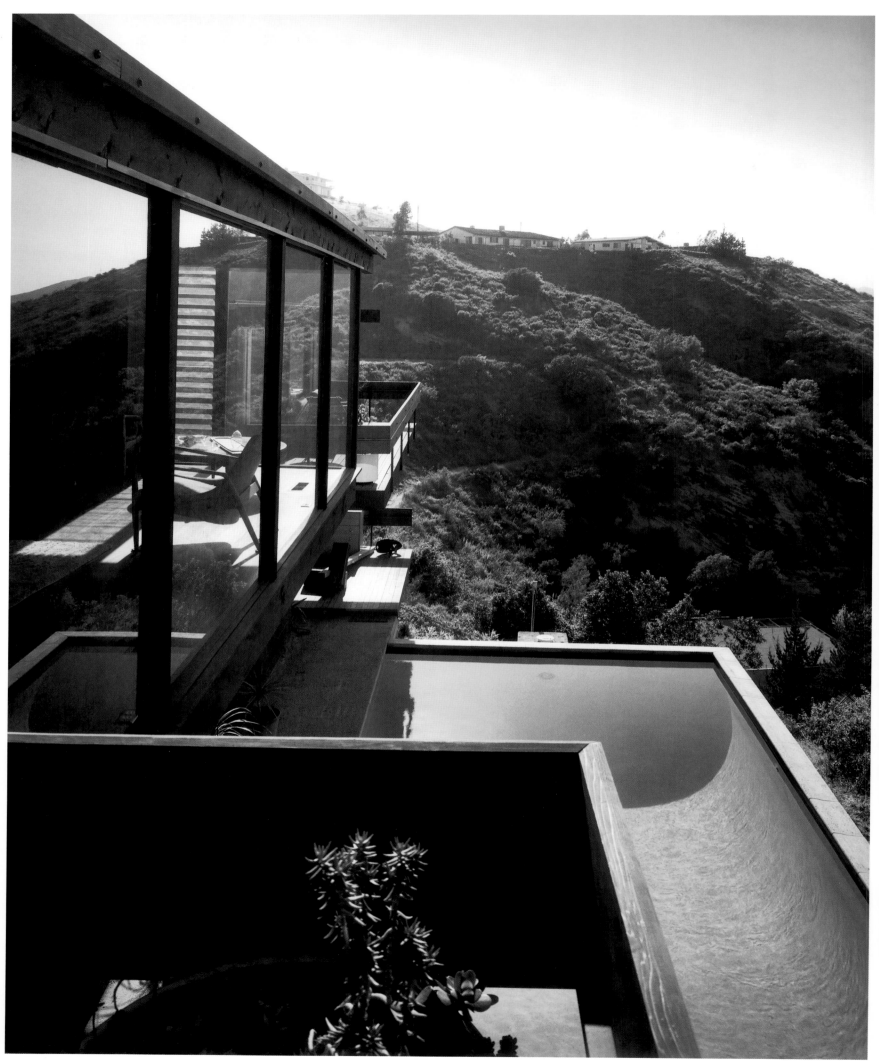

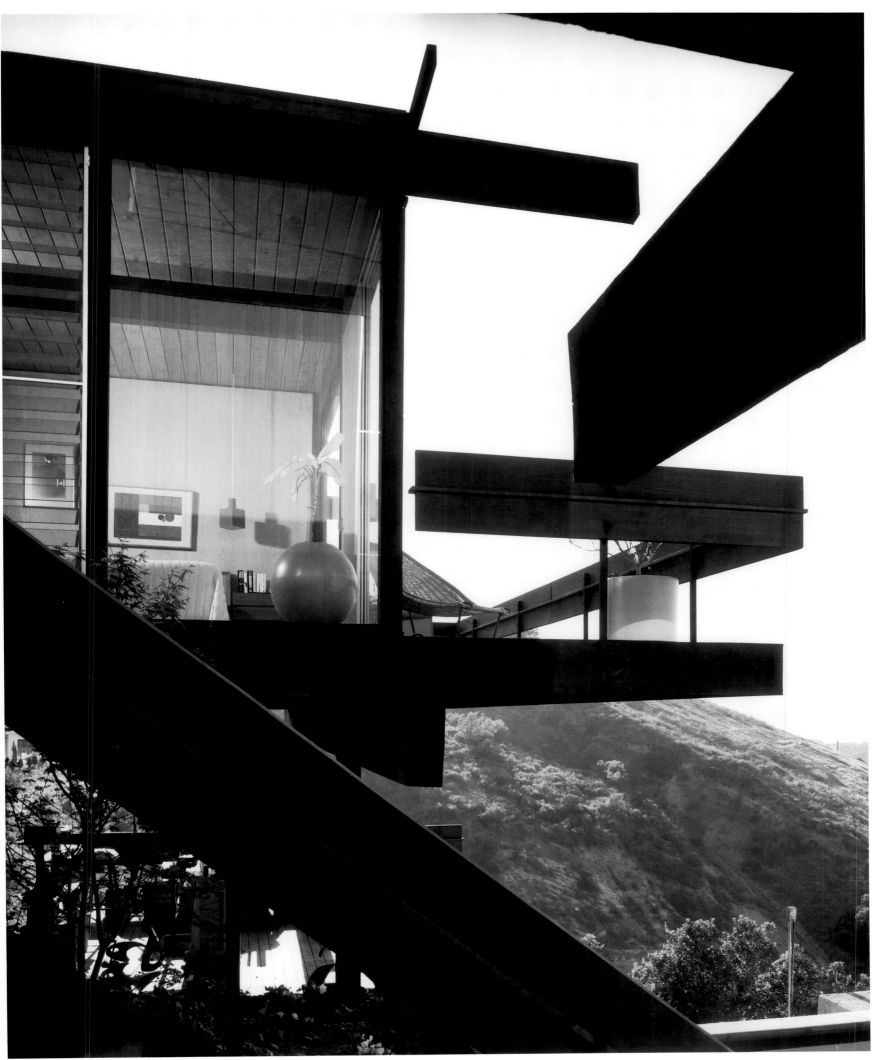

4036 **Uel Clifton Ramey**
Lutheran Church, University of Kansas, Lawrence, Kansas
May 28, 1966

The infrared overall view of this structure appeared in *Faith and Form*, a national journal specializing in religious architecture. The article was the editorial showcase for several awarded projects from all over the United States. Only in 1968 did the Lutheran Church and its adjacent Student Center get a Merit Award at the 29th National Conference on Religious Architecture, the project was completed in 1965.

Although usually attributed to Ramey and Jones, in the American *Architects Directory*, published in 1970, the church is listed among the designs authored by Ramey, yet it is not mentioned in Jones' biography. In addition, a brochure on the project, published by the local community and found in Shulman's archive, includes a short statement signed by Ramey on the architectural intents molding the space of the building. Both facts lead to the conclusion that Ramey might be the sole designer. The building was designed to accommodate the religious needs of the growing academic community of the University of Kansas.

Die Infrarot-Aufnahme dieses Gebäudes wurde in »Faith und Form« veröffentlicht, einer auf Sakral-Architektur spezialisierten Zeitschrift. Der Artikel eröffnete eine Serie über preisgekrönte Kirchen in den Vereinigten Staaten. Erst 1969 bekamen die Kirche und das angeschlossene Studenten-Zentrum eine Auszeichnung der 29. National Conference on Religious Architecture, obwohl das Projekt bereits 1965 fertiggestellt worden war. Meist wird dieses Projekt Ramey und Jones gemeinsam zugeschrieben. Im »American Architects Directory« von 1970 wird die Kirche Uel Clifton Ramey zugeschrieben, in Jones' Biografie wird sie jedoch nicht erwähnt. Außerdem enthält eine Broschüre der Gemeinde, die in Shulmans Archiv gefunden wurde, eine kurze Darstellung von Ramey über seine Vorstellungen zur räumlichen Gestaltung des Gebäudes. Beide Veröffentlichungen lassen darauf schließen, dass der Entwurf tatsächlich von Ramey allein stammt. Die Anlage wurde für die wachsenden Gemeinde der Universität von Kansas gebaut. Die Form

La photographie aux infrarouges de cette construction fut publiée dans « Faith and Form », revue de diffusion nationale spécialisée dans l'architecture religieuse. L'article présentait plusieurs projets d'églises primées, construites dans tous les Etats-Unis. Ce n'est qu'en 1968 que l'église et son Centre d'étudiants adjacent reçurent un prix du mérite de la XIXᵉ Conférence nationale d'architecture religieuse, bien que l'ensemble ait été achevé en 1965.

Bien que le projet ait été attribué à Ramey et Jones, d'après le « American Architects Directory » publié en 1970, l'église est citée parmi les projets de Ramey, et pas dans la biographie de Jones. Par ailleurs, une brochure sur le projet, publiée localement et retrouvée dans les archives de Shulman, reprend une courte déclaration signée de Ramey sur les intentions architecturales qui explique la forme du bâtiment. On peut donc penser que Ramey est le seul auteur de cette réalisation. La construction devait répondre aux besoins religieux de la communauté

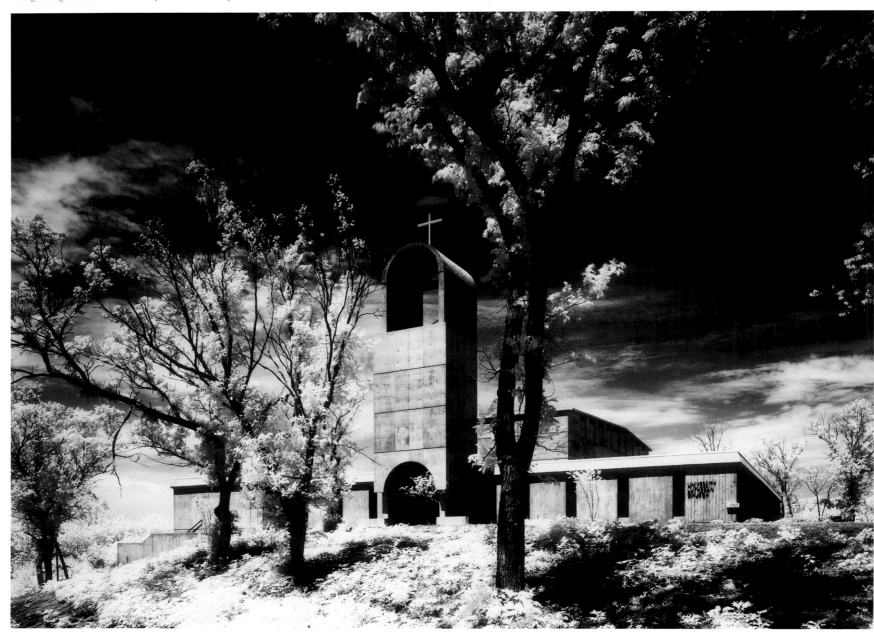

As shown in its diagrammatic plan, the form of the sacred enclosure originates from the pristine geometry of the square. The inner edges of the exterior walls house student facilities, whereas the altar occupies its core. As opposed to the traditional separation between worship space and congregation, the architect generated a space of intimate scale and encouraged a more active participation in the users by arranging the benches around the table. In the abstract, Ramey maintains that the archaic flavor of the tall bell tower with the barrel vault roof comes from architectural images belonging to the time and place of the birth of Christianity. Accordingly, the architect choose materials in the attempt to convey a message of permanence. The extensive use of reinforced concrete endows the project with a monolithic look reminiscent of designs that were produced during the period of architectural Brutalism.

des Sakralbereichs geht auf ein Quadrat zurück. In den äußeren Bereichen befinden sich studentische Einrichtungen, während der Altar das Zentrum der Anlage bildet. Entgegen der traditionellen Trennung zwischen Altarraum und Kirchenschiff hat der Architekt die Bänke rings um den Altar angeordnet und ermöglichte so eine aktivere Teilnahme am Gottesdienst. Ramey betonte, dass der archaische Charakter des hohen Glockenturms und das tonnengewölbte Dach durch frühchristliche Kirchen angeregt sei. Entsprechend wurden Materialien ausgewählt, die den Eindruck zeitloser Beständigkeit vermitteln. Die reiche Verwendung von Stahlbeton verleiht dem Bau eine monumentale Gestalt, die an Bauten des Brutalismus erinnert.

universitaire de l'Université du Kansas alors en plein développement. Comme le montre le plan, la forme du sanctuaire reprend celle d'un carré. Les installations pour étudiants sont repoussées sur les côtés, et l'autel occupe la partie principale. A la différence de la séparation traditionnelle entre le chœur et les fidèles, l'architecte a imaginé un espace plus intime avec des bancs groupés autour de l'autel pour encourager les fidèles à participer à l'office. Dans son résumé, Ramey soutient que l'allusion archaïsante du clocher à voûte en berceau vient d'images qui appartiennent à la naissance du christianisme. C'est dans cet esprit que l'architecte choisit des matériaux qui pouvaient véhiculer un sentiment de permanence. Le recours important au béton armé donne au projet un aspect monolithique qui rappelle certaines réalisations brutalistes.

Selected Bibliography:
- Faith and Form, July 1968
- Building Progress, December 1968

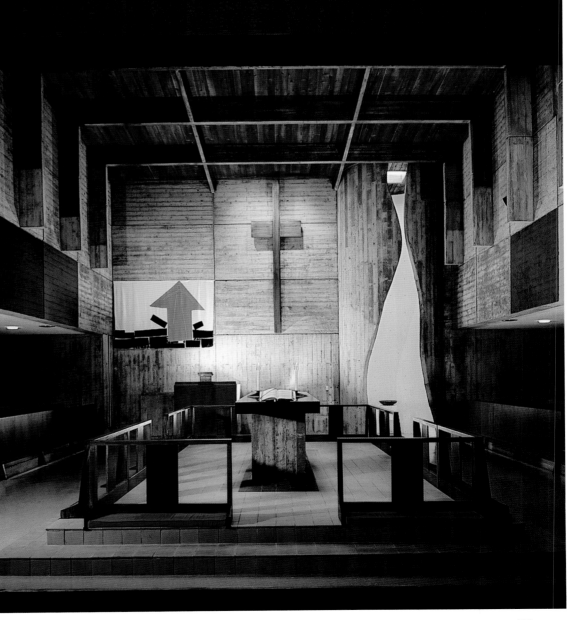

4073 **Killingsworth, Brady & Associates**
University Religious Center, Los Angeles, California
September 12, 1966

Five Protestant denominations –Methodists, Presbyterians, Lutherans, Baptists and Episcopalians – have office facilities and recreational rooms in this steel-frame complex for the University of Southern California.
A two-story colonnade of steel posts outlines a rectangular courtyard sheltered from the street, yet accessible from the outside from four points. The landing of the steel staircase connecting the two levels acts as podium for speeches in the courtyard and is treated as an outdoor auditorium. The 21-foot-tall chapel for 50 people is connected directly with the surrounding area. The street front incorporates four 60-year-old olive trees as part of the layout.

Fünf protestantische Kirchgemeinden – Methodisten, Presbyterianer, Lutheraner, Baptisten und Episkopalkirche – haben in diesem Stahlrahmenbau auf dem Gelände der University of Southern California Büros und Gemeinderäume. Eine über beide Geschosse reichende Stahlsäulen-Kolonnade umfasst einen rechteckigen Hof, den man von der Straße zwar nicht einsehen, an vier Ecken aber von außen betreten kann. Der Stahltreppenabsatz zwischen beiden Ebenen fungiert als Rednertribüne für Vortragsveranstaltungen und Gottesdienste im Hof. Die 6,30 m hohe Kapelle für 50 Gemeindemitglieder ist separat zugänglich. Die Straßenfront ist so gestaltet, dass 60 Jahre alte Olivenbäume erhalten werden konnten.

Cinq groupes religieux – méthodistes, presbytériens, luthériens, baptistes et épiscopaliens – possèdent des bureaux et des salles de réunion dans ce complexe à ossature d'acier édifié pour l'University of Southern California. Une colonnade composée de piliers d'acier sur deux niveaux entoure une cour rectangulaire abritée de la rue, bien qu'accessible de l'extérieur par quatre entrées. Le palier de l'escalier d'acier qui réunit les deux niveaux sert de podium pour des conférences ou des sermons aux fidèles réunis dans la cour, traitée comme un auditorium extérieur. La chapelle de 50 places et 6,30 m de hauteur est directement reliée à l'environnement. La façade sur la rue intègre quatre oliviers sexagénaires.

Selected
Bibliography: *- arts & architecture, January 1967*

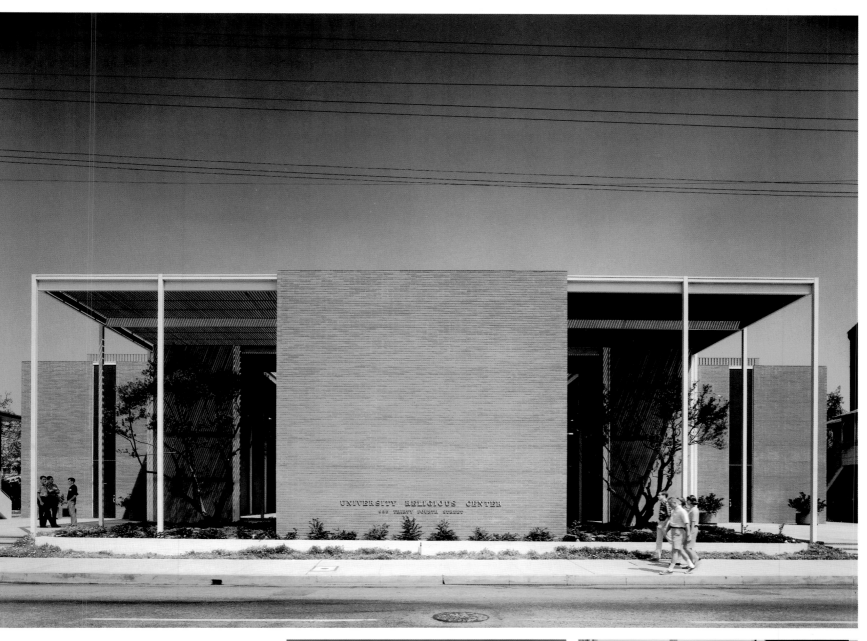

4075 Thornton M. Abell
Lebrun Residence, Zuma Beach, California
September 13, 1966

On an acre of land in a wide canyon heavily filled with vegetation, the architect configured a live-work space for an artist amidst an orchard of fruit trees. Southern coastal winds coming in from the ocean and the numerous sycamores on the northeast side of the lot dictated the layout of the residence.
The program requirement demanded a clear zoning separation between the studio and the living quarters to secure a minimum amount of disturbance. Abell apportions over half of the square footage to a work area for the artist, while the remaining area turns into a permanent exhibition space for Lebrun's artwork. The big studio provides spaces for the production of large-scale paintings, metal work, plaster sculpture, drawing, photography, plus storage space for the artwork and truck access to load

Der Architekt platzierte das Wohn- und Atelierhaus des Künstlers Rico Lebrun inmitten einer Obstwiese auf einem 1 Morgen großen Gelände in einem üppig bewachsenen breiten Canyon, der den von Süden – vom Pazifik – kommenden Winden ausgesetzt ist. Zahlreiche Platanen im Nordostabschnitt des Anwesens diktierten die Form des Grundrisses.
Lebrun hatte eine klare Trennung zwischen Atelier und Wohnbereich vorgegeben, und Abell wies Ersterem mehr als die Hälfte der Quadratmeterfläche zu. Der Wohnbereich entwickelte sich aber auch zum Ausstellungsraum für Lebruns großformatige Bilder, Metallarbeiten, Gipsplastiken, Zeichnungen sowie Fotos und enthielt Aufbewahrungsräume für Kunstwerke. Das Atelier versah Abell mit einer Art transluzentem Garagentor, so dass Lastwa-

C'est sur un terrain d'un demi-hectare dans un large canyon noyé dans la végétation, que l'architecte a créé pour un artiste, cet espace de vie et de travail situé au millieu d'un verger. Les vents de la côte et les nombreux sycomores en limite nord-est de la parcelle en ont en partie dicté le plan.
Le programme prévoyait une séparation nette entre l'atelier et l'habitation. Abell consacre plus de la moitié de la surface couverte à l'atelier, et fait des pièces de vie un lieu d'exposition permanent de l'œuvre de Rico Lebrun. Le grand atelier permet de réaliser des peintures de grand format, des sculptures en plâtre et en métal, des photographies. Il dispose d'un stockage et d'un accès réservé aux camions pour décharger les matériaux. Lorsque la porte de l'atelier de type garage, en panneaux

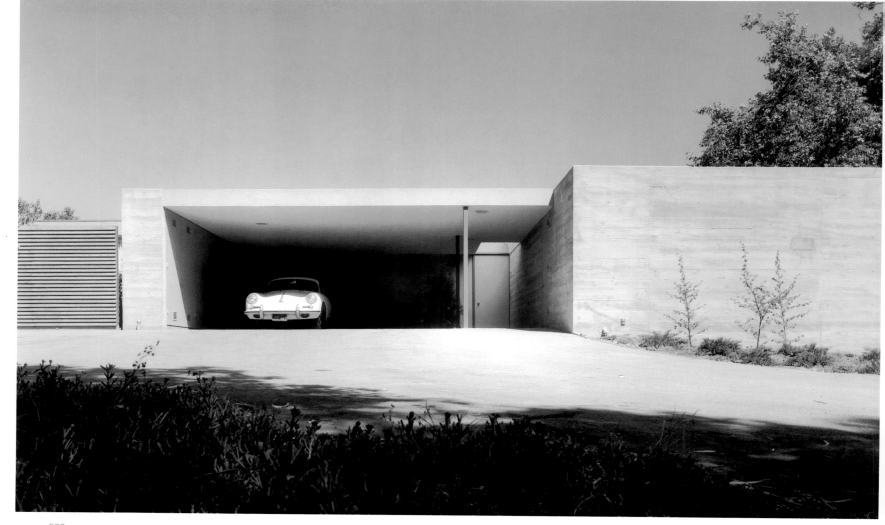

materials. When the garage-type door of the studio is raised, the inside work area extends outdoors sheltered by translucent panels.

Approached from an east road, the house appears closed to the exterior. The frame of the carport and the monolithic block containing the kitchen enclose the entry path. In sharp contrast with the solidity of the entry elevation, the interior space is lit through wide glass walls with thin window mullions and opens onto three exterior terraces and one interior court. Against the backdrop of the foliage, the texture of the wood reproduced in the board-formed concrete, used for both interiors and exteriors, create a visual continuity with the plank floors of the living room and bedrooms.

gen zum Verladen der Objekte heranfahren konnten. Geöffnet bildet das Tor ein Vordach, so dass der Künstler auch im Außenraum arbeiten kann. Von der Straße nach Osten wirkt das Haus verschlossen. Die Garagenwand und der monolithische Küchenblock fassen den Weg zum Eingang ein. Der durch breite Glasfronten mit dünnen Verglasungspfosten natürlich erhellte Innenraum bildet einen starken Kontrast zur Massivität der Eingangsfassade und öffnet sich zu den drei Außenterrassen und einem Innenhof. An den Sichtbetonmauern (innen wie außen) sind noch die Spuren der horizontal verlegten Schalungsbretter zu sehen, die für optische Kontinuität mit den Dielenbrettern im Wohnraum und in den Schlafzimmern sorgen.

translucides, est relevée, l'intérieur se dilate vers l'extérieur. De l'est, la maison semble entièrement fermée sur elle-même. La masse formée par l'abri aux voitures et le bloc monolithique qui contient la cuisine bordent l'allée d'entrée. Par contraste avec la masse extérieure, le volume intérieur est éclairé par de grandes parois de verre aux fins montants métalliques qui s'ouvrent sur trois terrasses extérieures et une cour intérieure.

Sur le fond de la végétation environnante, la texture du béton brut de décoffrage se retrouve à l'intérieur comme à l'extérieur et genère une continuité visuelle avec le sol en plancher du séjour et des chambres.

Selected Bibliography:
- arts & architecture, January 1967
- Architectural Record, December 1968
- Los Angeles Times Home Magazine, May 4, 1969

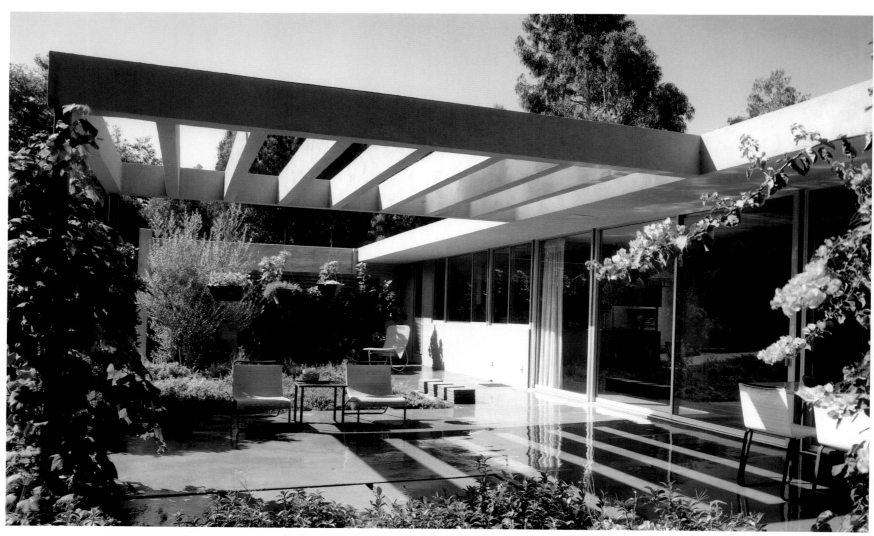

4079 **Killingsworth, Brady & Associates**
Killingsworth Residence, Long Beach, California
September 26, 1966

Seven years after the purchase of the property Killingsworth began construction of his own residence. The plan is composed of a set of integrated pavilions with outdoor extensions, surrounding a inner garden room. Ceilings and doors are 12 feet tall throughout, magnifying further the scale of the 3,200-square foot residence.

Both his wife, involved in the activities of the Long Beach Civic Light Opera, and their two sons have strong interests in the dramatic arts. The layout of the house reflects these interests in the landscaping of a garden, used as an open-air auditorium with a 200-seating capacity. The structure of the house continues beyond the wall line into a pergola ending with spider-leg posts. Between the pergola and the living room, a shallow 60-foot-long reflecting pool parallels the entry walk to the interior. The sons' sleeping quarters are a single room which can be subdivided into two bedroom alcoves with a common area between them, using sliding partitions. Due to the uncommon height of the walls, the master suite features a two-story closet.

Erst sieben Jahre nach dem Kauf des Grundstücks baute Killingsworth sein Eigenheim, eine Komposition aus miteinander verquickten Bungalows um einen Wintergarten, die sich mit Terrassen in den Garten erweitern. Alle Decken und Türen sind rund 3,60 m hoch, so dass das 295 m² umfassende Haus größer wirkt, als es ist. Mrs. Killingsworth, die für die Long Beach Civic Light Opera, ein Operettenhaus, tätig war, und die beiden Söhne interessierten sich sehr für alle darstellenden Künste. Der Entwurf entspricht dem mit einem Garten, der sich als Freilichttheater mit Sitzplätzen für 200 Zuschauer nutzen lässt. Das Dachtragwerk setzt sich in den Garten hinein in eine offene Pergola fort, die auf »Spinnenbein«-Stützen ruht. Zwischen Pergola und Wohnraum befindet sich parallel zum Zugangsweg ins Haus ein etwas über 18 m langes Wasserbecken. Für die Söhne entwarf Killingsworth einen großen Raum mit zwei durch Schiebewände abteilbaren Schlafkojen. Aufgrund der hohen Räume befindet sich im Elternschlafzimmer auch ein zweistöckiger begehbarer Schrank.

Ce n'est que sept ans après l'achat du terrain que Killingsworth lança la construction de sa maison. Le plan réunit un ensemble de pavillons intégrés dotés d'extensions vers l'extérieur autour d'une « pièce-jardin » intérieure. Les plafonds et les portes sont tous hauts de 3,60 m, ce qui renforce l'échelle de cette vaste résidence de 295 m².

Son épouse, étant très impliquée dans les activités du Long Beach Civic Light Opera, et ses deux enfants s'intéressant beaucoup à l'art dramatique, le plan qui intègre un jardin aménageable en auditorium de plein air pouvant accueillir 200 personnes. La structure se prolonge au-delà du périmètre des murs par une pergola qui se termine par des piliers en « patte d'araignée ». Entre la pergola et le séjour, une piscine de 18 m de long s'étend parallèlement au chemin d'entrée. Les enfants dorment dans une pièce unique divisée en deux alcôves séparées d'un espace commun par des cloisons coulissantes. Dans la suite principale, la hauteur inhabituelle des plafonds permet les placards à deux niveaux.

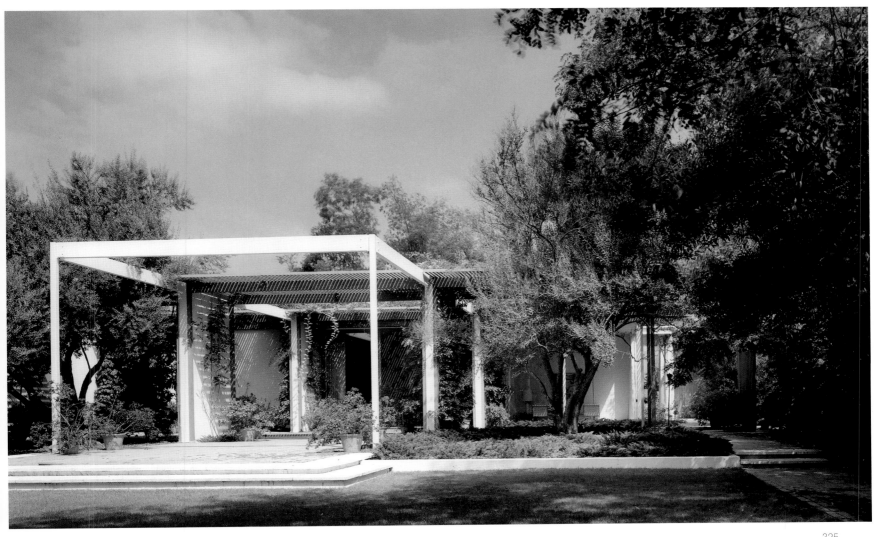

Selected - *Los Angeles Times Home Magazine,* - *Southland Sunday, October 1967*
Bibliography: *February 26, 1967* - *Architectural Record, November 1967*

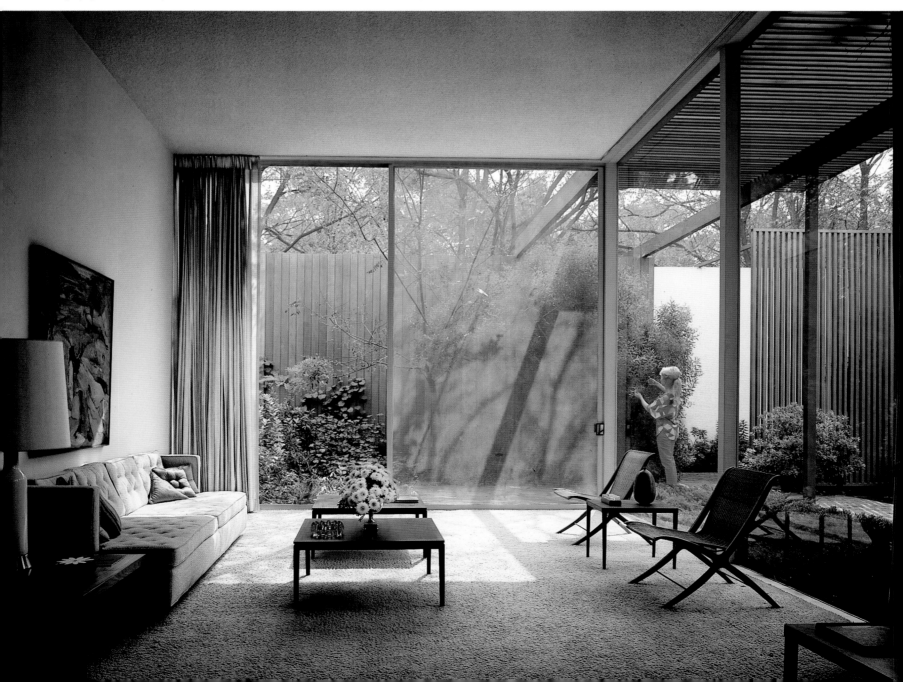

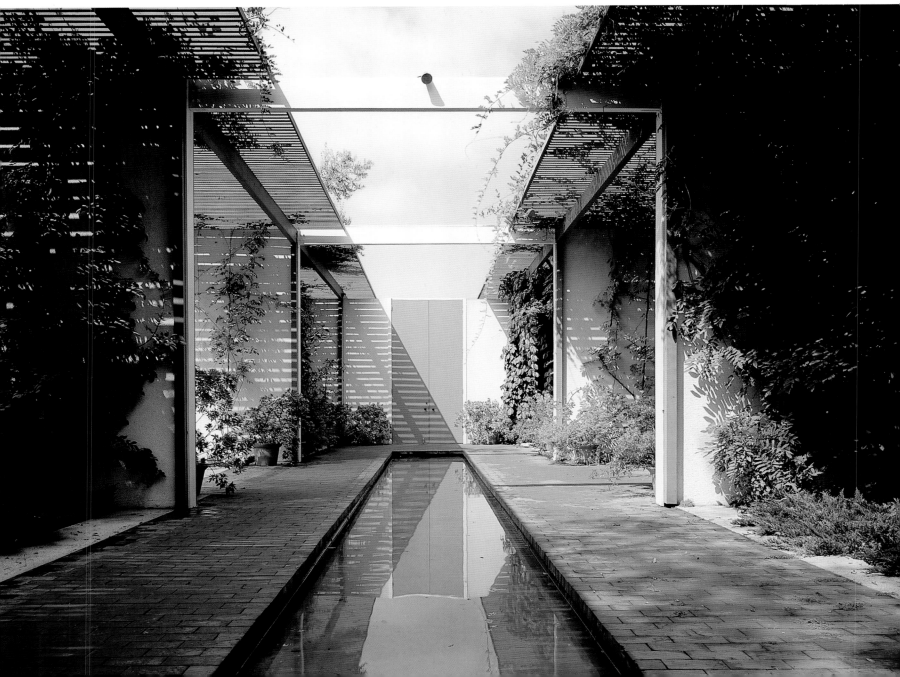

4184 Testa, Sanchez, Elia, Peralta, Ramos and Agostini
Banco de Londres, Buenos Aires, Argentina
March 1967

Over 22,000 people were present at the opening of the new headquarters of the Bank of London in Buenos Aires. Five years earlier, four Argentine firms had been invited to submit entries to give their architectural rendition of the detailed brief given by the bank promoters. Among the requirements, the architects were asked to provide 133 cashiers' positions and adequate circulation taking into account the Argentine preference for making payments by cash rather than checks. The new bank was to be built on the site the financial institution has occupied since its foundation in 1862.

The firm SEPRA (Sanchez, Elia, Peralta, Ramos and Agostini) involved painter/architect Clorindo Testa to produce the winning design. The central idea of their design was to distribute the program on seven interconnected levels overlooking a monumental interior void free of structural members. Above two internal towers providing separate vertical circulation for the public and the bank employees, two concrete beams, 15 feet tall and 2 feet wide, share the load of the inner edges of the five-balcony floors facing the banking hall. Concrete sunscreens form the exterior and shield the glass encasing all the bank's walls. The construction is in exposed reinforced concrete.

Zur Eröffnung der neuen Bank-Zentrale in Buenos Aires erschienen über 22 000 Gäste. Fünf Jahre zuvor waren vier argentinische Architekturbüros eingeladen worden, Entwürfe vorzulegen, die das detaillierte Raumprogramm erfüllten. Unter anderem sollten 133 Kassenschalter sowie adäquate Erschließungsflächen untergebracht werden, da die Argentinier es gewohnt sind, Rechnungen bar zu begleichen (statt mit Schecks oder Überweisung). Der Neubau sollte auf dem selben Grundstück entstehen, das die Bank bereits seit 1862 (nur wenige Jahre nach ihrer Gründung) innehat.

Das Büro SEPRA (Sanchez, Elia, Peralta, Ramos und Agostini) zog den Künstler und Architekten Clorindo Testa hinzu und produzierte zusammen mit ihm den Siegerentwurf. Ihre Hauptidee bestand darin, die erforderlichen Räume auf sieben untereinander verbundenen offenen Ebenen um einen monumentalen, stützenfreien Raum anzuordnen. Über zwei inneren Erschließungstürmen (einer für Kunden, einer für Bankangestellte) teilen sich zwei 4,50 m hohe und 60 cm breite Betonträger die Last der Innenränder der fünf Balkonetagen um die Schalterhalle. Sonnenschutzelemente aus Beton tragen die Außenränder und beschatten die Glasfassaden. Die Konstruktion besteht aus Sichtbeton.

Plus de 22 000 personnes assistèrent à l'inauguration du nouveau siège de la Bank of London à Buenos Aires. Cinq ans plus tôt, cinq agences argentines avaient été invitées à participer au concours selon un cahier des charges fixé par les banquiers. Parmi les contraintes, les architectes devaient prévoir 133 guichets de caisse et les circulations adéquates pour répondre à l'habitude locale de payer en argent liquide plutôt que par chèque. La nouvelle banque devait s'élever sur le terrain qu'elle occupait pratiquement depuis sa fondation en 1862.

L'agence SEPRA (Sanchez, Elia, Peralta, Ramos et Agostini) fit appel à la collaboration du peintre-architecte Clorindo Testa pour ce projet qui allait remporter le concours. L'idée maîtresse est de répartir le programme sur sept niveaux reliés entre eux donnant sur un vide intérieur, libre de toute structure. Au-dessus de deux tours intérieures prévues pour les circulations verticales séparées du public et des employés, deux portants en béton hauts de 4,50 m et larges de 60 cm se répartissent la charge des cinq étages en balcon, face au hall principal. Des écrans extérieurs protègent les façades intégralement vitrées. La construction est en béton armé brut.

Selected Bibliography:
- Architectural Review, February 1963
- Progressive Architecture, September 1966
- Architectural Design, January 1967
- Architettura Cronache e Storia, October 1967
- L'Architecture d'Aujourd'hui, December 1967-January 1968

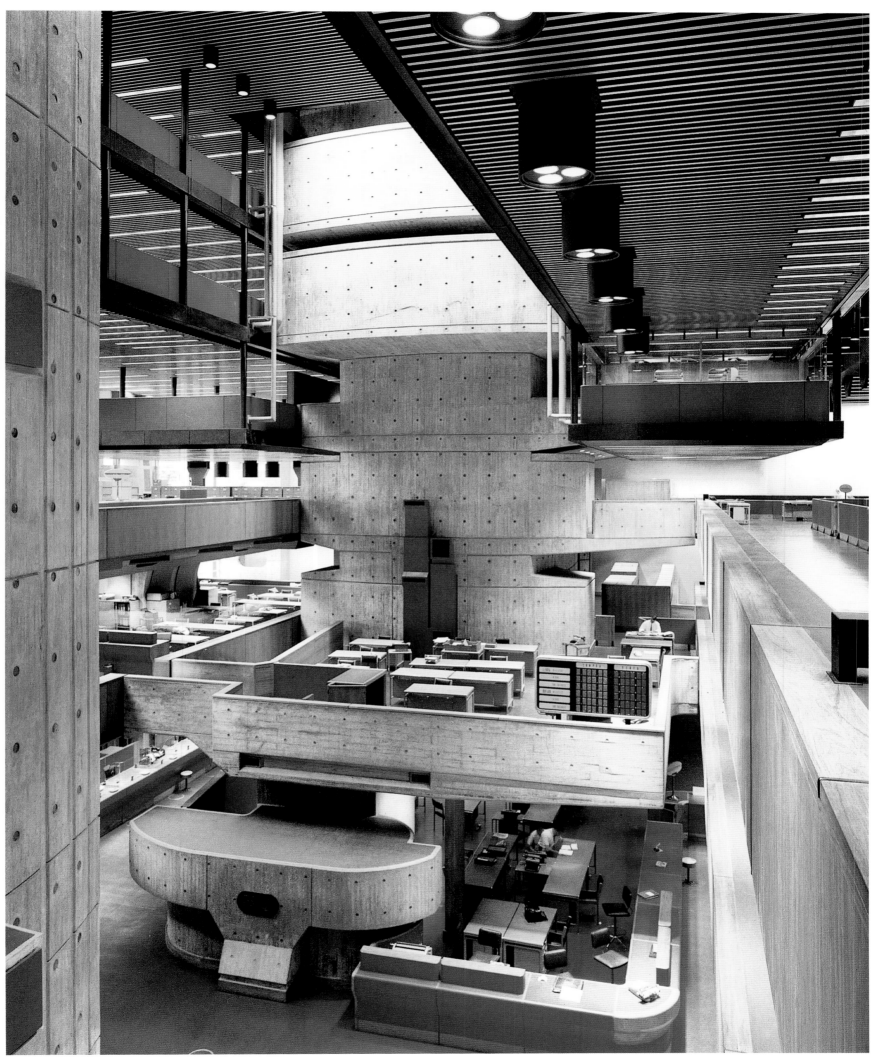

4186 Eladio Dieste
Church, Atlantida, Uruguay
March 1967

This 300-seat temple of worship serves a rural community 30 miles east of Montevideo and is the first unit of a planned parish complex. For special events the church can accommodate 500 parishioners. The plan, a 110 x 54-foot rectangular space, is shaped on the model of a Roman basilica and the geometry of the enclosure and the construction methods implemented to build the supporting walls bear witness to Dieste's technical virtuosity; he trained as a structural engineer.
All visible surfaces are constructed of bricks. The one-foot-thick conical side walls are generated by a straight line at the base and fragments of parabolic curves on top. Steel rods laid out on a wooden framework formed a template to position the

Dieser Sakralbau dient einer Landgemeinde 50 km östlich von Montevideo und ist der erste Bau eines Gemeindekomplexes. Er bietet Sitzplätze für 300 Gläubige, bei besonderen Anlässen haben 500 Gemeindemitglieder darin Platz. Im Plan rechteckig (33 x 16 m), ähnelt die Kirche einer römischen Basilika, die Geometrie der Umfassungsmauern und die Bauweise der tragenden Wände bezeugen jedoch die technische Virtuosität des gelernten Bauingenieurs Eladio Dieste. Alle sichtbaren Wandflächen bestehen aus Ziegelmauerwerk. Die konisch geformten Seitenwände ergeben sich aus dem Zusammenspiel von gerader Linie an der Basis und parabolischen Kurven in den oberen Abschnitten. Beim Bau wurden Stahlstäbe über das Holzrah-

Ce lieu de culte qui dessert une communauté rurale à 50 km à l'est de Montevideo, était à sa construction le premier élément d'un futur complexe paroissial. Prévu pour 300 places, il peut accueillir jusqu'à 500 fidèles en certaines occasions. De plan rectangulaire (33 x 16 m), rappelant celui d'une basilique romaine, sa volumétrie et les méthodes de construction utilisées pour le montage des murs porteurs témoignent de la virtuosité technique de Dieste, ingénieur de formation. Toutes les surfaces apparentes sont en brique. Les murs latéraux en forme de cônes de 30 cm d'épaisseur dessinent des lignes à la base qui se transforment en courbes paraboliques au sommet. En termes de construction, des tiges d'acier placées devant l'ossa-

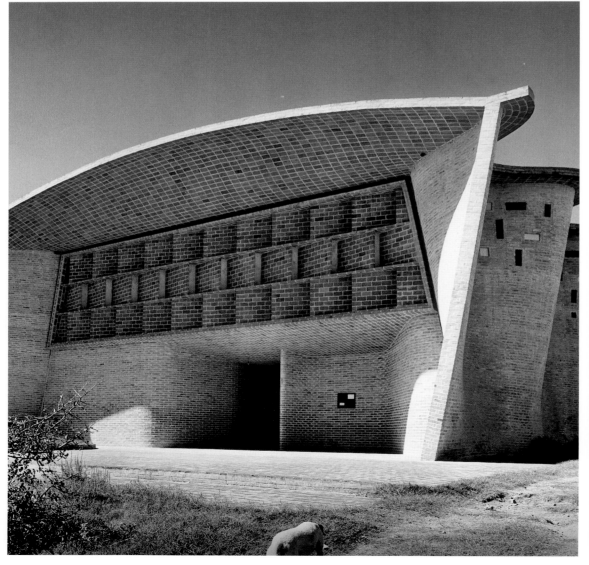

bricks, creating a unique undulation. Similarly, cross-sections of the barrel-vaulted roof describe antifunicular curves; here water-proof membrane is sandwiched between two layers of masonry. A large number of small openings diffuses the natural light into the interior which has intentionally been kept quite plain. A curved wall envelopes the sanctuary, where a rugged boulder stands for the altar. The total construction cost of the church was slightly over that of industrial structures built in the area. Constructed without scaffolding, the 50-foot-tall cylindrical bell-tower is a separate structure featuring a spiral staircase can-tilevered from the outer wall.

menwerk gelegt, als eine Art Schablone für die Backsteinver-kleidung, die so ihre einzigartige Wellenform erhielt. In ähnlicher Weise zeigt der Querschnitt des Gewölbedaches gegenläufige Kurven einer wasserdichten Membrane zwischen zwei Lagen Mauerwerk. Viele kleine Öffnungen lassen Tageslicht in den be-wusst schlichten Kirchenraum einfallen. Eine Mauer umfasst den Altarraum mit einem rauhen Felsen als Altartisch. Die Bausum-me lag nur wenig höher als die von Industriebauten in der Re-gion. Der freistehende zylindrische Glockenturm (15 m) wurde ohne Gerüst errichtet. Er wird von einer von der Außenwand vorkragenden Wendeltreppe umrundet.

ture bois permettent la pose des briques qui suivent un éton-nant mouvement ondulatoire. De même, les coupes transver-sales du toit en berceau composé d'une membrane étanche prise en sandwich entre deux couches de maçonnerie décrivent des courbes antifuniculaires. Les ouvertures, petites mais nom-breuses, diffusent une lumière naturelle à l'intérieur laissé volon-tairement neutre. Un muret entoure le sanctuaire dans lequel un rocher sert d'autel. Le coût total du chantier n'a dépassé que de peu celui des constructions industrielles édifiées dans la ré-gion. Le clocher cylindrique de 15 m de haut, est une structure indépendante. Il contient un escalier en spirale en porte-à-faux par rapport au mur extérieur.

Selected Bibliography:

- *L'Architecture d'Aujourd'hui, June-July 1961*
- *Architectural Review, September 1961*
- *Progressive Architecture, April 1962*

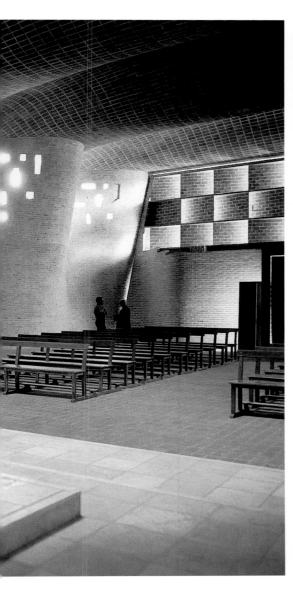

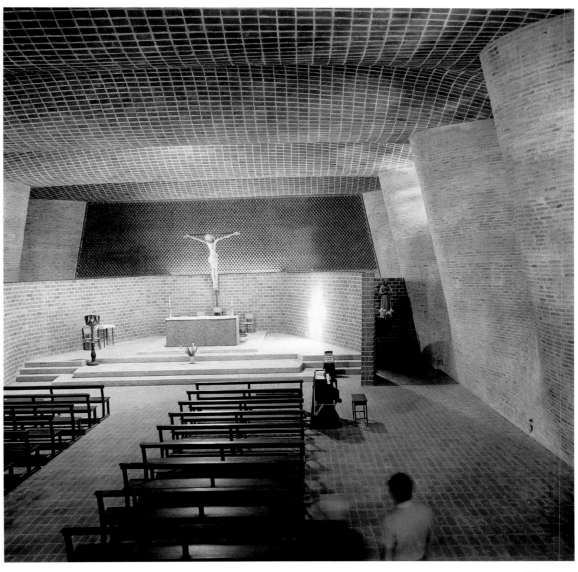

4197 **E. Fay Jones**
Merk Residence, Fayetteville, Arkansas
April 13, 1967

The entry to the house is located at the intersection of the cruciform plan. The sleeping quarters occupy the long axis, the living-dining-cooking areas are arranged on the short axis. Native Arkansas stone used throughout integrates the residence into its site. Two columns at the gable end expand the living room onto an outdoor terrace overlooking the treetops. Illuminated beams and skylights articulate the lighting of the interior.

Der Hauseingang befindet sich in einem Winkel des kreuzförmigen Grundrisses. Der längere Trakt beherbergt die Schlafzimmer, während Küche, Wohn- und Esszimmer den kurzen Flügel einnehmen. Der im ganzen Haus eingesetzte Naturstein aus einem Steinbruch in Arkansas verbindet das Haus eng mit seinem Standort. Zwei Säulen am Giebelende rahmen die Öffnung vom Wohnraum zur Balkonterrasse über den Baumwipfeln ein. Angestrahlte Balken sowie Dachoberlichter sorgen für die abwechslungsreiche Belichtung des Hauses.

L'entrée de cette maison est implantée à l'intersection de son plan cruciforme. Les chambres se succèdent sur l'axe longitudinal, tandis que la zone séjour/salle à manger/cuisine occupe une transversale de longueur réduite. Omniprésente, la pierre locale permet de mieux intégrer le projet à son environnement. Côté pignon, deux pilastres encadrent l'ouverture du séjour sur une terrasse extérieure qui donne sur la cime des arbres. Des daines voies entre les poutres laissent pénétrer la lumière à l'intérieur.

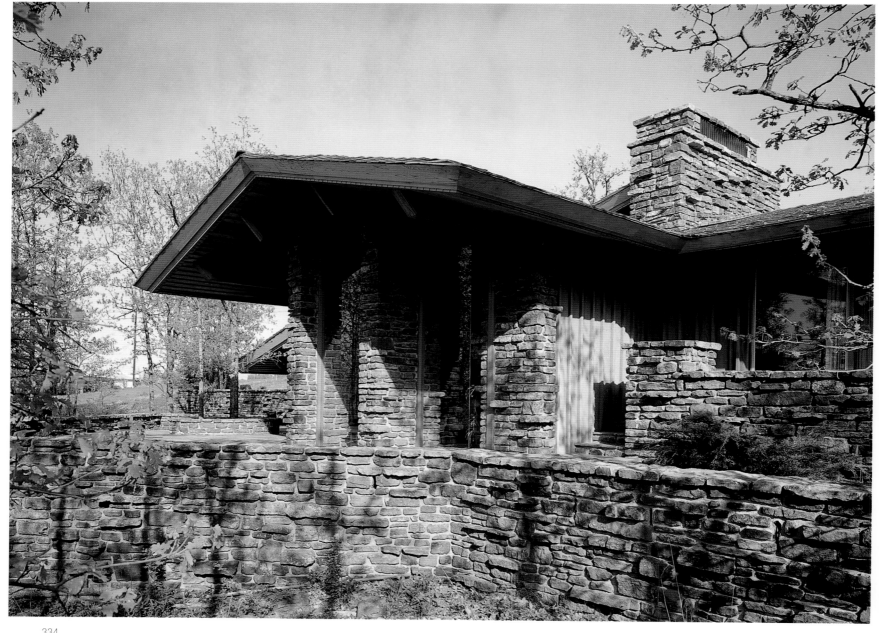

Selected Bibliography: - New Homes Guide, Summer/Fall 60th edition

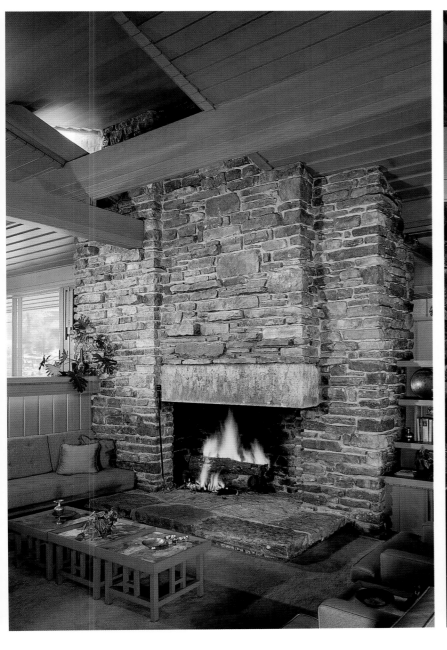

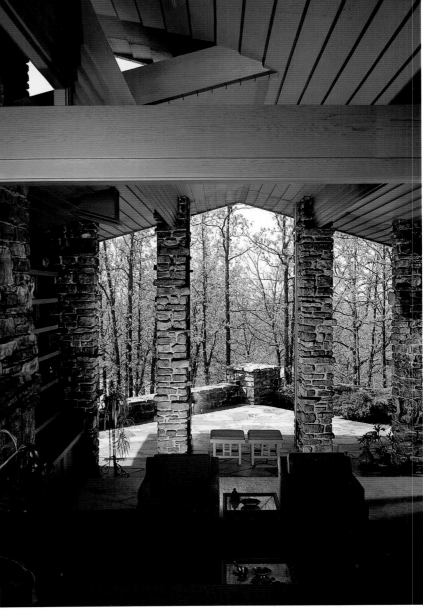

4238 **Frank L. Hope & Associates**
San Diego Stadium, San Diego, California
August 27, 1967

The concrete framework slanted toward the stadium supports the circulation system laid out on the outer edge of the plan. A series of volumes anchored to the perimeter of the concrete shell provide access to the different levels. In 1969, the project won an Honor Award from the National Chapter of the American Institute of Architects.

Die zum Sportfeld hin geneigte Betonkonstruktion untermauert buchstäblich das Erschließungssystem am Außenrand der Anlage. Eine Reihe von Treppenaufgangsschächten am Rande der Betonschale gewährt Zugang zu den verschiedenen Tribünenrängen. 1969 erhielt das Stadion vom American Institute of Architects einen Honor Award.

L'ossature de béton inclinée vers le stade sert de support aux circulations reportées à l'extérieur. Une série de volumes accrochés en périmétrie à la coque de béton donnent accès aux différents niveaux. En 1969, ce projet a remporté le Prix d'honneur du chapitre national de l'American Institute of Architects.

Selected - *Building Progress, October 1968*
Bibliography: - *Architecture/West, June 1969*

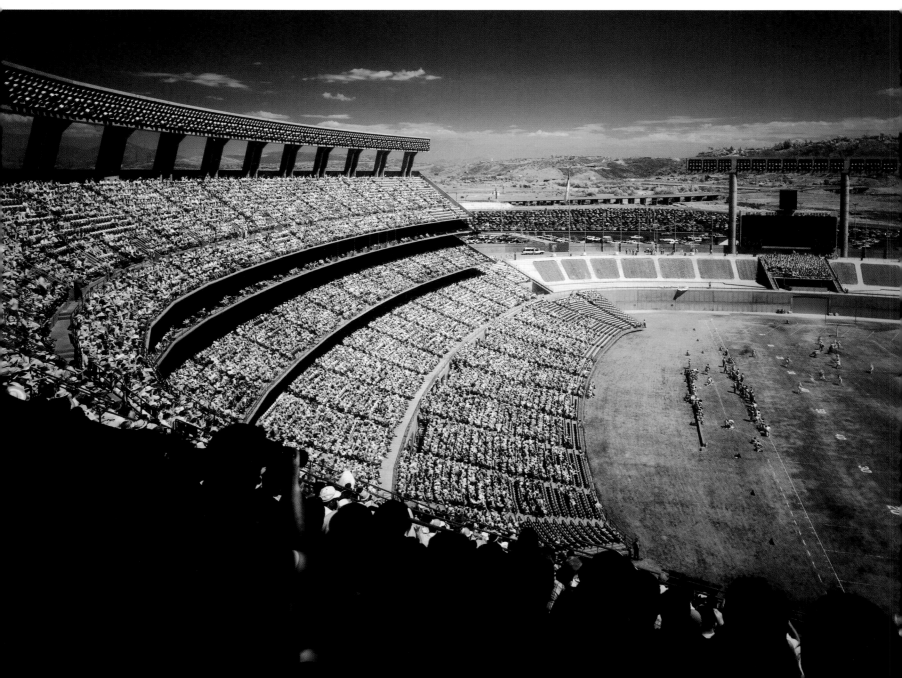

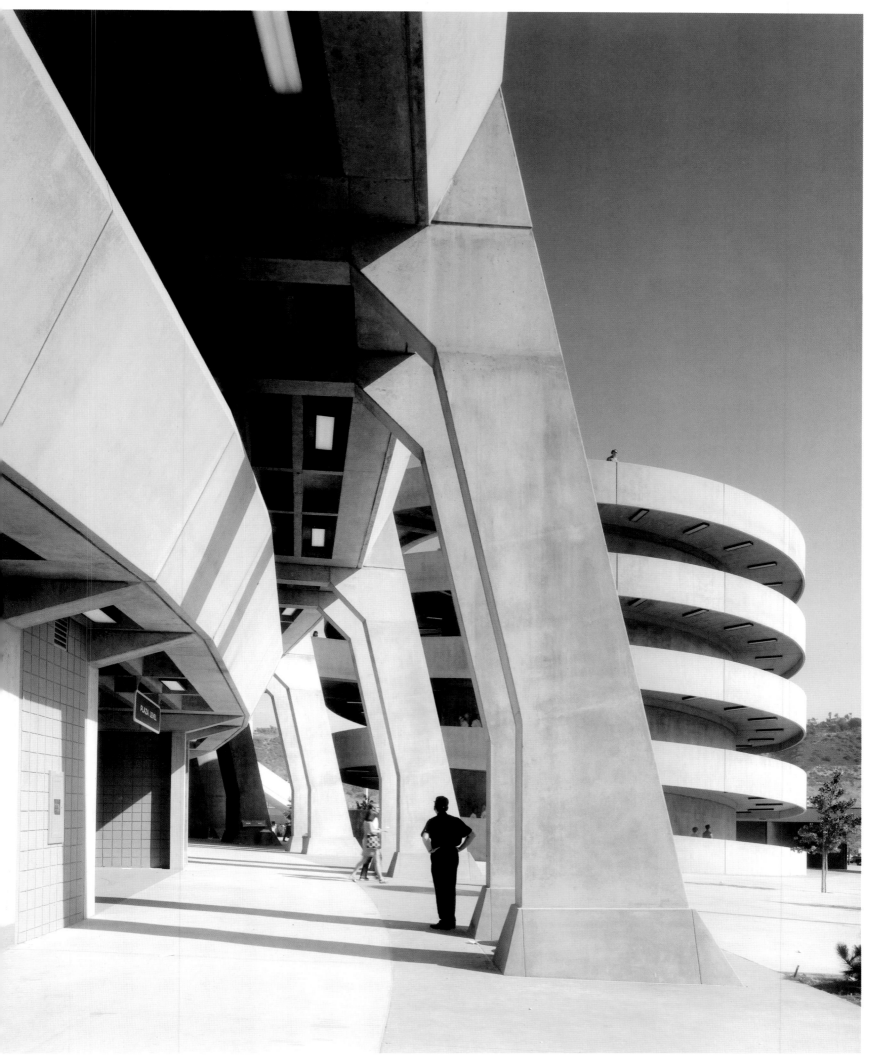

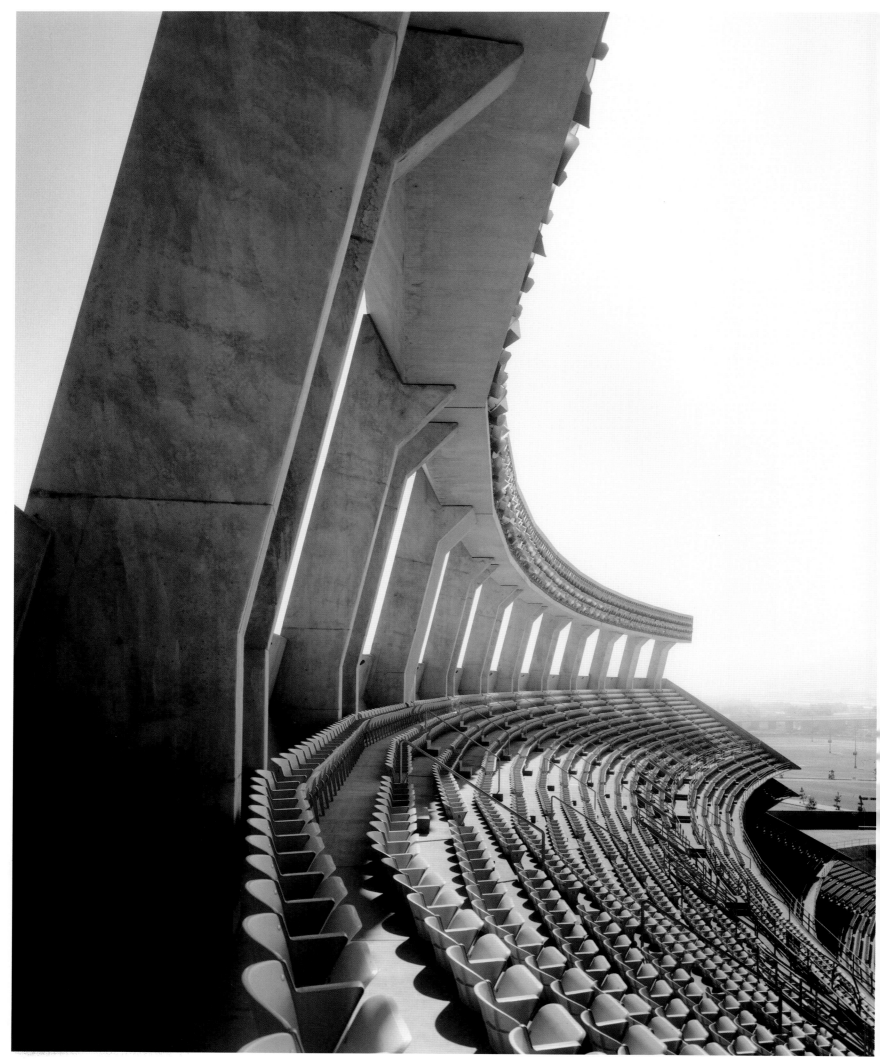

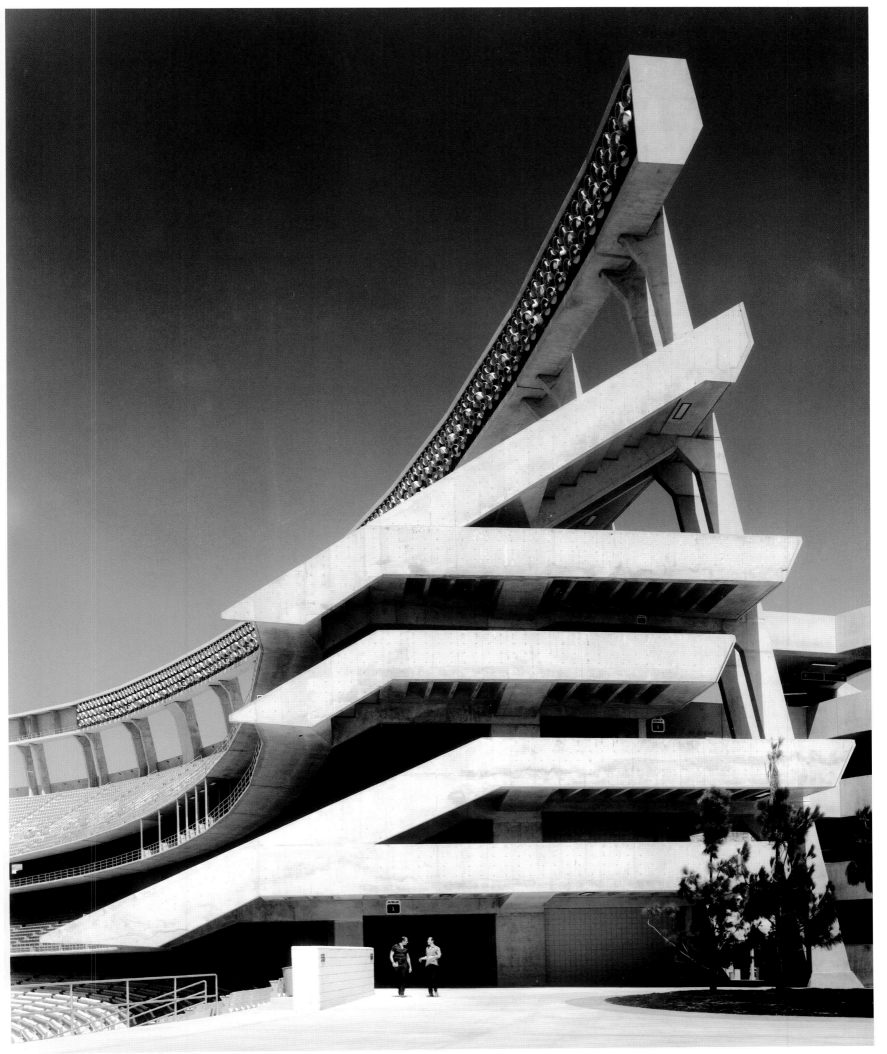

4250 **Crites & McConnell**
United Covenant Church, Danville, Illinois
September 29, 1967

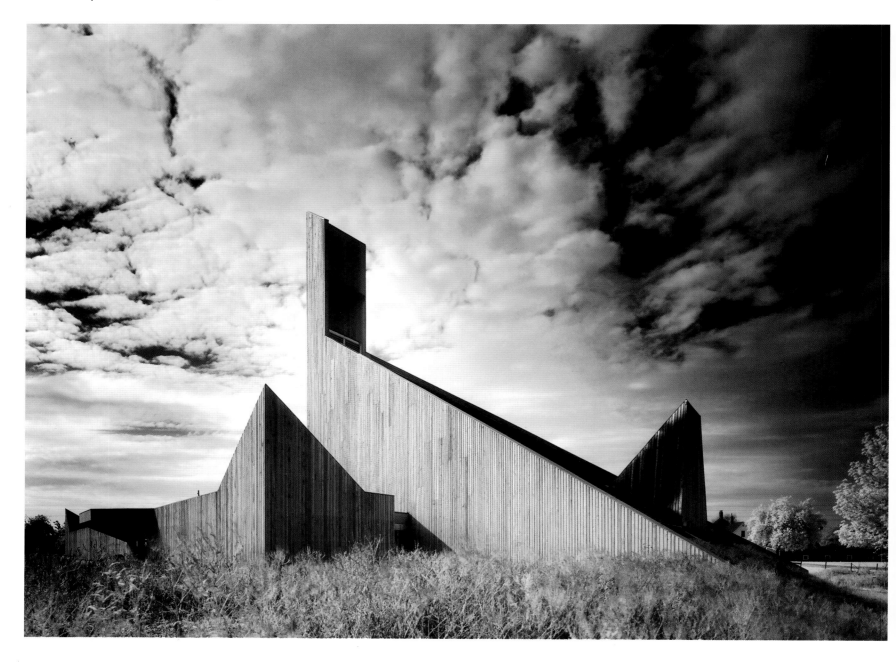

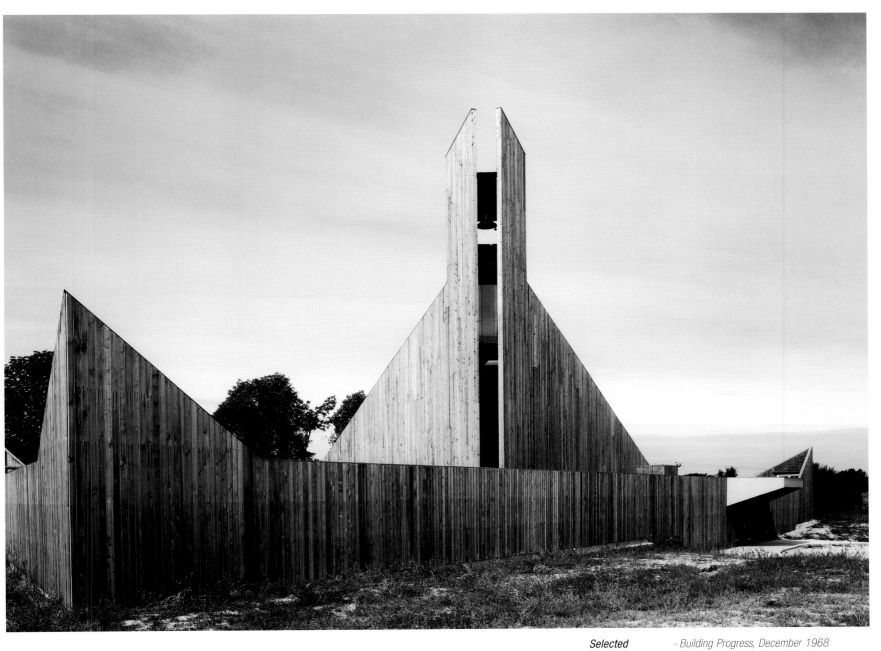

Selected
Bibliography: *- Building Progress, December 1968*

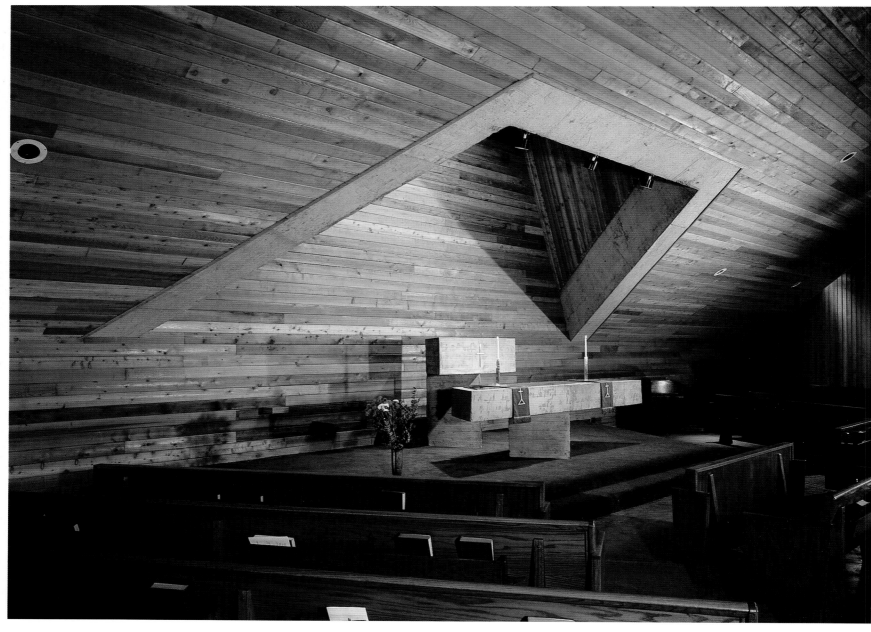

Religious symbolism informs the geometry of the complex, composed of two equilateral triangles. The first triangle stakes out the sacred enclosure whose facilities are located on the eastern side; the second, half the size of the first, outlines the actual church. Inside, the chancel occupies the west wall of the plan to increase the seating area near the communion table and pulpit. The extensive vertical wood paneling of the exterior dramatizes the relationship with the sky. The National Chapter of the American Institute of Architects accorded the design an Honor Award in 1967.

Religiöse Symbole bestimmten die Grundrissgeometrie des Kirchenbaus aus zwei gleichschenkligen Dreiecken. Das größere umreißt die Klausur, das kleinere (halb so große) den Kirchenraum. Das Chorgestühl platzierten die Architekten an der Westwand, um eine möglichst große Fläche für die Kirchenbänke vor dem Altartisch und der Kanzel zu gewinnen. Die senkrecht angebrachte Holzverkleidung der Außenwände zieht den Blick himmelwärts. Das American Institute of Architects zeichnete die Kirche 1967 mit einem Honor Award aus.

Le symbolisme religieux est très présent dans la construction géométrique de cet ensemble, composé de deux triangles équilatéraux. Le premier définit la périmétrie de l'ensemble dont les installations techniques sont situées en partie est. Le second, plus petit de moitié, délimite le lieu de culte. A l'intérieur, le chœur est repoussé contre le mur ouest pour laisser le plus de place possible aux sièges devant la table de communion et la chaire. A l'extérieur, le bardage de bois à pose verticale exprime la relation avec le ciel. Le chapitre national de l'AIA a décerné à ce projet un prix d'honneur en 1967.

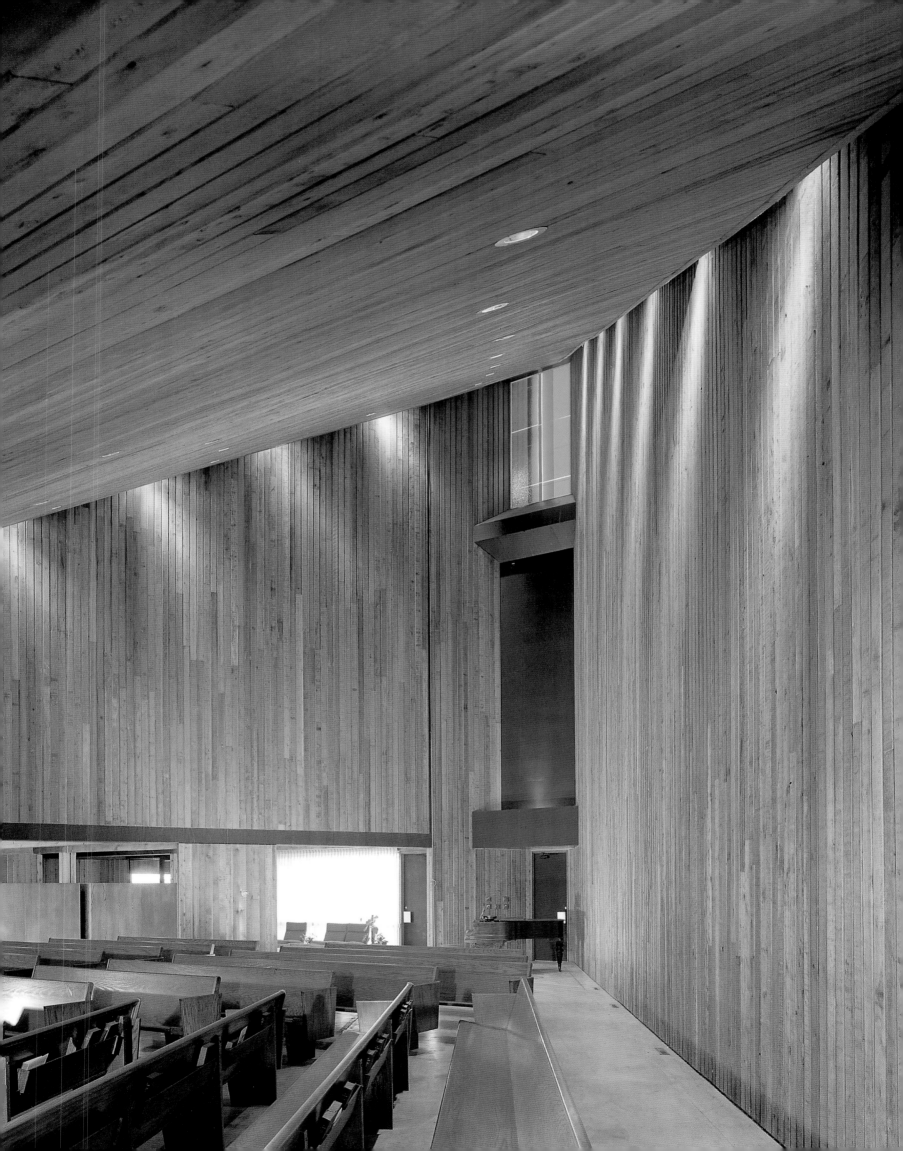

4327 Richard H. Dodd
Gaede Residence, Laguna Beach, California
April 22, 1968

The hexagonal configuration of the layout grows out of the unique terrain of the site. The 60- and 120-degree angles of the house maximize the level area on the rock formation. Built on a promontory with a panorama of the Pacific, the residence accommodates the needs of a family of four.
The owners' specifications listed an open plan that took advantage of the ocean vistas, a pool patio separate from the children's play yard, and areas for large social gatherings.

Der sechseckige Grundriss dieses Hauses auf einer Landzunge mit Panoramablick über den Pazifik ergab sich aus der einzigartigen Grundstücksbeschaffenheit: Mit seinen 60°- und 120°-Winkeln nutzt es die flachen Areale des felsigen Grunds voll aus. Die Auftraggeber, eine vierköpfige Familie, wünschten sich ineinander fließende Räume, um den Meerblick voll auszukosten, ein vom Spielplatz der Kinder getrenntes Schwimmbecken sowie ausreichend Platz für Geselligkeit mit zahlreichen Gästen.

La configuration hexagonale du plan doit beaucoup à la position exceptionnelle du terrain. La maison est implantée pour tirer le meilleur parti des zones rocheuses planes. Edifiée sur un promontoire et bénéficiant d'une vue panoramique sur le Pacifique, elle a été conçue pour une famille de quatre personnes. Les propriétaires souhaitaient un plan ouvert pour profiter de la vue la plus vaste possible sur l'océan, une piscine et un patio séparés de la cour de jeu des enfants, et des espaces suffisants pour donner des réceptions importantes.

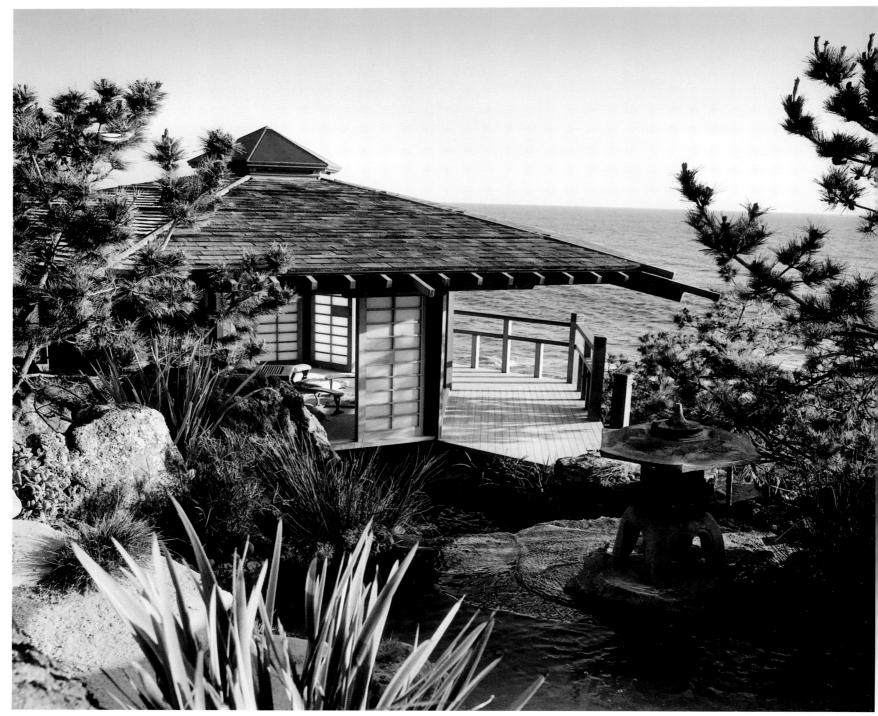

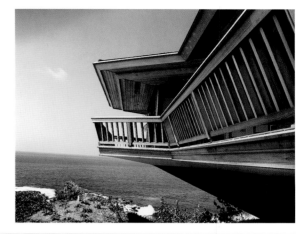

Selected
Bibliography: *- Architectural Digest, Summer 1968*

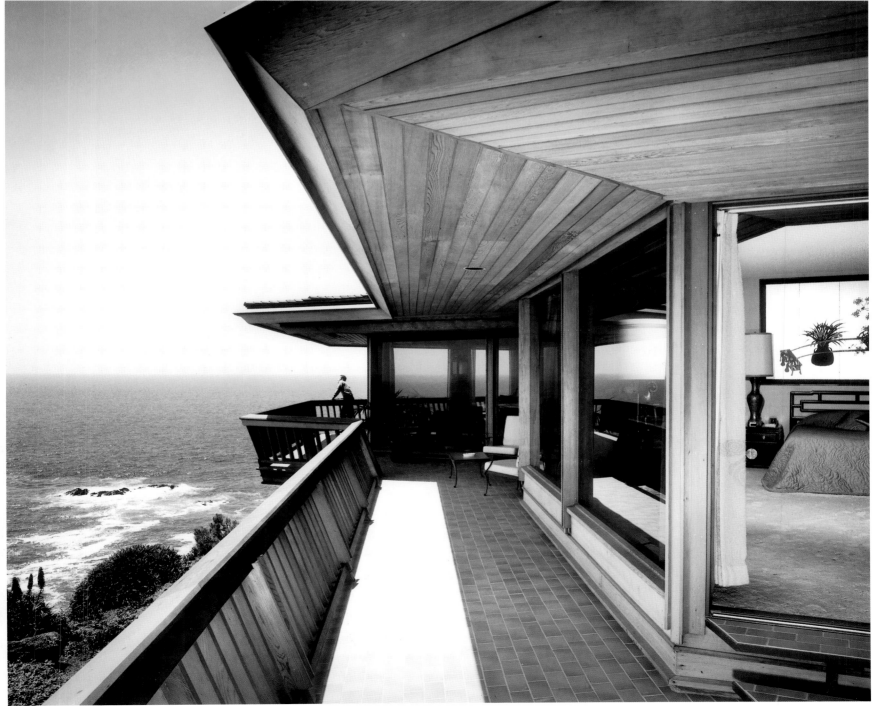

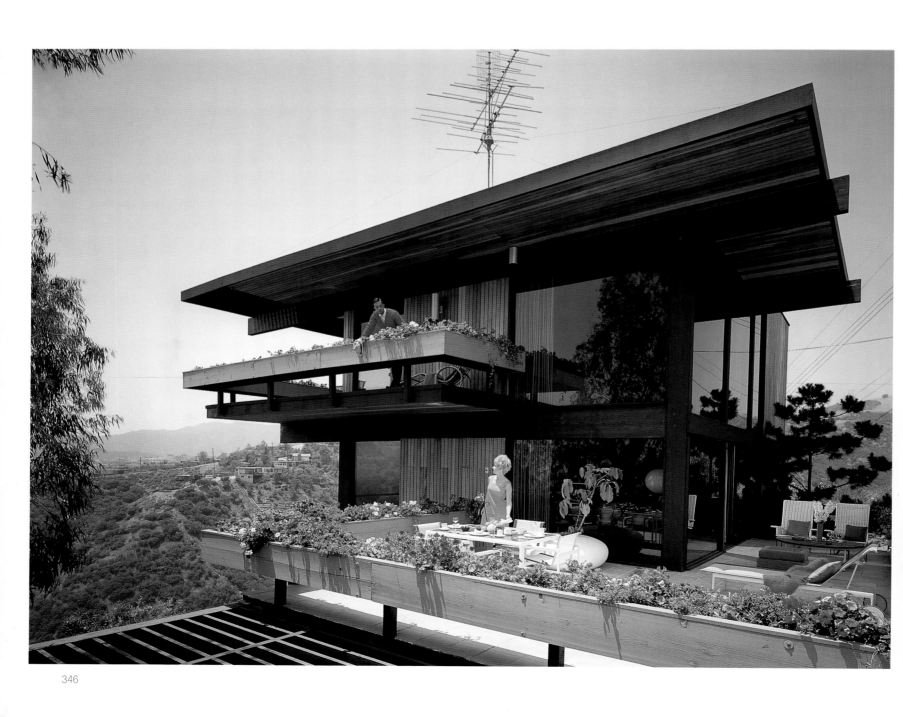

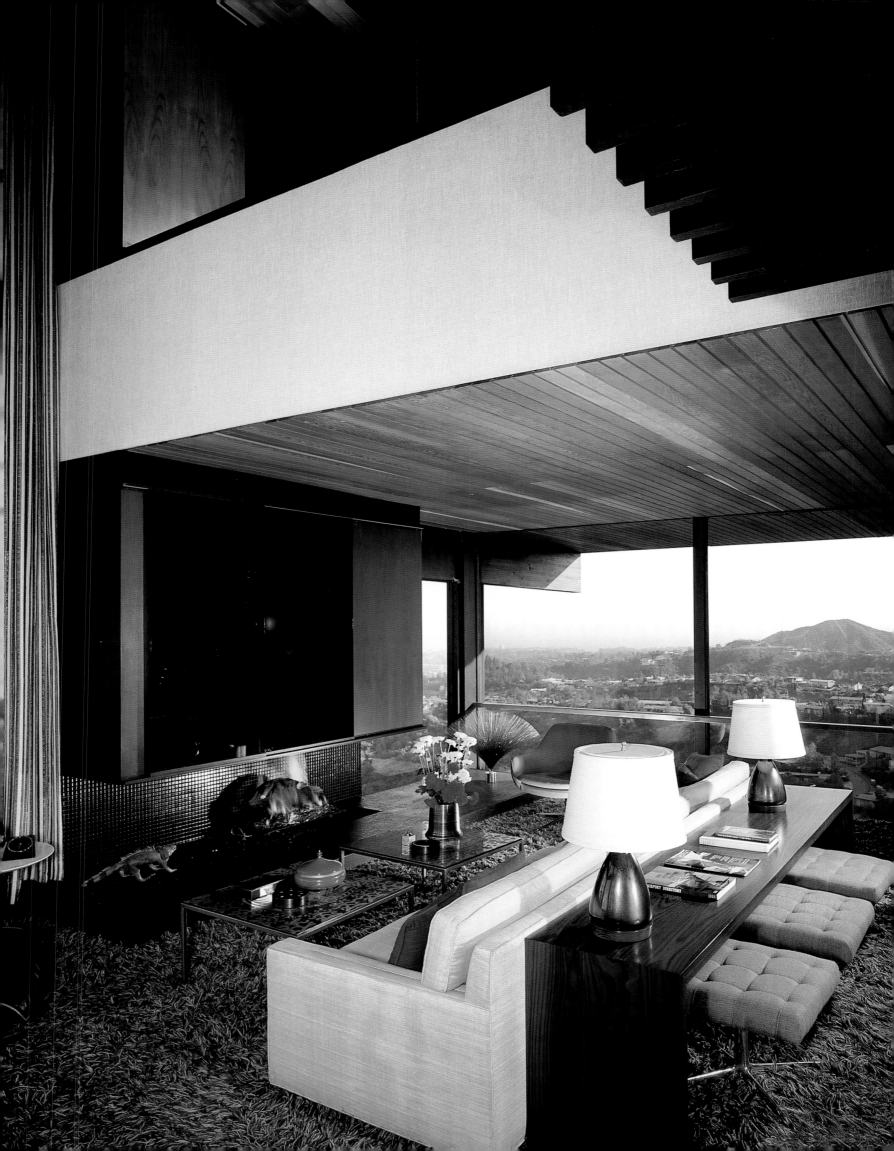

4452 **Killingsworth, Brady & Associates**
McConnell Center, Pitzer College, Claremont, California
February 26, 1969

 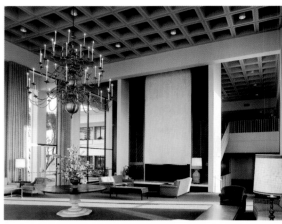

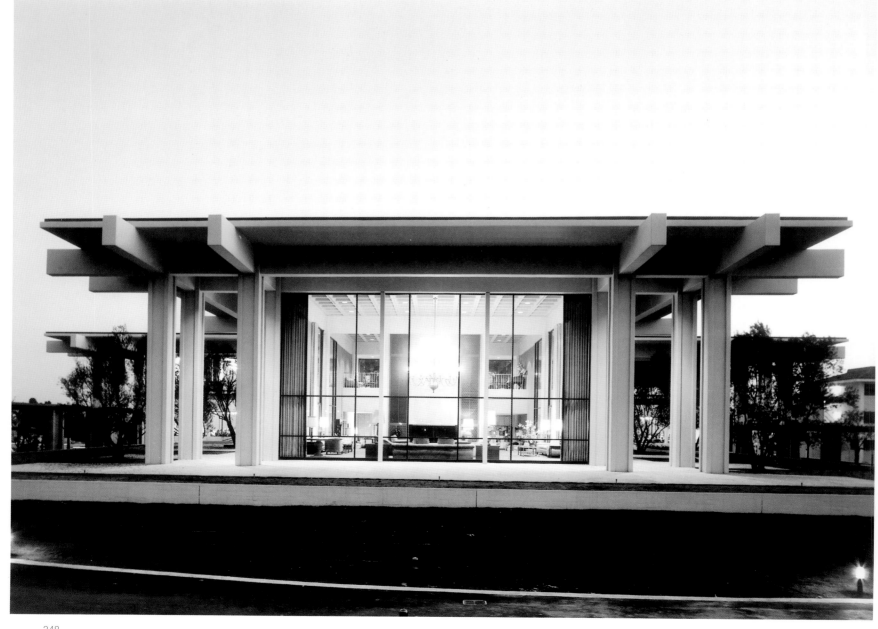

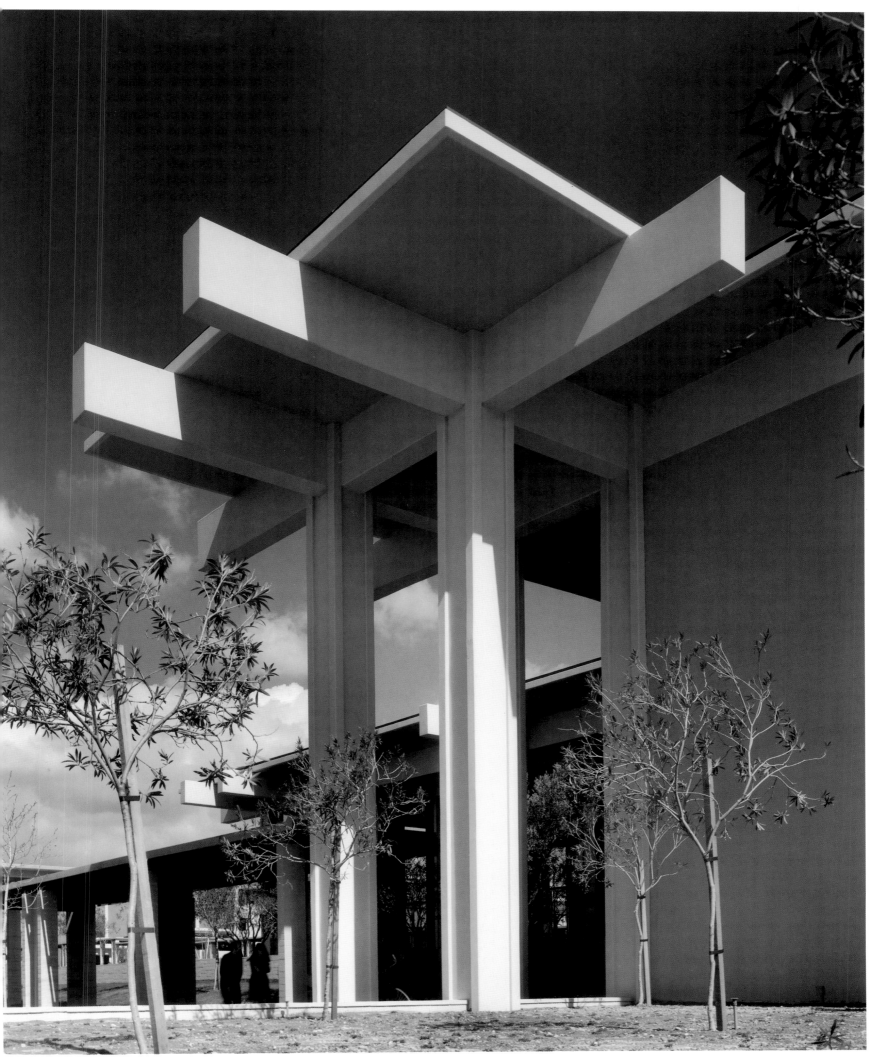

4458 **Carl L. Maston**
Maston Offices, Hollywood, California
March 11, 1969

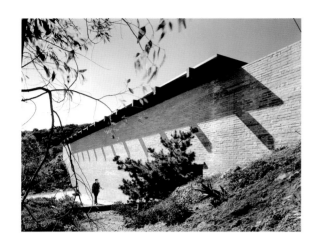

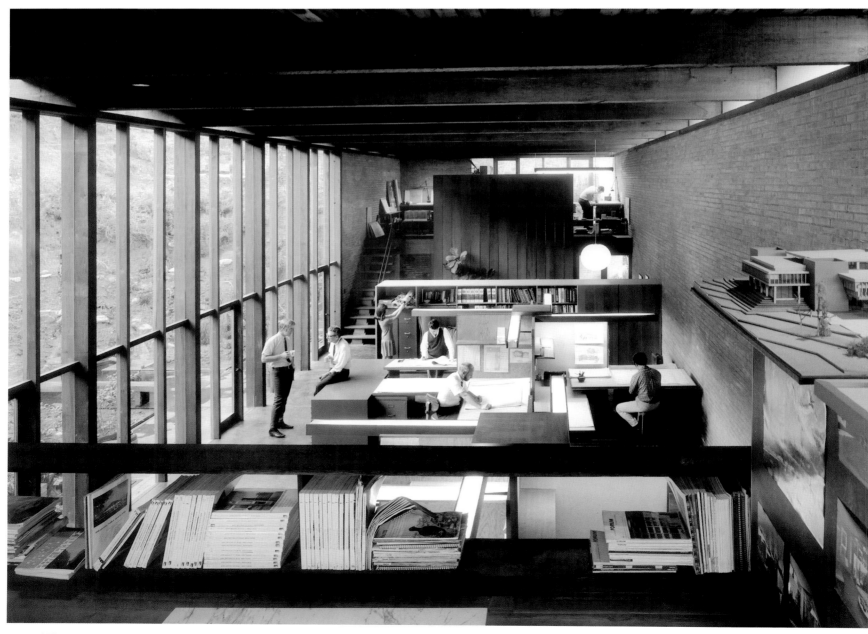

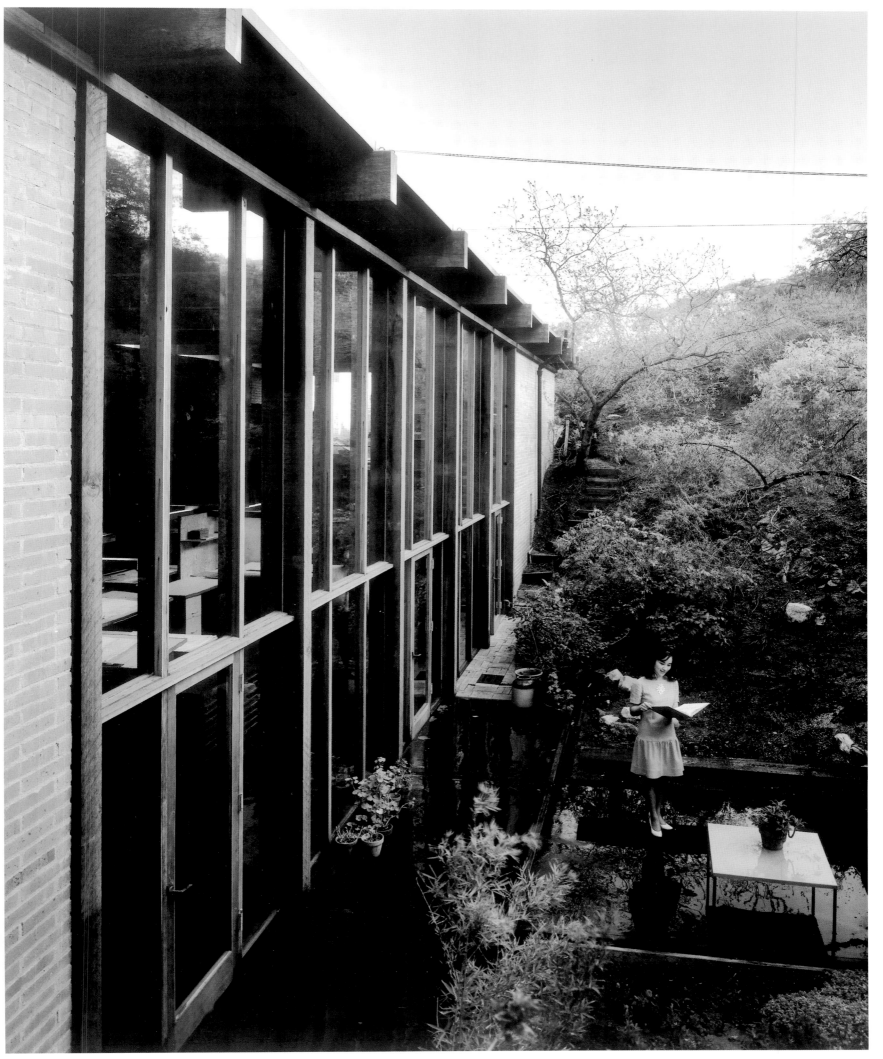

4503 **Ralph Anderson**
Runion Residence, Seattle, Washington
June 2, 1969

The site was part of a park in Magnolia, south of Fort Lawton, Washington. Built on a small triangular site, the residence emphasizes the vertival and features several cantilevered voumes. Wood siding is clear cedar.

Das Grundstück gehört zu einer Parklandschaft in Magnolia südlich von Fort Lawton. Da es klein und dreieckig ist, wächst das Haus in die Höhe und weist mehrere auskragende Bauteile auf, die mit naturbelassenem Zedernholz verschalt sind.

Ce terrain faisait partie d'un parc de Magnolia, au sud de Fort Lawton. Edifiée sur une petite parcelle triangulaire, la maison au dessin vertical est caractérisée par plusieurs volumes en porte-à-faux. Le bardage de bois est en cèdre clair.

Selected Bibliography: - *Los Angeles Times Home Magazine, November 2, 1969*

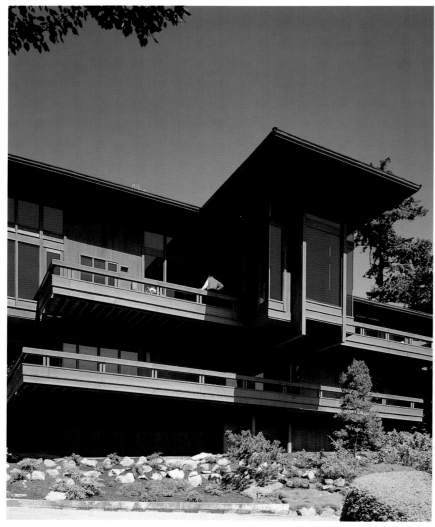
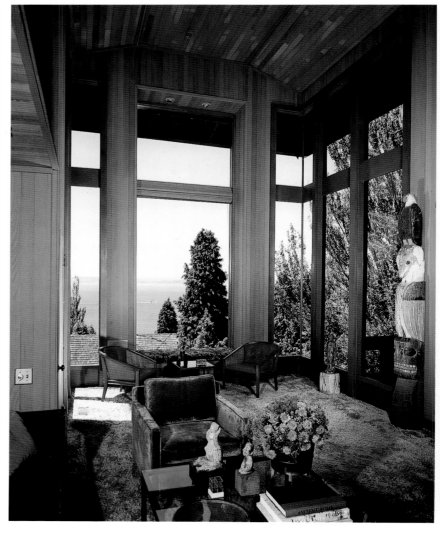

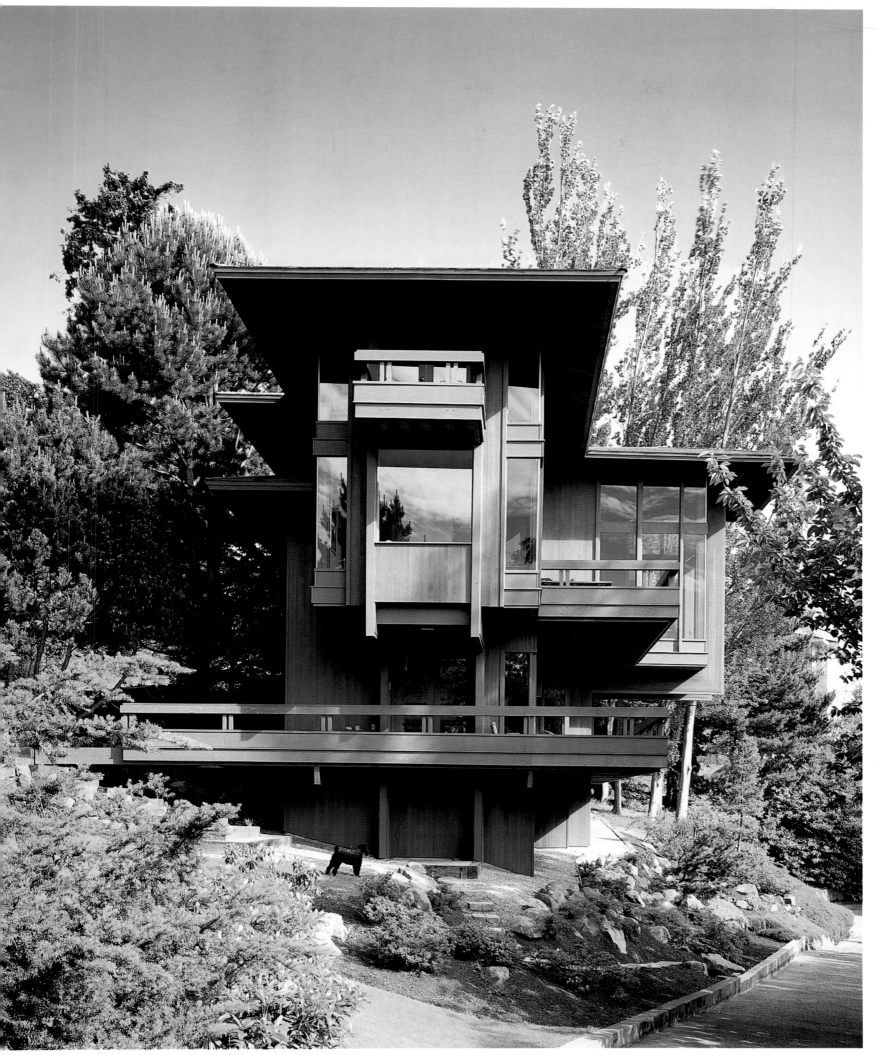

4535 A. Quincy Jones and Frederick E. Emmons
Sherwood Residence, Beverly Hills, California
June 9, 1969

Following a previously explored architectural idea (see p. 185), the architects accommodate all domestic functions under one grand pitched roof 80 feet in length. The exterior walls and the post and beam frames support the tent-like roof visible, from all the common rooms, whose ridge is 20 feet above the ground. Collective areas are located in the central section of the plan, while the sleeping areas are on the outer ends.

The glass gable gives continuity between the indoor and outdoor brick terrace.

Mit diesem Entwurf griffen die Architekten eine frühere Idee wieder auf (siehe S. 185) und brachten alle Räume unter einem großen, rund 24 m breiten Satteldach unter. Die Außenwände und konstruktiven Pfosten und Riegel tragen dieses zeltartige Dach, dessen First 6 m über dem Bodenniveau verläuft und dessen Unterseite in allen Gemeinschaftsräumen zu sehen ist. Diese bilden die Mitte des Hauses, die Schlafzimmer die beiden äußeren Enden. Die verglaste Giebelwand lässt das Hausinnere und die mit Klinkern gepflasterte Terrasse ineinander übergehen.

Dans la ligne d'un concept architectural exploré au préalable (voir p. 185), les architectes ont réuni toutes les fonctions domestiques sous un même vaste toit en pignon de 24 m de long. Les murs extérieurs et une structure à poteaux et poutres soutiennent ce toit en forme de tente, laissé visible dans toutes pièces communes, et dont l'arête s'élève à 6 m de haut. Les parties communes sont implantées au centre, les chambres aux deux extrémités. Le pignon de verre assure la continuité entre l'intérieur et la terrasse extérieure pavée de briques.

Selected Bibliography: - Process Architecture, number 41, October 1983

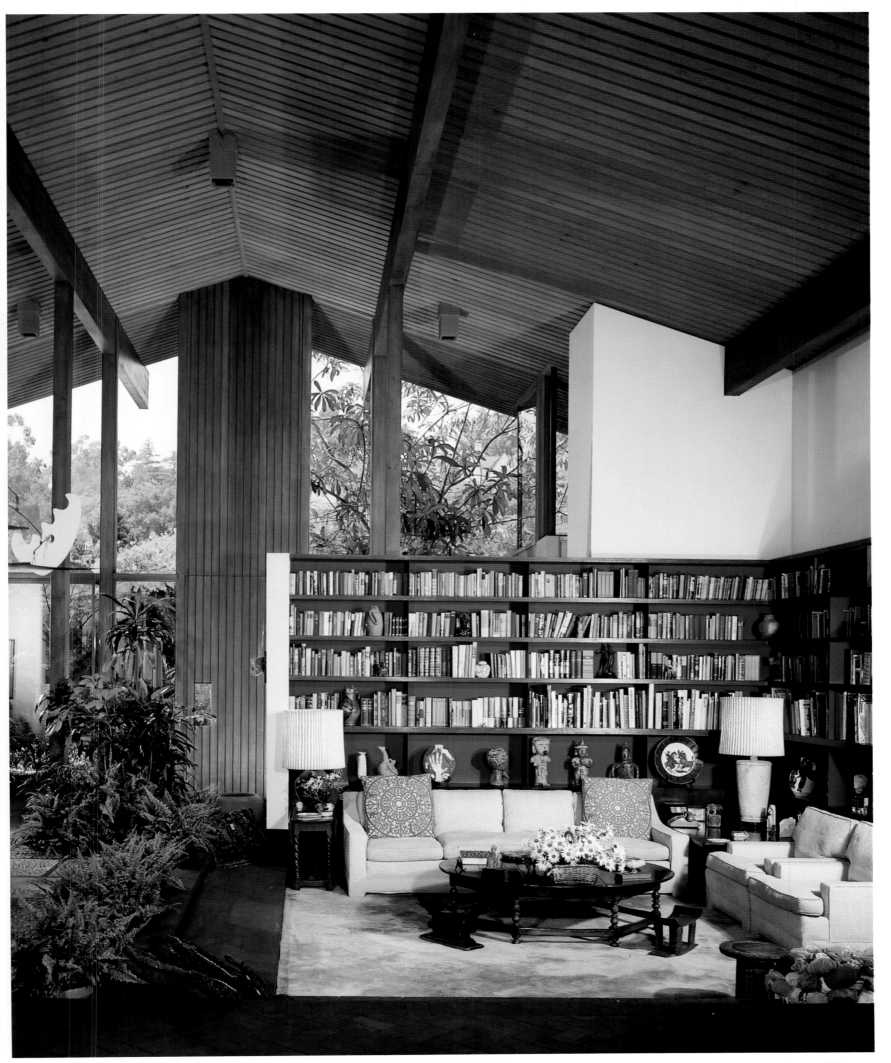

4581 **Raul Garduno**
Hummel Residence, Los Angeles, California
November 24, 1969

Buying an inexpensive "unbuildable" lot often requires a higher financial investment in building adequate foundations to support a residential structure. For this dwelling south of Glendale, the architect reinvented the ground condition by driving three concrete pillars 25 feet deep into stable soil. Three 56-foot-long steel beams are cantilevered both downhill and toward the slope to create a platform which serves as the new base for the house. From the initial 36-inch width on the caisson, the beams taper to 10 inches at their outer ends.

With the exception of the master bedroom, which is located on the upper level, all other functions are contained on the lower level and almost all rooms open onto a deck.

Der Preisvorteil beim Kauf eines »unbebaubaren« Grundstücks wird häufig durch die für eine adäquate Gründung erforderliche Investition wieder aufgehoben. Auf diesem Hang südlich von Glendale kreierte der Architekt sozusagen einen ganz neuen »Grund«, indem er Betonpfähle bis zu 7,50 m in festen Boden rammen und drei jeweils 17 m lange Stahlträger darauf montieren und nach vorne überkragen ließ, welche die Bodenplatte des Hauses tragen. Unter den Plattenkassetten sind die Stahlträger 90 cm breit und verjüngen sich dann bis zum Außenende auf 25 cm. Bis auf das Elternschlafzimmer im Obergeschoss befinden sich alle Räume auf einer Ebene; fast alle sind mit Balkonterrassen ausgestattet.

Souvent le prix d'un terrain « inconstructible » se paye par un investissement important pour les fondations. Pour ce terrain, au sud de Glendale, l'architecte a littéralement recréé le sol en enfonçant trois piles de béton à 7,50 m de profondeur pour le stabiliser. Trois poutres d'acier de 17 m de long compensent la pente pour créer une plate-forme qui sert de nouvelle base à la maison. De 90 cm de section sur ce caisson, la poutre ne mesure plus que 25 cm à son extrémité.

A l'exception de la chambre principale située au niveau supérieur, toutes les fonctions sont réunies au niveau inférieur. Presque toutes les pièces ouvrent sur une terrasse.

Selected Bibliography: - Los Angeles Times Home Magazine, *January 25, 1970*

4626 Crites & McConnell
C. Y. Stephens Auditorium, Iowa State University, Ames, Iowa
May 26, 27, 1970

The Auditorium was the first of four buildings to be completed as part of the Iowa State University Center. Aligned along the North-South axis, it sits on the Eastern edge of the old campus. Crites & McConnell, in a joint venture with Brooks, Borg and Skiles, designed the space to function as both a theater and a music hall. Acoustical demands and sightlines from seating to stage were central in shaping the enclosure and its exterior. The curved interior ceiling in hemlock and the concrete walls enhance sound dispersal, while carpeting provides the required sound absorption. 2,637 seats are arranged on four levels: 1,618 on the main floor, 400 each on the first and second balcony levels, and 200 on the third balcony. The rise between rows increases from 4 inches near the stage to 12 inches at the rear, creating an arched profile for the main level. At the upper levels, the slope of the balconies gets steeper. Using poured-in-place concrete as the principal material, the architects devised adventurous structural solutions to distribute the seating areas. The cascade of side balconies jutting out of the folded side walls seems to float over the main floor while affording additional viewing.

Four stair towers, placed at the corners of the hexagonal plan of the auditorium, lead to the side aisles feeding into the balconies of the second and the third level. Two entrance levels are positioned on the principal elevation: one is at the ground level; the other is located at the main floor level and reaches an outdoor circulation system of walkways and a plaza connecting all the buildings of the center. Due to the unconventional section of the interior, the roofline toward the main front is higher than the stage area. The exterior soffit in cedar is stained to blend with the concrete.

Dieser Bau war der erste von vier Gebäuden des Iowa State University Center. Er steht auf der Nord-Süd-Achse am Ostrand des alten Universitätsgeländes. Crites & McConnell entwarfen ihn in Zusammenarbeit mit Brooks, Borg und Skiles als Theater- und Konzerthalle. Akustische Erfordernisse und die notwendigen Sichtlinien zwischen Publikumssitzen und Bühne waren die bestimmenden Entwurfsfaktoren. Die gekrümmte Holzdecke und die Betonwände sorgen für gute Tonverteilung, der Teppichboden für die erforderliche Schallabsorbierung. Auf vier Ebenen sind 2 637 Sitze angeordnet: 1 618 im Parkett, je 400 auf dem ersten und zweiten Rang und 200 im Olymp. Die Sitzreihen steigen vom Orchestergraben zur hintersten Parkettreihe in zunehmend höheren Abständen an. Vorne beträgt der Höhenunterschied ca. 10 cm, hinten dann schon 30 cm. Die Steigung der Ränge wird noch steiler. Unter Einsatz von Ortbeton erfanden die Architekten originelle konstruktive Lösungen für die Verteilung der Sitze. Zum Beispiel schweben die kaskadenartig aus den gefalteten Seitenwänden vorstoßenden Rangabschnitte über dem Parkett und bieten gute Sicht auf die Bühne.
Vier Treppenschächte an den Ecken des sechseckigen Auditoriums führen zu den Seitengängen, dem zweiten Rang und dem Olymp. Zwei Eingangsbereiche befinden sich auf der Hauptebene, eine im Erdgeschoss, eine auf der Parkettebene mit direktem Zugang von den Wegen und der Plaza, die alle Gebäude des Geländes miteinander verbinden. Aufgrund des unkonventionellen Gebäudequerschnitts ist die Dachsilhouette von vorne gesehen höher als am Bühnenende. Die Unterseiten der Dachüberstände sind mit Zedernholz verkleidet, das so gebeizt wurde, dass es farblich zum Beton passt.

L'auditorium fut le premier des quatre bâtiments achevés dans le cadre de la construction de l'Iowa State University Center. Aligné sur un axe nord-sud, il est implanté en bordure est de l'ancien campus. Crites & McConnell, en association avec Brooks, Borg et Skiles, ont conçu ce bâtiment pour sa double fonction : théâtre et salle de concert. Les contraintes acoustiques et le champ de vision des spectateurs ont joué un rôle essentiel dans la détermination de la forme et des matériaux de l'enveloppe. Le plafond incurvé en sapin et les murs en béton améliorent la dispersion du son, tandis que la moquette l'absorbe. Les 2 637 sièges sont disposés sur quatre niveaux : 1 618 à l'orchestre, 400 au premier et au second balcon et 200 au troisième balcon. Le profil arqué de l'orchestre s'explique par la différence de hauteur entre deux rangées de sièges, qui passe de 10 cm près de la scène à 30 en fond de salle. Aux balcons, la pente est encore plus forte. Grâce au béton coulé sur place, les architectes ont pu proposer des solutions structurelles audacieuses pour la distribution des sièges. La cascade de balcons latéraux saillant des murs latéraux ondulés semble flotter audessus de l'orchestre tout en offrant une bonne vision.
Quatre tours d'escaliers, disposées aux angles de l'auditorium hexagonal, conduisent aux galeries latérales qui donnent accès aux balcons. Sur la façade principale, l'entrée peut se faire à deux niveaux différents : l'une au rez-de-chaussée, l'autre au niveau de l'orchestre relié aux allées et à la plaza, autour de laquelle sont répartis les bâtiments du centre. En raison de la coupe inhabituelle de la salle, le toit est plus haute en façade qu'au-dessus de la scène. Le soffite extérieur est en cèdre teinté d'une couleur qui s'harmonise à celle du béton.

Selected
Bibliography: - Architectural Record, December 1970

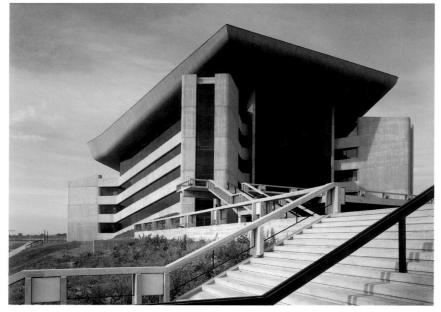
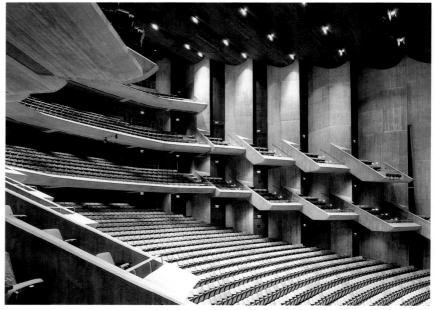

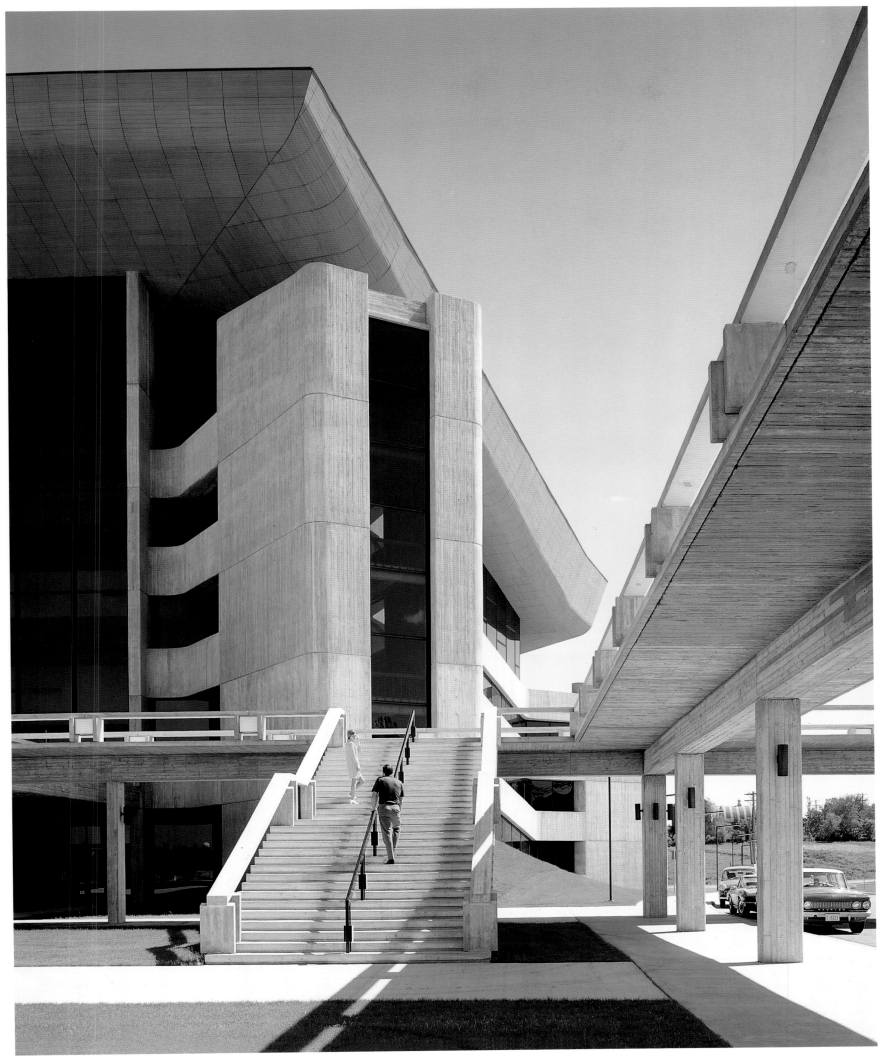

4642 Thomas McNulty
McNulty Residence, Lincoln, Massachusetts
June 24, 1970

Selected
Bibliography:
- *Architectural Forum, November 1965*
- *L'Architecture d'Aujourd'hui, February-*
 March 1966
- *L'Architettura. Cronache e Storia, March 1966*
- *Domus, October 1966*
- *Deutsche Bauzeitung, November 1966*
- *Los Angeles Times Home Magazine,*
 August 30, 1970

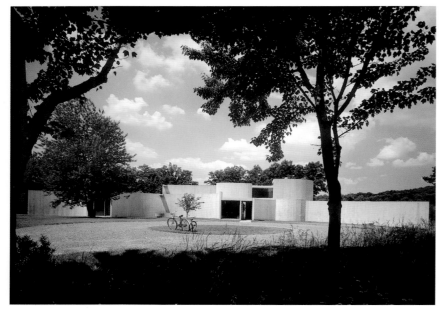
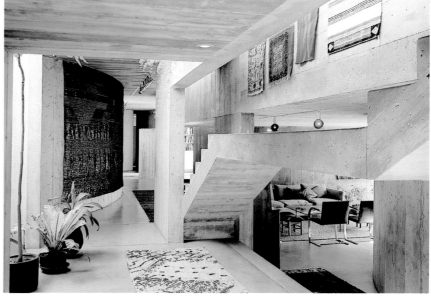

The architect-owners wanted their sculptural house to provide an experience of flow. Without sharp separation between rooms and corridors, functions blend into a spatial continuum defined by a set of cutout curves, positioned along a 150-foot axis. Each area contained between the ends of two walls merges into the central axis. The convexity of shapes gives an interstitial quality to the enclosure, almost an in-between condition, and activates movement through the residence. Essentially, the house reads as a single room with a few sculptural episodes unhampered by the customary compartments of conventional dwellings. Space expands and contracts ranging from a 10-foot width to 35 feet. The program is distributed on two levels. With the exception of the bathrooms, the guestroom and the entrance, there are no doors in the house. Privacy, instead, is acquired through distance and changes in level. On the first

Der Architekt wollte mit seinem eigenen Haus ein plastisch-flie-ßendes Architekturerlebnis schaffen. Räume und Flure sind zwar deutlich voneinander abgegrenzt, dennoch verschmelzen die verschiedenen Funktionsbereiche zu einem räumlichen Kontinu-um, erzeugt von mehreren geschwungenen Wandeinschnitten entlang der 45 m langen zentralen Raumachse. Jeder von zwei Stichwänden umfasste Bereich mündet in diese Mittelachse. Konvexe Formen verleihen dem Haus die Qualität eines Zwi-schenraums oder Zwischenzustands, der durchquert werden will. Im Wesentlichen liest sich das Innere als ein einziger Raum – unbehindert durch die »Raumabteile« gewöhnlicher Häuser – mit nur wenigen skulpturalen Elementen. Der Innenraum erwei-tert sich und zieht sich wieder zusammen, die Hausbreite schwankt also zwischen 3 m und fast 11 m. Die Funktionsberei-che sind auf zwei Ebenen verteilt. Nur die Bäder und das Gäs-

L'Architecte (et propriétaire) souhaitait que cette résidence sculpturale donne une impression de fluidité. A la différence de la séparation classique entre les pièces et les couloirs, les di-verses fonctions fusionnent en un continuum spatial défini par une succession de courbes brisées le long d'un axe majeur de 45 m de long. Chaque zone comprise entre deux pans de murs se fond avec cet axe dans sa partie ouverte. La convexité de ces « enceintes » génère une qualité interstitielle, un état d'entre-deux pour ainsi dire, et donne l'impression de mouvement. Pour l'essentiel, la maison se lit comme une pièce unique, ponctuée de quelques gestes sculpturaux et libérée de la compartimenta-tion habituelle des logements traditionnels. L'espace se dilate et se contracte de 3 m à 11 m. Le programme est réparti sur deux niveaux. Aucune porte, à l'exception de celles des salles de bains, de la chambre d'amis et de l'entrée. L'intimité est pré-

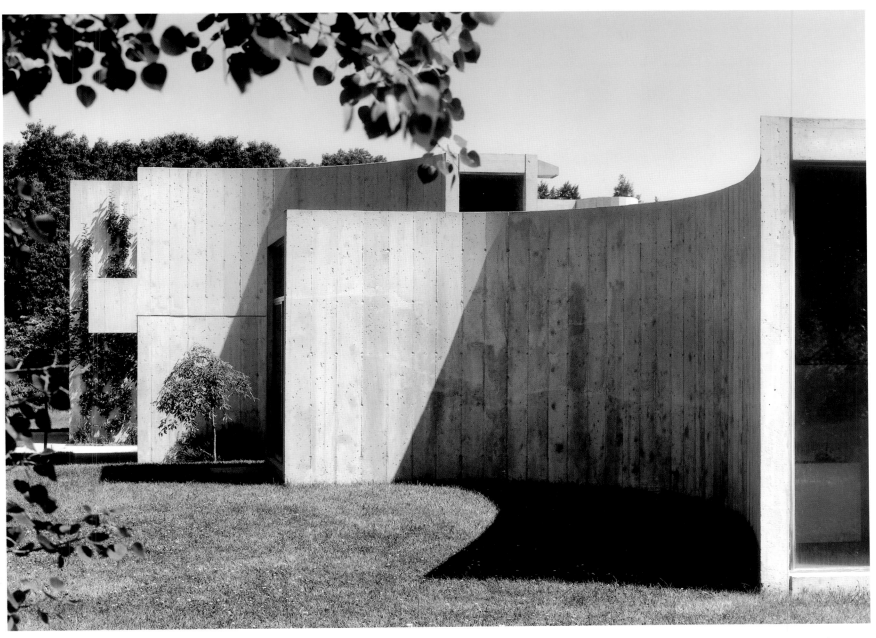

floor, one end of the residence is the domain of the architects' three kids; the other houses the kitchen and a guestroom; the communal space is in the middle. Upstairs, there is the master bedroom and a drafting studio. In the central area, an internal partition curves almost full circle and encloses the library as well as the upper studio, creating an interruption in the fluidity of space. A gentle ramp wraps around this concrete drum and to direct circulation.

The bare ribbons of poured-in-place concrete have no windows. The interior spaces are lit through elongated skylights and seven sets of sliding glass doors that connect indoors and outdoors. The fine-textured eight-inch exterior walls were patterned by 2 x 12-inch boards.

tezimmer haben Türen. Abgeschiedenheit entsteht ansonsten allein durch räumliche Distanz oder unterschiedliche Wohnebenen. Am einen Ende des Erdgeschosses befinden sich die Zimmer der drei Kinder, am anderen Ende Küche und Gästezimmer. Der Wohnbereich ist in der Mitte. Im Obergeschoss sind Elternschlafzimmer und ein Zeichenbüro untergebracht. Eine Wand im Mittelteil des Hauses gebietet vorübergehend dem fließenden Innenraum Einhalt, indem sie einen fast geschlossenen Kreis beschreibt und die Bibliothek sowie – darüber – das Zeichenbüro umfasst. Eine sanft ansteigende Rampe zur oberen Ebene umrundet diesen Betonzylinder.

Die Sichtbetonmauern sind fensterlos. Tageslicht dringt durch längliche Dachlaternen und sieben Paar Glasschiebetüren ins Innere. An den 20 cm dicken Außenmauern sind die Abdrücke der Schalungsbretter zu sehen.

servée par la distance et les changements de niveaux. Au rez-de-chaussée, l'une des extrémités de la maison est le domaine des trois enfants, l'autre est consacrée à la cuisine et à une chambre d'amis. L'espace commun occupe le centre. A l'étage, se trouvent la chambre des maîtres de maison et un atelier d'architecte. Dans la partie centrale, un cloisonnement décrit un cercle presque complet autour de la bibliothèque et du bureau de l'étage, rompant un instant la fluidité spatiale. Une rampe de circulation en pente douce s'enroule autour de ce tambour de béton. Aucune ouverture ne vient interrompre les rubans de béton nu coulé sur place. L'intérieur est éclairé par des verrières allongées et sept groupes de portes de verre coulissantes qui donnent sur le dehors. Les murs extérieurs de 20 cm d'épaisseur ont été finement texturés lors de la mise en œuvre au moyen d'un coffrage en planches de 30 x 5 cm.

4660 Raymond Kappe
Pregerson Residence, Pacific Palisades, California
September 8, 1970

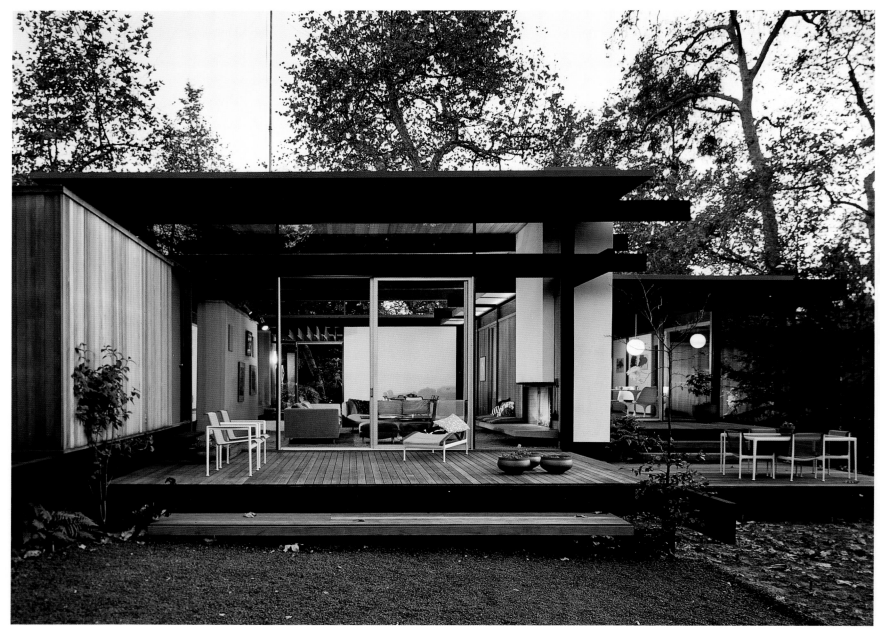

The site, bordered by a brook, had been covered with 10-foot-deep fill. Since the stream has a tendency to overflow, Kappe placed the residence on piles, spaced 16 feet apart, to create a more solid foundation.
Interlocking platforms on various levels articulate the program on one story. Clerestory windows make the flat roof appear to float in space. The siding is primarily redwood.

Ein Bach bildet die Grenze des Grundstücks, das mit 3 m Erdboden nivelliert worden war. Da der Bach bereits mehrere Überschwemmungen verursacht hatte, stellte Kappe das Haus auf Pfähle (in Abständen von rund 4,80 m), um eine stabilere Gründung zu erzielen. Ineinandergreifende, höhenversetzte Plattformen ermöglichten eine abwechslungsreiche Gestaltung des eingeschossigen Hauses. Seitliche Oberlichter lassen das Flachdach im Raum »schweben«. Die Verschalung der Fassaden besteht vorwiegend aus Redwood.

Le terrain bordé par un ruisseau avait été recouvert par 3 m de remblai. Le petit cours d'eau pouvant quitter son lit, Kappe suréleva la maison sur des pilotis espacés de 4,80 m afin de trouver un sol plus sûr.
Des plates-formes imbriquées à différents niveaux permettent d'articuler les différentes fonctions sur un seul étage. Les fenêtres hautes donnent l'impression que le toit flotte dans l'espace. Le bardage est essentiellement en bois rouge.

Selected Bibliography:
- Los Angeles Times Home Magazine, April 4, 1971
- Architecture California, Idioms of the Fifties, November/December 1986

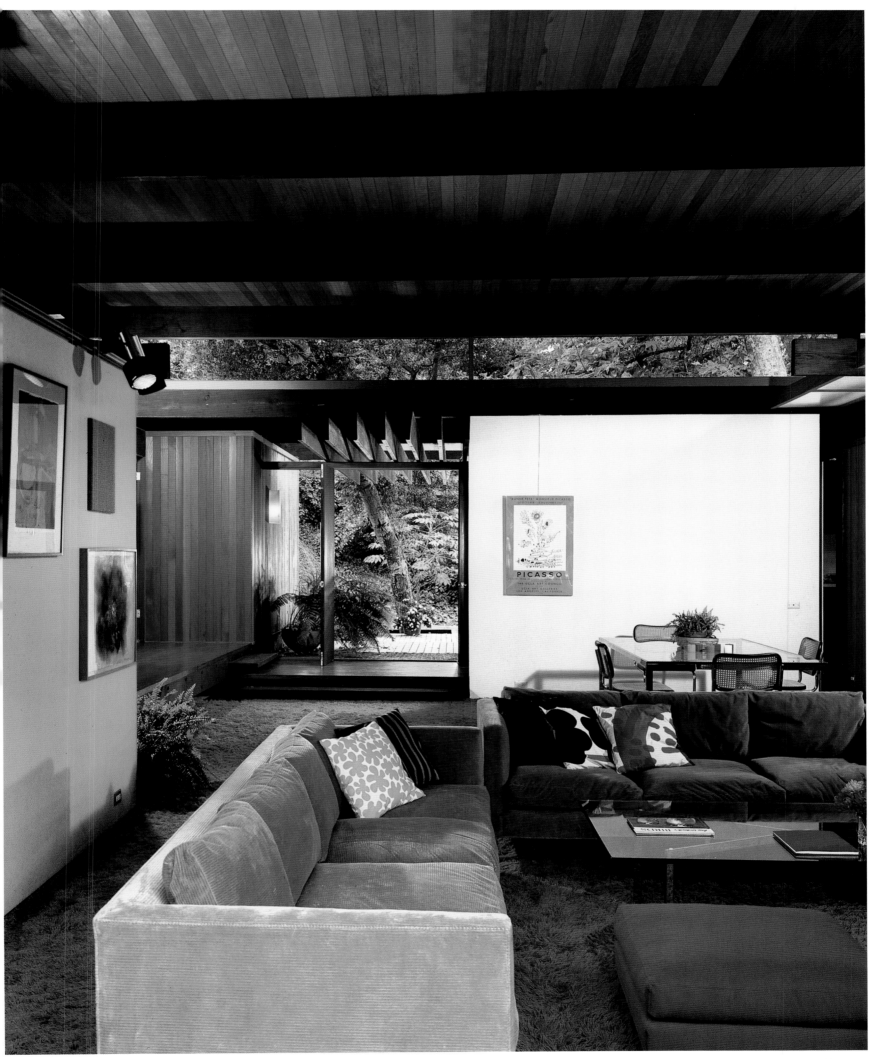

4833 Charles Lagreco
Lagreco Residence, San Bernardino, California
March 2, 1972

Dan MacMasters was the first journalist to cover the Lagreco Residence in a four-page article for the *Los Angeles Times Home Magazine*. In the text, the author discusses the advantages of adopting concrete as the main building material in residential work. The article reads like a promotion of concrete as a viable alternative to more conventional methods of construction. He argues that, being fireproof, concrete is an especially practical choice for structures erected in areas subjected to forest fires.

Designed for the architect's parents, the house is located on a sloping site adjacent to the San Bernardino National Forest, a territory frequently subject to fire hazards. Charles Lagreco's father was a general contractor whose firm, in the San Bernardino area, dealt mainly with schools and institutional projects. Lagreco's father specialized in concrete structures and personally undertook the construction of his residence. The

Dan MacMasters war der erste Architekturkritiker, der das Haus Lagreco mit einem vierseitigen Bericht im »Los Angeles Times Home Magazine« würdigte. Darin pries er die Vorteile von Beton als Hauptbaumaterial im Haus- und Wohnungsbau, so dass der Artikel sich wie der Werbetext eines Betonherstellers liest. Er plädierte besonders für Beton als feuerfestes Material der Wahl für Häuser, deren Umgebung öfters von Waldbränden heimgesucht wird.

Der Architekt baute das Haus für seine Eltern auf einem abschüssigen Grundstück im San Bernardino-Staatsforst, in dem immer wieder Flächenbrände ausbrechen. Lagrecos Vater war Bauunternehmer, baute vor allem Schulen und Institutsgebäude und hatte sich auf das Bauen mit Beton spezialisiert. Natürlich führte er sein eigenes Haus auch selber aus. Die Innenräume sind zwecks freier Ausblicke auf drei Ebenen untergebracht, auf der untersten die Haustechnik, eine Garage und ein Schwimm-

Dan MacMasters fut le premier journaliste à parler de la Lagreco Residence dans un article de quatre pages du «Los Angeles Times Home Magazine». Il y expliquait les avantages du béton comme matériau principal de construction d'une maison. L'article semble vouloir faire du béton une alternative viable aux méthodes plus traditionnelles. Il explique qu'étant insensible au feu, ce matériau est un choix particulièrement recommandé dans les zones sujettes aux incendies de forêt.

Conçue pour les parents de l'architecte, cette maison est située sur un terrain en pente près de la San Bernardino National Forest, territoire souvent menacé par le feu. Le père de Charles Lagreco possédait une entreprise générale dans la région de San Bernardino, et construisait essentiellement des écoles et des bâtiments publics. Spécialisé dans les constructions en béton, il dirigea personnellement le chantier de sa maison. Celle-ci s'articule sur trois niveaux pour mieux bénéficier de la vue sur

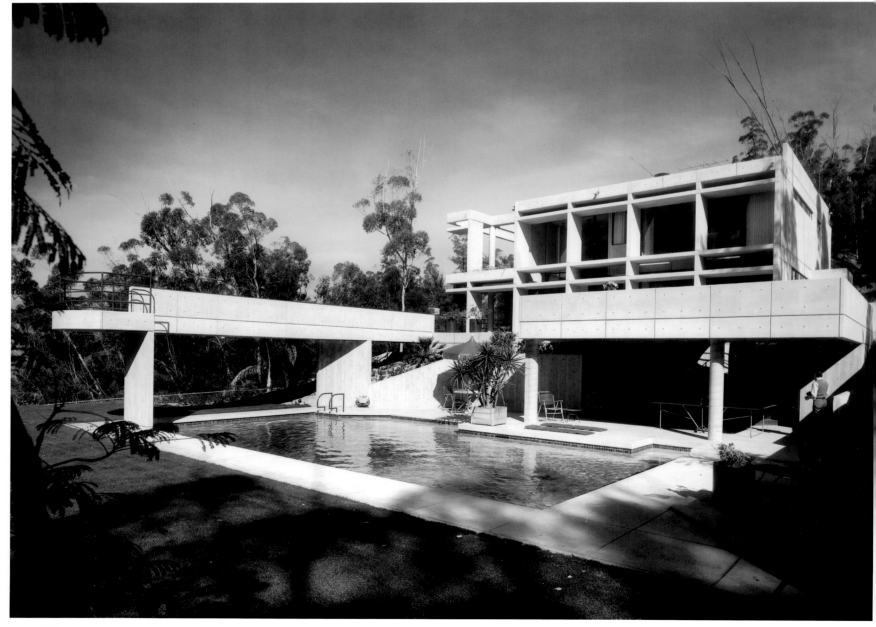

Selected
Bibliography:

- Los Angeles Times Home Magazine,
 July 2, 1972
- Global Architecture Houses, 1977
- LA Architect, November 1977
- Architecture & Urbanism, April 1978

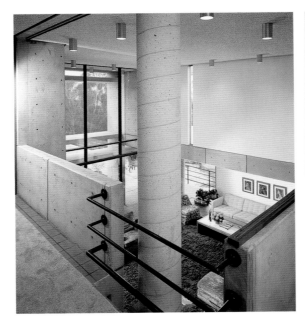
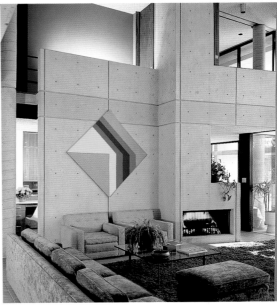

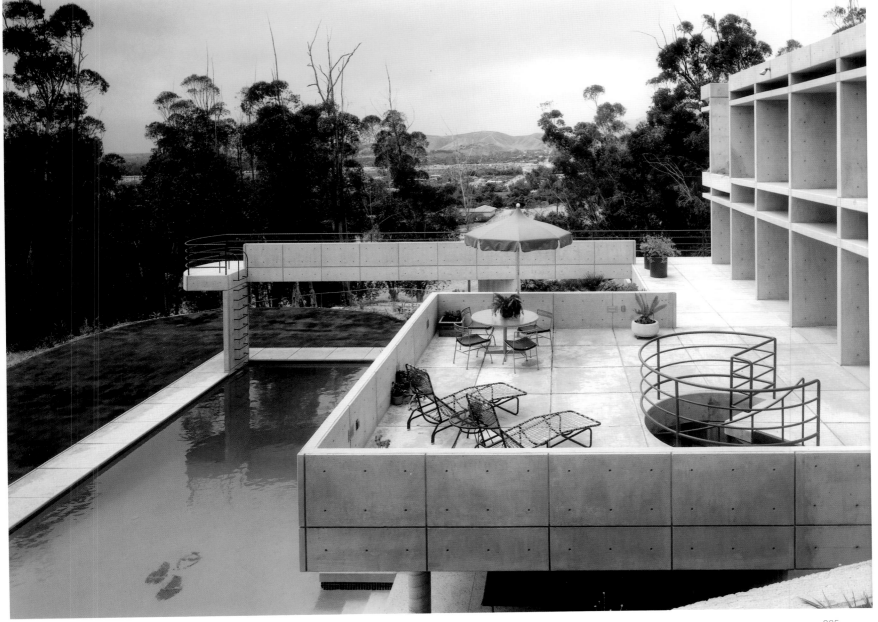

dwelling is articulated on three levels to take advantage of the view of the valley below. The lower level contains building services, a garage and a swimming pool; the main level accommodates communal spaces; the upper floor houses the private areas. Both the internal organization of the space and the alignments of the outdoor areas abide by the normative geometry of the square. Strictly modular in plan and elevation, the residence displays clear signs of the architectural references informing its design. On the main facade, the brise-soleil filtering sunlight on the main and upper floors resembles the deep concrete frame of the elevation of Villa Shodan, a residential project located in Ahmedabad, India, authored by Le Corbusier in 1956. The treatment of the exposed reinforced concrete in the Lagreco Residence carries the influence of the concrete work visible in Louis Kahn's Salk Institute in San Diego, California, completed in 1966. After the death of Lagreco's father, the residence was sold to its current owner. Today, the house is still standing and in good condition.

becken, im Hauptgeschoss die Wohnräume, im Obergeschoss die Schlafzimmer. Sowohl die Innengliederung als auch die Ausrichtung der Gartenflächen beruht auf der Geometrie des Quadrats. In Plan und Aufriss strikt modular, weist das Haus deutlich auf die Quellen des architektonischen Entwurfs hin: Die »Brisesoleils« der Hauptfassade erinnern an Le Corbusiers Villa Shodan in Ahmedabad, Indien, von 1956. (Auch dort gab es einen schmalen Wandelgang zwischen der Fassade und den vorgehängten Sonnenschutzblenden.) Die Behandlung der schalungsrauhen Stahlbetonoberflächen des Hauses Lagreco belegen den Einfluss der Betonarchitektur Louis Kahns, beispielhaft verkörpert in dessen Salk Institute in San Diego, Kalifornien (1966). Nach dem Tod von Lagrecos Vater wurde das Haus verkauft. Der jetzige Eigentümer erhält es in gutem Zustand.

la vallée en contrebas. Le niveau inférieur abrite les pièces de service, un garage et une piscine. Le niveau principal contient les espaces communs, le supérieur les chambres. L'organisation interne de l'espace et les alignements des aménagements extérieurs suivent la norme du carré. De plan et d'élévation strictement modulaires, la résidence affiche clairement ses références architecturales. Sur la façade principale, le pare-soleil qui protège les deux niveaux supérieurs rappele à la trame de béton toute en profondeur de la Villa Shodan, projet résidentiel réalisé par Le Corbusier à Ahmedabad, Inde, en 1956. Le traitement du béton armé apparent évoque le Salk Institute de Louis Kahn à San Diego, Californie, achevé en 1966. Après la mort du père de Lagreco, la maison fut vendue à son actuel propriétaire. Elle est toujours en très bon état.

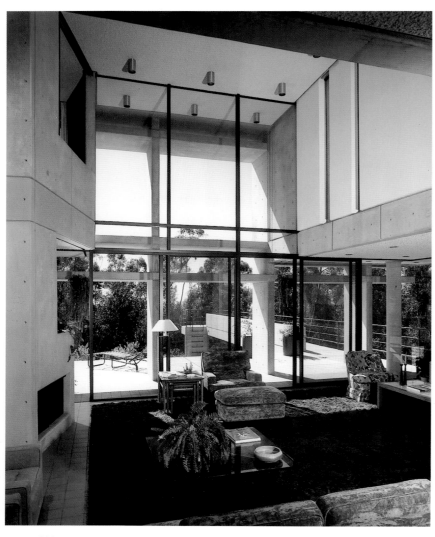

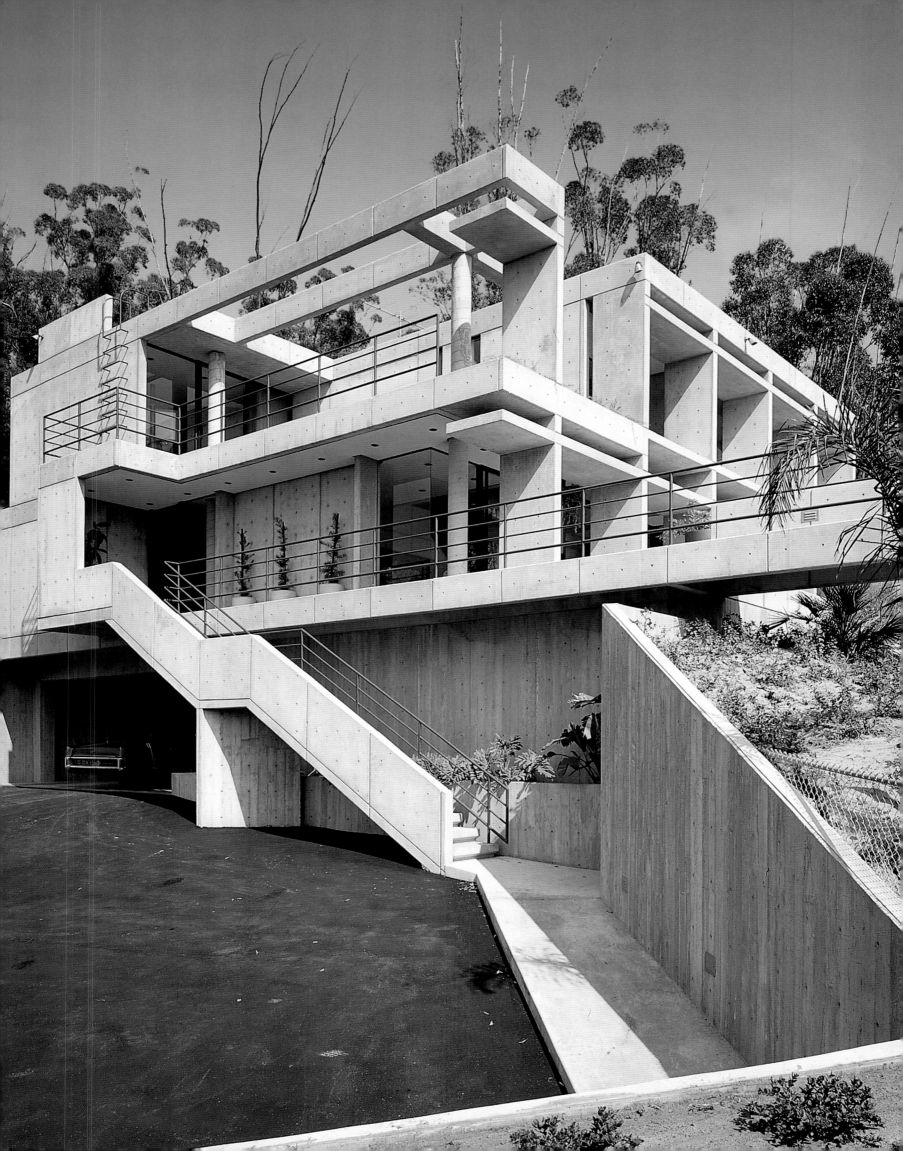

4869 Stephen Gassman
Romick Residence, Los Angeles, California
July 18, 19, 1972

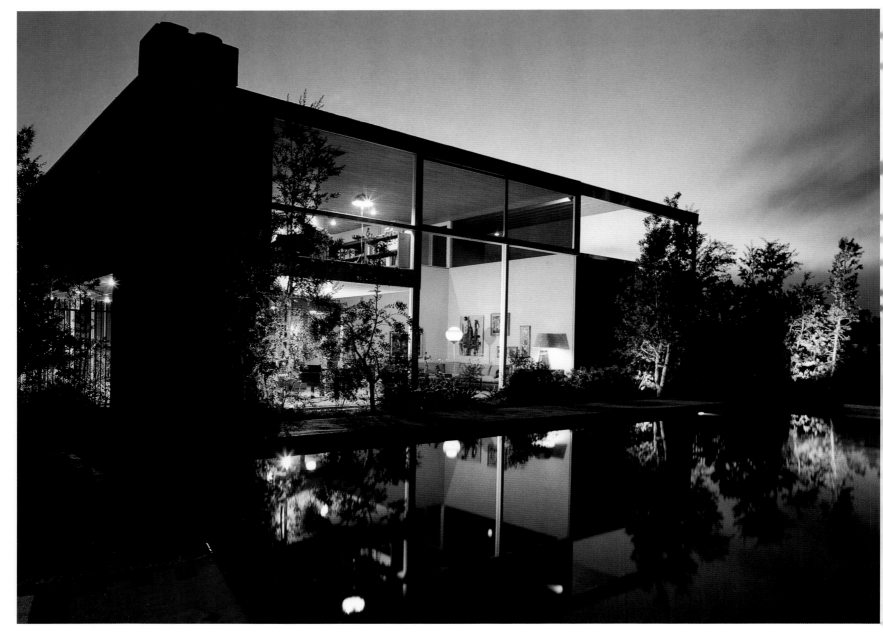

The house is tailored to the needs of a couple and their three young children. The architect, faced with a long, narrow lot, made the pool area, with its view of the San Fernando Valley, the focus of family activity. There are three outdoor spaces designed for social gatherings are: the pool area extending from the living room; the patio court extending from dining room and kitchen; and the playground section by the bedrooms.

Das Haus wurde für ein Ehepaar mit drei kleinen Kindern gebaut. Der Architekt musste es auf ein langes, schmales Grundstück stellen und machte aus dem Schwimmbeckenbereich vor dem Wohnraum mit Panoramablick über das San Fernando-Tal den Mittelpunkt des Familienlebens. Das Haus bietet zwei weitere Wohnräume im Freien: den Patio vor dem Küchen- und Esszimmerbereich und einen Spielplatz vor den Kinderzimmern.

Conçue pour une parcelle allongée, cette maison fut créée pour un couple et ses trois jeunes enfants. La piscine et la vue panoramique sur la San Fernando Valley constituent le centre de la vie familiale. Trois lieux différents permettent de se retrouver et de vivre à l'extérieur : l'aire de la piscine devant le séjour, une cour-patio à proximité de la salle à manger et de la cuisine, et une cour de jeux accessible des chambres.

Selected Bibliography: - *Los Angeles Times Home Magazine, October 8, 1972*

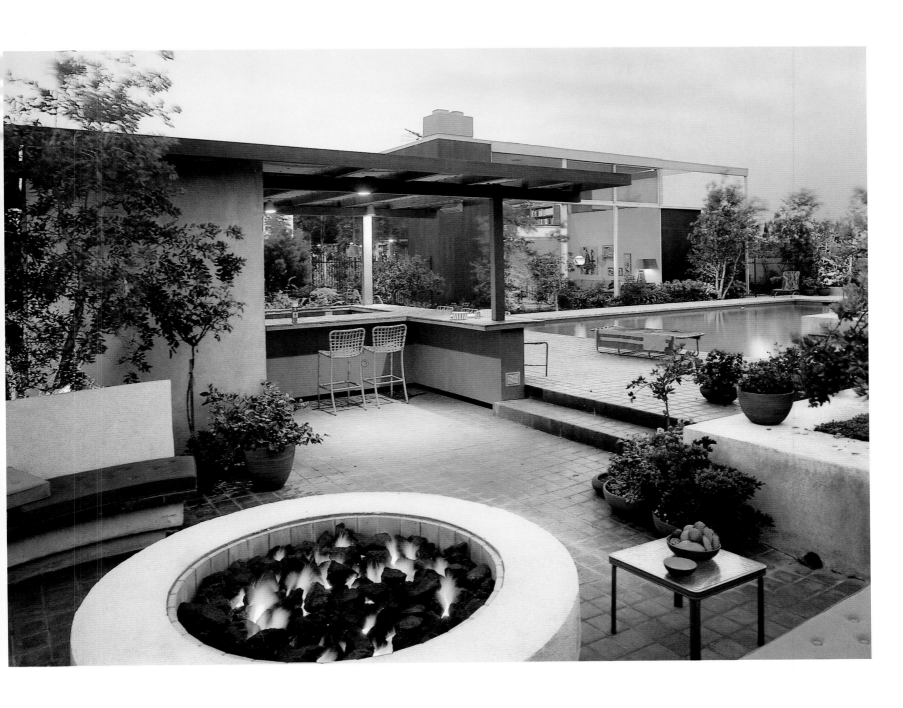

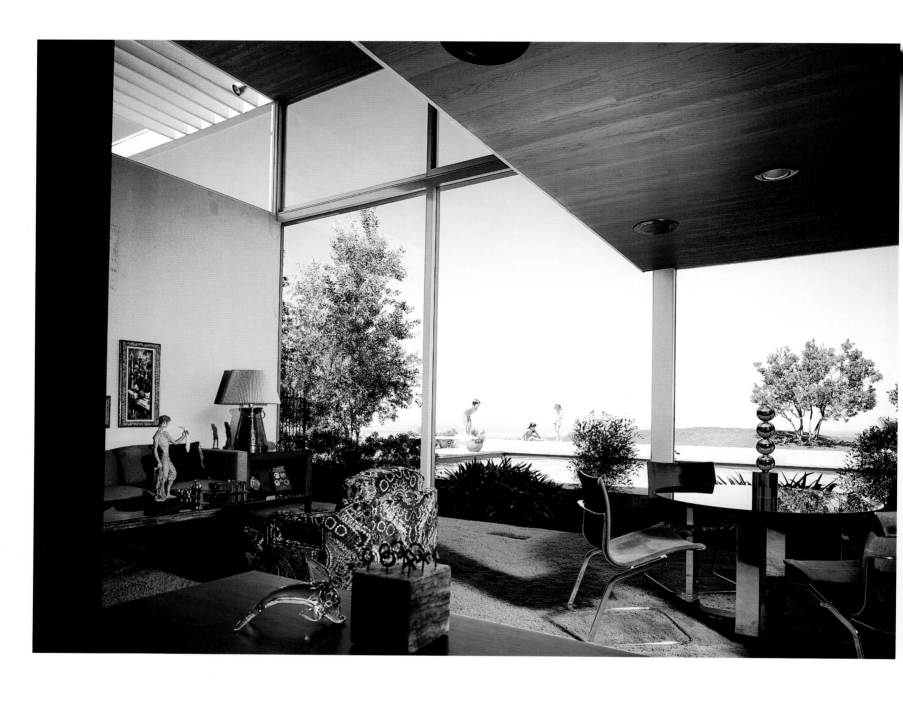

4912 **Karl Kamrath**
Gonzales Residence, Houston, Texas
November 8, 1972

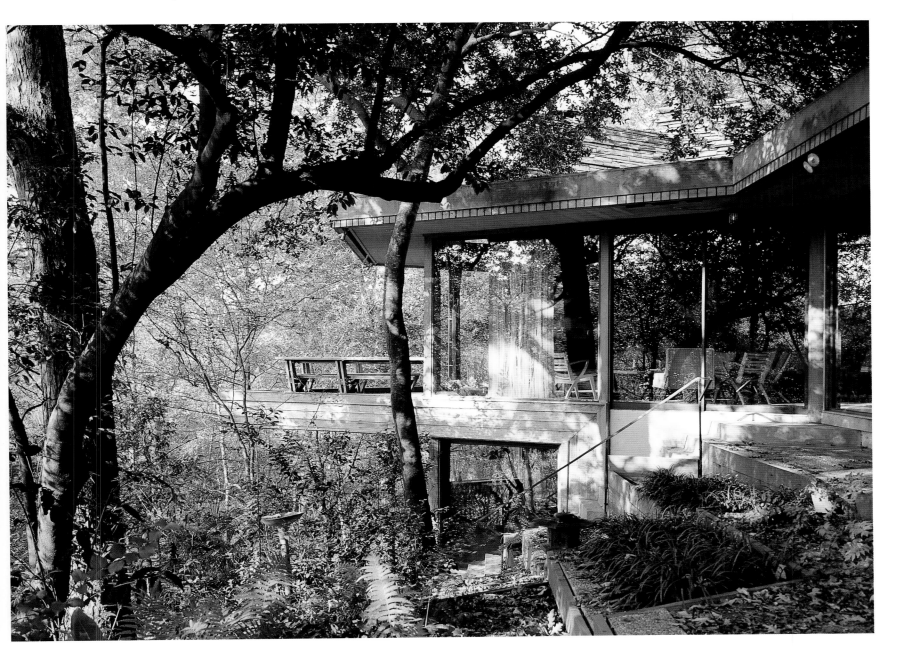

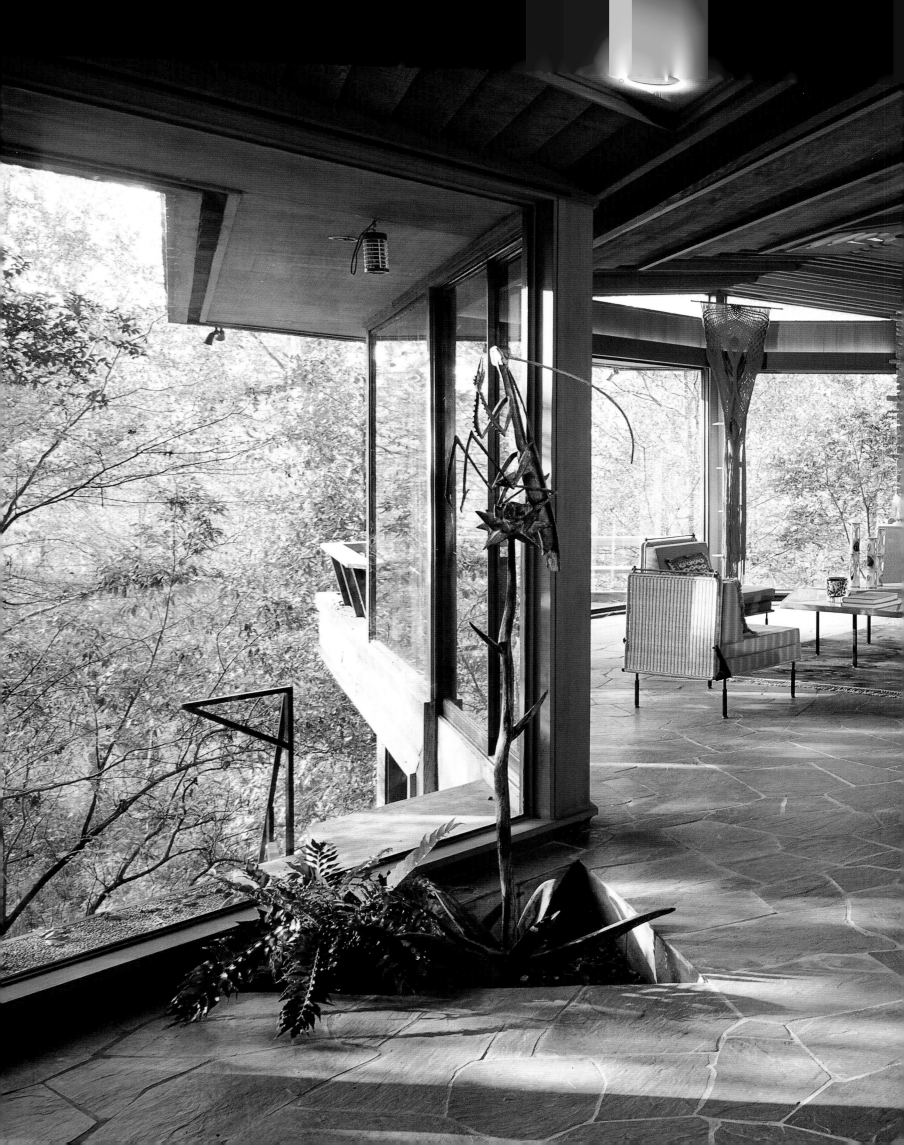

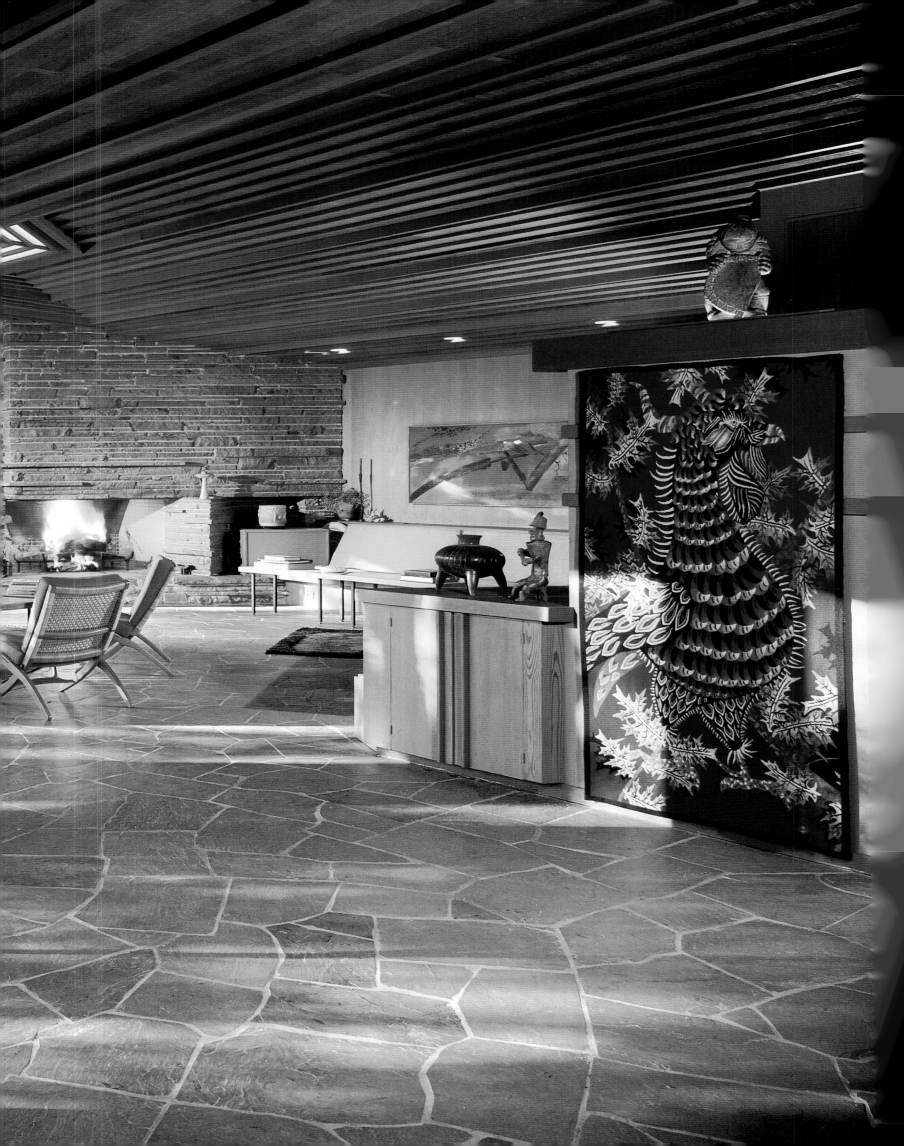

4933/5263 Raymond Kappe
Hattenbach Residence, Santa Monica, California
October 7, 1975

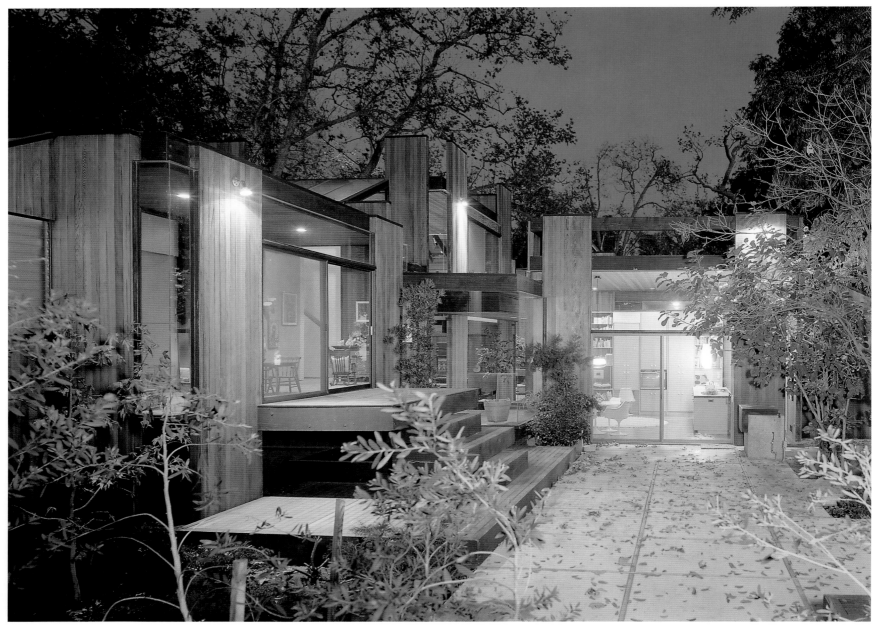

The idea behind this project was to develop a prototype for residence organized around the repetition of shapes variously oriented. On a level wooded site 100 x 130 feet in size, Kappe designed a domestic setting for Bert and Dawn Hattenbach and their two small children. The total area is 2,878 square feet and an equivalent of half of that floor area is glass. In plan, five cubes with a 20-foot side are arranged in pairs and served by corridors for circulation. The variable heights of the cubes, from 10 to 24 feet, articulate the rooftop against the natural backdrop of the trees. Smaller volumes attached to the outer envelope to the cubes house the baths, kitchen, workshop, and fireplace.

Der Entwurf hatte zum Ziel, den Prototyp eines Haus zu entwickeln, dessen Räume aus unterschiedlich ausgerichteten Standardmodulen bestehen. Das Haus für Bert und Dawn Hattenbach und ihre zwei kleinen Kinder entstand auf einem ebenen Waldgrundstück (ca. 30 x 40 m). Es besitzt eine Gesamtfläche von 265 m², die Hälfte davon raumhoch verglast. Der Plan umfasst fünf Rechtecke (Seitenlänge jeweils 6 m) – vier davon paarweise angeordnet – und einen Korridor in der Mitte. Die unterschiedlich hohen Räume (3 bis 7 m) ergeben eine höhenversetzte Dachlandschaft inmitten der Baumkronen. Kleinere kubische An- und Vorbauten beherbergen Bäder, Küche, Werkstatt und Kaminschacht.

Il s'agissait au départ de mettre au point un prototype de maison à partir d'un principe de répétition de formes identiques mais d'orientations diverses. Sur un terrain plat de 30 x 40 m au milieu des bois, Kappe conçut le nouveau cadre de la vie familiale de Bert et Dawn Hattenbach et de leurs deux jeunes enfants. La surface totale représente 265 m², dont une moitié est couverte de vitrages. En plan, les cinq cubes de 6 m de côté sont réunis par paires et desservis par un couloir. Leur hauteur variable, de 3 à 7 m, explique l'animation de l'articulation de la ligne de faîte qui se détache devant les arbres. Des volumes plus petits sont rattachés à l'enveloppe extérieure des cubes pour abriter les salles de bains, la cuisine, l'atelier et une cheminée.

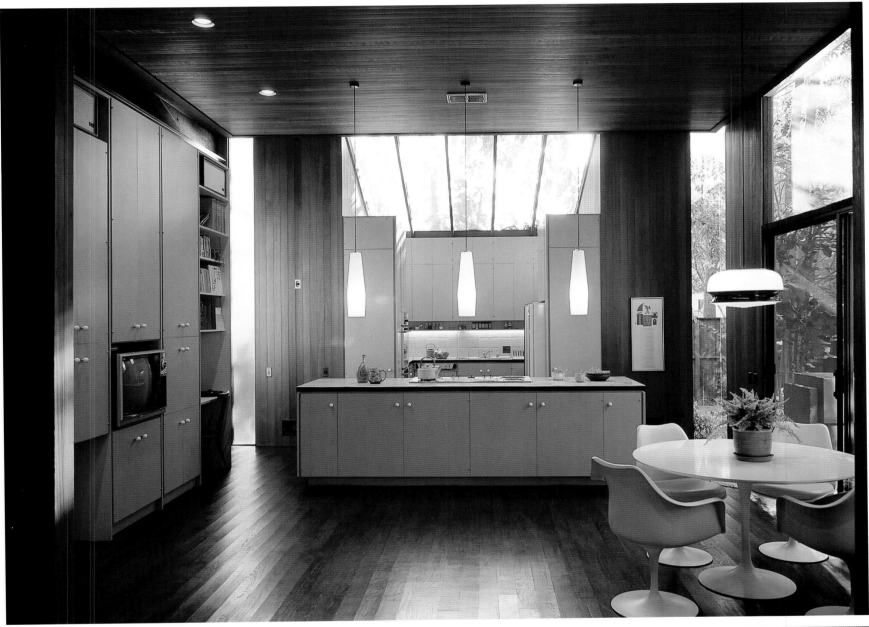

Selected - *Global Architecture Houses, 1, Tokyo 1976*
Bibliography: - *Los Angeles Times Home Magazine,*
 13 February 1977

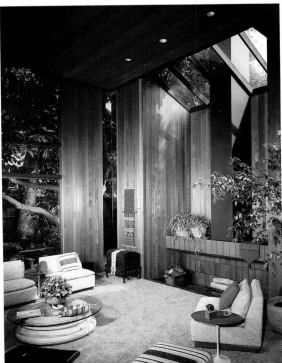

4934/5011 **Raymond Kappe**
Gertler Residence, Santa Monica, California
December, 21, 26, 1972

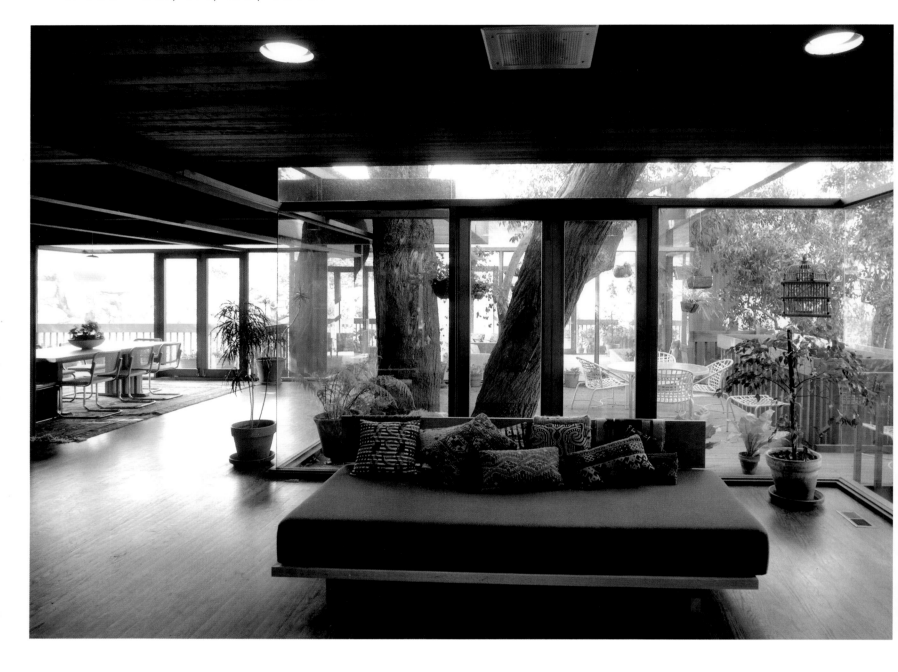

Selected
Bibliography:

- Los Angeles Times Home Magazine,
 February 17, 1974

- Global Architecture Houses, 1,
 Tokyo 1976

- Michael Webb, Themes and Variations: House
 Design by Ray Kappe, Victoria 1998

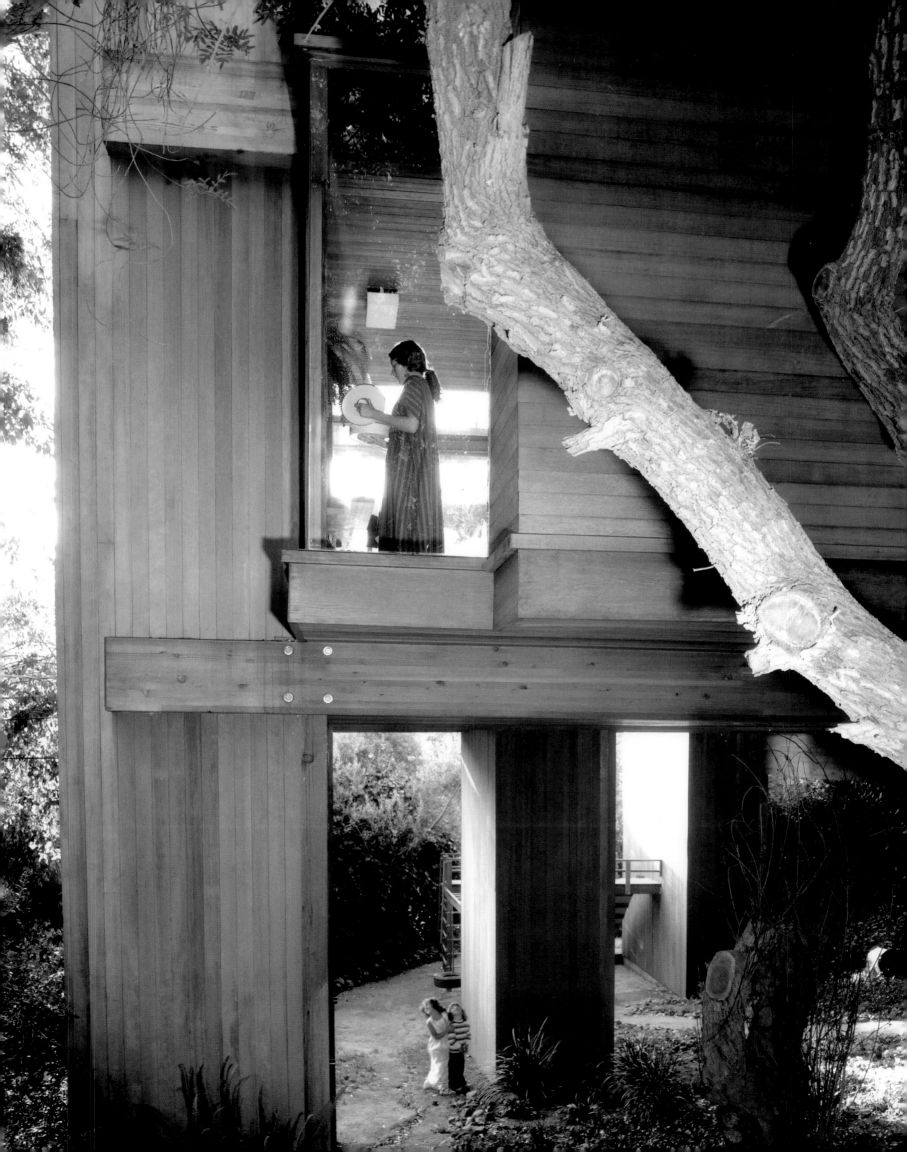

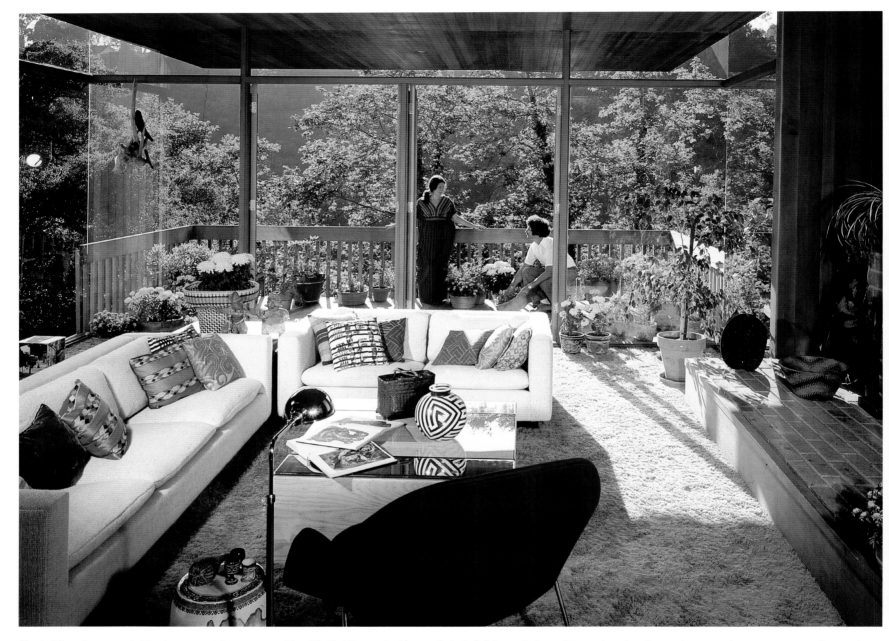

The building site surrounded by dense vegetation measures 60 x 120 feet and is located on a sloping terrain with a four-foot-fill. The five levels of the house are arranged between eight redwood towers which act as vertical supports. The owners wanted to save a eucalyptus tree located in the center of the site. Therefore, the footprint incorporated the tree into the visual imagery of the house. Almost every room has an outdoor extension. All beams are glue-laminated.

Die fünf Etagen des Hauses sind wie Brücken zwischen acht Turmpfeilern gespannt. Das dicht bewachsene Grundstück misst 18 x 36 m und umfasst ein um 1,20 m erhöhtes Stück Flachland. Die Gertlers wollten einen großen Eukalyptusbaum mitten auf dem Grundstück erhalten, die Außenmauer des Hauses bildet daher eine Nische um den Baum herum. Fast jedes Zimmer ist mit einer Terrasse versehen. Die Dachbalken bestehen aus Schichtholz.

Les cinq niveaux de cette maison sont en passerelle entre les huit tours de bois rouge constituant les supports verticaux. Entourée d'une végétation très dense, la parcelle de 18 x 36 m est située sur une déclivité recouverte de 1,20 m de remblai. Les propriétaires tenaient à épargner l'eucalyptus qui se trouvait au centre du terrain. Le plan du séjour est découpé de façon à l'incorporer dans la maison. Presque toutes les pièces possèdent une extension vers l'extérieur. Toutes les poutres sont en lamellé-collé.

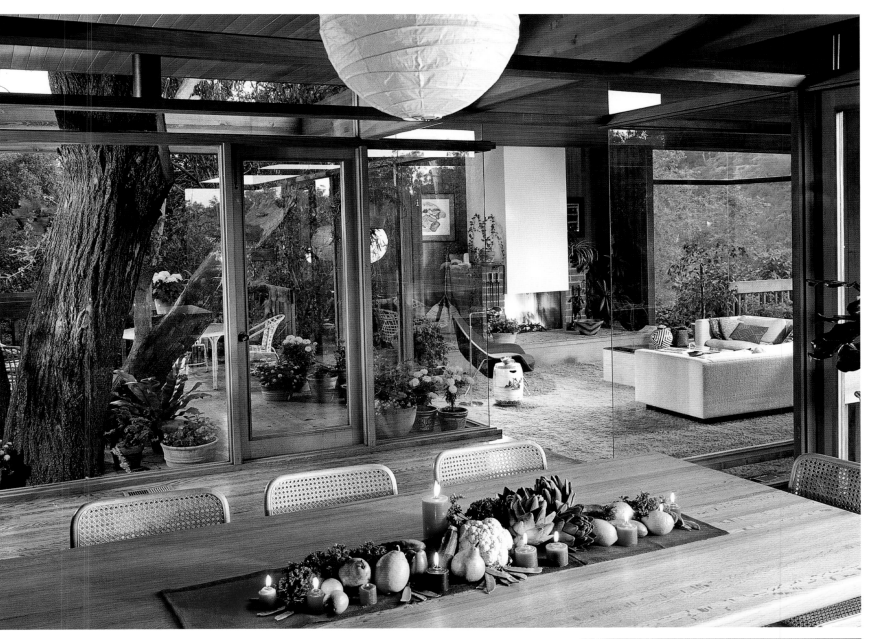

4946/5268 **Sidney Eisenstadt**
House of the Book, Brandeis, Simi Valley, California
February 15, 1973

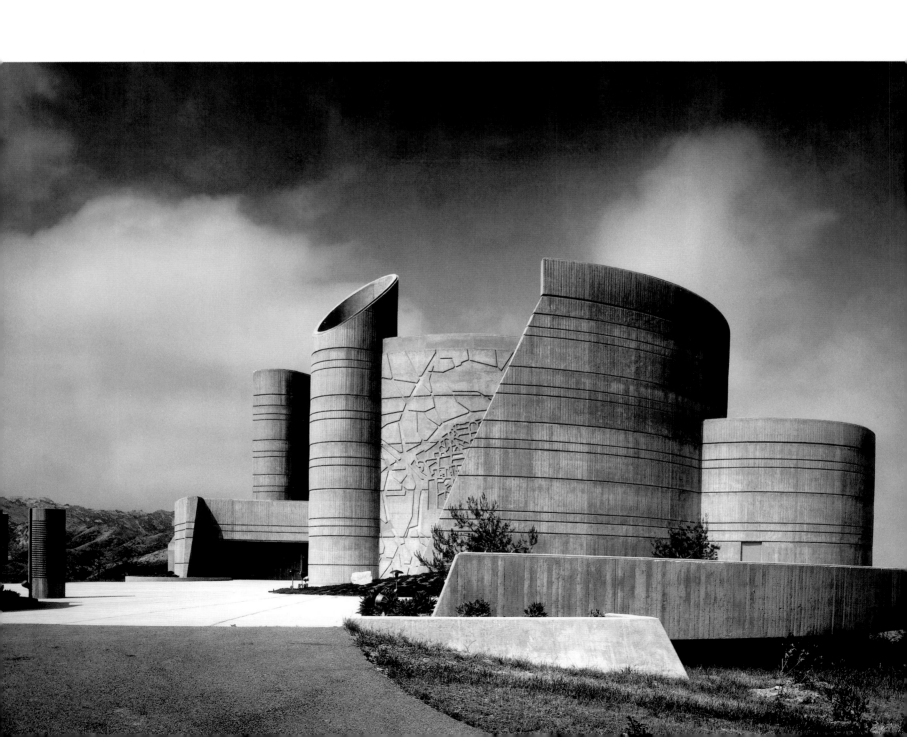

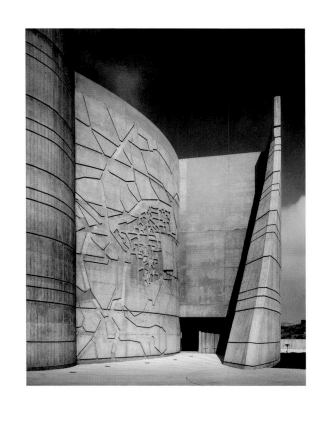

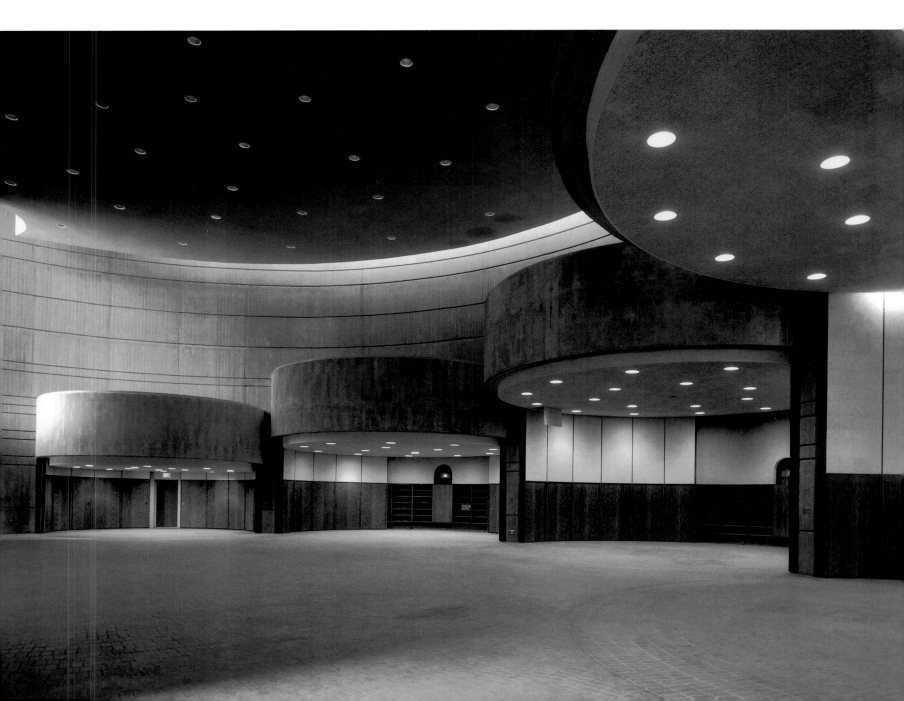

5019 **Ralph Anderson**
Patha Residence, Seattle, Washington
August 26, 1973

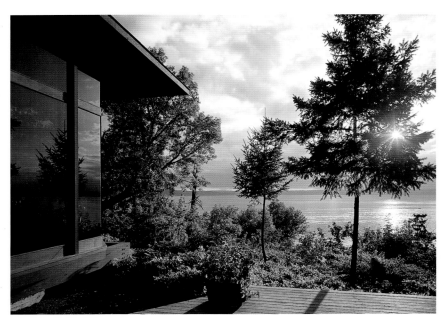
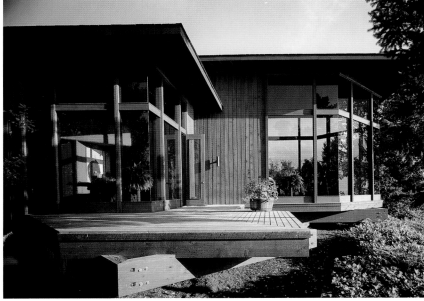

The 2,200-square foot residence is designed to integrate extensive portions of the breathtaking natural setting into the visual experience of the Patha family's domestic life. The site rises 100 feet above Puget Sound in Normandy Park south of Seattle.

The owners, John Patha, an employee of the Boeing Corporation, and his wife Darlene, a painter and art teacher, worked closely with the architect to identify their needs and design a congenial living scheme. The plan takes the form of a five-point star arranging the utilities and service rooms at the center. Three units are oriented toward the Pudget Sound providing views of the water through extensive glass windows; the two units on the street side accommodate Darlene Patha's studio and the carport. The large living room has a 17-foot-tall ceiling. From the master bedroom on the upper floor one has a view of the communal space. Outdoor decks cantilever, giving the design a light floating effect.

Anders als die üblichen Einfamilienhäuser in Südkalifornien bezieht dieses Haus große Teile der phantastischen Naturlandschaft in das visuelle Wohnerlebnis mit ein. Das Grundstück steigt über dem Wasserspiegel des Puget Sound in Normandy Park (südlich von Seattle) um etwa 30 m an.

Die Eigentümer, John Patha, der bei Boeing tätig war, und seine Frau Darlene, Malerin und Kunsterzieherin, arbeiteten eng mit dem Architekten zusammen, um den Entwurf auf ihre Bedürfnisse zuzuschneiden. Der Grundriss basiert auf einem fünfeckigen Stern, in dem Wirtschafts- und Versorgungsbereiche die Mitte bilden. Drei »Sternspitzen« orientieren sich zum Puget Sound und sind vollständig verglast, die anderen auf der Straßenseite enthalten Darlenes Pathas Atelier und die Garage. Das Haus umfasst insgesamt 205 m²; das Wohnzimmer ist rund 5 m hoch. Das Elternschlafzimmer im Obergeschoss öffnet sich zum Wohnbereich. Außenbalkone kragen aus der Fassade vor und verleihen dem Haus etwas Schwebendes.

A la différence des maisons de Californie du Sud, cette résidence voulait incorporer à son cadre de vastes portions de son flamboyant environnement naturel. Le terrain s'élevait à 30 m au-dessus des eaux du Puget Sound à Normandy Park, au sud de Seattle.

Le propriétaire, John Patha, collaborateur de Boeing, et sa femme, Darlene, peintre et enseignante en art, travaillèrent en collaboration étroite avec l'architecte et précisèrent leur programme. Le plan est en forme d'étoile à cinq branches. Les pièces techniques et de service sont regroupées dans le noyau central. Trois pointes sont orientées vers l'océan et vitrées, les deux autres, sur rue, accueillent l'atelier de Darlene et l'abri à voitures. La maison mesure 205 m² et le plafond du séjour atteint 5 m de hauteur. La chambre principale, à l'étage, donne sur le séjour. Des plates-formes extérieures surplombent l'ensemble et ressemblent à des structures flottantes.

Selected — *Los Angeles Times Home Magazine,*
Bibliography: *June 23, 1974*

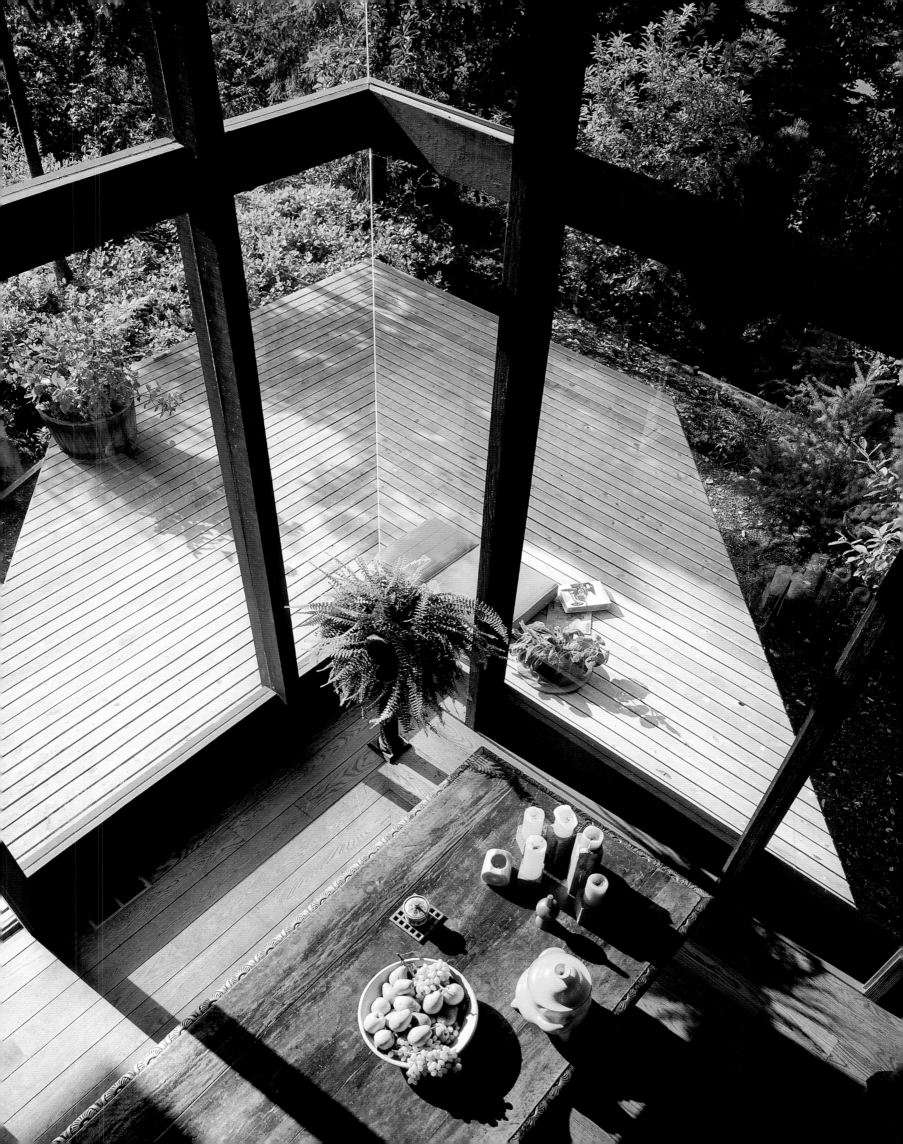

5077 A. Quincy Jones and Frederick E. Emmons
Smalley Residence, Beverly Hills, California
March 12, 13, 1974

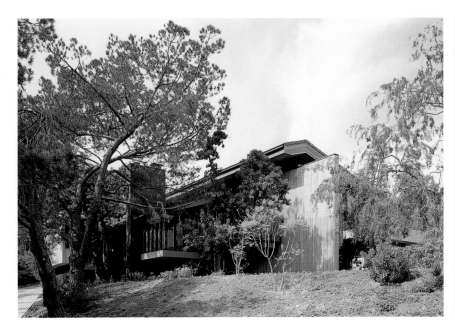
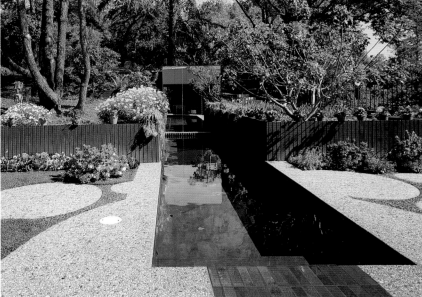

Program requirements and site irregularities added layers of complexity to the design challenge. The owners, contemporary art collectors, wanted their house to be a place for regular entertainment. A clear separation between the sleeping area for their four children and the master bedroom had to code the space zoning. The land measured 160 x 225 feet and featured 16 mature trees. From the street uphill, the terrain sloped 35 feet and presented uncompacted fill, problematic for the foundations.

In response to these constraints, the architects mapped out the domestic functions in a layout that turned the unforeseen soil condition into an architectural experience. A driveway slopes up to the carport cutting into the bank. The narrow entry path leads to an indoor garden, the pivot of the circulation system. From here it is possible to reach the children's wing and an all-purpose room on the east side; the cooking and dining area is in the core; and the living room and master bedroom on the west side. Throughout the house, indoor planting plays a central role.

The living room brings a dramatic change of scale to the residence. Once the fill was removed, the ground level was a full story below the rest of the house. A 26-foot-high wall dominates the overall image of the living space. Three-quarter-inch vertical strips of rough-sawn cedar positioned in four different depths, texture the surface of the wall which extends beyond the roofline into the garden. The opposite side of the cedar wall houses the master bedroom with an outdoor deck for private breakfasts. The gable roof is asymmetrical and broken close to the ridge to catch the west sunlight through a clerestory window.

Ein komplexes Raumprogramm und die unebene Grundstücks-konfiguration begründeten die Schwierigkeit der Bauaufgabe. Die Bauherren – ein Kunstsammler-Ehepaar – wünschten ein Haus mit drei klar voneinander getrennten Bereichen: Wohnräume für ihre häufigen kleineren und größeren Gesellschaften, Zimmer für die vier Kinder und schließlich das Elternschlafzimmer. Das mit 16 großen Bäumen bestandene Grundstück maß umgerechnet rund 48 x 68 m und stieg von der unten verlaufenden Straße um etwas über 10 m an.

Der weiche Hangboden erschwerte die Gründung des Hauses. Trotz dieser Einschränkungen entwickelten die Architekten eine Lösung, welche die Innenräume in ein architektonisches Erlebnis verwandelten. Die Zufahrt von der Straße nach oben zur Garage ist in den Hang eingeschnitten, die innere Erschließung des Hauses erfolgt über ein bepflanztes Atrium, von dem aus man alle Wohnräume und den Kinderzimmerflügel sowie den Mehrzweckraum auf der Westseite des Hauses erreicht. Im ganzen Haus spielen Pflanzbecken eine besondere Rolle. Der Wohnraum bringt einen dramatischen Wechsel in den Größenverhältnissen des Hauses: Als der Hangboden abgetragen war, lag dessen Erdgeschossniveau um ein ganzes Stockwerk tiefer als die übrigen Räume. Eine mit vertikal reliefartig versetzten, nur 1,85 cm schmalen Zedernholzbrettern verkleidete und knapp 8 m hohe Wand ist das beherrschende Element des Wohnzimmers. Sie setzt sich über die Dachkante nach außen in den Garten fort. Hinter der gegenüberliegenden Wand befindet sich das Elternschlafzimmer mit vorgelagerter Frühstücksterrasse. Das asymmetrische Giebeldach enthält knapp unterhalb der Firstlinie ein Oberlicht, durch das Sonnenlicht von Westen in den Raum fällt.

Les spécifications du programme et l'irrégularité du terrain ont multiplié la complexité de ce projet. Les propriétaires, collectionneurs d'art contemporain, aimaient recevoir et souhaitaient une séparation nette entre la zone des chambres de leurs quatre enfants et leur chambre principale. Le terrain mesure 48 x 68 m et comptait à l'origine 16 grands arbres. Il était instable – ce qui posa des problèmes de fondations – et sa dénivellation était de 10 m.

Pour résoudre ces problèmes, les architectes établirent une répartition des fonctions domestiques qui tirait parti de l'état imprévisible du sol. L'allée des voitures, taillée dans le flanc de la colline, monte vers le garage. L'étroite allée d'entrée débouche sur un jardin intérieur, pivot du système de circulation. De là, on atteint l'aile des enfants et une pièce polyvalente à l'est; la zone cuisine et repas au centre; le séjour et la chambre des maîtres de maison à l'ouest. Les plantations intérieures jouent un rôle essentiel dans l'organisation de l'espace. Le séjour apporte un changement d'échelle spectaculaire. Après déblaiement, il est situé un étage plus bas que le reste de la maison et se voit dominé par un mur de 8 m de haut. Un bardage vertical en fines lattes de cèdre brut et de profondeur variable texture le mur qui se poursuit au-delà de la ligne de toit, vers le jardin extérieur. Sur la face opposée de ce mur habillé de cèdre se trouve la chambre principale, dotée d'une terrasse pour le petit déjeuner.

Le toit en pignon asymétrique laisse place à une fenêtre haute qui capte le soleil de l'après-midi.

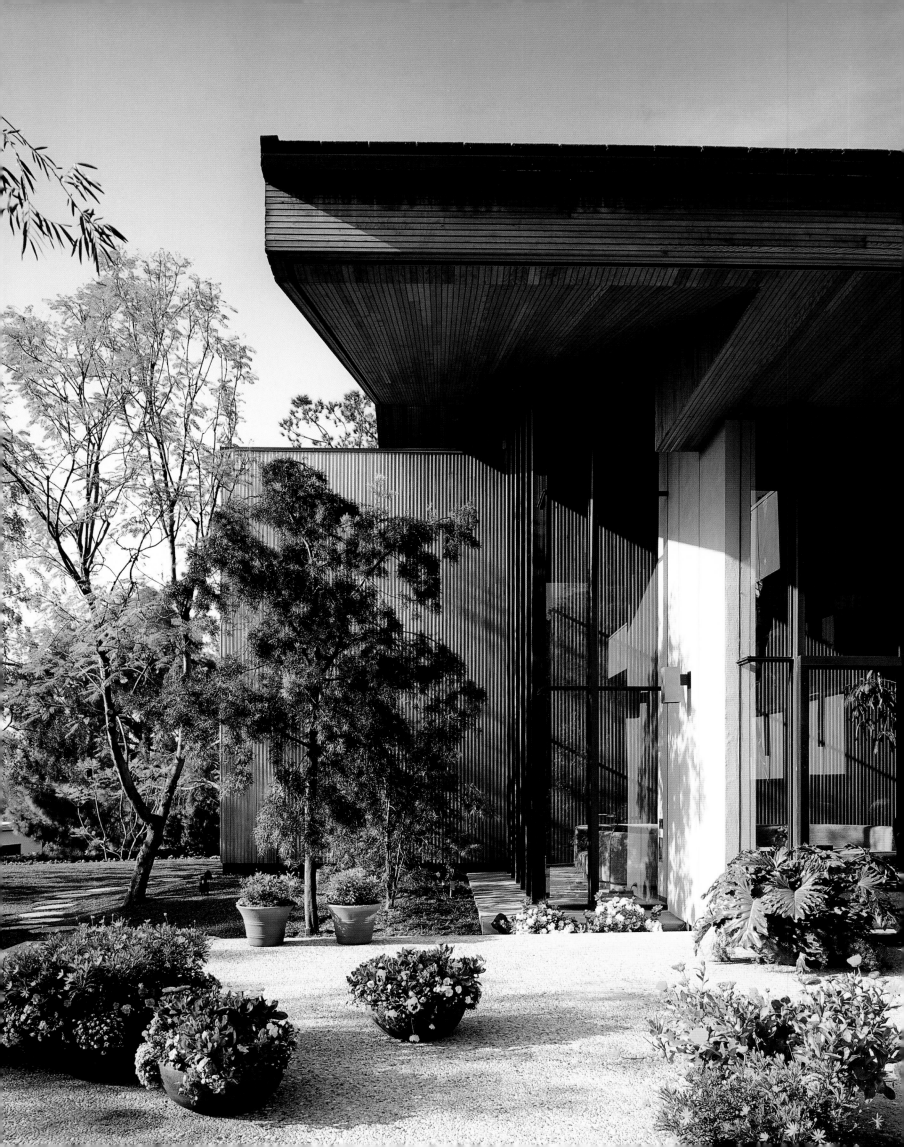

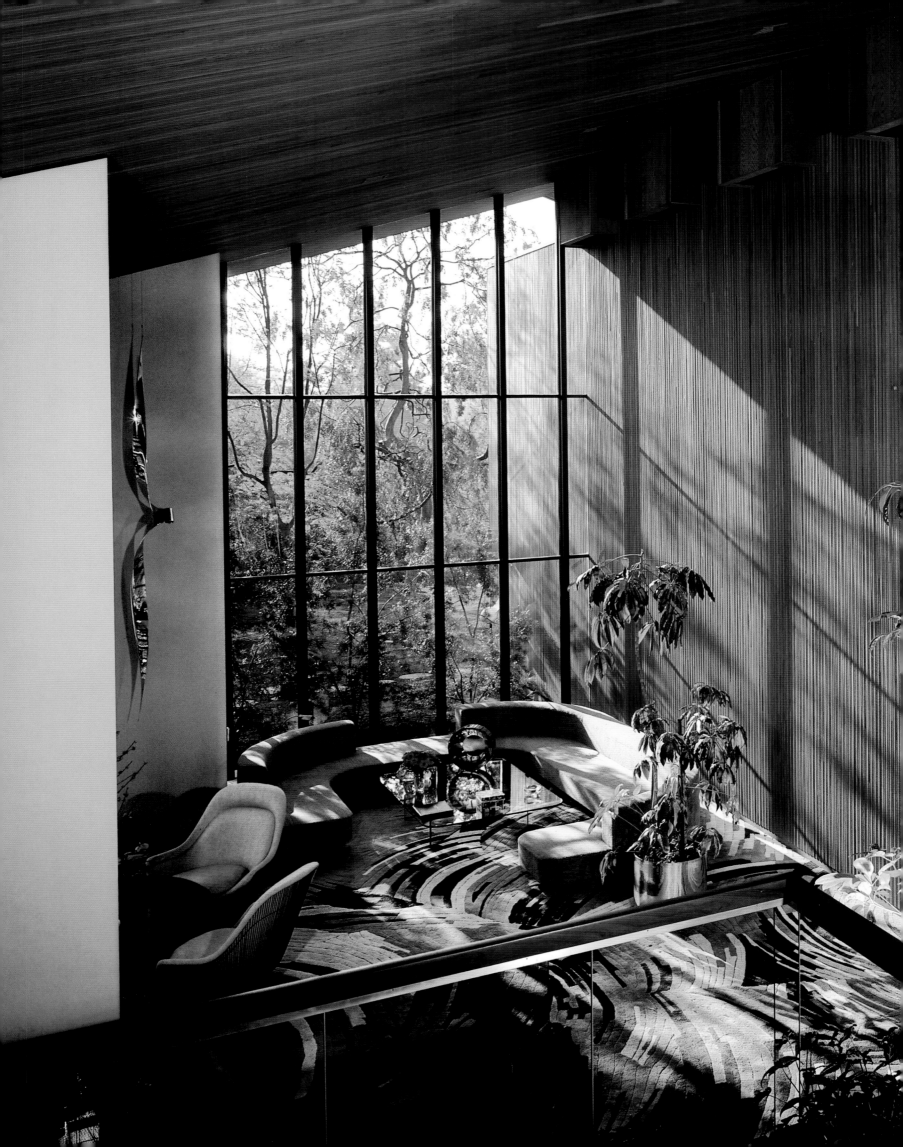

Selected Bibliography:

- *Los Angeles Times Home Magazine, September 29, 1974*
- *Process Architecture, number 41, October 1983*

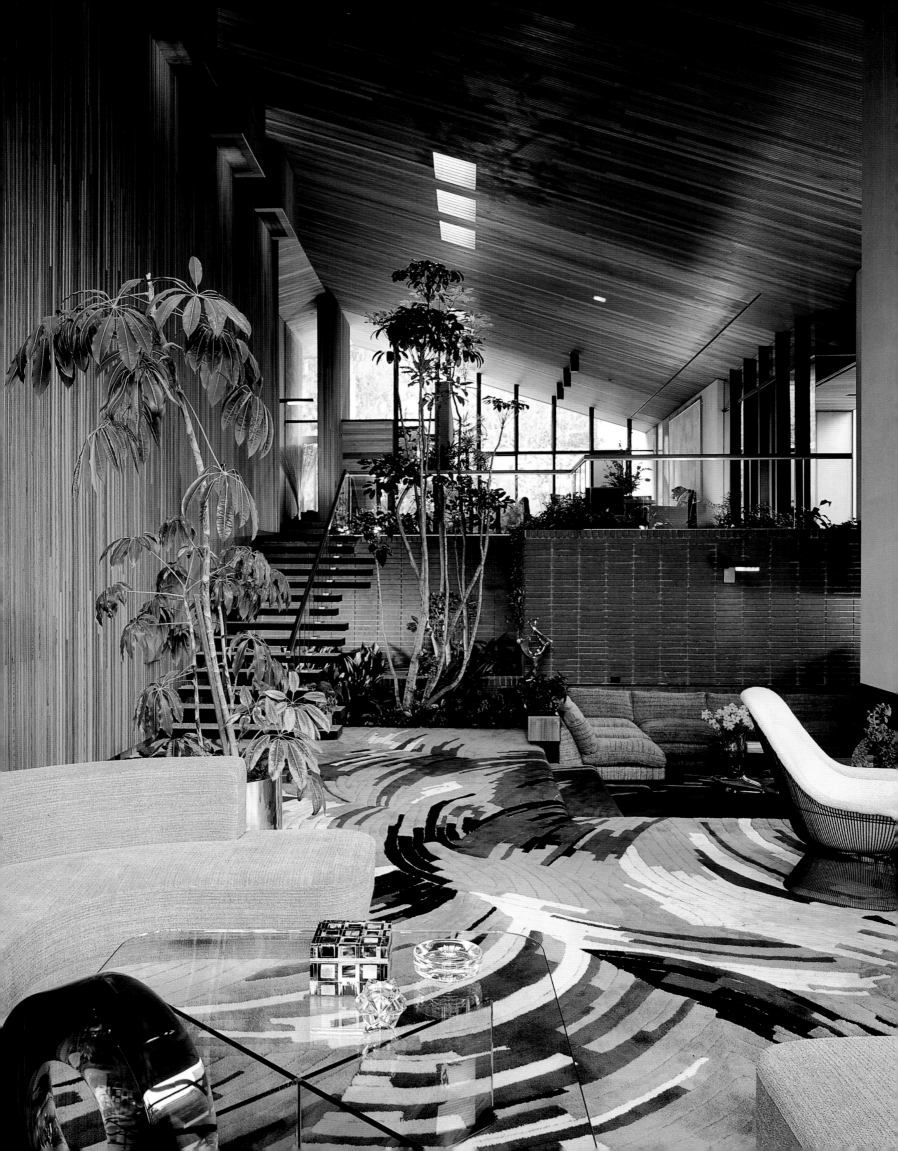

5242/5243 **Garland & Hilles**
Theater, Convention & Performing Arts Center, El Paso, Texas
August 3, 4, 1975

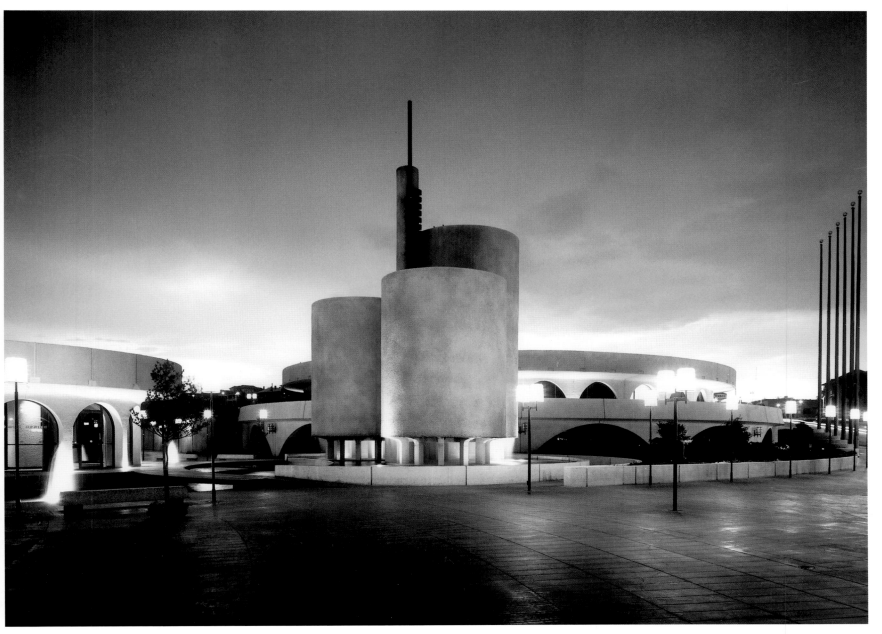

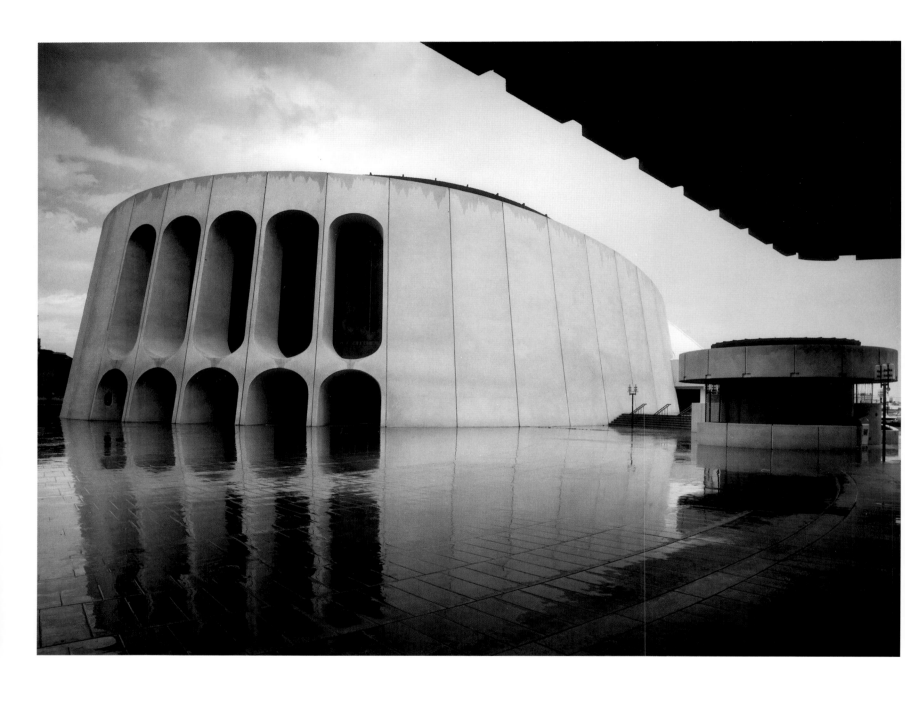

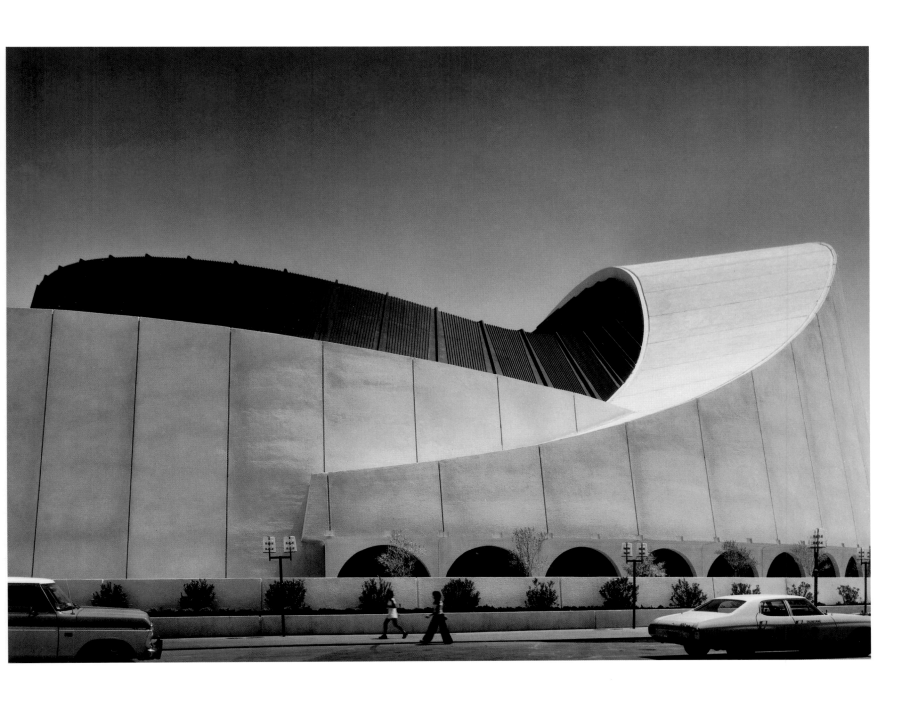

5335 Kahn, Kappe, Lotery
Soltan Residence, Santa Monica, California
May 3, 1976

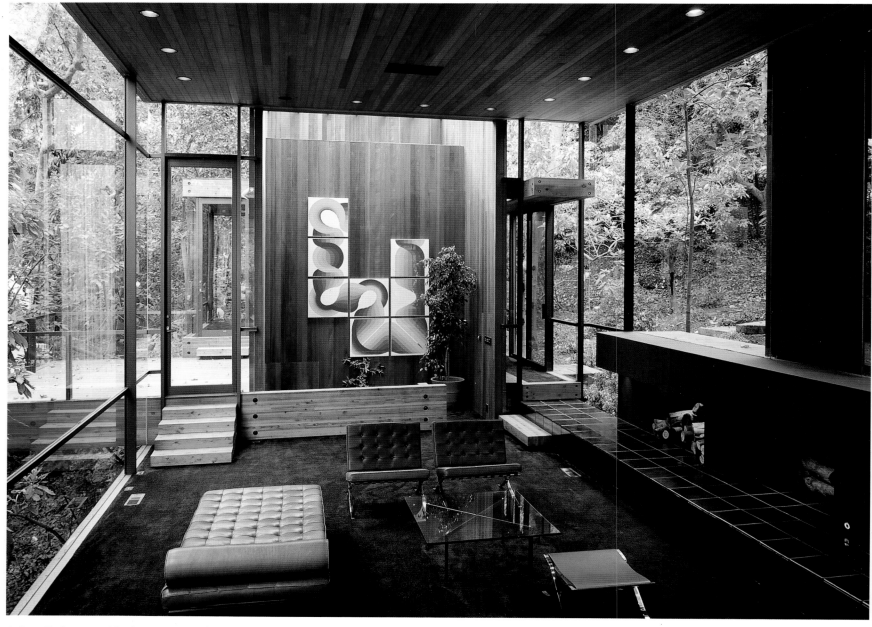

In line with the concept implemented in the Gertler Residence (see p. 520), Kappe apportions 7,000 square feet of program in a multilevel structure supported by eight redwood towers. The sloped site is enclosed by thick vegetation whose view is incorporated in the house interior through a numerous glass walls. With the exception of the towers', all walls are non-bearing.

Ähnlich wie beim Haus Gertler (siehe S. 520) brachte Kappe, der verantwortliche Architekt, das insgesamt 650 m² umfassende Raumprogramm auf mehreren Ebenen unter. Das Tragwerk des Hauses besteht aus acht Redwood-»Türmen«, das Hanggrundstück ist von dichter Vegetation umgeben. Die vielen raumhohen Verglasungen bieten also schöne Ausblicke ins wuchernde Grün. Mit Ausnahme der »Türme« enthält das Haus überhaupt keine tragenden Wände.

Dans la ligne du concept appliqué dans la résidence Gertler (voir p. 520), Kappe répartit 650 m² de programme sur une structure à plusieurs niveaux supportée par huit tours de bois rouge. Le site en pente est cerné par une végétation épaisse visible de l'intérieur de la maison par l'intermédiaire des nombreuses baies vitrées. A l'exception des tours, tous les murs sont non porteurs.

Selected Bibliography:
- Global Architecture Houses, 1, Tokyo 1976
- Connaissance Des Arts, March 1977
- Michael Webb, Themes and Variations: House Design by Ray Kappe, Victoria 1998

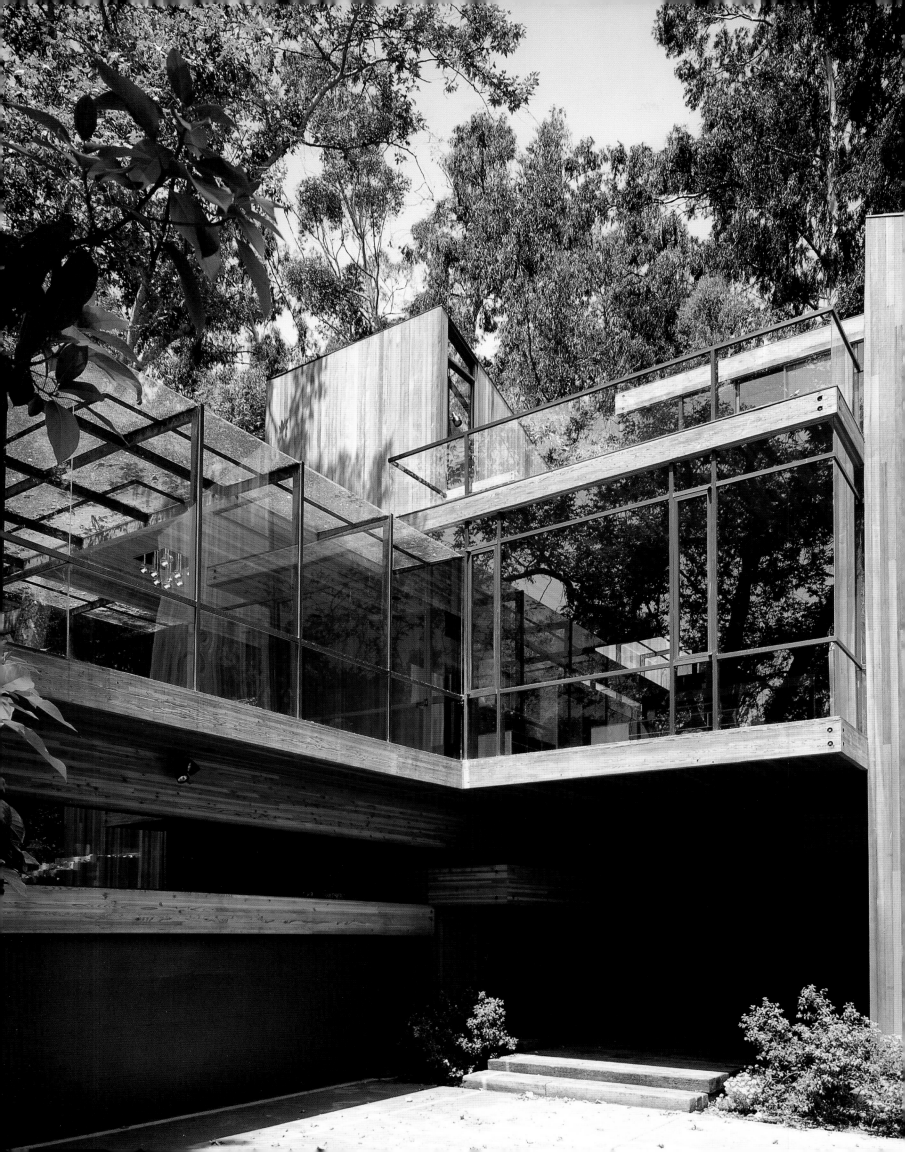

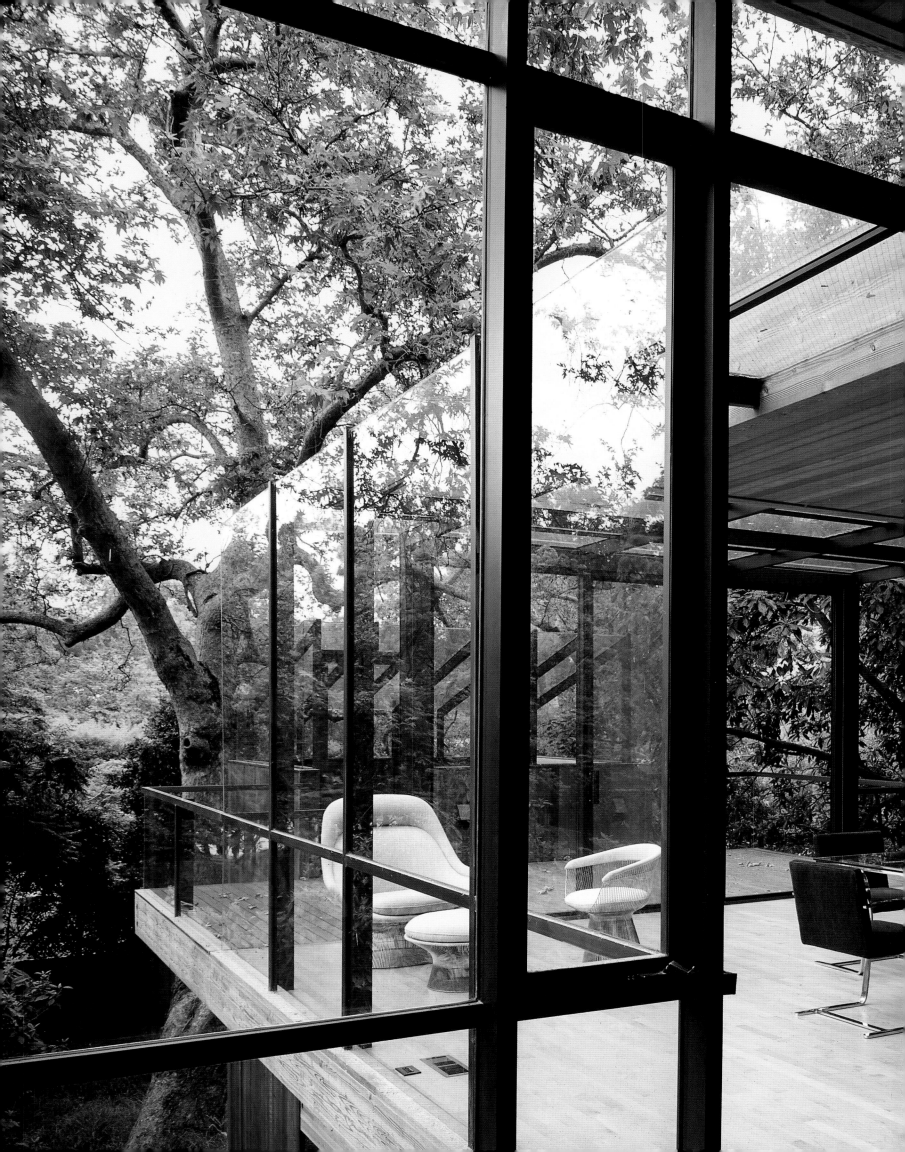

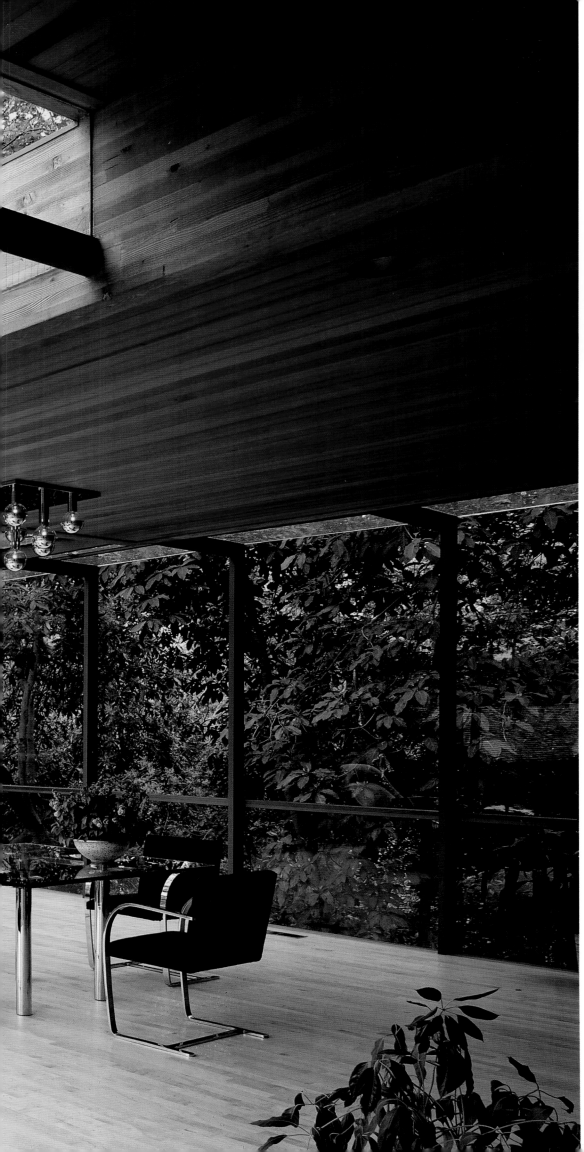

5348 Buff & Hensman
Hensman Residence, Hollywood, California
June 9, 1976

The privileged position of the site in the Santa Monica Mountains turns into an opportunity for the design of an architectural set to stage the vistas of the San Fernando Valley on the north side and the Los Angeles Basin and the Pacific Ocean on the south side.

Cruciform and symmetrical in plan, the 1,500-square-foot residence is stretched along the east-west axis and bisected by a bridge crossing over a swimming pool. An 8-foot module patterns indoor and outdoor areas, with exterior walls and plant-

Die privilegierte Grundstückslage in den Bergen von Santa Monica bot die Gelegenheit, hier eine Architekturkulisse zu schaffen, von der aus man nach Norden in das San Fernando-Tal und das Bassin von Los Angeles blickt und nach Süden über den Pazifik.

Im Plan eine symmetrische Kreuzform, erstreckt sich das knapp 140 m² umfassende Haus in Ost-West-Richtung und wird von einer Brücke über ein Schwimmbecken zweigeteilt. Der Grundriss basiert innen wie außen auf einem 2,40 m-Modul; Mauern

La position privilégiée de ce terrain dans les montagnes de Santa Monica offrait l'opportunité d'une mise en scène architecturée de vues superbes sur la vallée de San Fernando au nord, le bassin de Los Angeles et l'océan Pacifique au sud.

De plan cruciforme symétrique, la maison de 140 m² s'étire sur un axe est-ouest interrompu par une passerelle franchissant une piscine. Une trame de 2,40 m définit le rythme de l'intérieur comme de l'extérieur. Les murs extérieurs et des plantations font office de coupe-vent protecteur. A côté du garage au

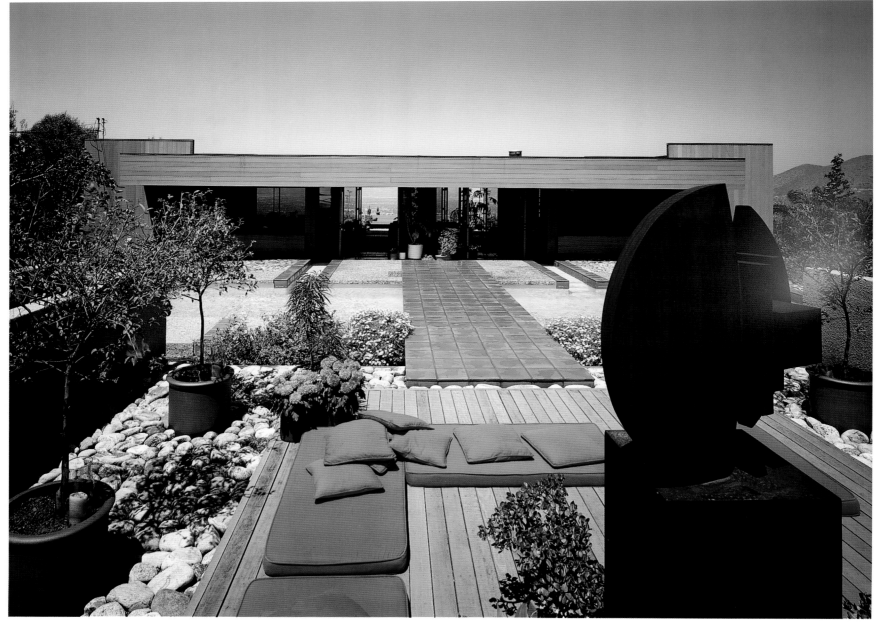

ing working as windbreaks to shelter the enclosure. Next to the garage at the lower level, a stepped path takes the guests to the entry adjacent to a sun deck on the top of the carport. The bridge leads to a loggia sheltering the south-side glass front from the late afternoon sun. Living, dining and kitchen quarters are one large room, subdivided by low cabinets and counters. Bedroom and bath are on the eastern end of the plan. Re-sawn redwood boards sheathe interior and exterior walls.

im Garten sowie Büsche und Bäume dienen als Windbarrieren. An der Garage entlang führt ein Treppenweg von der tieferliegenden Ebene zum Eingang neben der Holzterrasse auf dem Garagendach. Jene Brücke führt zu einer Loggia, welche die verglaste Südfassade des Hauses beschattet. Wohn- und Essbereich sowie Küche bilden einen großen Raum, der von niedrigen Regalen und Schränken unterteilt wird. Schlafzimmer und Bad sind im Ostabschnitt untergebracht. Innen- und Außenwände sind mit Redwood-Brettern verkleidet.

niveau inférieur, une série de marches mènent à l'entrée adjacente à un solarium aménagé au-dessus de l'abri aux voitures. La passerelle conduit à une loggia qui protège le mur de verre orienté vers le sud du soleil de fin d'après-midi. La salle de séjour, la salle à manger et la cuisine composent une vaste pièce, divisée par des meubles bas et des plans de travail. La chambre à coucher et la salle de bains se trouvent à l'est. Les murs intérieurs et extérieurs sont revêtus de lattes de bois rouge.

Selected Bibliography: - *Los Angeles Times Home Magazine, October 31, 1976*

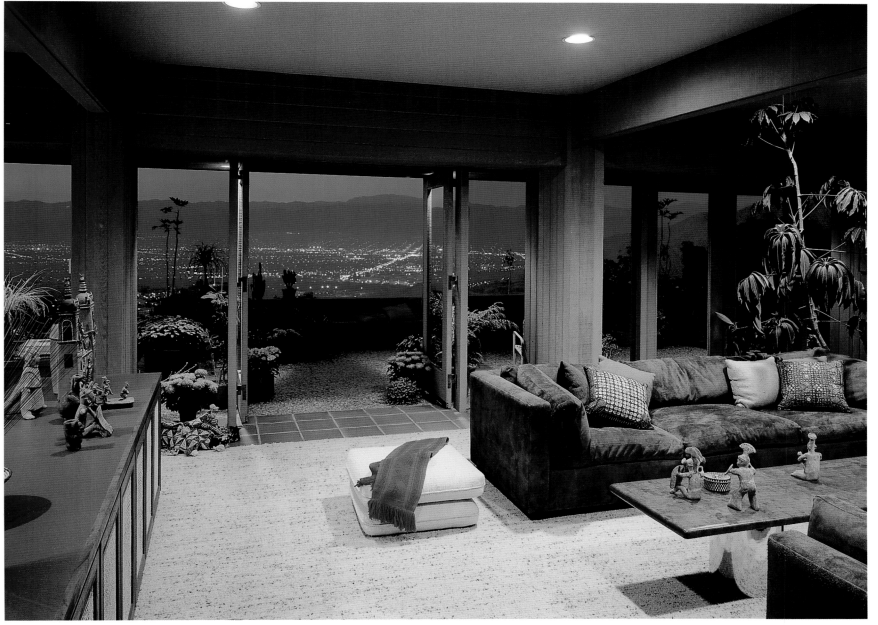

5370 Bernard Judge
Judge Residence, Hollywood, California
August 20, 1976

Years after the international acclaim of his geodesic house (see p. 332), architect-owner Bernard Judge designed a new residential prototype, called "The Pole Module", to develop hillside land in Los Angeles with minimum earth moving. In 1977, the proposal won a special award in the American Institute of Architects-Sunset Western Home Awards on the grounds that such a project could be assembled on virtually any site.

The architectural idea goes back to 1967. Then, Bernard Judge was commissioned to design a hunting lodge in the form of a tree house in Kenya. Using local technology, the structure had to be simple enough to be assembled with little instruction by Kenyans. That project was never built. After unsuccessfully proposing the project to contractors in the Los Angeles area, the architect set out to design a tree house for himself in the Hollywood Hills and completed it in 1975.

On a site with a 34-degree slope, Judge positions the structural cage on four caissons filled with concrete, generating a new ground level. On this pedestal, the crane places four 10 x 10-inch steel columns 50 feet tall on an eight-foot square. Trusses bolted all around the steel core support the lower floor and the roof, with the upper floor suspended between them, and define a closed load-bearing framework. Once the structure is assembled, the interior walls, nonbearing, can be arranged with complete flexibility accommodating many different programs. The 27 x 27-square-foot plan is modular. Access to the residence is from the upper level, where living room, dining room and kitchen create a unified space. A spiral staircase connects the two levels of 700 square feet each, decks included. At the lower level there are the sleeping areas and a library-study; each bedroom has its private deck.

With the frame left exposed and the wood unfinished, costs were reduced. Also it took only two days to set up the entire structure. Bernard Judge currently lives in his tree house.

Jahre nachdem sein »geodätisches Haus« (siehe S. 332) internationale Anerkennung gefunden hatte, entwarf Bernard Judge ein neues Haus für sich und seine Familie: ein Prototyp namens »The Pole Module« (Pfahlmodul) für die vielen Hanglagen im Gebiet von Los Angeles, der ein Minimum an Aushub bzw. Erdabtragung erforderlich macht. 1977 erhielt der Entwurf im Rahmen des »Sunset Western Home Awards« einen Sonderpreis des American Institute of Architects mit der Begründung, diese hervorragende Lösung lasse sich auf fast jedem Grundstück realisieren.

Die Entwurfsidee ging auf 1967 zurück, als Judge den Auftrag für eine Jagdhütte in Form eines Baumhauses in Kenia erhielt. Die möglichst einfach auf der Basis lokaler Bautechniken zu errichtende Hütte sollte auch von dortigen ungelernten Arbeitern ohne detaillierte Anweisungen gebaut werden können. Der Entwurf wurde jedoch nie ausgeführt. Nachdem er ihn verschiedenen Bauunternehmern in und um Los Angeles angeboten hatte – ohne Erfolg –, entwarf der Architekt sein eigenes »Baumhaus« für ein Grundstück in den Hollywood Hills und stellte es 1975 fertig. An einem Hang mit 34° Gefälle stellte Judge das Haus auf vier Betonkassettenplatten als neuem ebenen »Erdgeschossboden«. Darauf wurden die vier 15 m hohen Hauptstützen des Tragskeletts auf einem 2,40 m-Raster per Kran in Position gebracht. Umlaufende, mit dem Stahlkern verbolzte Fachwerkträger tragen die untere Geschossdecke und das Dach und bilden die Konstruktion der Außenfassaden, das Obergeschoss wurde dazwischen eingehängt. Die nicht-tragenden Innenwände lassen sich je nach Raumbedarf versetzen. Der modulare Grundriss des Hauses umfasst ca. 8 x 8 m. Der Eingang befindet sich auf der oberen Ebene, wo der Wohnbereich mit Essplatz und Küche einen durchgehenden Raum bildet. Eine Wendeltreppe stellt die Verbindung zwischen den jeweils 65 m² großen beiden Geschossen her. Das untere beherbergt die Schlafzimmer (jeweils mit Balkon) und eine Bibliothek. Judge reduzierte die Kosten, indem er die konstruktiven Elemente nicht verkleidete und die Holzoberflächen unbehandelt ließ. Es dauerte nur zwei Tage, die gesamte Konstruktion zu errichten. Judge bewohnt sein »Baumhaus« auch heute noch.

Des années après le succès international de sa maison géodésique (voir p. 332), l'architecte – et propriétaire – Bernard Judge conçut un autre prototype de maison appelé «The Pole Module», édifié sur un terrain des collines de Los Angeles en intervenant au minimum sur le sol naturel. En 1977, ce projet adaptable à n'importe quel terrain, remporta un prix spécial lors des Sunset Western Home Awards de l'AIA.

L'idée remontait à 1967. Puis, Judge reçut commande d'un pavillon de chasse en forme de maison dans un arbre au Kenya. Devant faire appel aux techniques locales, il fallait que la construction soit assez simple pour être aisément assemblée par la main-d'œuvre kenyane. Le projet ne fut jamais réalisé. Après l'avoir proposé sans succès à des entrepreneurs de la région de Los Angeles, Judge décida de construire pour lui-même cette maison dans les arbres dans les Hollywood Hills et l'acheva en 1975. Sur un terrain en pente à 34°, il installa une structure en forme de cage sur quatre caissons remplis de béton, afin de créer un nouveau niveau de sol. Sur ce piédestal, une grue positionna quatre piliers d'acier de 15 m de haut formant un carré de 2,40 m de côté. Des poutres, boulonnées à ce noyau central et constituant l'ossature porteuse, soutiennent le niveau inférieur et le toit, le niveau supérieur étant suspendu entre eux. Une fois l'ossature assemblée, les murs intérieurs, non porteurs, peuvent être disposés en toute liberté et s'adapter à n'importe quel programme. Le plan carré de 8 m de côté est modulaire. L'accès se fait par le niveau supérieur, où le séjour, la salle à manger et la cuisine occupent un espace homogène. Un escalier en spirale relie les deux niveaux de 65 m² chacun, plates-formes comprises. Au niveau inférieur se trouvent les chambres et un bureau-bibliothèque, chaque chambre possédant sa propre terrasse. L'ossature étant laissée apparente et le bois brut, le coût de construction fut réduit. Il ne fallut que deux jours pour monter la structure. Des économies plus substantielles auraient été obtenues en construisant des séries de maisons de ce type sur les terrains bon marché des collines. Bernard Judge vit toujours dans cette résidence.

Selected Bibliography:
- Los Angeles Times Home Magazine, April 10, 1977
- Sunset, November 1978

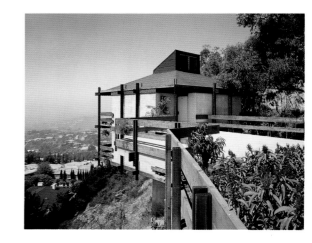

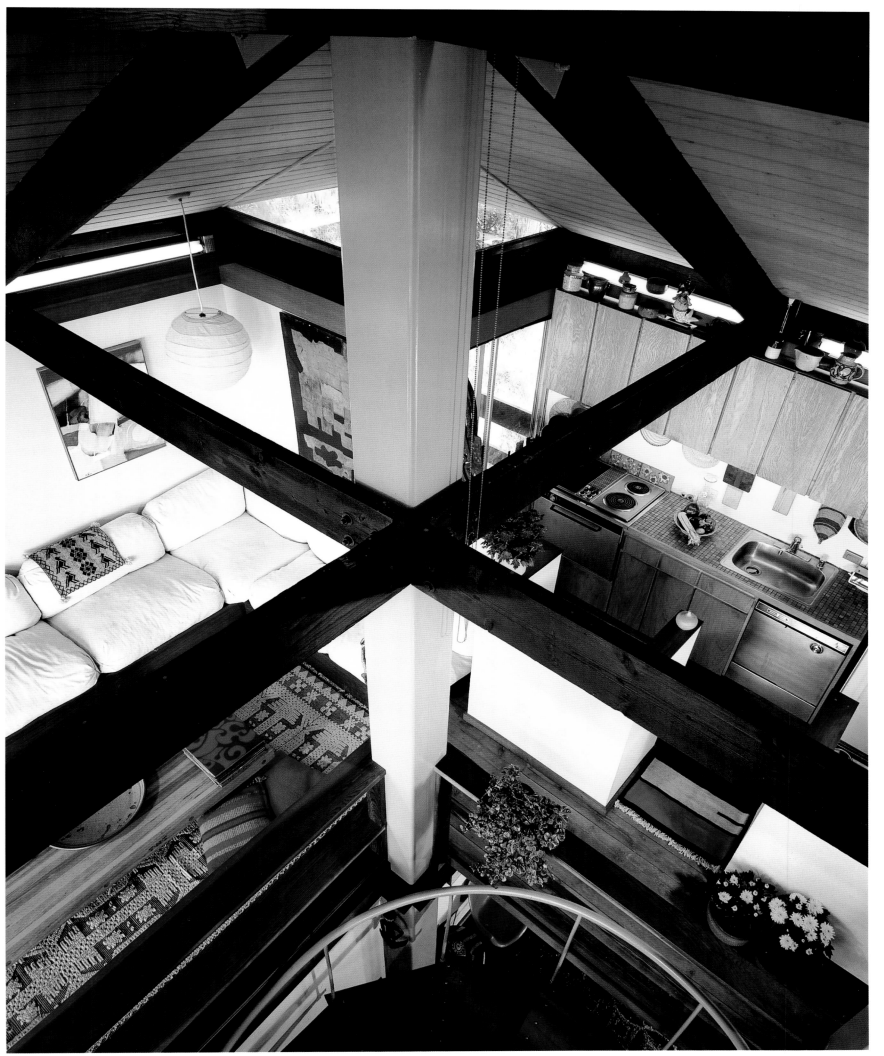

Selected Biographies | Ausgewählte Biographien | Biographies sélectionnées

Gregory Ain / Born in Pennsylvania in 1908, Ain received his architectural education at the University of California Los Angeles (UCLA) and at the University of Southern California School of Architecture. After an apprenticeship with Richard Neutra and R. M. Schindler, he established his own practice. His extensive work reflects a deep concern for affordable living. His most renowned accomplishment in this regard was the Tract Development in Mar Vista (1947), designed with Johnson & Day and Garret Eckbo for the landscaping. During his professional career, Ain taught at the University of Southern California and at Penn State University, Philadelphia, where he held the position of Dean of the School of Architecture. In 1967, Ain returned to Los Angeles and retired from teaching and his practice due to health problem. He died at the age of 79.

Ain wurde 1908 in Pennsylvania geboren und absolvierte sein Architekturstudium an der University of California Los Angeles (UCLA) und der University of Southern California School of Architecture. Nach Beendigung seiner Lehrzeit bei Richard Neutra und R. M. Schindler gründete er sein eigenes Büro. Ains umfangreiches Œuvre belegt sein Engagement für preisgünstige Wohnungen und Häuser. In dieser Hinsicht stellt die Wohnsiedlung Mar Vista von 1947, die er zusammen mit Johnson & Day und dem Landschaftsarchitekten Garret Eckbo realisierte, seine größte Leistung dar. Im Laufe seiner Karriere lehrte Ain an der University of Southern California und der Architekturfakultät der Penn State University, Philadelphia, deren Dekan er eine Zeit lang war. 1967 gab Ain diese Tätigkeit und sein Büro aus gesundheitlichen Gründen auf und kehrte nach Los Angeles zurück. Er starb im Alter von 79 Jahren.

Né en Pennsylvanie en 1908, Ain étudie l'architecture à l'Université de Californie Los Angeles (UCLA), et à l'Ecole d'architecture de l'Université de Californie du Sud. Il fait son apprentissage auprès de Richard Neutra et de R. M. Schindler, puis fonde sa propre agence. Son œuvre très vaste reflète ses préoccupations sociales. Sa réussite la plus accomplie à cet égard est le Tract Development de Mar Vista (1947), conçu en collaboration avec Johnson & Day et Garret Eckbo pour les aménagements paysagés. Au cours de sa carrière, il enseigne à l'Université de Californie du Sud et à Penn State University, Philadelphie, où il devient doyen de l'Ecole d'architecture. En 1967, il revient à Los Angeles. Il abandonne l'enseignement et toute activité professionnelle pour des raisons de santé, et disparaît à 79 ans.

William Sutherland Beckett / Beckett was born on June 14, 1921 in Kansas City, Missouri. After having graduated from the Yale School of Architecture (1943), he worked for Douglas Aircraft, Spaulding and Rex, and C. Gordon de Swarte. He taught design studios at the University of Southern California, in Los Angeles (1956–57) and at the University of California Los Angeles (UCLA) (1957–58). From 1958 to 1973, he worked for the Los Angeles County Museum. In his early 30s, he established a successful practice building a large number of institutional, commercial and residential projects. His architecture reflects the influence of the Case Study House Program in the frequent application of prefabricated materials and rectilinear geometry as well as in the organization of the layouts and the extensive use of glass screens. No recent information on William S. Beckett was available.

Beckett wurde am 14. Juni 1921 in Kansas City, Missouri, geboren. Nach Abschluss seines Studiums an der Yale School of Architecture (1943) arbeitete er nacheinander bei Douglas Aircraft, Spaulding and Rex sowie C. Gordon de Swarte. Er lehrte architektonisches Entwerfen an der UCLA (1956–57) und an der University of Southern California School of Architecture (1957–58). Von 1958–73 arbeitete er auch für das Los Angeles County Museum. Als junger Mann von Anfang 30 gründete er sein Büro, mit dem er erfolgreich tätig war und zahlreiche Institutsgebäude, Wohn- und Geschäftshäuser baute. Mit ihren vorgefertigten Bauteilen, rechtwinkliger Geometrie, der Art der Grundrissgliederung und großflächiger Fensterung spiegelt seine Architektur den Einfluss des Case Study Haus-Programms wider. Zur weiteren beruflichen Laufbahn von William S. Beckett lagen keine Informationen vor.

Beckett naît le 14 juin 1921 à Kansas City, Missouri. Diplômé de la Yale School of Architecture (1943), il travaille pour Douglas Aircraft, Spaulding and Rex et G. Gordon de Swarte. Il enseigne la conception de projets à l'Université de Californie du Sud, Los Angeles (1956–57) et à l'Université de Californie Los Angeles (UCLA, 1957–58). De 1958 à 1973, il travaille pour le Los Angeles County Museum. Au début des années 1950, il crée avec succès son agence et mène à bien un grand nombre de projets résidentiels, institutionnels et commerciaux. Son architecture reflète l'influence du Case Study House Program dans son recours fréquent aux matériaux préfabriqués, à l'orthogonalité, aux murs de verre et dans l'organisation des plans. Nous ne disposons pas d'informations plus récentes le concernant.

Conrad Buff III / A native of California, Conrad Buff III was the son of the noted landscape painter, Conrad Buff II. Following his father's wish to be an architect, Buff studied at the University of Southern California School of Architecture where he met Donald C. Hensman, founder of Buff, Straub & Hensman, who taught design studios at the University of Southern California until 1962, before he devoted himself entirely to architecture. Catering to a wealthy clientele drawn from the world of film and entertainment, the firm won 30 American Institute of Architects awards and dozens of other prizes, particularly for their residential work. Conrad Buff III died in Pasadena, California, in 1988, at the age of 62.

Conrad Buff III. war gebürtiger Kalifornier und Sohn des bekannten Landschaftsmalers Conrad Buff II. Auf Wunsch seines Vaters studierte er Architektur an der University of Southern California, wo er Donald C. Hensman begegnete, dem Mitbegründer des späteren Büros Buff, Straub & Hensman, der bis 1962 Architekturdesign gelehrt hatte, bis er sich ausschließlich dem Bauen widmete. Das Büro arbeitete für wohlhabende Bauherren aus der Welt des Kinofilms und des Entertainment, erhielt vom American Institute of Architects insgesamt 30 Auszeichnungen sowie Dutzende von Preisen von anderen Institutionen, vor allem für Einfamilienhäuser. Conrad Buff III. starb 1988 im Alter von 62 Jahren in Pasadena, Kalifornien.

Né en Californie, Conrad Buff III est le fils du célèbre peintre paysagiste Conrad Buff II. Son père désirant qu'il soit architecte, il étudie à l'Ecole d'architecture de l'Université de Californie du Sud où il rencontre Donald C. Hensman, avec lequel il fonde Buff, Straub & Hensman. Celui-ci enseigne à l'université jusqu'en 1962, avant de se consacrer entièrement à l'architecture. Appréciée d'une riche clientèle souvent issue des milieux du cinéma et du spectacle, leur agence remporte 30 distinctions de l'American Institute of Architects et des dizaines d'autres prix, en particulier pour des maisons individuelles. Conrad Buff III meurt à Pasadena, Californie en 1988 à l'âge de 62 ans.

Mario Francis Corbett / Born in New York City in 1901, Corbett was raised in Southern California. He served seven years as an apprentice in his father's practice and received his formal education in architecture at the San Francisco School of Fine Arts. Following a ten-year period working for various firms throughout the United States, he established his private practice in San Mateo, a suburb of San Francisco, in 1934, and moved his office to San Francisco in 1937. He taught architecture at the University of California and was visiting critic at Yale University. His most renowned works, the Hope Lutheran Church in the San Francisco South Bay and the Thomsen House in Vina, California, show the influences of Bernard Maybeck. No recent information on Corbett was available.

Raymond David Crites and Richard McConnell / Raymond David Crites, born in Danville, Illinois, on December 6, 1925, and Richard Duncan McConnell, born in Brooklyn, New York, on January 30, 1922, started their professional association in Cedar Rapids, Iowa, in 1958. Crites had studied at the Iowa State University School of Engineering where Richard McConnell was teaching. The Iowa State Chapter of the American Institute of Architects repeatedly awarded the firm prizes for their accomplishments in residential architecture and their commercial and institutional projects. They received a national American Institute of Architects Honor Award for the McFarland Clinic in Ames, Iowa (1966) and the United Covenant Presbyterian Church in Danville, Illinois (1968). In addition, four of their custom-designed residences received Home for Better Living awards in three consecutive years during the mid-1960s. Their large body of work was published in major professional journals in the United States and abroad. Crites lives and works in Danville, Illinois. No information on Richard McConnell was available.

Gordon Drake / A native of Texas, Gordon Drake spent several years in Hawaii, before pursuing his architectural education at the University of Southern California under Carl Troedsson and Harwell Hamilton Harris. In World War II, he served in the Marine Corps, and afterwards founded his private practice in Los Angeles, where he built his award-winning private residence. He then moved his office to Carmel and finally to San Francisco. During his brief career, his residential work, which was influenced by Japanese traditional architecture, won him national and international recognition. He died on January 15, 1952 during a snow storm in the California Sierra, only 34 years old.

1901 in New York City geboren, wuchs Corbett in Südkalifornien auf. Sieben Jahre lang lernte er den Architektenberuf im Büro seines Vaters und absolvierte parallel dazu sein Studium an der San Francisco School of Fine Arts. Nach einer zehnjährigen Tätigkeit in Architekturbüros in verschiedenen Städten Amerikas ließ er sich 1934 mit einem Büro in San Mateo, einem Vorort von San Francisco, nieder und zog 1937 mit dem Büro nach San Francisco um. Er lehrte an der University of California und betätigte sich als Gastkritiker der Universität Yale. Seine bekanntesten Bauten (die Hope Lutheran Church in San Francisco South Bay und das Haus Thomsen im kalifornischen Vina) belegen den Einfluss von Bernard Maybeck auf sein Schaffen. Zu seiner weiteren Laufbahn lagen keine Informationen vor.

Raymond David Crites (am 6. Dezember 1925 in Danville, Illinois, geboren) und Richard Duncan McConnell (am 30. Januar 1922 in Brooklyn, New York, geboren) gründeten 1958 ihr Büro in Cedar Rapids, Iowa. Crites hatte unter McConnell an der Ingenieurbaufakultät der Iowa State University studiert. Die Sektion Iowa des AIA verlieh der Architektengemeinschaft zahlreiche Auszeichnungen für ihre Wohnhäuser, Bürobauten und Institutsgebäude, u. a. einen Honor Award für das McFarland-Ärztehaus in Ames, Iowa (1966) und die United Covenant Presbyterianische Kirche in Danville, Illinois (1968). Außerdem wurden vier ihrer Einfamilienhäuser Mitte der 60er-Jahre in drei aufeinander folgenden Jahren mit dem »Home for Better Living«-Preis ausgezeichnet. Das umfangreiche Werk von Crites & McConnell wurde in der amerikanischen und ausländischen Fachpresse publiziert. Crites lebt und arbeitet heute in Danville, Illinois. Über Richard McConnell lagen keine weiteren Informationen vor.

Der gebürtige Texaner Gordon Drake lebte einige Jahre auf Hawaii, bevor er unter Carl Troedsson und Harwell Hamilton Harris an der University of Southern California Architektur studierte. Im 2. Weltkrieg diente er in der Marine und gründete dann sein eigenes Büro in Los Angeles, wo er seine mit Preisen bedachten Einfamilienhäuser baute. Später zog er mit dem Büro nach Carmel und schließlich nach San Francisco um. Während seiner kurzen Laufbahn gewann Drake mit seinen von der traditionellen japanischen Architektur geprägten Wohnhäusern nationale und internationale Anerkennung. Er kam im Alter von nur 34 Jahren am 15. Januar 1952 in einem Schneesturm in der kalifornischen Sierra ums Leben.

Né à New York en 1901, Corbett grandit en Californie du Sud. Il est pendant sept ans apprenti dans l'agence de son père et reçoit une éducation formelle en architecture à la San Francisco School of Fine Arts. Après avoir travaillé pendant dix ans pour diverses agences, il crée la sienne en 1934 à San Mateo, une banlieue de San Francisco et transfère ses bureaux à San Francisco en 1937. Il enseigne l'architecture à l'Université de Californie et est critique invité à Yale. Ses réalisations les plus célèbres, la Hope Lutheran Church, dans le sud de la baie de San Francisco, et la Thomsen House à Vina, Californie, témoignent de l'influence de Bernard Maybeck. Nous ne disposons pas d'informations plus récentes le concernant.

Raymond David Crites, né à Danville, Illinois, le 6 décembre 1925 et Richard Duncan McConnell, né à Brooklyn, New York, le 30 janvier 1922, s'associent à Cedar Rapids, Iowa en 1958. Crites avait étudié à l'Ecole d'Ingénierie de l'Iowa State University où McConnell enseignait. Le chapitre de l'Iowa de l'American Institute of Architects leur accorde plusieurs prix pour leurs réalisations résidentielles et leurs projets institutionnels et commerciaux. Ils ont reçu un prix d'honneur national de l'AIA pour la McFarland Clinic d'Ames, Iowa (1966) et la United Covenant Presbyterian Church de Danville, Illinois (1968). Par ailleurs, quatre résidences construites pour des clients privés ont été primées par « Home for Better Living », trois années consécutives au milieu des années 1960. Leur œuvre importante a été publiée dans les plus grands journaux professionnels américains et étrangers. Crites vit et travaille à Danville, Illinois. Nous ne disposons pas d'informations plus récentes sur Richard McConnell.

Natif du Texas, Gordon Drake a passé plusieurs années à Hawaii, avant d'entreprendre des études d'architecture à l'Université de Californie du Sud auprès de Carl Troedsson et de Harwell Hamilton Harris. Pendant la seconde guerre mondiale, il sert dans les Marines, puis fonde son agence à Los Angeles où il construit sa maison qui remporte plusieurs distinctions. Il s'installe ensuite à Carmel et finalement à San Francisco. Au cours de sa brève carrière, son travail sur les maisons individuelles influencé par l'architecture traditionnelle japonaise lui vaut une notoriété nationale et internationale. Il meurt le 15 janvier 1952, à l'âge de 34 ans, au cours d'une tempête de neige dans la California Sierra.

Craig Ellwood / Born in Clarendon, Texas, in 1922, Ellwood came to Los Angeles with his family as a child. Although Ellwood was mostly self-taught, receiving his formal education through evening courses in structural engineering at the University of California Los Angeles (UCLA), he achieved international recognition and success as an architect. His apprenticeship in a construction company provided him with a deep understanding of construction processes. Among his acclaimed projects, the Security Pacific Bank Building at Wilshire Boulevard and the Art Center College of Design in Pasadena (1976) reveal the influence of Mies van der Rohe. In both his residential and commercial work, Ellwood used steel frame construction to striking effect. In the late 1970s, he retired as an architect and devoted his attention to painting. Craig Ellwood died in 1992, at the age of 70 in his home in Pergine-Valdarno near Florence, Italy.

Frederick E. Emmons / Born in Olean, New York, in 1907, Frederick Emmons studied architecture at the College of Architecture, Art and Planning at Cornell University, Ithaka, New York, and received his B. Arch. in 1929. He trained for two years in the office of McKim, Mead & White in New York, and then moved to Los Angeles in 1932. In 1938, he worked for one year for William Wurster, San Francisco, who later formed the renowned firm Wurster, Bernardi and Emmons with Emmons' late brother, Donn. In 1950, he founded a partnership with A. Quincy Jones, a practice which gained national recognition for the Eichler residence and several institutional projects. In 1970, he retired from the forefront of the architectural scene, moved to the San Francisco Bay Area and devoted himself to writing. In 1999, Emmons passed away in Belvedere, California, at age 91.

Ralph Carlin Flewelling / In 1894, Ralph Carlin Flewelling was born the son of a minister in St. Louis, Michigan. After receiving his Bachelor of Science from the Wesleyan University, Middletown, Connecticut, in 1916, he studied architecture at the Massachusetts Institute of Technology (MIT), Cambridge, Massachusetts. In the late 1920s, he established his practice in Los Angeles, focusing on residential work in Beverly Hills and West Los Angeles. In 1945, he founded Flewelling & Moody and built the Hall of Philosophy, the School of Architecture and the Fisher Gallery of Fine Arts at the University of Southern California. Although his residential achievements received national awards, Flewelling's main body of work is represented in his designs for educational facilities. He died at the age of 81 in Pasadena, California on December 30, 1975.

1922 in Clarendon, Texas, geboren, kam Ellwod als Kind mit seiner Familie nach Los Angeles. Obwohl er im wesentlichen Autodidakt war (er hatte lediglich Abendkurse in Tragwerksplanung an der UCLA besucht), wurde er ein erfolgreicher, international anerkannter Architekt. Während seiner Lehrzeit in einer Baufirma eignete er sich gründliche Kenntnisse der Bautechnik an. Zu seinen hervorragenden Bauten gehören das Gebäude der Security Pacific Bank am Wilshire Boulevard und das Art Center College of Design in Pasadena (1976), die Mies van der Rohes Einfluss auf Ellwood dokumentieren. Ellwood entwarf seine Bauten – ob Wohn- oder Geschäftshäuser – vorwiegend auf der Basis von Stahlrahmentragwerken als raumbildenden architektonischen Elementen. Ende der 70er-Jahre ging er in den Ruhestand und widmete sich der Malerei. Craig Ellwood starb 1992 im Alter von 70 Jahren in seinem Haus in Pergine-Valdarno bei Florenz, Italien.

Frederick Emmons – 1907 in Olean, New York, geboren – studierte Architektur am College für Architektur, Kunst und Städtebau der Cornell University, Ithaka, New York, und schloss sein Studium 1929 mit einem B. Arch. ab. Danach arbeitete er zwei Jahre lang im Büro McKim, Mead & White in New York, bevor er 1932 nach Los Angeles zog. 1938 war er ein Jahr lang bei William Wurster in San Francisco tätig, der später mit Emmons Bruder Donn das Büro Wurster, Bernardi and Emmons leitete. Im Jahr 1950 gründete Frederick Emmons mit A. Quincy Jones ein gemeinsames Büro, das für sein Haus Eichler sowie mehrere öffentliche Bauten landesweite Anerkennung erhielt. 1970 ging er in den Ruhestand und widmete sich in seinem Haus in der »Bay Area« von San Francisco der Schriftstellerei. 1999 starb er in Belvedere, Kalifornien, im Alter von 91 Jahren.

Ralph Carlin Flewelling wurde 1894 in St. Louis, Michigan, als Sohn eines Pfarrers geboren. Nach Abschluss seines Studiums (Bachelor of Science) an der Wesleyan University in Middletown, Connecticut, (1916) studierte er Architektur am Massachusetts Institute of Technology (MIT), Cambridge. Ende der 20er-Jahre machte er sich in Los Angeles selbständig und konzentrierte sich auf den Entwurf und Bau von Einfamilienhäusern in Beverly Hills und West Los Angeles. 1945 gründete er das Büro Flewelling & Moody und baute die Hall of Philosophy, das Gebäude der Architekturfakultät und die Fisher Gallery of Fine Arts an der University of Southern California. Obwohl er mit seinen Wohnhäusern nationale Preise gewann, baute er vor allem Schulen und Universitätsgebäude. Flewelling starb am 30. Dezember 1975 im Alter von 81 Jahren in Pasadena.

Né à Clarendon, Texas, en 1922, Ellwood arrive encore enfant à Los Angeles. Bien qu'il soit essentiellement autodidacte, il suit des cours du soir d'ingénierie de structure à l'Université de Californie Los Angeles (UCLA). Il acquiert rapidement succès et notoriété. Son apprentissage dans une entreprise de construction lui apporte une connaissance approfondie des processus techniques. Parmi ses projets les plus applaudis : le Security Pacific Bank Building sur Wilshire Boulevard et l'Art College of Design à Pasadena (1976) révèlent l'influence de Mies van der Rohe. Dans son travail sur l'habitat aussi bien que sur des projets commerciaux, il met en valeur des éléments d'ossature en acier utilisés de manière architecturale. A la fin des années 1970, il cesse ses activités d'architecte et se consacre à la peinture. Il meurt en 1992 à l'âge de 70 ans dans sa maison de Pergine-Valdarno près de Florence, Italie.

Né à Olean, New York, en 1907, Frederick Emmons étudie l'architecture au College of Architecture, Art and Planning de Cornell Univesity, Ithaka, New York, dont il sort B. Arch. en 1929. Il se forme pendant deux ans dans le cabinet de McKim, Mead & White à New York, puis s'installe à Los Angeles en 1932. En 1938, il travaille un an pour William Wurster, San Francisco, qui plus tard créera la célèbre agence de Wurster, Bernardi et Emmons, avec le frère cadet d'Emmons, Donn. En 1950, il crée un agence avec A. Quincy Jones, agence qui se fera connaître sur le plan national grâce à la Eichler Residence et plusieurs projets institutionnels. En 1970, il abandonne la pratique de l'architecture, s'installe dans la baie de San Francisco et se consacre à l'écriture. Il meurt à Belvedere, Californie, à l'âge de 91 ans en 1999.

Ralph Carlin Flewellin, fils de pasteur, naît en 1894 à St. Louis, Michigan. Licencié ès Sciences de Wesleyan University, Middletown, Connecticut, en 1916, il étudie l'architecture au Massachusetts Institute of Technology (MIT), Cambridge, Massachusetts. A la fin des années 1920, il crée son agence à Los Angeles, se consacrant essentiellement à des résidences privées édifiées à Beverly Hills et West Los Angeles. En 1945, il fonde Flewelling & Moody et construit le Hall of Philosophy, l'Ecole d'architecture et la Fisher Gallery of Fine Arts de l'Université de Californie du Sud. Bien que ses réalisations de maisons individuelles aient reçu des prix nationaux, ses contributions les plus importantes restent dans le domaine des constructions scolaires et universitaires. Il meurt à 81 ans à Pasadena, Californie, le 30 décembre 1975.

Donald Charles Hensman / Born in Omaha, Nebraska, in 1924, Donald Charles Hensman received his architectural education at the University of Southern California, graduating in 1952. At the school he met Conrad Buff III, with whom he founded the firm Buff, Straub & Hensman, which received numerous awards for their residential designs. From 1952 until 1963, he taught design at the University of Southern California. Since then, he has devoted himself entirely to his private practice, lecturing only occasionally. Hensman passed away in 2002.

A. Quincy Jones / Archibald Quincy Jones, known as "Quincy", was born in Kansas, Missouri in 1913, but grew up in Southern California. He received his B. Arch. from the University of Washington, Seattle, Washington, in 1936. For six years he worked in various firms, including Honnold and Russell. During World War II, he served in the Navy, and after the war, opened his private practice in 1945. From 1950–69, he formed a partnership with Frederick E. Emmons and then took over the sole ownership of the firm. Jones's accomplishments are predominantly in the field of residential, particularly merchant-built houses. His major projects include Case Study House #24, and steel houses in San Mateo, California, for builder Joseph L. Eichler, Palo Alto, California. Recipient of numerous awards, the firm received the Award of the American Institute of Architecture. Jones also taught at the University of Southern California and served as the Dean of the School of Fine Arts. He died in Los Angeles on August 3, 1979.

Bernard Judge / Judge was still a student when the design of his own geodesic house received nationwide exposure. From 1954–55, he studied at the École National des Beaux Arts in Paris, France and completed his architectural studies at the University of Southern California, graduating in 1960. In 1965, he founded his private practice under the name "The Environmental System Group", whose portfolio of work encompasses residential design, resort planning and historic preservation. Bernard Judge's work is informed by his interest in sustainability, rationalized components, and the preservation of ecosystems as well as local cultural values. Among his most noted achievements are the Master Plan for Marlon Brando's Tetiaroa Atoll in Polynesia, and the Subway Terminal Building in Los Angeles. Bernard Judge lives and works in Los Angeles and the South Pacific.

Hensman wurde 1924 in Omaha, Nebraska, geboren und studierte Architektur an der University of Southern California (Abschluss 1952). Dort lernte er Conrad Buff III. kennen, mit dem er das Büro Buff, Straub & Hensman gründete, das zahlreiche Preise für seine Einfamilienhäuser einheimste. Von 1952–63 lehrte Hensman architektonisches Entwerfen an der University of Southern California. Seitdem widmete er sich ausschließlich der Tätigkeit in seinem Büro und hielt nur noch gelegentlich Vorlesungen. Hensman starb im Jahr 2002.

Archibald Quincy Jones (genannt »Quincy«) wurde 1913 in Kansas, Missouri, geboren, wuchs aber in Südkalifornien auf. Sein Architekturstudium an der University of Washington, Seattle, schloss er 1936 mit dem B.Arch. ab. Sechs Jahre lang arbeitete er in verschiedenen Architekturbüros, u. a. bei Honnold und Russell. Im 2. Weltkrieg diente er in der Marine; unmittelbar nach Kriegsende gründete er 1945 sein eigenes Büro, das er von 1950–69 mit Frederick E. Emmons führte und danach wieder alleine. Jones' Leistungen umfassen vorwiegend Wohnbauten, an erster Stelle für Immobiliengesellschaften und Bauinvestoren. Jones' Hauptwerke sind das Case Study-Haus Nr. 24 sowie Stahlhäuser in San Mateo für den Bauunternehmer Joseph L. Eichler aus Palo Alto. Viele seiner Einzelbauten erhielten Preise und Auszeichnungen, und das Büro den »Award of the American Institute of Architects«. Jones lehrte auch an der University of Southern California und war Dekan der Kunstakademie. Er starb in Los Angeles am 3. August 1979.

Judge war noch Student, als sein Entwurf für sein eigenes »geodätisches Haus« landesweit Aufsehen erregte. Von 1954–55 studierte er an der École Nationale des Beaux Arts in Paris, Frankreich, und schloss sein Architekturstudium 1960 an der University of Southern California ab. 1965 gründete er sein eigenes Büro, »The Environmental System Group«, und baute in der Folge Wohnhäuser, Ferienclubanlagen und Hotels. Darüber hinaus betätigte sich die Gruppe in der Baudenkmalpflege. Bernard Judges Arbeiten sind geprägt von seinem Engagement für Nachhaltigkeit, rationalisierte Komponenten und die Bewahrung von Ökosystemen und den kulturellen Werten des jeweiligen Ortes. Zu seinen bekanntesten Werken zählen der Generalplan für Marlon Brandos Tetiaroa-Atoll in Polynesien und das Gebäude des Subway Terminal in Los Angeles. Judge lebt und arbeitet in Los Angeles und im südpazifischen Raum.

Né à Omaha, Nebraska, en 1924, Donald Charles Hensman fait ses études à l'Université de Californie du Sud dont il est diplômé en 1925. Il y rencontre Conrad Buff III avec qui il crée l'agence Buff, Straub & Hensman, qui reçoit de nombreuses distinctions pour ses maisons individuelles. De 1952 à 1963, il enseigne la conception de projets à l'Université de Californie du Sud, puis se consacre entièrement à sa clientèle privée, donnant des conférences à l'occasion. Il meurt en 2002.

Archibald Quincy Jones, dit « Quincy », naît à Kansas, Missouri, en 1913, mais grandit en Californie du Sud. Licencié de l'Université de Washington, Seattle, en 1936, il travaille pendant six ans pour diverses agences, dont Honnold and Russell. Pendant la seconde guerre mondiale, il sert dans la marine, puis ouvre son agence après guerre, en 1945. De 1950 à 1969, il est associé à Frederick E. Emmons puis conserve seul la direction de l'agence. Ses réussites dans le domaine de la maison individuelle, en particulier de maisons de promoteurs, sont remarquables. Parmi ses projets les plus notables figurent la Case Study House n° 24, et des maisons en acier à San Mateo, Californie pour l'entrepreneur Joseph L. Eichler, Palo Alto, Californie. Bénéficiaire de nombreuses distinctions, son agence reçoit le prix de l'American Institute of Architecture. Jones a également enseigné à l'Université de Californie du Sud et été doyen de l'Ecole des Beaux-Arts. Il meurt à Los Angeles le 13 août 1979.

Encore étudiant, Judge dessine une maison géodésique qui le rend célèbre aux Etats-Unis. De 1954 à 1955, il étudie à l'Ecole Nationale des Beaux-Arts de Paris, puis achève ses études à l'Université de Californie du Sud, dont il est diplômé en 1960. En 1965, il crée son agence sous le nom de « The Environmental System Group», dont les interventions couvrent les maisons individuelles, la création d'équipements de vacances, et la restauration de bâtiments historiques. Son travail est marqué par l'intérêt qu'il porte à la perennité, aux composants rationalisés à la préservation des écosystèmes ainsi qu'aux valeurs culturelles locales. Parmi ses réalisations les plus remarquées : le plan directeur de l'atoll de Tetiaroa, propriété de Marlon Brando, et l'immeuble du terminal du métro de Los Angeles. Il vit et travaille à Los Angeles et dans le Pacifique Sud.

Raymond Kappe / After graduating from the University of California at Berkeley in 1951, Raymond Kappe completed a two-year apprenticeship under Carl Maston. In 1954, he established his private practice in Brentwood, California, authoring numerous custom-built houses based on modular systems. Most of his housing projects use wood, and focus on the relationship of indoor-outdoor living, both reminiscent of the Bay Area Style and Southern Californian residential architecture. He typically concentrated on developing alternative design solutions through prefabrication. Chairman of the Department of Architecture at California State Polytechnic University, Pomona, California, in 1972 he founded the Southern California Institute of Architecture (SCI-Arc). Raymond Kappe lives and works in Los Angeles.

Nach Abschluss seines Studiums an der University of California in Berkeley (1951) verbrachte Kappe eine zweijährige Lehrzeit im Büro von Carl Maston. 1954 eröffnete er sein eigenes Büro in Brentwood und baute eine große Anzahl von Einfamilienhäusern (jeweils »Sonderanfertigungen«) auf der Grundlage modularer Bausysteme, die meisten mit Holztragwerken und geprägt von der Beziehung zwischen Innen- und Außenraum. Das erinnert an den sogenannten Bay-Area-Stil (um San Francisco) und südkalifornische Wohnarchitektur. Kappe konzentrierte sich in der Regel darauf, auf der Basis der Vorfertigung alternative Designlösungen zu entwickeln. Als Dekan der Architekturfakultät der California State Polytechnic University in Pomona war er 1972 ein Mitbegründer des Southern California Institute of Architecture (SCI-Arc). Raymond Kappe lebt und arbeitet in Los Angeles.

Diplômé de l'Université de Californie Berkeley en 1951, Raymond Kappe fait un apprentissage de deux années chez Carl Maston. En 1954, il crée son agence à Brentwood, Californie où il signe de nombreuses maisons individuelles construites d'après un système modulaire. La plupart de ses projets font appel au bois et s'attachent aux relations entre le dedans et le dehors, rappelant à la fois le Bay Area Style et l'architecture résidentielle de Californie du Sud. Il s'intéresse surtout aux solutions alternatives de conception via la préfabrication. Président du département d'architecture de la California State Polytechnic University, Pomona, Califonie, il crée en 1972 le Southern California Institute of Architecture (SCI-Arc). Il vit et travaille à Los Angeles.

Edward A. Killingsworth / Born in Tafte, California, in 1917, Edward A. Killingsworth graduated *cum laude* at the University of Southern California in 1940. For eight years he worked in partnership with Kenneth S. Wing in Long Beach, California. In 1953, he formed a partnership with Jules Brady and Waugh Smith until Smith retired in 1963. The firm continued under the name Killingsworth Brady and Associates until 1967, when Jules Brady retired. During this time, the offices designed the Case Study Houses #23, #25 and #26. In addition to residential commissions, Killingsworth designed numerous hotels in Asia, which won him numerous awards. Edward A. Killingsworth died in 2004 in Long Beach, California.

Killingsworth wurde 1917 in Tafte, Kalifornien, geboren. 1940 graduierte er »cum laude« an der University of Southern California, worauf er acht Jahre lang in einer Architektengemeinschaft mit Kenneth S. Wing in Long Beach arbeitete. 1953 gründete er dort eine Partnerschaft mit Jules Brady und Waugh Smith, bis Smith 1963 in den Ruhestand ging. Das Büro firmierte als Killingsworth Brady and Associates, bis Jules Brady sich 1967 ebenfalls aus Altersgründen zurückzog. Bis zu diesem Zeitpunkt hatten Killingsworth und seine Partner die Case-Study-Häuser Nr. 23, 25 und 26 gebaut. Neben Wohnhäusern realisierte Killingsworth zahlreiche preisgekrönte Hotels in Asien. Er starb im Jahr 2004.

Né à Tafte, Californie, en 1917, Killingsworth est diplômé «cum laude» de l'Université de Californie du Sud en 1940. Pendant huit ans, il travaille en association avec Kenneth S. Wing à Long Beach, Californie. En 1953, il s'associe à Jules Brady et Waugh Smith. Celui-ci se retire en 1963. L'agence continue sous le nom de Killingsworth Brady and Associates jusqu'en 1967, lorsque Brady prend sa retraite. Au cours de cette période, elle signe les Case Study Houses n° 23, 25 et 26. En dehors de résidences individuelles, Killingsworth conçoit de nombreux hôtels en Asie, qui lui valent de multiples distinctions. Il meurt en 2004.

Thornton Ladd / Born in Portland, Oregon, in 1924, Thornton Ladd was brought up in Oregon and California. For a few years he tried to establish a career in music, but then focused on architecture. He received his formal training at the University of Southern California and gained his practical experience working for a general contractor at first, and later for two architects. Subsequently, he established his own practice with offices in Pasadena and Santa Barbara, California. Throughout his career, he aspired to integrate architecture, landscape architecture and interior design. No recent information was available on Thornton Ladd.

Ladd wurde 1924 in Portland, Oregon, geboren und wuchs in Oregon und Kalifornien auf. Einige Jahre lang versuchte er, als Musiker Karriere zu machen, wechselte dann jedoch zur Architektur und studierte an der University of Southern California, bevor er zunächst in einem Bauunternehmen und danach in zwei Architekturbüros praktische Erfahrungen sammelte. Danach machte er sich selbständig und unterhielt Büros in Pasadena und Santa Barbara. Mit allen Entwürfen zielte Ladd auf die Integration von Architektur, Landschafts- und Innenarchitektur. Neuere Informationen über Thornton Ladd lagen nicht vor.

Né à Portland, Oregon, en 1924, Thornton Ladd est élevé en Oregon et en Californie. Pendant quelques années, il s'essaye à une carrière musicale, puis se réoriente vers l'architecture. Il étudie à l'Université de Californie du Sud et acquiert une expérience pratique auprès d'une entreprise générale puis de deux architectes. Il crée son agence installée à Pasadena et Santa Barbara, Californie. Tout au long de sa carrière, il s'efforce d'intégrer dans ses projets l'architecture, l'aménagement paysagé et l'architecture intérieure. Nous ne disposons pas d'informations plus récentes le concernant.

Charles A. Lagreco / Charles A. Lagreco was born in New York in 1944; his family moved to San Bernardino, California in 1946. He received his education at Princeton University. From 1971–76, Lagreco worked as a Senior Project Designer for Caudill, Rowlett and Scott (CSR) in Los Angeles, and won awards for institutional projects. In 1974, Lagreco received a teaching position at the University of Southern California School of Architecture, where he is currently Associate Dean. When the CSR Los Angeles office was dismantled in 1976, he established his own private practice, Architecture Collective, a firm which is still active.

Paul László / Paul László was born in 1900 in Hungary. At the age of 24, he opened his own interior design studio in Vienna, Austria, in 1924. In 1936, he emigrated to Los Angeles to escape persecution by the National Socialists. Already a well-known architect and interior designer, László built Modernist residences, restaurants, luxury stores, showrooms and casinos. He also was involved in building sets for the film industry. Among his clientele were Cary Grant, Elizabeth Taylor, Barbara Stanwyck, Robert Taylor and Barbara Hutton. Paul László died in 1993 in Santa Monica, California.

Charles Luckman / From 1950–58, Charles Luckman worked in a partnership with William Pereira, specializing in large-scale projects such as office buildings, airports, hotels and Air Force bases, primarily in California. Charles Luckman was born in Kansas City in 1909 and began to study architecture at the University of Illinois, Urbana-Champaign, in 1931. During the Great Depression he worked in the advertising department of the Colgate-Palmolive-Peet Company and later advanced to sales manager of the Pepsodent Company. In 1937, he was featured on the cover of *Time Magazine*. In 1946, Luckman became President of Lever Brothers and was instrumental in commissioning the company's new headquarters, a major landmark in New York. Entrepreneur at heart, Luckman merged his passion for architecture with his sense of business, and acquired ambitious commissions throughout the United States. In 1998, Charles Luckman died in Los Angeles at the age of 89.

Lagreco wurde 1944 in New York geboren, wuchs jedoch in San Bernardino, Kalifornien auf (ab 1946). Er studierte Architektur an der Universität Princeton unter Michael Graves und Peter Eisenman. Von 1971–76 arbeitete er als Senior Project Designer (leitender Projektarchitekt) bei Caudill, Rowlett and Scott (CSR) in Los Angeles und entwarf preisgekrönte Institutsbauten. 1974 wurde er an die University of Southern California School of Architecture berufen, deren stellvertretender Dekan er derzeit ist. Als CSR das Büro in Los Angeles 1976 aufgab, machte Lagreco sich mit dem »Architecture Collective« selbständig, das heute noch besteht.

Paul László wurde 1900 in Ungarn geboren. Im Alter von 24 Jahren eröffnete er sein eigenes Büro in Wien. Um der Verfolgung durch die Nazis zu entgehen, emigrierte er 1936 in die USA und kam nach Los Angeles. Er hatte sich als Architekt bereits einen Namen gemacht und realisierte in Kalifornien zahlreiche moderne Einfamilienhäuser, Restaurants, Luxus-Boutiquen, Ausstellungsräume und Spielkasinos. Außerdem betätigte er sich als Filmarchitekt. Zu seinen Bauherren zählten Cary Grant, Elizabeth Taylor, Barbara Stanwyck, Robert Taylor und Barbara Hutton. Paul László starb im Alter von 93 Jahren in Santa Monica.

Von 1950–58 arbeitete Luckman in Partnerschaft mit William Pereira. Ihr Architekturbüro war auf Großprojekte spezialisiert – Bürokomplexe, Flughäfen, Hotels und Luftwaffenstützpunkte. Luckman wurde 1909 in Kansas City geboren und studierte ab 1931 Architektur an der University of Illinois in Urbana-Champaign. Während der großen Wirtschaftsdepression war er in der Werbeabteilung von Colgate-Palmolive-Peet tätig und arbeitete sich später bei Pepsodent bis zum Verkaufsleiter hoch. 1937 zierte sein Bild die Titelseite des »Time Magazine«. 1946 wurde Luckman Vorstandsvorsitzender von Lever Brothers und sorgte dafür, dass das Unternehmen seinen neuen Hauptsitz in New York bauen ließ, heute ein bedeutendes Baudenkmal der Metropole. Luckman war der geborene Unternehmer und verband seinen Geschäftssinn mit seiner Leidenschaft für Architektur. Er baute überall in den Vereinigten Staaten. Im Alter von 89 Jahren starb er in Los Angeles.

Charleds A. Lagreco naît à New York en 1944, mais grandit à San Bernardino, Californie à partir de 1946. Il étudie à Princeton University auprès de Michael Graves et Peter Eisenman. De 1971 à 1976, il travaille comme concepteur de projets senior chez Caudill, Rowlett and Scott (CSR) à Los Angeles et remporte des prix pour des projets institutionnels. En 1974, il devient professeur à l'Ecole d'architecture de l'Université de Californie du Sud, dont il est actuellement doyen associé. Lorsque l'agence de Los Angeles de CSR cesse ses activités en 1976, il crée sa propre agence, Architecture Collective, toujours active.

Paul László naît en Hongrie en 1900. A 24 ans, il ouvre son propre studio de décoration à Vienne. En 1936, il émigre à Los Angeles pour échapper aux persécutions nazies. Architecte et architecte d'intérieur déjà connu, il réalise des maisons, des restaurants, des boutiques de luxe, des showrooms, des casinos d'esprit moderniste. Il crée également des décors pour le cinéma. Parmi ses clients figurent Cary Grant, Elizabeth Taylor, Barbara Stanwick, Robert Taylor et Barbara Hutton. Il meurt à l'âge de 93 ans, en 1993, à Santa Monica, Californie.

De 1950 à 1958, Charles Luckman, associé à William Pereira, se spécialise dans les projets de grande envergure comme les immeubles de bureaux, des aéroports, des hôtels et des bases militaires aériennes, essentiellement en Californie. Né à Kansas City en 1909, il commence ses études d'architecture à l'Université de l'Illinois, Urbana-Champaign, en 1931. Pendant la Grande Dépression, il travaille dans le département de publicité de Colgate-Palmolive-Peet et devient responsable des ventes de Pepsodent. En 1937, il fait la couverture de « Time Magazine ». En 1946, président de Lever Brothers, il joue un rôle majeur dans la construction du nouveau siège de la société à New York. Entrepreneur né, Luckman associe sa passion pour l'architecture au sens des affaires et remporte des commandes importante dans tous les Etats-Unis. Il meurt à Los Angeles en 1998, à l'âge de 89 ans.

Maynard Lyndon / Born in Howell, Michigan, Maynard Lyndon moved to Los Angeles in the early 1940s, where he established his own architectural practice and led design studios at the University of Southern California School of Architecture for two decades. During his professional career he focused on school design, winning both national and international awards. His best known projects include the Meiners Oaks School, Ojai, the Apperson Street School, Los Angeles, and the Webster School in Malibu as well as his own residence on Point Dume in Malibu, California. In 1973, Maynard Lyndon moved with his wife moved to Küssaberg, Germany, where he died at the age of 92.

Carl L. Maston / Maston received his formal education at the University of Southern California School of Architecture. During his formative years, he was not sure whether he wanted to pursue a career in music as a solo pianist or enter the architectural profession. Eventually he focused on architecture, designing more than 100 buildings, including private residences, apartment buildings, shopping centers and large-scale institutional projects. Among his most noted accomplishments are the School of Environmental Design at California Polytechnic State University, Pomona, and the Creative Arts Building at the California State University, San Bernardino. Carl Maston was 77 when he died in Hollywood in 1992.

William L. Pereira / William Leonard Pereira was born in Chicago, Illinois, on April 25, 1909. He is mainly known for his corporate, industrial and institutional architecture, such as the Los Angeles County Museum of Arts, the Master Plan of the University of California at Irvine and the Transamerica Pyramid skyscraper in San Francisco. He established a partnership with Charles Luckman, former president of the Lever Brothers Company, New York. Their work was frequently published in the professional journals, especially *arts & architecture* by John Entenza. Until 1959, he held a teaching position at the University of Southern California School of Architecture, Los Angeles. In 1958, Charles Luckman left the practice leaving Pereira as the sole principal of the firm. Pereira's projects were widely acknowledged by the architectural media. He died in Los Angeles on November 13, 1985.

Lyndon stammte aus der Stadt Howell in Michigan und kam Anfang der vierziger Jahre nach Los Angeles, wo er sein eigenes Büro gründete und zwei Jahrzehnte an der University of Southern California School of Architecture lehrte. Er baute vor allem Schulen, mit denen er nationale und internationale Auszeichnungen gewann. Zu seinen bekanntesten Werken zählen die Meiners Oaks School in Ojai, die Apperson Street School in Los Angeles und die Webster School in Malibu sowie sein eigenes Haus am Point Dume in Malibu. 1973 übersiedelte Lyndon mit seiner Frau nach Süddeutschland (Küssaberg bei Waldshut an der Schweizer Grenze), wo er im Alter von 92 Jahren starb.

Als junger Mann war sich Maston nicht sicher, ob er eine musikalische Karriere als Solo-Pianist anstreben oder lieber Architekt werden sollte und entschied sich dann doch für Letzteres. Er studierte an der University of Southern California School of Architecture und baute im Laufe seines Berufslebens über 100 Gebäude, darunter Einfamilien- und Mehrfamilienhäuser (Wohnungen), Einkaufszentren und große öffentliche Gebäude. Zu seinen besten und bekanntesten Werken zählen die School of Environmental Design (Schule für ökologische Architektur) an der California Polytechnic State University in Pomona und das Creative Arts-Gebäude der California State University in San Bernardino. Carl Maston starb 1992 im Alter von 77 Jahren in Hollywood.

William Leonard Pereira wurde am 25. April 1909 in Chicago, Illinois, geboren. Bekannt wurde er für seine Firmengebäude, Fabriken und öffentlichen Bauten, zum Beispiel das Los Angeles County Museum of Arts, den Generalplan der University of California in Irvine und das Hochhaus »Transamerica Pyramid« in San Francisco. Seine Partnerschaft mit Charles Luckman, dem früheren Vorstandsvorsitzenden von Lever Brothers, New York, arbeitete höchst erfolgreich. Ihre Arbeiten wurden in der Fachpresse veröffentlicht und gewürdigt, besonders von John Entenza in »arts & architecture«. Bis 1959 lehrte Pereira an der University of Southern California School of Architecture, Los Angeles. Nach dem Ausscheiden Luckmans im Jahr 1958 führte Pereira das Büro alleine weiter. Seine Bauten wurden von den einflussreichsten Fachzeitschriften weithin anerkannt. Pereira starb am 13. November 1985 in Los Angeles.

Né à Howell, Michigan, Maynard Lyndon s'installe à Los Angeles au début des années1940, où il crée son agence et enseigne la conception de projets à l'Ecole d'architecture de l'Université de Californie du Sud pendant vingt ans. Au cours de sa carrière, il se concentre sur l'architecture scolaire, remportant diverses distinctions nationales et internationales. Parmi ses réalisations : la Meiner Oaks School, Ojai, l'Apperson Street School, Los Angeles, et la Webster School de Malibu ainsi que sa propre maison à Point Dume, Malibu, Californie. En 1973, il quitte les Etats-Unis et s'installe à Küssaberg, Allemagne, où il meurt à l'âge de 92 ans.

Maston fait ses études à l'Ecole d'architecture de l'Université de Californie du Sud. Au cours de sa formation, il hésite entre une carrière de pianiste et l'architecture. Par la suite, il réalise plus de 100 projets dont des résidences privées, des immeubles d'appartements, des centres commerciaux et d'importants projets institutionnels. Parmi ses réussites les plus remarquées : la School of Environmental Design de la California State University, Pomona, et le Creative Arts Building de la California State University, San Bernardino. Il meurt à Hollywood en 1992 à l'âge de 77 ans.

Né à Chicago, Illinois, le 25 avril 1909, William Leonard Pereira est essentiellement connu pour ses projets industriels, pour de grandes entreprises, comme le gratte-ciel Transamerica Pyramid à San Francisco, et institutionnels, comme le Los Angeles County Musuem of Arts et le plan directeur de l'Université de Californie à Irvine. Il s'associe à Charles Luckman, ancien président de Lever Brothers Company, et leur agence va de succès en succès. Leurs réalisations sont fréquemment publiées dans les journaux professionnels, en particulier, dans « arts & architecture » de John Entenza qui les apprécie. Jusqu'en 1959, il enseigne à l'Ecole d'architecture de l'Université de Californie du Sud, Los Angeles. En 1958, Luckman se retire de l'agence, dont Pereira conserve la direction. Ses projets sont reconnus par les médias professionnels influents. Il meurt à Los Angeles le 13 novembre 1985.

Joseph J. Railla and Lawrence Robbin / Joseph J. Railla, born in New York on October 21, 1934, joined practice with Lawrence Robbin from 1964–68. The practice received an Award of Excellence for House Design for the Browder Residence, which was featured in a 1966 issue of *Architectural Record*. Today, Lawrence Robbin lives and practices in Los Angeles. No recent information was available for Joseph Railla.

Uel Clifton Ramey / Uel Clifton Ramey, born in Seligman, Montana on January 6, 1918, worked in partnership with Jack Russell Jones in Wichita, Kansas, from 1962–67. Among his many institutional and religious projects, all located in Kansas, the University Lutheran Church at the University of Kansas, Lawrence, received the widest exposure. Besides a busy professional practice, Russell also held a teaching position at Kansas State Teachers College, Lawrence, from 1964–69. No information is available on his life and work after 1970.

John Rex / John Rex was born in 1909 in Angeleno, California. From 1927–32, he studied architecture at the University of Southern California, and later at the Art Center College in Los Angeles. He worked in partnership with Sumner Spaulding, Douglas Honnold and Jan De Swarte, and for the US Navy. He taught Design at the University of Southern California and at the University of California Los Angeles (UCLA), and was involved in residential and institutional commissions. He designed several educational facilities, and together with Richard Neutra and others co-authored the design for the Los Angeles County Hall of Records.

Paul Robert Schweikher / Born in Denver, Colorado, on July 28, 1903, Paul Robert Schweikher was personally acquainted with Mies Van der Rohe, Louis Kahn and George Howe. The Schweikher & Elting Partnership, established in 1938, ended in 1953. The firm originally included a third partner, Ted Lamb, who had been engaged in residential projects built predominantly in the Eastern United States; he died in an airplane accident in 1943. The architecture of Paul Schweikher, the firm's leading principal and chairman of the Department of Architecture at Yale in 1953, reflects the transitional period directly before the language of Modernism introduced by Josef Albers and Mies Van der Rohe found general acceptance. Schweikher always operated a small practice and divided his time between teaching and building. He died in 1997.

Joseph J. Railla (geb. 21. Oktober 1934 in New York) und Lawrence Robbin arbeiteten von 1964–68 zusammen in einem gemeinsamen Büro. Für ihr Haus Browder, das 1966 in der Zeitschrift »Architectural Record« publiziert wurde, erhielten sie einen Award of Excellence für Wohnhausarchitektur. Lawrence Robbin lebt und arbeitet heute in Los Angeles. Über Joseph Railla lagen keine neueren Informationen vor.

Uel Clifton Ramey (geb. 6. Januar 1918 in Seligman, Montana) hatte von 1962–67 in Wichita, Kansas, ein gemeinsames Büro mit Jack Russell Jones. Unter den zahlreichen Institutsgebäuden und Sakralbauten (alle in Kansas) ist die Lutherische Kirche der Universität Kansas in Lawrence am meisten beachtet worden. Neben seiner Berufstätigkeit als viel beschäftigter Architekt lehrte Russell Jones von 1964–69 auch am Kansas State Teachers College in Lawrence. Zu seinen Werken nach 1970 lagen keine weiteren Informationen vor.

John Rex wurde 1909 in Angeleno, Kalifornien geboren. Von 1927–32 studierte er Architektur an der University of Southern California und später am Art Center College in Los Angeles. Er arbeitete in den Büros von Sumner Spaulding, Douglas Honnold und Jan de Swarte und war auch für die US-Kriegsmarine tätig. Er lehrte architektonisches Entwerfen an der University of Southern California und der University of California Los Angeles (UCLA) und baute Wohnhäuser und Gebäude für große Institutionen. Außerdem entwarf er mehrere Lehrgebäude und war zusammen mit Richard Neutra und anderen am Entwurf der Los Angeles County Hall of Records beteiligt.

Paul Robert Schweikher wurde am 28. Juli 1903 in Denver, Colorado, geboren. Er unterhielt freundschaftliche Beziehungen mit Mies van der Rohe, Louis Kahn und George Howe. Das 1938 gegründete Büro Schweikher & Elting Partnership bestand bis 1953. Ursprünglich waren es drei Partner: Ted Lamb, der vorwiegend Wohnhäuser im Osten der USA entwarf, kam jedoch schon 1943 bei einem Flugzeugabsturz ums Leben. Die Bauten Paul Schweikhers, Primus inter Pares des Büros und 1953 Dekan der Architekturfakultät der Universität Yale, repräsentieren den Architekturstil der Übergangszeit kurz bevor die von Josef Albers und Mies van der Rohe eingeführte moderne Formensprache allgemeine Akzeptanz fand. Schweikher führte stets ein kleines Büro und teilte seine Zeit zwischen Bautätigkeit und Lehre. Er starb im Jahr 1997.

Joseph J. Railla, né à New York le 21 octobre 1934, travaille en association avec Lawrence Robbin de 1964 à 1968. Leur agence reçoit un prix d'excellence des résidences individuelles pour la Browder Residence présentée dans un numéro de 1966 de « Architectural Record ». Lawrence Robbin vit et travaille à Los Angeles. Nous ne disposons pas d'informations récentes sur Joseph Railla.

Uel Clifton Ramey, né à Seligman, Montana, le 6 janvier 1918, travaille en partenariat avec Jack Russell Jones à Wichita, Kansas, de 1962 à 1967. Parmi les très nombreux projets religieux et institutionnels, tous dans le Kansas, le University Lutheran Church pour l'Université du Kansas, Lawrence, est la plus connue. En dehors d'une activité professionnelle chargée, Russel enseigne également au Kansas State Teachers College, Lawrence, de 1964 à 1969. Nous ne disposons pas d'informations plus récentes.

John Rex naît en 1909 à Angeleno, Californie. De 1927 à 1932, il étudie l'architecture à l'Ecole d'architecture de l'Université de Californie du Sud puis au Art Center College de Los Angeles. Il travaille en partenariat avec Sumner Spaulding, Douglas Honnold et Jan de Swarte, et pour l'US Navy. Il enseigne la conception de projets à l'Université de Californie du Sud et à l'Université de Californie Los Angeles (UCLA). Il réalise des projets dans les domaines résidentiel et institutionnel. Il conçoit plusieurs équipements scolaires et, avec Neutra et d'autres, signe le projet du Los Angeles County Hall of Records.

Né à Denver, Colorado, le 28 juillet 1903, Paul Rober Schweikher entretient des relations personnelles avec Mies van der Rohe, Louis Kahn et George Howe. Le Schweikher & Elting Partnership dure de 1938 à 1953. L'agence comptait à l'origine un troisième partenaire, Ted Lamb, responsable de projets résidentiels essentiellement sur la côte Est décédé, dans un accident d'avion en 1943. L'architecture de Paul Schweikher, président du département d'architecture de Yale en 1953, est à l'image de la période de transition qui précède l'acceptation par le grand public du langage moderniste introduit par Josef Albers et Mies van der Rohe. Il conserve longtemps une petite agence, et partage son temps entre l'enseignement et la construction. Il meurt en 1997.

Whitney Rowland Smith / Born in Pasadena, California in 1911, Whitney Rowland Smith graduated from the University of Southern California in 1934, and worked for various firms, including Harwell Hamilton Harris. He designed Case Study Houses #5 and #12 and the Mutual Housing project in Brentwood, California, in collaboration with A. Quincy Jones and Edgardo Contini. In 1949, he went into partnership with Wayne Williams, an association that lasted until 1973, and produced numerous award-winning projects, including private residences, schools, community buildings, and recreational facilities. The partnership's work is renowned for the use of wood, which inspired the architectural historian Esther McCoy to write about a Pasadena School. Whitney Rowland Smith retired from practice in 1988 and passed away in 2002.

Sumner Spaulding / Born in Ionia, Michigan, in 1892, Sumner Spaulding began his architectural education in 1911 at the University of Michigan, and completed them the Massachusetts Institute of Technology (MIT), Cambridge, Massachusetts, graduating in 1916. He sat on numerous design and planning committees. His residential buildings include the Case Study House #2 with John Rex; among his large-scale public projects are the Catalina Casino on Catalina Island near Los Angeles, and a terminal for Los Angeles International Airport. He taught at the University of Southern California and at Scripps College at Claremont, California. Sumner Spaulding died in 1952.

Rodney Walker / Born in Salt Lake City on September 15, 1910, Rodney Walker was brought up in Ely, Nevada. He studied engineering at the Pasadena City College and art at the University of California Los Angeles. After graduation he worked for a few months for Rudolph M. Schindler. His work bears witness to his interest in developing new domestic prototypes using low-cost technologies and materials. Walker received international attention for his contribution to the Case Study House program, with houses #16, #17, #18. In the mid-1950s he moved his family and architectural practice to Ojai, north of Los Angeles. In 1971, he retired from architecture and devoted himself to running the Oaks Hotel in Ojai and selling jewelry that he designed and crafted himself. Rodney Walker died in June 1986.

1911 in Pasadena geboren, studierte Whitney Rowland Smith Architektur an der University of Southern California (Abschluss 1934) und arbeitete dann in verschiedenen Büros, u. a. dem von Harwell Hamilton Harris. Er entwarf die Case Study-Häuser Nr. 5 und 12 sowie die Mutual Housing Wohnsiedlung in Brentwood (in Zusammenarbeit mit A. Quincy Jones und Edgardo Contini). 1949 ging er eine Partnerschaft mit Wayne Williams ein, die bis 1973 bestand und zahlreiche preisgekrönte Bauten schuf – Einfamilienhäuser, Schulen, Gemeindezentren, Erholungs- und Sportstätten. Die Arbeiten des Büros sind bekannt für ihre Verwendung von Holz. Die Architekturhistorikerin Esther McCoy fühlte sich dadurch veranlasst, von einer »Pasadena-Schule« zu sprechen. Whitney Rowland Smith zog sich 1988 aus seinem Büro zurück und starb 2002.

Sumner Spaulding wurde 1892 in Ionia, Michigan, geboren und studierte ab 1911 Architektur an der University of Michigan und dann am Massachusetts Institute of Technology (MIT) in Cambridge, wo er 1916 seinen Abschluss machte. Zu seinen Einfamilienhäusern zählen das Case-Study-Haus Nr. 2 (mit John Rex), zu seinen großen öffentlichen Bauten das Catalina Casino auf der Insel Catalina bei Los Angeles sowie ein Abfertigungsgebäude des Internationalen Flughafens von Los Angeles. Spaulding lehrte an der University of Southern California und am Scripps College in Claremont, Kalifornien, und diente in zahlreichen Bau- und Planungsausschüssen. Er starb 1952.

Rodney Walker wurde am 15. September 1910 in Salt Lake City, Utah, geboren und wuchs in Ely, Nevada, auf. Er studierte Ingenieurbau am Pasadena City College und bildende Kunst an der University of California Los Angeles (UCLA). Nach Abschluss seines Studiums arbeitete er einige Monate im Büro Rudolph M. Schindler. Seine Bauten belegen seine Suche nach neuen Haus-Prototypen unter Verwendung preisgünstiger Bautechniken und -materialien. Walkers Case Study-Häuser Nr. 16, 17 und 18 wurden international beachtet. Mitte der 50er-Jahre zog er mit seiner Familie und seinem Büro nach Ojai um, nördlich von Los Angeles. 1971 ging er in den Ruhestand und widmete sich der Leitung des Oaks Hotel in Ojai und dem Verkauf von Schmuck, den er selbst entworfen und gearbeitet hatte. Rodney Walker starb im Juni 1986.

Né à Pasadena, Californie, en 1911, Whitney Rowland Smith, diplômé de l'Université de Californie du Sud en 1934 travaille pour de nombreuses agences, dont Harwell Hamilton Harris. Il conçoit la Case Study House n° 5 et 12 et le projet de logements Mutual Housing de Brentwood, Californie, en collaboration avec A. Quincy Jones et Edgardo Contini. En 1949, il s'associe à Wayne Williams. A cette association qui dure jusqu'en 1973 sont dus de nombreux projets primés dont des maisons individuelles, des écoles, des bâtiments publics et des équipements de loisirs. Leurs interventions sont connues pour leur utilisation du bois et ont inspiré l'historienne de l'architecture Esther McCoy dans ses écrits sur l'Ecole de Pasadena. Whitney Rowland Smith se retire en 1988 et meurt en 2002.

Né à Ionia, Michigan, en 1892, Sumner Spaulding commence ses études d'architecture en 1911 à l'Université du Michigan et les achève au Massachusetts Institute of Technology (MIT), Cambridge, Massachusetts, dont il est diplômé en 1916. Il participe à de nombreux comités de planification et de conception. Parmi ses travaux résidentiels figure la Case Study House n°2, avec John Rex et, parmi ses grands projets, le Catalina Casino sur l'Ile de Catalina, près de Los Angeles, ainsi qu'un terminal de l'aéroport de Los Angeles. Il a enseigné à l'Université de Californie du Sud et au Scripps College à Claremont, Californie. Il meurt en 1952.

Né à Salt Lake City le 15 septembre 1910, Rodney Walker grandit à Ely, Nevada. Il étudie l'ingénierie au Pasadena City College et l'art à l'Université de Californie Los Angeles. Son diplôme acquis, il travaille quelques mois pour Rudolph M. Schindler. Son œuvre témoigne de son intérêt pour le développement de prototypes à partir de matériaux et de technologies économiques. Ses contributions au Case Study House Program (maisons n° 16, 17, 18) attirent l'attention internationale. Au milieu des années 1950, il s'installe à Ojai, au nord de Los Angeles. En 1971 il abandonne l'architecture pour se consacrer à la gestion de l'Oaks Hotel à Ojai et vendre des bijoux qu'il dessine et fabrique lui-même. Il meurt en juin 1986.

Paul Williams / Paul Williams built his professional reputation on mansions which he designed for movie stars such as Tyrone Power, Frank Sinatra, Humphrey Bogart, Lauren Bacall and Cary Grant. He was the first African American to be a member of the American Institute of Architects. Born in 1896 in Los Angeles, Williams became an orphan at the age of four. He received his formal education in architecture at the University of Southern California and practiced from 1915–73, when he retired. His firms had branches in Los Angeles, Washington, D.C. and Bogota, Colombia. He designed and built about 1,000 residences. Among his most celebrated public works is the Saks Fifth Avenue building with John and Donald Parkinson and the Los Angeles County Courthouse from the 1950s. Paul Williams died in January 1989.

Wayne Richard Williams / Born in Los Angeles in 1919, Wayne Williams received his B. Arch. from the University of Southern California in 1942. During the World War II, he designed hangars and military facilities. From 1949-1973 he formed a partnership with Whitney Smith in Pasadena, California, co-authoring all the practice's projects. Wayne Williams lives in Southern California.

Adrian Wilson / In 1929, he founded Adrian Wilson Associates, which he sold to the TI Corporation in 1970. His architectural firm had offices in Japan, Vietnam, Korea, the Philippines, Turkey and Thailand and he designed numerous landmarks in downtown Los Angeles. His portfolio of built projects include the Arnold Schoenberg Center at the University of Southern California, and the Pueblo del Rio Public Housing project in Vernon (1942), the Criminal Courts and Hall of Administration buildings in Los Angeles, and the Anaheim, Las Vegas and Honolulu convention centers. Adrian Wilson died in Los Angeles at the age of 90.

Paul Williams begründete seinen Ruf mit Luxusvillen für Filmstars wie Tyrone Power, Frank Sinatra, Humphrey Bogart, Lauren Bacall und Cary Grant. Er war der erste Afro-Amerikaner, der Mitglied des American Institute of Architects wurde. 1896 in Los Angeles geboren, wurde Williams im Alter von vier Jahren Vollwaise. Er studierte Architektur an der University of Southern California und war von 1915 bis 1973 als Architekt tätig. Sein Büro hatte Niederlassungen in Los Angeles, Washington D.C. und Bogotà, Kolumbien. Insgesamt entwarf und bauten er und seine Mitarbeiter rund 1000 Einfamilienhäuser. Zu seinen berühmtesten öffentlichen Gebäuden zählen das Saks Fifth Avenue (mit John und Donald Parkinson) und das Landgericht von Los Angeles aus den 50er-Jahren. Paul Williams starb im Januar 1989.

Wayne R. Williams (geb. 1919 in Los Angeles) schloss sein Studium an der University of Southern California 1942 mit einem B.Arch. ab. Im 2. Weltkrieg baute er Flugzeughangars und militärische Anlagen. Von 1949–73 arbeitete er zusammen mit Whitney Smith in Pasadena an allen Projekten des gemeinsamen Büros. Wayne Williams lebt heute in Südkalifornien.

Im Jahr 1929 gründete Wilson das Büro Adrian Wilson Associates, das er 1970 an die TI Corporation verkaufte. Er unterhielt Büro-Niederlassungen in Japan, Vietnam, Korea, den Philippinen, der Türkei und Thailand und baute zahlreiche bedeutende Gebäude in der Innenstadt von Los Angeles. Sein Oeuvre umfasst z.B. das Arnold Schoenberg Center der University of Southern California und die Sozialbausiedlung Pueblo del Rio in Vernon (1942), das Gebäude der Strafkammer und die „Hall of Administration" (Stadtverwaltung) in Los Angeles sowie die Kongresszentren von Anaheim, Las Vegas und Honolulu. Adrian Wilson starb im Alter von 90 Jahren in Los Angeles.

Paul Williams doit sa réputation internationale à des résidences luxueuses qu'il réalise pour des vedettes de cinéma comme Tyrone Power, Frank Sinatra, Humphrey Bogart, Lauren Bacall et Cary Grant. Il est le premier Afro-américain membre de l'American Institute of Architects. Né en 1896 à Los Angeles, orphelin à quatre ans, il étudie l'architecture à l'Université de Californie du Sud et exerce de 1915 à 1973. Son agence a des filiales à Los Angeles, Washington D.C. et Bogota, Colombie. Il a conçu et construit environ 1000 maisons. Parmi ses œuvres les plus connues figurent l'immeuble de Saks Fifth Avenue, avec John and Donald Parkinson, et le tribunal du Los Angeles County, tous deux des années 1950. Il meurt en janvier 1989.

Né à Los Angeles en 1919, Wayne Williams sort licencié de l'Université de Californie du Sud en 1942. Pendant la seconde guerre mondiale, il conçoit des hangars et des installations militaires. De 1949 à 1973, il est associé à Whitney Smith à Pasadena, Californie, avec lequel il signe tous les projets de leur agence. Il vit aujourd'hui en Californie du Sud.

En 1929, il fonde Adrian Wilson Associates, qu'il cède à TI Corporation en 1970. Son agence possède des bureaux au Japon, au Viêtnam, en Corée, aux Philippines, en Turquie et en Thaïlande. Il a construit de nombreux immeubles importants du centre de Los Angeles. Parmi ses réalisations ; le Centre Arnold Schoenberg de l'Université de Californie du Sud, et le Pueblo del Rio Public Housing Project à Vernon (1942), les bâtiments des cours pénales et le hall de l'administration de Los Angeles ainsi que les centres de congrès d'Anaheim, Las Vegas et Honolulu. Il meurt à Los Angeles à l'âge de 90 ans.

Bibliography | Bibliographie | Bibliographie

On Californian and American Architecture
Articles

John Entenza, The Case Study House Program, in *arts & architecture*, January 1945

Arthur Gallion, Architecture of the Los Angeles Region, in *Architectural Record*, May 1956

Esther McCoy, 7 Pioneers Who Showed the Way, in *Los Angeles Times Home Magazine*, September 9, 1956

Esther McCoy, Roots of California Contemporary Architecture, in *arts & architecture*, October 1956

Various Authors, *L'Architecture d'Aujourd'hui*, October 1956

James Ackerman, *Report on California*, October 1956

Various Authors, *Architectural Review*, May 1957

Esther McCoy, Young Architects in the United States, in *Zodiac*, August 1961

Esther McCoy, West Coast Architects VI (Quincy Jones-Emmons), in *arts & architecture*, May 1966

Michael Franklin Ross, The Japanese Influence, in *Architecture California*, September/October 1985

Ray Kappe, Regionalism: Climate, Site, and Materials, in *Architecture California*, February 1991

Books

Frank Harris and Weston Bonenberge, *A Guide to Contemporary Architecture in Southern California*, Los Angeles 1951

Henry-Russell Hitchcock and Arthur Drexler (eds), *Built in USA: Post-War Architecture*, New York 1952

Douglas Honnold, *Southern California Architecture: 1769-1956*, New York 1956

Esther McCoy, *Five California Architects*, Los Angeles 1960

Esther McCoy, *Richard Neutra*, New York 1960

Wolf Von Eckart, *Mid-Century Architecture in America. 1949-1961*, Washington D.C. 1961

David Gebhard, *Schindler*, London 1971

Reyner Banham, *Los Angeles: The Architecture of Four Ecologies*, New York 1971

David Gebhard and Harriette Von Breton, *L.A. in the 30's*, Los Angeles 1975

Esther McCoy, *Case Study Houses, 1945–1962*, Los Angeles 1977

David Gebhard, *The Architecture of Gregory Ain*, Santa Barbara 1980

Esther McCoy, *arts & architecture: The Entenza Years*, Cambridge, Mass. 1980

Paul Gleye, *The Architecture of Los Angeles*, Los Angeles 1981

Thomas Hines, *The Search for Modern Architecture: Richard Neutra*, New York 1982

Esther McCoy, *Guide to U.S. Architecture, 1940–1980*, Santa Monica 1982

Stefanos Polyzoides, Roger Sherwood, James Tice, *Courtyard Housing in Los Angeles*, Berkeley 1982

Robert Judson Clark and Thomas Hines, *Los Angeles Transfer: Architecture in Southern California*, Los Angeles 1983

Esther McCoy, *The Second Generation*, Salt Lake City 1984

August Sarnitz, *R. M. Schindler. Architekt*, Wien 1986

Mary A. Vance, *Architecture of Los Angeles: Journal Articles 1979–1987*, Los Angeles 1987

Cleo Baldon, Ib Melchior, *Steps and Stairways*, New York 1989

Joseph Rosa, *Albert Frey – Architect*, New York 1990

Various Authors, *Blueprints for a Modern Living: History and Legacy of the Case Study Houses*, Los Angeles 1991

Lisa Germany, *Harwell Hamilton Harris*, Austin 1991

Lesley Jackson, *Contemporary Architecture and Interiors of the 1950's*, London 1994

Karen E. Hudson, *Paul R. Williams, Architect. A Legacy of Style*, New York 1993

Frank Escher, *John Lautner, Architect*, London 1995

On Architecture and Photography: Theory and Techniques
Articles

Julius Shulman, The Architect and the Photographer, in *AIA Journal*, December 1959

G.E. Kidder Smith, How To Photograph Architecture, in *Architectural Forum*, April 1959

Ezra Stoller, Photography and the Language of Architecture, in *Perspecta*, 1963, n.8

Julius Shulman, How to Look at a Building: Part I, in *The Professional Photographer*, February 1965

Julius Shulman, How to Look at a Building: Part II, in *The Professional Photographer*, March 1965

Julius Shulman, How to Look at a Building: Part III, in *The Professional Photographer*, April 1965

Julius Shulman, How to Look at a Building: Part IV, in *The Professional Photographer*, May 1965

Julius Shulman, How to Look at a Building: Part V, in *The Professional Photographer*, June 1965

Julius Shulman, Project: ENVIRONMENT USA, in *AIA Journal*, August 1965

G.E. Kidder Smith, Photography for the Architect, in *RIBA Journal*, September 1965

John Donat, The Camera Always Lies, in *RIBA Journal*, February 1968

Julius Shulman, Angles in Architectural Photography, in *AIA Journal*, March 1968

Julius Shulman, A Case for an Honest Awards Image, in *AIA Journal*, August 1968

Fuller Moore, Spatial Distortion in Architectural Photography, (unpublished paper), 1971

Julius Shulman, A Photographer's Perspective on Neutra, in *AIA Journal*, August 1977

Tom Picton, The Craven Image, in *Architectural Journal*, July 25, 1979

Tom Picton, The Craven Image: Part II, in *Architectural Journal*, August 1, 1979

Carlo Bertelli, La Fotografia come Critica Visiva dell'Architettura, in *Rassegna*, June 1984

Gaddo Morpurgo, Architettura e Trascrizione Fotografica dello Spazio, in *Rassegna*, June 1984

Pier Paride Vidari, Fotografia per Comunicare l'Architettura, in *Rassegna*, June 1984

Thomas Fisher, Image Building, in *Progressive Architecture*, August 1990

Various Authors, Architecture and Photography, in *Architecture California*, May 1992

Simon Niedenthal, "Glamourized Houses": Neutra, Photography, and the Kaufmann House, in *JAE*, November 1993

Joseph Rosa, Architectural Photography and the Construction of Modern Architecture, in *History of Photography*, Summer 1998

Books

Julius Shulman, *Photographing Architecture and Interior*, New York 1962

Eric de Maré, *Architectural Photography*, London 1975

Susan Sontag, *On Photography*, New York 1977

Roland Barthes, *Image, Music, Text*, New York 1977

Julius Shulman, *The Photography of Architecture and Design*, New York 1977

Akiko Busch, *The Photography of Architecture: Twelve Views*, New York 1987

Roland Barthes, *Camera Lucida*, New York 1981

Joseph Rosa, *A Constructed View*, New York 1994

On the Nature of the Archive, on the Notion of Authorship, on Representation and on the Media
Books

George Kubler, *The Shape of Time: Remarks on the History of Things*, New Haven 1962

Marshall MacLuhan, *Understanding Media*, New York 1964

Walter Benjamin, *Illuminations*, New York 1968

Michel Foucault, *L'Archéologie du Savoir*, Paris 1969

Guy Debord, *La société du spectacle*, Paris 1971

John Berger, *Ways of Seeing*, New York 1972

Carolyn M. Bloomer, *Principles of Visual Perception*, New York 1976

John Berger, *About Looking*, London 1980

John Tagg, *The Burden of Representation: Essays on Photographs and Histories*, Amherst 1988

Marshall MacLuhan, *The Medium and the Messenger*, Toronto 1989

Beatriz Colomina, *Privacy and Publicity: Modern Architecture as Mass Media*, Cambridge, Mass. 1994

Sara Mills, *Discourse*, New York 1997

Index | Index | Index

Acknowledgements | Danksagung | Remerciements

To my parents, Maria Giulia Miano and Giuseppe Serraino
(1924–1999)

I owe gratitude to a large number of people who supported this
book. The major concept of the book was part of my thesis for
my Master of Arts in Architecture at the University of California
Los Angeles. I am grateful to Sylvia Lavin, chair of the Depart-
ment of Architecture, for having introduced me to Julius Shul-
man. My heartfelt gratitude goes to Judy McKee for her dedi-
cation to this book and her moral support. I want to particularly
thank my publisher Benedikt Taschen and my editor Peter
Goessel for understanding the importance of the topic and
their trust in my ability to complete such an ambitious project
with scholarly skill; I am indebted to Elizabeth Douthitt Byrne,
librarian at the College of Environmental Design at the Univer-
sity of California in Berkeley, for her untiring ability to answer
my many questions; to Tino, Dina and Giovanna Trischitta for
providing shelter during my numerous trips to Los Angeles;
and to Julia Ng for her infinite patience in editing my often un-
clear texts. I would like to thank the AIA/AAF Scholarship Com-
mittee for awarding me a Fellowship for Advanced Study or
Research in 1997 to support my research.
Above all, I wish to thank Julius Shulman for the gift of our
unique time together.

Pierluigi Serraino

Dieses Buch widme ich meinen Eltern
Maria Giulia Miano und Giuseppe Serraino (1924–1999)

Für vielfältige Unterstützung bei der Erstellung des Manuskripts
bin ich vielen Menschen zu Dank verpflichtet. Die Grundlagen
zu diesem Buch legte ich mit meiner Magisterarbeit an der
University of California in Los Angeles (UCLA). Die Direktorin
des Fachbereichs Architektur, Sylvia Lavin, vermittelte mir dan-
kenswerterweise den Kontakt zu Julius Shulman. Judy McKee
danke ich für ihre Ermutigung und moralische Unterstützung.
Dem Verleger Benedikt Taschen und dem Herausgeber Peter
Gössel möchte ich meinen Dank dafür aussprechen, dass sie
an die Wichtigkeit des Themas geglaubt und mir vertraut haben,
dass ich dieses ehrgeizige Publikationsvorhaben mit der nötigen
wissenschaftlichen Kompetenz zu einem guten Ende bringen
würde. Elizabeth Douthitt Byrne, Bibliothekarin am College of
Environmental Design der University of California in Berkeley hat
auf alle meine möglichen und unmöglichen Fragen immer eine
Antwort gewusst. Tino, Dina und Giovanna Trischitta haben mich
während meiner zahlreichen Aufenthalte in Los Angeles gast-
freundlich aufgenommen. Julia Ng hat meinen an vielen Stellen
unklaren Text mit unendlicher Geduld redigiert. Der Stipendien-
Ausschuss des AIA/AAF gewährte mir 1997 ein Forschungs-
stipendium, das mir die Arbeit an diesem Projekt ermöglichte.
Ihnen allen gilt mein tief empfundener Dank.
Vor allen anderen aber danke ich Julius Shulman für das
einzigartige Geschenk unserer Begegnungen und Gespräche.

Pierluigi Serraino

A mes parents Maria Giulia Miano et Giuseppe Serraino
(1924–1999)

Je suis redevable à de nombreuses personnes qui m'ont aidé à
réaliser cet ouvrage. Il a été conçu comme faisant partie d'un
mémoire de maîtresse présenté dans le cadre de mon Master
of Arts en architecture à l'Université of Californie Los Angeles.
Je suis reconnaissant envers Sylvia Lavin, directrice du départe-
ment d'architecture, de m'avoir présenté à Julius Shulman. Ma
gratitude la plus sincère va à Judy McKee pour le temps qu'elle
a consacré à ce travail et son soutien moral. Je tiens à remer-
cier Benedikt Taschen, éditeur, et Peter Gössel pour avoir cru
à l'importance de ce sujet et à ma capacité à mener à bien
un travail aussi ambitieux dans un esprit universitaire; Elizabeth
Douthitt Byrne, bibliothécaire au College of Environmental De-
sign de l'University of California Berkeley, pour son talent à
répondre à mes questions impossibles; Tino Dina et Giovanna
Trischitta pour m'avoir accueilli chez eux lors de mes nombreux
voyages à Los Angeles; Julia Ng pour sa patience infinie dans
la révision de mes textes souvent peu clairs; le Comité des
bourses de l'AIA/AAF pour m'avoir accordé une bourse d'étude
en 1997 afin de m'aider dans mes recherches.
Par-dessus tout, je veux remercier Julius Shulman pour tous les
moments exceptionnels que nous avons passés ensemble.

Pierluigi Serraino

Imprint

Photo page 2: Benedikt Taschen, 1998
Photo page 4: William L. Pereira & Associates, Pereira
Residence, Los Angeles, California, February 20, 1962
Endpapers: Buff, Straub and Hensman, Recreation Pavilion,
Mirman Residence, Arcadia, California, February 3, 1959

To stay informed about upcoming TASCHEN titles, please
request our magazine at www.taschen.com/magazine or
write to TASCHEN, Hohenzollernring 53, D-50672 Cologne,
Germany; contact@taschen.com; Fax: +49-221-254919.
We will be happy to send you a free copy of our magazine,
which is filled with information about all of our books.

This book is an abridged edition of TASCHEN's original
version published in 2000.

Edited by Peter Gössel
Editorial coordination by Nicola Senger
Design: Sense/Net, Andy Disl and Birgit Reber, Cologne
Cover design: Sense/Net, Andy Disl and Birgit Reber,
Cologne

German translation: Annette Wiethüchter, Kyra Stromberg
French translation: Jacques Bosser

Printed in China
ISBN 978-3-8365-0326-6

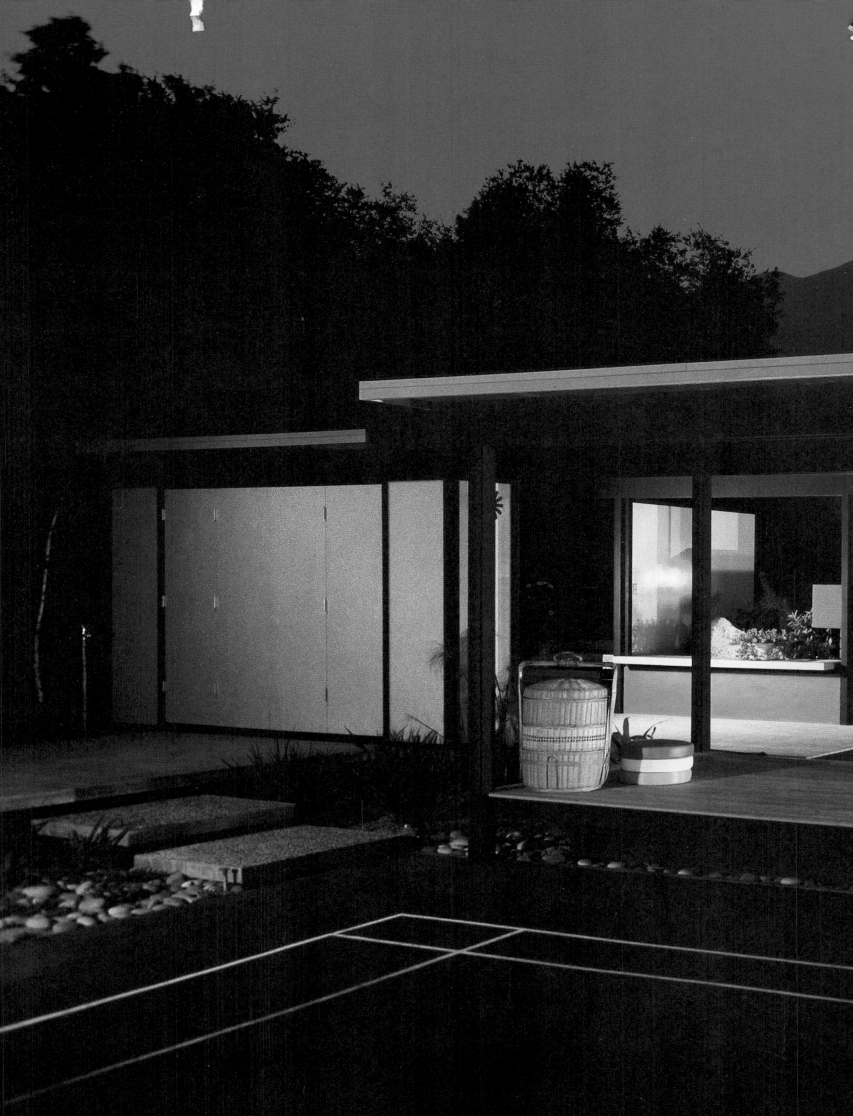